MICHELANGELO'S THEORY OF ART

Other volumes on the Renaissance by the author:

Critical Theory and Practice of the Pléiade
(Cambridge, Mass., Harvard University Press, 1942)

Platonism in French Renaissance Poetry, with Robert V. Merrill
(New York, New York University Press, 1956)

The Peregrine Muse: Studies in Comparative Renaissance Literature
(Chapel Hill, University of North Carolina Press, 1959)

Picta Poesis: Literary and Humanistic Theory in Renaissance Emblem Books
(Rome, Edizioni di storia e letteratura, 1960)

The Poetry of Michelangelo
(forthcoming)

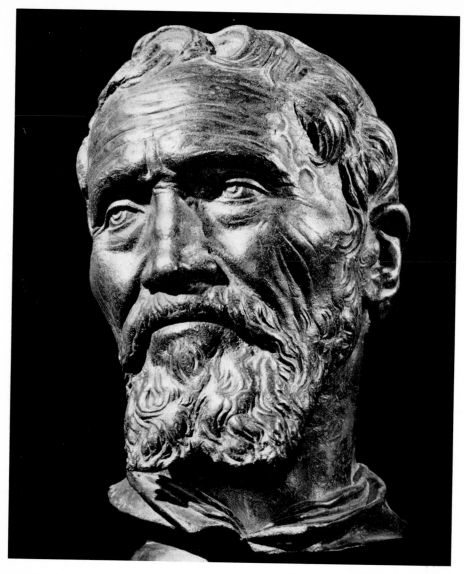

MICHELANGELO BUONARROTI,

BRONZE AFTER DEATH MASK

Daniele da Volterra. Milan, Pinacoteca Comunale

"La pittura e la scultura, la fatica e la fede m'àn rovinato, e va tuttavia di male in peggio. Meglio m'era ne' primi anni che io mi fussi messo a fare zolfanelli."

"Painting and sculpture, fatigue and faith have ruined me, and things are still going from bad to worse. It would have been better if in my youth I had hired myself out to make sulphur matches."

See pages 386 – 87.

MICHELANGELO'S THEORY OF ART,

ROBERT J. CLEMENTS

NEW YORK UNIVERSITY PRESS · 1961

CB1

PARENTIBUS CARISSIMIS

MILDRED WARNER CLEMENTS
EARL WILLIS CLEMENTS

Preface

A STUDY of such a broad and subtle topic as Michelangelo's thought and aesthetics has necessitated calling upon the specialised talents of several learned friends and colleagues. The counsel of Leon Battista Alberti seemed especially applicable to this volume:

Bisogna dunque por nelle cose una diligenza moderata, chiederne parere agli amici, anzi nel metter in atto detto lavoro, è bene stare ad ascoltare, a chiamare a vederlo di tempo in tempo quasi ciascuno.

While several friends were thus called upon over a decade of study, thanks are due especially to Professor Ulrich Middeldorf, whose vast erudition and penetrating judgement were so constantly at my disposition that he became no less than a collaborator on this volume. Professors Elio Gianturco and Charles de Tolnay shared their wisdom as well as their knowledge, as did Dr. Eugenio Battista, the prolific Renaissance scholar in Rome. The administration of the Joseph H. Clark Bequest of Harvard University and the Council on Research of the Pennsylvania State University kindly voted financial assistance toward the preparation of the typescript and plates. Publication was finally assured by generous grants from the Cesare Barbieri Endowment and the American Council of Learned Societies. The editors of the Journal of the Warburg Institute (London), of *Italica*, and of the Publications of the Modern Language Association have given permission to reproduce portions of this investigation already published in those reviews.

In closing, a last vote of gratitude goes out to Caird and Cleveland

and Helen Card Clements, who refrained admirably from echoing the plaint of Samuel Clemens in *Innocents Abroad*:

I do not want Michelangelo for breakfast, for luncheon, for dinner, for tea, for supper, for in between meals!

<div align="right">R. J. C.</div>

New York City

Contents

Preface ix

Introduction xvii

Lack of source materials by Michelangelo—xvii; Meanings of his art—xix; Primary and secondary source materials available—xxi; Aims of present investigation—xxiv; Chapters and divisions—xxviii; Coincidence of artistic and literary theory—xxix; Editions used—xxxi.

Chapter I: Beauty, Intellect, and Art 1

Platonistic concepts, images, ideals of beauty—3; Inner and exterior vision—7; The concept of the *intelletto*—14; Art forms, *concetti*, predetermined in the materials—20; "Compasses in the eyes"—29; Partnership of mind and hand —35; Recognition of one's limitations—37; Quantitative and qualitative production—39; Unity—41; Art vs. nature: inspiration and creative fury—43; Music and the "unmusical"—52; Effort—55; Alacrity in art—61; *Sprezzatura*—64.

Chapter II: Religion, Morality, and the Social Function of Art . 67

Michelangelo's faith and mysticism—69; Religious definition of art—74; Moral nature and function of art—80; The iconolatrous controversy—83; Personal morality of artists—84; Bisexuality—88; *Terribilità*—93; Katharsis —95; Michelangelo's immoral painting—99; Religion and architecture—103; Christian vs. pagan themes—104; Sweetness vs. utility—110; Art as veiling or feigning—111; Art as a socio-political force—112; Art and war—118; Michelangelo's moral indictment of art—126.

Chapter III: Neoclassical and General Theories 131

Classical themes—133; The cult of Glory—135; Signatures and self-portraits
—136; Commercialism—141; Loss of works—143; Imitation—146; Portrai-
ture—153; Plagiarism—157; Innutrition—160; Quarrel of the Ancients and
Moderns—165; Insistence upon form—169; Anatomy and the male nude—170;
Titanism—173; *Furia*, the line of Beauty, and *contrapposto*—175; Baroque
—179; Art as the capture of basic form—185; Form vs. content—186; Women
as subjects—187; Decorum—192; Knowledge—195; Taste—198; Scorn of
the *profanum vulgus*—199; Ivory towerism—201; Realism and verisimilitude
—207; Disinterest in external nature—208; The grotesque and Gothic—214;
Invention—219; Words of *Dì* and *Notte*—222; Allegory and iconography
—225; Nobility and sublimity—233; *Ut pictura poesis*—239; Techniques and
tricks of the trade—242; Models—244; Concurrent projects—248; Color vs.
line—249.

Chapter IV: Applied Criticisms 253

Michelangelo as critic—255; Criteria of criticism—255; Nationalistic bias
—257; Rome vs. Florence—259; Veneration of classic art and artists—262;
Spain—264; Germany—266; Flanders—268; France—270; Italian centers of
art—271; Favorable comments on Italians: Painting—275, Sculpture—282,
Architecture—285; Unfavorable comments: Painting—286, Sculpture—290,
Architecture—292; Michelangelo's twenty-four bases of criticism—294; Con-
clusion—297.

Chapter V: Comparison and Differentiation of the Arts . . . 300

Early preference for sculpture—301; Evolution from sculptor to painter—303;
Michelangelo Trismegistus—306; Design and draftsmanship—307; Painting
equated with design, unifier of the arts—309; The Paragone: rivalry between
painting and sculpture—311; Architecture—318; Vitruvius—320; The minor
arts—326.

Chapter VI: The Ordeal of Art 329

Genius per aspera—329; Financial distress—330; The patronage system—332;
Financial unconcern for self—335; Technical troubles in art—342; Challenge
of materials—343; Adverse weather—345; Inadequate assistants—347; Mi-
chelangelo's failure to create a "school" of art—351; Senescence and thana-
tophobia—354; Illnesses and exhaustions—360; Pressures and servitude of
the artist—365; Humiliations—373; Persecution complex and sensitivity to

dangers real and imagined—375; Rumors and slander—379; Michelangelo's irascibility and asociability—383; Resultant condemnations of the fine arts —386; Compensations and therapeutic values of art—388; Stoicism, positivism, optimism—393.

Chapter VII: Summations and Paradoxes 395

Continuity or discontinuity of his thought—395; Orthodoxy or heterodoxy of his thought—399; Consistency or inconsistency of his thought—409; Paradoxes in his personality—410; The artist revealed in his work—413; The sling and the bow—415.

Notes 421

Bibliographical Note 458

Table of Italian and English Titles of Michelangelo's Major Works 459

Plates 462

Indexes 463

Plates

FRONTISPIECE Michelangelo Buonarroti, Bronze after Death Mask, *Daniele da Volterra. Milan, Pinacoteca Comunale.*

I. San Matteo. *Florence, Accademia delle Belle Arti.*

II. Study of Figures for Medici Tombs, with Analytical Lines. *London, British Museum.*

III. Madonna, Detail from the Giudizio Universale. *Rome, Sistine Chapel.*

IV. Brutus. *Florence, Museo Nazionale.*

V. Il genio della Vittoria. *Florence, Palazzo Vecchio.*

VI. Portrait of Duke Alfonso of Ferrara, *Titian. New York, Metropolitan Museum.*

VII. Sibilla Eritrea, Detail. *Rome, Sistine Chapel.*

VIII. Rest on the Flight into Egypt, *Flemish School, XVI*th *Century. New York, Metropolitan Museum.*

IX. La Battaglia di Cascina, Detail. *From copy by Aristotile da Sangallo. Norfolk, Holkham Hall. Detail, from engraving by Marcantonio Raimondi. Boston, Museum of Fine Arts.*

X. Sketches of Grotesques. *London, British Museum.*

XI. Pisa Cathedral, West Façade, Detail of Capital.

XII. La Notte. *Florence, Medici Chapel.*

XIII. Eva Prima Pandora, *Jean Cousin the Elder. Paris, Louvre.*

XIV. Adam, *Albrecht Dürer. Madrid, Prado Museum.*

XV. Resurrection of Lazarus, *Sebastiano del Piombo. London, National Gallery.*

XVI. Saint Mark, *Donatello. Florence, Or San Michele.*

XVII. Projects for the Basilica of Saint Peter's, *Raphael, Peruzzi, Antonio da Sangallo, Bramante, Michelangelo.*

XVIII. Palazzo Farnese, Window and Cornice, *Michelangelo. Rome.*

XIX. The Belvedere Torso. *Rome.*

XX. Sketch for Bronze David, with Study of Right Arm of Marble David. *Paris, Louvre.*

Introduction

*Chi mi darà la voce e le parole
Convenienti a sì nobil subietto?*

LODOVICO ARIOSTO
Orlando furioso

OF THE several meanings a work of art holds, not the least
important is its significance to its composer. Unfortunately, most artists
do not leave behind them, as did Leonardo, Joshua Reynolds, and Dela-
croix, a welcome corpus of thoughts on art, or exegeses like that of the
unhappy Veronese before the Venetian Inquisitors. Nor do they, like
Cellini, take the time and pains to describe the personal or doctrinary
relationships existing between themselves and their creations, thereby
enabling us to view these creations as they intend we should. Michelangelo
Buonarroti did not write a treatise on art, and our feeling of loss is height-
ened by the knowledge that on several occasions he expressed the intention
of doing so. In the *Dialoghi* of Donato Giannotti (1546), Luigi del Riccio
asks whether it is true that Michelangelo wishes to write on painting. The
artist replies, "Io ve l'ho detto, et lo farò ad ogni modo, se Dio mi darà
tempo che io lo possa fare."[1] ("I've told you that I would, and I shall one
way or another, if God will give me the time to do it.") Elsewhere we
learn that he planned a study to be entitled *(Il Trattato) di tutte le
maniere de' moti umani, e apparenze, e dell'osse; con una ingegnosa Teo-
rica, per lungo uso ritrovata.*[2] The closest he ever approached such a study
was the fragment of a madrigal in tercet rime (XCIII) designed to teach
painters how to do an eye: "El ciglio col color non fere el uolto." His
unfulfilled plan was compensated only somewhat by the appearance of

De re anatomica (1559) by his friend and physician Realdo Colombo and of Vincenzo Danti's *Delle perfette proportioni* (1567), Buonarrotian in spirit. Actually Vasari's proems are closer to that spirit. Perhaps—and it is this same Vasari whom we quote—Michelangelo did not set down his theoretics because "he mistrusted his ability to express in writing what he would have liked, not being trained in discourse."[3] Condivi wrote of Michelangelo, who had reached his maturity, "Nor does he think that he can express his fancy to the world in writing."[4] For this reason, it is inferred, Michelangelo revealed his thoughts to Ascanio, who was to record them for him. Unfortunately, Condivi did not establish, and perhaps could not have established, an aesthetics for Michelangelo; he died prematurely by drowning. Even the more learned Vasari missed his chance. The painter-biographer relates that during one holiday period he was with Michelangelo daily, including "one day in Holy Year when together they joined a cavalcade visiting the Seven Churches." On this occasion they exchanged many fine, rewarding, and eager (*industriosi*) reasonings about art. Vasari says that he will set down the dialogue and publish it.[5] While nothing of the sort saw the light of day, the aforementioned theorising in the proemia of his *Vite* gives us an excellent clue as to what might have been the tenor of their conversations.

Symonds expressed a regret shared by all: "For the anxious student of his mind and life-work, there is nothing more desolating than the impassive silence he maintains about his doings as an artist. He might have told us all we want to know, and shall never know about them. But while he revealed his personal temperament and his passions with singular frankness, he locked up the secret of his art and said nothing."[6] More recently Valerio Mariani concurred as follows: "Perhaps no one has ever kept more to himself than Michelangelo what was stirring in his soul during the act of creation."[7]

If further proof of Michelangelo's hesitancy about writing prose were needed, there is his epistle to young Cavalieri recalling the dictum that "the pen cannot even approach one's right intent."[8] This thought behind his reticence he expressed again in a confessional sonnet to God (CXL): "onde non corrisponde / La penna all'opre e fa bugiardo 'l foglio." ("whence the pen does not correspond to the workings of my spirit and

makes the sheet a falsehood"). He was modest and unsure of his ability to express himself in prose and equally self-conscious about his poems, those "silly things," "heavy pastries," or even "rubbish" (Letter CDLXV), as he called them (see Chapter III). He apologised that his dabbling in poetry proved him back in a second childhood (*rimbambito*). Yet his contemporaries considered him, as we do today, an accomplished man of letters, especially after the pedantic Varchi guaranteed his belletristic reputation in 1549, the publication date of the latter's *Due lezioni.*[9] On Michelangelo's catafalque his contemporaries placed effigies representing the arts of design and the art of poetry, the latter figure being made by Domenico Poggini.[10]

Even without having completed these tracts which he planned to leave to posterity (he knew his Horace too well to forget that words can outlast monuments), Buonarroti threw off hints in incidental conversation, in letters, in *richordi* and marginal notations, in poems—disparate sources opening up new avenues of understanding. The poems depicting the artist being torn asunder by love explain his drawing of Tityus (x). A reading of Michelangelo's invective against the godless of Rome who vend the blood of Christ enables one to understand better the *Cristo giudice,* or the *Cristo risorto,* for which Michelangelo contracted just a year or two after the poem was written. By studying one of his autograph stanzas one learns that the four Times of the Day in the Medici Chapel signified for Michelangelo the velocity of time. His quatrain on the *Giorno* and the *Notte,* as we shall learn, reveals to us the political meaning which the Tomb of Duke Giuliano eventually came to hold for him. A quatrain inscribed on the lost bronze *David,* known only in French translation, tells, as we shall see, of the youthful hero's consciousness of his prowess, explaining the triumphant pose finally assumed by that bronze. A brief scholium, perhaps penned by chance, points the way to the subjective significance of the two Davids, marble and bronze, a significance otherwise sealed hermetically within the materials. As a final case in point, an investigation of Michelangelo's convictions about mimesis, uttered to a group of friends, will help us decide whether, for example, his *Adamo* of the Sistine Ceiling was inspired by the gates of Ghiberti, as alleged.

Therefore, a new and virtually unexplored approach to understand-

ing the creations of Michelangelo emerges from a study of the thoughts, spontaneous and symptomatic, which he voiced or penned at occasional moments. It is true that a vast amount of scholarly criticism and interpretation has been devoted to Michelangelo. The Steinmann-Wittkower *Michelangelo-Bibliographie* lists 2,107 titles, and this total does not include the numerous titles which have appeared since 1926 (see Bibliographical Note). Despite this brilliant pioneering—despite the original investigations of Grimm, Symonds, Thode, Borinski, Gotti, Frey, Steinmann, De Tolnay, Papini, Panofsky, and others—it is probably accurate to state that no single volume has set out to accomplish precisely the task to which this book is dedicated. This task is to gather from their many and divers sources the artist's every recorded statement on his art and, using these primarily, to reconstruct his personal aesthetic or critical system, confident that patterns exist behind the variety and even inconsistency. Existence and accessibility of such a system will, it is hoped, afford clues to the inner meanings of his creations or at least multiply the possible number of exterior meanings. If, as one student of Michelangelo claims, few critics have ever studied this artist's work taking into account his true intentions,[11] this fact alone would justify the attempt to reassemble in these pages a critical system recognisable as Michelangelo's own. Sherman Lee concludes while studying the meaning of Michelangelo's curious *Sogno*, "We can be fairly safe only when we add to our eyes and our science the eyes and minds of those people we are studying, however laborious the task of recreating their point of view."[12]

Only in recent years have Michelangelo scholars even approached such a reconstruction. Nesca Robb and Anthony Blunt have assessed briefly some of the art theory and Neo-Platonism of the *Rime*.[13] In a little-known article in *Escorial*, Juan Ramón Masoliver has collected key passages from the familiar sources and has commented brilliantly but summarily upon them.[14] Similar in nature and scope is Rezio Buscaroli's *Il Concetto dell'arte nelle parole di Michelangelo*, which is the printed form of an introductory lecture to his course on Michelangelo at the University of Bologna.[15] Like Buscaroli's study, Bianca Toscano's superficial *Il Pensiero di Michelangelo sull'arte* is merely an article printed singly as a monograph.[16] A rich analysis of Michelangelo's thought as revealed in

his poetry is found in the sensitive *Poesia di Michelangelo* of Valerio Mariani, who draws numerous analogies between Buonarroti's artistic and literary purposes.[17] Charles de Tolnay has touched upon Michelangelo's aesthetics on several occasions before proceeding to his definitive biography of the artist, and he will be quoted *passim*.

That none of these scholars, despite their erudition and subtlety, has tried the full reconstruction attempted by this volume is understandable. Michelangelo was extremely reluctant to talk shop, as his contemporaries testify, and he therefore left scant evidence for the establishment of a critical system. Fra Ambrosio da Siena once told Francisco de Hollanda that Michelangelo would steadfastly refuse to be drawn into a conversation about painting. Michelangelo's letter to Varchi written at the time of the humanist's referendum on the relative merits of painting and sculpture is testimony that Michelangelo was less interested in philosophising about art than in exercising his craft. When Vasari himself tried to sound him out on this referendum, Michelangelo refused to explain his position ("nè volle risolvermi niente").[18] This disinclination to discuss art, this avoidance of what he called *abboccamenti* (lengthy mouthings), even more than modesty about his prose, explains why he never wrote his treatise. This is not unusual among artists. Degas claimed that to write about painting is to waste words, that the message of the painter is conveyed right in the paint. The articulate Delacroix held that to devise treatises on the fine arts *ex professo* is wrong, a waste of time, a false and useless idea. Michelangelo betrays this disinclination in his correspondence. When his letters touch upon his profession, it is not to reveal some kernel of wisdom about art, but more usually to dicker about wages and accounts (humanising the *richordi,* so to speak), to complain about the Vatican's lack of co-operation, to insist upon his diminishing powers and aging body, and so on. His vague references to the Sistine Chapel ("dipigniere qua cierte cose," "la Capella che io dipignievo," etc.) are exasperatingly noncommittal. Only Dürer's travel journal in Holland, with its consistent avoidance of speculation on art, is as disappointing. Yet we shall not agree entirely with the assertion, "Of his own writings, the letters contain almost nothing of interest from the point of view of theory."[19] Here and there, after all, as in the letters to Giovanni Fattucci, Sebastiano

del Piombo, and Benedetto Varchi, a gleam of the critic appears, and no *obiter dictum* will be so trifling as to escape our notice.

The *Rime*, or, as Michelangelo once curiously called his poems, the *novelle*, contain numerous references to art.[20] These varied and confessional pieces, penned casually on the backs of letters, on margins of sketches, or on plans, penetrate his thought directly—if not, indeed, his subconscious, since a few (CIX, 77, and CIX, 78) were dreamed up at night ("nata di notte in mezzo al letto"). True, a few of these references to art merely supply the poet with a metaphor or a vehicle for his special brand of Petrarchism. Typical of these love sonnets couched in the imagery of his craft, but revealing nothing of Michelangelo's artistic persuasions, are "Non più che 'l foco il fabbro il ferro istende" and "Io mi son caro assai più ch' io non uoglia." Yet others complement or explain his artistic thought and expression in a manner unique. One cannot understand, for example, what led Michelangelo to portray himself in the skin of St. Bartholomew until one has read over a score of poems in which Michelangelo renounces his mortifying pelt. Or again, it would be pointless to study Michelangelo's feeling for nature without reading his bucolic stanzas. His poetry is both sensitive and intensely reflective. His rhyming was not merely a mechanism to escape the duties and pressures of his workshop, as Michelangelo would have you and me believe. There are several pieces of crucial importance to an understanding of his aesthetic ideas. Stressing this particular value of the *Rime*, Mariani writes that "Michelangelo never deigns to give a formulation [on art] other than a poetic one."[21] And Masoliver states that the poems can acquaint us with Michelangelo's artistic idearium just as the Sistine paintings give us insight into his theology.[22] It would be difficult to exaggerate the importance of these poems, especially the Neo-Platonic ones, which illuminate the state of mind of the artist, his concept of beauty, and his relationship with his craft and his works. There is general agreement that "his poems are a kind of spiritual autobiography that links up the chronicle of fact, as recorded by Condivi, with the movements of the inner world that was bodied forth in the vault of the Sistine and the Medici tombs."[23] And in, we hasten to add, the three *Pietàs* and the *Deposition*. If we consider Buonarroti's inherent honesty and the earnestness of his relations with the individuals to whom

so many of the poems were directed (Tommaso Cavalieri, Lodovico Beccadelli, Luigi del Riccio, Vittoria Colonna, and Christ), the poet's sincerity can scarcely be questioned.

Beyond the letters and poems, there are other possible avenues of investigation into Michelangelo's mind and into his aesthetics. There is the testimony of Francisco de Hollanda, as close to a Boswell or an Eckermann as Michelangelo ever had. Francisco has been assured a modest paragraph in the ledger of history for three principal reasons: he was a competent miniaturist, one of Portugal's most enthusiastic humanists, and an acquaintance of Michelangelo. This last relationship constitutes his chief title to fame. In the month of October, 1538, he was present at three conversations on art in which participated, among others, Michelangelo and his respected friend Vittoria Colonna. Together with a fourth dialogue in which Michelangelo does not figure, these *Dialogos em Roma* form the latter half of Francisco's *Da pintura antigua*, published in 1548 at Lisbon. None can dispute the interest of these dialogues and almost none have endeavored to contest their authenticity. The two exceptions are Hans Tietze and Carlo Aru, who are disposed to reject the good faith of Francisco and consider the conversations an arbitrary exercise in the dialogue genre, so popular in a Renaissance Italy nurtured on Plato.[24] The vast majority of Michelangelo scholars not only accept Francisco's truthfulness, but make constant use of his testimony. Symonds admits that "we may fairly accept his account of these famous conferences as a truthful transcript."[25] Elías Tormo states categorically, "After reading the work, there can be no one who will doubt the authenticity of the colloquies held in San Silvestro."[26] Menéndez y Pelayo finds in De Hollanda's *reportages* "such spontaneous and simple diction with such honest enthusiasm that they exclude any notion of fiction or rhetorical artifice and permit one to give wholehearted credence to the many and curious bits of historical evidence which the dialogues contain."[27] Although discerning a certain "polemic accentuation" in them, Mariani utilises the dialogues quite readily.[28] Confronted with identical evidence in Vasari and De Hollanda, Buscaroli concludes, "The equivalence is such—neither writer knew the other—that it could not be explained without supposing the information to be from the selfsame source, Michelangelo himself."[29] Probably the most extravagant claim made for the *Dialogos* is

· *xxiii*

that of Emilio Radius, to whom they "constitute as much as there remains of Michelangelo's aesthetics."[30] Certainly De Hollanda's transcript seems authentic in both letter and spirit. If one reads the *Dialogos* immediately after setting down the collected letters and *Rime* of Michelangelo, they ring genuinely true. In order to discount certain unfounded objections leveled at statements in the *Dialogos* and to justify my use of them in this volume, I have devoted an article to a demonstration of their reliability, in so far as this may be established after four centuries.[31] Similar demonstrations have been undertaken in Italy by Irene Cattaneo, Bessone Aureli, and Bianca Toscano.[32] Probably one can criticise the portrait of Michelangelo in the dialogues only as one might criticise Francisco's single extant drawing of his idol: one might wish for more details, but the accuracy of what one has is attested by a comparison with other evidence.

Obviously, the testimony of other contemporaries, and especially the biographers, will be utilised when it deals with Buonarroti's thoughts and criticisms on art. Ascanio Condivi, Donato Giannotti, Benedetto Varchi, Giorgio Vasari, Benvenuto Cellini, Giovan Paolo Lomazzo, Lodovico Dolce, Anton Francesco Doni, Vincenzo Danti, Paolo Pino, Raffaello Borghini, Giovan Battista Armenini, Federico Zuccaro, Baccio Bandinelli, Girolamo Ticciati, Raffaello da Montelupo, Pomponio Gaurico, Luca Pacioli, the Anonimo Magliabechiano represent some of the Italian Renaissance writers on art in whose works we have sought information concerning Michelangelo's thoughts and prejudices. The reader will find testimony from several Spanish Renaissance sources hitherto neglected or unknown. Evidence has turned up in even such unexpected quarters as Castelvetro's *Poetica* and Giraldi Cinzio's *Hecatommithi*. Even the later testimony of Bernini in the *Journal du Voyage du Cavalier Bernin* will be weighed, but with considerably greater caution. Thus, while the principal aim of this study is to provide a sort of intellectual synthesis, it will contain in addition a few "new"—that is, hitherto unexploited—materials.

Having stated in general terms the task which I have prescribed for this volume, let us examine more specifically what particular purposes it may serve. Irrespective of other functions, the work becomes by its very nature a repertorium of Michelangelo's every recorded pronouncement on art, whether written or quoted, whether from primary or secondary sources.

In general, these pronouncements will be presented in both the language of the original source (especially Michelangelo's exact words in Italian) and in English translation. The advantage of retaining the original language seems irrefutable, even to some extent when Michelangelo's thoughts have been recorded in Portuguese. Three categories of readers would obviously prefer such an arrangement: English-speaking readers who read foreign languages; readers whose native tongue is not English and who do not wish their sources tampered with; readers who subscribe to the *traduttore traditore* persuasion that nothing, least of all poetry, can ever be completely equated in a translation. As proof of this latter contention, some of the Neo-Platonic vocabulary (e. g., *intelletto*) might not have an exact equivalent in English to accommodate every context. Keeping in mind this anthological value of the present volume, I shall in general adopt the principle of reproducing the written or spoken words of Michelangelo rather than paraphrasing them or reintegrating them into this text.

We shall set for this study the task of seeking the sources of Michelangelo's ideas and concepts, including those on the periphery of his art theory. We shall look for them in Plato, Aristotle, Plotinus, and in other Hellenic or Alexandrian writers available in translation or widely discussed in the Cinquecento, for apparently Michelangelo knew no Greek. We shall hunt for them in Horace, Ovid, Vitruvius, Ficino, Poliziano, and other Latin and neo-Latin writers. Did Michelangelo know Latin? His schoolmaster Francesco da Urbino must have taught him some Latin "in its least graceful and grimmest form" (Brion), but his schooling ceased early. Every bit of meager evidence indicating that Buonarroti knew Latin well proves inconclusive upon closer inspection. The *Madonna della febbre* was signed in Latin, but the brief inscription ("Michael-Ãgelvs Bonarotvs faciebat")— similar to that on the *Furia* sketch—was a standard pretension of his time. Some of his artistic contracts, drawn up in Latin, exist also in Italian translation, as if for his benefit. In the *Dialogos em Roma* he quotes from the poetic art of Horace, but only the three well-known verses from the opening page ("Pictoribus atque poetis," etc.). He paraphrases the Latin of Vitruvius, but only after Vitruvius is abundantly available in Italian versions. That he knew Latin and Greek works might seem indicated by his remark to Donato Giannotti apropos of Dante's description of dawn, "Dico che io

non ho sentito mai che alcuno poeta, o latino o greco, habbia descritto in tal maniera l'aurora"[33] ("I say that I've never heard of any poet, either Latin or Greek, having described dawn in such a way"). Even here Michelangelo might be referring to authors available in translation. Buonarroti alone of the Florentine academicians petitioning Leo X about the disposition of Dante's bones (1518) signed in Italian.[34] Michelangelo's early association with the younger humanists of the Academy, plus the fact that Pope Clement offered him the opportunity to take minor orders, would seem to indicate that he knew some Latin. Also, as Bandinelli records (*Memorie ix*), Latin and Greek were freely exercised in the Rome of Michelangelo. An occasional Latin verse from Petrarch or another poet may be found among the artist's notes or sketches.[35] The most direct testimony from Michelangelo himself is encountered in Giannotti's "stenographic report." Someone mentions favorably Francesco Priscianese's elementary Latin grammar. Michelangelo observes that he is almost tempted to study from this manual:

per imparare lettere latine. Io ho pure sentito dire che Catone Censorino, cittadino romano, imparò lettere grece nel LXXX anno della sua età; sarebbe egli però così gran fatto che Michelangelo Buonarroti, cittadino fiorentino, imparasse le latine nel settantesimo? [36]

to learn Latin letters. I've heard it said that Cato the Censor, a Roman citizen, learned Greek letters in the eightieth year of his life; would it then be so surprising if Michelangelo Buonarroti, a Florentine citizen, were to learn Latin in his seventieth?

Michelangelo was in fact seventy-one at the time. Although it might be advanced that this remark was made in jest, that it was the conventional disclaimer of all students who have had only a modicum of "school" language, it seems a strong disclaimer taken in context. Elsewhere, in a note to his madrigal (LXXIII, 14) on Cecchino Bracci's death, he admits to speaking "grammatica" sometimes, "se bene scorretto." Philological indications that his Latin was "incorrect" are such forms as "rocta" on the scholium accompanying the sketch of the *David* in the Louvre (see Plate XX) and the pidgin-Latin phrase "sine pechata" in the aforementioned madrigal. In any case, Jonson's remark about Shakespeare's Latin and Greek would seem applicable to Michelangelo, at least toward the term of his life. Guasti is wise when he alludes ambiguously to "quel suo tanto latino"[37] and Frey comes to an even more negative conclusion.[38]

Returning to the second specific aim of this investigation, we shall search among the *trecentisti* and, more especially, the *quattrocentisti* for influences and affinities. Among these possible sources we shall reconnoiter for similarities of theory, of applied criticism, and of iconographical concepts. Correlations will be set up between Michelangelo's theories and those of his contemporaries with a view to showing in which ways Michelangelo's thought patterns were either conventional or individualistic. Since plagiarisms—so common among other Renaissance thinkers—will be almost non-existent in the case of this individualistic theorist (one notable exception: his paraphrase of Vitruvius), we shall not try in weighing possible plagiarisms to emulate those zealous scholars who have exploited source studies *ad absurdum* by finding a source for almost every gesture, pose, and line of Michelangelo's painted or sculptured figures. When we find that his ideas on design corresponded to those in Lorenzo Ghiberti's unpublished *Commentarii,* we shall not stretch our imagination to establish a *rapprochement.* It will be important to determine the extent to which Michelangelo's thinking is conventionally neoclassic or conventionally Christian, even though the modification and expression of that thinking remain peculiarly his. Is that biographer right who wrote that Michelangelo's life, unlike Raphael's, was divorced from moment and milieu? Or is Guillaume's contention more correct: "Michel-Ange eut en partage toutes les idées de son temps, et pour cela il est plus qu'un grand artiste; il est un grand homme"?[39]

Nor can we escape the obligation to correlate Michelangelo's theories with his creative productions in all the arts, seeking their meaning to their composer, as I stated at the outset. The reader is reminded, however, that the reconstruction of a latter-day *ars pictoria* for Michelangelo is in itself a vast undertaking and that the comprehensive and sustained correlation of this theory with all of Michelangelo's works is not the principal task of this volume, whose size would be considerably swollen if such were the case. If a considerable amount of such correlation is undertaken, this volume paves the way for further writers to carry on this collation. Since such correlations have heretofore been sometimes subjective and even fanciful in the case of Michelangelo, I shall try to limit ours to more verifiable instances.

We shall study in what measure his theoretical ideas affected his

technique and even his choice of subject matter. Finally, we shall hope to explain some of his persuasions about his art in the light of events in his life. Thus, the reader must expect to find the substance of these pages slowly progressing from abstract theory, the product of his humanistic and religious indoctrination, to concrete opinion and prejudice, the product of specific biographical factors.

Given the various raw materials contained in the letters, the *Rime*, the dialogues, the biographies, and other sources mentioned above, one may separate them into the realms of theory and criticism by which they naturally classify themselves. The unity of this study is established and circumscribed by the nature of the available materials themselves. These materials which have come down to us through mere fortuity (the conversations at San Silvestro just happened to touch upon the social value of art; Armenini or Lomazzo just happened to recall a certain statement by Michelangelo) will at times seem to resist any attempt to create out of them an organic unity and completeness, will seem "d'une forme au travail rebelle." We shall not try to force a unity upon the work, but shall accept as our task that prescribed by Alberti for the painter setting out to execute something of merit: "Finally, we shall take pains that everything be thought out and examined by us so that in our work there need be nothing of which it may be said that we do not know in which part of the work it is to be placed." As a result, not all the chapters will assume an equal length. As a further result, a few familiar elements of Renaissance theory are developed only slightly or even omitted altogether. For example, Michelangelo said and wrote disappointingly little about the artist's function of veiling truth or about the θεία μανία, the creative spasm which inspires an artist to achieve his greatest creations. Even so, the categories into which the materials fall will include most of the basic issues of aesthetics. These general categories will correspond to our chapters:

I. Beauty, intellect, and art
II. Religion, morality, and the social function of art
III. Neoclassical and general theories
IV. Applied criticisms
V. Comparison and differentiation of the arts

VI. Art as Ordeal

VII. Paradoxes.

The sixth chapter will not treat exclusively of abstract theorising on art, but largely of Michelangelo's personal relations with his craft. Even these quasi-autobiographical passages will serve the dual purpose of the excerpts contained in the other chapters. They will enrich our understanding of Michelangelo's opinions on art, and they will assist us in appreciating and interpreting better some of his artistic creations. Sainte-Beuve wrote that to understand an artist's work it is necessary to follow him as far as possible into his home.

As the reader examines the several topical categories which will make up the chapters of this volume, it becomes appropriate to recall a passage in Buscaroli's essay on Michelangelo's concept of art: "I do not know why Michelangelo has not yet found his place in the history of Renaissance philosophy of art, a place which he naturally deserves as a firm point of ideological reference."[40] While granting that Buonarroti was not a theorist in the ordinary sense, Buscaroli adds, "But a Michelangelesque theory of art can claim the right of a greater recognition, and it will be at one and the same time philosophy, as Vasari admitted, aesthetics and art criticism, that is, an essay of superlative spiritual unity."

Michelangelo's literary activities and his contacts with literary theorists would obviously seem to be reflected in his aesthetics. This is because in the Renaissance even more than today the theorising on literature and on art coincided in many ways and at many levels. Simonides' rediscovered comment that painting is mute poetry and poetry is spoken painting was a stimulant to this Paragone. In any case, the aesthetic problems which may be traced to antiquity and which interested the poet and painter alike were the same for each: art vs. nature, instruction vs. delight, form vs. content, ancients vs. moderns, imitation vs. invention. Such problems were debated in much the same terms in the literary academy and the artistic atelier. Petrarchism and Neo-Platonism affected the imagery of the poet exactly as they did the iconography of the artist. Michelangelo as artist "imitated"

Dante, Villani, and the *Dies Irae*—whereas writers "imitated" plastic sources. Witness how Sadoletus strove to imitate the classic craftmanship of the newly unearthed *Laokoön* in "elegant verse,"[41] even though, as Lessing pointed out, the marble group was already an "imitation" of a Vergilian passage. And Giovanbattista Zappi "translated" Michelangelo's *Mosè* into a sonnet. Marini's *Galleria* includes poetic "statues," "paintings," "portraits," and so on.[42] (See pp. 239–241.) I have assembled a number of these poetic-pictorial identifications in the first essay of my volume *The Peregrine Muse: Studies in Comparative Renaissance Literature* (Chapel Hill, 1959).

Unusual as it may seem, both poets and artists drew upon the same treatises of antiquity for their theoretical ideas about their crafts. The *Poetics* of Aristotle and the *Ars poetica* of Horace, which were the archsources of Renaissance literary thinking, were also the primary influences upon artistic thinking of the day. There was some talk of a corpus of artistic theory having existed in antiquity, but no one had ever seen the texts. In his *Idea del tempio della Pittura*, Lomazzo devotes a chapter to ancient and modern writers on art, but after listing the names of Polycletus, Lysippus, Praxiteles, and Apelles he acknowledges that he can say nothing of their writings since none has come safely down from classic times.[43] In *Della Pittura* Alberti also mentions learnedly (while recalling Pliny, Vitruvius, and Diogenes Laertius) that among the ancients, Euphranor, Antigonus, Xenocrates, Apelles, and Demetrius the Philosopher had written about art.[44]

What sources, then, could the Renaissance draw upon for its ideas on art? A good book has yet to be written on art theory in antiquity, continuing such pioneer studies as Franciscus Junius' *De pictura veterum* (1637) and H. Brünn's *Geschichte der Griechischen Künstler* (1889). It will have to analyse fragments scattered through the writings of Pausanias, Xenophon, Plutarch, Philostratus, Menaechmus, Quintilian, and Cicero in addition to those writers mentioned above. Treatises dedicated exclusively to art were almost nonexistent in antiquity. Chambers, in his *Cycles of Taste*, has remarked this lack and used it to refute Winckelmann's thesis that a conscious sense of beauty and aesthetics was alive in the Golden Age of Pericles.[45] The dependence of the Renaissance on the two treatises of Aristotle and Horace has been noted by Rensselaer Lee. He demonstrates

that, as the learned men of Renaissance knew only these, "they did not hesitate to appropriate as the foundation of their own theory many basic concepts of the two ancient treatises, making them apply in a more or less Procrustean manner to the art of painting for which they were never intended."[46]

If in our time the bridge between belletristic and bellartistic aesthetics is not quite so easily crossed, the crossing was a much simpler matter in the sixteenth century. Not only were the issues similar, but even a single vocabulary served both types. Setting down the various issues to be treated in the following pages, and especially the neoclassical issues of the third chapter, one is struck by their similarity with the problems of Renaissance literary theory. At all events, the scope of this study embraces both belles-lettres and fine arts. Without such purely literary sources as the *Rime*, this book could not have been written.

Quotations from the *Rime* of Michelangelo refer to the edition prepared by Carl Frey (*Die Dichtungen des Michelagniolo Buonarroti:* Berlin, 1897). Although Frey's authority and feeling for his material have been questioned, successive editions have followed the trail of this pioneer work with its carefully recorded variants. It was the first anthology to establish a chronological sequence of the poems, a sequence which later editors have adopted until the authoritative new edition of Girardi (Bari, 1960). Roman numerals in small capitals throughout this volume will refer to poems and fragments in the Frey edition. Excerpts from the correspondence carry the pagination of the collection gathered by Gaetano Milanesi, that tireless student of the Renaissance (*Le Lettere di Michelangelo Buonarroti:* Florence, 1875). Capital Roman numerals will identify letters in the Milanesi collection. As in the case of the poetry, later editions of the letters have appeared, but the standard scholarly edition remains that of Milanesi. Two qualified editions exist of De Hollanda's dialogues, each prepared by Joaquim de Vasconcellos (Francisco de Hollanda, *Vier Gespräche über die Malerei* [Vienna, 1899]; Francisco de Hollanda, *Da Pintura antigua* [Porto, 1930]). The earlier edition, published with facing German translation, has the better critical apparatus. Yet, since the two editions carry approximately the same text, I have referred in my notes to the later, Porto edition, since

it has enjoyed a wider distribution. The edition of Vasari used throughout is that prepared by Milanesi (Florence, 1878—1882; reprinted in 1906). Of the several Italian versions of Condivi's *Vita di Michelangelo* I have chosen for our purposes the Pisa, 1823, printing.[41]

Translation of Italian, Portuguese, or other non-English quotations throughout the volume were executed by the present writer, some of them for the first time. It is to our discredit that the complete poems of Michelangelo were not Englished before 1960. The letters are unavailable in English. While it has become the fashion for English and American students of Michelangelo to use the J. A. Symonds versions of the sonnets, Symonds' attempt to render into English rhymed verse causes him often to arrive at a meaning or a spirit at one or two removes from the original. I have already noted the need for lexical precision in a work of this sort. I shall supply translations liberally, recalling that Hugo's remark ("Not everyone is obliged to know Greek") can be easily applied to Italian and Portuguese. If the meaning of the foreign word or phrase should be clear from the context, then a translation will be omitted.

Some of Michelangelo's verse is enigmatic in meaning and obscure or garbled in syntax. While the bulk of translations will be literal and un-rhymed, we shall occasionally be obliged to "explain" even while translating. Lest the reader judge that this is taking undue license, let him remember that the Italian text is so complex for the Italians themselves that Guasti in his edition (Florence, 1863) has supplied a paraphrase in Italian for each poem, as have recent editions by Ceriello and Girardi.

Michelangelo, like many of his contemporaries, had a curious uncon-cern about spelling and grammar. Confronted with such Tuscanisms as "l'opre suo" and "mie lavoro," the temptation becomes almost overpower-ing to besprinkle the text with *sic's* or to play proofreader. I have restrained these impulses, however, on the theory that without access to autographs it would be presumptuous to alter the orthography of difficult texts which have been established at great cost of time and effort by such scholars as Frey, Guasti, and Milanesi.[48] Indeed, Michelangelo's curious language and spell-ings often tell us something of the man himself (e. g., that even when he was an honorary citizen of Rome, late in his life, he was still pronouncing initial palatals in the Tuscan manner: *chaggia,* if not, indeed, dropping them alto-

gether: *iaccia*.) Nor have I tampered with the curious spelling and syntax of other contemporary texts of which I reproduce excerpts.

NOTE: The titles of Michelangelo's works of art are usually given in the text in their Italian form, not only to make this book more understandable to readers in other than English-speaking countries, but also because the names are more standardised in Italian. A majority of the titles (*Mosè, Creazione di Adamo, La Deposizione*) will be apparent to English-speaking monoglots. However, since others will be less recognizable to these readers (*Fetonte, Giudizio universale, Il Diluvio*), a table of English-Italian equivalents is appended just before the Index (*Fetone-Phaeton,* and so on).

MICHELANGELO'S THEORY OF ART

CHAPTER I

Beauty, Intellect, and Art

Wär nicht das Auge sonnenhaft,
Wie könnten wir das Licht erblicken?
Lebt' nicht in uns des Gottes eigne Kraft,
Wie könnt' uns Göttliches entzücken?

GOETHE

I've seen much finer
Women, ripe and real,
Than all this nonsense of
Their stone ideal.

BYRON

THE EVENING is cool and clear in this waning year of 1505. Idling on a high slope overlooking the Ligurian Sea, a nervous, black-bearded man of thirty watches a distant craft skirting the coast and making its way north toward Genoa. He is dead-tired, *stanco morto*, both from his visits to the marble quarries of Carrara and from working on a statue with which he has been diverting himself, but his mind is keen. His lean fingers toy with a branch picked up along the path. He is weary of this prolonged stay in the mountains and would rather be back in Florence among friends. Furthermore, he is bored with nature. He is not one of those fellows who reads poesy into the veinous pattern of a leaf. His is no sylvan muse issuing from some Arcadia to stir him to greater heights. No temptation crosses his mind to recapture in paint the configurations of the coast or the baroque radiance of the setting sun.

Offshore the bark seems to be making little progress. He wonders if the sailors aboard can sense that he is watching their advance from his lofty vantage point. He knows of course that they cannot, but it is a thought

which occurs to people on mountain slopes. If they are looking up in his direction, their glances must mount past him and fix on the peaks behind him. Mechanically he turns and contemplates two summits, upthrust like sentinels. Do the mariners use these as beacons? There is one especially high crag upon which his eye rests. It could serve as beacon better than the others. Instantly an idea overpowers his restless mind. It is an idea which has plagued him before, but never have its possibilities attained such a vast scale. In that alpine rock there is a hermetic form waiting to be released. A colossus stifles confined in his huge lithic prison, like a hamadryad in an oak or a *spirto in un' ampolla* ("spirit in a bottle"), awaiting release. If you look carefully, if your vision is true vision, you can already see the contours of the massive head and shoulders. The figure suddenly emerges so clear that it is impossible not to discern it. It was one of those giants who were to haunt him during his lifetime:

> *Vn gigante u'è ancor d' alteza tanta,*
> *Che da sua ochi noi qua giu non uede . . .*
> *Al sol aspira e l' alte torre pianta*
> *Per agiugnier al cielo . . .*
>
> *A giant there is of such a height*
> *that here below his eyes do see us not . . .*
> *He yearns for the sun and plants his feet*
> *on lofty towers in order heaven to attain*

or again:

> *E son giganti di si grande alteza,*
> *Ch' al sol' andar ciascun par si dilecti,*
> *E ciechi fur per mirar suo chiareza*
>
> *Giants they are of such a height*
> *that each it seems doth take delight*
> *in mounting to the sun, to be blinded by its light.*

Do the sailors down there see it? A few of them must. It is greater by far than the colossus of Nero, greater than that of Nebuchadnezzar, sixty cubits high. Just as the towering Apollo erected by Chares astraddle the port of Rhodes guided sailors into the harbor, so could this monumental pharos guide the Tuscan and Ligurian boatmen off the coast or

far out to sea. There is no reason why he cannot release it. He will get help from his garzoni and he will have the necessary time to execute his plan, since he has been in these hills for months and he will be in them many months more. By the age of thirty-one he will have created his masterpiece, so that if he lives only another ten years, as he firmly expects, his fame will be secured. His destiny rises before him up there, right where God has implanted it in the hard and alpine stone. The beauty and perfection of form are guaranteed beforehand by God himself, the master sculptor.

Deinokrates failed to turn Mount Athos into an effigy of King Alexander, but he, Michelangelo, will not fail.

For Michelangelo Buonarroti the forms in which art is embodied are concepts (*concetti*), images (*immagini*), ideas or ideals (*idee*). He employs all three terms. Like Platonic Ideas, they will exist in nature whether or not human beings recognise them or try to imitate or reproduce them. These forms are reflections of beauty, and since the term "beauty" could be substituted for the word "art" in most of the Neo-Platonic Michelangelo's statements, it is with his conception of beauty that we approach the *concetto.* Beauty is the artist's reason for being. He is not born to create beauty, as one might think, but to discern and reproduce pre-existing beauties in nature or, again, in Plotinian terms, to match uncorporeal with corporeal beauties. The acceptance of beauty as "at once the ultimate principle and highest aim of art" (Goethe) by Michelangelo and his colleagues of similar intellectual formation was a factor in the "arts of design" becoming known in the Romance languages as the "beautiful arts" by the time of the Abbé Du Bos.

In Paolo Pino's dialogue on painting, Lauro asks Fabio to define beauty, only to have the latter object, "You know, after all, that I am a painter and not a philosopher."[1] Yet Pino himself termed painting a "species of natural philosophy."[2] Lauro's justified assumption is symptomatic of the sixteenth century. One cannot know Michelangelo without having an inkling of Plato and the Neo-Platonic system. Panofsky called Michelangelo "the only genuine Platonic among the many artists influ-

enced by Neo-Platonism." Carl Frey to the contrary, Michelangelo had several tutors in Platonic philosophy, including Ficino, Poliziano, and Francesco da Diacceto.[3] Neo-Platonism infused his mind and, if one were to believe the witty and perceptive Francesco Berni, both the poems and paintings of this "Apollo-Apelles":

> *Ho visto qualche sua compositione,*
> *Sono ignorante, e pur direi d'havelle*
> *Tutte lette nel mezzo di Platone.*[4]

> *I've seen some of his compositions;*
> *I am ignorant and yet I should say that I have*
> *read all of them in the middle of Plato.*

It behooves us, then, to recall momentarily minimal premises of Plato's theory of art and beauty, as well as those of his continuators, Plotinus and Ficino. To Plato sensuous beauty is the reflection of absolute Beauty, which transcends sense and which was customarily written with a capital initial letter by Michelangelo's generation. Without absolute or universal Beauty there could be no sensuous beauty. "Beauty absolute informs not only sense, but also the dispositions of the soul and the aspects of knowledge. Beauty, like the Good, may be taken as the highest category."[5] As a man looks on reflected beauty he discerns a vision of his own perfected nature and this initiates a desire for perfection within him.

The text of the *Enneads* of Plotinus was as well known to the Neo-Platonists as any by Plato. Its discussion of beauty was common coin. Twice in the *Enneads* Plotinus poses the question of the relationship between the beauty of this world and that in the supreme universe (I, VI, and V, VIII–IX). He explains that beauty here below is generated by communion in Ideal Form. Wherever the artist is able to commune with divine thought or wisdom, his works take on the co-ordinated beauty and unity of divine archetypes. Beauty is equated with the Good and with Wisdom. Only those endowed with the Intellect-Principle may perceive it. In a line which might have inspired the verses of Goethe in incipit position above, Plotinus wrote, "Never did the eye see the sun unless it had first become sunlike, and never can a soul have vision of the first beauty unless it itself be beautiful."[6] For the reader who would like to find a systematic pre-

4 ·

sentation of the thoughts of Plotinus arranged by Porphyry, a compilation of extracts forming a conspectus of the Plotinian system is available.[7] Whereas immediate affinities between Plotinus and Michelangelo will be noted throughout the following pages, it can be stated forthwith that the general Plotinian influence is considerable. Three specific influences include Buonarroti's consistent use of the word *intelletto* (the νοῦς of Plotinus), his preoccupation with inner and exterior vision, and his belief that the eye or soul distinguishes divine forms within materials.

Michelangelo certainly knew the commentary on the *Symposium* by Marsilio Ficino, with whom he had broken bread in the Medici household. If one does not find in "Ficino, the philosophical mouthpiece of the Renaissance, a doctrinal justification of that age's worship of beauty and an explicit analysis of its artistic ideals,"[8] there is nevertheless his definition of beauty as that ray which, parting from the visage of God, penetrates into all things. One chapter of his *Commentarium in Convivium* (V, IV) is entitled "Pulchritudo est splendor divini vultus." Another chapter, "Pulchritudo est aliquid incorporeum" (V, III), which demonstrates that Neo-Platonists sometimes found it easier to define beauty in terms of what it is not, will assist us in understanding Michelangelo's cast of thought. Several of Ficino's key ideas—the distinction between exterior and interior visions of beauty (already noted in Plotinus), the notion of divine grace, God as the source of art—will be retraced in Michelangelo.

What other texts treating of beauty were especially well known to Michelangelo? Girolamo Savonarola was not only his favorite orator but one of his favorite writers, for we are told of the great enjoyment he took in hearing and reading the friar's sermons. Savonarola adhered to a classical, Aristotelian definition of beauty. We translate from his "Predica III su Amos e Zaccaria": "Of what does beauty consist? Colors? No. The effigy? No. Rather beauty is a form which results from the correspondence of all members and colors. From this harmony there results a quality which the philosophers call beauty." True, the Ficinian philosophers held that sensual beauty originated in the *concordia* of lines and colors, although they were more preoccupied with spiritual beauty. It is in the "Predica XVII su Ezekiele" that Savonarola joins them in this pre-

occupation. (Is it not amusing to see this hard-shelled Piagnone get caught up in the language of his humanistic enemies, as happened so often?) "You won't say that a lady is beautiful just because she has a beautiful nose or beautiful hands, but only when all the proportions are present." This is again a thought of Ficino: "Proportio, illa cuncta includit corporis composita membra, neque est in singulis, sed in cunctis," etc.[9] The Dominican friar continues: "This beauty then comes from the soul, and you see that once the soul is absent, the body remains pale and wasted, and there is no longer any beauty in it." Yet it is the twenty-eighth sermon on *Ezekiel* that Savonarola begins to sound most like a Neo-Platonist, distinguishing between Higher Beauty and its reflected earthly counterpart: "Thus the beauty of man and woman is greater and more perfect in so far as it is similar to the primary beauty."

We have taken time to tarry over Plato, Plotinus, Ficino, and Fra Girolamo, since Michelangelo knew their works in one form or another and they were guides to his own convictions. Other contemporaries were theorising on beauty, of course. Alberti, of the preceding generation, agreed that the major aim of the artist was to know and express beauty. He did not define the term in his *De Statua*, "evidently assuming that his readers will know beauty when they see it" (Blunt). Yet his treatise on architecture defines beauty as an harmonious ensemble in the stock Vitruvian tradition. Vasari made a distinction between beauty and grace, which could scarcely have derived from his cavalcade conversation with Michelangelo: "Beauty is a rational quality dependent upon rules, whereas grace is an indefinable quality dependent upon judgement and therefore on the eye."[10] Lomazzo was to draw freely upon Ficino. By 1541 there appeared Agnolo Firenzuola's *Dialogo delle bellezze delle Donne*, which defined beauty in such traditional terms as proportion, harmony, *concinnitas*, and concord. Albrecht Dürer declared with his usual honesty, "Beauty is so illusive in human beings and our judgements so doubtful that we may find it in two people differing from each other in every respect and proportion . . . I certainly do not know what the ultimate measure of true beauty is." In general, however, Dürer's *Proportionslehre* assumes that beauty is an agreeable concordance of lines and proportions.

6 ·

Whereas the others discussed this abstract value in formal tracts, Michelangelo left us only poems to reveal the Platonic imprint on his thought. In these poems, more often than not the beauteous object of the *senso visivo* is not a scene in nature to be reproduced but the divine lady or man to whom the poet dedicates his verse. (Much of Ficino's discussion of beauty, too, is in an amatory context.) In Michelangelo's sonnet, "Dimmi di gratia, Amor, se gli ochi mei" (XXXII), he asks Love whether the beauty he contemplates on his lady's countenance is the true beauty to which he aspires. Love replies that beauty seen through the eye is indeed true and inherent beauty, but that when it passes through the eye to the soul it becomes (again) something divine. It is this transfigured beauty which constitutes the real attraction and motivation. The question reads:

> *Dimmi di gratia, Amor, se gli ochi mei*
> *Veggon 'l ver della beltà, ch' aspiro,*
> *O s' io l'o dentro, allor che, dou' io miro,*
> *Veggio scolpito el uiso di costei ...*

> *Tell me please, Love, if my eyes*
> *see the true nature of the beauty for which I long*
> *or if I possess it within me when, gazing on the face*
> *of my lady, I see it sculptured.*

Love replies:

> *La belta che tu uedi, è ben da quella*
> *Ma crescie, poi ch' a miglior loco sale,*
> *Se per gli ochi mortali all'alma corre.*
> *Quiui si fa diuina, onesta, e bella*
> *Com' a se simil uuol cosa inmortale.*
> *Questa, e non quella, a gli ochi tuo precorre.*

> The beauty which you see comes truly from your lady; but this beauty grows, since it ascends to a better place when through mortal eyes it passes on to the soul.
> There it is made into something divine, worthy, and fine, since any immortal thing wishes other things similarly immortal. It is this divine beauty, and not the other, which guides your eyes onward.

The process by which this sensual image grows into something finer within the soul is described by Ficino: "Nam procedente tempore ama-

tum non in mera eius imagine per sensus accepta perspiciunt, sed in simulacro iam ab anima ad ideae suae similitudinem reformato, quod ipso corpore pulchrius est, intuentur."[11] Two sonnets, "Ben posson gli occhi miei, presso e lontano" (CIX, 8) and "Non so se s'è la desiata luce" (LXXV), develop the idea that the image of beauty penetrates the inner eye to the heart and awakens passion. If the image does not reach the inner eye, a true love is not possible, a thought contained in the cryptic fragment (XXVIII) "Che mal si puo amar ben chi non si uede."

When the true artist sets out to reproduce some beauty, it is not merely a facsimile of visible beauty which he tries to set down, but rather the image which develops (*crescie*) within him. What must be reproduced is "a concept of beauty, an image cast or seen within the heart" (LX):

> *un choncetto di belleza,*
> *Inmaginata o uista dentro al core...*

This could make a high-flown answer to those literal-minded critics who found fault with the features of his Medici dukes or the proportions of his *Pietà* in St. Peter's.

Another piece (XXXIV) refers to the manner in which the outward image is received into the mind and grows until it is transmuted into an inner image, invalidating entirely its former self:

> *Mentre c' alla belta, ch' i' uiddi im prima*
> *Apresso l' alma, che per gli ochi uede,*
> *L'inmagin dentro crescie, e quella cede*
> *Quasi uilmente e senza alcuna stima.*

> As I draw my soul, which sees through the eyes, closer to beauty
> as I first saw it, the image therein grows, and the other recedes
> as though unworthy and without any value.

Or again (XXXVI):

> *Cosi l'inmagin tua, che fuor m'inmolla*
> *Dentro per gli ochi crescie, ond' io m'allargo.*

> *Thus thy image, which immolates me outside,*
> *Grows inside through my eyes, whence I am enlarged.*

To this artist, who counseled his nephew Lionardo not to look for mere physical beauty in a wife and who almost alone among his contemporaries found beauty in the features of the aging Marchioness of Pescara, it is clear that spiritual qualities are essential in the formation of this important inner image. These two poems, like sonnet XXXII partially reproduced above, date from about 1530. The poems with the highest Neo-Platonic content were written after Michelangelo had reached his fifties and after the year he met Tommaso Cavalieri. From this period dates a madrigal (CIX, 99) which holds that the eyes are just as greedy for beauty as the soul is for salvation, sight being the only sense which perceives this beauty, as Ficino made clear: "Si oculus solus agnoscit, solus fruitur."[12] Like the soul, the eyes ascend heavenward in their quest:

> *Gli ochi mie, uagi delle cose belle,*
> *E l'alma insieme della suo salute*
> *Non anno altra uirtute*
> *C' ascenda al ciel che mirar tucte quelle.*

> *My eyes longing for beautiful things*
> *together with my soul longing for salvation*
> *have no other power*
> *to ascend to heaven than the contemplation of beautiful things.*

The poem borrows for its conclusion the notion of Ficino and others that beauty is a splendor which streams down from the highest heavens.

People of perception (*persone accorte*) glimpse through their senses the higher beauty which comes into visible presence from its higher sphere:

> *A quel pietoso fonte, onde sian tucti,*
> *S'assenbra ogni belta, che qua si uede,*
> *Piu c' altra cosa alle persone accorte,*
> *Ne altro saggio abbian ne altri fructi*
> *Del cielo in terra; e chi u' ama con fede*
> *Trascende a Dio e fa dolce la morte.*

> Every beauty which is seen here below by persons of perception resembles more than anything else that celestial source from which we are all come; nor can we on earth have any other foretaste of its beauty or other fruits of heaven; and he who loves you loyally transcends to God and death is made sweet.

In this sonnet (LXIV), also, the Ficinian definition of beauty as the beam from God's visage is thematic.

All of the evidence thus far introduced to explain the nature of Michelangelo's preoccupation with beauty has come from poems and fragments addressed to friends. There is textual testimony of another sort. The following chapter will cite testimony from De Hollanda's *Dialogos em Roma*. Then, too, there is Condivi's fervent allegation, "Not only did he love all human beauty, but universally every beautiful thing, a beautiful horse, a beautiful dog, a beautiful countryside, a beautiful plant, a beautiful mountain, a beautiful wood, and every site and thing beautiful of its kind."[13] Although this is a symptomatic passage, Condivi exaggerated to absurdity Buonarroti's fondness for external nature. In fact we shall see in Chapter III that Michelangelo views the trappings of *paysagisme* as lures to "deceive the exterior vision." Condivi is weakly trying to explain away Michelangelo's reputedly excessive interest in the male nude. Michelangelo does a more convincing piece of explaining in those poems where he voices his belief that divine beauty makes itself most manifest in a noble human body (CIX, 105):

> *Nè Dio, suo gratia, mi si mostra altroue*
> *Piu che 'n alcun leggiadro e mortal uelo;*
> *E quel sol amo, perch' in lui si spechia.*

> Nor does God, in his grace, show himself to me in any other aspect more clearly than in a beautiful human veil; and that form alone I love, for in it he is mirrored.

A comparison imposes itself with Ficino's belief that God's image is mirrored at three levels, of which one is the human body: "Unus igitur dei vultus tribus deinceps per ordinem positis lucet in speculis, angelo, animo, corpore mundi."[14] The idea of corporeal manifestation of divine beauty is treated in further poems to Tommaso Cavalieri, whose comeliness Michelangelo found so elevating, and in the sonnet "Non uider gli occhi miei cosa mortale (LXXIX)." This preoccupation with masculine beauty made it doubtless all the harder for him to bear his lifelong disfiguration from the impact of Torrigiano's fist.

Beauty being the canton-stone of art, it must possess the timelessness of art. Just as a given beauty exists before the artist captures it in a piece

of sculpture, it will go on existing even after that sculpture has under-
gone the decomposition of all artistic monuments which Vasari called the
"second death" (LXXXV):

> *Molto dilecta al gusto intero e sano*
> *L'opra della prim'arte, che n'assembra*
> *I uolti e gli acti e con piu uiue membra*
> *Di cera o terra o pietra un corp' umano.*
> *Se po' 'l tempo ingiurioso, aspro e uillano*
> *La rompe o storce e del tucto dismembra,*
> *La belta, che prim' era, si rimembra*
> *E serba a miglior loco il piacer uano.*

For him who has a whole and sane judgement, a work of the
prime art [sculpture] offers much delight, as it portrays for us
faces and actions and, with more lifelike parts, a human body,
either in wax or earth or stone.

If afterward time, harmful, harsh, and villainous, breaks it,
distorts, or completely shatters it, there remains the remembrance
of the beauty which once was; and the empty pleasure is pre-
served for a more lofty plane.

Some have conjectured that Michelangelo called sculpture the "prime
art" because God used it to form man—a common Renaissance cliché.
We shall see in Chapter V that the phrase held a more personal meaning
for Michelangelo. Of these quatrains Mariani observes that only a
sculptor would have used the verbs *rompere* (works of marble and terra)
and *storcere* (works of metal or wax).[15]

Another sonnet ("Sol perchè tue bellezza al mondo sieno") spec-
ulates on the eternal duration of beauty. Although it might appear that
the beauty of Donna Vittoria or some latter-day Laura diminishes with
age, beauty is never lost, merely metamorphosed. "Only in order that
thy beauties may be eternal in time, which gives them and steals them
back, does Nature, I believe, take back unto herself that which each day
lessens in thee: and that it may serve for the birth from a greater womb,
with better fate and greater care, to form anew a figure which may have
thine angelic and serene face." As an example of nature's "taking back"
a woman's "external" beauties, we note Michelangelo's interest in this
unhappy subject in his pen drawing (fol. 40b) showing the doubling

chin and sagging breasts of an aging woman, probably this same Vittoria Colonna.

Being thus perdurable, beauty can no more be extricated from eternity than heat divided from fire: "Come dal foco 'l cald' esser diuiso / Non puo 'l bel dall'eterno." If the mere substance of an artist's works, like everything of physical composition, is destined to perish in time, the beautiful works may still outlast some of the objects they portray, just as they outlast the artist himself, until that moment when nature ceases to cast the reflection of Beauty. The artist, on earth for a few paltry days, can capture and render beauties visible and give them a less ephemeral existence than his own. Art for a time defeats nature, in that effect defeats cause, and this Michelangelo knows as a trade secret (CIX, 92):

> Chom' esser, Donna, puo quel c' alcun uede
> Per lunga sperienza, che piu dura
> L'inmagin uiua im pietra alpestra e dura
> Che 'l suo factor, che gli anni in cener riede?
> La cause al' efecto inclina e cede,
> Onde dall' arte è uinta la natura.
> I' 'l so, che 'l pruouo in la bella scultura
> C' all' opra il tempo e morte non tien fede.

> How can it happen, milady—that which we observe through long experience—that the living image in the alpine and hard stone lasts longer than its maker, who with the passing of years returns to ashes?
> Cause to effect bows and gives way, whence nature is bested by art. This I know, as I experience it in beautiful sculpture, in which work time and death fail to achieve their ends.

In a madrigal addressed to the Marchioness of Pescara (CIX, 45), Michelangelo goes a step further and decides that if nature underlies art, then it cannot really be bested by art. In this piece the contest is not between statue and maker, but between statue and living model. Here the archetype is Vittoria herself, and the derivative is that bust of the lady purportedly executed by him and since lost. If art retains the sculptured image long in stone, what ought not God do for his living creation?

Sol d' una pietra uiua
L'arte uuol che qui uiua
Al par degli anni il uolto di costei.
Che douria il ciel di lei,
Sendo mie questa, e quella suo factura
Non gia mortal, ma diua
Non solo agli ochi mei?
E pur si parte e picciol tempo dura.
Da lato destro è zoppa suo ventura,
S' un sasso resta, e pur lei morte affrecta.
Chi ne fara uendecta?
Natura sol, se de suo nati sola
L'opra qui dura, e la suo 'l tempo inuola.

Art wishes that the face of milady live here throughout the years alone in the living stone. How indebted to her heaven should be, this humble sculpture being mine, but the lady being the creation of heaven, more of a goddess than a mortal in everyone's eyes! And yet she departs, staying here but a short time. Her luck is bad when it should be good, since a mere stone remains while she has hastened to her death. Who will avenge her? Nature alone, if only the work of those born of nature remains, whereas time sweeps away her own work.

Since Michelangelo did not seem particularly inclined to go along with the traditional, Aristotelian view of beauty as an harmonious concord of lines and colors (except in architecture, where he docilely accepted Vitruvius' theories), what was his practical canon of beauty? The answer seems scarcely to be found in the *Giudizio universale*, which he was painting (1534–1541) when many of these Neo-Platonic verses were composed. There is little of the beauty which inspires sonnets or of beauty "from the celestial source" in this masterpiece, of course, other than on the face of the Mother of Christ (Plate III). His placid ideal of beauty remained rather that of the *Madonna Medicea*, completed in 1534. It is an ideal which sets little premium on delicacy, mansuetude, or winsomeness—in a word, grace. Aretino (in Dolce's dialogue) was right when he granted Michelangelo beauty but little grace. Later Bernini was to comment that Buonarroti "had had more art than grace." There were Raphael and others to supply that in abundance. Earlier, his rival Leonardo had spelled beauty to most people and, as De Tolnay notes, Michelangelo's work after the turn of the century had been a protest

against the concept of beauty found in Leonardo's *Santa Anna*.[16] It would be premature for us to try to establish a fixed canon or definition of beauty for Michelangelo at this point. Many relevant elements of such a definition will emerge from the succeeding pages.

We turn now to Michelangelo's concept of the *intelletto,* an understanding of which is indispensable to an understanding of his thought. The faculty of discerning beauty and harmony with which God endows certain individuals is called an *intelletto.* This power is granted to the fortunate artist at birth (xciv):

> Per fido esemplo alla mia uocazione
> Nel parto mi fu data la bellezza,
> Che d'ambo l' arti m'è lucerna e specchio:
> S' altro si pensa, è falsa opinione.
> Questo sol l'occhio porta a quella altezza
> Ch' a pingere e scolpir qui m'apparecchio.
> Se giudizij temerarij e sciocchi
> Al senso tiran la beltà, che muoue
> E porta al cielo ogni intelletto sano,
> Dal mortal al diuin non uanno gli occhi
> Infermi e fermi sempre pur là, doue
> Ascender senza grazia è pensier uano.

As a faithful guide for my vocation, beauty was given me at birth, which is a beacon and mirror for me in both arts; if anyone thinks otherwise, his opinion is wrong. This alone bears the eye up to those lofty visions which I am preparing here below to paint and sculpture.

If those of rash and stupid judgement attribute to sense that beauty which stirs and bears to heaven every whole *intelletto,* it follows that infirm eyes do not pass from the mortal to the divine, nor even eyes fixed firmly on those heights where it is a vain hope to ascend without possessing grace.

The initial couplet, self-confident and revealing, shows Buonarroti's conviction that a sensitivity to beauty is an essential component of genius. (Is there double meaning here? He told Condivi that he had been born under a favorable conjunction of Mercury, Jupiter, and Venus, the goddess of beauty.) Yet these first two lines, with their reminiscence of Sappho ("Since childhood Destiny made it my lot to love all beauty");[17]

are not so important as the ninth, including the word *intelletto*, which resembles closely the posie of Michelangelo's personal emblem. Vasari states that the device accompanying Michelangelo's symbol of three inter-woven coronals was "Levan al cielo nostro intelletto" ("They [the three arts] raise our *intelletto* to heaven").[18]

Apparently we are the first to point out the origin of this motto in Petrarch's sonnet to the elder Stefano Colonna ("Gloriosa Colonna in cui s'appoggia"). Petrarch laments his friend's absence in the otherwise inspiring setting of Avignon; where the firs, beeches, and pines "levan di terra al ciel nostro intelletto." Michelangelo, no nature lover, borrows the verse but not the thought. Considerably closer to Michelangelo's thinking on art would be the lines in Petrarch's canzone, "I' vo pensando, e nel pensier m'assale":

> *Mille fiate ho chiesto a Dio quell' ale*
> *Con le quali del mortale*
> *Carcer nostr' intelletto al ciel si leva ...*

> A thousand times I have requested of God those wings with which from this mortal prison our intellect doth rise to heaven...

where the three arts would represent exactly those wings.

Whereas most of the Renaissance theorists on art and literature adhered to the usual classical (non-Platonic) vocabulary in ascribing genius to an artist or poet, Michelangelo clung to the word *intelletto*. Michelangelo even calls this dispensation given the artist a *grazia* (cxx), a word which will in his last poems refer to his own salvation. He also mentions specifically the word *eletto* (*eletta*). "Elect" was a fighting word in his day and sounds strangely Reformational, coming from a very Catholic artist.

Michelangelo's use of *intelletto* is further evidence that he had "frequented the doctors and saints" of Neo-Platonism. Plotinus had written of the perceptive faculties of the νοῦς in seeking beauty. This Greek word became universally *intellectus* or *intelletto* in the deliber-ations of the Italian humanists. English-speaking readers may do well to remember that *intellectus* in Latin denoted not "intellect" but "per-ception" or "a perceiving." Ficino wrote that the human faculty furthest

· *15*

outside the body itself is the *intellectus divinus* or *angelicus,* which man shares with God. This is part of man's Higher Soul. The Lower Soul contains the external perception, the *sensus exterior,* divided into five parts, of which one is *vista (visus).* Michelangelo borrowed not only his *intelletto* from the Neo-Platonists, but also his associated theory of "exterior" and "inner" vision.

What further occurrences of this key term, *intelletto,* can be found in his writing? There is one sonnet which definitely makes this faculty part of the Higher Soul. Since art-forms pre-exist in nature, the artist possessing this perception will be able to draw them out. The works of this Demiurge will be neither greater than nor different from the predetermined Ideas. Once again drawing his illustration from sculpture, which he considered until 1530–1540 the primary artistic medium, Buonarroti gives us his most famous quatrain (LXXXIII), the last verse of which is especially meaningful:

> *Non ha l'ottimo artista alcun concetto,*
> *Ch' un marmo solo in se non circonscriua*
> *Col suo souerchio, et solo à quello arriua*
> *La man, che ubbidisce all' intelletto.*

> The best artist has no concept which some single marble does not enclose within its mass, but only the hand which obeys the *intelletto* can accomplish that. [Or... and only that can the hand which obeys the *intelletto* achieve.]

In his essay on Corot, Paul Valéry writes that Michelangelo's first two lines describe that happy moment when there is no longer any discrepancy between the intentions and the means of the competent artist. They describe an intimate correspondence between the master's thoughts and material, "remarquable par une réciprocité dont ceux qui ne l'ont pas éprouvée ne peuvent imaginer l'existence." Vincenzo Danti, who separated sculpture into three components (*intelletto, mano, materia*) regretted that a poor marble could nullify this correspondence, a fact only too familiar to Buonarroti.[19] Valéry further calls these first two verses the formula of Michelangelo's sovereign ambition.

In his sonnet (CIX, 68) to Gandolfo Porrino on the death of the recently-identified Faustina Lucia Mancini, Buonarroti claims that he

cannot capture the beauty of the lady "with chisels in stone, with the brush on paper." God alone is able to fashion La Mancina's beauty anew in heaven: "E quel solo e non io far la potea." Again the *intelletto* is mentioned, with the graphic admission that the *intelletto* of the individual artist is to that of God as the stars are to the sun.

A fifth occurrence of this key word in the *Rime* needs to be noted (CIX, 8). Since the *intelletto* is that part of man which enters into closest relations with divinity, it is perhaps inevitable that Michelangelo should, as he does, identify it with the soul:

> *L'anima, l'intellecto intero e sano*
> *Per gli ochi ascende piu libero e sciolto*
> *Al' alta tuo belta ...*

The soul, the *intelletto* entire and whole, ascends more free and loose through the eyes to thy lofty beauty ...

Finally, in the sonnet "Se ben concietto à la diuina parte" (CXXXIV), this intellectual faculty is called "la diuina parte" and its function viewed as "giving life to rocks."

This theory of the *intelletto* became known not only to such scholarly associates of Michelangelo as Varchi. Paolo Pino and others were using the term in this specific way by mid-century. In 1561 Angelo Bronzino dedicated a sonnet to his "master" Buonarroti, in the course of which he gratefully acknowledged, "I consecrated to you my Hand and my *Intelletto*." Philippe Desportes imported Michelangelo's theory into France soon afterward by translating the quatrain above (LXXXIII) in his *Cléonice*, dubiously rendering *intelletto* as *entendement*.

Michelangelo, insistent poet and correspondent, went to the extreme of applying his theory of predetermined forms to writers as well as artists. He began a sonnet (LXV) to Tommaso Cavalieri:

> *Siccome nella penna e nell'inchiostro*
> *È l'alto e 'l basso e 'l mediocre stile,*
> *E ne' marmi l'inmagin richa e uile,*
> *Secondo che 'l sa trar l'ingegnio nostro.*

Just as in pen and ink there is high and low and intermediate style, there are in marbles rich and base images, in so far as our genius can draw them out.

· *17*

Although it is a more likely assumption that the first couplet refers to literary style, it is tangentially possible that the lines refer to quality of handwriting, for Michelangelo thought of calligraphy as an art in itself, as attested by the many careful recopyings of his letters. As Mariani speculates, these rewritings give evidence of Michelangelo's "decisive will to dominate form even through handwriting."[20]

We shall return shortly to this notion of forms sealed potentially within the materials of art.

The key word *intelletto*, which he adopted to denote a special type of genius in the *Rime*, is specifically attributed to Buonarroti three times in the *Dialogos em Roma*, still recognisable through the opacity of translation. While other collocutors employ other words to describe genius (*engenho, spirito, graça, entendimento*), Michelangelo is consistently reported as using *inteleito*.

During one of the conversations he explains that a great painter eschews social intercourse with those incompetent in the fine arts, lest the latter should reduce his perceptive acuity ("abaxarem o inteleito).[21] Or, again, it is Michelangelo who posits that painting is a copy of the perfections of God and, like music, something that only the *intelletto* can comprehend:

porque a boa pintura não é outra cousa senão um terlado das perfeições de Deos e uma lembrança do seu pintar, finalmente uma musica e uma melodia que sómente o inteleito póde sentir, a grande deficuldade.[22]

for fine painting is nothing other than a copy of the perfections of God and a remembrance of his painting, and lastly a music and melody which only the *intelletto* is capable of hearing, with great difficulty.

This is the only time in his writings that Michelangelo viewed art as a remembrance and it would seem to indicate a temporary interest in the Platonic doctrine of anamnesis. In still another passage the artist tells Messer Lattanzio that successful painters must lead a saintly life, explaining:

Mas tenho eu que lhe é necessario ser de muito boa vida, ou inda, se ser podesse, sancto, para no seu inteleito poder inspirar o Sprito Sancto.[23]

But I hold that it is necessary for him to be of a very good life—even a saintly life, if possible—so that the Holy Spirit may breathe upon his intellect.

A full textual analysis on the sonnet "Non ha l'ottimo artista alcun concetto" was delivered by Benedetto Varchi before the Florentine Academy one Lenten Sunday in 1546.[24] Michelangelo was grateful and flattered on learning of this attention. While the exegesis is a pedantic one, with the inconclusive *rapprochements* in which scholars so often indulge, Varchi was perhaps the first to discover the underlying theory of artistic creation which guided Buonarroti. He placed the *intelletto* in correct Neo-Platonic relation to the *fantasia, immaginativa,* and *cogitiva.* He even harks back to the Peripatetics and their notion that any creation is translation from the potential to the actual. However, he does not relate this particular sonnet to the corpus of Michelangelo's other poems on art or to conversations which the two must have held.

Obviously the Florentine humanists were beginning to use the word *intelletto* in nonartistic contexts. Pico, Poliziano, and even Lorenzo used the word to describe the perception of things divine. Michelangelo's first patron writes, for example:

> *Così nostro intelletto al tuo risponde,*
> *e, se intendiam, l'intelligenzia tua*
> *ci illumina alle cose alte e profonde.*[25]

> *Thus our* intelletto *corresponds to thine,*
> *and if we understand, thy intelligence*
> *will light our way to lofty and deep things.*

It remained only for Michelangelo to apply strictly to the fine arts this broad systematic pattern of thinking which was intended for an even broader philosophical and epistemological application.

In Michelangelo's theory, the intellect-principle which enabled the artist to create great works also enabled the spectator to appreciate them. However, spectators so endowed were even more rare than the artists, and in a class with "the Mikado's hereditary connoisseur" whom Yeats encountered in the British Museum. Referring to the vast majority of spectators who indulged in judging art, Michelangelo cried out, in

· *19*

circumstances explained in a later chapter, "Il mondo è cieco!" ("The world is blind!").

The difference between competent artists and the great train of the incompetent depends precisely on this intellectual faculty which is so sensitive to beauty. Michelangelo is quoted directly:

Mas nunca soube desejar bem nesta sciencia senão aquele entendimento que entende o bem e quanto póde alcançar d'elle. E esta é grave cousa do stremo e deferença que ha entre o desejo do alto entendimento na pintura ao baxo.[26]

But none has ever known how to aspire well in this science except that intellect which understands beauty and how it can be attained. And this is a serious matter, this distance and difference which exist between those who aspire to the lofty in painting and those with a lower aim.

William Hazlitt wrote, "one is never tired of painting, because you have set down not what you know already, but what you have just discovered." This conception of the artistic or literary process as a "finding" would be difficult to trace to its origins. It was inevitably a belief of Michelangelo, who thought of art-forms as sealed in the ὕλη. In a generous tribute to the painter as the master of all arts, Michelangelo refers to him as "capable in inventing what has never been found before."[27] Nor should one forget the passage (*v.* Chapter II, note 46) where the painter recalls that God told Moses that he would give to moral painters the faculty of finding beauties. In these passages, *inventar* (like *achar,* which it complements) carries its original value of "find."

The artist as *Erfinder,* troubadour, finder—this is obviously Neo-Platonic in spirit, as we shall see, but it also has an affinity with the *trobar clus* of Provençal theory. Michelangelo knew no Provençal. Was there a connecting link? Mariani, by the way, refers to Buonarroti's technique of verse as an "unconsciously medieval return to the *trobar clus* of the obscure troubadours.[28] Without pressing the point, one might suggest as the missing link none other than that scholarly and pompous academician from whom we have quoted above, Benedetto Varchi. Varchi was not an intimate of Michelangelo, but each had a certain regard for

the other's particular merits. A Provençal scholar, Varchi made in his writings many references to the literature of the *langue d'oc*. He even composed a Provençal grammar. In his essay "Dei Sensi" he ascribes to the *intelletto* discovering powers similar to those in Michelangelo's theory. Was this interest of Varchi's the topic of one of their conversations? We shall never know, and the thread of evidence is too fragile to support the drawing of conclusions.

Whatever the merits of a confrontation with Provençal theory, most of the passages in which Michelangelo presents his theory of art-forms as concepts, images, or Ideas are couched in Neo-Platonic vocabulary. Obviously under his influence, Vasari clarifies the relations between this *concetto* and design by defining the latter as "nothing but an apparent expression and declaration of the *concetto* which one carries in the soul and of that which is likewise imagined in the mind and formed in the Idea."[29] The notion of art-forms existing in the world of the soul and coexisting in the world of matter is Neo-Platonic. Plato had posited "three categories of Divine Forms: Ideas, Concepts, and Seeds," explains Ficino. Although Plato was more interested in these Forms in their incorporeal state, he does acknowledge that they assume form in matter: "Eodem ordine a natura in materiam formae descendunt."[30] Once this *concetto* is admittedly resident in matter it offers the basis for Michelangelo's thesis that the gifted artist partaking of the divine mind infallibly discerns these corporeal counterparts of divine Ideas lodged in stone, paint, and even lower media.

Art-forms, then, exist whether artists exist or not. They have existed before the artist and will survive him. Independent of man, the marbles of Carrara are "guardians of pure contour," to borrow Gautier's words. Michelangelo was familiar with Cicero and Pliny, who related how men working in quarries at Chios and Paros had split open marble blocks which disclosed contours of Paniscus and Silenus already formed.[31] Nature placed these contours therein (LXXXIV):

> *Si come per leuar, Donna, si pone*
> *Im pietra alpestra e dura*
> *Una uiua figura*
> *Che là piu crescie, u' piu la pietra scema . . .*

· *21*

> Just as taking away, milady, brings out a living figure in alpine
> and hard stone, which there grows the more as the stone is
> chipped away . . .

Michelangelo concludes this poem with the thought that a great love brings out the true inner man, that the *soverchio* of flesh is hewn away to reveal the soul (*concetto*) within. He applies this artistic motiv to love poetry elsewhere, and tributes such as "il mio soverchio lima / Vostra mercè" ("your mercy files away my *soverchio*") are not uncommon (CXXXIV).

In his "Idea," printed as an introduction to his biographies, Bellori frames an important definition of Michelangelo's *concetto*, seeing it as a "perfection of Nature, miracle of art, prefiguration of the *Intelletto*, example of the mind, light of the imagination."[32] Had Michelangelo used more consistently the word "Idea," as did his followers, he might thus have acknowledged even more openly the Neo-Platonic cast of his thought, the Neo-Platonism pointed out by Ficino (note 30).

Did earlier Platonists than Ficino influence Michelangelo's view of art-forms? Plato himself did not mention ideas specifically as art-forms in nature. Plotinus comes closer to Michelangelo and could, indeed, have provided him the premise on which to make a final formulation. "There is in nature-principle an ideal Archetype of the beauty that is found in material forms."[33] "Statues and hand-wrought things cannot be realised out of their materials until the Intellect-Principle imparts the particular Idea from its own content."[34] Michelangelo's *concetto* theory is often implicit, never quite explicit, in Plotinus, for whom Beauty is not pre-planted in the marble but is transferred "as the stone yields to art." He parts company with Michelangelo in his statement that "form is in the designer before it ever enters the stone."[35]

In the Quattrocento literature on art there is a passage with a ring familiar to students of Michelangelo. Alberti, in his *De Statua* (*ca.* 1464), clearly alludes to the sealed-figure concept: "figura indita et abscondita." In Bartoli's translation (1568) Alberti describes the action of sculptors as "removing that which is superfluous in a given material, sculpturing and making a form appear in the marble, or a man's figure which was hidden there from the first and *in potenza*."[36] The phrase *in*

potenza was used by Varchi in his public lecture on Michelangelo's theory of the *concetto* and seems to have become common coin by the mid-Cinquecento. It is to be compared with the Latinised version of a passage in Aristotle's *Metaphysics*: "In lapide est forma Mercurij in potentia." Transferring the *concetto* theory to other branches of art, as did Buonarroti, Alberti adds that sculptors are brothers of those who "keep carving in seals the lines of faces which were hidden in them." Alberti, then, precedes Michelangelo in his interest in the hermetic art-form. Whether Michelangelo ever read the Latin redaction by chance cannot be known. Nor can one decide whether Alberti himself drew upon his readings in Neo-Platonism to distill them. "Many of the fundamental ideas in his philosophy are ultimately Platonic in origin, and Alberti very likely derived them from the Florentine followers of Plato in the fourteenth or early fifteenth centuries, such as Petrarch or Bruni."[37]

In Michelangelo the *concetto* theory was basic, explicit, and accompanied with dramatic implications. Thus he knew that the artist gifted with *intelletto* can see the inner form which the marble block hides from others. He saw the *David* hidden but "potential" in the block offered him in 1501, whereas Sansovino's weaker "mind's eye" failed to see the inner form which would not require supplementary marbles. Thus he saw the "potential" *Notte*. Nicolas Audebert quotes Michelangelo as explaining that it was an easy matter to chip away the *pezzettini* surrounding the *Notte* and bring the inner figure into view.[38] Traveling to Seravezza in 1568, Vincenzo Danti noted many stones marked "M" (for Michelangelo),[39] in which Michelangelo's gifted eye had discerned latent forms.[40] Such a block may be actually seen in a sketch reproduced in Goldscheider's *Drawings of Michelangelo* (p. 37). Recent photographs reproduced by De Tolnay show to what an extent the *Notte* and *Giorno* informed and coincided with the blocks from which they were hewn, demonstrating how well Michelangelo matched concept with material.[41] Yet the work which best illustrates his *concetto* theory is the *San Matteo*, whose unfinished appearance gives the illusion that the artist was interrupted in his work of chipping away the superfluous marble just as the inner form was beginning to "grow" (Plate I).

Other magnificent illustrations are the *Prigioni,* now in the Accademia delle Belle Arti, still half embedded in the "alpine and hard stone." Symonds felt that Michelangelo's two *tondi* may have been purposely left incomplete and rough to illustrate this theory.[42] Both Vasari and Cellini explained that Michelangelo had perfected a way to "extract figures from marbles"[43] in a manner a sculptor might employ if he actually felt that he was uncovering an enclosed form. He would uncover first the highest reliefs over the entire surface, and then work gradually into the deeper planes. Although this precise method was obviously not used to produce the *Prigioni,* the latter, like *San Matteo,* seem to struggle to free themselves from the rock which has encased them.

De Tolnay sees the entire architectural conception of the Medici Tombs as an illustration of this principle on a large scale: "With Michelangelo the tomb architecture is a mass with emphasised projections and recesses, animated by its inner forces, and the figures seem incarnations of the vital energies potentially present in this mass itself."[44]

Michelangelo's theory of the form embedded in lithic nature coincides with his addiction to the phrase "alpine and living stone." In a variant reading of sonnet CXXXIV to Vittoria Colonna, "Da che concecto à l'arte intera e uiua," Michelangelo says that a sculptor planning a portrait makes his final version in living stone, *pietra viva.* We have already reproduced the passage which notes that "the living figure in alpine and hard rock" outlasts the sculptor (CIX, 92). In one of his madrigals (CIX, 50) he writes:

> *Negli anni molti e nelle molte pruoue*
> *Cercando il saggio al buon concecto arriua*
> *D'un inmagin uiua,*
> *Vicino a morte, im pietra alpestra e dura;*
> *C' all' alte cose nuoue*
> *Tardi si uiene e poco poi si dura.*
> *Similmente natura*
> *Di tempo in tempo d'uno in altro uolto*
> *S' al sommo errando di bellezza è giunta,*
> *Nel tuo diuino è uechia e de' perire.*

By seeking through many years and many trials, the wise [artist] only when near death attains in the hard alpine rock the right Idea of a living image; so one arrives late at lofty and unusual

things and one remains little time thereafter. In like wise, if
errant nature with the passing of time proceeding from face to
face has arrived at the consummate beauty in thy divine face,
then she is old and must perish.

Mariani describes as surprising this analogy between the artist and nature
proceeding by degrees toward perfection.[45] It is, indeed, an unusual way
of restating the compromise position concerning the comparative impor-
tance of art and nature in the artistic process. The idea of succeeding
rebirths of beauty "from a greater womb" we have already encountered
(CIX, 46). The idea that "art can go no further" occurs again among
Michelangelo's applied criticisms (see Chapter IV).

From these passages one understands that the word *concetto* (and
alternate terms) is the basis and goal of the artistic process. The theory
has interesting implications. What, for example, becomes the function of
the wax or clay model if the God-created form is sealed in the marble?
Michelangelo is not abashed by any contradiction here. In a sonnet to
the Marchioness of Pescara (CXXXIV, variant) he specifies that there are
two stages in sculpture. Already aware of the unchangeable *concetto* in
the finer material, the artist merely practices techniques of freeing it on
the baser clay or wax or crayon. This is the sculptor-painter, incidentally,
who eventually ordered many *schizzi* burned so that none might see how
he had "tried out his genius."[46] The sketch or the model is the pledge of
the really beautiful form promised by the hammer. After this practice
stage comes the second and more important phase in which his now-
practiced hand can more easily extricate the preconceived form:

> Da che concecto à l'arte intera e diua
> Le membra e gli acti d' alcun, poi di quello
> D'umil materia un semplice modello
> È 'l primo parto che da quel deriua.
> Po' nel secondo im pietra alpestra e uiua
> S'arrogie le promesse del martello,
> E si rinasce tal concecto bello,
> Che 'l suo ecterno non è chi 'l preschriua.

When perfect and divine art has conceived the form and actions
of someone, then of that person it makes a simple model in a
humble material. This is the first birth which derives from that

> concept [first creative process of the artist]. Then in the second
> process the promises of the hammer are fulfilled in the living
> stone; and thus the concept is reborn so beautiful that there is
> none who might ever limit its immortality.

The references to "living stone" quoted above apply to the rock teeming with life even before the sculptor touches it. They recall his conjecture in sonnet LXV that rocks out in nature may have the power of speech, a possibility to which he alludes in Letter XXXVII, "Se le pietre avessino saputo parlare, etc." One finds equally in Michelangelo the familiar notion of the statue's becoming alive when completed, a notion as old as the Pygmalion myth. Indeed, in one of his gay *stanze* (XXXVI) Michelangelo imagines himself a Pygmalion:

> *Io crederrei, se tu fussi di sasso,*
> *Amarti con tal fede, ch' i' potrei*
> *Farti meco uenir piu che di passo ...*

> *If thou wast of rock, I believe*
> *that I could love thee with such devotion*
> *that I could make thee come to me on the run.*

The notion received more impersonal treatment in Vergil, who wrote of artists forgoing "graceful and breathing bronze statues" and who "draw [*ducunt*] living figures from marble."[47] He wrote also of "Parii lapides spirantia signa."[48] Never hostile to classical ideas and metaphors, Michelangelo held that sculpture reproduced subjects "with members more alive," and he on two occasions granted his *Notte* the power of speech (the reply to Giovanni Strozzi [CIX, 17] and the recital of the *Giorno* and the *Notte*) (XVII). Doni, by the way, made of the *Aurora* a living and speaking being, as Strozzi did of the *Notte*.[49] Furthermore, Michelangelo imagines the dead youth Cecchino dei Bracci apostrophising his tomb (LXXIII, 22) as a living being with the faculty of memory ("Tu sol pietra il sai!"). The tomb headstone responds in several stanzas with flattering and nostalgic praise of Cecchino. Michelangelo even interpolates a specific note (LXXIII, 36): "The sepulcher speaks to whoever reads these verses: 'Foolish things,' but since it is wished that I do a thousand of them, there has to be a bit of everything." One stanza is

headed "Sotto la testa che parli" ("Under the head that it may speak"), apparently making the four lines (LXXII, 41) the outcry of the bust of the curly-locked Cecchino executed by Michelangelo's beloved assistant Urbino.

Sometimes the living and alpine rock of the mountaintop does not wish to become the living and breathing stone of the museum or mausoleum. Michelangelo listens to the complaint of what is apparently the headstone on Cecchino's sepulcher (CXXV):

> *Dagli alti monti e d'una gra' ruina*
> *ascoso e circumscricto d'un gran sasso*
> *discesi a discoprirmi in questo basso*
> *contra mie uoglia, in tal lapidicina.*

> *Down from the high mountains and from a great quarry,*
> *hidden and guarded within a great rock,*
> *I descended to be uncovered,*
> *against my will, in such a headstone.*

Here again struggle is implied. The resistant block does not wish to be displaced or "uncovered." Here Michelangelo sympathises with the stone itself rather than with the human forces that drive it out of its natural setting.

In a moment of irony, Michelangelo even conjectures that a portrait by a weak artist summons up the power of speech to complain of its own poor execution (see Chapter IV, note 118).

We saw earlier that Michelangelo applied his theory of predetermined form to the style contained within ink. He applied it also to the art of the goldsmith, of which, incidentally, Cellini declared him "totally ignorant." Just as the outer surface of the rock awaits the ministrations of the sculptor, so waits the mold "full of anticipation" for the gold or silversmith (CIX, 61):

> *Non pur d'argento o d'oro,*
> *Vinto dal foco, esser po' piena aspecta,*
> *Vota d'opra prefecta,*
> *La forma, che sol fracta il tragge fora.*

> As the empty form waits to be full of gold or silver liquefied
> by the fire; from that form then, just by breaking it, one ex-
> tracts the perfected work.

It has been suggested that Michelangelo transferred to the field of painting his theory of art-forms swelling and barely contained in their blocks, that the limited spaces into which the Sistine Ceiling was divided were spatial challenges, with Michelangelo having to circumscribe swelling figures into the "blocks" allotted to the biblical histories: this supposition seems to work better with the Prophets and Sibyls in their pendentives.

Mariani would have us believe that the artist transferred this theory even into his versifying. "Thus, the procedure of composition of his best lyrics is that of his sculpture and that, in sum, of his art. He sets before him his 'block' and the still hermetic 'problem' of the sonnet, the canzone or the epitaph. This problem has its rigid laws of structure and pre-ordained form which the author is encouraged to puzzle out; no correction through superstrating is possible (and for this Michelangelo denies validity to sculpture which is carried out by means of laying on [*porre*]). It is at the very heart of the 'circumscribed' problem (how often this term is repeated in Buonarroti's poetry!), within its formal limits, that one must insert the vital complex mass of members, that is, the new structure of the images and sentiments which live within the limits of poetry itself but press onward and outward toward greater spaces."[50] While this attractive thesis might be debated at length, it is generally true that Michelangelo adopted difficult forms of prosody and versification, and that his thoughts are full and crowded within their stanzas.

Did Michelangelo's *concetto* theory die out with him in 1564? Although it would be pretentious to claim that it left a permanent stamp upon world art history, the theory made sporadic reappearances until fairly recent times. Galileo used Michelangelo's own vocabulary when he asked, "And when would you know how to remove the excessive stone [*soverchio*] from a piece of marble and discover the beautiful figure which was hidden within?"[51] Philippe Desportes' translation beginning "Le sculpteur excellent desseignant pour ouvrage" has already been mentioned. Joseph Addison signaled the idea's arrival in England, writing, "The statue lies hid in a block of marble; and the art of the statuary only clears away the superfluous matter and removes the rubbish."

As late as 1931 a professional artist was still quibbling about it. In *The Sculptor Speaks,* Jacob Epstein reveals his complete misunderstanding of Michelangelo. "There is apparently something romantic about the idea of the statue imprisoned in a block of stone, man wrestling with nature. Michelangelo himself has written a poem [*sic*] about the subject, but he was a modeler as well as a carver [*sic*]. He is patronised as a modeler of talent, even of genius, but merely as a modeler."[52] All this merely proves that Epstein could be as wrong about Michelangelo as was his contemporary Diego Rivera, who alleged that Michelangelo was a social revolutionary. As we shall see in due time, Buonarroti considered true sculpture only "that which is done by means of taking away: that which is done by means of adding on is similar to painting." As a consequence of his art-form theory, Michelangelo worked almost exclusively with marble blocks, which Alain, in his *Système des beaux-arts,* called Michelangelo's "matière, appui, et premier modèle."[53] The limitations of the stone became a challenge and the result was, to concede a point, "man wrestling with nature."

It was suggested above that the *concetto* theory had several curious implications, seeming to involve several paradoxes. One such paradox concerns Michelangelo's proud and personal belief that a gifted artist has "true proportion in his eyes," just as a musician has "true pitch" in his ears ("nè sordo nè cieco"). He takes pride that his eye is so keen that his works, whether architectural elevations or major statues, have been executed without the aid of compasses or rulers or T squares, an accomplishment of which few can boast. Yet, at the same time, he realises as a Platonist that these geometric measurements which some like Pacioli have mistakenly called "divine proportion" are not identical with the proportions of divine Ideas, resisting *quadrature* and mathematical tables, which the artist endowed with *intelletto* must "capture" in stone or pigment.

It would seem that a genius capable of discovering pre-existent forms would have little need of the tricks and instruments of the trade. He would scorn the mirrors (even granting [XLIX] that "lo specchio 'l uer

dice"), plumb lines, and measuring devices of his contemporaries. Dissenting from a Pythagorean tradition and fearful lest it become a manacle or an artistic nostrum, a Michelangelo must deplore the rigid mathematical formulations of the human body established by Vitruvius and continued by Luca Pacioli's *De divina proportione* (1497), Pomponio Gaurico's *De Sculptura* (1504), Vincenzo Poppa's *Trattato della Pittura* (n.d.), and Alberti's thorough tabulation of the exact measurements of the various members of the body. This very precise formulation in *De Statua* was based on the examination of many different models, Alberti admittedly having been inspired by Zeuxis' achieving the proportions of the Crotonian Venus by taking the best features of several virgins. (Actually, Zeuxis was aiming not at striking an average, but at making a composite, as if mindful of the Greek epigram, "Thou hast the eyes of Hera, the hands of Athena, the breasts of the Paphian, the ankles of Thetis.")[54] Michelangelo felt that Dürer's figures lost rather than gained by the German's reliance upon ratios, geometric patterns, reticles, and even lutes.[55] He would renounce quantitative resolutions of form, from the Greeks' *teleon* down to later "golden sections," not because he would disagree that these formulations afforded a pleasing rectangle, but because he felt that the eye unaided might find an equally harmonious ratio. Michelangelo entertained definite convictions about balance, *contrapposto,* and the serpentine line, as Lomazzo tells us, but his only passing interest in numerical ratio was in shaping his bodies as many as eleven *facce* in length, and his pyramidal constructions on a 3:2:1 ratio.[56] He did not use these ratios, however, as guides or checks. Although Michelangelo disapproved of Da Vinci's formulae on proportion, he could only applaud Leonardo's games invented to improve the eyes' ability to judge distances and proportions. In fact, Michelangelo made Piero Soderini the unwilling participant in such an improvised game. The gonfaloniere told the sculptor that the nose of the marble *David* was too long. Concealing some marble dust in his palm, Michelangelo climbed up his ladder and, feigning to work with his hammer and chisel, appeared to reduce the proportions of the offending member. After a while, he solicited another opinion from Soderini, and the latter cried, "I like it much better that way. You have given life to the statue."[57] To Michelangelo, who did

not take criticism easily, as we are aware, this proved satisfactorily that still another employer lacked what every person of perception should have: "compasses in the eyes."

At least four texts testify to Michelangelo's belief that a gifted artist carries his compasses in his eyes. In Lomazzo's *Trattato* one reads:

Onde egli una volta trovandosi a Monte Cavallo in Roma ebbe a dire queste o simili parole: che i pittori e scultori moderni dovrebbero avere la proporzione e le misure negli occhi per poterle mettere in esecuzione: volendo accennare che questa scienza appresso i moderni era perduta rispetto a quelle statue maravigliose degli antichi, come quelle di Fidia e Prassitele collocate ivi in Roma (II, 165).

Whence, finding himself once at Monte Cavallo in Rome, he had more or less the following words to say: that the modern painters and sculptors ought to have proportion and measures right in their eyes, in order to put them into execution: wishing to point out that this science had been lost among the moderns, if compared to those marvelous statues of the classic artists, such as those of Phidias and Praxiteles located there in Rome.

Elsewhere in the *Trattato*, Lomazzo states that Michelangelo measured these statues at Monte Cavallo and learned that "the faces had to be made proportionally larger as the figures were placed higher, so that the work might appear most proportionate to the eye" (I, 45). Such ease in handling foreshortening resulted from the fact that these ancient artists "kept their measures in their eyes."

There is a more succinct quotation in Vasari (VII, 270), who cites Michelangelo as declaring "che bisognava avere le seste negli occhi e non in mano, perchè le mani operano, e l'occhio giudica" ("that it was necessary to keep one's compass in one's eyes and not in the hand, for the hands execute, but the eye judges"). One must depend on the inner eye, even when working in architecture. Thus, Michelangelo is said to have designed his model for the cupola of St. Peter's "sans règles, sans calcul, avec le seul sentiment qui guide un grand artiste."[58] Vasari, so often a mouthpiece of Buonarrotian thought, twice asserts that "the judgement of the eye" is more reliable than compasses or instruments (I, 148, 151).

Lomazzo's *Idea*, echoing Michelangelo's remark about compasses, observes that the Florentine's use of proportions is unusual but admir-

able: "He gave his figures the proportion of Saturn, making the head and feet small and the hands long, composing the members with great accuracy [*ragione*] and forming them with great breadth; the contours are wondrous, very great due to the depths of the muscles and preserving the order of the design and of the anatomy, regarding which it is written that he used to say that proportion should be in men's eyes so that they might know directly how to judge what they see."[59] Finally, in Lomazzo's *Trattato*, Michelangelo is quoted as stating that "mathematics, geometry, and perspective are to no avail unless the eye is accurate to begin with and trained in seeing." He adds that however much the eye may practice lengthily with these perspectives, "only when it can see without the aid of angles, lines, or distances any longer can it become apt and cause the hand to execute on the figure all that is desired and leave nothing to be hoped for by way of perspective" (II, 36).

Michelangelo's justifiable reliance on his trained eye is documented by none other than Castelvetro. A few years before there had been excavated the statue of a river-god with beard broken and missing, although the tip remained fixed on the chest. No one could imagine how the beard must have looked in its original state. Michelangelo, whose own Fiumi were to be bearded,[60] requested some clay and executed the missing beard, knotting and twisting it so that it fitted exactly onto the remnant tip. All marveled, concludes Castelvetro, at his ability to grasp total basic form without need of instruments to assist him in visualising the missing portion.[61]

A further evidence of Michelangelo's mistrust of mathematical praxis to guarantee accuracy of proportion is the mere fact that, among the drafts and outlines which have come down to us, there are just two figures whose major proportions are plotted out in *braccia* by two or three horizontal and vertical lines. These are two studies of a river-god for the Medici Tombs, now in the British Museum (Berenson, 1491, Plate II).[62]

It is understandable from all this if an occasional painted or sculptured figure of Michelangelo's is out of proportion. Milton Nahm complains that "Michelangelo actually painted some of the stooping figures in his compositions as much as twelve 'heads' in height."[63] Warren

Cheney observes that the *Sibilla Libica's* right thigh is nearly one-third longer than her left and that the right leg of the *Aurora* is 15 per cent longer than the left.[64] In the face of such charges, Michelangelo the Platonist could respond that a work could have a proportion sufficient to itself and its own needs, transcending such instrumental measurements as in Dürer's *Proportionslehre*. This he definitely felt in the case of the *Madonna della Febbre,* for example, where the cadaver of Christ in the Virgin's lap is unnaturally small, yet pleasing to the spectator. Warren Cheney calls this quality "creative proportion" and views it as a characteristic by which Michelangelo anticipates modern sculptors.[65] Whether or not one agrees with Cheney, the proportions of Christ and the Virgin are not those of the models, but, as we have said above, of *typoi* existing in the *intelletto.*

Bellori and Danti echoed the language of Michelangelo. Bellori, defining his "Idea," notes that his Idea "measured by the compass of the *Intelletto* becomes the measure of the hand."[66] Vincenzo Danti lauds the efficacy of "la misura intellettuale" in painting and sculpture, although not in architecture—a timid reservation! In his *Trattato delle perfette proporzioni* he claimed for Michelangelo the discovery of the authentic proportions of the human body, thanks not only to long study of anatomy but equally to this "intellectual vision." He goes so far as to posit replacement of "material compasses" by "compasses of judgement" as the ultimate purpose of striving for perfect proportions.[67]

Whereas the vision of competent artists is unfailingly accurate, incompetents require gadgets to capture exact proportions. Even with such aids and such experiments in optics as Leonardo's, the accuracy of their vision is not guaranteed. There are, as any Neo-Platonist worth his salt could tell you, an inner and an exterior vision. As Ficino among others noted, there is an inner or higher vision which is part of man's *anima prima* and which Plotinus had described as "another vision to be awakened within you, a vision, the birthright of all, which few turn to use" (*Enneads* I, vi, 9). One of the faculties of the Lower Soul, the *anima secunda,* is the exterior vision. This very terminology is used by Michelangelo in the *Dialogos em Roma* when he is criticising Flemish painting.[68] It denotes a vision which cannot discern the true Idea through the

· *33*

veil of matter, a vision which cannot perceive unity and form behind the obvious and apparent, even with the help of such externals as mirrors or reticles. And—this was important to Michelangelo—a vision which is satisfied with bright colors. Writing in his *De' veri precetti della Pittura* (Ravenna, 1586), Armenini managed to sound very much like Michelangelo himself instructing a young garzone in the art of painting: "One must not follow merely the judgement of the exterior eye, which judgement can be easily dazzled by the charm of a variety of colors; and it would be all too easy to judge the works of this art if one followed only this judgement; but one must have recourse to the eye of the *intelletto*, which eye, illumined by the requisite rules, recognises the True in all things."[69] Pico and Ficino held that the Intellect sees "with an incorporeal eye" and "calls itself away not only from the body, but also from the senses and the imagination"; it thus transcends and becomes a "tool of the divine."[70]

Is it any wonder that we find such severe condemnations of the senses in Michelangelo's written works (e.g., "Voglia sfrenata el senso è, non amore, che l'alma uccide"—"unbridled desire is lust, not love, and kills the soul")[71] with his Neo-Platonic and his Christian principles marshaled against them? Persuaded that *persone accorte* were few and far between, he developed an Horatian scorn for the great majority. He was sure that most of the public admitted to see his paintings in the Sistine Chapel would not understand their excellence or discern their beauty—even those confreres who sat for hours attentively copying his figures until he was moved to sarcasm. As George Santayana once observed, "There are portentous works, like those of Michelangelo and Tintoretto, to which everyone will assign a high rank in the history of art; but the interest and wonder which they arouse may rarely, and only in some persons, pass into a true glimpse of the beautiful."[72]

Leon Battista Alberti compounded two Platonic images to make of a winged eye his personal emblem. Michelangelo might have done likewise. One of his poems, perhaps an echo of a pseudo-Platonic epigram, dramatises especially the crucial function of the eye in taking in beauty through an "active contemplation," a beauty which grows (*cresce*) and occupies the entire being:

fa' del mie corpo tucto un' ochio solo;
nè fie poi parte in me che non ti goda![73]

Make of my entire body one single eye, nor let there be then
any part of me not taking pleasure in thee!

Ficino (V, III) anticipated Michelangelo in recognising that some beauties
are too overpowering to be taken in by "the small pupil of the eye":
"quo enim pacto caelum, ut ita loquar, totum parva oculi pupilla ca-
peretur . . . ?" Ficino, rather than Catullus, is the source here.

The preceding paragraphs treat of the relationship between the eye
and the hand, separate and yet interdependent, like the eye-principle
and hand-principle which Plotinus saw included within the intellect-
principle.[74] Michelangelo held definite ideas also regarding the relation-
ship between the brain (mind) and the hand. One day Benedetto Varchi
paid him one of those extravagant compliments to which the academician
was addicted, "Signor Buonarroti, you have the brain of a Jove." The
sculptor, for so his reply characterised him at the moment, responded,
"Si vuole il martello di Vulcano per farne uscire qualche cosa" ("But
Vulcan's hammer is required to make something come out of it").[75] This
incident serves to introduce us to Michelangelo's conviction that between
the conceptions of the mind and the realisations of the hand, there is, as
the Italian phrases it, "the whole sea."

The original inspiration comes to the mind (representing nature),
and the hand (representing art) may or may not be qualified to execute
it. Each has to perform under optimum conditions. In 1542 Michelangelo
wrote to an unknown prelate at the court of Paul III, complaining of his
difficulties with the Duke of Urbino, "Io rispondo che si dipinge col cier-
vello e non con le mani" ("I reply that one paints with the brain and
not [merely] with the hands").[76] One must have a free mind to work,
for *mens agitat molem*. This genius who was prey to constant tribulations,
real or imagined, claimed that he could not create when troubled, that
pressures were a curb and not a spur. This genius in whose mind thanato-
phobia dwelled like a leitmotiv asserted in a poem that if he set to think-
ing upon death, "both art and genius vanish" (hand and mind fail to
respond) and he could create nothing. The immediacy of the correlation

· *35*

between hand and mind is stated in a letter to Fattucci: "chè e' non si può lavorare con le mani una cosa, e col ciervello una altra, e massimo di marmo" ("for one cannot shape one thing with one's hands, and another with one's brain, especially in marble").[77]

Michelangelo was scarcely flattered or pleased by the well-intended but ingenuous strophe addressed to him by Fausto Sabeo, with its line, "Fingimus, ingenio namque ego, tuque manu" ("We both feign, I with my mind and you with your hand").[78] Not only was the comparison audacious, but revealed a basic misunderstanding of the artist's intellectual independence. Michelangelo would deny that he was a mere handworker as vehemently as he denied that he was a shopkeeping artist. He and his confreres were bent intensely upon raising the popular conception of painting and sculpture as a trade identifiable with guilds and shops not only to the level of a profession but also, as Paolo Pino suggested, to the status of a liberal art and branch of philosophy.[79] For this reason, Leonardo's statement that "painting is a mental thing," which appears at first sight like a trivial little jotting, was a tenet, a program, and a challenge to be taken with high seriousness.

More consonant with Michelangelo's taste and more laudatory than Sabeo's line was Bronzino's verse quoted above, "I consecrated to you my hand and my *intelletto*."[80]

This insistence on the mental phase of painting and sculpturing implied a demand for more freedom of conception and ideation on the part of the artists, the freedom proclaimed in those verses of Horace ("Pictoribus atque poetis," etc.) which Michelangelo quoted from memory to Diego Zapata in the course of the "Roman dialogues."

The loftier the conception of which the *intelletto* is capable the greater the challenge to the hand. This issue was by no means a theoretical one to Michelangelo, who was being pressured to undertake tasks exceeding his preparation as early as the Sistine Ceiling ("e ancora el non esser mia professione") (Letter X and *passim*). Remembering the Horatian counsel to set a goal commensurate with one's powers ("Sumite materiam vestris aequam viribus"),[81] Michelangelo draws therefrom a distinction between the competent and the incompetent artist. The able painter is timid about essaying even that type of painting he knows best,

whereas an ignorant dauber audaciously loads his canvas with subjects and effects of which he has not mastered the technique:

E nisto se conhece o saber do grande homem, no temor con que faz uma cousa quanto melhor a entende, e polo contrario, a inorancia d'outros na temeraria ousadia com que enchem os retavolos do que não sabem aprender.[82]

And hereby one recognises the wisdom of a great man, in the fear with which he does the thing which he understands the best, and conversely, the ignorance of others in the audacious temerity with which they encumber pictures with what they cannot really learn to do.

(Michelangelo's casting into the singular the concept of the wise man and into the plural that of the ignorant man is unconscious and symptomatic.) Similarly, he will censure Flemish painting (see Chapter IV, note 49) for trying to cover so many things that it does none well. Alberti had given a similar piece of advice to artists: "To try to keep doing more than you really can or more than is suitable is the sign of a talent rather obstinate than diligent."[83] Leonardo put the thought into a sonnet: "Chi non può quel che vuol, quel che può voglia / Che quel che non si può, folle è volere."[84]

Michelangelo more than once felt unable to match with technique the tremendous concepts of which his intellect was capable. Such a concept was his colossus to be sculptured from a mountaintop at Carrara, a project which remained an unfulfilled desire.

Both Condivi and Vasari admit that he keenly sensed and resented this disparity between mind and hand, implicit in Horace, which he felt so tragically during the final lusters of his long life when he kept chiseling even though "he could hardly hold up his head" (Don Miniato Pitti). In a late letter to Lionardo he cried, "La mano non mi serve."

CONDIVI: He is also endowed with a most forceful imaginative power; the result of this is that he has scarcely ever been satisfied with his creations and has belittled them; it has not seemed to him that his hand has succeeded in executing that Idea which he conceived within himself.[85]

VASARI: He had such a powerful and perfect imaginative faculty that the subjects which presented themselves to his intellect were such that, being unable to express with his hands so great and terrible concepts, he often abandoned his works and even destroyed many of them.[86]

These passages, incidentally explaining Michelangelo's many *non finiti*, show the tragic implications of the famous line in the sonnet "Non ha l'ottimo artista alcun concetto," where Michelangelo stated that there was no disparity between the conceptions of a great artist and his realisations in stone, provided the hand was really capable of obeying the intellect. Sometimes, despite all his efforts, the conceptions resisted translation even into sketches or models, that stage which Michelangelo called the "first birth of the concept."

Whereas Horace's advice referred directly to the magnitude or the nature of the literary or artistic subject, it could apply indirectly to number. Buonarroti himself admitted that a great painter's mind is constantly assailed by lofty imaginings: "continuas e altas imaginações de que sempre andam embelesados."[87] His own inspirations cascaded into his mind with such persistence that he frequently had several works proceeding concurrently. Condivi alleged of him that, "being so loaded with concepts, he is compelled to give birth to one every day."[88]

Michelangelo's subscription to the Horatian principle of not exceeding one's capacities was carried into other activities of his intellectual life. In the *Dialoghi* of Donato Giannotti he is reluctant to enter into a discussion of some phase of the *Divine Comedy*, for it is a "subject which surpasses my abilities."[89] Since Michelangelo knew so thoroughly the *Commedia* and Landino's commentary, one has here an example of the "great man's fear to do the thing which he understands the best," mentioned by Michelangelo.

His assertion that "one paints with the mind" must have found agreement among his contemporaries. Leonardo, who insisted that "painting is a mental thing," might have had recourse to it to explain his mysterious inactions to the Prior of the Convent of the Graces when, according to Bandello and Giraldi, he gazed for several days at the incompleted *Ultima Cena* without touching his brush.

Michelangelo supplies us with two further opinions regarding this relationship between intellect and hand, which constitute a "doppio valor." His sonnet "Se ben concietto à la diuina parte" (CXXXIV) suggests that if the *intelletto* has captured aright the divinely implanted form in the material, then a lesser effort of art (the hand) is required: "e non

è forza d'arte." He observes that poor painters will never be tormented by the failure of their hands to carry out their conceptions. The reason? Poor painters cannot visualise the Idea through their exterior vision; moreover, they cannot possess a powerful imaginative faculty:

O mao pintor não pode nem sabe imaginar nem deseja de fazer boa pintura na sua Idea.[90]

The poor painter is neither able nor knows how to project images, nor even desires to do good painting according to his Idea.

The poor results will be due to a weak hand expressing a weak *immaginativa*.

If one gives credence to Michelangelo's writings, the artist knew that he was one of the elect granted the grace of intellect, that God was the donor of this faculty, and he knew the manner in which the divine intellect guided the artist's hand. He knew these things as faithfully as he knew the catechisms of the Church or of Platonism. He would disagree emphatically with the nineteenth-century theory of spontaneous creation as reflected in Shelley's *Defence of Poetry:* "A great statue or picture grows under the power of the artist as a child in the mother's womb: and the very mind which directs the hands in formation is incapable of accounting to itself for the origin, the gradations, or the media of the process."

After his remarks in the Roman dialogues on the Horatian *sumite materiam,* Michelangelo adds that a painter need not create a thousand works of art to demonstrate his genius.[91] It was superfluous, in other words, for that swarm of ideas to invade his mind daily. A master may excel in his craft and have painted but one canvas or wall. "He may know more about what he doesn't get done," Michelangelo explains, "than the others know about what they keep doing." Michelangelo was working on just one painting when he said this, but it was the *Giudizio universale!* Greene adduces the example of Michelangelo to disprove the

artist's own thesis that a genius need not exhibit sustained production, adding: "Witness the last compositions of Beethoven and Bach, Titian and Cézanne, Michelangelo and Shakespeare."[92]

Was Michelangelo incidentally reacting to the excessive number of paintings by some contemporaries, especially those daubers who had to keep turning out canvases to make a living? Tempesti, the pupil of Santi di Tito, is a tardy example; he executed innumerable paintings and then, relaxing from painting by doing engravings, completed 1,500 of them in his lifetime. Perhaps Michelangelo was reflecting that, despite Greene, the number of his own paintings was limited. Most likely of all, he was merely stating an inevitable conclusion premised on this *intelletto* theory. A painter could not be one of the chosen "elect" at one time and yet be expelled from that group at another. Michelangelo's theory of artistic predestination was as rigorous as any preordination thought up in Geneva. If an artist did one inspired painting evidencing possession of the *sensus interior*, he did not have to furnish other proofs of genius.

Buonarroti presses his point. Not only may the competent painter stand revealed by one canvas; he need merely make a rapid sketch, just as though he were plotting out a picture, and by that alone he will be recognised as an Apelles, if he is an Apelles—or an ignorant dauber, if such he really is. The eye of the expert judge will require no lengthy scrutiny. Protogenes recognised the hand of Apelles by a single line. Similarly, the artist who can paint a hand, a foot, or a throat will be able to paint anything in creation. Michelangelo concludes that there will always be, moreover, painters attempting every sort of subject so imperfectly and unrecognisably that they had better paint nothing at all.

Michelangelo, believing in the *ex ungue leonem,* parted company with Horace, whose patterns of thought he followed so often. Persuaded that genius is not parceled out in parts, he dissented from the Roman theorist's claim that a masterful sculpturing of hair or hands does not guarantee mastery of the larger conceptions.

> *Aemilium circa ludum faber imus et ungues*
> *Exprimet et molles imitabitur aere capillos,*
> *Infelix operis summa, quia ponere totum*
> *Nesciet.*[93]

Leonardo sided rather with Horace on this issue: "Surely it is no great achievement if by studying one thing only during his entire lifetime one attain to some degree of excellence therein . . . He is but a poor master who makes only a single thing well."[94] An incident in Michelangelo's life, recorded by Condivi, helps to explain his conviction (and supports the authority of De Hollanda). When the Cardinal of San Giorgio sent an emissary to Michelangelo to discuss a possible commission, the artist was embarrassed, having no sample of painting to exhibit. He picked up a pen and drew a hand with such superb artistry that the agent "remained stupefied thereat."[95] Indeed, Michelangelo's sketches of hands, not to forget the curious hand exhibiting the obscene *fica* (see Frey, *Dichtungen*, p. 385), seem ends and unities in themselves.

Michelangelo's belief in transfer, then, persuades him that a painter may be great through one painting and that the painter who does one type of subject well will do many types well. This tenet of belief has implications for his theory of artistic nationalism, treated in Chapter V. One is not surprised to read in the *Dialogos* his affirmations that Italians could, after all, do more than the nudes and symmetries for which they were renowned. Yet it also explains his otherwise unexpected admission in the dialogues that a Flemish master can by the same token excel in other subjects than the textiles and foliage for which the Flemings are known.

Before proceeding to the issues of inspiration and the conflict between art and nature, let us pause to note that the theory of the *concetto* guarantees unity to the talented artist's work. The reader has noticed Michelangelo's references to the "arte intera" and "opera perfecta," revealing that a neoclassical desire for unity lurked in his mind throughout. Later on we shall find him claiming unity to be a guiding principle of architecture. We shall study his letter to Rodolfo da Carpi in which he asserts that since all parts of an architectural unity must harmonise, if one part be changed, the others must be altered to preserve that unity. There is a Michelangelo anecdote on this subject. Daniele da Volterra was showing an elevation to Michelangelo and explaining certain changes which he would have to make in it: reduce a wall here, thicken it there, cut another window, and so on. Michelangelo cried out a warning:

Ha! per levar tutti questi tantini, bisogna un tantone, e per questo far come quel che ha un fosso da passare più largo che non converria per poter saltar da l'altra banda, che bisognerebbe alcuni palmi di larghezza di manco; allora deve allontanarsi per poter far il salto.[96]

Ha! To change all these trifles, major changes become necessary, and to accomplish that you must imitate a man who has to pass a ditch too wide for him to jump to the other side, too wide by several palms. In such a case he must retreat in order to be able to leap forward.

Incidental to the matter of unity is the important issue of the *veduta unica*. The question as to whether Michelangelo's statues show unity from all sides has arisen in both modern times and the Renaissance itself, in those days when Cellini claimed that a figure should display not one view but more than a hundred views,[97] even though claiming elsewhere never to have seen a statue which looked well on all sides.[98] If Michelangelo sometimes used the method of carving figures attributed to him by Vasari, it was in an effort to preserve their unity from all sides. This method, contrasting with the extracting procedure described above (note 43), consisted of copying from a model situated in a pan of water, carving down from the top gradually as the waterline in the pan was lowered. Carlo Aru, in an article on "La veduta unica e il problema del non finito in Michelangelo," asserts that the reason Michelangelo left incomplete or destroyed so many works was his dissatisfaction with the additional perspectives of his works, even though the first one pleased him.[99] This explanation of the *non finiti* is to be contrasted with that of Vasari (note 86). Cellini agreed that the combined challenge of the *vedute* and the *materia* several times kept Michelangelo absorbed in a single statue for six months.[100] Aru has further alleged that Michelangelo's plastic ideal found its realisation more easily in painting, in which it is indeed possible to impose a *veduta unica* satisfactorily. To which Buscaroli retorts with the oversimplification, "Exactly the opposite of the language of Michelangelo, always and especially a sculptor."[101]

Did considerations of lighting incline Michelangelo toward accepting the limitations of the *veduta unica* for statuary? If he did not write on the *ricevimento dei lumi*, as his contemporaries did, one remembers his interest in the works of Cellini receiving the most favorable lighting.

Some have claimed that he created his statues in such a way that each might benefit most by a specific directional illumination. "It is essential, for example, that Michelangelo's Lorenzo de' Medici be illumined primarily from a point in front of, and above, the figure, in order that the shadow cast by the helmet be correctly placed."[102]

As for architectural unity, De Tolnay notes that the unity of the Medici Chapel can be perceived from behind the mensa and that "this 'transcendental' viewpoint is the presupposition also of some other works of Michelangelo, as for example the Capitol, which reveals its unity only from the stairway of the Senatorial Palace."[103]

A recent rebuttal to the proponents of the *veduta unica* thesis aims to demonstrate that Michelangelo's ideal of total and complete beauty compelled him (unlike his contemporaries) to perfect the rear surfaces of his statues as carefully as the front.[104] Whether or not one concedes that the temptation to neglect the unobservable backs of statues was so great for most Renaissance sculptors as Phillips claims, the latter documents his position on Michelangelo with new photographs showing the backs of several of the statues allegedly more complete and detailed than heretofore believed. Photographs recently reproduced by De Tolnay (in *The Medici Chapel*) show clearly such important rear detail as the grotesque mask on the back of Duke Giuliano's cuirass, a mask specifically designed to impress the spectator with its *terribilità*.

What of the traditional conflict between art and nature in the formation of talent and what of the neoclassic imagery of inspiration? Michelangelo remembers that the spring of Helicon can be counted on to some extent; having promised to write fifty funereal poems for Luigi del Riccio, he traces in chalk the complaint (LXXIII, 33): "Cose goffe. La fonte è secca; bisogna aspettar che piova" ("Clumsy pieces. The fount is dry; I must wait until it rains"). Astrological images of inspiration were of course in vogue. Says Pino, "We are guided to such perfection through the medium of a good disposition of nature, which becomes infused in us by certain conjunctions of the most benign planets, at our conception [*generatione*] or at our birth."[105] Indeed, Condivi (IV) attributes Michelangelo's artistic genius to such a conjunction. Buonarroti admits as much (CIX, 89):

Po' c' a destinguer molto
Dalla mie chiara stella
Da bello a bel fur facti gli ochi mei.

Since my eyes were given me by my shining star to distinguish
easily one beauty from another.

What of the creative fury, the *sacra pazzia,* or Corybantic exaltation
which was supposed to seize upon artists and poets in neoclassic as well
as classic times? In his *Trattato,* Lomazzo observed, "In painting as in
poetising the fury of Apollo courses throughout."[106] As a frequenter of
both Plato and Horace Michelangelo remembered that each had poked
fun at the notion of creative fury which transmutes itself into physical
action. Yet Plato subscribed most seriously to it in the *Phaedrus.* The
Neo-Platonists accepted this fury, Pontus de Tyard calling it "l'unique
escalier par lequel l'âme peut trouver le chemin qui la conduise à la
source de son souverain bien."[107] Cellini claimed that Michelangelo
created best under the spell of a *furia* or *furore*[108] (another contemporary
alleged that he did the *Noli me tangere* cartoon in *furia*).[109] Blaise de
Vigenère also was astonished by this fury of Michelangelo's (see note
163). In Michelangelo's own vocabulary the word *furia* had rather the
specific meaning of the appearance of dynamism and action-in-check
which he wished his figures to display. He does not speak of creative
fury in conventional (Platonic) terms.

Did Michelangelo, then, really understand and experience this ec-
static creative mood—one of the four furies (amoristic, creative-poetic,
sacerdotal, and divinative)? Or did he set to work with the cool deliber-
ation commemorated in Delacroix's *mot* about Ingres: "Je sors de chez
M. Ingres; je l'ai laissé dans tout le froid de la composition"? One
evening he did admit to Riccio that the *furor poeticus* had not visited
him and he had written only a few verses: "la poesia stanotte è stata in
calma" (LXXIII, 45). Croce felt that Michelangelo received the thrills of
the rapid visitation by a muse or daemon. Borrowing from Shaftesbury,
as Middeldorf reminds us, Croce records that Il Domenichino, spied upon
through the fissure in a wall, was seen trembling and agitated, rolling on
the floor, rearing and trotting like a horse, mouth agape, eyes fixed,
murmuring and roaring. Still translating, Croce adds that this exaltation

was not unknown to Michelangelo, who created "out of his nights without rest, out of his meditations, dreams, ecstasies, and *rabiosa silentia*."[110] Perhaps typical is that ecstatic vision during which Michelangelo beheld and drew a three-tailed comet (see Chapter II, note 9). It is true that Michelangelo admitted that if he had not taken up the fine arts he would not always be "in such a passion."[111] This heated concern which he felt when plying his art also came over him when merely thinking, talking, or writing about the fine arts. In sum, one may conclude that Michelangelo experienced and recognised the creative fury, not only from such written or spoken evidence as Cellini's but also from the knowledge that he adopted a freehanded, rough-hewing technique with the chisel, revealing a trust in his *intelletto*. Of this freehanded procedure, by which he injured the *Deposizione*, more will be said.

Whatever one may believe about Michelangelo's creative furies, there was in his work at least a total absorption which withdrew him completely from the concerns and even awarenesses of everyday life. During these periods of intense immersion, when he did not eat regularly and dropped off to sleep fully clothed, he lost all sense of time. At these periods the necessity of dating a letter became a minor annoyance. Thus, one reads such amusing datings as "I don't know what date this is, but yesterday was St. Luke" (Letter LXXI), "I don't know what date this is, but tomorrow is Epiphany" (LXXIV), "I don't know the date" (LXXXVIII), "It's some date in February, according to my servant girl" (CCCLXXVI), and the wonderfully absent-minded notation of 6 January, 1548: "I don't know the date, but today's Epiphany." These withdrawals from the calendar coincided with periods of furious creativity, periods of what he called *passioni* or *gelosie*.

The issue of inspiration immediately raises that old puzzler which, like some elusive Philosopher's Stone, was resisting exact formulation in the Renaissance, namely, does art or nature form the artist or poet? Are men born artists or must they train themselves to be? To some of the theorists both genius and training were held to be necessary. Alberti wrote, "Let none then set his hand to work without the escort of genius, and let him be trained and instructed."[112] Most of the critics of antiquity had come around to this view, some tipping the balance slightly in favor

of nature. Plato, Longinus, and Quintilian were of this latter persuasion.[113] At first thought it would seem that Michelangelo's Neo-Platonism assigned him to the faction represented by these three. So might his Christianity place him there. In Salviati's *Primo libro delle Orationi* it is said that in Michelangelo art had contested with divinity.[114] To Michelangelo the question was phrased as between art or discipline and direct intervention by God. True, other neoclassicists, like his contemporary Vida, with whom we must align him, had considered that the contest was not between art and nature, but between art and God. But to these the god was not the Christian Jehovah of the Sistine Ceiling:

> *Quando non artes satis ullae; hominumque labores,*
> *Et mea dicta parum prosint, ni desuper adsit*
> *Auxilium, an praesens favor omnipotentis Olympi.* [115]

> But art alone is not enough; neither man's exertions
> Nor all my counsels will be of profit, lest from above
> Aid comes forth, and favor present from omnipotent Olympus.

Michelangelo's God-Nature was no dweller on Olympus. His identifying nature with the Christian God in the Roman dialogues very likely discloses a Dantean indoctrination:

> *come natura lo suo corso prende*
> *dal divino Intelletto e da sua arte...*[116]

> *as Nature takes her course*
> *from the Divine Intellect and from its operation...*

On this issue one must align Michelangelo against Bembo, Calcagnini, and Ricci, who were crediting the precepts of training and practice with making successful writers and painters. After all, *intelletto* by its very definition denotes an independence of rules, disciplines, and training. Michelangelo's theory of the *musico* (see below), a variant on his theory of the *intelletto*, also assigned him a place with those favoring *ingenium* over *ars*.

Yet Michelangelo's position is not so simply established. As with most Renaissance theorists who were also practitioners of either arts or letters, the exigencies of his craft, the long training period, the concentration of "exertions" and interest—all these made Michelangelo

recognise that the greatest innate talent cannot escape the complementary requisites of rules and practice. The insistence upon training in Michelangelo's poems and letters, the anguish caused by technical problems (see Chapter VI), will demonstrate how keen was this realisation. The possession of *intelletto* by the Finder does not obviate the necessity of searching for form and beauty. Mere possession of a divining rod does not eliminate the hunt.

Michelangelo had access to several manuals teaching the secrets of his profession: the technique of mixing colors, portraying actions, and achieving proportions. The popularity of these texts in the Cinquecento indicates how difficult it was for the humanists to indoctrinate their contemporaries with the ancient and venerable theory of inborn creative genius. Even the authors of these *artes pictoriae* who began their treatises by paying lip service to the idea of all-sufficient genius concluded them with chapters of technical instruction. They all insisted that the painter must dedicate himself to becoming an erudite man (see Chapter III, note 182). On the other hand, no writer of these manuals claimed that training by itself sufficed. In Lomazzo's *Idea del tempio della Pittura* the author lists the many disciplines which a painter must acquire, but then unexpectedly qualifies that these will be of no utility whatsoever if the learner is not "born to be a painter" and has not "borne invention and grace with him since the days of his cradle and swaddling clothes."

In various ways Michelangelo reveals how he modified his trust in the all-sufficiency of genius. In the sonnet "Se ben concietto à la diuina parte" the requisite double action of the intellect and hand is called a dual power (*doppio valore*). In fact, in the eye-hand and brain-hand dichotomies we examined above, vision or mentality tended to represent nature whereas the hand represented art. In the madrigal "Non posso mancar d'ingegnio e d'arte" he states that the combination of art and nature which enters into his imitation cannot enable him to do justice to the woman he would like to portray.

In his *De' veri Precetti* Armenini notes specifically that Michelangelo would assist budding artists if convinced that they were endowed with genius and yet able to endure the harsh disciplines of training (*arte*).[117]

It has been conjectured that Michelangelo drew upon art or nature

at different moments and for different purposes, that he executed his crayon sketches of nudes with scrupulous and deliberate exactitude while falling back "with audacity" upon his natural, freehanded technique for the larger paintings based on these sketches. It has been found that after plotting outlines for some of the figures on the Sistine Ceiling (first phase: art), Michelangelo then proceeded to neglect them during the excitement of painting (second phase: nature). When these two phases were re-enacted in sculpture, models replaced sketches. We shall hereafter refer to these stages as the "art-phase" and the "nature-phase."

In the light of the above, the recent discovery that the word *ingegno* (as in "Se ben concietto à la diuina parte") could mean "initial draft" seems a paradox.

Judgement, as well as genius, could constitute the counterbalance to art in Michelangelo's thinking. Someone, praising a certain architect to him, explained, "He has a great genius [*ingegno*]." Michelangelo replied, "Gli è vero, ma gli ha cattivo giudizio" ("That's true, but he has poor judgement").[118]

When it was something more than verbal gesture, what precisely was the import of the common Renaissance compliment paid to artists and writers, namely, that they in their art rivaled nature? "The necessary rule was laid down for the guidance of all painters and sculptors that it is the object of art to hold a mirror up to nature. The conquest of nature by art was therefore the proper theme of panegyric in honor of successful artists."[119] Typical is Cardinal Bembo's encomium to Raphael, stating that "nature feared to be vanquished by her preserver Raphael and to die at his death":

> *Ille hic est Raphael; timuit quo sospite vinci*
> *Rerum magna parens et moriente mori.*

Michelangelo himself, frequently so caustic, was also capable of such panegyric. His sonnet (CXXXIII) commemorating the appearance of the first of Vasari's *Vite* lauds Giorgio for bettering nature.

> *Se con lo stile e coi colori hauete*
> *Alla natura pareggiato l' arte,*
> *Anzi a quella scemato il pregio in parte,*
> *Che 'l bel di lei più bello a noi rendete.*

Poi che con dotta man posto ui sete
A piu degno lauoro, a uergar carte,
Quel che ui manca a lei di pregio in parte
Nel dar uita ad altrui tutta togliete.

If in drawing and painting you have made art equal nature, you have in fact even caused nature to lose a bit of its advantage, since you render its beauty even more beautiful for us.

Now having set for yourself a more worthy task, that of writing books with a learned hand, you are taking away from nature the other part of the advantage which you lacked, that which consists in giving life.

Hailing an artist as the rival or vanquisher of nature was on the order of calling him a "new Apelles." Actually, it would be contrary to Michelangelo's most basic beliefs to assume that a modern artist could really surpass nature or surpass Apelles. He would agree with Francis Bacon that art is man added to nature—intaglio added to stone, as he wrote— but never man independent of or superior to nature.

In a number of passages Michelangelo revealed further the importance he attached to study and discipline as partners of nature. Bernini relates that Michelangelo was asked on his deathbed if he had any regrets. He admitted to two: that he had not done all he might have for his salvation and that he was about to die when he was only beginning to learn to spell in his profession.[120]

Practice is necessary not only at the outset but during the major part of an artist's career (CIX, 50):

Ch' all' alte cose e nuoue
Tardi si uiene, e poco poi si dura

(Full translation above, page 24) See also the fragment (LXXX, 2):

Non ha l'abito intero
Prima alcun, c' al' estremo
Dell' arte e della uita.

One does not gain a complete mastery
before the term of art and of life.

Bernini's record, supported by these fragments, makes a final and convincing demonstration of Michelangelo's belief that nature must await the accompaniment of art. It is significant, by the way, that Michelangelo

believed one mastered one's craft late in life, for it was at this stage of his own career that he dedicated himself to religious subjects exclusively. A parallel turning to religion was at this late date manifesting itself in his poetry.

Michelangelo suggests that experience enables one to economise on effort or, looking at it in another way, redouble those efforts (CXIII). Just as a training period breaks in tigers, snakes, and lions, so a novice in art, exerting himself at his work, after practice and perspiration redoubles his forces (wind):

> *E 'l nuouo artista, all' opre afaticato,*
> *Coll' uso del sudor doppia suo lena.*

The need for effort over and above natural endowment is noted in a rare passage (CIX, 94) where Michelangelo implies that art can overcome nature by outshining nature when the artist exerts himself to the utmost:

> *A la bell' arte, che, se dal ciel seco*
> *Ciascun la porta, uince la natura,*
> *Quantunche se ben prema in ogni loco.*

[I was born] for that fine art which defeats nature if one bears it down from heaven with him, although one must exert himself greatly in every way.

Another hypothetical manner by which art (here, the work of art) vanquishes nature is raised in the sonnet "Com' esser, Donna, può quel alcun uede" (CIX, 92), where Michelangelo notes that the artist's creation in stone outlives him and that therefore art can defeat nature:

> *La causa all' efecto inclina e cede*
> *Onde dall' arte è uinta la natura.*

The theme of art over nature occurs in a third poem. In the curious madrigal "Costei pur si delibra" (CIX, 77) the artist notes that when he stands looking in a mirror beside a harsh woman who torments him his ugliness sets off her heavenly beauty even more. "And yet it is a great good fortune if in making her more beautiful I defeat nature." Since this the lady of the madrigal is very possibly an allegorical figure of art itself, the madrigal has enhanced meaning for Michelangelo's view on the issue of art's contention with nature. There are, by the way,

several verses which strengthen the notion that this entire piece is an important allegory. The passion and torments to which the lady (art) subjects him, the blood which leaves his veins and fibers, and the ruthlessness with which art throws body and soul out of joint—these are all complaints of the artist which are exactly consonant with the complaints in Chapter VI. They are reminiscent of such lines as "nelle opere mie caco sangue" and "non vi si pensa quanto sangue costa" to which we shall return. The three verses

> La si gode e rachoncia
> Nel suo fidato spechio,
> Oue se uede equale al paradiso

> There she admires herself and primps
> at her faithful mirror,
> in which she seems equal to paradise

are most likely a tribute to the inherent mimetic nature of art which imitates the finest archetypes of nature. Michelangelo's insistence upon his own ugliness and old age, both of which are personal betrayals of nature visited upon him (cf. "tradito dallo specchio" in XLIX), makes him exult the more that he as an artist can defeat nature.

In one of his sonnets he takes the position that art improves nature, since a stone which has been sculptured (*aggiuntovi l'intaglio*) is of greater worth than the original rock.

Is there an inconsistency between these few passages and our previous flat assertion that in Michelangelo's thinking art or the artist could not loom superior to nature itself? There is no inconsistency, since Michelangelo qualifies art as "borne down from heaven." The seeming paradox is resolved by the words of Shakespeare:

> ...Nature is made better by no mean
> But nature makes that mean: so, over that art
> Which you say adds to nature, is an art
> That nature makes.

In his criticisms and assessments of other artists Michelangelo unwittingly revealed the importance he attached to innate talent. His criticisms will be analysed later (Chapter IV), but it might be recalled here that he considered Italian artists, through the mere accident of their birth

on the peninsula, more naturally endowed. Elsewhere he praised Il Parmigianino for being born with a brush in his hand, a familiar image of native genius. His praise of Raphael was modified by the reservation that the younger artist was not naturally gifted, but learned his art "through long study."

Yet even in his criticisms he could find long study a desideratum. Vasari records Buonarroti's comment when shown some drawings made by a youth of whom it was explained, "He's been studying for just a short time." Michelangelo responded, "E' si conosce" ("That's obvious").[121] He is reported to have made this identical reply when told that Vasari's paintings in the Sala della Cancelleria had been executed in a few days. This is the natural reaction of one who, as Condivi recorded, added to his natural talents much hard study.[122] There is a curious and little-known story told by Lomazzo which illustrates how Michelangelo continued to study "the spelling of his art" long after his success had been secured. Michelangelo was found one day by Cardinal Farnese walking purposefully in the direction of the Colosseum. As snow was falling, the Cardinal wondered why Michelangelo should be risking his delicate health braving the elements. The reply was utterly simple: "Io vado ancora alla scuola per imparare" ("I'm still going to school to learn").[123]

In the *Dialogos em Roma,* Michelangelo attempts a definition of good painting. In his endeavor he characterises good painting as "uma musica e uma melodia que sómente o inteleito pode sentir, a grande deficuldade" ("a music and melody which only the *intelletto* is capable of hearing, and that with difficulty").[124] The image of art as music is characteristic of Buonarroti and of the Neo-Platonic movement of which he was a peripheral member. There are echoes of it in the *Dialogos* and even in the *Rime.* Since this is such a little-known element of his thought, let us reproduce the relevant passages before analysing the image itself.

In his dismissal of Flemish painting, Michelangelo scoffs that it is attractive only to certain categories of women, friars, and "alguns fidalgos desmusicos da verdadeira harmonia" ("certain gentlemen unmusical

where true harmony is concerned").[125] This same adjective is applied to treasurers of whom competent painters are reduced to requesting their pay: "nem o grandissimo desgosto que recebe em pedir a paga ao desmusico thesoureiro" ("nor the very great distaste one feels in asking his pay of an unmusical bursar").[126] When deploring the lack of appreciation of the fine arts on the Iberian Peninsula, Michelangelo observes that the Portuguese would not be so "desmusicos" as to neglect painting if only they lived amid the beauty of painting common to Italy.[127]

Some of the commentators have professed to be puzzled that Michelangelo should coin this image. Yet Michelangelo heard in both Florence and Rome discussion on the *ut pictura musica* theme, generally in a Neo-Platonic or Pythagorean reference. Leonardo wrote: "Music is not to be called anything other than the sister of painting.... Rhythms circumscribe the proportionality of the members of which harmony is composed, not otherwise than the circumferential line surrounds the members of which human beauty is generated."[128] Vitruvius, whose book everyone was buying in the mid-century, presented at the very outset a number of ingenious technical reasons why architects and builders must know music.[129] In his *Dialogo di Pittura*, Paolo Pino advised that the painter must restore himself by listening to poetry, vocal and instrumental music. He reminds us that Dürer composed an opera, Il Pordenone was a good musician, Sebastiano played the lute, and Bronzino was interested in music.[130] Penning his *Idea del tempio della Pittura* Lomazzo declares that music is so necessary to the painter that he could not exist without it.[131] In this same work, brilliant and imaginative, young Lomazzo states that Michelangelo, Leonardo, and Gaudentio "arrived at harmonic beauty by way of music" and by way of studying the human body "which is also composed of musical harmony [*concento*]."[132] Probably some salon wit in the Renaissance called architecture "frozen music" long before Schelling or Mme. de Stael adopted the phrase. It was understood that everyone should have a smattering of music and in Castiglione's famed book on manners one reads, "Those who do not like music—one may be sure that their spirits are discordant one from the other,"[133] words which recall Lorenzo's "The man that hath no music in himself" in the *Merchant of Venice*.

· *53*

Michelangelo himself followed the pattern and evinced some interest in music. He was not an amateur musician, as was Leonardo, whom Lodovico Sforza invited to Milan not only as an artist but also as an expert on stringed instruments. Cellini tells that a comely young *chansonnier*, Luigi Pulci (grandson of the celebrated writer of comic romance), used to sing in the streets of Florence and that whenever Michelangelo knew he was performing he would go to hear him with much "pleasure and desire."[134] A more reliable proof of Buonarroti's interest in music is his gratitude to the composers Arcadelt, Tromboncino, and Costanzo Festa, who set to music several of his madrigals, such as "Spargendo il senso il ardor cocente" and "Com' arò dunque ardire."[135] Wondering how to express his gratitude to Arcadelt, he purposed to send him enough wool cloth to make a greatcoat.[136]

Let us return to Michelangelo's curious adjective "desmusico." It is likely that his word is merely purloined from the Greek and illustrates a type of lexical larceny which linguisticians like Speroni and Du Bellay were encouraging at the time. The denotation of "unmusical" in classic Greek was less familiar than the primary, literal meaning of "without the Muses; without sensitivity or taste; crude." It is used in these senses in Plato's *Phaedrus,* for example, a dialogue well known to Michelangelo's friends and certainly to the artist himself. It is reasonable to conclude that Michelangelo's borrowing means merely "insensitive." However, it is still plausible to suppose that the enlarged, Neo-Platonic view of music, with its levels, was not divorced from his mind. He knew that Plotinus considered the beauty of music in the same breath as that of art: "Beauty addresses itself chiefly to sight, but there is a beauty for the hearing, too." Michelangelo's early friend Ficino conformed to this thought. In his *De amore,* "he places the beauty of sounds on an equal plane with that of visible forms and thoughts."[137] To Marsilio music was born in the harmony of the heavens and every soul was endowed with it along with other heavenly properties. The sound which one hears from musical instruments and in songs is merely an imitation of this harmony: "Huius musicae ratione noster olim donatus est animus. Cui enim est origo caelestis, merito caelestis innata dicitur harmonia. Quam deinde variis instrumentis et cantibus imitantur."[138] To Ficino music

performed the same function which Michelangelo saw as the reason for being of art: music could "elevate the mind as much as possible to sublime things and God."[139] Since the primordial harmony underlying any art presided over by the Muses ($\mu o \upsilon \sigma \iota \kappa \acute{\eta}$) is the goal of all artistic pursuit, then there must be an "inner hearing" corresponding to "inner vision." The *intelletto* will grant one acuity of vision and hearing. So Michelangelo claims (CIX, 94):

> ...*io naqqui a quella ne sordo ne cieco.*
>
> ...*I was born neither deaf nor blind to that art.*

This is still Neo-Platonic in spirit, of course, and reminiscent of Ficino: "Idque munus similiter divinae providentiae nobis est amore concessus."[140]

Michelangelo once declared to his good friend Bartolommeo Ammannati, with that blunt wording which characterises his Bernesque verse, "Nelle opere mie caco sangue!" ("In my works I stool blood!")[141] On the relief of a *Deposizione* which the artist did for Vittoria Colonna he inscribed the Dantean verse, "Non vi si pensa quanto sangue costa" ("They think not how much blood it costs"),[142] which applies to the efforts demanded by this pathetic and grandiose subject, even while evocative of Michelangelo's schismatic belief in justification through faith in the blood of Christ.[143] A third reference to these sanguinary demands of the fine arts is located in his aforementioned allegorical madrigal "Costei pur si delibra" (CIX, 77) where he speaks of his exertions in art:

> *Ch' i' arda, mora, e chaggia*
> *A quel c' a peso non sie pur un' oncia,*
> *E 'l sangue a libra a libra*
> *Mi suena e sfibra e 'l corpo all' alma sconcia.*
>
> *That I should burn, die, and fall*
> *For what, if weighed, would scarcely be an ounce,*
> *And by the pound takes the blood from my veins and fibers*
> *And disarranges the body from the soul.*

Finally, he admits to his brother Buonarroto (Letter LXXXVII) that as an artist "I strain [*stento*] harder than any man who ever lived."

Michelangelo expressed himself, as we have seen, in various ways on the conflict between nature and art, training, or technique. Another antonym of nature could be effort. This section will record and analyse Michelangelo's thoughts on the subject of effort in artistic creation, to be followed by his persuasions on the related issue of facility and rapidity of composition. In anticipation, let us set down in quick review a few earlier opinions on art and effort with which he was doubtless familiar. Cicero had written that there is an art to seeming artless, a notion which had already crystallised into the proverb, "ars artem celare est." Quintilian echoed that the perfection of art is to conceal art. Even in the Middle Ages, the period which applauded obvious effort, *tours de force*, and the ideal of χαλεπὰ τὰ καλά, rapid and effortless techniques were recommended. Lionello Venturi, investigating art criticism in the Trecento and Quattrocento, concludes that the earlier art criticism of the fourteenth century apparently reasoned that swift and improvised execution sealed in the completed work the freshness of intuition.[144]

In Michelangelo's day two colorful amateurs of the fine arts recorded opinions revealing a continuity of the Ciceronian view. Michelangelo's admired Savonarola sermonised that painters hold natural figures created effortlessly to be superior to and more pleasing than those which betray effort.[145] Was Michelangelo present at this homily which the grim though sophisticated friar delivered on 20 May, 1496? It is possible. The young artist stayed in town until the following month. A second opinion, in which Buonarroti himself figured, is contained in Lodovico Dolce's *Dialogo della Pittura*. In this dialogue Aretino, the selfsame scourge of princes who often serves Dolce as spokesman herein, develops the idea that "facility is the principal argument for excellence in any art, and it is the hardest thing to attain: it is an art to conceal art."[146] Then Aretino, whose real-life temperament clashed with that of Michelangelo and created an estrangement, observed that Buonarroti's inability to create effortlessly made him inferior to Raphael. Pietro was aiming at Michelangelo the very criticism which the latter aimed at Raphael. "I have heard him say merely that Raffaello did not get this art from nature, but through long study," records Condivi,[147] a statement which clashes violently with the official view of the Pre-Raphaelites: "What had cost

Michelangelo more years to develop than Raphael lived, he [Raphael] seized in a day—nay, in a single inspection of his precursors' achievements."[148] Later on in this dialogue Aretino accuses Michelangelo of having always sought the difficult in art.[149] (Aretino raised the art of insult to a sublime level by studying assiduously his victim's foibles; knowing Buonarroti's weakness for nobility, Aretino was capable of the crushing observation, "Michelangelo has painted porters and Raphael has painted gentlemen.")[150] Aretino's censure has been more moderately expressed recently by Mariani: "One might say that Michelangelo required difficulties, that he himself set them up to provoke from them an intensification of creativeness which becomes thus more gigantic as a result."[151]

Two further contemporary variants on the *ars artem celare* are found in Vida and Castiglione. Vida's poetics recasts the thought into the language of Cicero and Quintilian: "Cunctamque potens labor acculat [occulit] artem."[152] The echo in Castiglione's *Libro del Cortegiano* will be translated fully at the conclusion of this chapter.

What, then, are Michelangelo's own words on this subject?

He believed that even a talent endowed by God himself demands effort to realise its potentialities:

[I was born] for that fine art which defeats nature if one bears it down from heaven with him, although one must exert oneself fully in every way.[153]

This awareness does not prevent him from voicing his ideal of effortless art in Francisco de Hollanda's *Dialogos em Roma*. In this record he announces that he is going to divulge one of his trade secrets and anticipates that Francisco will agree with him:

This is what one has most to labor for and perspire over in creating works of painting: with a great amount of work and study [zeal], to do the work that it may appear, although labored over a great deal, as if it had been done almost hurriedly and almost without any work—and quite effortlessly, even though this is not the case.[154]

This attitude is corroborated by another source than De Hollanda. Giovan Battista Gelli, in his *Ragionamento* on the language of Florence, avers: "Michel Agnolo was wont to say that only those figures were good in doing which the artist had eliminated effort [*fatica*], that is, executed

· *57*

with such great skill that they appeared things done naturally and not by artifice."[155] Michelangelo adds in De Hollanda's presence that sometimes an artist can actually toss off a skillful creation with a minimum of labor. But he acknowledges that this rarely happens and affirms that the meticulously created product appearing spontaneous is the desideratum.

How does this theory coincide with Michelangelo's own practice? In his *Essai sur la création artistique,* Liviu Rusu classifies all artists into one of two types, labeled "inspiration-jeu" and "inspiration-effort." Rightly he places Michelangelo in the latter category, in the company of Beethoven, Goethe, Flaubert, Leonardo, and others.[156] In Michelangelo's thinking, the creative process of art was divided into two separate stages, identifiable in theory if not always in practice. In the first stage, the "art-phase," studies, *pensieri,* small-scale wax or clay models, and even outlines on prepared surfaces were carefully and deliberately worked out. They could be altered or revised. While at this stage of composition, Michelangelo perforce agreed with Leonardo's preachment that the painter should proceed slowly and laboriously, not striving consciously for speed.[157] In these *ingegni* Buonarroti was aiming not merely at capturing essential and general form (a concept or challenge which had an even greater importance for him late in life), but at accuracy of detail, as so many of his red-chalk drawings demonstrate. Eventually, after 1542, Michelangelo "no longer made studies," but seemed to consider his drawings as works of art in themselves,[158] as he had his mythological drawings for Tommaso Cavalieri. These, with their *sfumatura* and rubbing, come closer than the disciplined earlier studies to achieving the goal of apparent effortlessness. Since Michelangelo hoped to live up to his theory of creating without evident effort and so wished to minimise the "art-phase" even as a preliminary, shortly before his death he burned many of his drawings, sketches, and cartoons, like a latter-day Apollodorus, so that no one might realise to what great pains he had gone and the ways in which he had exerted his genius "to give no other appearance than that of perfection."[159]

It was in the theoretical second stage, the "nature-phase," that Michelangelo tried hardest to live up to his ideal of effortless painting. In

general, fresco, which demanded such preparations as tracing, perforating, and coating, would seem like one continuous art-phase. Yet fresco offered a nature-phase, when all the plaster was moist and colors mixed, challenging Michelangelo to paint fast and make the final product display facility and spontaneity. "Sometimes, in the lunettes and secondary figures, he worked without any traced outline at all."[160] The medium of paint on plaster requires, in fact, that sections must be finished in a single day. "The outlines of the architectural framework, always made with the stylus, sometimes pass over a part of the figures."[161] One may conclude that such short-cutting resulted in faster rather than slower execution. Thus, a progression from art-phase to nature-phase in the "fury" of creation occurred when Michelangelo began painting sections of a plastered wall. "At the beginning, he made small strokes like those of a draftsman, and at the end bold and large strokes like those of a true painter."[162] These bold strokes are comparable to his freehanded technique in sculpture for which he became famous and which Guillaume claimed was the same direct attack practiced by the ancient Greeks. Blaise de Vigenère, in his exegesis on Callistratus (1579), wrote of Buonarroti's "striking more chips from the hardest marble in a quarter-hour than would be hewn by three young stonecutters in three or four times as long: an incredible thing to someone who has not seen it! He went at the marble with such an impetus and fury as to make me believe that the entire work was going to pieces. With a single stroke he would split off morsels of three or four inches in thickness; yet with such exactness was each blow delivered that if he had chipped away a trifle [tantino] more of marble, he would have incurred the risk of ruining the whole thing."[163] The risk was not always so safely run. It was precisely because of his hewing too deeply (and not because of dissatisfactions with *vedute uniche*) that so many of Michelangelo's works (e.g., the *Deposizione*) remain unfinished and imperfect.

Vasari tells a story to prove Michelangelo's embarrassment at letting even a friend and fellow worker know how much effort it required to repair a hasty error—and at letting a friend know that his hand had failed him in the nature-phase. One night Michelangelo noticed Giorgio eying some alterations he was making on a figure, more specifically, on

the leg of the Christ of this same *Deposizione* which he was later to in-
jure. Purposely Michelangelo let his lamp fall and the room go black.[164]

It was an abiding consciousness of the great energies required by
carving which caused Buonarroti to repeat as a leitmotiv throughout his
poetry the phrases "pietra dura" and "duri sassi." From one whose life
was in great part a battle against resistant alpine rock they are a per-
sistent reminder.

Ut pictura poesis. Certainly Michelangelo's poetry is labored, as is
shown not only by the intensity and complication of the thought but also
by the numerous *rifacimenti*. One finds many variant forms of the same
madrigal or sonnet on which he toiled. There are even variant versions of
some of his letters which he considered particularly important, such as
letters about his career or epistles to Tommaso Cavalieri.

As quoted by De Hollanda and Gelli, Michelangelo insists more
upon making the work appear effortlessly done than upon doing it with-
out effort. His own works, artistic or literary, do not appear hastily or
easily wrought. Even the *Mosè*, which has such a rough-hewn aspect, is
polished over its entire surface. The perfection of these works is not
manifest from one hasty inspection. In the poetics of Horace, which
Michelangelo knew well enough to quote partially from memory, paint-
ings are classified into two sorts:

> *Haec placuit semel, haec decies repetita placebit.*[165]
>
> This pleased [seen] once, and this will please many, many times.

Michelangelo's painting and sculpture is of the second type. The larger
conceptions at least cannot be appreciated at a single viewing. Because
of the mental effort expended by the artist, effort is certainly required
of the spectator who would understand the overt meanings of his in-
ventions (whether Dejanira is present in the *Centauromachia*), the covert
meanings (the significance of the crouched figures in the *Saettatori*
drawing or the pointed fingers of *Giona* on the Sistine Ceiling), or would
merely appreciate his skillful use of proportion, foreshortening, dis-
tortion, *contrapposto*, and the like. Knowing the physical effort which
he expended on his works, we may be sure that there was a comparable

mental effort, for Michelangelo knew as a Neo-Platonist that the hand-principle was inseparable from and coactive with the mind-principle.[166] In fact, the mind-hand dichotomy appears even in his correspondence.[167]

Aware of Michelangelo's goal of making a work slowly elaborated appear quickly and effortlessly done, a goal he attained in none of his works with the possible exception of the *sfumati* drawings, Vasari was in a position to pay his friend the supreme compliment (although most surely with tongue in cheek). After viewing the vast expanse of the *Giudizio universale,* he recorded the fantastic tribute that it was a work "which appears done in a single day."[168]

Just as Michelangelo's theory of the *intelletto* and divine intercession must inevitably incline him toward a theoretical preference for effortless painting, so must it predispose him in favor of rapidity, a corollary of effortlessness. In the *Dialogos em Roma,* he affirms that a long period of time devoted to a painting is no guarantee of artistry. A master's canvas hastily composed is worth a higher price than the laborious creation ("nascetur mus") of a mediocre artist (perhaps one should not speak of a "mediocre" artist, for in Michelangelo's view there was no real *aurea mediocritas* which meant anything: artists were good or bad, as his applied criticisms attest):

For works are not to be evaluated by the length of useless and wasted time spent on them, but rather by the worth of the knowledge and the hand which produce them.[169]

Michelangelo cannot resist the temptation again to remind us that art is an intellectual as well as a manual process. Compare this passage with the following lines in Paolo Pino's *Dialogo di Pittura* (1548):

One does not base judgements in our art according to the time spent on a work, but only according to the perfection of that work by which one recognises the excellent master from the ignorant fellow [*goffo*].[170]

Michelangelo pursues this line of reasoning. It would be stupid to pay for a work of art according to the time it required without taking talent into consideration. Otherwise, by the same token, one would pay less to a barrister to examine a weighty case for an hour than to a tiller for a day's work or to a weaver for a life's work. (Michelangelo entertains a low

opinion of artists of the loom and once stated that a single room decorated with one statue would be as superior to a room hung with gold-woven tapestries as a palace room to a nun's cell.)[171] A patron, then, pays for talent and not for time. If Protogenes took seven years to do a single painting, if Michelangelo spent fifty-one months on the Sistine Ceiling, their patrons were to reward them with a bounteous sum and not with wages calculated on a calendar. Michelangelo disliked especially collecting his pay from "unmusical" and calculating bursars.[172]

Poor painters who work rapidly are almost as pitiful as poor painters who labor on to no purpose. Buonarroti entertains the company gathered at San Silvestro with the story (actually from Plutarch's *Moralia*)[173] of the unworthy painter who shows one of his masterpieces to Apelles, announcing triumphantly that he had completed it within a brief time. Apelles replied, "Even if you had not told me, I should have recognised it as done by you and in haste. What surprises me is that you don't do quantities of these!" Michelangelo adapted this rejoinder himself on two occasions, commenting on the drawings of the unknown youth and the Sala della Cancelleria paintings of Vasari (see notes 121 and 122 above).[174]

An unexpected testimony concerning Michelangelo's views on rapidity in art occurs in the *Hecatommithi* of his Ferrarese contemporary, Giraldi Cinzio, that worthy inspirer of Shakespeare. Michelangelo is quoted as saying,

Hurry does not pay in any case, except in knowing how to seize an occasion which offers itself at a given moment, and at that moment escapes him who does not recognise it. But in matters of art, this hurry lacks judgement and may be said therefore to be blind. Whereas Art, which is imitative of Nature [if it wishes to be praised for its function] should not depart from that very method which we see Nature using in the generation of animals; the longer the life that these animals are to have, the more time Nature spends in producing them.[175]

Michelangelo adds that a long gestation period is needed to bring animals to perfection. "And if it perhaps happens that through some strange accident they come forth to the light of day before the appropriate term, we see them born imperfect and weak. This can clearly demonstrate to

us that for the perfecting of things, be they of art or nature, Intelligence, Diligence, and Time are necessary."

If the intelligence (nature) and diligence (art) are exceptional, the time can be cut to a bare minimum. Nevertheless, in this passage Michelangelo is in no mood to restate his basic belief that a great genius can create quickly, for he is here admonishing one of his younger pupils, Alazone, for trying to abridge the learning and training process and consider himself a master prematurely.

Michelangelo pondered this matter of alacrity in art a final time in the *Dialogos*. It is good and useful, he tells Francisco de Hollanda, to do one's work with dexterity and rapidity. It is a gift granted by God to be able to paint in a few hours what others spend several days painting. "Were it otherwise, Pausias of Sicyon would not have worked so hard to paint in a single day the perfection of a child. Thus, if he who paints quickly does not for that reason paint worse than one who works slowly, he deserves as a consequence all the more praise. But if he, with the rapidity [*ligereiza*] of his hand, should exceed certain limits which one is not permitted to overstep in art, he ought rather to paint more slowly and studiously. For an excellent and skillful man [Michelangelo continues] does not have the right to let his tastes err through his indulgence in speed, if this indulgence causes him in any way to lose sight of or neglect his obligation of perfection. Hence, there is nothing wrong if one wants to paint a bit slowly, or very slowly if necessary, or even devote considerable time and effort, if this is done merely to achieve a greater perfection; lack of knowledge is the one defect."

Yet a moment later he qualifies, "However, I should prefer [if one must err or be correct] that one should err or be correct quickly rather than slowly, and that my painter ought rather to paint rapidly and less well than one who might be very slow, painting a little better, but not much better." Certainly this afterthought constitutes a self-justification on the part of the artist, answering the petty criticisms often leveled at his own works. The quotation also supports Michelangelo's theoretical predilection for the nature-phase over the art-phase.

From these various opinions, especially those expressed in the *Dialogos*, one may set up a hierarchy of painters and sculptors varying

from those whom Michelangelo admired most to those he scorned completely:

A.	Gifted with *intelletto*	and executes rapidly (effortlessly)
B.	Gifted with *intelletto,* but paints a shade less well than C	and executes rapidly (effortlessly)
C.	Gifted with *intelletto*	and executes slowly (effortfully)
D.	Not gifted with *intelletto*	and executes rapidly (effortlessly)
E.	Not gifted with *intelletto,* and paints even more poorly than F	and executes rapidly (effortlessly)
F.	Not gifted with *intelletto*	and executes slowly (effortfully)

Thus, Pausias of Sicyon would rate in the top category (A) and the unknown painter mentioned by Plutarch, Michelangelo (and Alberti, by the way), would rank near the very bottom (E).

Various of Michelangelo's contemporaries were impressed by his speed of execution, especially during the nature-phase, as they were by his expenditure of energy and effort. Cellini testifies, "And I sometimes happened to see that between morning and evening he had finished a nude with the diligences which art permits, since he was many times seized by certain awesome furies which came over him as he worked."[176] Armenini also was impressed with Michelangelo's very rapid faculty of invention. Buonarroti felt grateful to the young Ferrarese artist Vasaro for some service and volunteered a favor in return. Vasaro handed him a sheet of paper and asked him to draw a standing Hercules. Michelangelo withdrew to a nearby bench, his elbow on his knee, and his right hand against his chin. After staying a moment immersed in thought, he dashed off the drawing immediately, handed it to the delighted youth, and went on his way. Armenini, who saw it later, thus lending the story authenticity, claimed that its lines, shading, and finished qualities made everyone judge that it had taken a month to complete, "quanto egli doveva essere facile in far le sue invenzioni."[177] Here, then, is one of those rare cases when the art-phase gives over completely to the nature-phase.

Buscaroli calls this facile gift "bravura di mano" and reminds us that it is what Vasari had in mind using the phrase "maniera difficile con facilissima facilità.[178] Buonarroti required a real *bravura* to complete one full figure of the Sistine Ceiling every nine days for a period of over

four years,[179] an operation requiring time for designing, cartooning, transferring, and painting.

To sum up, the quality which Michelangelo wished his works to reveal, although he never quite hit upon the word, was *sprezzatura*. Can this word be rendered exactly by any single English equivalent? Hoby's standard translation of the famed passage in Castiglione's *Libro del Cortegiano* proposed "recklessness," which is hardly compatible with Michelangelo. This English word would describe more aptly the undisciplined speed which Paolo Pino objected to in Tintoretto and Schiavone or the impatient haste which Aretino urged Tintoretto to abandon.[180] Lightness of touch, easiness of manner, effortless deftness, the semantic value of *sprezzatura* is somewhere in this area. Many Renaissance theorists came close to the word. In his precepts on painting, Armenini held that the artist must give evidence of "prestezza senza fatica."[181] Alberti calls meticulous creativeness *diligenza* and uses *prestezza* to denote the faculty under discussion which combines alacrity and effortlessness. Paolo Pino calls it merely "prontezza di mano."[182] In the *Dialogos em Roma*, where one must work back to the Italian from the Portuguese, the two words used by Michelangelo are "ligereiza" and "despejo," each implying a quick and easy deftness. *Sprezzatura* was an ideal not only of the Cinquecento artist, but for the contemporary gentleman who cultivated the art of good living. Michelangelo confessed to Donato Giannotti and his friends that this quality was a social as well as artistic virtue to him:

Whenever I see someone who possesses some virtù, who displays some agility of mind, who knows how to do or say something more suavely than the rest, I am constrained to fall in love with him . . .[183]

Perhaps the double tragedy in Michelangelo's life is that as a man his intensity proscribed in him anything of the easy manner he saw in the genteel men about him or in the ideal "affable and courteous" gentleman-painter blueprinted in Paolo Pino's *Dialogo di Pittura*, while as an artist he too often failed to execute works with the rapid, effortless technique he advocated, most of his masterpieces remaining rather the result of long and labored attention.

The ideal of *sprezzatura* had its most articulate and forceful formu-

· *65*

lation in the speech of Count Lodovico, that suave and courtly gentleman of the Canossa *stipite* to which Michelangelo believed himself related, addressed to the colloquists of Castiglione's *Libro del Cortegiano*. The Count announces that he has found a new and universal rule which may be applied to all human situations and activities:

perhaps, to invent a new word, to use in all things a *sprezzatura,* which may hide art and demonstrate that whatever we say and do comes to us without effort and almost without thinking. I firmly believe that grace derives from this: since everyone knows the difficulty involved in rare and well-done things, so does any facility in these create widespread wonder. On the contrary, forcing something or straining [*tirer per i capegli*] leads only to unfortunate results and causes people to value a thing little, no matter how great it may be. Whence one may say that art is true art which does not appear to be art; nor should one strive for any other art except to conceal art; for if that striving is discovered, this fact takes all the credit away from a man and makes him little esteemed.[184]

Of Castiglione's insistent reiterations on the requirement of social grace Blunt writes, "Indeed, the account of grace in its social sense in the *Cortegiano* is so close to Vasari's view of it applied to the arts, that we may conclude that he derived the idea direct from this source."[185] That Castiglione had Raphael in mind while recording this eulogy to grace and indictment of affectation has been claimed.[186] That Raphael and Michelangelo served as *cortegiano* and *anti-cortegiano* to their contemporaries we remember from Lomazzo's testimony that "while Michelangelo always sought the difficult in his works, Raphael aimed at ease."[187] The two men themselves were aware of the social and artistic contrast they personified, Raphael viewing Buonarroti as a lonely and antisocial "hangman" and Michelangelo characterising his popular and gracious rival as the "provost" (*proposto*) or "troop commander" (*bargello*).

So this heartfelt and desired artistic and social goal was a philosophical product of Michelangelo's moment and milieu. It matters not too much that his everyday experience obliged him to recognise finally that as a philosophic conviction it must remain a pure luxury for him. What matters more is that once again in the history of ideas, the bellartistic, belletristic, and social patterns of thought coincide.

CHAPTER II

Religion, Morality, and the Social Function of Art

καὶ βουλομένῳ μὲν σοφίζεσθαι θεῶν τὸ εὕρημα
διά τε τά ἐν γῇ εἴδη . . .

<div style="text-align:right">PHILOSTRATUS</div>

*"Michelangelo," rief Gott in Bandigkeit, "wer ist
im Stein?" Michelangelo horchte auf; seine Hände zitterten.
Dann antwortete er dumpf: "Du, mein Gott, wer denn sonst?"*

<div style="text-align:right">RILKE</div>

I T IS WARM and sultry outside, but within the spacious Duomo it is cool. It is a Monday of the Great Fast and the crowd is thicker than ever. In fact, the young artist has had to find a place on an improvised platform over the entrance to the choir. The preacher has warmed to his theme from *Ezekiel*: "Transiens autem per te, vidi te conculari in sanguine tuo."[1] His voice is shrill and curiously compelling. The cowl thrown back, his flattish head is revealed, with its strong nose and jaw. His eyes are prophet's eyes, but today he is not foretelling the doom of Italy, of Florence, or of his audience. He is urging his flock to settle accounts with God. It is only in doing God justice that you do justice to yourself:

Però bisogna che si rivolti con la buona volontà a Dio. La buona volontà non può essere sforzata in quanto volontà.

But you have to turn to God of your own good will. Free will can't be forced in so far as it's will.

<div style="text-align:right">· 67</div>

This day is one of decision in the young sculptor's life. His elder brother Lionardo has long since succumbed to the appeal of this Dominican friar and become a novitiate in his order. He himself has deliberated taking the same step, troubled by soul-stirrings and a desire to serve God more fully. It is not a plan on which he has been willing to consult with his Florentine friends, those humanists who are known to urge their neighbors, for example, not to corrupt their prose style by reading such works as the Epistles of St. Paul. Yet even a few of those friends are here in the basilica this very day. He can see Pico, who was an admirer of Savonarola even in his teens. Others are probably somewhere in the crowd, more affected than they would be willing to admit.

There have been other painters who took this step, after all. Agostino di Paolo entered Savonarola's order a couple of years ago. There is talk of Baccio's doing the same. Michelangelo's attention returns to the sermon, suddenly aware that the friar has turned to the subject of religion and art.

"Figures represented in the churches are the books of the unlettered, of women and children. So we should be more scrupulous about this than the pagans. The Egyptians never permitted the painting of anything indecent. First of all, we should cast out all questionable figures and refuse to admit compositions which might inspire laughter by their mediocrity. In our churches only the most distinguished masters should paint and they should paint only noble things."

The sermon shrills on, but this last sentence rings over and over in the artist's ear. It is a thought he will repeat some forty years later to a group of Florentines in Rome, thinking it his own. It is the thought which is to shape the pattern of his entire life, this thought which has somehow wormed its way into a sermon based on *Ezekiel*. The young man has often rationalised to himself that as a sculptor, even as a painter, he would be serving his God, but this has sometimes seemed little more than wishful thinking. Yet here is the most militant Christian of all, the man who may one day become pope, pointing out the need of great artists in the Church hierarchy. The young man recalls that the friar has called the Crucifixion the greatest prayer book of all. He himself will plan to do a splendid statue of the Christ high on his cross.

As the crowd grows more rapt and excited under each hammered sentence of the Dominican friar, the youth grows progressively more relaxed until he has attained that calm which is the product of decisions rackingly made. It will be just under threescore years before he will wonder whether this was a wise decision, whether "art has taken up the time given him to contemplate God."

Michelangelo Buonarroti was one of the most devout men of the Renaissance, lay or cleric. A *cristocentrico* (Papini), he was the logical candidate to develop and beautify the Church founded by the Apostle of Christ. On repeated occasions in his later poetry he hails the blood of Christ as the agent of his own hoped-for redemption: "Tue sangue sol mie colpe laui e tocchi" (CLII; also CXLII, CLI, CLX, CLXV). Here *toccare* of course refers to the healing touch; other verbs denoting his desired redemption are *purgare* (purge), *sanare* (make whole), *far beato* (beautify) and *aprire* (open heaven's gates). In his meager and hostile *Michel-Ange et Valéry*, Jean Choux complains that Renan overstated Michelangelo's religiosity and made of him a theologian.[2] Yet it is impossible to overemphasise that religious fervor. It was something heartfelt, compelling, intransigent, which came to Michelangelo early in life and stayed till death. From his earliest letters, where he thanks God for the first interest the Pope evinced in him, to the last ones, where he looks happily forward to the balm of heaven, his conviction is uncompromising. Admonitions to thank, trust, or pray to God fill his letters to his family. In his last poems he pleads for grace and begs for death. Thode's suppositions to the contrary, Michelangelo practiced the formal devotions of the Church. A letter from Don Miniato Pitti to Vasari (10 December, 1563) mentions Pitti's meeting Michelangelo at mass.[3] An incidental remark by Vasari records their attending mass together at the Church of Santa Maria Maggiore.[4] Condivi reports that as soon as Michelangelo arrived in Bologna, where his reconciliation with Pope Julius was to occur, he attended mass at San Petronio.[5] He went often to hear Savonarola (Condivi). In the Introduction we noted that Vasari and Michelangelo spent one holy day as members of a cavalcade visiting one church after another. This artist

· *69*

who disliked traveling even from Rome to Tuscany announced his firm intention of making a pilgrimage to the shrine of St. James of Compostela, although he never did make the rough journey to Galicia. When his brother Giovansimone died, Michelangelo wanted "particularly" to know if he had received the viaticum ("se è morto confesso e communicato, con tutte le cose ordinate dalla Chiesa"). He showed an identical concern (Letter CCLXXXIII) when his brother Gismondo passed away. Michelangelo believed in the efficacy of prayer. Writing to his nephew (*ca.* 1548), he affirms that he has greater trust in prayer than in medicines to rid him of his stone.[6] In at least three letters to his father, he asked old Lodovico to pray that his work on the Sistine Ceiling would come out all right and to the satisfaction of the pontiff. One may rightfully assume that he had recourse to prayer himself. Guasti reproduces a prayer found among Michelangelo's papers which the artist might well have written. It is consonant with the spirit of his mystical poetry, especially in its plea:

. . . Donami gratia, che tutto quanto il tempo che io starò in questa carcere inimica de l'anima mia, nella quale tu solo mi tieni, che io ti laudi.[7]

. . . Give me grace, that so long as I shall stay in this prison unfriendly to my soul, in which Thou alone dost hold me, I may exalt Thee.

Rilke, who not only translated Michelangelo but understood him as few moderns have, correctly views Michelangelo's dedicated artistic power as a form of prayer in his story, "Von Einem, der die Steine belauscht": "Viele Gebete waren zu dieser Stunde von der Erde unterwegs. Gott aber erkennte nur eines: die Kraft Michelangelos stieg wie Duft von Weinbergen zu ihm empor."[8]

This prayer, printed by Guasti, with its anticipation of deliverance from this earthly prison and its reminiscences of the "muero que no muero" of Santa Teresa or the *Prisons* of Marguerite de Navarre, harmonises with both a sonnet and a madrigal to Vittoria Colonna referring to the earth as a terrestrial prison from which he would flee, "the soul turned toward the Divine Love which opens its arms to receive us and closes them in embrace." Other references to the *carcer terreno* are nu-

merous (LXXXII, 19; CIX, 103 and 105). In his sonnet, "Di morte certo, ma non già l'ora," he speaks of "l'alma, che mi priega pur ch' i' mora" ("the soul, which begs me that I die"). Further poems in which Michelangelo expresses a mystic's desire for death are LVIII, LXXXI, and CXIX. Several of the statues, including the *Prigioni*, seem to portray the struggle of the individual to free himself from matter. But, however keen is the anticipation of death, one cannot even consider self-destruction:

S' alcun se stesso al mondo ancider lice

for both his revered Plotinus and the Christian fathers had decreed that the soul must wait for the body to be severed from it. Keen also was his anticipation of the Day of Judgement and the reclothing of souls. This great day seems ever-present in his thinking and intrudes upon his poetry (LXXIII, 8; LXXIII, 49). Indeed, that "gran dì" was Michelangelo's *trionfo della fede*. His late poetry shows a continuous fear that he may not have grace to escape the dreadful judgement ("ne ho grazia interna e piena").

A curious and detached evidence of a mystical experience which befell Buonarroti is recorded by two followers of Savonarola, Agricola and Serpe.[9] One summer night (1513) Michelangelo went out into the garden of his house on Macello de' Corvi, only to behold a three-tailed comet in the sky. One tail, silver like a sword, cut toward the east; a fire-colored tail arched toward Florence; a blood-red tail led to Rome, where, as Michelangelo wrote in the diatribe that was perhaps composed on the death of Savonarola, the blood of Christ was sold by the bucket. The vision was most likely inspired by one of those prophecies of Savonarola's regarding the destruction to be visited upon Italy by the flailing sword of the archangel. Rather than dismiss this tale as evidence that Michelangelo, like Dante or Hans Sachs or Paracelsus, was becoming a legendary, "apocryphal" figure, we find it a close parallel to those dreams which warned the artist to flee from Florence to save his skin.

If we pause in this way to assess Michelangelo's religiosity, it is because his intense faith was a primary cause of the greatness of his works. As we shall see, this religiosity did more than affect the nature of his work—it affected his very thinking on the origin and function of art.

While he was influenced in his youth, his "new life," by the human-

ists with their neopagan beliefs and values and whereas he boasted in later years that he had been on intimate terms with almost all the Florentine academicians, these were not the most important influences in his intellectual formation. Poliziano, who befriended him when Michelangelo was an apprentice in the Giardino Mediceo, never influenced him so much as did Savonarola. Condivi reports that late in his life Michelangelo recalled the very voice of Fra Girolamo. It is known that the artist nearly became a friar in Savonarola's order and that in Rome he became enrolled in the Company of San Giovanni Decollato. Recently De Tolnay has presented new evidence purporting to show that Michelangelo's thinking was influenced by two other contemporary priests, Frate Lorenzo delle Colombe and Fra Lorenzo Viviani.[10] Still another priest impressed him greatly in later years. He was so taken by the young Spaniard Ignatius Loyola that he volunteered to build the mother church of the Order of the Society of Jesus, the Gesù. Loyola wrote a circular letter (1554) to his fellows of the order, jubilant over the offer.[11]

Michelangelo, named after the archangel, consecrated his life to his faith. The penury he suffered for a while was endured not only because of the unquenchable flame of egotism but through a conviction that with his chisel or brush he could best serve God. Vasari notes that when Michelangelo was selected to replace Sangallo as director of the Vatican fabric, Michelangelo asked the pontiff to declare in an official *motu proprio* that he was serving for the love of God without gain ("per l'amor di Dio e senza alcun premio").[12] When Clement VII offered him an ecclesiastical benefice if he would take minor orders, he refused. If one likes, one may conjecture that the refusal was due to Michelangelo's desire to retain his independence as an artist, which he no longer could enjoy wearing the soutane. A more basic reason for the refusal was his consciousness that he was already dedicating his life to his God in the most effective and efficient way possible, a consciousness which reminds us of the medieval juggler immortalised in Anatole France's *Jongleur de Notre-Dame*. Furthermore, Michelangelo knew perfectly well that a saintly man need not and often does not wear the cloth. *L'habit ne fait pas le moine.* Once Michelangelo encountered in the street a man whom he considered of dubious character and who now wore priestly garb. When the priest

greeted the artist, the latter pretended not to recognise him. The priest, discomfited, was obliged to recall his name to Michelangelo. The artist, feigning surprise and delight, answered with his ever-present weapon of sarcasm:

Oh voi siete bello! Se fossi così drento come io vi veggo di fuori, buon per l'anima vostra![13]

Oh, you're a fine one! If you were as fine inside as I see you are outside, 'twere good for your soul.

Voltaire was delighted with Dante's "placing popes in hell." Michelangelo would not go so far, but he was capable of a similar scorn for cardinals, several of whom he condemned in his letters. In the course of time he even lost his deferential manner toward popes. By his own admission he sometimes forgot to bare his head in the Pope's presence, particularly when the talk settled on fine arts projects. In the *Dialogos em Roma* he admits that he does not always respond when the Pope summons him. He complains that at least one pope is insensitive to art: no illusions of infallibility here. Popes, cardinals, bishops, priests, monks, they are all—like painters—servants of God, and it is up to each to try to serve him best, both in the excellence of his works and in the morality of his living. It is significant that the majority of conjectured self-portraits among Michelangelo's productions show him as a saintly person—Nicodemus, Proculus, John the Baptist, and Bartholomew.

The firm belief in divine omnipotence which led him to consider himself as artist a mere collaborator of God coincides with ideas expressed in several of his letters. After a casting has come off poorly, Michelangelo takes pen in hand: "I thank God for it, since I esteem everything for the best."[14]

How did Michelangelo react to the stirrings of Protestantism? He approved of vigorous critics like Savonarola within the Church and wished for reforms in the hierarchical body, as did Vittoria Colonna. He even approved unorthodox dogma (justification through faith in the blood of Christ). Yet his loyalty to the Roman Church could not admit of schismatics. He felt no antipathy to the unbaptised Jews (who revered his *Mosè* as though he had made it for them), for in Venice he chose to live

· *73*

in the Giudecca—a stay commemorated in a painting by Giovanni Strada. Yet he felt no such tolerance for Calvinists, Lutherans (who decried the nudes of the *Giudizio*), or, one assumes, the Zwinglian Anabaptists, with their socialism, polygamy, and their ideas on baptism. This we gather from a criticism of the inclusion of a monk in a painting by Sebastiano del Piombo in San Pietro a Montorio; Michelangelo could not refrain from an ironic observation about heretical monks "avendo eglino guasto il mondo" ("they having spoiled the world").[15] This has been generally accepted as a slur against Luther rather than as a sample of anticlerical humor. Although he disapproved of Julius II playing at *condottiere*, his later approval of Loyola was an endorsement of the militant side of the Counter-Reformation. In Michelangelo's set of values, one should no more deviate from Rome in favor of a Gothic heresy than an artist should abandon Roman classicism in art for some heretical Germanic or Flemish manner.

In view of the intense Catholicism of Michelangelo, it is inevitable that his abstract theorising on art was largely inspired or affected by his religious devotion. The following topics will be investigated in this chapter: Michelangelo's religious definition of art, the moral aim and effects of paintings and statues, moral demands upon the artist, Michelangelo's artistic "immorality," his scriptural subject matter, the conflict between pagan and Christian. The last section of the chapter will raise the related issue of the social function of art.

We have observed that God or God-Nature created all beauty and art-form and then endowed a certain minority of artists with a talent for finding that beauty. Perhaps one of Michelangelo's most characteristic statements, once he had discarded his artistic chauvinism, was made in the *Dialogos em Roma*: "This most noble science belongs to no single country, for it came from heaven" ("Esta nobelissima sciencia não é de nenhuma terra, que do ceo veio").[16] A confirmation of this feeling is noted in the *Rime* (CIX, 94):

> *Alla bell' arte che, se dal ciel seco*
> *Ciascun la porta . . .*

In that fine art which, if everyone brings it down from heaven
with him ...

Art as the joint product of nature and heaven is an element of the sonnet
"Per ritornar là, donde venne fora" (CIX, 105):

> Nè altro auien di cose altere e nuove
> In cui si preme la natura, el cielo
> È ch' a lor parto largo, s'apparechia.

Nor does it happen otherwise with proud and new things in which
nature has a hand, and heaven which makes ready for their slow
birth.

Nor should we forget here Michelangelo's statement that the gift of paint-
ing rapidly is a gift "received from the immortal God."[17]

In the third of the *Dialogos*, Messer Lattanzio takes advantage of
Buonarroti's offer to devote the evening to further discussion of painting,
since they have already sacrificed part of the afternoon to this recreation.
Lattanzio asks of what painting consists, this painting which is the sub-
ject of so many ambitions but so rarely achieved. He poses several ques-
tions in quick succession. If the questions on first inspection seem naïve,
they actually raise basic issues. Since the replies are obvious to Michel-
angelo, he does not deign to give an answer to each. The answers which
he neglected to supply can be extracted from various sections of the
present volume.

"Should painting represent jousts and battles?" ("It may.")
"Kings and emperors covered with brocade?" ("No.")
"Damozels superbly dressed?" ("No.")
"Landscapes, fields, and villages?" ("No.")
"Or, perchance, saints and angels?" ("Yes.")
"Or the actual form of this world?" ("No, the ideal form.")
"Should painting be done with gold and silver?" ("Preferably not.")
"With the most delicate colors?" ("Yes.")
"With the brightest colors?" ("Never.")

Now let Michelangelo take the floor and proceed to his actual reply.
He explains that he would not define painting in terms of the subject

matters or media just enumerated. The painting which he celebrates and praises will be the imitation of some single thing among those which the immortal God made, with great care and wisdom. ("Sómente a pintura, que eu tanto celebro e louvo, será emitar alguma só cousa das que o imortal Deos fez, com grande cuidado o sapiencia.")[18] It will represent anything that God himself invented or painted as a master craftsman, up and down the scale, whether beasts or birds, dispensing perfection to each according to its merit.

Then follows Michelangelo's contention that great art transcends choice of subject matter, or even of medium, even though all subjects or media are not equal in the hierarchy of values. In the following words, Michelangelo is preparing the way for his ultimate assertion that a painter who executes one thing well will paint all other things equally well, his theory of transfer noted in the preceding chapter,

"In my judgement excellent and divine painting is that which most resembles and best imitates some work of the immortal God, whether it is a human figure, a wild and strange animal, a simple and uncomplicated fish, a bird of the air, or any other creature. And this neither with gold nor silver, nor with very high colors, but merely drawn with a pen, pencil, or brush, in black and white. To imitate each one of these things as perfect of its species seems to me to be nothing other than wishing to imitate the art [o officio] of the immortal God. Nevertheless, that thing will be the most noble and perfect in works of painting which will in itself copy the subject most noble and requiring the greatest delicacy and knowledge."

Frequently students of Michelangelo are confused by the fact that when he discusses the nature or applications of painting, he seems rather to be talking about drawing or design (see Chapter V). The solution to the paradox is contained in the words above, which Francisco de Hollanda must have heard viva voce.

All painting imitating a divine creation must partake of some nobility. But this is not enough for the Renaissance theorist. He must stress even more the classic canon of sublimity. After all, even in God's creations there is a hierarchy of sublimity. Buonarroti explains: "Who has such a barbarous judgement that he does not understand that man's foot

is more noble than his shoe, his flesh more noble than the sheep's skin from which his clothing is made? And who by this token cannot discover the merit and rank of every subject?" The substance of these remarks is that, while God may provide the power and inspiration for painting, he also supplies directly the most noble subject matter, particularly the human body. Not only does a painter discover beauty, as we have already learned, but he imitates it as well.

There is abundant further confirmation of Michelangelo's contention that "painting comes from heaven." In a letter to Niccolò Martelli, he characterised his work as "quell'arte che Dio m'à data" ("that art which God has given me").[19] As proof that Michelangelo affected the thinking patterns of Vasari, consider the latter's comment on the *Guidizio universale*. This expanse "is that model of our art, that great painting sent by God to men on earth in order that they may see how fate acts when *intelletti* descend from the highest sphere to earth and infuse men with the grace and divinity of wisdom."[20] This appraisal, couched in the very terms and concepts favored by Michelangelo, could only have delighted him.

Another confirmation is the following fragment (IV) wherein Buonarroti holds God to be the original artist:

> *Colui, che 'l tucto fe, fece ogni parte*
> *E poi del tucto la piu bella scelse*
> *Per mostrar quiui le suo cose eccelse,*
> *Com' a facto or cholla sua diuin' arte.*

> He who made the whole made every part,
> and then from the whole chose the most beautiful part,
> to exhibit here below his most lofty creations,
> as he has now done with his divine art.

Indeed, God is finally the supreme artist who must correct nature itself. In a memorial quatrain (LXXIII, 35) Michelangelo finds that God's creations are more infallible than those of nature itself. This curious dissociation of God and nature occurs when he hails the beautiful young Bracci, "with whose face God wished to correct nature."

One of the most famous sonnets (CI) and one of the best in Michelangelo's canzoniere was apparently inspired by the death of Vittoria

Colonna. It is thoroughly Neo-Platonic, illustrating as well as any writing of Buonarroti his concept of God as the artist who guides the sculptor's hand. Since Michelangelo's work frequently served as a refuge against his emotions, even in choosing a theme to express his sorrow he turns again to that work.

> *Se 'l mie rozzo martello i duri sassi*
> *Forma d'uman aspecto or questo or quello,*
> *Dal ministro, che 'l guida iscorgie e tiello,*
> *Prendendo il moto, ua con gli altrui passi.*
> *Ma quel diuin che in cielo alberga e stassi*
> *Altri e se piu col proprio andar fa bello;*
> *E se nessun martel senza martello*
> *Si puo far, da quel uiuo ogni altro fassi.*
> *E perche 'l colpo è di ualor piu pieno*
> *Quant' alza piu se stesso alla fucina*
> *Sopra 'l mio questo al ciel n'è gito a uolo.*
> *Onde a me non finito uerra meno,*
> *S' or non gli da la fabbrica diuina*
> *Aiuto a farlo, c' al mondo era solo.*

If my rude hammer gives human aspect to the hard rocks, portraying now one person, now another, since it takes its motion from that minister who guides, escorts, and controls it, it follows in another's steps; but that divine hammer which dwells and stays in heaven makes other things beautiful and even more beautiful makes itself, with its own motion; and since no hammer can be formed without another hammer, so on that living hammer is every other one based. And since in the smithy the stroke has greater power as [the hammer] is lifted higher, this divine hammer has gone off to heaven, leaving mine below. Whence my imperfect hammer will fail me, if now the divine fabric does not give it help, since that divine hammer was the only effective one on earth.

Guasti was apparently the first to claim that "this Platonic doctrine of the earthly instrument which is empowered through a divine exemplar is found in the *Cratylus*; and Buonarroti knew it from the Platonists of that time."[21] Actually, there is only a remote resemblance between Michelangelo's theme that his own hammer takes its power and movement from a prototypical hammer and the speculation of Socrates that there is a natural instrument to perform every technical task, an "instrument which

the nature of things prescribes must be employed." The discussion in the *Cratylus*, furthermore, has nothing to do with the fine arts. Frey agrees with Guasti that the comparison with the idea of the *Cratylus* is undeniable, although he grants that Michelangelo may never have read the dialogue. "On the contrary, the acceptance of the idea shows clearly that Michelangelo does not draw directly on the *Cratylus*, but rather follows foreign renderings and attaches an entirely different interpretation to it."[22] In any case, the idea of the divine hammer is an inevitable concomitant, with Platonic embellishments, of Michelangelo's certainty that God is the *summus artifex*. We remember that he referred to the effort required to convert ideations into artistic creations as "the hammer of Vulcan."[23]

It is noteworthy how so many of the epitaphs, madrigals, and sonnets composed in the 1540's, and especially after Vittoria's demise in 1547, strike a deep religious note. Symonds makes the point that most of the drawings from the last period of Michelangelo's genius are religious in inspiration and correspond exactly to the spirit of the poems composed at this period. The Crucifixion was thematic in these sketches, although it never advanced to the point of becoming a painting or statue.

From this period comes the sonnet "Da che concecto à l'arte intera e diua," translated earlier, expressing Michelangelo's belief in divine participation in the creative process. One of the variant readings of this sonnet (Frey, p. 228), which characterises the artist's talent as his "divine part," is sufficiently different to merit partial translation here:

> *Se ben concietto à la diuina parte*
> *Il uolto e gli attj d'alcun, po' di quello*
> *Dopio ualor con breue e uil modello*
> *Dà uita a sassi, e non è forza d'arte.*
> *Ne altrimenti in piu rustiche carte,*
> *Anz' una pronta man prende 'l pennello,*
> *Fra dottj ingengnj il piu accorto e bello*
> *Proua e riuede e suo istorie comparte.*

If the divine part of the artist has conceived well one's face and one's actions, then by means of a brief and humble model he gives life to stones; having had recourse to that double power [*intelletto* and hand], he needs no greater effort of technique.

> Nor is it any different in the humbler procedure of painting:
> before a quick hand takes up the brush, it tries out and retries
> the most sensitive and finest among the learned first drafts and
> then disposes its subjects.

Guasti and others accept *ingegni* as "minds," but the special contemporary meaning of "first draft" fits well here. One should not overlook in these quatrains further substantiation that in Michelangelo's theory the creative process was divided into a slow and meticulous art-phase, followed by a rapid nature-phase.

Like any good Platonist, Michelangelo was alert to the moral or immoral nature and effect of art. Yet his own conclusions ranged him closer to Aristotle, for he found that the greatest purpose and justification of art was to inspire pious feelings in the spectator.

The idea that painting, like poetry, should be a handmaid of theology was widespread throughout the Middle Ages and had by no means disappeared in Michelangelo's time. Alberti wrote, "Religion has been able to make use of painting on a large scale, that religion by means of which we are principally conjoined to the gods. Painting has helped souls to persevere with a certain religious integrity."[24] The conventional view was that art's purpose was to inspire piety and keep the wayward in line and that religious art was the prayer book of illiterate men. Gregory the Great had written, "Gentibus pro lectione pictura est. Saltem in parietibus videndo legunt quod legere in codicibus non valent." When, in the late Middle Ages, the painters of Siena incorporated themselves into a guild and established their bylaws, the preamble of their articles of incorporation declared them to be the instructors of the uncouth and the illiterate.[25] The Council of Nicaea admitted the use of pictures in churches, but stipulated that "the composition of the pictures should not be the invention of the artist, but should follow the rules and traditions of the Church." Even in Michelangelo's time, almost everyone who saw his Sistine Chapel paintings considered them automatically as sermons in pigment rather than creations of beauty divorced from didactic purpose. Leonardo felt that art is the prayer book of even literate men, since these

latter will beseech help of paintings as they would never ask it of a printed page.[26] And Savonarola, fixing his burning eye on some humble scapegoat in his audience, personalised this attitude by shouting, "You, fellow ignorant of letters, go to pictures and contemplate in them the life of Christ and his saints."[27] Perhaps he cried this in Michelangelo's presence. Again, he urged his parishioners to keep a painting of Paradise in their rooms to inspire them.[28] In a sense, Michelangelo's productions continued the moral teachings of Savonarola after the dispersal of the Piagnoni, persevering with the work halted when the Dominican was hanged and burned on the stake and pyre. Thus, Thode sees in the *Cristo risorto* a condemnation of corrupt Rome, a favorite theme of Savonarola's vituperations. Similarly, Michelangelo becomes a teacher or *manifestatore* when as *Nicodemo* he "displays" the sufferings of Christ on the Florentine *Pietà*.

A medallion, signed and dated 1561, by Leone Leoni shows a blind Michelangelo led by a dog, clutching a rosary, and leaning on a knotty staff. The posie is taken from a Biblical psalm: "Docebo iniquos ut et impii ad te convertantur."[29] Mariani suggests that it is possible that Michelangelo himself chose the subject of the figuration and also the scriptural phrase, being so sensitive about matters concerning himself. Whereas Mariani conjectures that "iniquos" refers to the hostile sect of Sangallo, it is far more probable that the phrase stems from Buonarroti's consciousness of his religious and didactic function as artist to direct the iniquitous toward salvation. The iniquitous who prompted him to write his powerful verses (LXIX) on the seven deadly sins: "These seven born to them roam over the earth, / seek together the one and the other pole / and only against the just turn their intrigues and warfare. / And a thousand heads has each one of his own. / The eternal abyss for them opens and narrows, / Such prey do they take in the universal throng; / and their members gradually enfold us / as ivy covers the wall overrunning stone after stone."

Since lofty painting is "a copy of the perfections of God and a remembrance of his painting" (Chapter I, note 37), it is so rare that almost "no one" can approach it. ("E por isto é esta pintura tão rara que a não sabe ninguem fazer nem alcançar.")[30] Because of this origin in

the Godhead, painting is predestined to inspire devotion among the on-lookers:

E a boa (pintura) desta não ha cousa mais nobre nem devota, porque a devoção, nos discretos nenhuma cousa faz mais lembrar nem erguer que a deficuldade da perfeição que se vai unir e ajuntar a Deos.[31]

And there is nothing more noble or devout than this good painting, for nothing causes devotion more to be remembered and stirred up among worthy people than the difficulty of the perfection which is going to unite with and join God.

Carlo Aru supposes that Michelangelo's definition of art as the copying of the perfections of God comes out of Leonardo,[32] a dubious attribution which would have made Michelangelo wince.

Discussing the depiction of religious subjects, Michelangelo averred that princes of the Church and state should authorise only the most illustrious painters of their domains to undertake to portray the goodness and mansuetude of the Redeemer or the purity of the Virgin and saints (see translation accompanying Plate III).

Quanta mór razão têm os principes eclesiasticos ou seculares de pôrem mui grande cuidado em mandarem que ninguem pintasse a benignidade e mansidão de Nosso Redemptor nem a pureza de Nossa Senhora e dos sanctos, senão os mais ilustres pintores que podessem alcançar em seus senhorios e provincias.[33]

After all, as Michelangelo the poet reminds us (LVII) "Ai dipinti s'appiccon uoti e s'accendon candele" ("to paintings one hangs ex votos and lights candles").

This insistence on the artist's morality, like so much in this chapter, could have derived directly or indirectly from Savonarola. Blaming certain painters in a Lenten sermon for overdressing the Virgin and saints, the friar claimed that such incompetent or insensitive men of art made their subjects resemble strumpets and profaned the cult.[34] Almost duplicating Michelangelo's words, he wrote elsewhere, "In churches only the greatest of painters should be allowed to paint."[35] Again we remind the reader that Michelangelo both read and heard Savonarola with utmost pleasure,[36] and that Condivi cites Savonarola and Dante as the artist's heroes.[37]

In any case, Michelangelo's specific concern about the manner in which God, the Virgin, and the saints should be treated was of course one of the basic concerns of the Church fathers. The iconoclastic controversy of the Eastern Church, erupting in the Council of Constantinople (754), ended with a pronouncement that none should have the audacity to figure Christ or the Logos. The Council also attacked those who would needlessly paint figures of the saints. By the time of the Council of Nicaea (787), however, it seemed agreed that if paintings are a picture or prayer book for the unlettered, it becomes necessary to portray Christ and the saints. "For the more frequently they are seen in artistic representation the more readily will men be lifted up to the memory of their prototypes, and to a longing after them." According to De Tolnay's debatable thesis, this lifting up or *ascensio* is the major function of the Sistine Ceiling, if the histories are viewed in "Neo-Platonic" succession, that is, from depravity of Noah to the separation of light and dark.

Michelangelo gained a reputation (Niccolò Martelli remarked on it in 1544)[38] as a portrayer of generalised, nonrealistic features on his figures. The principal reason for this, we shall learn, was his neoclassical desire to achieve abstraction and idealisation. It is also true, however, that since his figures were so frequently from the theological or Biblical hierarchy, he felt that to portray actual likenesses of his models was sacrilege. He may have remembered Savonarola's urging painters and sculptors not to use young Florentines as models, lest the local populace could point out some miscreant in the streets and say, "There goes that awful Beppo. He's John the Baptist in our church." Or lest someone entertaining feelings of piety genuflect before a Madonna, only to discover that Our Lady bore a striking resemblance to a fishmonger's salesgirl or worse.

So Christian tradition had only grudgingly permitted artists to paint God, the Virgin, and the saints and had devised a repertory of symbolism for such depiction, even though the medieval mythographers readily accepted Apollos as God or Daphnes as the Virgin Mary. In 1523, at the very moment that Michelangelo was working on the Medici *Madonna*, the mass and image worship were abrogated at Zurich. By 1563 the Council of Trent, cautious about such charges as idolatry, authorised

church images of Christ, the Virgin, and the saints (omitting God) in almost Neo-Platonic language: "The honor which is showed them is referred to the prototypes which those images represent."[39] Yet Michelangelo was equally subjected to a classical tradition which tolerated a constant portrayal of gods and demigods. Philostratus the Younger reminds us of the classical license: "The poets introduced the gods upon their stage as actually present, and with them all the accessories which make for dignity and grandeur and power to charm the mind; and so in like manner does the art of painting, indicating in the lines of the figures what the poets are able to describe in words."[40] Alberti recalled that in classic times painters traditionally brought the gods closer and that, by a painting of Zeus in Aulis, Phidias "contributed much to the already conceived religion."[41]

Faced by a conservative Christian tradition dating from the Decalogue and an indulgent classical precedent, Michelangelo took the middle position, discernible from his various comments, that one may portray God and the Holies provided that one

(1) is a master of his craft,
(2) idealises his portraiture,
(3) has the power to evoke feelings of piety from his audience,
(4) is of unimpeachable moral character himself.

If a man is not a talented painter, then it is unfair for him to depict deities and saints for several reasons: First, he will not give them grave, beautiful, and noble features. The loftiest criterion of beauty which Michelangelo the poet can call to mind (XXXVII) is the "uomo che dipinto in chiesa sia" ("man painted in church"). Second, he will be making an obvious bid for favorable criticism, since an onlooker would naturally be favorably predisposed toward a religious subject. This latter point is at the basis of Michelangelo's censure of Flemish art, which he felt to be mediocre in character and direction. "Pintam em Frandes ... ou cousas que vos alegrem ou de que não possaes dizer mal, assi como santos e profetas" ("They paint in Flanders things which either make you gay or about which you cannot speak ill, such as saints and prophets").[42]

Michelangelo was confident that he satisfied to a sufficient extent the four requirements enumerated above, even though he occasionally wrote poems on his moral inadequacy. Neither Christian humility nor aesthetic principles disinclined him to paint God or the Madonna. He was even willing to pioneer in sculpturing the Christ Child with his back to the devout. He knew that no subject was more "loaded" to awaken reactions of piety, commiseration, and virtue than that of the Mater Dolorosa who has just lost her son that humanity might be saved. His success in handling this subject can be measured in a stanza dedicated to the *Madonna della Febbre* by Giovan Battista Strozzi.[43] As we have suggested, these statues evoked feelings of piety not only among the Christians but also among the Jews of Rome, who were to be seen in droves on Saturdays, visiting and praying to the *Mosè,* as to not a human but a divine thing.[44]

We have recorded that Michelangelo felt an unassailable moral character to be a prerequisite to an artist's engaging in church art. He tells his version of the story of the Ark of the Covenant[45] to show how God must inspire painters. Wishing to decorate the Ark with consummate artistry, as befitted the repository of the Mosaic tablets, God took pains to ensure the quality of the craftsmanship. "And even in the Old Testament God the Father wished that those charged exclusively with decorating and painting the *arca foederis* should be not only remarkable and great masters, but even touched by his grace and wisdom and intelligence from his own spirit, so that they might be able to invent and do all that could possibly be found and done."[46] If God wished the *arca foederis* to be decorated with such perfection, reasons Buonarroti, how much more care and gravity must he demand of those who would reproduce his divine visage or that of his Son, or the composure, chastity, and beauty of the glorious Mary, painted by the Evangelist Luke—like the face of the Saviour, he adds, which one finds in San Giovanni in Laterano. He is not forgetting the Neo-Platonic definition of beauty as streams of light shining from the face of God.

Obviously, the artist who wishes to possess the *intelletto* must remain a good Christian. As Dolce pointed out, recalling the "Si vis me flere" of Horace, "the Painter cannot move us if he does not feel beforehand in his soul those emotions or feelings which he would instill in the souls

of others."[47] Paolo Pino also prescribed that the painter abhor all vices: avarice, gambling, ignorance, sloth, gluttony. "Let the Painter be a good Christian!"[48] The more moral the artist the less fluctuation of the *trovatore* spirit there will be, and greater the works resulting. Buonarroti must have been chagrined by the example of Perugino, as Vasari describes him, or by Fra Filippo Lippi, who painted holy Madonnas even as he pursued a series of young women, only to be poisoned by one virgin's truculent family.

The most direct statement on this matter by Michelangelo was made to Messer Lattanzio in the third of the Roman dialogues. Lattanzio confides to Michelangelo that he had always noted a curious impertinence in poor painters. This is their lack of devotion when they are painting for churches. Certainly one cannot approve the irreverence which these ill-advised artists display. The stupidity of their creations even makes one laugh instead of instilling reverence and tears.[49]

Michelangelo concurs. "This sort of painting is a great undertaking. In order to imitate even partially the venerable image of our Lord, it is not enough for a painter to be a master, great and well-advised. I maintain that it is necessary for him to be of a very good life, or even saintly, if he can, so that the Holy Spirit may inspire his *intelletto*." There is further authority to corroborate this evidence in De Hollanda. Ammannati quoted Michelangelo as telling him that "good Christians make good and beautiful pictures."[50] Two recent writers have commented on this quotation concerning the Holy Spirit. Buscaroli curiously disregards the orthodoxy both of this notion and of Michelangelo's Christianity, whose only deviation is in the direction of mysticism: "We ought not, however, attach excessive value to this affirmation, which would lead us into the familiar error of mysticism. The religiosity here has no other meaning than the transcendence which art requires to overcome the dualism between external reality and inner truth."[51] This relationship between personal morality and divine inspiration, from Masoliver's complicating perspective, "does not, in my opinion, suppose—as one might surmise at first—a return to the primitive (a Giotto, a Lorenzetti, a Masaccio) but rather a glimpse of modern biopsychological conceptions."[52]

This idea has probably a longer belletristic than bellartistic ante-

cedence. Strabo had set down an oft-quoted passage in his *Geography* to the effect that a great poet must be a worthy and good man and, in any case, Cinquecentisti like Minturno were keeping the idea alive.[53] Vasari, in his life of Fra Angelico and *passim*, echoed that painters working on holy subjects should be devout men. Da Vinci himself echoes the thought.[54] Savonarola had orated that "every painter expresses himself. All his works bear the stamp of his thought,"[55] and "carnal and debauched men are the enemies of the fine arts."[56] In his *Idea del tempio della Pittura*, Lomazzo wrote of the perfection and authority of art which caused to spring forth from the soul as ordained by God "the beauty and profundity of the Ideas descended from above through direct channels from the supreme Idea, which represents itself to us with a clarity corresponding to the degree to which we are purged and chaste [*purgati & mondi*]."[57] Plotinus, who influenced Lomazzo, held that when the soul passes from the perception of Beauty seen through the senses to that perceived through Intellect, then one beholds what is akin to oneself; only a great and good soul can perceive great art.

The practicing Christian artist finds in his religion a wealth of themes. Armenini, having found the greatest masters adopting such themes, decided that artists must of necessity be acquainted with Biblical and Church literature and lore, specifying "the sacred histories, the Bible, the New Testament, the life of Christ, of the Madonna, of the virgin-saints and martyrs, the legendary of the saints, the lives of the Holy Fathers, with the Apocalypse of St. John."[58] These great themes serve in themselves as guarantors of great art, as Michelangelo enunciated to Niccolò Franco (see Chapter III).

Michelangelo's belief that only good Christians create good art was, then, one which he shared with many contemporaries. It was an integral part of his concept of God as collaborator of the artist. He accepted Savonarola's allegation that painters record themselves in their works, rephrased by another preacher (Beecher) as, "Every artist dips his brush in his own soul and paints his own nature into his pictures." Michelangelo incorporated this selfsame idea into two madrigals, "Se dal cor lieto diuien bello il uolto" and "S'egli è che 'n dura pietra alcun somigli."

Del resto non saprei
Mentre mi strugge e sprezza,
Altro sculpir che le mie afflicte membra.[59]

While she destroys and disdains me, I could not moreover sculpture anything else than my own afflicted members.

Michelangelo's tremendous sincerity could not let him agree with the principle underlying, let us say, Diderot's paradox on acting or the thesis of Gustave Flaubert, derived from Diderot, "Moins on sent une chose, plus on est apte à l'exprimer comme elle est" ("The less you feel a thing the more likely you are to express it as it really is").

Just how saintly a personal life Michelangelo led has been the subject of some sprightly comment. His habits were regular. Like Cennini, he wanted artists to observe temperance in eating and drinking, a regula he observed himself. Vasari records that Michelangelo was "moderate in eating and in coitus." If one could turn a deaf ear to the damaging slurs of Aretino and accept Papini's whitewashing of the "blackmailers" Febo di Poggio and Gherardo Perini, Michelangelo's slate looks very clean. However, both Aretino and Papini take extreme, if opposing, views of Michelangelo's sexual conduct. Since Michelangelo's art and poetry have many *intrecciature* with his moral convictions and his personal relationships, a brief conspectus of his sexual life and habits is in order. Michelangelo was obviously ambisexual, as his letters and poetry reveal. He entertained powerful feelings for both men and women, loves which he constantly tried to sublimate or idealise. Petrarchism and Neo-Platonism assisted him in rationalising these attachments. Yet his passion often broke the bounds of these conventional admirations. If his feeling for the widowed Vittoria Colonna was Platonic, he brooked a slight resentment over this, even after her death. This one gathers from a Bernesque note to his sonnet (CI) to the deceased Marchioness, who had taken nun's vows until she might rejoin her husband in heaven: "Arà in cielo chi almeno merrà i mantici, chè quaggiù non avea nessun compagno alla fucina, dove si esaltano le virtù" ("In heaven she'll at least have someone to work her bellows, since down here she had no male companion at the smithy, where virtues are exalted"). This note may, of course, be read perfectly well without a sexual implication, but it seems to correspond to

the alleged dual sketch of Michelangelo in a boar's coif staring at an un-
happy Vittoria with sagging breasts, joined by a hand forming the vul-
gar *fica* (Frey, *Dichtungen*, p. 385). There were doubtless other women
for whom he felt desire: the tightly dressed girl in Bologna, the "donna
aspra e fera," the "donna bella e spietata," just as there were no doubt
more young men than Febo and Gherardo. Since his love of the male nude
figure was so great that he used male models even when painting women
(see Chapter III), the physical beauty of Giovanni da Pistoia, Cecchino
Bracci, and Tommaso Cavalieri drew him easily to them. The passionate
letters to Febo and Tommaso are there for us to read, as well as such
an anguished poem, no doubt addressed to Febo (XXXIII), as "Che ne ri-
porterà dal vivo sole / Altro che morte?" ("Who will deliver us from
the fiery sun [Phoebus] other than death?"). This latter sonnet, whose
confessional nature has been neglected by the editors, speaks of the
"shame" of his attachment which destroys him gradually as he surrenders
to it. In his effort to discredit those who consider Michelangelo a pederast,
Papini reads into the correspondence dating from 1520 to 1522 that the
artist became syphilitic around 1520.[60] (Yet science today shows that
incidence of such diseases is high among homosexuals.) In sum, Papini,
author of the best study yet of Michelangelo *vivo*, believes it self-evident
that his idol was moderately heterosexual, by no means libidinous, nor
yet an impotent or eunuch, who begrudged any sexual activity draining
off energies which might otherwise be spent on art. Even in his chapter
on Cecchino Bracci, Papini avoids accusing Michelangelo of improper
relations. Yet there is strong reason to suppose that the artist entered
into homosexual relations with the fifteen-year-old Cecchino, at whose
death he composed fifty poems of an admiring nature but revealing no
nobility of feeling. Indeed, the ribald verses of LXXIII, 19, with their sala-
cious footnote to Luigi del Riccio, which editors also pass under silence,
compromise both the artist and his friend Del Riccio. The boy is made to
confess:

> *Fan fede a quel ch' i' fu' gratia nel lecto,*
> *che abbracciaua . . .*
>
> *Attest to the grace that I was in bed*
> *When I embraced . . .*

Michelangelo, hard pressed by Luigi del Riccio to compose a long series of poems, adds impatiently, "Take these two [variant] verses below, since they're a moral thing; and this I send you to pay off the fifteen IOU's." Such an outburst as this makes more understandable, without excusing, the discretion of the maligned Michelangelo the Younger in tampering with the text of the *Rime*.

Some scholars find a patent homosexuality exhibited through the *ignudi*. Masoliver reads admission of the homosexual tendency in the verses:

> *Passa per gli occhi al cor in un momento*
> *qualunque obbietto di beltà lor sia*
> *d'ogni età, d'ogni sesso...*[61]

> Whatever object of beauty passes through the eyes to the heart
> in an instant, be it of any age or any sex...

Others find a disclaimer of homosexuality in the first four lines of the madrigal "per fido esemplo alla mia uocazione" (translated in Chapter I), where Michelangelo admits that he lives for beauty alone and adds, "If anyone thinks otherwise, his opinion is wrong."

An evidence of Michelangelo's bisexuality is suggested by the drawings. If the herm of the *Saettatori* (Archers) represents Michelangelo himself, let it be noted that he is assailed by the arrows of women as well as men, women being in the minority. In brief, to those who refuse to recognise the obvious evidences of homosexuality in Michelangelo we can only echo the distich (CXXXVIII) of Michelangelo himself:

> *Chi non uuol delle foglie*
> *Non ci uenga di maggio.*

> He who doesn't want leaves,
> Let him not come around in May.

Michelangelo's love, whether physical or sublimated, whether for men or for women, was most intense and disturbing. The anguishes of his earthly love are just as racking as the torments of his love of God in his late, mystical poetry. Indeed, no poet from Hellas to the present has ever written a greater tribute to the power of love than Michelangelo's lines (CIX, 95) with their Christlike confidence:

I' uaglio contra l'aqqua e contra 'l foco
Col segnio tuo rallumino ogni cieco
E col mie sputo sano ogni ueleno.

I have power against water and against fire,
With thy sign I give light again to every sightless man
And with my spit heal every poison.

His love for Tommaso Cavalieri affords him this same power (Letter CDXVI): After writing that Cavalieri's mere name is the food upon which he thrives, Michelangelo adds that this name nourishes his body and soul and that, remembering it, he can no longer experience vexation or the fear of death.

As Michelangelo grew older his soul-searching was intensified. He who set up in his poetry a distinction between *uoglia sfrenata* (unchecked desire) and *amore* grew to regret his earthly attachments. In the sonnet "Scarco d'un' importuna e greve salma" (CLII) Buonarroti urged Christ not to raise up his arm and point to the blemishes in his past:

Non mirin con iustizia i tuo' santi ochi
il mio passato, e 'l castigato orechio
non tenda a quello il tuo braccio seuero.

Let not thy holy eyes look righteously upon my past; nor thy chaste ear attend it; raise not toward it thy severe arm.

In this passage Michelangelo is visualising the *Cristo giudice* of the Sistine wall and echoing the appeal made by Thomas of Celano in the *Dies irae:* "Juste iudex ultionis / Donum fac remissionis!" Michelangelo's fearsome line (x) comes to mind: "E pur da Cristo pazienza cade!" ("Christ's patience is waning just the same!"). Elsewhere (LXXXVII) Michelangelo begs that Christ instead extend his arms to him in pity:

Signior, nell'ore estreme
Stendi uer me le tuo pietose braccia
Tom' a me stesso e famm' un che ti piaccia!

Lord, in the last hours
Stretch toward me thy forgiving arms,
Withdraw me from myself and make me one who may please you!

· *91*

Peccadilloes became sins, until finally Michelangelo feared that he had no further control over his will.

> *Viuo al pechato, a me morendo uiuo;*
> *Vita gia mia non son, ma del pechato.*
> *Mie ben dal ciel, mie mal da me m'è dato,*
> *Dal mie sciolto uoler, di ch' io son priuo.*
>
> *I live in sin, I live dying unto myself;*
> *Nor yet even a life of my own, but of sin.*
> *My grace was given of heaven, my evil of myself,*
> *My will dissolved, free will have I no more.*

Obviously, this concern reveals the intensity of his morality rather than his immorality. The adjective "divine," so universally applied to him by his contemporaries (including Cervantes), and of course the punning epithet of "angel" did not refer exclusively to his artistic eminence. Had he not enjoyed a reputation of probity, the adjective would not have come into such general use. Nor did hard-skinned Berni wish to burn incense to him as to a saint. Michelangelo was by no means alone among artists in his concern over his conduct, if we believe Dejob's thesis that the painters of the late Renaissance, excepting Lanfranco and Caravaggio, were a particularly upright lot. And this "at a time when amateurs of every field of endeavor had furnished an example of naughty behavior."[62]

Let us return to the question of the moral effect which good art is to exert. Just what constitutes moral art? On this issue the Church councils and inquisitions left little room for doubt. There is the specific pronouncement on art by the twenty-fifth and final session of the Council of Trent. Michelangelo, who theorised that all good art—church or lay—originates in God, died less than a year after the closure of the Council, preserved by God, writes Guasti, to see initiated dubious reforms which he had fostered. The pronouncement forbade church images related to erroneous dogma or designed to deflect the simple from the paths of righteousness; all impurity must be eliminated and no image out of the ordinary could be placed in a church without approval of the bishop.

One of the basic properties of appropriate church painting is divulged by Michelangelo in his colloquy with Messer Lattanzio: "For many times badly painted images distract and cause people to lose devotion, at

least those who have little devotion; and on the contrary, those paintings which are done divinely stir even the least devout and lead even those least responsive to contemplation and tears and, by their grave aspect, instill in them great reverence and fear."[63]

In Michelangelo this "grave aspect" becomes the well-known *terribilità,* an awesomeness of conception and execution and (Vasari) of thought and feeling (*affetti*). The word *terribilità* is correctly associated by Mariani with the "sacred fear of the ancients." The term itself is by no means a latter-day invention to describe the dominant quality of many of Buonarroti's works. Several of his contemporaries, and even he himself, used it. Sebastiano del Piombo wrote him (1520) that the Pope had declared the Florentine's works "terrible" and difficult. Sebastiano's defense: "And I replied to his Holiness that your *terribilità* harmed no one and that you appear *terribile* because of the love and importance you attach to your great work."[64] That Michelangelo used the word to describe himself we learn also from Sebastiano, "As for that *terribilità* you mention in your letter, I for my part don't consider you *terribile*."[65] This also dates as early as 1520. Vasari coupled the two adjectives *grave* and *terribile,* the former being required to explain the latter; he notes that the *Mosè* has a "gravissima" aspect and resembles a "true saint and *terribilissimo* prince" and that, as one watches it, one wishes that the statue's face might be veiled.[66] Vasari again described the sheer physical reaction which this quality elicits: in the *Giudizio universale,* the "terribility" of the faces of the seven angels blowing seven trumpets causes one's hair to stand on end.[67] Lomazzo also coupled the concepts of gravity and terribility in commenting on the Sistine wall (and the Cappella Paolina). He explained that Michelangelo forsook a beautiful manner "to show all the difficulty of this art" and "expressed such a terrible air, proud and full of gravity, in the faces of his figures, that it terrifies whoever regards them."[68] On another page Lomazzo proposed that Michelangelo's symbol should be the dragon, because of the latter's terribility.[69] Finally, in Dolce's dialogue on painting, Aretino refers to this same terribility of Michelangelo.[70]

These emphases on the physical impact of art remind one of Savonarola's sermon saying that if an artist paints well his paintings will so

move men as to leave them enthralled (*sospesi*) and rapt in ecstasy.[71] But it is Michelangelo himself, in the quotation above (note 63), who makes explicit the purpose of his terribility—namely, to stir the soul of the least pious and sensitive onlooker contemplating his *Giudizio*, reminiscent of the *Dies Irae*, or his spandrel *David e Golia*, which makes us catch our breath as the still-active giant starts to raise himself menacingly on one elbow. In a moment we shall view Michelangelo's belief in the doctrine of katharsis as a result of his humanistic background. Whereas Vasari and Lomazzo stressed the terrifying function of *terribilità*, note from his quotation that Michelangelo wishes to stir the onlooker not only to tears and fear but also to reverence and contemplation. This is the "sacred fear of the ancients," mentioned by Mariani, the Aristotelian θαυμαστόν, or third agent explicitly mentioned in the *Poetics* as capable of purifying the emotions as well as the agents of pity and fear.

Not everyone agrees, of course, that only great art inspires piety. Goethe remarked that miracle-working pictures are usually bad works of art. "Certainly beautiful things should be more worshipful than unbeautiful things," reads a comment on Michelangelo's statement, "but this is not the case in Italian churches, where the devout are not preoccupied by the questions of aesthetics or technique."[72] Nor can we deny the efficacy of primitive art in the ritualistic religions of less civilised peoples. Michelangelo's theory allows for disparity of tastes among the onlookers. He observed, one remembers, that Flemish art affected people despite its poor quality. It will bring tears to certain specific categories of devout people, "and this not through the force and goodness of that painting, but through the goodness of that so devout person."[73] The categories most affected by this mediocre Northern art are very old and very young women, monks, nuns, and certain other artistically insensitive if oversentimental people. A tabulation of Michelangelo's statements permits the following four propositions:

1. Divine painting affects persons of perception (*accorte*)
2. Divine painting affects persons without perception
3. Poor painting does not affect persons of perception
4. Poor painting affects persons without perception

Incidentally, various writers from the Middle Ages through the Renaissance concurred that the greatest miracle-working "painting" of all time was Christ's face which the Saviour himself "painted" on the veil of St. Veronica.[74]

As intimated above, one cannot weigh Michelangelo's feelings about the moral effect of art without tying them in with the doctrine of katharsis, so much in the minds and on the tongues of the academicians and learned men all over Italy. Robortelli, Cinzio, Vettori, Castelvetro, and others were commenting on it. Michelangelo's remark to Lattanzio that painting inspires contemplation, tears, reverence, and fear was cast in Aristotelian terms, scarcely by accident. It seems much closer to Aristotle than such generally expressed earlier statements as Alberti's "la sua pittura intratterrà, e commoverà gli occhi e gli animi de' riguardanti" ("painting will entertain and move the eyes and souls of the onlookers").[75] As a neoclassicist, as a Christian, and as an individual, he approved of this justification of serious art through purgation of the emotions. His particular mentality may have inclined him toward this doctrine of fear and pity. With some hesitation we quote the psychiatrist Kretschmer, "Among the typical schizothymes we find the tendency to classical beauty of form . . . and extreme tragic pathos, as with Michelangelo and Grünewald."[76]

There are traces of the katharsis principle in Michelangelo's poetry, as in a madrigal (CXXVII) composed on the death of Vittoria Colonna:

> Se 'l duol fa pur, com' alcun dice, bello
> Priuo piangendo d' un bel uolto umano,
> L' essere infermo è sano,
> Fa uita e gratia la disgratia mia:

> If sorrow then makes one fine, as they say, since I am weeping here deprived of a beautiful human face, my infirm, being is made whole and my misfortune creates life and grace.

In the Roman dialogues Vittoria herself made a pronouncement on katharsis to which Michelangelo assented: Painting incites the impenitent to compunction, the worldly to penitence, the least devout and contemplative to contemplation, fear, and shame for their faults.[77] Not only in his art did Michelangelo try to express an example of moral purification, but in his own life as well. His self-imposed sufferings and occasional asceticism

he welcomed as an ethical purgation. Several references to this personal experience are found in his verse:

> *Mille piacer non uaglion un tormento*[78]
> A thousand pleasures are not worth a torment
>
> *La mia allegrez' è la maninconia*[79]
> My happiness is melancholy.
>
> *Tanto piu chi m' uccide mi difende*
> *E piu mi gioua doue piu mi nuoce*[80]
>
> All the more does the one who kills me defend me,
> And all the more good does he [she] do in tormenting me.

A counterpart of katharsis is the searing experience which the soul undergoes at the contemplation of beauty. It is indisputable that in Michelangelo's theory, as in Plato's, the contemplation of beauty ennobles. Even more, the image manifest to the eyes and present in the heart generates an organic disturbance as violent as katharsis itself (LXXV):

> *Di sè lasciando un non so che cocente,*
> *Ch' è forse or quel ch' a pianger mi conduce.*
>
> Leaving some sort of scorching pain
> which is perhaps what now leads me to weeping.

Another type of katharsis is found in Buonarroti by Panofsky.[81] He views one of Michelangelo's stanzas to Vittoria Colonna as proof that katharsis need not always be a self-purification, as in Plotinus, or even a purgation through pity and fear, as in Aristotle. It may, on the contrary, be a purifying accomplished by the merciful intervention (*Wirken*) of Vittoria herself. The first four lines of this piece (LXXXIV) have been translated on an earlier page.

> *Si come per leuar, Donna, si pone*
> *In pietra alpestra e dura*
> *Una uiua figura,*
> *Che là piu crescie, u' piu la pietra scema,*
> *Tal alcun' opre buone*
> *Per l'alma, che pur trema,*
> *Cela il superchio della propria carne*

Col' inculta sua cruda e dura scorza.
Tu pur dalle mie streme
Parti puo' sol leuarne,
Ch' in me non è di me uoler ne forza.

Just as taking away, milady, brings out a living figure in alpine
and hard stone, which there grows the more as the stone is chip-
ped away, thus some good works which belong to the trembling
soul are concealed by the superfluous matter of flesh, which is
for the soul a crude and hard husk. Thou alone canst remove this
husk from the outermost parts of my soul, for in me there is no
independent will or power.

In a sense this might be considered a katharsis, in that the lady rids the
poet-sculptor of the base, irrelevant, and nonspiritual elements of his
being just as the sculptor pares away the superfluous and meaningless.

Yet since Michelangelo's eventual decision is to deny even such a
lofty love as this one and, as a Christian mystic to love only God, he views
earthly love as a cleansing fire which purifies gold and readies the soul
for God: "Com' or purgata in foco, a Dio si torna" (CXXVI).

Returning to the more conventional Renaissance acceptance of ka-
tharsis as a purgation of the emotions effected through pity and fear—
and awe, as Michelangelo implied to Lattanzio—let us measure the
extent to which Michelangelo's themes were chosen to inspire compassion
and fear. Rodin said of his predecessor, "Les thèmes favoris de Michel-
Ange, la profondeur de l'âme humaine, la sainteté de l'effort et de la
souffrance sont d'une austère grandeur."[82] Symonds held that Michel-
angelo could not inspire both pity and fear by a single work. "The long
series of designs for Crucifixions, Depositions from the Cross, and Pietàs
which we possess, all of them belonging to a period of his life not much
later than 1541, prove that his nature was quite as sensitive to pathos as
to terror; only, it was not in him to attempt a combination of terror and
pathos."[83] Yet some of the sketches do seem intended to arouse such an
emotional combination in a single glance. There is the drawing of Isaac's
offering in the Casa Buonarroti (Berenson, 1417), the three sketches
of the fall of Phaethon (Berenson, 1513, 1501, 1617), or the study of
Tityus cruelly attacked and about to be eviscerated by a huge bird of
prey, a work found in the Windsor Royal Library (Berenson, 1615r).

Certainly, as one attending the unearthing of the *Laokoön*, he knew how forcefully the two sentiments might be evoked at once. However, Michelangelo's major works do tend to evoke either pity (the *Pietà*, the *Deposizione*, etc.) or fear (the *Battaglia di Cascina* or various details of the *Giudizio: Minos*, the *Dannati*, and so on). Even at his most "terrible," Michelangelo never makes a more overt or conspicuous attempt to cause his public to shudder and weep than do his contemporaries. After all, he was by choice and by instinct a neoclassic. Roger Fry has defined "classical the work which to provoke emotion depends on its own formal organization" rather than "count on the association of ideas which it sets up in the mind of the spectator." Whether or not Michelangelo was so hyperclassical as this, he did rival the ancients in his ability to elicit pathos quietly, without sesquipedality in his artistic vocabulary. He strove for nobility as well as emotive effect and, as Braque reminds us, nobility arises from reticence of the emotion. Not only critics and historians but artists themselves have sung Michelangelo's praises for this reticence. Aristide Maillol is one of the many, "One can express sorrow by calm features, not by a twisted face and a distorted mouth. When movement is excessive, it is frozen: it no longer represents life. A work of art contains latent life, possibly movement. One always talks of Donatello, but never of Della Quercia. Yet Della Quercia invented Michelangelo's style before Michelangelo."[84]

The best examples of this reticence are the *Deposizione* and the *Pietà*, which emphasise pity rather than fear. Condivi wrote that the *Deposizione* "represented an attitude of marvelous pathos."[85] The *Pietà* in St. Peter's is more stirring, however. The only gesture of grief brought out of Michelangelo's repertory is the helpless, outstretched hand of the Virgin, repeated as a symbol of grief, by the way, in the sketch of the weeping women in the British Museum (Berenson, 1514). Like a sculptor of antiquity working on a Niobide group, Michelangelo could rely on his audience's thorough knowledge of this story of maternal anguish and could thus eliminate subjective details. Such statues revealed the quality which Winckelmann found in Hellenic figures, a great and composed soul.

De Tolnay claims to discern an evolution in the emotional content

of the three *Pietàs* of Michelangelo's later period. In the *Pietà* drawn for Vittoria Colonna the sculptor renders the grandeur of Christ's sacrifice in an abstract manner. The Florentine *Pietà* becomes an image of concrete pain. The Rondanini *Pietà* expresses neither the sacrifice nor the pain, but the spiritual state resulting from the Crucifixion and the communion of two souls sharing a holy love and a state of blessedness.[86]

In his study of Buonarroti's sculpture, Guillaume propounds a curious theory. He suggests that the face of the *Giorno* of the Medici Tombs was left under the "voile de l'ébauche," since the artist despaired of being able to make it express sufficiently his indignation. This is reminiscent not only of Vasari's remark on the *Mosè* but of the Greek artist who veiled Agamemnon, fearing his inability to portray a father's anguish at seeing his daughter sacrificed.

Despite the importance Michelangelo accorded katharsis in both his theory and his practice, he never bequeathed to posterity the greatest and most pathetic painting or sculpture which he planned and sketched several times: the Crucifixion of Christ.[87]

Do any of Michelangelo's works fail to meet the high standards which he set for Christian art? We refer not to standards of technical excellence, for some of the *non finiti* and works done after his eightieth year would not measure up to them. Nor yet to standards of inspirational character, for there are a few scattered works which do not inspire. The Doni *Madonna* does not impress us with the purity or spiritual quality which Michelangelo claimed appropriate to that subject (see note 33). The *Cristo risorto* is more like the "Heros" of Vida's *Christiad*. Ruckstull complains that this Christ "fills us with derision."[88] Some of the *putti* of the Sistine Ceiling (immediately below *Daniele*, *Geremia*, and the *Libica*) are scarcely calculated to evoke feelings of either fearsome piety or pious fear. No, we refer rather to the so-called immorality of Michelangelo's art.

Asked if she did not object to posing in the nude for Canova, Princess Borghese answered, "Why, not at all, for you see, Canova has a warm stove in his studio." The anecdote is not irrelevant, for it depicts

that complete objectivity about nudity which was shared by Buonarroti, who must have wondered how a great cleric like Jean Gerson could specifically forbid nudes in church decoration. Many of his contemporaries, and especially Aretino, viewed this objectivity with a raised brow. Michelangelo was slandered, as Baccio Bandinelli was slandered for placing a nude Adam and Eve (reviled as "lordi e sporchi" by a contemporary)[89] behind the altar of Santa Maria del Fiore. Condivi had to explain away Buonarroti's love of beautiful male nudes as of the same order as his love of beautiful trees. Condivi's embarrassed state of mind was similar to that of Michelangelo the Younger trying to rewrite and edit the artist's sonnets. Michelangelo had such an honest conviction on the matter that he could only be shocked by Ammannati, who late in life and no longer under Buonarroti's influence, petitioned the Duke of Tuscany for permission to clothe all the nude statues he, Ammannati, had created. In a letter to the Academy of Design in Florence (1582), Ammannati asked: "Isn't the *Mosè* in San Pietro in Vinculis at Rome praised as the most beautiful figure ever made by Michelangelo? Yet it is completely clothed." As for Michelangelo, he kept his conviction to the end, and the Rondanini *Pietà*, like the Palestrina *Pietà*, centered upon a male nude.

In his *Intersexualité dans l'art*, Langeard voices a common but questionable interpretation of Michelangelo's infatuation with the nude. He views it as a token of narcissism, "une tentative désespérée pour atteindre dans un Moi idéal la beauté perdue."[90] To those who complained of this infatuation Michelangelo might have given several ready justifications in addition to those suggested earlier.

First there was the convention, noted by Alberti, and eliciting no complaints, of drawing a preliminary nude before drawing the draped figure.[91] There was the tradition of emphasising nudes under drapery to express movement and life, so that "bodies will appear almost nude under the veiling [*velamento*] of the cloth."[92] Granting this enlivening value of the nude, Michelangelo could logically ask why, then, one should bother with drapery at all and point to his *Giuliano de' Medici*, with its emancipated treatment. He could quote Pliny to remind his critics that this entire debate over the nude had long since been settled by antiquity: Praxiteles' nude Aphrodite was evaluated above the entire public debt

of Knidos, whereas his draped Aphrodite had enjoyed little repute—the lesser repute of Goya's clothed *Maja*. Michelangelo's final answer to these critics would merely be that he had studied anatomy for twelve years, a study which had made severe demands and even left him with a weak stomach. Why not then apply the knowledge gained from this experience of over a decade? We shall discuss this interest again in Chapter IV.

In any case, considering the artist's many-sided sexuality, it is probably unrewarding to try to explain away this infatuation through his theories alone or to view it as in conflict with his personal Christianity.

As a dogged believer that good church painting elicited Christian responses, Michelangelo was surprised and chagrined when his own works produced the contrary effect. The *Giudizio universale* engendered such impious reflections that at least five popes wished it retouched or whitewashed. Indeed, we have a report of his astonishment and irritation upon learning that a pontiff felt that the pudenda of many of the figures needed loin bibs. Sharply he retorted, "Dite al papa che questa è piccola faccenda, e che facilmente si può acconciare; che acconci egli il mondo, chè le pitture si acconciano presto" ("Tell the Pope that this is a trivial matter, and that it can be easily arranged. Let him set to straightening out the world, for pictures are quickly straightened out").[93] He was assailed during and after his lifetime for alleged indecency. In November, 1545, Aretino, embittered because Michelangelo had disregarded his letters and requests for a work of art, wrote Michelangelo "une lettre de Tartuffe" (Romain Rolland) to charge that the indecent figures in the Sistine Chapel would befit a bordello, were an offense to Christ and the clergy, and that his own dialogue on prostitution, *Nanna*, was more respectable. (Later in a Bernesque poem [LXXXI] Michelangelo is to claim that his drawings graced privies and bordellos.) Aretino also continued his attack as a collocutor in Dolce's dialogue on painting. As is well known, Daniele da Volterra, Michelangelo's deathbed friend and the sculptor who executed the bust on the frontispiece of this volume, earned for posterity the surname of Il Braghettone (the breeches maker) for touching up the nudities of the *Giuduzio*. Dejob, making the point that before the time of the Council of Trent people had not thought seriously about the moral

obligations of the artist, writes that the adoption of this nickname indicates "what were, between 1555 and 1559, the dispositions of the public whom it behooved one to make accept the form of [Counter-Reformational] art."[94] The attacks on Michelangelo's *Giudizio* by Gilio da Fabriano will be mentioned later in another connection.

Not all Renaissance artists had Michelangelo's professional innocence. We have mentioned the guilt feelings of Ammannati. Such a dispassionate theorist as Alberti had taught that one should shroud "the parts of the body which are ugly to the sight and similarly those other parts which have little grace, with either clothes or fronds or the hand."[95] Girolamo da Fano repainted his figures of Sts. Blasius and Catherine because they were in an "atteggiamento incomposto." Michelangelo knew of the examples of Lorenzo di Credi and Fra Bartolommeo, who had burned their studies of nudes on Savonarola's famous Pyre of Vanities.[96] The Dominican friar even influenced Botticelli to abandon painting.[97] Finally, the amoral Leonardo, who pictured sexual union, warned in his *Trattato* that some painters had portrayed such libidinous and luxurious acts as to cause their onlookers to indulge in the same *festa*.[98]

Fashions in morality, like fashions in art, prove fickle. In 1573 Veronese was summoned before the Tribunal of the Holy Office and arraigned for including in his Supper of Christ, in the Refectory of SS. Giovanni e Paolo in Venice, dogs, jesters, Germans, drunkards, and dwarfs. When Veronese humbly tried to defend himself by the then-familiar expedient of citing the *Giudizio universale*, the Inquisitor ruled correctly that the nudity of Michelangelo's fresco was spiritual in every way, that the fresco was not debased by jesters, dogs, or weapons. Animals were frowned upon in church painting, as Lomazzo decreed in his *Trattato*. Lomazzo specifically warned against letting the croups of horses loom into pictures, a rule of decorum surprisingly violated by Michelangelo in the *Conversione di San Paolo* of the Pauline Chapel. Later he observed that Michelangelo depicted lascivious acts (apparently the *Leda*), but excluded them from his church art. The *Leda*, by the way, whose somewhat spiritualised treatment was lost on Louis XIII's minister of state, was apparently ordered destroyed on grounds of indecency.

At no age could Buonarroti take criticism easily or graciously. Criti-

cism on moral grounds was the least acceptable of all. Biagio da Cesena complained to the Pope about the nudity in the Sistine Chapel, and the next thing Biagio knew his features were being worn by Minos, in the Inferno of the *Giudizio*. In this case one must sympathise with the righteous wrath of the artist who had represented the probity and strait-laced self-discipline of Savonarola's Florence in contrast to a corrupt and profane Rome, which had viewed the reign of Alexander VI with indifference and occasionally amused sympathy. It was the righteous wrath of the one artist whose paintings have evoked more feelings of piety and suscepti-bility to prayerfulness than have those of any other artist in history. The assigned role of painter laureate to a centripetal Christendom was one which he prized as a trust as well as an honor. He wrote Vasari in 1555 that if he abandoned his work at the Vatican, the rock of the faith, "sarebbemi grandissima vergogna in tutta la Cristianità" ("it would be to my great shame throughout all Christendom").

We have thus far made no reference to architecture as an expression of religiosity. Dejob regretted that the moral ruling about art set down at the time of the Council of Trent did not refer to architecture. He recalls that Daniele Barbaro, who translated and glossed Vitruvius in 1556, composed a treatise on perspective which opened and closed with a prayer.[99] The absence of moral considerations from the theorising on architecture is all the more remarkable in view of the genius for synthesis and accommodation of ideas displayed by the High and Late Renaissance theorists. Even Michelangelo's letter on architecture to Paul III contained no trace of such speculation. Yet Michelangelo must have felt his monu-ments a major contribution among the services he was rendering his God and his Church. Other than such works of civil architecture as the Farnese Palace, the Porta Pia, and the Palazzo de' Conservatori the greater part of Michelangelo's architectural activity was dedicated to ecclesiastical monuments.

If recent theories on the spherical divisions of the Medici Chapel are correct, Michelangelo knew that the organic structure of a Renaissance church or chapel could assist in imparting a Christian or Christian-Platonic message. He knew equally that mediocre architecture can dispel pious thoughts just as quickly as can a poor fresco filling in the expanses

of a clerestory. We might accept as indirect testimony his censure of the "cricket cage" cupola on the Florentine Duomo.[100] He must have been chagrined by the testament of St. Francis, who declared that Franciscans must be content with miserable, abandoned churches. This would have served to deepen Michelangelo's preference for the Dominicans and Jesuits, had not the Franciscans of his time renounced this particular attitude of Sts. Francis and Bernard. Of course, if the church architecture is inadequate, inspiring painting can ennoble it. This was impressed upon him by a request from Aldiosi, Cardinal of Pavia, on 3 May, 1510: "Having constructed in La Magliana a good-sized edifice and having placed in it a little chapel, we should like to compensate for the smallness of the chapel by the excellence of the pictures." The Cardinal is confident that if Michelangelo will do a canvas of John the Baptist immersing our Lord, the nobility of the little chapel will be assured.[101]

Yet it was harder for Michelangelo to apply his aesthetic theories to architecture, harder to believe that architectural form preexisted in nature (although Scamozzi wrote a volume on the Idea of architecture), harder to assume that the architect imitates nature, and finally, without working through "divine proportions" and the Pythagorean mysticism of numbers, to feel that God guides one's hand across the drafting board in the same way he guides the sculptor's mallet. And it was manifestly impossible for a large and impersonal monument to assume the nature of a prototype of virtue with which the spectator could share that mystical communion which is at the basis of any religious experience.

Michelangelo lived in an age when an epic poem about the Christ treated him as a classic hero, an age when a painter honored a school of pagan philosophers by picturing them in the chamber of the successor to Peter, an age when artists remembered that Prometheus suffered as much as Christ for humanity. Michelangelo became enmeshed several times in this curious opposition of classic and Christian. For example, while Savonarola's Pyre of Vanities was blazing away in the Piazza della Signoria, our artist was sculpturing a *Cupido* which was to be sent to Rome for sale as a pagan antique.

The desire to reconcile and even assimilate the two opposing themes continued keen in Michelangelo, as in other Renaissance minds. Grimm spoke of this ability to make a synthesis of contrasting currents as typical of the Latin temperament, but baffling to the Germanic mind. Buscaroli offers a convenient and oversimplified explanation of this ability of Michelangelo to synthesise: Just as the artist's religiosity was a protest against his immediate surroundings, so did he turn with longing and sadness from the vulgar and banal present to the classic past. "This is why and how a feeling for antiquity and religious sentiment could not merely coincide, but fuse themselves in Michelangelo's inspiration, by means of a single spiritual need: re-evocation and regret expressed in a form affording glimpses of an intuition saddened, discomforted, and discomforting."[102]

The inclusion of the nude athletes in the Doni *Madonna* is a sincere example of this synthesising, even though the results are not successful, since the impression of unity is lessened. The *Giudizio universale* is a better example, if, in Mariani's figure of speech, this fresco was conceived as a Christian gigantomachia. A notable example is the statue of Duke Giuliano, fingering his baton as a captain of the Church while garbed in Roman costume. In the first plan of the Tomb of Julius II, Michelangelo had attempted a blend of Christian and pagan elements evenly balanced, not in itself an innovation. Yet the addition of the cappelletta with its Madonna and saints then swelled the Christian element as the slaves and victories were dropped. "The final result bears witness not only to an individual frustration of the artist, but symbolises also the failure of the Neo-Platonic system to achieve a lasting harmony between the divergent tendencies in post-medieval culture: a monument to the 'consonance of Moses and Plato' had developed into a monument to the Counter-Reformation."[103] How about the assimilation to be found on the Sistine Ceiling? Blunt generalises that "the iconographical scheme of the Sistine Ceiling frescoes is based on the most erudite theology, but the forms in which it is clothed are those of pagan gods."[104] This statement would seem to overemphasise the pagan element, physically present in the *Ignudi* and the *Sibille*, but still considerably less significant than the many Christian figures and concepts. However, just as revisions reduced

· *105*

the pagan element of the Tomb of Julius II, revisions increased the pagan element of the Sistine Ceiling. The original plans had called for twelve apostles along the outside of the histories. Then Christian orthodoxy lost ground and the apostles gave way to the prophets and sibyls, Christian and pagan types which "had already been associated in the writings of Lactantius and in Italian art since the eleventh century (S. Angelo in Formis)."[105] The dilemma facing the artist who hoped to assimilate pagan and Christian elements was ironically highlighted in a letter from Sebastiano del Piombo to Michelangelo in 1533. Sebastiano humorously proposed that his friend do a Ganymede for the cupola of the Medici Chapel but that, to please the Pope, Michelangelo could paint a nimbus over the figure so that Ganymede would look like St. John of the Apocalypse being wafted heavenward.[106]

One deeply ingrained persuasion inclined Michelangelo toward classical subject matter: this was his aforementioned predilection for the male nude. By adopting classical themes he could obviously indulge more easily in this preference. Moreover, since he finally gravitated toward Christian themes, he brought the nude, as both a central subject and a decorative motiv, to those themes.

After going to Rome (1496), Michelangelo for a while turned wholeheartedly to pagan themes (the *Bacco*, the *Adone*, and still the *Cupido*), as a passing reaction, perhaps, to the misplaced zeal of Savonarola. There is even a legend that Savonarola burned one of Michelangelo's own pictures.[107] Yet the *Pietà* was soon to follow, and then a long succession of Christian subjects. Panofsky concludes that "with the exception of the bust of Brutus, which is a political document rather than a manifestation of artistic propensities, no secular subject is found among Michelangelo's works produced after 1534." Panofsky, among others, notes the correlation between the Christian trends in Michelangelo's art and his poetry, but his comment is more severe than that of Symonds or others: "Thus in Michelangelo's last works the dualism between the Christian and the classical was solved. But it was a solution by way of surrender."[108]

It is stated above that Michelangelo's preference for the nude inclined him toward classic themes. In his *Christian Art*, Morey makes a lucid statement on the manner in which this conflict between Christian

and pagan affects even the composition of a nude figure: "Michelangelo's powerful inhibited figures reflect the disparity between Christian emotion and the antique ideal, free human will and the will of God: the rational forms of classic sculpture were not made for the ecstasy of a Christian mystic; they writhe in the possession of an unfamiliar spirit and betray, by brutal distortion, incongruous proportions and discordant composition, the force of the collision of medieval Christianity and the Renaissance."[109]

When Michelangelo worked for private patrons, his subjects tended to be more classical in nature. Had he not become the chief artistic steward of Christendom he might have furnished us with many more Hellenic and Roman themes. His artistic output was conditioned by the patronage system, as Tolstóy claimed of all Renaissance artists. Nevertheless, the "surrender" to Christian themes was a voluntary one, paralleling the eager mystical "surrender" in his poetry. He thoroughly enjoyed reading the Holy Writ, that source of so many themes, as Vasari testified.[110] These stories and scenes which Armenini recommended to painters (see note 58) were more than historical narratives or evocations of systematic theological *typoi*; they were dramas so well known that Michelangelo could treat them without redundant detail and local color. In this respect they could then appeal to Michelangelo in the same way as the more familiar classic subjects (e.g., *Fetonte*). In the Bible he found the story of the sacrifice of Isaac, as well known as the immolation of Iphigenia, offering the heart-rending spectacle of a father about to smite his young son while an angel momentarily stays his arm. He found the story of wicked Haman, chief minister of Ahasuerus, hanged on the gallows he had prepared for Mordecai; Michelangelo follows a Dantean tradition and crucifies him; in the pained and contorted figure the public might learn that evildoers must suffer the consequences of their own mischief. He found the legend of the Brazen Serpent, to demonstrate how *le merveilleux chrétien* can save one from peril. Or the avarice of the wicked Heliodorus (II *Machabaeorum*, III), treated before Raphael by Michelangelo (in a medallion formerly thought to depict the death of Uriah). Or the blessedly meek Judith, still fearing the wrath of the decapitated Holophernes as she disposes of the head.

In the Scriptures Michelangelo found not only apostles (Peter, Paul,

Matthew, Bartholomew) but great prophets (Jonah, Daniel, Joel, Ze-
chariah, Jeremiah, Ezekiel) endowed with *intelletti* divining not only the
present but also the future will of God. In the Writ there was the father
of laws, to be conceived "du même jet" as the prophets of the Sistine
Vault.[111] There were all the "begetting" ancestors of Christ, to be pictured
for the first time for the faithful eligible to enter the Sistine Chapel. There
were devils and demons in the Bible. Michelangelo's earliest known work
(after Schongauer) depicted St. Anthony struggling against demons. One
of Hegel's few mentions of Michelangelo was the curious assertion that
"he was pre-eminent in the delineation of devils."[112] There was a multi-
tude of scenes from the second *Liber Regum* and the second *Samuelis*
which might decorate medallions. There was the thrilling story of David
and Goliath and the history of Samson and the Philistines. All these
themes Buonarroti utilised. The older he grew the more he realised that
the Bible was the greatest source manual of noble themes. He may have
mentioned this to Vasari, who recorded, "Most willingly in this, his old
age, he adopted sacred themes, that they might turn to the honor of God."

Michelangelo also drew on Early Christian and medieval icono-
graphy. Christ is symbolised by the carving of a pelican giving blood
to its young, on one of the candelabra of the Medici Chapel altar. Early
Christian and medieval hagiography also furnished inspirational subjects,
such as Pius the Martyr and Gregory the Great, executed on the Piccolo-
mini Altar.

Of course, the greatest opportunities afforded a painter or sculptor
by Christian lore were those of translating God, Christ, or the Madonna.
Michelangelo did not fear to paint God any more than Phidias had been
timid about portraying Zeus. (If one could accept the attribution to
Michelangelo of an alabaster relief kept until recently at Viterbo in the
property of the Della Rovere family, then Michelangelo even carved God
in stone, for this curious *Pietà* shows the dead Christ [as in El Greco's
Holy Trinity] in the arms not of the Virgin but of a saddened God the
Father).[113] We have discussed the iconolatrous issue above. Although his
theory of beauty made of God a sort of mystical incorporeality, the artist
accepted the anthropomorphic conception wholeheartedly in his Sistine
Ceiling, forgoing the alternative of symbolic representation. Some of his

contemporaries were a bit uneasy about this, just as the elder Seneca had been about Phidias's boldness.

The Madonna herself offered a splendid and pathetic subject, whether treated as a classical and abstract symbol of maternity unconscious of the presence of the Child, the reflective listener in an Annunciation scene (Frey, 259), or an attentive mother nursing him with her milk. This last portrayal of the Mother and Child, which the public sometimes witnessed in medieval mysteries, is found in the British Museum study.

The life of Christ, with so much event crowded into thirty-three years, furnished Michelangelo with numerous themes. If such incidents as the expulsion of the money-changers (Frey, 252, 253, 255) captured Michelangelo's imagination, the dominant themes concern the Passion. The Flagellation, the Crucifixion, the Deposition, the Resurrection, the *Noli me tangere*, Christ in Limbo, these impressed him most. The commission Michelangelo accepted from Pier Francesco Borgherini in October, 1515, may have been a Flagellation;[114] it is more certain that he did a small drawing of a Flagellation from which Sebastiano did a fresco.[115] The Resurrection, coinciding with his Neo-Platonic interest in *ascensio*, filled him with the same awe as that which transfixed the guards watching the Saviour defy the petty laws of gravity. Some even hold that the Resurrection is the theme of the Medici Chapel. His drawing of Christ in Limbo (Berenson, 1407) was sent to Sebastiano as a basis for the latter's painting in the Prado.[116]

Yet the greatest subject of all pagan or Christian history was the Crucifixion. We have stated that Michelangelo never left us a Crucifixion. This assertion must be qualified. He did at least three studies of this subject on paper, one now in the Windsor Royal Library, one in the British Museum, and one at Oxford. His original drawing for Vittoria Colonna is known only through copies, and although a letter of this noblewoman would indicate that he painted a Crucifixion for her, this is generally doubted. Wittkower discovered a new black-chalk drawing of this subject as recently as 1941.[117] There is also the report of Vasari that Michelangelo did a wooden Crucifix for the Church of the Santo Spirito in Florence and a minority, including Papini, believe that the present statue in this church may be authentic. A Crucifixion in the Metropolitan

Museum is believed a possible copy from an original by Michelangelo.[118] In the *Archivo español de arte,* Gómez-Moreno proposes at least three Crucifixions (Naples, Madrid, and his own collection) which he believes cast from a model by Michelangelo.[119] Many peasants around Valdarno owned what no pontiff ever owned: Michelangelo carved a little Crucifix for Menighella, who, as a practical fellow, made a mold of it and sold copies around the Tuscan countryside.

All in all, it is safe to say that Michelangelo planned to do justice to this tremendous theme when the right commission or inspiration (Vittoria Colonna) came along, but only after adequate preparation and planning. "One arrives late at the lofty and unusual things" (CIX, 50). Too many artists would execute a Crucifixion at the drop of a few ducats. Penning a meaningful little entry in his notebooks, Da Vinci asks ironically:

"Alas! Whom do I see? The Saviour crucified again?"

If Michelangelo was so slow and cautious about undertaking this greatest of all subjects that he never realised it in a masterwork of marble or color, then one must seek the explanation in his statement that "one recognises the wisdom of a great man in the fear with which he does the things he understands the best."[120] What the Crucifixion of Christ actually meant to Michelangelo, then, we know best not from his art but from a powerful sonnet reproduced at the conclusion of this chapter.

While the Italian theorists and aestheticians of the generation of Robortelli and Castelvetro were debating in their studies and classrooms whether art and letters should be primarily didascalic or hedonistic (and generally reaching the Horatian compromise), the upper classes upheld the hedonistic side of the argument. Tolstóy claims that kings, popes, and other patrons made art a denial of religion. But for Michelangelo art became completely didactic in a moral sense. In most cases the only pleasure it might convey was the complementary one incidental to a religious experience. As Guillaume wrote of Michelangelo's sculpture, "No, such works of art are not made merely to be looked at or to delight the senses ... they are made to meditate upon and discuss."[121] That art should express beauty does not alter its didactic aim, for that beauty is

an attribute not merely to give pleasure to the senses but to awaken the soul to goodness, the ancient principle of the καλὸν κἀγαθόν.

Did Michelangelo feel that the function of the artist is to feign, to cloak truth, to communicate only through willful distortion or obscuration, to reproduce the *Schein* rather than the *Sein* of truth? After all, in Latin, *fingo* had carried the meaning of creating, forming, molding, or modeling in art, especially in sculpture. The best literary theorists of the Renaissance claimed that the vatic function of the poet or artist required him to veil his message rather than tell it directly, as Boccaccio had reiterated so many times in his *Genealogia*. Ronsard wrote that "the poet who writes things as they are is not worth so much as the poet who feigns them." This theory did not take such firm hold among the theorists on art or among the artists themselves, but occasionally one finds a mention of the "veil" of art, showing that it was not entirely lost to them. Alberti wrote that the painter must "fingiere quello si vede."[122] Lomazzo, in his *Idea del tempio della Pittura*, wrote that painters, like poets, have a "license to feign and invent" and elsewhere justified their creating a veil (*velame*) in feigning.[123] In his *Trattato* the same critic says that Michelangelo's idealisation of his subjects constitutes use of the veil of art (*il velo d'arte*).[124] Aretino, in Dolce's *Dialogo della Pittura*, affirms that Michelangelo imitated the philosophers who veiled truths.[125] In Pino's *Dialogo*, painting and poetry are accepted as media of feigning (see Chapter III). Joachim du Bellay (who had lived in the Palazzo Farnese when Michelangelo's cornice was being constructed) finds that Ronsard and Michelangelo, unlike Clouet and Paschal, "more boldly and with an unlimited art, hide truth under a thousand fictions."[126]

Michelangelo never gives a textual indication that he accepted this theory of feigning or veiling the truth, unless indirectly in the statement (CIX, 105) that God, the supreme artist, reveals himself in the mortal veil of man, the artist's favorite subject: "Nor does God, in his grace, show himself to me in any other aspect more clearly than in a beautiful human veil." If Michelangelo does not accept directly the notion or the vocabulary of feigning, he certainly agreed that art should avoid teaching by obvious means. Art should not descend to the details of the narrative. When he elects to tell the story of the victory of Florentine arms over the Pi-

san, in the *Battaglia di Cascina,* he rejects all stage props (Plate IX). Any human situation can be portrayed without elaborate settings or props. Even the hoe and spade in the *Crocifissione* of St. Peter in the Cappella Paolina represent unusual supererogations. Art must teach through the suggestion and not the development of ideas. Just as Michelangelo was interested in the minimum key form or clue form in his plastic creations, he hoped to rely upon only the minimum key suggestion or clue suggestion to convey his message. A soaring Ganymede will reveal to Cavalieri the "uplifting" qualities of the artist's love. One might anticipate from this that Michelangelo depended on symbols as the best medium of minimal suggestion. As we shall see below, he did not use iconology to a greater extent than one was supposed to at his time. Instead, he uses what he calls his *concetto* as the simplest unit of expression, the lowest common denominator of expression. This type of suggestion will not communicate to all spectators with equal clarity. Those with wit and perception will be in the minority. Art is didactic, but not in the sense that it aims to reach the peasants of his rustic *stanze* (CLXIII), or "il vulgo isciocco e rio" ("the vulgar and evil crowd"), or the *desmusicos,* or again "old and young women, friars, nuns, and insensitive gentlemen." Art will reach most easily those who are morally and intellectually endowed.

Before leaving the issue of art as mere veiling or suggesting of truth, we should note that Mariani found this suggestiveness reappearing in Michelangelo's poetry. Akin to certain vaguenesses in Michelangelo's art are the "dubitative" expressions so frequent among his verses: "Non so se s'è," "un non so che," "ch'è forse," "nè so ben veder," "un si e un no," etc.[127] To this we might add the astonishing statistic that 46 of Michelangelo's poems begin with "if" (*se*) and 27 with negatives.

We have tarried over Buonarroti's persuasions as to the moral and didactic functions of art. What did he think of the social function of the artist? Should art become a political or social force?

In an essay on "The Revolution in Painting," Diego Rivera develops the proposition that "whenever a people have revolted in search of their fundamental rights, they have always produced revolutionary painters."

He names thirteen artists whose "art plays an essential political role," including Michelangelo in such company as Goya, Daumier, and Posada.[128] His picture would make Michelangelo a proletarian and anticlerical fighter like his twelfth-century ancestor Buonarrota, who had erected barricades around Santa Maria Novella, or his familial descendant Filippo Buonarroti (1761–1837), deported in turn from both Italy and France as a communist revolutionary. Certainly Michelangelo's political role in Florence and his devotion to the Medici (excepting Dukes Alessandro and Cosimo), which at times loomed as great as his concern for the interests of the commune, do not support Rivera. His warnings to his family to pay no attention to political squabbles, his avoidance of Florentine exiles (except for a few intimates and Cardinals Salviati and Ridolfi), his lack of sympathy for the Bolognese rebels (Letter CXXVI), his most famous flight from Florence (even though he mistrusted Malatesta Baglione, and this was a factor in that flight), his concern lest Duke Cosimo should condemn him for his relations with the Strozzi—these are scarcely the earmarks of a revolutionary. Such was his political caution that when writing to his brother Buonarroto from Rome in 1497 and speaking of Rome's antagonism to the "heretical" Savonarola, the artist curiously identifies himself merely as "Piero." In 1547 he wrote to Lionardo, his nephew, "That gentleman who replied that I was not a statesman [uomo di Stato] cannot fail to be kind and discreet, because he spoke the truth. Artistic matters in Rome give me as much worry as matters of politics."[129] As a member of the Gran Consiglio of Florence, Michelangelo was passive or even inert. One remembers his written observation to Luca Martini (Letter CDLXIII), "meglio è tacere, che cascare da alto" ("It's better to keep still than fall from high"). He traveled in the capacity of Florentine ambassador in 1506, but merely that diplomatic immunity might protect him against the caprices or reprisals of Julius II. The first draft of the Noli me tangere was executed for Alfonso Davalos, an enemy of the commune of Florence.

Revolutionary as his art is aesthetically, it is not so politically. Whether any individual piece is known for certain to have been motivated by political thinking is a question over which we must now pause. In a recent article in London Studio, McGreevy advances the notion that the

angry demeanor of the Christ in the *Giudizio universale* expresses the Redeemer's fury at the destruction of Italian liberty by Charles V and the lesser princes.[130] Yet the religious grounds for this wrath out of the *Dies Irae* are so obvious and traditional that it seems gratuitous to posit political grounds. Another article, in the *Gazette des beaux-arts,* supposes that Michelangelo's medallion on Heliodorus' expulsion from the temple, sometimes interpreted as the death of Uriah, was designed at Julius II's behest to represent the expulsion of the French and foreigners from Italy.[131] It has even been conjectured that Michelangelo chose the theme of the *Noli me tangere* as a veiled warning to Alfonso Davalos that occupied Florence "was not to be touched by sinful hands."[132]

It has become a common error to suppose that Buonarroti was brooding over the loss of liberty in Florence when he formed the Allegories and Captains of the Medici Tombs and that this state of mind is revealed in the reflectiveness of the figures. The history of this notion is neatly summarised by De Tolnay: "Under the influence of the ideas which led to the French Revolution and to the revolutions of the first half of the nineteenth century, a romantic-patriotic content was proposed. Michelangelo wanted to express in the Allegories his grief as a patriot for the loss of the liberty of Florence—Guillaume (1876) and Ollivier (1892); and, furthermore, in the statues of the dukes his hatred for the tyrants of the Medici—Niccolini (1825). Springer refuted these views, showing that the epigram of the Night [see Chapter III, note 265] was written by Michelangelo long after he executed the statue, and so cannot be used to interpret the figure. Moreover, the composition of the monuments was planned about nine years before Florence lost her freedom, and at that time the artist had not hated the Medici as tyrants."[133] Having been written fifteen or sixteen years after execution of the *Notte,* the epigram does not convey any original political meaning of the figure. It is nonetheless interesting that it had an eventual political meaning, and a painful one, to its creator (see Chapter III).

As though recalling that Rhodes had been redeemed from her enemies by one single picture, Michelangelo did plan one work with an exclusively political aim which was never executed. In 1544 he wrote to Luigi del Riccio requesting the latter's patron Roberto Strozzi to enlist

the aid of Francis I to liberate Florence from Duke Cosimo. As an inducement Michelangelo offered gratis via Del Riccio and Strozzi an equestrian statue of the French King for the Piazza della Signoria.[134] It has been conjectured that he also sent two *Prigioni* to Strozzi at Lyon to use as a bribe with Francis, who accepted them. In 1502 Buonarroti worked on the bronze *David* which the Florentine Republic intended to offer to Pierre de Rohan, favorite of Louis XII. Afterward Michelangelo sought unsuccessfully an opportunity to serve politics through art: he was to do an *Ercole* (the model is in the Casa Buonarroti) to stand with his *David* outside the Palazzo Vecchio as guardians of civic autonomy, a project opposed for political reasons by the papal curia. Bandinelli was commissioned to do it after all.[135] The work most patently created with political intent was the *Bruto* (Plate IV), which bust may have been inspired by "the regicide of Lorenzino [who stabbed Alessandro de' Medici] and by the conversations with Giannotti, Strozzi, Riccio, and other exiled Florentines."[136] Vasari claims that the work was done at Giannotti's request for the *fuoruscito* Cardinal Ridolfi. If Michelangelo had Lorenzino in mind, it is important to remember his subsequent words in the *Dialoghi* of Giannotti, "It is therefore clear that he who kills a tyrant does not commit homicide. He does not kill a man, but rather a beast. Brutus and Cassius did not sin, then, when they killed Caesar."[137] We see in these words, by the way, an echo of Cicero's *De Officiis* (III, 19): "Num igitur se astrinxit scelere, si qui tyrannum occidit," etc. Michelangelo herein distinguishes between usurpers or tyrants and hereditary princes who govern by the will of the people. Political motivation seems all the more probable in the case of the *Bruto*, since only a strong feeling could have drawn Michelangelo away from the Christian muse which dominated his production completely by this stage of his career.

The point which we are proceeding to make is that, while it is misleading to view Michelangelo the artist as an active participant in political matters, still as a man he reflected upon them in the best Renaissance tradition. It was perhaps this preference for inert speculation which explains why Lomazzo applied to him the curious term "gymnosophist."

Despite Mariani's claim that Michelangelo "loved humanity ardently,"[138] there remains the disturbing and symptomatic fact that in the

Giudizio universale the Book of the Dead, listing souls to be damned, is much larger than the Book of Life, listing human beings worthy of salvation. Nor did Michelangelo nurture a great demophilia, despite his verse (XC): "Chè 'n parità non cape signoria" ("For in equality there's no room for overlording"). Quite the contrary. We shall learn below that in typical Renaissance fashion he tended to identify nobility of birth with nobility of soul (before Quevedo and others set out to destroy the notion), that he set a high premium on family name, and that other things being equal he preferred the sons of noblemen as pupils. Yet his constant impatience with ignorance and corruption among the ruling classes was so great that he became a democrat by default—politically more than socially. He was as hostile to tyranny as was Etienne de La Boétie, who wrote a book against tyrants, but more as a theorist than a militant. Thus he can theorise (CLXIII) against tyranny and the *semper plus ultra* of Charles V:

> *Colui che 'l mondo impera, e ch' è sì grande*
> *Ancora desidra e non à pace poi...*
>
> *He who rules the world and who is so great*
> *Wants more and more and then is not appeased...*

He chose national liberators as subjects: David, Moses, Esther, and Brutus. He joined the Florentine front against a tyrannical dynasty in 1527 almost, it would seem, to demonstrate the essentiality of architecture in warfare. Only in moments of religious humility does Michelangelo class himself with humanity at large, or in such a poem as "O notte, o dolce tempo benche nero," where he refers to the healing powers of night and cries out,

> *Tu rendi sana nostra carn' inferma*
> *Thou makest whole our infirm flesh.*

Regarding his feelings about the "great unwashed," it might be noted that, like Rousseau, he felt that workers and peasants could be perfectly happy without letting art play any part in their lives. In his stanzas in praise of rustic life (CLXIII) he pictures the simplicity and happiness of the peasant's life. Then he reflects that extreme and strange customs and the masterpieces of art ("le cime dell'arte") are all things about which

the husbandman is extremely indifferent ("son tutte cose piane"). Although he knew that in the city-state the judgement of the crowd ("il lume della piazza") could help make or break reputations, he did not feel, as did Alberti, that art should cater to popular taste.[139]

On two occasions he was moved, like La Boétie, to write against tyrants. His madrigal "Per molti, donna, anzi per mille amanti" (1545–1546) is a verbal exchange between a political exile and the Florence ravished by Cosimo de' Medici. The *fuoruscito* speaks:

> *Per molti, donna, anzi per mille amanti*
> *Creata fusti e d'angelica forma;*
> *Or par, che'l ciel si dorma,*
> *S' un sol s'apropria quel ch' è dato a tanti.*
> *Ritorna a nostri pianti*
> *Il bel degli ochi tuo', che par che schiui*
> *Chi del suo dono in tal miseria è nato.*

Thou wast created, milady, and endowed with angelic semblance for many, even a thousand, lovers. But it now seems that heaven sleeps that one single man appropriates unto himself that which was given to so many. On hearing our plaints, give us back the sunshine of thine eyes which seems denied to him who is born in the miserable state [of exile].

Florence replies as might Michelangelo's *Ester* or *Giuditta:*

> *De, non turbate i uostri desir santi*
> *Chè chi di me par che ui spogli e priui*
> *Col gran timor non gode il gran pechato;*
> *Che degli amanti è men felice stato*
> *Quello oue'l gran desir gran copia affrena*
> *C' una miseria, di speranza piena.*

Alas! Do not disturb your righteous wills, and reflect that he who has deprived you of me, as it seems, living in great suspicion cannot enjoy tranquilly his great sin. For the state of lovers whose great desire is checked by the very abundance of ill-gotten gains is less happy than a wretched state sustained by hope.

In another brief dialogue in madrigal form, "Io dico che fra noi, potenti dei" (CIX, 64), the poet suggests to an exile from Florence that he will have a right to exact a dire vengeance after his return to Tuscany. The

· *117*

exile rejects all vindictive thoughts and observes that "a generous, lofty, and noble heart pardons and bears love to its offender." This preachment against violence coincides with Michelangelo's remarks on Sulla and Caesar in the dialogues of Giannotti.

If Michelangelo's theorising never reached an analysis of art's relation to politics, he did speak a few thoughts which might have come right out of a sixteenth-century *De educatione principis,* those manuals for princes and dauphins. In October, 1538, Michelangelo affirms that great monarchs ought to covet and maintain peace in order to allocate their moneys to great painting. (Four months earlier, 18 June, Charles V and Francis I had concluded the truce of Nice.) There should be two motivations for their support of the fine arts:

SOCIAL: For the ornament and glory of their state ["por ornamento de seu stado e gloria"].

PERSONAL: To receive from painting particular spiritual satisfactions and stirring spectacles ["para receberem d'ella spirituais e particulares contentamentos e fremosos spectaculos"].[140]

The passage from which these lines are excerpted clamors for translation, since it presents a virtually unknown facet of Michelangelo's thoughts on the social function of art.

At a given moment in the third Roman dialogue the discussion centers on the function of art in war (see below, after note 145). Michelangelo decides that it is high time to demonstrate that the fine arts have a real value in periods of peace and the toga, when princes generally take pleasure in spending their moneys and indulging their fancies on things of little importance and, one may say, of no value. "In time of peace we see that some men find themselves so expert in idle things that they are capable of making a name for themselves with things of no nobility, profit, knowledge, or substance. They are able to win profit, honor, and substance for themselves, and whoever gives them their profit, let him take a loss. In the domains and states which are governed by a senate and republic, we see people utilising painting in many public works, such as cathedrals, temples, tribunals, courts, porticoes, basilicas, palaces, libraries, and other public showplaces of this nature. Similarly, every

noble citizen individually possesses in his palaces or chapels, villas or farms, a goodly number of paintings. But if, in those states where no one is permitted to make more of a display than his neighbor, they give commissions to painters which make them appear rich and well-off, with how much more reason, in obedient and peaceful kingdoms where God has permitted only a single person to defray these magnificent expenses and commission all the sumptuous works which his taste and honor may wish and demand, should people avail themselves of this rewarding art and science? What a great opportunity it is for one person to be able to do alone, without any adviser, many things which a number of men cannot do collectively. A prince would be wronging himself, to say nothing of the fine arts, if after having attained tranquillity and a holy peace, he were not disposed to undertake great projects of painting for the ornament and glory of his state and for his personal satisfaction and recreation of his spirit.

"Furthermore, in peacetime there are so many profitable uses to which painting may be put that it almost seems that peace is sought by such strife of arms for no other reason than to bring about an opportunity to effect painting's productions and achievements in the quiet which they require—and merit, after the services which painting has rendered during wartime. Nor will the name of any man prevail after a great victory or feat of arms, if afterward in peacetime he does not leave behind to dwell in our memories through the power of painting and architecture arches, triumphal monuments, sepulchers, and many other things. This provision is an important and necessary one among men.

"Augustus Caesar did not disagree with this statement of mine when, during a period of universal peace in all countries, he closed the gates of the Temple of Janus. For in closing those doors of iron, he opened the doors to the gold of the imperial treasuries, in order to spend larger sums in peace than he had in war. And by chance he may have paid as much for a single figure of painting as he would pay a company of soldiers in a month, especially when one considers with what ambitious and magnificent works he decorated Mount Palatine and the Forum.

"This is why I say that peace should be desired by eminent princes: in order that they may commission great works of painting for their

republics, for the ornament and glory of their state, and to receive from them particular spiritual satisfactions and stirring spectacles."

The conversation then drifts onto the subject of the inadequate salaries paid painters in Spain, a theme to which we shall return in another chapter. Without pressing the point, we might note that art's function of expressing the glory of the state had been emphasised in Vitruvius' *De Architectura*, which Michelangelo knew so thoroughly. Vitruvius held that "the majesty of the empire was expressed through the eminent dignity of its public buildings."[141]

Because of this reference to Spain, some have thought that De Hollanda has distorted the record or re-created the conversation tendentiously. Yet these doubters forget that two of the small group listening to Michelangelo were from the Iberian Peninsula, Zapata and De Hollanda. (The letters mention two Spanish apprentices who had already been in his employ.) Furthermore, one need only examine Michelangelo's biography briefly to understand why he had good reason to feel more deeply, even vehemently, on this matter than the Portuguese miniaturist. There had been the year 1510, when war caused the Pope to leave Rome and Michelangelo's payments to stop abruptly. There had been the year 1520, when Cardinal Giulio had annulled the contract for the Façade of San Lorenzo, probably because "as a result of the threat of war the papal treasury was depleted, and the Cardinal wanted to bind him [Michelangelo] to a less expensive task for the time being."[142] There had been the year 1521: if we keep in mind Michelangelo's resentment that wars may waste a prince's money and distract his attention from fine art, we can well imagine his feelings on receiving a certain letter from Sebastiano in September of that year. Michelangelo had written a recommendation for Sansovino addressed to Sebastiano's Roman patron. Sebastiano replied for his duke: nothing could be done for Sansovino, since "it was necessary to concentrate on arms now and not on marbles."[143] War's usurpation of capital was almost as irksome to Michelangelo as war's destruction of those artistic masterpieces which are supposed to gain immortality for the artist (see Chapter III).

Michelangelo was not, then, one of those Renaissance theorists who felt that literature and the arts bloomed during wars. Of times of turmoil

he could only conclude, in a letter of October, 1509, that they "sono molto contrari all' arte nostra" ("they are distinctly unfavorable to our art"). Like Protogenes, continuing to paint, undaunted but resentful, during the siege of Rhodes, Michelangelo worked on the Medici Chapel while Florence was engaged in war. He knew that no warrior could equal the social role of the artist and must have assented under his breath when the artillery lieutenant Miniato wrote him in 1530: "Would God that I might do a hundredth part of that honor which you do the fatherland: I should call myself blessed."[144] Since wars seemed to be inevitable, however, Buonarroti was ready and willing to demonstrate that the principles of art were immediately adaptable to the successful waging of war. It is a demonstration which would have astounded Machiavelli.

In April, 1529, two years after the death of Machiavelli, Buonarroti was made commissioner for the fortification of Florence. The city was under assault from both papal and Spanish troops. (Did he reflect at this moment that the Spanish troops would not be there if the Spanish princes were more liberal patrons of art?) As he stated in the Roman dialogues, Michelangelo knew that he could rely upon his art to solve many problems of defense. "And what more profitable thing is there than painting in matters and undertakings of war, and what can better serve the laying of sieges or the planning of sudden attacks?"[145] He then recalls with an immodesty echoing Cellini's account of the Sack of Rome, that when the troops of Pope Clement and of Spain had besieged Florence, it had been due to his own work and efficiency *(obra e vertude)* that the Florentines and their city were defended for a considerable length of time. "And the enemy captains and soldiers on the outside were terrified as they were assailed and killed in great numbers by means of the defenses and strongholds which I constructed on the towers." He explains how one night he covered the weaker sections of the city walls with protective bags of wool and other materials. He would have his listeners believe that he filled sacks with a fine explosive powder with which he "burned the blood" of the Castilians and blew them to bits. Da Vinci, by the way, explained how one made such missiles, filling them with sulphur and inflammatory materials.

We might pause to examine the solidity or authenticity of this re-

miniscence, which precedes a long and detailed justification of the role of art in warfare. One remembers the quarrelsome scene before Paul III where Michelangelo boasted to Antonio da Sangallo of knowing little about painting and sculpture, but of knowing through experience and reflection a great deal about fortifications.[146] There are several contemporary accounts of Michelangelo's military achievement, not all in agreement but at least proving that the boast was not a mere gasconade. There exist also the plans of the fortifications themselves. Condivi testifies: "As soon as he had arrived in Florence, the first thing he did was to fortify the campanile of San Miniato, which had been riddled by the continual firing of the enemy artillery and threatened to cave in with time. Having taken a great number of mattresses filled with wool, he lowered them at night by means of sturdy ropes, from the summit to the base of the tower, and covered the most exposed sections."[147] This account explains that Michelangelo thwarted the force of the enemy's fire "for an entire year." The report is not unlike that of De Hollanda, even though it makes no mention of fire bombs. As Condivi's *Vita* appeared in July, 1553, Francisco could not have cribbed from it.

A brief reference to this episode is contained in Giannotti's *Della repubblica fiorentina*. Giannotti praises his friend Michelangelo: "He had fortified the mount, set up the bastion of San Giorgio, and built up the protection of the Porta della Giustizia, which operations were the principal and most important defensive safeguards of the city."[148] Vasari mentions the endeavors, but his account follows Condivi's closely.[149] A discordant note is struck in the *Lettere sopra l'assedio di Firenze*, addressed by Giambattista Busini to Benedetto Varchi. Busini's personal impression is that Michelangelo botched things up considerably, until the Dieci finally sent him to Ferrara, nominally to study the fortifying walls of that city, but actually to get rid of him. As proof of his hypothesis, Busini claims that when Michelangelo returned all his constructions had been dismantled.[150]

We shall not examine the discrepancies among these contemporary accounts. Busini's theory seems to be outweighed by other evidence. Various scholars have studied the subject since these chroniclers. Gotti reproduced the text of the order conferring upon Michelangelo the office

of fortifier of Florence.[151] Symonds reproduced documents officially stating that wool was collected for the purpose Michelangelo specified.[152] Others, from pedants to military technicians, have written learnedly about the theory of *rimbalzo* (rebound) which Michelangelo is supposed to have fathered with his sacks of wool. An historical drama on the event was composed by Cesare della Pace Bellani. Matteo Rosselli commemorated it with a painting, now in the Casa Buonarroti. The great Vauban re-established the measurements of Michelangelo's fortifications. It remained for Gotti and De Tolnay to bring to light and make available several plans of fortifications done in pen and bistre by Michelangelo about 1529, the period of the siege. Studying these, Gotti and Thode established that Buonarroti was busy with the fortifications of the entire city and not merely with San Miniato, as one gathers from Condivi and Vasari. Their conclusions support the authenticity of De Hollanda's record, where Michelangelo speaks of fortifying the walls in general. In any case, for the reader who may be willing to pursue this curious matter, there is an entire section in the Steinmann–Wittkower bibliography relating to these muniments. The important conclusion for us to retain is that Michelangelo's belief in art's social value for protecting cities had a basis in his own experience. He was entrusted with the strengthening not only of Florence but of other Tuscan towns. Clement VII asked his advice about girding Bologna. He gained a certain reputation among his contemporaries as an expert in architecture and artillery.[153] He finally made the public boast that he knew more about fortification than Antonio da Sangallo and all the Sangalli together.[154]

There follows in the *Dialogos em Roma* a remarkable monologue in which Michelangelo enumerates the many ways by which art serves Caesar. He decrees that great painting is not only useful but necessary to the waging of war in this "evil and barbarous age." Thereupon ensues an unexpected description of the engines and instruments of war which the artist is capable of designing: catapults, rams, mantlets, shield screens, armored towers and bridges, mortars, hurling devices, strengthened cannons and arquebuses. This sounds much like the list of machines of war on whose manufacture and operation Leonardo gave instruction in his *Notebooks*.[155]

Even more important, the artist designs the form and proportions of all fortresses, positions, bastions, ditches, mines, countermines, trenches, and casemates. Art is necessary for cavalry shelters, ravelins, gabions, marlins, and battlements, for the construction of bridges and ladders, for the laying out and setting up of camps, for the disposition of battle lines and the measuring of squadrons. Art is necessary for the originality and design of arms, for emblems of flags and standards, for the shield devices and headpieces, as well as for new arms, escutcheons, and medals which are awarded on the battlefield for feats of valor. An artist may even be called upon to paint the trappings of a prince's horse or shield or tent, but rather than give himself to the service of people of lesser consequence he shall merely instruct some apprentice dauber on the general lines of their needs. In fact, in wartime the artist should be responsible for the reasoned distribution and selection of all matériel and for the designing and matching of the colors and uniforms, a thing which only a few can successfully handle.

Without trying to minimise the originality of Michelangelo's thinking or seeking immediate parallels, we must point out that some of these ideas are to be found in other texts known to that artist. In Vitruvius (I, v) there is a lengthy section on protective walls and towers. Vitruvius devotes his entire tenth book to the architect's contributions in time of warfare and sieges. The military machines he describes are in many instances identical with those treated by Michelangelo: catapults, crossbows, battering rams, *testudines,* movable bridges. Michelangelo seems to reveal that he is once again thinking of the ancient text of Vitruvius when he remarks about the present "evil age of steel" in which these weapons are outdated. Even the placing of protective materials around the towers to ward off enemy missiles came to him from Vitruvius, who thus may lay claim to the title of father, or grandfather, of the *rimbalzo* technique. Vitruvius recommended not wool but hides, after the manner of Diades, military architect of Alexander.[156] As we shall see presently, Michelangelo refers in his monologue to Alexander's use of military artists, even though he could have as easily drawn upon recent Italian history. A reading of the tenth book of Vitruvius and the third of the *Dialogos em Roma* leaves one with the feeling that at this juncture Mi-

chelangelo definitely had in mind Vitruvius' standard manual, just as he did six years later when writing to Paul III on architecture (see Chapter V, note 84). Michelangelo's walls, fortified with jutting strong points, however, differ from the purely circular fortifications proposed by Vitruvius, for the new "iron-age" architecture had to adjust itself to firearms.

There remains a conclusion to Michelangelo's monologue, describing the artist's functions as cartographer. Before quoting him, let us note that there are similar observations in Castiglione and Lomazzo. In the *Cortegiano* it is stated that painting has a multiplicity of uses, "and especially in war, in the drawing of landscapes, sites, rivers, bridges, strongholds, fortresses, and such things."[157] In his *Idea del tempio della Pittura*, Lomazzo writes that painting is not only advantageous but necessary in war, in mapping out military positions and topography; that painting will enable the "cavalier" to know better the beauty of arms, uniforms, cities, and fortresses."[158] In this connection one should recall in passing Dürer's large project entitled "Siege of a Fortress" and the cartographical accomplishments of Leonardo.

Still leading the conversation, Michelangelo proceeds toward his conclusion. "In addition to these uses, the services of a draftsman are extremely useful in war. He indicates on a drawing the position of distant places and the shape of mountains and harbors as well as ranges. He shows bays and seaports, the configuration of cities, high and low fortresses, walls and gates and their locations; he indicates roads and rivers, beaches, lagoons, and swamps which must be avoided or bypassed; he marks out the course and extent of wastelands and deserts along the bad routes, as well as woods and forests. If one attempted to show these things in any other way, he would be but imperfectly understood, but by drawing and sketching everything will become clear and understandable. All these things are of great importance in military campaigns, and these drawings of the painter can greatly assist and favor the intentions and plans of the commander."

He continues: "Captains must be in possession of field maps of the areas they are to conquer. Alexander the Great must have used Apelles, unless he himself could draw." (Michelangelo could have mentioned

that the belligerent Julius II had taken Bramante along in early 1511 as military engineer.) "Caesar in his *Commentaries* clearly shows that he took advantage of the presence of some competent artist in his army." Michelangelo conjectures that Caesar himself must have been very able in painting. Pompey drew capably, and if he was defeated by Caesar it proves that Caesar was a better draftsman. A modern military commander who leads a large army will win no laurels if he cannot draw. Buonarroti adds that Italian opinion has it that if Emperor Charles V had employed an artist to plot the course of the Rhone, in 1536, he would not have suffered a disastrous rout in Provence. (Whether or not this was true, modern historians attribute Charles's failure to Montmorency's brilliant tactics of strategic withdrawals and scorched earth.)

Michelangelo's unwonted talkativeness on this subject is curious. It is almost as though his tongue were unleashed by the good Trebbiano his nephew kept sending him. He concludes with the remark that a commander who enlists the services of good artists will know where he is going and what he is about. He knows how and where he will break through or where he may retreat. He will know how to make his victory seem more complete. Then the famous irony of Michelangelo breaks out, lest one forget that it is really he speaking:

And what country warmed by the sun is more bellicose than our Italy, or has more continuous wars and routs and sieges ? And in what country warmed by the sun do they more esteem and celebrate painting than in Italy ?

There comes to mind a contemporary proof of Michelangelo's persuasion that great commanders who paint or draw well may be invincible. In *Richard III* the Earl of Richmond retires early on the eve of battle to his tent hard near Bosworth Field. To ensure that his forces will soundly rout those of Richard, he sits down and orders:

> *Give me some ink and paper in my tent;*
> *I'll draw the form and model of our battle.*[159]

How Richmond reaped the rewards of this study is only too well known.

This chapter on the moral and social functions of art opened with some new and some old evidences of Michelangelo's intense religiosity.

It then recorded to what an extent the subjects of his painting and sculpture became more and more Christian, as his classical convictions and his artistic self-consciousness diminished. Further evidences of religiosity show how, as his life ebbed, a compulsion to renounce every earthly interest, including his art, laid hold of his soul. Other motives and, indeed, exasperations enumerated in Chapter VI will lead Michelangelo to an occasional condemnation of the fine arts. Our immediate interest is in his indictment of art as a Christian or mystic.

Two sonnets especially reveal how in his late years painting and sculpture had become not means whereby he could best serve his God but rather a vanity of vanities. The first, dating from 1554 (CXLVII), was dedicated to Giorgio Vasari. Although Michelangelo had long anticipated death, he knew now that it would not long delay.

> *Giunto è gia 'l corso della uita mia*
> *Con tempestoso mar per fragil barca*
> *Al comun porto, ou' a render si uarca*
> *Conto e ragion d' ogni opra trista e pia.*
> *Onde l' affectuosa fantasia,*
> *Che l'arte mi fece idol' e monarca,*
> *Conosco or ben, com' era d'error carca,*
> *E quel ch' a mal suo grado ognuom desia.*
> *Gli amorosi pensier, gia uani e lieti,*
> *Che fien' or, s' a duo morte m' auicino?*
> *D' una so 'l certo, e l'altra mi minaccia.*
> *Ne pinger ne scolpir fie piu che quieti*
> *L'anima, uolta a quell' amor diuino*
> *C' aperse a prender noi 'n croce le braccia.*

Now the course of my life has arrived with its fragile boat over a tempestuous sea into the common port, whence one passes over to the place where one must give an accounting and reason for his every worthy or unworthy act. Now I well recognise how the indulgent fancy came about which made of art my idol and sovereign, and how very much this fantasy was laden with error, and what it really is that every man wishes in spite of himself.

What may now become of amorous thoughts, futile and shallow, as I approach a double death? Of the corporeal death I am sure, and the other death hangs over me. Neither painting nor sculpture will there be to calm my soul, turned toward that divine love which, to receive us, opened its arms on the cross.

On the autograph manuscript of this poem, as if to emphasise the repentance, Michelangelo penned the variant, "Or veggio ben com' era d'error carca."

A second sonnet (CL) sent to Vasari betrays a similar dissatisfaction with the fine arts and all mortal pursuits.

> *Le fauole del mondo m' anno tolto*
> *Il tempo, dato a contemplare Idio,*
> *Ne sol le gratie suo poste in oblio,*
> *Ma con lor piu che senza a pechar uolto.*

> The vanities of the world have stolen from me the time given me
> to contemplate God; not only have I neglected his kindnesses,
> but more often than not have turned them to sinful use.

A note attached to the bottom of this page reads: "Messer Giorgio, I am sending you two sonnets; and although they are a stupid lot, I am doing this so that you may see where I am keeping my thoughts: and when you will be eighty-one years old, as I am, you will believe me." Yet he had meditated upon the *vanitas* theme earlier and deplored "le fallace speranze e 'l van desio" (XLIX).

One of his most beautiful lyrical efforts is the following powerful sonnet to the Redeemer. This piece (CLX), reminiscent of a medieval hymn, almost atones for the fact that Michelangelo left us no statue or painting of the Crucifixion or the Resurrection:

> *Non fur men lieti che turbati e tristi,*
> *Che tu patissi e non gia loro la morte,*
> *Gli spirti eletti, onde le chiuse porte*
> *Dal ciel in terra al huom col sangue apristi:*
> *Lieti, poiche creato, il redemisti*
> *Dal primo error di suo misera sorte;*
> *Tristi a sentir, ch' a la pena aspra e forte*
> *Seruo de' serui in croce diuenisti.*
> *Onde e chi fusti, il ciel ne die tal segno*
> *Che scurò gli ochi suoi, la terra aperse,*
> *Tremorno i monti, e torbide fur l' acque.*
> *Tolse i gran padri al tenebroso regno,*
> *Gli angeli brutti in piu doglia sommerse:*
> *Gode sol l' huom, ch' al battesmo rinacque.*

> The blessed spirits were no less happy than disturbed and sad on seeing that not they, but thou wast condemned to death, by which thou didst with thy blood open the gates of heaven to man. They were happy, since, having created man, thou didst redeem him from original sin which had made his fate so miserable. They were sad, since they felt that with harsh and cruel pain thou hadst become on the cross like unto a slave of slaves. But whence thou camest and who thou wast heaven showed by a certain sign, for the skies darkened, the earth opened, the mountains trembled, and the waters became turbid. The patriarchs were taken from the shadowy kingdom, the evil angels were submerged in greater sorrow; only man exulted, for at his baptism he was reborn.

Traduttore traditore. It is next to impossible to capture in translation the primal grandeur of these verses. Frey can explain the power of these lines only by imagining that Michelangelo had a Crucifixion before him as these thoughts were composed.

This poem bears a striking resemblance to Vittoria Colonna's sonnet on the same theme ("Gli angeli eletti e quel bene infinito"), published in 1540 and possibly preceding Michelangelo's version.

Whether Michelangelo succeeded best in communicating the intense religiosity of his late years in verse or in sculpture makes for interesting speculation. Mariani feels that Michelangelo struggled mightily with the materials of his last *Pietàs* in the knowledge that words might fail to express what his art was able to convey. Perhaps he was mindful, as Mariani suggests, of Dante's thought in the *Paradiso* (I, 70): "Trasumanar significar per verba non si poria" ("Transhumanising could not be expressed by words").

The greatest expression of renunciation and pessimism, the most complete adherence to the *vanitas vanitatum* theme, is the *Canto de' morti.* Michelangelo the Younger claims that this brief piece (CXXXVI) is of the artist's own invention. It is found in the master's handwriting, so that it may well be. At best it was his composition and at least it was a poem which struck home. It is a macabre song, in a way reminiscent of Villon's "Epitaphe en forme de ballade" (more famous as the "Ballade des pendus"), to be sung by such miserable dead as are found among the damned of the *Giudizio universale*:

Chiunche nascie a morte arriua
Nel fuggir del tempo; e 'l sole
Niuna cosa lascia uiua.
Mancha il dolcie e quel che dole,
E gl' ingiegni e le parole;
E le nostre antiche prole
Al sol ombre, al uento un fumo.
Come uoi uomini fumo,
Lieti e tristi, come siete;
E or sián, come uedete,
Terra al sol di uita priua.

Whoever is born arrives at death with the flight of time; and the sun leaves not a single thing alive. The sweet and the painful alike pass away, and the thoughts we have thought and the words we have spoken. Our generations gone by are like shadows in the sun or smoke on the wind. Like you, we were men. Like you, happy and sad. And now we are, as you see, lifeless earth under the sun.

And then a *ritornello*: "Ogni cosa a morte arriua" ("Everything comes at length to death").

The simple crudity of these verses does not rule them out as the probable work of Michelangelo. They were in all likelihood written very late, and the crudity is analogous to that of the Rondanini *Pietà* or the unfinished Palestrina *Pietà* in Florence, among his last figures. Close literary affinities may be found for this canzone among the macabre *canti carnascialeschi* or the stanzas in some contemporary emblem book accompanying the woodcut of a *Totentanz*.

In sum, the realisation that painting, sculpture, and architecture are but vanities which have merely drawn him away from man's true charge, the total dedication to God, made him wonder late in his life whether the decision recounted in the opening pages of this chapter was a wise decision. As he feared for the salvation of his soul the old man reflected seriously on this question. He it was who wrote to his nephew (21 November, 1552):

E' mi pare che le cose che ànno cattivo prencipio non possino aver buon fine.

It seems to me that things which have a bad beginning cannot come to a good end.

CHAPTER III

Neoclassical and General Theories

To say to the painter that Nature is to be taken as she is is to say to the player that he may sit on the piano.

WHISTLER

L'artiste sera ou plagiaire ou révolutionnaire.

GAUGUIN

Aristotle has reminded us that the impossible but likely is more credible than the possible but unlikely. How else could we explain the presence of Michelangelo Buonarroti here on the farm of the peasant Felice de Freddis, near the thermae of Titus, on this January morning in 1506? A group of men stand in a circle out in the center of a half-plowed field. Picks and mattocks have been softening the ground within the circle. An architect is directing a band of laborers who have extricated a large statue from the cold earth and are engaged in wiping away the clinging soil. As the dirt gives way, the white Pentelic marble appears, fine and smooth. The sculptured group now exposed represents three figures enlaced by serpents. The peasants are talking excitedly and comment on the strange contorted figures which have remained almost intact through the centuries. Someone nervously suggests that the statue must be possessed of an evil demon which has caused the faces to twist with a strange emotion. Snakes are an ill omen. One prudent farmer, aware of the omnipresence of the Evil Eye, furtively touches the metal of his fork.

The architect who has supervised the unearthing has spoken nothing except a few orders necessary to the operation. Almost until this moment,

this has been merely another of those excavations which the Pope has asked him to supervise. Once again, a farmer's plow or fork has encountered an unfamiliar stone in Latian soil. Or so it has seemed. But for several minutes now the architect has realised that this is a more momentous occasion than anyone has expected. In fact, it is almost unbelievable.

At his side stand his young son and our sculptor of about thirty years, who is utterly silent. The three of them had been breakfasting when the news arrived, or rather the summons to get horses and hasten out to the farm of the peasant Felice.

"Conosciete voi quest' opra che avemo scoperta?" the architect asks of his sculptor friend. The black-bearded man makes no sign of assent, but seems to be searching in the recesses of memory.

"'Tis the *Laokoön*. The *Laokoön* described by Pliny in his history. The group in the Palace of Titus which Pliny called the greatest work of art of all times. It was done by three sculptors from Rhodes and carved out of a single block."

The youth Francesco interrupts him with a natural question. Who was Laokoön and what is happening in this statue? Giuliano explains: This poor man had been a priest at Troy. He had been shrewd enough to penetrate the ruse of the wooden horse and had hurled a spear at it . . . Giuliano's voice trails on.

As he stares pensively at the marble group, a great *concetto* being freed of its *soverchio*, Michelangelo's mind is assailed by a storm of thoughts. Here again is proof that sculpture, the "prime art," has a permanency unequaled by any of the other arts, even architecture. Look how those thermae in the distance have been abused by time and the elements. Yet this white stone is beginning to recapture the look it had that day when those three Rodioti completed it. He hopes that during his life he can remain primarily a sculptor and not have to waste his time on ephemeral painting.

Another reflection wells up. Here is further proof that Italy is one great new lapidary museum or treasure house of art. This is a thought which he has expressed before and will voice again. Is it any wonder that no other country produces art to equal Italy's? Of all the Christian

lands, and even great new continents that people are beginning to talk about, he has been fortunate enough to be born in Italy. When people speak of the patrimony of the ancients they have in mind just such statues as this one which he and Giuliano are the first to see. Before the sun is at zenith all the antiquarians in Rome will make a pilgrimage to this spot, as to some shrine. What other treasures mentioned in Pliny's famous chapter are buried under the very ground they are treading? How much closer than we realise is antiquity! A few inches away.

Among his other musings as he stands contemplating this strange statue about which men will write books, there is one which pleases and encourages him. This central figure of Laokoön—it seems to burst with life. A powerful spirit and soul are trying to escape from the confines of that stone. Here is the *furia* which he has wished to embody in his own figures, frowned upon by his friends of the Donatellian tradition. Here is proof from the ancients themselves that one expresses the greatest emotion through the attitude of the body and not just the aspect of the face, through the serpentine pose and through handling of the *contrapposto*. This statue may redefine the conception of the classic figure and liberate the sculptors attending the rebirth of the arts which people are beginning to sense.

This revolutionary central figure, which gives him license for greater inventive freedom, will remain so engraved in his memory that a few years later, having to depict the anguish of a crucified enemy of the Jews, he will re-create it in pigment.

In assessing Michelangelo's classicism one must bear in mind the difference between classic and pagan. He revered the former, but kept reservations about the latter, like Dante, who decried the "stench of paganism" while revering Aristotle as "the master of those who know." Michelangelo could not make of classicism a pagan cult, like Ficino, who burned a candle twenty-four hours a day before a bust of Plato. The two pagan gods he sculptured, *Apollo* and *Bacco,* are ungodlike indeed. However, if he did not know Greek and possessed only a modicum of Latin, his acquaintance with the humanists and their texts opened his

eyes to the vast thematic storehouse contained in classic literature and mythology.

Ancient themes abound in his paintings, drawings, and sculpture. The scholars and academicians of the Medici circle suggested some of these. Condivi (x) reports that Poliziano proposed the subject of the *Centauro-machia*. Among the subjects of his statuary (either extant or lost) Hellenic themes outnumber the Roman: *Ercole, Ercole e Caco, Apollo, Bacco,* the *Genio della Vittoria, Cupido,* the *Vittorie* for the mausoleum of Julius II, the *Prigioni* (likened by Goldscheider to Hellenistic representations of Marsyas), *Bruto,* and finally centaurs, karyatids, fauns, and masks. A recent article suggests that the relief of a Centaur and Lapith in combat should be added to the classical productions of the youthful and immature Michelangelo.[1]

Among the classical subjects of the paintings and drawings one finds *Leda, Ercole* and his labors, *Venere e Cupido, Atlas, Hypnos* (so identified generally, but refuted by Panofsky), *Cleopatra* and *Zenobia* (among the disputed drawings for Cavalieri),[2] the tragic figures of *Tritone, Ganimede, Fetonte, Tizio* (Tityus), along with the river-god *Eridano* and Phaethon's sisters, the Heliades, and such standard classical baggage as satyrs and masks, sibyls, and furies. Two of Michelangelo's most enigmatic drawings, the *Saettatori* and the *Baccanalia dei putti* (which Panofsky claims to be more "pervaded by a pagan spirit" than any other of Michelangelo's works)[3] are obviously classic in spirit. Fewer figures from classical mythography are found in his poetry, but one finds Daedalus, the Medusa, Venus, Cupid, the phoenix, and the salamander.

These subjects offer overt testimony to the classic bent of this age and of this artist who costumed Dukes Lorenzo and Giuliano as noble Romans. Deeper and less obvious evidences are the classic patterns of his theory and critical thinking on art. The critical issues which we have already found occupying him weighed equally upon writers of antiquity: inspiration, nature vs. training, divine participation in art, moral effects of art, katharsis, sweetness vs. utility. Other issues recognisable as concerns of the ancient theorists will be treated in this chapter. Some of these are: the cult of glory, imitation, the ideal of form, decorum, taste, wisdom, the *profanum vulgus* prejudice, invention, sublimity, and the

notion of *ut pictura poesis*. In turning his attention to these issues, Michelangelo was characteristic of the moment and milieu in which he lived. However versatile his thought patterns, the issues themselves are quite familiar to students of Renaissance theories on art or literature and do not support the picture, which some have constructed, of a Michelangelo apart from his society and generation. But he was, it is true, at the vanguard of that generation.

In the Casa Buonarroti there is a portrait, by Francesco Curradi, of Michelangelo being led up a stair by Fame, identifiable by her wings and clarion. It is a pictorial translation of Doni's letter to Michelangelo affirming that the artist should be raised by angels to the upper reaches of Paradise. The cult of fame in the Renaissance was as active as it had been in antiquity, in the days of Pindar, Cicero (who called fame "the nurse of the arts"), and Horace. The theorists on art accepted the traditional belief that art would bring honor and ease. Leon Battista Alberti added his voice in *Della Pittura*: "So long as you shall honor it, this art will bring delight and praise and riches and perpetual fame."[4] Da Vinci wrote that artists may be called "descendants of God."[5] Pindar had noted that art opens a double avenue to fame, one for the artist and one for the person portrayed, which idea became a commonplace. Alberti mentions this latter avenue: "Just as the faces of the dead live, in a sense, a lengthy life by means of painting."[6] The double track is clearly claimed for art by Michelangelo, writing to Vittoria Colonna (CIX, 92) that he can bestow a long span of life on both her and himself by means of painting or sculpture:

> *Dunche posso ambo noi dar lunga uita*
> *In qual sie modo o di colore o sasso,*
> *Di noi sembrando l' uno e l' altro uolto;*
> *Si che mill' anni dopo la partita*
> *Quanto uoi bella fusti, e quant' io lasso*
> *Si ueggia, e com' amarui i' non fu' stolto.*

> Thus I can give long life to both of us, portraying either in color or in stone the face of each; so that a thousand years after we have departed, one may see how thou wast beautiful and how I miserable, and how I was not unwise in loving thee.

In the first of the Roman dialogues, the Marchioness herself remarks to Michelangelo regarding the painter: "He gives life for many years to him who dies." The artist preserves not only the memory but the actual semblance of his subject. In Michelangelo's poem on the death of Cecchino Bracci (LXXIII, 47), the youth whose effigy executed by Urbino commemorates his comeliness cries out from his shroud, "I beg that the tomb which encloses me be not opened, that I may remain handsome to those who loved me when I was alive." Thanks to sculpture, Cecchino's beauty will soar up again after his death, like the phoenix (LXXIII, 39).

Michelangelo pays his respects to the prevalent notion that *scripta manent* in a poem to Vasari (CXXXIII), congratulating him on the first appearance of the *Vite*:

> *Hor le memorie altrui, gia spente, accese*
> *Tornando, fate hor, che fien quelle e uoi,*
> *Mal grado d' esse eternalmente uiue.*

And now, despite nature, you cause memories of men once spent to become rekindled, so that their works and you yourself may live eternally.

He is also aware that Vittoria Colonna's 215 sonnets will remain imperishable (XCVIII):

> *Ne mecter puo in oblio,*
> *Ben che 'l corpo sie morto,*
> *I suo dolci, leggiadri e sacri inchiostri.*

> *Nor can it, although thy body be dead,*
> *blot out the memory of thy sweet,*
> *charming and holy inks.*

And claims as much for the divine *carmi* of Berni (LVII).

Without emulating the hybris of Zeuxis, who wore his name in gold on the hem of his robe, the Renaissance artist, neoclassic in spirit, could partake of the cult of glory as readily as the man of letters. It was in the Cinquecento that artists outgrew the hesitancy of their medieval predecessors about signing names to their creations. Although this was to be no means a regular practice with Michelangelo, his name nevertheless accompanies a few of his creations. The most obvious "signature" is the

inscription "MICHEL-ÃGELVS BONAROTVS FACIEBAT" carved boldly across the bodice of the *Madonna della Febbre*. Vasari states that the reason for this nicety was that the work was being falsely attributed to another sculptor, Cristoforo Solari. There are autograph inscriptions on three studies: the sketch of the bronze *David* in the Louvre (Berenson, 1585r), that of the *Sibilla Libica* in Madrid (Frey, 4:5), and that of the battle scene in the Ashmolean (Berenson, 1556). It has been conjectured, by the way, that Michelangelo inscribed the *Madonna della Febbre*, conscious that it was the first work in which he had reached the plenitude of his genius and his seriousness of purpose. The *Bruto* bears in a curious disposition the letters M, A, B, F—Michael Angelus Bonarotus Florent (or Fecit).

Probably the reason Buonarroti did not sign more of his work was that, excepting the drawings which were not first drafts, his name was indelibly associated with his productions by his contemporaries as it would have been with the mountain-peak colossus which he planned at Carrara "as a memorial to himself" (Vasari, VII, 163). He was not, as he reminded his nephew, a "commercial" artist obliged to place a trademark on his creations. He may also have felt that his technique itself was identification. Cellini believed that Michelangelo left a peculiar touch on most of his sculpture which served as a signature. This enables one, for example, to corroborate the documents recording which statuettes of the Piccolomini Altar at Siena were done by Buonarroti—even to decide which parts of the *San Francesco* were done by him and which by the ill-starred Torrigiani. Yet there remained those cases where an assistant pretended to be the executor of one of his works, and this understandably exasperated him. Such a difficulty arose with the *Cristo risorto*, when people credited it to Pietro Urbano. In this connection Sebastiano del Piombo penned to Michelangelo what appears to be a request to place his name or identifying mark on the statue: "Take care that it should be clearly seen to be the product of your hand, so that the scamps and gossipers may burst."[7]

Every artist portrays himself in his work, as Girolamo Savonarola and others had declared. "E natura altrui pinger se stesso / ed in ogni opra palesar l'affetto." He further reiterated this in his own ironic way.

· *137*

"Every painter draws himself well," he remarked of a painter who had done a picture the best part of which was an ox.[8]

He dedicated a madrigal to the thesis that an artist paints his subjective self into his portraits of others; that if the artist is unhappy, his subject will appear so (CIX, 89):

> *Dunc' ambo n' arien bene,*
> *Ritarla col cor lieto e 'l uiso asciucto:*
> *Se farie bella e me non farie bructo.*

> *Thus each would benefit thereby,*
> *To paint her with light heart and dry eyes,*
> *She would be made beautiful, nor should I be made ugly.*

In any case, it is intriguing to conjecture to what extent Michelangelo portrayed himself in his works, just as Cellini did in the rear view of the *Perseo* or Botticelli in his *Adorazione*. In his self-portraits Michelangelo, as Longinus said of Homer, "often seems himself to live the great lives of his heroes."[9] We are not referring of course to the two alleged *autoritratti*, one in the Uffizi and one in the Chaix d'Este-Ange collection, sold in this century at public auction in Paris.[10] We refer rather to those works in which he projected himself into the historical figure portrayed. Hill finds this tendency of Michelangelo admitted in his strophe, "S'egli è che 'n pietra dura alcun somigli," adding, "With a sublime egoism, he found that whenever he set himself to carve a portrait, the only features that would come were his own."[11] It must be conceded forthwith that no definite self-projecting portrait has been identified to universal satisfaction. But at least eight possibilities have been advanced. The *San Proculo* executed in Bologna in 1494 is held by Thode to be a self-portrait by the nineteen-year-old Michelangelo, even though the attribution is debatable. Such disparate heads in the *Giudizio universale* as those of the *Monaco* and the pelt of *San Bartolommeo* have been proposed as self-portraits. This latter example appears a self-caricature rather than a self-portrait, and whereas it seems an exact corollary to Michelangelo's verbal self-caricature, "I' sto rinchiuso come la midolla," describing the distortions to his person brought about by painting the Sistine Ceiling, it is much closer in spirit to the mystical

poems in which he denies his flesh (pelt, leather, skin, and so on). An unusual instance of autobiographical statuary would be the *Genio della Vittoria,* where the youth triumphing over the aged man would allegorise Tommaso Cavalieri's domination of the artist (Plate V). No other interpretation has been generally accepted. Occasionally people have surmised that the *Geremia* was none other than the artist. The most likely example of *autoritratto* is *Nicodemo* of the *Deposizione,* very possibly destined for his own proposed sepulcher in Santa Croce.[12] This identification is welded in Florentine legend, as this writer learned during his student days at the University of Florence. De Tolnay proposes a seventh possibility, again a curious one. He believes that the head of the decapitated *Oloferne* carried on a tray by Judith on the spandrel of the Sistine Ceiling must be a self-portrait. He finds support in a comparison with the profile portrait of Michelangelo by Giulio Bonasone and notes that the idea of presenting himself as accursed also impelled Michelangelo to translate himself into *San Bartolommeo*'s skin.[13]

An eighth probability is the bearded man coifed in a boar's head and staring at a proud and mature woman with tired breasts—a curious drawing reproduced in Frey's *Dichtungen* (p. 385) very likely portraying Michelangelo and Vittoria Colonna.

Among the more dubious attributions, Kriegbaum conjectures that the *San Paolo* of the Piccolomini Altar in the Duomo of Siena is an idealised self-portrait. The herm of the *Saetattori* must be considered a possible self-projection. Some have even wondered whether the sad and bitter *Mosè* is a spiritual reflection. Goldscheider believes the soldier behind the centurion in the *Crucifixion of St. Peter* is none other than the painter. If Michelangelo did not depict himself as *David,* he identified himself intimately with that young warrior (see Chapter VII). De Tolnay would even add the scornful *Bruto* to this list of self-portrayals, believing it to be "unconscious."[14]

This habit of painting himself under the name and person of his subjects has a literary parallel in his penning his own sentiments in a capitolo "under the name of Fra Bastiano" (LVII) and assuming the identity of Sebastiano del Piombo.

Whether or not these hypotheses are well-founded, Michelangelo

felt as keenly as did his contemporaries that personal immortality was to be secured by his works. He often regretted that he and most of his brothers had no children to award them lineal immortality and to perpetuate the Buonarroti-Simoni name. According to Vasari, a priest deplored in Michelangelo's presence that the latter had no offspring. The artist replied, "Io ho moglie troppa, che è quest' arte, che m'ha fatto sempre tribolare, ed i miei figluoli saranno l'opere ch'io lasserò; che se saranno da niente, si viverà un pezzo" ("I have too much of a wife, and that is this art, which has already given me tribulations, and my children will be the works I shall leave. For even if they will be of little value, they will live for a while").[15] One need not take too seriously the modest reservation in this last sentence in view of the self-assured statements regarding his competence which we shall evoke in discussing his differentiation of the arts. The period he would assign to his works is rather that mentioned in his piece (CIX, 45) "Sol d'una pietra uiua," and that is "al par degli anni" ("throughout the years"). Guasti and Ceriello translate this phrase as "forever." Michelangelo himself ascribes "eternity" to works of architecture made up of concrete blocks (CIX, 88: "Sì amico al freddo sasso è 'l foco eterno").

Michelangelo's conception of his art as a demanding wife is not unusual. (Emerson called art a "jealous mistress.") Fabio, in Pino's *Dialogo*, observed that "when a painter takes on a wife, he should deprive himself of art" and that no great painter of antiquity was married until Alexander passed Campaspe over to Apelles.[16] Michelangelo must have told his followers that women cut down a man's artistic creativeness, for Sebastiano del Piombo, who always closed his letters with a brief ingratiating thought he knew would please Michelangelo, announced almost eagerly that he had discarded his mistress: "Rejoice in the fact that it is now twenty days since I sent away *la comare* and I am now in pristine liberty."[17]

Michelangelo sought comfort in the thought that an artist's works can grant him a posthumous fame which children themselves cannot guarantee. While Ghiberti's children and grandchildren have squandered all that Lorenzo left, "yet the gates [which Michelangelo judged worthy of Paradise] are still in their place."[18]

A curious inscription is found under one of his drawings for the Medici Chapel:

La fama tiene gli epitafi a giacere;
non ua inanzi ne indietro,
perche son morti, e e' loro operare fermo.[19]

The sense of these lines is that fame brings to a halt the fleeting times of day (*epitafi*); fame can no longer go forward or backward; time and its work of destruction are stilled. This inscription accompanies a drawing of Fame, of which Panofsky writes: "The figure of Fame, however, did not make its appearance in funerary art before the very end of the High Renaissance. The figure of Fame in Michelangelo's project for the Tomb of the Magnificent ... seems to be one of the earliest instances; but the idea was already abandoned in the following project." Extending the meaning, De Tolnay notes that *giacere* symbolises the immovable state following death and that "this would signify that by death the instability of terrestrial life is overcome and eternity is thereby attained."[20]

The cult of Glory, by the way, made real artists snub their confreres for whom selling was an objective. In May of 1548 his nephew Lionardo wrote Michelangelo that a Florentine citizen would like to have an altar table painted. Despite the dominance of Mercury at his birth, favoring commercial talents, Michelangelo replied haughtily, "Io non fu' mai pittore nè scultore come chi ne fa bottega" ("I never was the sort of painter or sculptor who keeps a shop").[21] An artist excellent enough to be subsidised or whom commissions sought out needed no shop. (Cf. Da Vinci, in the fragment of a letter, "I have satisfied myself that he accepts commissions from all and has a public shop; for which reason I do not wish that he should work for me at a salary," etc.)[22] As Blunt has rightly pointed out, "The principal aim of the artists in their claim to be regarded as liberal was to dissociate themselves from the craftsman."[23] In his magnificent lesson explaining the qualities to be desired in painters, Paolo Pino's spokesman Fabio says of the artist, "Let him abhor playing merchant (*far mercato*), a thing most vile and mechanical and even unsuitable for our art."[24] When in 1528 Pope Clement offered Michel-

angelo employment and payment "alle giornate," the artist refused.[25] So firmly did Michelangelo avoid the taint of mercantilism that he once wrote to Vasari that he did not answer letters promptly "per non parere mercante" ("to avoid appearing like a merchant").[26] In the *Dialoghi* of Giannotti, Michelangelo apologises at one point for speaking "mercantescamente." Vincenzo Giustiniani wrote that a minor sculptor, jealous of Michelangelo, was asked to do a mortar for pounding spices. Aware of Buonarroti's sensitivities, the sculptor directed the buyer instead to Michelangelo. Recognising the malicious intent of his confrere, Michelangelo did not object, but rather carved a beautiful mortar, highly ornamented with arabesques, foliage, and masks.[27]

Michelangelo's scorn of the shopkeeping artist, while symptomatic of the High Renaissance, had its origins in the very first stage of that artistic *rifioritura*. In his *De' veri precetti*, Armenini tells that Giotto was painting a clothed figure for a certain gentleman who began to complain that Giotto should not shade the color of the cloth with *oscuro*. Giotto reasoned with him for a while, but finally exploded, "Go to the shopkeeping painters [*bottegai*] if that's how you wish it."

Despite all the foregoing evidences, there were two very important reservations in Michelangelo's subscription to the cult of Glory. First of all, his Christian humility sometimes reminded him that professional ambitions dissuade us from the Christian obligation of honest introspection. After all, in the pen sketch for Lorenzo's tomb mentioned above, the projected Fama is overshadowed in the zone immediately above her by a much larger Virgin. Ambition and envy are decried in Michelangelo's stanzas in praise of rustic life. In Giannotti's *Dialoghi*, Michelangelo tells the assembled company that ambition is one of the vices "che l'huomo all'huomo rubano e lo tengono disperso e dissipato, senza mai lassarlo ritrovarsi e riunirsi" ("which rob a man from himself and keep him scattered and dissipated, without ever letting him find and unite himself again").[28] The wording of this complaint, inevitably reminiscent of the androgyne legend so much in vogue, reflects the Christian asceticism and soul-searching which characterised his late years. It also brings to mind his objections to his bondage to art. Fame itself led to an overtaxing of his strength. Michelangelo complained of this to his friends.

Sebastiano wrote to him after some such complaint, "There is no one but yourself who hurts you: I mean your eminent fame and the greatness of your works." As we learned in the preceding chapter (sonnet CL), fame could not compensate for the fact that his artistic activities "have stolen from me the time given to contemplate God."

His second reservation about the cult of Glory would be as follows: for all the claims by writers and artists that their works will endure through eternity (on Michelangelo's sepulcher an effigy of Eternity vanquished a *Morte Secca*), even they must realise that these works through accident or time come to an end or are lost. Michelangelo's favorite Petrarch had taught in his *Trionfi* that Fame triumphs for a while over Death, but that in the end Time triumphs over Fame. Condivi thought that this very lesson was the theme of the Medici Tombs and that the Allegories signified "Time which consumes all." Michelangelo could read Vasari's regret that time "consumes everything" and that so many works of antiquity disappeared that we have no record of them or their creators.[29] It was to frustrate this "second death" that Giorgio decided to write his biographies.[30] The utter brutality with which time can destroy works of art is accentuated by the word choice in two lines (LXXXV) quoted earlier:

> *Se po' 'l tempo ingiurioso, aspro e uillano*
> *La rompe o storce e del tucto dismembra...*
>
> *If afterward time, harmful, harsh, and villainous,*
> *breaks it, distorts it, or completely shatters it...*

Of all the Italian masters, Cimabue sustained the greatest losses of his works. In Michelangelo's case, some creations were lost or damaged in his own lifetime. Antonio Mini reported how vandals entered the studio in Via Mozza and stole fifty drawings, including designs for the Medici Tombs. Vasari claimed that the cartoon of the *Battaglia di Cascina* was rent to pieces and pilfered by apprentices and artists of the Casa Medicea when Duke Giuliano was bedridden. (In his second edition Vasari lays the blame on Bandinelli.)

Some works were destroyed as an immediate consequence of war. A few discerning souls in the sixteenth century stated that war was the mor-

tal enemy of a poet's or an artist's fame. "God does not will it, who covers under the earth so many lost books and so much laborious art, flotsam of war."[31] Violence seems to join forces with ignorance in wartime, and Michelangelo no doubt knew of the flagrant case (*ca.* 1390) when the superstitious Sienese smashed a masterful ancient statue by Lysippus, thinking that it brought them ill luck in their war against Florence. He knew also of the many works of art destroyed during the eight days following the Sack of Rome (May, 1527) by the unruly Spaniards and the Protestant *Landsknechte*. Even though Michelangelo taunted Leonardo about the latter's unfortunate equestrian statue of Francesco Sforza, he could not fail to resent the fact that the French occupying Milan used for target practice the model of this statue on which Da Vinci had worked sixteen years. The charges against Lysippus' masterpiece found an echo among the Florentines: during deliberations on the placing of Michelangelo's *David,* the first herald of Florence won the removal of Donatello's *Giuditta* from the entry of the Signoria, alleging that the statue brought military disaster to the commune and even cost defeat at the hands of the Pisans.

Michelangelo's works have suffered through wars down to the present century. When the Medici were expelled from Florence in 1527, the left arm of the marble *David* was fractured in three places by a bench hurled from a window. Even so late as 1797 one of the *Ignudi,* part of a medallion, and a section of the sky of the *Diluvio* were partially obliterated when a gunpowder explosion in the Castel Sant' Angelo reached the Sistine Ceiling. The debated *Cupido* in the Victoria and Albert Museum was damaged by pistol shots. The most humiliating impact of war was when, in 1511, Michelangelo's bronze *Giulio II* was melted down into a cannon, called *La Giulia,* by the vengeful people of Bologna after the Bentivoglio regime was restored. Even World War II was one of those periods he called "distinctly unfavorable to our art." The National Socialist hierarchs appointed themselves the protectors of European art, seized the *Madonna* from the Cathedral of Bruges and shipped it off to Alt Aussee in Austria, destined for Hitler's museum in Linz. When this war reached Italian soil, the famous *Bacco* was spirited off to the Villa Poggio at Caiano, near Florence, where it stayed long

enough to be listed as missing in an important postwar inventory, *Le Gallerie di Firenze e la guerra*.[32] Fortunately, these and his other works came out unscathed.

Wars helped indeed to prove the truth of Michelangelo's tercet (CXXXIII) to Vasari:

> *Che se secolo alcuno omai contese*
> *In far bell' opre, almen cedale, poi*
> *Che conuien, ch' al prescritto fine arriue.*

> For if any century struggled with nature to produce beautiful works, let it nevertheless give in, for all things must arrive at their prescribed end.

On seeing his *Giulio II* metamorphosed into a cannon (one biographer claims that Michelangelo was shown the weapon) or his drawings pilfered, Michelangelo could only take solace in his belief that an artist can win glory and establish his mastery by a single work, provided that it betrays genius.[33] He felt this so keenly that he prized quality over quantity of production, a facet of his theory developed in Chapter I. His dissatisfaction with many of his statues and paintings caused him to abandon them. Not only wars and the ravages of time were responsible for the destruction of his works. We remember that he himself burned many drawings so that he would "appear only perfect."[34] One of his letters (1546) records a quarrel with Luigi del Riccio, provoked by the latter's refusal to destroy the engraving of one of Michelangelo's works and the copies which had been run off.[35] This incident may explain the angry sonnet the offended artist wrote to Luigi (LXXIV). We shall learn from our probe into Michelangelo's ivory tower instincts that he wished fame not among the masses but among the sensitive and discriminate minority. This typical humanistic view of Glory in the Cinquecento was part of the Horatian revival: "Principibus placuisse viris non ultima laus est."[36] In his *Giudicio*, Bartolommeo Cavalcanti was writing characteristically, "I say to you that it is better to deserve the praise of ten or fifteen men of judgement than to win the favor of the whole crowd."[37]

Michelangelo's friends and a few of his patrons realised the high seriousness with which he regarded his art and the premium he set on lasting fame. Julius III was most sympathetic when he announced his wish

to have Michelangelo's body embalmed so that it would be as lasting as his works.[38] But, alas, that good pontiff went to his reward almost a decade before the death of the artist.

Michelangelo's friend and biographer, Giorgio Vasari, gave testimony that Renaissance painters, no less than their literary contemporaries, viewed the doctrine of imitation as licensing the copying of both nature and older masters. "For I know that our art is wholly imitation, of nature first of all, and then, because it cannot rise so highly by itself, of things done by those whom one judges better masters than oneself."[39] The imitation of nature alluded to here meant to some a literal representation (from photographic to "discreet"); to others an ideal representation advanced by the Neo-Platonists. A "discreet" or selective imitation might convey an impression of reality better than the unselective "mirroring" so common in modern painting. To the second group the "idea" (such as Michelangelo's beardless Duke Lorenzo) was more important than the fact. As for Michelangelo, we possess scattered written evidence which reveals his feelings about *imitatio*. His remarks will recognise both types of imitation mentioned by Vasari. We shall learn that Michelangelo was more reserved than most Cinquecentisti about approving literal imitation, that his conception of ideal imitation is tempered by his intense religiosity, and that he entertained definite prejudices about copying other masters.

To what stage had the doctrines of imitation evolved at the beginning of Michelangelo's creative period, the dayspring of the sixteenth century? Giorgio Valla's Latin translation of Aristotle's *Poetics* (1498) had already appeared. Its famous prescription about art imitating nature was made applicable to painting as well as poetry. Of course, the ideal of facsimile imitation was as old as art itself. The ancients loved to tell the story of Alexander's captain Cassandrus who, seeing an effigy of the dead Emperor, trembled with his entire heroic body. In the Trecento, Boccaccio held that a "photographic" talent accounted in large measure for Giotto's renown. "He possessed a genius of such excellence that nature produces nothing which he, with stylus, pen, or brush, cannot depict so

closely that his painting appears not merely similar, but seems to be the thing itself. So true is this that many times one finds that the visual sense of men mistakenly believed to be real that which was merely painted."[40] This literal view of imitation lived on into the Cinquecento, of course, and Lomazzo—of all people—was enthusiastic over the painting of a yawning man which sets the onlooker to yawning. Michelangelo never considered art a slavish mimicking of nature, even though Montaiglon and Thode suggested that his crouching figure of an ape skulking behind one *Prigione* (and barely visible behind another) represented Painting, "la scimmia della natura," a symbol found early in Ripa (*s.v.*: "Pittura"). The simple fact that Michelangelo's theory of imitation is so far removed from the mimetic procedure suggested in Ripa lends support to Panofsky's rejection of Montaiglon and Thode's hypothesis.[41]

Leon Battista Alberti's mechanism to facilitate the imitation of nature (a net held against the painter's eye and on which outlines were traced; a table establishing norms of proportion) could lead precisely to the type of mechanical or geometric copying decried by Michelangelo. We have seen (in Chapter I) how Michelangelo felt that in the process of imitation the naked eye must replace all measuring instruments. Whatever the means adopted, Alberti opined that, since painting imitates nature, the artist's lines and colors should appear in relief and like the object imitated.[42] Despite his occupation with technical devices, Alberti believed in selectivity and idealisation. He preceded Michelangelo in his belief that the artist should imitate the beautiful elements in nature.[43] Like Buonarroti, he claimed that "the idea of beauty does not let itself be recognised by the ignorant; it scarcely even lets itself be discerned by those who know."[44]

Leonardo believed that art must imitate, even mirror, nature. His Aristotelian interest in observable phenomena and scientific experiment kept him studying how a painter might best and most accurately reproduce external nature. He advised painters to carry mirrors with them and called mirrored reflections "the true painting." (Alberti had also advised the use of such a control during the painting process, since "it is a marvelous thing how every defect in painting appears more ugly in the mirror.")[45] Leonardo wrote, "That is the most praiseworthy painting

which has the most conformity with the object imitated."[46] Nevertheless, Da Vinci acknowledged that imitation had a broader meaning and felt that such tricks of the trade as mirroring should be used only "by those who have enough knowledge of theory, that is to say above all of perspective, to be able to check their work according to scientific standards."[47] Such, at least, is the wishful thought of Blunt. What is more certain is that Michelangelo would have concurred with Leonardo's section, "Dell'imitare Pittori," in which Da Vinci (after Alberti, *De pictura*, II) warns his colleagues not to imitate other painters, lest they then be called grandchildren rather than children of nature.

The writer whose ideas on mimesis coincided most closely with Michelangelo's was Lodovico Dolce, that critic who joined with Aretino to attack the *Giudizio universale* as morally improper. The main point of similarity is their mutual conviction that the painter portraying the human body should make an idealised imitation, should, in Aristotelian terms, portray life as it ought to be and not as it is. Dolce urged the traditional procedure of making a composite of several models, and we shall see shortly that this was Michelangelo's occasional practice. A point of dissension was Dolce's inciting the artist to surpass nature, which aim will be proved incompatible with Michelangelo's aesthetics. Dolce's doctrine of ideal imitation and Varchi's claim that artists must imitate nature "with a certain discretion" ally them with Buonarroti and Danti.

The foregoing names represent the principal theorists treating of *imitatio* whose ideas might have been known to Michelangelo. The Neo-Platonic view on the matter was amply investigated in Chapter I. Michelangelo's theories differ in varying degrees not only from those of his predecessors and contemporaries but even from those of his survivant Bellori. The closest affinity with Michelangelo after Dolce is to be found in Lomazzo, whose Neo-Platonic view of imitation did not appear until the issuance of his *Idea del tempio della Pittura* in 1590.

We have polled many of the theorists of Michelangelo's time who took a stand on the issue of imitation. As the reader has observed by now, we have never really finished with a topic until we have heard out Savonarola. On this particular issue the friar took the simple view that if art equaled man and nature equaled God, then art could never duplicate

the marvels of nature. "Art cannot imitate nature in everything: there is a certain living quality and a certain something [*un certo non so che*] in natural things which art cannot express." His clinching argument is that birds will not fly to a painted grape. (A popular plate in Renaissance emblem books held this to be possible.) He skirts Neo-Platonism for an explanation: "It is not because of the eye, which sees only the colors. It is because of a living part of the soul called cognitive, which distinguishes that which is good from that which is not." In Buonarrotian terms, the friar is merely stating that true inner vision is found in all of God's creatures.

Given this frame of reference, we turn now to Michelangelo's thoughts on the two major types of imitation stated by Vasari above. After recording his views on these two issues and pausing over occasional *rapprochements* among writings of his contemporaries, we shall then proceed to an examination of his stand on the Quarrel of the Ancients and the Moderns. For, as it is impossible to stress too often, ancient artists were not only the archetypes or models to follow but were equated in Renaissance theory with nature itself.

Michelangelo Buonarroti, like his fellow craftsmen, held art to be an imitation, but for him it was as much an imitation of God's forms as of Plato's natural ones. In the third of the dialogues in Rome, Messer Lattanzio elicits the following definition of painting from Michelangelo:

The painting which I so celebrate and praise will be merely the imitation of some thing from those which the immortal God made, with great care and wisdom, and which he invented and painted like a master painter.[48]

He further explains that painting will be excellent insofar as it resembles and best imitates some work of God, whether man, beast, fish, or fowl. Buonarroti restricts his definition of the works of God to living things. We are a long way from the bed which Plato used in his *Republic* (X) to illustrate how the painter imitates an imitation of a creation of God. The most noble imitations, Michelangelo continues, will be those representing the most noble (living) things with the greatest delicacy and knowledge. In both theory and practice he is disinterested in the copying of inanimate objects, a fact which strikes us as we leaf through his draw-

ings and studies. We have noted elsewhere his conviction that a man's foot is a more worthy subject for imitation than his shoe, or a man's flesh than his clothing.

The artist's function is not to reproduce the entire multiplicity of nature described by Spinoza. The artist's function is to select and represent beauty in God's universe. The necessity of selecting well is never forgotten. One criterion by which Michelangelo judges good painting and a quality he misses in Flemish painting is "advertencia do escolher" ("attention to choosing"). Nature, the *natura naturans*, presents an infinite variety of choice and, as Michelangelo remarks in the *Dialogos*, "By such varying nature is beautiful," a Renaissance commonplace which Cervantes and others echoed.[49]

As we have seen, the beauty to be selected comes into visible presence from a higher source and is more readily apparent to sensitive (*accorti*) artists than to others. We found Michelangelo effecting a conciliation between the Neo-Platonic Idea of beauty and a Christian recognition that God is the source of all form and art. In this he was closer to Plato than to the Neo-Platonists. A sentence which Lee applies to Lomazzo describes with equal aptness Michelangelo, who "could temporarily divert the theory of imitation entirely from Aristotelian channels by declaring that ideal beauty, the image of which one sees reflected in the mirror of his own mind, has its source in God rather than in nature —a quasi-religious and mystical doctrine in harmony with the serious temper of the Counter Reform, and one that did not empirically find a standard of excellence in selecting the best from concrete and external nature, but discovered it in a Platonic fashion in the subjective contemplation of an inward, immaterial idea."[50] The "subjective contemplation of an inward idea" comes naturally to Michelangelo, whose artistic ideal is "un choncecto di bellezza, immaginata o uista dentro al core."[51]

Among some Cinquecentisti the goal of the artist was "non solo d'imitar, ma di superar la natura" ("not only to imitate, but to surpass nature").[52] In Michelangelo's theory, as we have stated, this becomes pointless arrogance or thoughtless rhetoric. God places beauty of form and color in the artist's media themselves—rock or pigment—and the artist's function is to find it and bring it to light:

Secondo che 'l sa trar l'ingegnio nostro.[53]

To the extent that our genius can draw it out.

God grants to a happy few the *intelletto* for reproducing or even imitating these forms. Since all art is pre-existent in nature, placed there by the *Sommo Fattore* (Dante's title becomes especially appropriate here), then no artist could in his imitation surpass nature, that is, improve upon God. The best he can possibly do is imitate. To be capable of even this much the artist must be a genius.

Two verbs are used by De Hollanda in quoting Michelangelo: *emitar* (imitate) and *terladar* (copy). In his poem "Molto diletta al gusto intero e sano," Michelangelo initiates an unusual usage of the verb *assembrare* in the sense of "imitate."

Bernini has left us an indicative story which illustrates Michelangelo's impatience with the fetish of literal imitation. Daniele da Volterra, working on a Pallas, had trouble painting the shield on her arm, which he was copying from a real shield. In despair he turned to his good friend Michelangelo and asked the older man to do this part for him. Michelangelo agreed, on condition that Daniele leave the room while he did it. Volterra retired to an adjoining chamber. Michelangelo unhurriedly removed the shield from its position near the painting and turned it face down on the floor in a corner. After a moment he picked up a brush, walked to the door, and recalled Volterra, asking him how he liked the imitation now. Marveling at the painted shield which could no longer be compared with the original, poor Volterra now found the imitation perfect.[54]

Buonarroti's lack of interest in nonidealised imitation spared him from the role of court portraitist, an indignity suffered by even the best artists in an age when society made sycophants of them. His insistence upon capturing the inner or spiritual man and abandoning realistic portrayal in favor of "transcending to the universal form" led him to generalise his few portraits, busts, or statues. In doing so he adhered to a long tradition of artists. In Xenophon's *Memorabilia*, Socrates is discussing imitation with the sculptor Kleiton. Socrates asks, "Does not the exact imitation of the feelings which affect bodies in action also procure a

sense of satisfaction in the spectator?" When Kleiton assents, Socrates concludes, "It follows then that the sculptor must represent in his figures the activities of the soul."[55] In more modern times Lord Chesterfield wrote, "By portraits I do not mean the outlines and coloring of the human figure, but the inside of the heart and mind of man."

In the Renaissance, Alberti's *De Statua* explained that there are two premises (*destinationes* in the Latin version, *risoluzioni* in the Italian) underlying portrait sculpture: the abstract (it does not matter whether the faces look like Socrates or Plato, provided they resemble man) and the particular (the work must not only resemble the subject in features, but also in clothing and attitude). Alberti, mindful of Pliny xxxv, reflected that the great artists of antiquity caught not only physical resemblance but also the character and ethos of their subjects. Euphranor painted Paris in such a way that the beholder could recognise the judge of the goddesses, the paramour of Helen, and at the same time the slayer of Achilles.[56] Another painted Ulysses so that "you could recognise in him not the true, but the feigned and simulated madness."[57]

Michelangelo definitely preferred the abstract premise. This "resolution" is consonant with the Neo-Platonic belief that Ideas are absolute and impersonal. Thus, Ficino's commentary on the *Symposium* notes that the images created by the soul are preferable to the images captured by the senses: "Itaque istam potius quam tuus animus fabricavit et animum ipsum eius artificem, quam exteriorem illam mancam dispersamque amato."[58] When people complained that there was no actual resemblance portrayed in the faces of Giuliano and Lorenzo over the Medici sarcophagi, Michelangelo countered with, "Di qui a mille anni nessuno non ne potea dar cognitione che fossero altrimenti" ("A thousand years from now no one could judge that they were otherwise").[59] This was the abrupt type of reply which he inevitably made when he chose not to discuss his art with people of little acumen. His *Bruto* does not resemble any Roman bust or image of this tyrannicide. When Catherine de Médicis wrote Michelangelo from Blois, requesting him to do an equestrian statue of her husband, Henri II, she stipulated that she wanted a good likeness; she sent his picture by an agent and gave specific instructions in a covering letter. In view of Michelangelo's intransigent atti-

tude about good likenesses, one can easily believe Vasari's statement that Michelangelo rejected portrait work, since he abhorred "reproducing *il vivo*," at least if it was not infinitely beautiful.[60] His attitude probably inspired Bellori to write that imitation of an individual model is never so noble as imitating an Idea. Bellori's precursor Danti held that portraiture was like "writing history," whereas imitation was like "writing poetry."[61] Incidentally, Vasari himself did not prefer the abstract resolution. In his life of Domenico Puligo he clearly implies that an unbeautiful face resembling the subject is to be preferred to a beautiful face portraying abstractly.

Michelangelo's option for the abstract resolution extended beyond portraits of known people. His *Madonnas* do not look Semitic, although this particular bit of generalising was common enough at the time, as Samuel Clemens grumblingly observed. Only the *Cleopatra* attributed to him shows a concession to realism in the Eastern features of the queen.

Echoing Vasari, Bernini recalled that Michelangelo had never wanted to do a bust or portrait. There were exceptions. Whether Michelangelo executed his bust of Vittoria Colonna is not certain. He definitely did a portrait of Tommaso Cavalieri "in cartone grande di naturale" full enough to include the hands, which held a picture or medallion.[62] He, like Cellini, received a commission to execute a bust of Duke Cosimo de' Medici, but, as with Henri II's statue, never fulfilled it.[63] In a sense the destroyed bronze *Giulio II* was a portrait for which the pontiff posed at Bologna. It is highly doubtful that he did a portrait of Andrea di Rinieri Quaratesi, although the latter's grandson claimed that a Carlo Dolce engraving of Andrea was from an original by Michelangelo.[64] Buonarroti became expert in extricating himself from the obligation to do portraiture. In the case of Catherine de Médicis he managed to have the commission offered to Daniello Ricciarelli "per essere vecchio."[65] To this excuse of old age he added blindness ("non veggo lume") for good measure in declining to do the portrait of Duke Cosimo.[66] He evidently turned down the Genoese Senate's request that he do a statue of Andrea Doria.[67] Even Aretino's blackmail did not make him accede to Pietro's covertly worded request to be painted, although it may be that the *San Bartolommeo* of the Sistine wall is none other than Aretino

clutching the pelt with Michelangelo's own "faccia di spavento." If Michelangelo turned down those pleas, he was inwardly pleased to be solicited by kings and noblemen. For in the *Dialogos* he notes the importance Alexander the Great attached to having his portrait done by just one artist, Apelles, and he approves of Alexander's good judgement.[68]

Considering his disinclination toward portraiture, was it his affection for Cavalieri and Vittoria Colonna that made him willing to consider making exceptions of them? Probably so. But he was further compelled by their "infinite beauty." This is the reason adduced by Vasari, who said that, after the portrait of Cavalieri, Buonarroti never did another.[69] And in a sonnet to Vittoria (CXXXXI), quoted above, Michelangelo says that he will do the lady in color or stone so that the world will see how beautiful she was. A really fine and beautiful face imparts force and grace:

> *La forza d' un bel uiso a che mi sprona?*
> *C' altro non è c' al mondo mi dilecti:*
> *Ascender uiuo fra gli spirti electi*
> *Per gratia tal, c'ogni altra par men buona.*

> *To what does the force of a beautiful face drive me?*
> *Since there is nothing else in the world which may delight me,*
> *it incites me to ascend living among the chosen souls,*
> *through that grace beside which every other seems less good.*

Again, Michelangelo cannot be referring to mere physical beauty, since Papini and others demonstrate that Vittoria was physically graceless and unfeminine, qualities commemorated in Michelangelo's reference: "Un uomo in una donna" ("A man in a woman").[70] Unfortunately, faces of such physical or spiritual beauty are seldom found among patrons. (Sargent wrote, "Every time I paint a portrait I lose a friend.") In forsaking portraits Michelangelo was neither obliged to immortalise ugly physiognomies or souls like Goya nor yet to use subterfuges as did the ancient artists at the court of Pericles who, because of the Athenian statesman's long and ugly head, never represented him bareheaded but always with his helmet.[71] It must have been, then, a very real admiration which moved Michelangelo to praise Titian's portrait of Alfonso d'Este (Plate VI) and Luca Longhi's painting of Monsignor Guidiccione.[72]

Was there a Christian bias in his dislike of portraiture? It is possible. A partisan of the Piagnoni could feel this as strongly as a Puritan. Was it not a lack of humility, was it not an empty gesture of vanity to place on display a picture or bust of oneself? Especially if one's chief claim to fame was merely a social or political or economic success which accorded one enough scudi to hire the services of an artist. Let us again note an affinity with Savonarola. The worthy friar also disliked portraits as vanities, even though Fra Bartolommeo painted him on two occasions,[73] and urged his faithful to burn them as well as lascivious pictures. As we have noted above, he did not even wish likenesses on religious figures.

Thus, a Christian or theological motivation combined with Neo-Platonism to form Michelangelo's preference for the abstract resolution. The theological motivation also prompted him to make the Virgin of the *Pietà* too youthful-looking, eliciting complaints from his more literal-minded contemporaries.[74] Nor was consistency important: witness, in three successive panels of the history of Adam on the Sistine Vault, how man's common ancestor changes between the *Creazione di Adamo* and the *Espulsione,* even to the shade of his hair.

The idealisation which Michelangelo practiced on his portraits of Giuliano and Lorenzo and on the face of the Virgin of the *Pietà* was called by Lomazzo "il velo d'arte" ("the veil of art"). Lomazzo advised its adoption in portraiture, although not at the complete sacrifice of *similitudine,* and added that Michelangelo was good at this veiling.[75] One critic has tried to describe the generalised type of head which resulted from Michelangelo's preference for the abstract resolution: "the type which includes the heads of all Michelangelo's most famous statues —the high-bridged nose and its depressed end, the hollow between the chin and jaw, the flattening of the end of the chin, the horizontal depression running in Greek fashion across the middle of the forehead."[76] Aretino complained in Dolce's dialogue that "he who sees one figure of Michelangelo sees them all."[77] Vasari explains how Michelangelo sought to "transcend to the universal form" in sculpturing figures. "He was wont to make his figures nine, ten, and twelve heads long, seeking only, in placing the figures together, to leave a certain gracious harmony in the ensemble which natural proportions would not create."[78]

Someone has remarked a bit arbitrarily that this idealisation is most complete in the histories of the Sistine Ceiling, almost as complete in the *Profeti, Sibille,* and *Ignudi,* and very terrestrial and realistic in the figures of the spandrels and lunettes. In terms of Aristotle's *Poetics,* it is a progression from the manner of Polygnotus, past that of Dionysius of Colophon, toward that of Pauson.

Even though Michelangelo tended to idealise his subjects rather than render a likeness, he was unwilling to attempt the portrait of someone who was absent in death. When Cecchino Bracci, the handsome Roman youngster of fifteen, died, Buonarroti wrote to Cecchino's friend Riccio that he could not do a bust ("intagliar la testa," to use Riccio's words) of the lad whom he had so cherished, he would have to portray him through his beloved friend Riccio (LXXIII, 15):

> *Dunche, Luigi, a far l'unica forma*
> *Di Cecchin, di ch' i' parlo, im pietra uiua*
> *Ecterna, or ch' è gia terra qui tra noi,*
> *Se l'un nell' altro amato si trasforma,*
> *Po' che sanz' essa l'arte non u' arriua,*
> *Conuien che per far lui ritragga uoi.*

> Then, Luigi, to portray the beauty, unique in the world, of Cecchino, of whom I speak, and render it eternal in living stone, now that he is transformed to dust among us—art, not having this beauty before it, cannot succeed in picturing it. It is fitting that, to portray him, I should picture you, if it is true that one of the loved is transformed into the other.

Again Michelangelo avoids having to "far somigliar il vivo" and his disciple Urbino does the bust. When Gandolfo Porrino wants a bust of the deceased Faustina Lucia Mancini, he is gently brushed off with a similar sonnet (CIX, 68). The burden of the sonnet to Riccio, that an individual relives in the person of a loved friend, recurs in Michelangelo's "Veggio co' be' uostri occhi un dolce lume."

Among those critics who espoused ideal rather than literal imitation, Dolce (and even Alberti, as we saw) urged painters to follow the plan of Zeuxis in representing Helen (more usually Venus) and to choose the best feature from several models. Condivi suggests that Michelangelo was partial to this procedure and that it was part of his true theoretics.[79]

Michelangelo was no doubt impressed to find his intellectual mentor, Ficino, whom he had listened to in the Medici Palace on Via Larga, making of Zeuxis' old composite a Neo-Platonic concept: "Quicquid ubique rectum est, colliges; figuram apud te integram ex observatione omnium fabricabis, ut absoluta humani generis pulchritudo, quae in multis reperitur sparsa corporibus, in animo tuo sit unius imaginis cogitatione collecta."[80] Raphael found that slim pickings made it difficult to follow the lead of Zeuxis, even though he, too, expressed his feelings in Neo-Platonic language. He wrote to Castiglione: "To depict a beautiful woman, I ought to see a number of women, but since there is a dearth of beautiful women, I make use of a certain Idea which comes to mind."[81]

The second major conception of imitation—plagiarism—was only a shade less acceptable to the artists than to the poets. This type of mimesis, which had been identified in the precepts of Dionysius of Halicarnassus and perpetuated by Quintilian (who had insisted, however, that only the best creative minds should be plagiarised), had its most stanch proponent during Michelangelo's lifetime in Vida, who incited fledgling writers to steal repeatedly from the masters who had preceded them. In the fine arts plagiarism of classic artists especially was condoned. In his dialogue, Dolce wrote: "And in part one should imitate the beautiful marble or bronze figures of the antique masters. Those who fully savor and possess the admirable perfection of these will be surely able to correct many defects of Nature and make their paintings attractive and pleasing to everyone; for things of antiquity contain all the perfection of art and can be exemplars of all that is beautiful."[82] In a sense, all the Cinquecentisti indulged in plagiarism, for novice painters and sculptors continued to copy from previous models even more than they had in the Middle Ages. Sculptors were expected to copy such statuary as the *Laokoön*, unearthed in Michelangelo's presence. Painters, without pictorial models from antiquity, had either to copy from this same statuary (Alberti remarked that painters learned more copying statues than copying paintings) or to accept Trecento and Quattrocento artists as their ancients. Scores of hopeful painters, for example, started their careers, as did the young Michel-

angelo, copying figures from Masaccio's frescoes in the Brancacci Chapel of Santa Maria del Carmine in Florence or from Giotto's *Ascension of St. John the Evangelist* in Santa Croce. Giotto and Masaccio had to stand in for Zeuxis and Apelles. Michelangelo, in fact, claimed that Raphael had thus learned from him. Incidentally, Vico attributes the poverty of Renaissance sculpture and the richness of Renaissance painting to this very fact that the painters, having no Hellenic predecessors to follow, were obliged to imitate nature itself. Indeed, he wonders whether it might be better to destroy all ancient models of art in order to heighten the level of modern artistic performance.[83]

Part of Michelangelo's early fame rested on his ability to copy ancient drawings. Vasari relates pridefully that Michelangelo counterfeited ancient drawings so artfully that the copies were indistinguishable from the originals.[84] He implies that Michelangelo was not trying to deceive anyone and absolves him of blame by explaining that he merely wished to keep the originals as samples of others' art to emulate and surpass. After all, he did give back the imitations! The exculpation is typical of the Renaissance, as is the ruse itself: Ariosto pretending to draw upon a chronicle of Turpin and Cervantes upon an Arabic autograph manuscript; Cardinal de' Medici hoping to pass off Bandinelli's copy of the *Laokoön* as the original to Francis I.[85] The story of Michelangelo's *Cupido dormente,* carved and artificially aged to simulate an ancient statue and sold as such in Rome, is a familiar one. In fact, this forgery was the production which won him his first contract in that capital. Moreover, the work which first drew him to the attention of Lorenzo de' Medici was the imitation of a marble faun's head which Michelangelo encountered in the Giardino Mediceo.

Before quoting Michelangelo directly upon the subject of plagiarism or copying from earlier craftsmen, let us examine to what extent he, like other Cinquecento artists and writers, has been subjected to study of his sources. To make a complete list of all the purported bellartistic borrowings would fill an entire monograph in itself. There are various catalogues of these indebtednesses already in existence.[86] We shall list a sampling of the *rapprochements* brought to light by several generations of scholars. First, the paintings: Grimm held that the *Adamo, Noè,* and

the *Golia* owe their essential idea to the gates of Ghiberti, which Michelangelo judged worthy of Paradise. The motiv of the nude athletes in the Doni *Madonna* is said to be derived from Signorelli's *Madonna*. Symonds claimed that Charon and Minos in the *Giudizio universale* are borrowings from the *Divina Commedia*. The *Sibilla Eritrea* was supposedly lifted from a nude youth in Signorelli's *Last Will of Moses*. The *ignudo* to the right and above the *Eritrea* derived from an ancient gem representing Diomedes with the stolen Palladium (Justi). It has often been alleged that Michelangelo copied from himself: that the large oil study of the *Leda* in the National Gallery shows that the original must have resembled the *Notte* in pose. De Tolnay writes that "for the most part, the poses of the Sibyls are also organically developed from Michelangelo's own earlier works. The only exception is the Erythrean."[87] There are, of course, the inevitable charges of plagiarism based on the most exiguous of evidence. For example, Michelangelo is said to have taken one of his *Dannati* in the *Giudizio* from a drawing of an abandoned Christ by Dürer. The basic anatomical poses are somewhat similar, but every other element (costume, mood, setting) is dissimilar, to say nothing of doubts that a damned soul would have been inspired by a melancholy Christ. Still, stranger pillaging was going on.

Among the sketches, an unfinished nude seen from the rear (Berenson, 1656) is said to originate in the Hercules of a sarcophagus in the Lateran. The figure of a sack-laden *putto* on the Louvre drawing of *Mercurio* (Berenson, 1588r) has been traced to a statue on the Fontana Cesi in Rome. Two sketches of a nude woman in the Musée Condé at Chantilly (Berenson, 1397r) are purported to derive from an antique group of Graces in the Libreria Piccolomini in Siena; a nude study in the Louvre may have originated in the ancient Sidamara Sarcophagus.

Finally, some examples from statuary: the *Bruto*, according to Vasari, was imitated from a Roman cornelian owned by Giuliano Ceserino, and is now thought to be modeled on a bust of Caracalla. The open-handed gesture of the *Madonna della Febbre*, with the limp right arm of Christ, evokes the *Pietà* of Jacopo del Sellaio which had been in the Church of San Frediano in Florence. Mackowsky and others have pointed out that the *San Matteo* has similarities with the *Laokoön*, which Michel-

angelo knew so intimately, while Grünwald posits that the ancient *Pasquino* was the original model. Others—and we assent—have found the wicked Haman of the Sistine Ceiling a more obvious recall of the *Laokoön*. The head of the marble *David* was presumably derived from the head of Donatello's *San Giorgio*. De Tolnay even finds that the composition of the *Pietà* in St. Peter's "can hardly be explained otherwise than by Michelangelo's fascination with the figure of Christ in Leonardo's *Last Supper*."[88] Did Michelangelo ever see this work, not mentioned among his criticisms (see Chapter IV)? Melani finds that in Donatello's *San Giovanni* "there is the future *Mosè* of Michelangelo."[89] As in the case of the paintings, Michelangelo supposedly pirated from himself. Thus, the pose of the *Crepuscolo* is thought to be taken from one of his earlier lunette figures. As in the case of the paintings, Michelangelo raided literary sources for his sculpture. According to Brockhaus, the *David* and the Medici Chapel figures originated in Savonarola's preachings.[90]

Many other plagiarisms are alleged. Even in the field of architecture, it is conjectured that the "house of the dead" conception of the Medici Chapel may have come to Michelangelo from a sarcophagus placed alongside the entrance to the Florentine baptistery.[91] Every year or two a new source turns up for some figure. If only a few of these allegations were valid, and some must be, they would illustrate that Michelangelo followed the practice of Renaissance writers in culling the best from earlier masters and processing it into their own works. This culling device became a common practice in literature and was specifically endorsed by Minturno, Camillo, Boiardo, and others.[92] Condivi applied this bee image to Michelangelo himself, "thus choosing the beautiful from nature, as the bees gather honey from flowers, making use of it later in their works."[93] This process of distilling the best from others has been given by Faguet the name of "innutrition." In the fine arts it goes back through medieval workshop practices to Lysippus, who fashioned a goblet out of a variety of different cups. Bellori supplies several further examples from antiquity. Vasari claimed that Michelangelo's success at innutrition was so complete that it passed unnoticed. "Michelangelo was of such tenacious and profound memory that after seeing someone's works once he remembered

and used them in such wise that almost no one ever noticed it."[94] Vasari could ill foresee the extent to which scholarly detectivism would finally contradict him.

Yet Michelangelo never admitted to borrowing ideas or forms. Quite the contrary. As for ideas, he felt that he had his own personal thoughts to convey. The poems are an eloquent proof of this. In his poetry Michelangelo stood apart from contemporary poets and did not plagiarise. Even when his sonnets and madrigals are most Petrarchan or Platonistic in spirit, one can find none of the direct copying indulged in by even the best Renaissance craftsmen. The only poet on whom he apparently drew directly was his old Florentine mentor, Poliziano. It seems to us that Michelangelo's "Fuggite, amanti, amor, fuggite 'l foco" derives closely from Poliziano's "Pigliate esemplo, voi ch'amor seguite" and we have found other less striking resemblances in the canzonieri of these two men. His individual poetic style he borrowed from no one. He felt that his artistic style was equally individual and would have heartily approved a recent statement by Panofsky: "A comparison between Michelangelo's 'borrowings' and their prototypes makes us particularly aware of certain compositional principles which are entirely his own and remained essentially unaltered until his style underwent the fundamental change discernible in his very latest works."[95]

Michelangelo, like Leonardo and the rest, would grant that apprentice artists and learners should copy from the established masters. Danti's *Trattato* instructed beginners to "inanimirsi" ("form their kernels") from Michelangelo.[96] Whether or not Buonarroti was guilty of the imitations charged to his account, whether they were conscious or unconscious, he was in principle against either plagiarising and copying, except by novices. Although he was exposed to a lax tradition regarding copying, his reluctance to duplicate his own formal inventions carried over to the duplication of inventions of others. He scoffed that if one has no real talent one cannot even imitate well enough to justify the effort: "Colui che va dietro ad altri non li passa innanzi e chi non sa far bene da sè, non può servirsi bene delle cose d'altri" ("He who goes along behind others never passes ahead of them, and he who isn't able to do well by himself cannot utilise well the works of others").[97] This basic

· *161*

statement is attributed to Michelangelo by Armenini as well as by Vasari.[98] Armenini states that the artist is referring to a contemporary who claimed to have copied some Greek marbles and improved on them; others say that Michelangelo was specifically voicing a slur on Bandinelli. A counterpart to the quotation above are the further words cited by Vasari, "L'artista può essere superato solo da sè stesso" ("The artist can be surpassed only by himself").[99] Michelangelo set his thought to verse in a sonnet (LXXXIX):

> *Che chi senz' ale un angel seguir uole,*
> *Il seme a sassi, al uento le parole*
> *Indarno ispargie e l' intellecto a Dio.*

> *For he who would without wings*
> *follow an angel, in vain he casts*
> *seed on rocks, words on wind, and intellect to God.*

Vasari gives further testimony regarding Michelangelo's prejudices on plagiarism by telling an ironic, revealing anecdote. Buonarroti was shown a storey painted by an artist who had appropriated so many parts from other drawings and paintings that there was little original left in it. His cutting remark was:

"Bene ha fatto; ma io non so al dì del Giudizio, che tutti i corpi piglieranno le lor membra, come farà quella storia, chè non ci rimarrà niente."[100]

"He's done well, but I don't know what that storey will do on Judgement Day when all bodies will take back their members, for there won't be anything left to it." (*Cf.* below, Chapter VII, note 6.)

A temperate reminder by Michelangelo that painters would do well to copy living subjects rather than the plastic creations of other artists was related by Armenini:

"E sappiasi ancora che le scolture e i rilievi à i quali le perfette pitture debbono assomigliarsi non s'intende solamente essere quelle di marmo e di bronzo, ma più tosto le vive, com'è un bell'huomo, una bella femina, un bel cavallo, & altre simil cose."[101]

"And let it be known also that the sculptures and reliefs which perfect paintings must resemble are not only, of course, those of marble and bronze, but rather living ones, such as a handsome man, a beautiful woman, a fine horse, and such."

This statement condemning the imitation of imitations was spoken while the artist was making a distinction between good and bad painting.

How did Michelangelo feel when painters and sculptors who were no longer novices elected to copy him? Did he feel, like Cyrano de Bergerac, that this was the greatest compliment one could pay him? No, even in such flattering circumstances Michelangelo was adamant, more so than usual. Armenini tells that Michelangelo entered the Sistine Chapel in the company of a certain bishop and encountered a zealous band of artists hard at work copying. With his usual frankness, Michelangelo exclaimed: "O quanti quest' opra mia ne vuol ingoffire!" ("Oh, how many there are who want to make something clumsy of this work of mine!") [102] As Baldinucci relates the story, Michelangelo's words were, "Questa mia maniera vuol fare di molti goffi artefici" ("This manner of mine will make many into clumsy artists"). [103]

We must keep in mind three types of copying: conscious copying as a form of training or discipline, unconscious copying after the imitator has absorbed the master's manner, and outright plagiarism or forgery. Michelangelo seemed particularly concerned about the second type, the unconscious copying, as the Baldinucci version of his complaint attests. This "inimitable" artist, as he was called by his contemporaries, viewed as dangerous to his own reputation such imitators as the Venetian Battista Franco, who spent so much of his lifetime copying Michelangelo that he never got around to doing anything of his own until too late and he could produce only literal imitations. This could happen to greater artists than Franco. Scivoli studied Bernini's style after the latter had been copying the *Giudizio universale* and commented:

"You're a rogue [*furbo*]. You aren't doing what you see. This is pure Michelangelo!" [104]

Perhaps Michelangelo's sensitivity on this point was motivated by a knowledge that imitators of great artists tend to imitate weaknesses or peculiarities rather than strong points. This fact has been enunciated in recent times by Gide: "Dans toute l'oeuvre d'art, le défaut, la faiblesse passe à la faveur du parfait; c'est l'imparfait que reprend le disciple parce que c'est cela seul qu'il peut espérer de pousser plus loin." Gide cites as proof the cases of Balzac, Baudelaire, and Michelangelo. [105]

Once a plagiarist had been imbued with the style of Michelangelo he could undertake independent forgeries, as did Giuliano Leni with his project for the façade of St. Peter's. Plagiarists could offend on the planes of both economics and amour-propre. Michelangelo's feelings must have been sharpened by the unfortunate case of copying when Rosso Fiorentino apparently copied his *Leda* before 1530 and sold the copy to Francis I before Mini arrived in France (1531) to offer the King the original.[106] Ironically, copies survived while the original disappeared.

In sum, we must class Michelangelo with Lomazzo, who decided that people who are not favored by nature, but only by art, try merely to imitate others and turn out odious things.[107]

As for those zealous sleuths who would detect imitations within the works of Michelangelo themselves, claiming despite the evidence of their eyes that the *Leda* and the *Notte* have a common pose, we recall the following claim by Condivi, capital to an understanding of Buonarroti's feelings about imitation:

È stato di tenacissima memoria, dimanierachè avendo egli dipinte tante migliaia di figure, quante si vedono. non ha fatto mai una, che si somigli l'altra, o faccia quella medesima attitudine: anzi gli ho sentito dire che non tira mai linea che non si ricordi, se più mai l'ha tirata; scancellandola, se si ha a vedere in pubblico.[108]

He was of a most tenacious memory, so that having painted so many thousands of figures, as may be seen, he never did one which resembles another or shows the same pose; in fact, I have heard him say that he never draws a line but that he remembers whether he has ever drawn it before—and then erasing it if it is to be seen in public.

Even if one takes the first part of Condivi's statement as the rhetoric of hero worship, the quotation itself is most important. Michelangelo makes a doctrinary point on the matter, as though repetition were a reflection on his inventiveness. Note that he has no hesitation about repeating subject matter—only form and pose—allowing us to conclude that, in the face of the debated dichotomy of form and content, Buonarroti here reveals the neoclassic preference for form.

Vasari gives similar testimony:

...nor among his works did he ever do one which duplicates [riscontri] another [formally], for he remembered all that he had done.[109]

It was one of those rare points on which he agreed with Leonardo, who felt that "the greatest defect among painters is to repeat the same movements and the same expressions."[110] Alberti had been less demanding, decreeing only that no gesture or pose should be repeated in the same picture.[111] To appreciate that Michelangelo was not out of joint with his times on this point, remember the public outcry ("sonnets and villainies") directed at Perugino when he repeated figures; in vain did he try to defend himself, "These figures were once praised by you and pleased you infinitely. If now they displease you and are not praised, what can I do about it?"[112]

Supporting his thesis that Michelangelo had a tenacious memory for lines and poses, Vasari relates the following anecdote: "In his youth he was once dining with some of his friends, painters, and they started up a contest at drawing clumsy and crude figures like those match-stick figures [fantocci] that silly people make and scrawl upon walls. Here his memory served him well, for remembering having seen on a wall one of these clumsy drawings, he reproduced it just as though he had it before his eyes at that moment and won over all those painters; a difficult thing for a man so full of design and so accustomed to a highly selected art, to be able to come out on top so clearly."[113]

Michelangelo's view on the doctrine of imitation, both of nature and of established artists, sheds light upon his stand in that Quarrel of the Ancients and Moderns which provoked so much debate in the sixteenth and seventeenth centuries. One could and should imitate ancient works. Michelangelo carried this to the extreme by covering his fraudulent *Cupido* with an artificial patina. But could one surpass the ancients, as Condivi claimed for this *Cupido*? We shall find in Chapter IV that he often compared contemporaries with ancient artists; in fact, rivalry with the ancients is one of his twenty-four criteria of criticism. Despite a few rhetorical relapses, he did not and could not feel that a modern could surpass an ancient. His reason can be expressed most simply as a syllogism:

THESIS: Ancient artists are so close to nature and divinity as to become natural and divine to a greater degree than is possible in modern times. (Cf. Pope, "Nature and Homer were the same.")

PARATHESIS: A modern cannot surpass nature.

SYNTHESIS: A modern cannot surpass ancient artists.

Just as the literary theorists of the Renaissance held that the earliest generation of Hellenic writers (Amphion, Orpheus) were closest to nature and divinity, so does Vasari prove that this belief was held concerning the earliest artists: "Quei primi uomini, i quali quanto manco erano lontani dal suo principio e divina generazione, tanto erano più perfetti e di migliore ingegno, essi per loro, avendo per guida la natura"[114] ("The less distant those first men were from their origin and divine beginnings, the more perfect and possessed of genius they were, having nature as their guide"). Bellori wrote that one should study the ancient works of statuary carefully, the classic artists "havendo usato l'Idea mervigliosa," since they were closer to that Idea; he adds that Michelangelo has restored the Greek Idea.[115]

As a boy, having left the atelier of Ghirlandaio and engaged in copying the ancient statues of the Giardino Mediceo, he must certainly have felt that one could do no more than approach the ancients. As life went on, his goal became *aemulatio* rather than *imitatio*. Condivi wrote that Michelangelo's desire to do a colossus at Carrara was inspired by "emulation of the ancients." We have already noted his blunt remark that those who follow after artists slavishly cannot surpass them. When his contemporaries began to hail him as the new Apelles, or as "divino"—that very quality which Vasari says artists possessed in proportionately greater measure the further back in time they lived—his consciousness of being part of a Renaissance was intensified. The Renaissance conception of Italy as the third home or phase of classicism was obviously entertained by Michelangelo. He came to feel that Italian artists were the natural successors to the ancients (Hellenic rather than Roman) and that "the mode of painting in Italy is that of antique Greece."[116] Unaided by

any theory of evolution, he and his contemporaries assumed that being a direct descendant implies potentialities of equality with the ascendant. In the Cinquecento they did not go so far as to suppose potentialities of Darwinian or Mendelian improvement.

This chronological self-consciousness, this feeling that a new age of Pericles or Augustus had returned, was widespread during the latter half of Michelangelo's lifetime. Whereas the concept was coined as early as Brunelleschi and Ghiberti, it is generally with Vasari that one associates earliest mention of a *rinascita* of the arts, Giorgio thus anticipating by far Michelet's coinage of the term "Renaissance."[117] Lomazzo viewed the Italian High Renaissance as a *risorgimento* and, more important for us, considered Michelangelo's art the epitome of that resurgence. He deals with this subject in three passages, twice in the *Idea del tempio della Pittura* and once in the *Trattato*.[118] The substance of these three texts is that art had been dead since the days of the Emperor Constantine: "the arts lay as if interred." A resurgence began to make itself felt in the time of Cimabue, and reached its culmination at the time of Buonarroti. Some credit is due Maximilian and Charles V, who made art "resurge more beautiful than ever." Armenini does not use the word *rinascita*, nor *risorgimento*, but spoke of a reflowering of the arts. With this consciousness of a new golden age becoming widely experienced, and with such intransigent moderns as Leonardo speaking of ancient works as "queste anticaglie" ("this out-of-date stuff"), Michelangelo could easily acquire considerable self-confidence in the rivalry with the ancients. This attitude of his entitles one to question whether Michelangelo committed a fraction of the artistic plagiarisms upon antiquity which zealous scholarship has laid at his door.

There were, Michelangelo knew, certain individual skills and techniques in which the ancients excelled, beyond their advantage of more natural inspiration. On seeing certain statues of Phidias and Praxiteles in Rome, he is reported by Lomazzo to have stated that the classic workers were superb in making colossi, a matter also discussed in Alberti and Gaurico. "I shall not pass over what the divine Michelangelo was accustomed to say on the art of making them, that is, that the ancients possessed the true science of knowing how to view statues from both near

and far" ("gli antichi avevano la vera scienza del saper mirar le statue d'appresso e di lontano").[119] By this Michelangelo meant that the ancients "had compasses in their eyes" and could manipulate proportions to create an optical illusion of exactness. Michelangelo went on to observe that this basic science was lost among the moderns.

Of course, Buonarroti kept hearing himself lauded as equal and superior to the ancients. He was the epitome of the modern quite often in the Quarrel of the Ancients and Moderns. Cosimo Bartoli credited him with the fact that Italy no longer needed to be jealous of ancient Rome. The eulogies at the ceremonies of Buonarroti's burial in Florence almost unanimously pictured him as the equal or better of Apelles, Phidias, and Vitruvius.[120] Michelangelo could compare other countrymen favorably with the ancients, as we have stated. From his enumeration, in the *Dialogos em Roma,* of Italian centers of art and architecture one understands clearly that he considered his fellow Italians as rivaling the ancients, while artists of other countries lagged behind. When Fra Guglielmo della Porta restored the legs of a Hercules in the Farnese Palace, only to have the missing legs brought to light, Michelangelo ruled that Della Porta's reparation should stay, in order to show, Baglione wittily claimed, "by that so worthy restoration that the works of modern sculpture could stand on equal footing with ancient works."[121] Discounting such a peripheral remark as Michelangelo's exclamation on Begarelli's terra cottas, "If this terra cotta became marble, alas for the ancient statues!" (see Chapter IV), he did not really assume that any contemporary surpassed either the ancients or nature itself. However, when he executed plans for a church for the Florentines in Rome, Renaissance enthusiasm won out for the moment and he claimed that, if the designs were carried out, "nè Romani nè Greci mai ne' tempi loro feciono una cosa tale" ("neither Romans nor Greeks ever accomplished such a thing in their temples").[122] We are reminded of Bramante's boast that his Basilica of St. Peter's would be the Basilica of Constantine crowned by the Pantheon.

These, then, are Michelangelo's thoughts on the Quarrel of the Ancients and Moderns. Oscar Wilde once asserted that all good art looks perfectly modern. Michelangelo would have put it that all good art looks perfectly ancient.

The most classical element in the aesthetics of Michelangelo is his love of form. His insistence upon form and design, his acceptance of *disegno* as the common basis of all arts, these are familiar convictions of his. Most discussion of form in Buonarroti becomes a discussion of the human figure, even when that discussion treats of architecture. Long before a Brancusi could maintain that nude men are plastically less beautiful than toads, Alberti had written in *Della Pittura* that "in the composition of bodies consists all the genius and all the praise of the Painter,"[123] a thought echoed in Vincenzo Danti.[124] To Michelangelo the male figure was the supreme challenge to the artist and it "required the greatest orderliness of composition" (Danti). It embodied "universal form," as one gathers from Michelangelo's verses honoring Cavalieri. It is God's handiwork, the only raiment with which God clothed man: "Signior mie caro, tu sol che uesti e spogli" (CLVX). The body was, moreover, the concrete and visible manifestation of God himself. We have already quoted the piece "Per ritornar là donde uenne fora," where Michelangelo specified that God is reflected in the human figure as in a speculum. We learned that according to the Neo-Platonists, the human body constitutes one of the three levels at which God is mirrored. The sonnet "Veggio nel tuo bel uiso, Signior mio" also supports Michelangelo's belief that the body is infused with divinity and light and thus reflects God, a belief held in common with Ficino: "Non enim corpus hoc vel illud desiderat: sed superni luminis splendorem per corpora refulgentem admiratur, affectat, et stupet."[125] This Neo-Platonic belief in the divinity of the body, contrasted with the orthodox Christian negation of the body, allowed Michelangelo to take a firmer stand on the issue of anthropomorphism and iconolatry. God, Christ, and the Virgin may be represented in human form; the Gods of the Sistine *Creazioni* may resemble noble patriarchs.

In the sonnet "Per ritornar là donde uenne fora," Buonarroti implies that beautiful forms descend to earth only to return to heaven whence they came. Some critics have seen in the Adam of the *Creazione di Adamo* the male figure of the *Sogno,* and the *Prigioni* human figures striving to rise to divinity. It was common theory in the Renaissance that the body was the expression of the soul, reflecting its perfections and

imperfections. To Michelangelo the goal of art was to conceive man as perfect and then execute that perfection. "He could only strive to make man himself the image of the divine, to suggest by the outward form the infinity within. But it is an infinity cramped and tormented, ill at ease under earthly conditions. Michelangelo might share his contemporaries' belief that man was a terrestrial god, but not their contented acceptance of his mortal state. For him the god was in exile, the ruler of the earth and yet a stranger on it. The sense of strain and dissatisfaction in his work is apparent even in his earliest classical efforts and grows steadily more marked in the works of his maturity."[126] It may be fruitful to keep in mind this Neo-Platonic interpretation of the Man (his sketch of the crouching Samson also comes to mind) who has absorbed so much attention in Michelangelo's work. To still other interpreters the emphasis has been not on strain but on strength and vitality. To Farinelli this figure who dominates the grandiose frescoes is "man with his exuberance of life."[127]

Michelangelo's interest in male nudes induced him to introduce them into his productions at any cost. He once observed to Vasari that where marble figures could be used as a decorative element there was no need for foliage or anything else.[128] Bernini also reports a variant of this opinion. Recalling that Michelangelo had not liked decorative borders, he adds, "c'est aussi la raison pourquoi Michel-Ange ne voulait pas qu'on ornât les niches, et disait toujours que la figure était l'ornement de la niche."[129] He "kept hammering the point home" to De Hollanda that figures and faces should stand out prominently, occupying only part of the painted surface and leaving empty and dilated spaces to give them an unattached freedom and clarity. The most surprising and incongruous appearance of decorative nudes is in the background of the Doni *Madonna*, where the unexplained (unless by these testimonies of Vasari and Bernini) nude athletes seem out of harmony with the subject. It is said that the artist strove to surpass Signorelli's *Madonna*, which had the same circular setting and four nudes in the deeper plane. One may seriously question whether the *Ignudi* of the Sistine Ceiling, which Wölfflin saw as developments of those in the Doni *Madonna*, have a valid artistic function, for their position and iconographical function are ap-

parently little more than those of the *putti* accompanying the medallions. They are probably mere decorative motivs rather than symbols of Neo-Platonic forces and desires. In neither the *Madonna* nor the Sistine Vault did Michelangelo even bother to make angels of them, any more than he deigned to grace with wings the little genii who hover about the *Profeti* and *Sibille*.

The *David* of marble furnishes a further illustration of his preoccupation with the male nude. Poggi notes that when Michelangelo started to work the marble, which had been partially carved by Agostino di Duccio and possibly others, there was a knot (*nodus*) on the chest which may have indicated that a mantle was to cover the figure. Michelangelo lost no time in cutting off the knot to execute the nude *David*. In the Medici Chapel, Duke Giuliano wears a baffling cuirass, absolutely transparent to reveal the surface and musculature of his anatomy. Another curious example of this interest in male form (and unconcern for context) is the *Saettatori*, of which only a copy is known to us, showing seven male and two female figures apparently shooting arrows at a herm. While most of them are in the tense posture of drawing back the bowstring, they carry no arrows whatsoever, and several of the arrows have already reached their mark; the contortions and movements of the archers interest Michelangelo, but stage trappings do not, leading Panofsky to seek in Pico a Neo-Platonic meaning for the work. On the Sistine Ceiling, Noah's sons appear as naked as their father, despite the tradition and the Biblical source. The earliest example of Michelangelo's infatuation with nudes in quantity was the *Battaglia di Cascina*. Commissioned to paint this action fought in 1364 between Florentines and Pisans, Michelangelo picked from Villani's *Cronaca* no scene of dusty and arms-weighted battle, but a moment when the Florentine soldiers are bathing and are warned by Manno Donati of the enemy's approach. Of the resulting cartoon, Müntz said that no comparable horde of human bodies had ever been seen in Renaissance art, with the one exception of Signorelli's frescoes at Orvieto. Similarly, Michelangelo's two red-chalk sketches of the *Attack of the Serpents* and the *Healing through the Brazen Serpent* serve as exercises for the execution of swarms of contorted bodies and an orgy of the serpentine (no pun) line.

It was observed in Chapter II that Michelangelo's preoccupation with the nude was strengthened by his long studies of anatomy. His earliest figures, like the sketches for the *Battaglia di Cascina* in Vienna's Albertina Museum, were close to anatomical studies. Vincenzo Danti, who boasted of performing over eighty-three anatomical dissections, wrote that an artist arrived at a sense of proportion through "diligent anatomy" and "observation of Michelangelo's works,"[130] equating these two disciplines. Michelangelo desired to be an expert *membrificatore* (Leonardo's word). "For there is no animal whose anatomy he had not wanted to study, and so many anatomical studies of man that those who have spent their entire lives in this pursuit and make a profession of it, scarcely know so much about it," records Condivi.[131] Michelangelo is reputed to have received corpses from Florence's charity hospital through the connivance of his friend, the Prior of San Spirito. Condivi reports that Michelangelo finally gave up dissections because they turned his stomach. So firm was his belief in the science of anatomy that for him even architects must know it, an insistence on the parallel articulations and proportions of architecture and the human body known to the Middle Ages, but which he probably acquired from reading Vitruvius.[132] One realistic record of these studies is Bartolommeo Passarotti's drawing of Michelangelo manipulating a cadaver (in the Louvre). Michelangelo learned from anatomy that nature had created in the human organism unity and balance and a *conveniente consenso* (fitting harmony), to use the phrase from his brief commentary on Vitruvius (see Chapter V). Obviously, most of the artists of the Renaissance were advocating a knowledge of this science, as was Danti. Ghiberti stipulated that the painter and sculptor must know the position of each bone and muscle.[133] Lomazzo claimed that Michelangelo made muscles more prominent and fierce than nature had placed them in his subjects, especially in Christ, to demonstrate his perfect knowledge of anatomy.[134]

Bones and muscles, however, are only a means and not an end. The muscles are merely the fixative elements of a plastic unity. Michelangelo was able to follow in part that advice which Joshua Reynolds was later to give: Learn anatomy and then forget it. Doing so, he proceeded to "transform it into his own style of modeling and to impress upon his works that

swollen and altered character that was his personal element."[135] The quotation is from Canova. It is claimed that Michelangelo's taste for strong and robust figures caused him to refuse to do the missing hand on the Adonis of Campo di Fiori in the house of the Bishop of Norcia; he who admired Dürer's "delicate manner" would have nothing to do with soft and sweet Adonises.[136] Some have gone so far as to explain the rugged, thickset qualities of Michelangelo's figures by an Etruscan influence, which theory, as the Italian would say, "while not true, is well discovered."

Considerations of anatomy and musculature lead us to the subject of Michelangelo's *titanismo* or *gigantismo,* betraying the late Renaissance love of magnitude. Michelangelo has been as severely censured for his manner of executing nudes as for his infatutation with them as subjects. Joshua Reynolds, an admirer, wrote that there can be "too great an indulgence" in enthusiasm, adding, "It has been thought, and I believe with reason, that Michelangelo sometimes transgressed these limits; and I think I have seen figures by him, of which it was very difficult to determine whether they were in the highest degree sublime or extremely ridiculous. Such faults may be said to be the ebullition of genius; but at least he had this merit, that he was never insipid."[137] Bernini testifies that Annibale Caracci was not so kind. With an irony worthy of Michelangelo himself, Caracci observed of the *Cristo risorto* that it was interesting to see how bodies had looked in the days of Buonarroti."[138]

One does not find in his writings a direct explanation of Michelangelo's predilection for *gigantismo* after he had abandoned the stricter Hellenic or Donatellian line. His poem "Molto diletta al gusto intero e sano" tells that sculpture reproduces the human body "con più uiue membra." Was this gigantic treatment, then, intended to animate and dramatise his figures? Or does the answer lie in his belief that paintings and statues should "instill reverence and fear through their grave appearance"? Weightiness is at the core of gravity, as the etymon shows. Even Michelangelo's bambini (e.g., the *Madonna che allatta il Figlio:* Berenson, 1603r; the sketches for Madonna and child: Berenson, 1502) and old men (the *Crepuscolo*) show this gigantism. An article by Phillips studying the extent to which Michelangelo finished all perspectives of his statuary makes the debatable claim that many of his statues appear from

· *173*

the rear even more heroic than previously judged: the *Cristo risorto, Giuliano de' Medici,* and the *Crepuscolo.*[139]

Probably one must conclude that this gigantism was part and parcel of his *terribilità,* discussed in Chapter II. This conclusion was arrived at by Delacroix also. Delacroix complained that Michelangelo did not paint man at all, but merely muscles and poses, and these poorly. He granted withal that the isolated limbs painted by Michelangelo are remarkable for their grandiose and *terribili* qualities, even though dissociated from the total unity and action.

It is all too easy to find these aggrandised forms in the better-known works. But there are equally prominent cases where Michelangelo executed more trim and disciplined figures. The God of the *Creazione di Adamo* is weightless and meteoric, needing no swollen limbs to impress the beholder, as might a prophet or saint. The *Pietro* of the Crucifixion scene in the Cappella Paolina and the sketch of the dead Christ in the Albertina Museum (Berenson, 2503) are further examples. The *Lorenzo de' Medici* shows this more moderate and chastened modeling, leading De Tolnay to assume that, when working in Florence, Michelangelo "performed his works in the Florentine idiom," which opposed gigantism.[140]

Whether Michelangelo's indulgence in gigantism resulted from a narcissistic projection of ego, an ebullition of genius, a desire to animate and dramatise, or an effort to convey gravity and terribility, to his admirers and disciples this titanism bespoke only his attempt to achieve proportional perfection. "It is enough to note that the intention of this singular man did not wish to set about painting anything other than the perfect and most proportionate composition of the human body. He finally opened the way to facility in the principal intention of this art, which is the human body."[141] And a bevy of Florentine artists, really believing that Michelangelo had "opened the way" to a truer conception of the human body, obediently interested themselves in *magna ossa lacertosque* (Luigi Lanzi).

A more lasting legacy to his followers was Buonarroti's manner of catching the dramatic moment (albeit a covert drama) and the dynamic tension in stone.

An old apocryph remembered by Walter Pach runs more or less to
the effect that when Donatello had done a certain lifelike figure he tapped
it on the shoulder and ordered, "Speak." Recalling this, Michelangelo
ordered one of his figures, "Walk."[142] The story illustrates that what Mi-
chelangelo wanted to express in many of his figures was action-barely-
restrained, a quality he gave the name of *furia*. To understand this latent
dynamism of Michelangelo's figures, which Robert Louis Stevenson com-
pared (strange metaphor!) to the coiled spring of a dog, one must under-
stand his use of the serpentine line and *contrapposto*.

Only one writer of the Cinquecento did more than mention Michel-
angelo's interest in serpentine composition. In Lomazzo's *Trattato* there
is a specific quotation of Michelangelo's, possibly transmitted by Pelle-
grino Tibaldi (Papini), to work from:

It is said then that Michelangelo once gave this piece of advice to Marco da Siena,
a painter who was a disciple of his: that he should always make a figure pyra-
midal, serpentine-formed, and multiplied by one, two, and three ["che dovesse
sempre fare la figura piramidale, serpentinata, e moltiplicata per una, due, e
tre].[143]

Lomazzo adds that he subscribes to this as an assurance that a figure
will have *furia* and *leggiadria* (grace). He explains that when a figure
is of a general conical form, it is like a flame trying to ascend to its
sphere. If the upper part of the body is to be the narrow point of the
cone, then the torso must twist and one shoulder will come forward. If
the lower part is to be the narrow point, then the shoulders are shown
fullface and one leg is thrust before the other.

Lomazzo further explains that Michelangelo's serpentine line, derived
from a flame, should be combined by the painter with the pyramidal
form. The serpentine represents the "tortuosity of a living snake when
crawling, which is the very shape of a flame of fire when it flickers."
The form is akin to that of an S, and this general form must be observed
in the limbs as well as the trunk. Papini notes that Michelangelo's interest
in movement and light is illustrated by the serpent and the flame, re-
spectively.

The appearance of action-in-check attained through the serpentine conception enriches the fourth-dimensional (durational) quality of the work. "To explain to oneself the movement of a figure according to this pattern of design, it is really necessary to represent to oneself rationally the preceding moment, as a determinant of the action, and the subsequent moment, as a result of the action."[144] This is of course true for poses expressing more overt action. Michelangelo's accomplishment is that he achieved this durational effect without portraying that overt action.

Granted that *contrapposto* may help the artist render the inner tension of his subject, can it reveal centripetal as well as centrifugal forces? While both of the Medici dukes are posed with this *contrapposto*, De Tolnay makes the audacious claim that they no longer show "tension from an internal force," but are rather "like vehicles through which a force passes, coming from without, and going again outward."[145]

What is meant, according to this testimony of Lomazzo, by Michelangelo's prescription about multiplying the figure by one, two, and three? "And in this consists the basic ratio of proportion. For if you take the thickest part of the leg between the knee and foot, it is in double proportion to the thinnest part; and the thighs are in triple proportion to that part which is narrowest." This proportion is somewhat like that established by Alberti in his ideal figure:

MICHELANGELO		ALBERTI
3	Thigh	6 gradi
2	Calf	4
1	Ankle region	2.5

Naturally, it would be fruitless to seek a clear-cut case of a 1–2–3 accentuation of the pyramidal pattern in Michelangelo's single figures. However, the *Deposizione* is an excellent example of the *piramide serpentinata,* even to the pointed tip of the cowl of Nicodemus. Sagging bodies foreshorten the serpentine line.

It is only this little-known passage in Lomazzo which prevents one from flatly denying Croce's statement in the *Estetica* (II, II): "Michelangelo fixed an empirical canon for painting in general, indicating the

manner of giving movement and grace to figures by means of certain arithmetical relationships."

The secret of *contrapposto* is also explained by Lomazzo: "Whatever action a figure is engaged in, its trunk should always appear twisted, so that if the right arm is extended forward or makes any other gesture designed by the artist, the left side of the body shall withdraw and the left arm be subordinate to the right. Likewise the left leg will advance and the right recede." If the marble *David* does not fit into this pattern, the *Genio della Vittoria* does, as do the *Cristo risorto*, the *David-Apollo*, the "heroic" *Prigione* in the Louvre, and the *Ercole e Caco*. Seated figures embodying this symmetry of contrast are the prophets *Ezechiele* and *Gioele,* with modifications of it in several of the genii. This artfully balanced treatment of a twisted figure has little to do with the contortions of the *Centauromachia*. The slightly twisted form preferred by Michelangelo created a modified serpentine line which Hogarth exploited and claimed to be one of the two basic lines of beauty. This precise line Hogarth christened the Line of Grace. He reproduced a *piramide serpentinata* as an introductory colophon in his *Analysis of Beauty:*

Hogarth considered this to be the fundamental line of Michelangelo's art. Hogarth knew the passage in Lomazzo and derived from it his conclusion and his emblem (see illustration) which could serve as a linear schema for the Florentine *Deposizione.*

Naturally, scholars have "discovered" sources for Michelangelo's principle of the serpentine. It has been said that he derived it from the

Discobolus of Myron, where it has, indeed, an extreme application. Wilde also believes that Michelangelo's treatment of movement and *furia* were borrowed from the ancients.[146] This is possible, since he was surrounded by classical statuary. It may have resulted from his observance of the organic S-line in musculature. It was, in any case, one of the conventional poses which sculptors talked about when together. Leonardo discussed this stance in his *Trattato,* preferring to see the body even more twisted and producing an even more dramatic effect.[147] This dramatic tension was, in fact, a normal compromise between action and inaction for a man who felt, as did Socrates, that a painting or statue should portray the movements of the soul. Or as Alberti, who had written before Leonardo that it is not with expressions but with bodily movements that the painter expresses the "affetti degli animi."[148]

Michelangelo is believed to have covered with drawings the pages of a copy of the *Divina Commedia.* This volume has disappeared, but what a wealth of serpentines and *furia* it must have contained!

The appealing quality of the *contrapposto* or the serpentine pose has been stoutly and lengthily asserted by Hogarth. No one can really deny its charm when adeptly used. Poore says of this line of Hogarth's: "To express this line both in the composition of the single figure and of many figures was the constant effort of Michelangelo. As an element of grace alone, it affords the same delight as the interweaving curves of a dance or the fascination of coiling and waving smoke."[149] Incidentally, Michelangelo the poet was equally fascinated by the heightened serpentines of a flame assailed by winds: "Come fiamma piu crescie piu contesa dal uento" (CV) and, again, "Quante piu legnie o uento il foco accende" (XLII). Since one considers force rather than grace as the key to Michelangelo's art, it should be added immediately that *contrapposto* is as crucial an element of forceful as of graceful rendering. The more exaggerated the serpentine the more heightened and dramatic the effect and the greater the terribility. This was acknowledged by Lomazzo, commenting on Michelangelo's use of form: "He was also most stupendous in this phase, and like one who recognises this as most difficult, devoted long and continuous study to it. As a consequence one sees in his paintings the most difficult movements, and expressed in an un-

common way; but for this reason tending toward a certain savagery and terribility."[150]

The rubric of baroque has been occasionally applied to Michelangelo. This creative artist differs from the leading exponents of baroque in art and in poetry in that, whereas he exemplifies several characteristics of baroque, other prominent elements of this movement are totally lacking in him. Artistically, the most immediate feature that comes to mind is his addiction to contorted nude figures, censured even during his lifetime by such Counter-Reformational voices as Gilio da Fabriano. (Lee states that Gilio was striking through Michelangelo "at the general tendency in Mannerist art to sacrifice meaning to empty aestheticism.")[151] Canova decried Michelangelo's alleged overdramatisation, charging that he deliberately chose contorted and convulsed movements.[152] The most cursory glance over the drawings particularly strengthens Canova's charge, as well as supporting criticisms we list elsewhere in our discussion of Michelangelo's gigantism. Such restless overdramatisation was found in the *Centauromachia,* the *Battle of Cascina,* and the *Last Judgement,* and these works were certainly forerunners of European baroque.

However, baroque is understood nowadays as something more complex than a tendency toward distorted pose and overt emotionalism. True, these two qualities were impressed upon Michelangelo's mind that morning when he and the architect Sangallo watched the unearthing of the *Laokoön* on the peasant's farm. The figure of the Trojan priest displayed the contortion and the anguish of baroque. Just as El Greco acknowledged his debt to the sculptors of Rhodes by doing a *Laokoön* in painting, so did Michelangelo copy the figure in his *Haman* of the Sistine Ceiling. However, the Greek priest mentioned in Vergil illustrated not only these two familiar elements of baroque, but also the overthrow of values and impact of what the Spaniards called *desengaño.* Great indeed was the disenchantment of the worthy priest who sought to save his countrymen from the Trojan Horse, only to see himself and his sons destroyed.

The vacillating character of the baroque personality caught between contrasting polarities leaves him in a moral dilemma or even aboulia.

· *179*

Sometimes the individual cries out in distress, as in the following context of love (LXXXIX):

> *Che fie di me? Qual guida o qual scorta*
> *Fie che con teco mai mi gioui o vaglia*
> *S'appresso m'ardi, e nel partir m'uccidi?*

> *What is to become of me? What guide or what escort*
> *Will there ever be who may help or avail me with thee*
> *If thou dost burn me when I'm near and kill me when afar?*

Sometimes his will is left subjected to the slightest tip of the scales (LXXV):

> *...un sì e un no mi muoue.*

The inability of the baroque mind to view life as a positive or a reality with well-defined values led him to the Calderonian premise that life is a dream. Michelangelo, subject to panic-dreams and admitting that poems came to him in dreams, chose rather his art than his poetry to insist on the dreamlike quality of life. No work shows this thought so clearly as his curious drawing, *The Dream*, or *The Dream of Human Life*, although there are obvious traumatic expressions on his *Prigioni*, the soporific figure in the right foreground of the *Children's Bacchanal*, and even his *Adam*, awakening like Calderón's Segismundo from a long sleep. Life, as it was to the mystics, is unstable, paradoxical, and contradictory. Nothing is to be taken for granted (CXLIII):

> *E morte or m'è, che m'era festa e gioco.*
> What used to be sport and game is death to me now.

No unity is to be presupposed. Antitheses find no easy syntheses. No positive expression is possible. Thus, Michelangelo's sonnet "S' un casto amor, s' una pietà superna" (XLIV) begins ten clauses with *se* (if).

The reader of Michelangelo's letters, with their emphatic affirmations and trenchant opinions may find it hard to imagine him as an individual "caught between polarities." If the works of art offer a few glimpses of this side of the artist, it is the poetry that best illustrates the uncertainty and mutability of the artist's thinking. Most illustrative is the later poetry, when he questions the value of his daily life, his associations, and even his art—when the love poetry, still employing the same conceits and images, begins to refer not to earthly love but to the

amor bueno of the mystics. Probably the highpoint of these outpourings is the confessional sonnet CXL, which beseeches God to snatch away the veil of doubt and accord Michelangelo grace. The very first two verses are magnificent examples of baroque paradox and indecision:

> *Vorrei uoler, Signior, quel ch' io non uoglio.*
> *Tra 'l foco e 'l cor di iaccia un uel s'asconde . . .*
>
> *I want to wish, my Lord, what I cannot wish.*
> *A veil is hidden between the fire and the heart of ice . . .*

These are not mere Petrarchan antitheses and oxymora: these baroque contradictions were very much a part of the mature Michelangelo's character. Note the ambiguities in the following paradoxical verses:

> *Tanto piu chi m'uccide mi difende (XLII)*
> *The more one kills me the more one defends me.*
>
> *Crescer la uita, doue cresce il mal (LXI)*
> *Life grows as the malady grows*
>
> *E piu mi gioua doue piu mi nuoce (XLII)*
> *And does me good when most harming me*
>
> *Tanto piu nuoce quanto piu diletta (CLVIII)*
> *And harms most when most delighting*
>
> *Ch' oggi in un punto m'arde e ghiaccia 'l core (XV)*
> *That now at one moment burns and freezes my heart*
>
> *E men ti piaccio se piu m'affatico (III)*
> *The harder I try, the less you like me.*

Baroque has been viewed widely as an outgrowth of the Counter Reformation. It is interesting that Michelangelo was the first architect approached by Ignatius Loyola with the request to undertake the mother church, the Gesù, which is often cited as a model of baroque architecture. Loyola's invitation was a tribute not only to Michelangelo's stature as director of the Vatican fabric, but also to the artist's intense religious spirit. This spirit dominates his late poetry just as it informs his art. Sometimes Petrarchism and Platonism intrude upon it. Petrarchism in his *Rime* parallels and even apes their religiosity. Platonism vacillates

between serving Michelangelo's lovers and mistresses and Michelangelo's God. The artist is martyrised by love in his madrigal "Se 'l uolto di ch' i' parlo, di costei" and by Christian repentance in "Penso e ben so ch' alcuna colpa preme." Amore in the poems will be now sacred and now profane. The anguishes of Petrarchan love are not to be confused with the erotic ecstasy of a mystic longing to be rejoined to God. And one must read well into a poem before understanding whether the Signore to whom it is addressed is God or Christ or one of the men on whom Michelangelo lavished affection—Febo di Poggio, Gherardo Perini, or Tommaso Cavalieri. As one isolates baroque elements in Michelangelo's verse one finds the legitimate concepts and vocabulary of baroque (anguish, ecstasy, earth-as-prison) spilling over into poems on earthly love. The baroque devices spill over as well (paradox, antithesis, dilemma, oxymoron, emphasis, exaggeration, contrast of multiplicity and unity, of clarity and obscurity).

Granted that the leading baroque poets of Europe were the effusive Catholic mystics who made of verse a kind of anxious and impatient prayer and self-humiliation, then Michelangelo belongs in their ranks. Like Teresa de Ávila, Gongora, Quevedo, Crashaw, Johannes Arndt, Jacob Balde, and Marguerite de Navarre, he poured out his desire to be freed from this prison:

> *Che del carcer terreno*
> *Felice sie 'l dipor suo greve salma (CIX, 103)*
>
> *For it will be a happy moment*
> *To set down the burden out of this earthly prison*

> *In che carcer quaggiu l'anima uiue (LXXIII, 19)*
> *In which prison here on earth the soul doth dwell*

> *Per ritornar la donde uenne fora*
> *L'immortal forma al tuo carcer terreno (CIX, 105)*
>
> *To return up there whence came forth*
> *Immortal form to thy earthly prison.*

God is the anthropomorphic lover whose embrace is longed for:

> *Stendi uer me le tuo pietose braccia (LXXXVII)*
> *Extend toward me Thy merciful arms*

and whose rejection is feared:

> *Non tenda a quello il tuo braccio seuero!*
> *Point thou not with thy severe arm at my past!*

The baroque anguish which made the mystic wish to escape this uncertain existence and cry with St. Teresa "muero que no muero" is found in many of Michelangelo's poems. Michelangelo writes to his deceased father Lodovico that he is "not without envy" of the father's death and divinity (LVIII). In one of his quatrains on the death of Cecchino Bracci (LXXIII, 3) the poet asks death why he too cannot die before his time, as has the fifteen-year-old youth. Again, the request might burst out like a cry of pain:

> *Ch' i' son disfatto s' i' non muoio presto (LXXXI)*
> *For I am undone if I do not die soon!*

Or it may be a perplexed inquiry why the death "ch' i' bramo e cerco" will not come sooner (XCIX) and resentment that

> *Crudel pietate e spietata mercede*
> *Me lasciò uiuo ...*
> *Cruel pity and pitiless mercy*
> *Have left me living ...*

Sometimes, as after the death of Michelangelo's father, the death of a loved one intensifies this natural desire to escape from the earth to the arms of God. And after Urbino's death he wrote to Vasari (Letter CDLXXVII): "In dying he taught me how to die, not with displeasure, but with desire for death." In any case, there is always the mystical conviction (albeit reinforced by Michelangelo's hypochondria) that death is imminent. This certainty, too, is a motiv of his verse. He "eats on credit at the hostel of death":

> *... è l' osteria*
> *E morte dou' io uiuo e mangio a scotto (LXXXI)*

Even when imminent, death comes too slowly:

> *Tal m'è morte uicina,*
> *Saluo piu lento el mio resto trapassa (CIX, 83)*

· *183*

So near to me is death,
Except that my body declines more slowly.

He is "so close to death and so far from God" (XLVIII). He must "repent, make ready, and take counsel with himself with death near" (XLIX). He feels death "at hand" (CIX, 28). He has attained his "last hours" (CIX, 34). His very birth was already playing with death (CXXII). Suddenly the sight of his white head and his many years reminded him that he "had already in hand the plow of the other life" (CXXII).

Turning from the baroque temperament of Michelangelo as revealed in the *Rime* to the baroque elements of his art, one finds that the components of this style describe many an artist flourishing after 1550 better than they describe Buonarroti: exaggeration, propagandism, distortion, exuberance, horror, martyrdom, anguish, ecstasy, synesthesia, antithesis, instability, and surprise. It is not difficult to find these elements occasionally apparent or anticipated in Michelangelo's works. Thus, an example of antithesis or surprise: the nude athletes in the Doni *Madonna*; the "Jacob's ladder" device: the entire plan of the Sistine Chapel; oxymoron: the navel "modifying" Adam; metamorphosis: the pelt of *Bartolommeo* in the *Last Judgement*; synesthesia: the trumpet blares and stenches of the same eye-arresting fresco, as well as the feel of a strong wind; baroque asyndeta, as well as accumulation: the multiple symbols identifying the *Notte*. As for punning, this was common in the poetry and present in the art. The puns in the poetry usually played with proper names: Tommaso Cavalieri (LXXVI), Febo di Poggio (CIII), Julius II (III), Clement VII (LVII), Carnesecchi (LVII), La Mancina (CIX, 67), and Cecchino Bracci (LXXIII, 6 and 44). The puns in Michelangelo's art are exemplified by the horns of the *Mosè* or by the far-sighted Cumaean Sibyl who reads at a distance. Yet these scattered features do not compound to make of Michelangelo a baroque artist so much as do his Christian mysticism and his passion for burdening his figures with almost intolerable tensions.

Jacob Epstein shares a widely held view when he writes: "There is a very great difference between genuine vitality and the forced dramatic element of baroque. Michelangelo is called the father of baroque, but

there is no trace of that restlessness in his work. He is very much an unwilling father. Baroque came into being through pygmies trying to follow a giant."[153] All in all, the opinion which has prevailed is that sensed by Bellori at a very early date: the good sense of the generation of Michelangelo, their perception of true Ideas, these have been replaced by "la maniera, o vogliamo dire la fantastica Idea."[154] Bernini has generally been considered the villain in the piece. Croce called him the "corrupter of sculptors, apostate of the art of Michelangelo." Bernini's *Apollo and Daphne* has been cited as an example of what Michelangelo's style could evolve to. Knowledge that overdramatisation might lead to baroque gesture is said to have elicited Michelangelo's statement that a statue should have a compact, pyramidal form, and that a good statue can roll down a hill without suffering damage. Admitting that this latter quotation is apocryphal, Panofsky rightly considers it a "rather good description of his artistic ideal."[155]

Michelangelo's conception of the work of art as a form which must be found and reproduced allowed him to attach more importance to the finding process than to the perfecting process. It enabled him to feel that the main task of the artist is to capture the basic form and that the rest is simple after this initial challenge has been met. Thus Apelles left his portrait of Aphrodite unfinished after he had captured the basic form. Vasari related that Michelangelo went at a figure with zest, art, and judgement. When, despite this compounded attack, an initial error was made, he would abandon the figure and turn to another. Vasari quoted Michelangelo as admitting this as the reason for his doing so many incomplete figures. The so-called problem of the *non finito* in Michelangelo revolves about this desire of his to attain the basic form or nothing, just as Apollodorus destroyed works in which he was "unable to reach the ideal he aimed at."[156] If Michelangelo felt that he had grasped the essential form, then he was impatient with criticism of details.

Viewing the capture of essential form as almost an end in itself, Michelangelo was willing to sketch or plot out *concetti* for others to elaborate. Indeed, this is the only possible explanation for the tremen-

dous number of *pensieri* handed over to dozens of other artists for completion. For this reason he consented to make the initial design of Atlas bearing the globe for Cellini to bring to completion, to design an *Annunciation* for Marcello Venusti, to undertake sketches for Pontormo and others to execute, to determine the figures of Ganymede, Cecchino Bracci, and Faustina Lucia Mancini for others to carry out, and even to design the third storey and cornice of the Farnese Palace, leaving the detailed execution to Vignola. Further instances of his capturing basic forms for others to execute will be found in Chapter IV. Once the major task of securing the basic form, of "breaking the formula," is done, then the final touches can even be entrusted to assistants. Sebastiano del Piombo, who urged Michelangelo to conserve his strength, wrote that Michelangelo could ideate a building, furnish plans and models, and then leave the details to others, "provided that there is a bit of your odor about it."[157] In a sense, architectural drafting especially is nothing more than the science of capturing essential form.

Almost as if to demonstrate his mastery in apprehending essential form and to minimise the finishing process, Michelangelo gave a simple stonemason a set of oral instructions on how to carve a statue. While the fellow hammered away, Michelangelo would order him to hew away here and level off there. When the figure was completed, it was satisfactory to all.

"How does it look to you?" Michelangelo asked.

"Very good. I'm greatly obliged to you."

"Why so?"

"Because thanks to you I've discovered a power I didn't know I had."[158]

As Doni relates this incident, it takes on further accretions of Michelangelo's thought. The grateful stonecutter exclaims, "Who would have thought that there was such a handsome man in this ugly rock? If you had not made me uncover it, I should never have seen it within."[159]

Although Michelangelo never took a stand in his writings on the issue of whether form or content is more crucial, an issue which became a critical preoccupation *pari passu* with neoclassicism itself, it is apparent that the formal pattern of his works, even those

designed to evoke emotive responses, was more important to him than to other artists. Schiller held that "in a really beautiful work of art, the substance ought to be inoperative, the form should do everything." Michelangelo might not accept such an extreme statement, but he certainly felt that form could elicit emotional responses just as surely as content. He censured Flemish painting because it relied largely on its subject matter to stir the spectator and was devoid of a sense of form and symmetry. In his greatest work, the Sistine Ceiling, form was a more pressing consideration than content, if one may be given the primacy. Michelangelo "seems to have evolved the content of the work by adapting it always to the various artistic solutions which he projected in his drawings; it was only after he had definitely established the solution of the architectonic framework within which he was to paint that he peopled it with his world of figures and historical scenes."[160] The summarily sketched plan of the Ceiling in the British Museum verifies this conclusion. Certainly, Michelangelo's Neo-Platonism and his *concetto* theory, with all the consequent notions about design, foreshortening, the serpentine, and *contrapposto*, stress his preoccupation with form independent of content.

In our discussion of form and the human figure, statues or paintings of women have played an inconsequential role. Yet Michelangelo lived in an age and milieu where woman held the center of the literary and artistic stage. Raphael and Titian, the Petrarchists, the Neo-Platonists, the imitators of Anacreon, Ovid, and Catullus, all paid homage to beautiful women. Statesmen like Lorenzo de' Medici and churchmen like Bembo would take time to extol woman's beauty, and Ariosto portrays the sensuous Angelica with all the attentions of a painter or sculptor ("I should have thought that she was feigned of alabaster or some other illustrious marble," etc.). As titillating as Ariosto's poetic description (or Ovid's depiction of Andromeda) was Fabio's complete and voluptuary account of the ideal female body in Pino's dialogue on painting, evocative of contemporary *blasons*. Yet Michelangelo had little in common with these artists and poets.

Michelangelo's lack of interest in women, despite the ascendancy of Venus at his birth, has become legendary. We have discussed this at-

· *187*

titude in an earlier chapter as it affected his personal life. One must now assess its effects on his art. At the risk of sounding facetious, one could propose as symptomatic evidence Michelangelo's portrayal of the rape of Dejanira, done in his youth, in which no one has yet been able with certainty to locate the woman.

We know little of the role women with their *pompe e pazzie* (coquetries and madnesses) (Letter CCXLII) played in Michelangelo's earlier years. Taking as evidence the sonnet "Quanto si gode, lieta e ben contesta" (VII), it has been generally concluded that around 1507 Michelangelo was enamored of a young Bolognese woman whose embracing girdle filled his mind with jealous velleities:

> *E la schiecta cintura, che s'annoda,*
> *mi par dir seco: qui uo' stringer sempre,*
> *Or che farebbon dunche le mie braccia?*

> *And her simple girdle which ties at the waist*
> *seems to be saying to itself: I shall always embrace here.*
> *What, then, might my arms do?*

Even though the sonnet seems to bespeak a passion, the culminating theme is a poetic one which reappears in Waller's "On a Girdle," Tennyson's "The Miller's Daughter," and in Politian. Newell, publishing some in of Michelangelo's poems, conjectured a passion for another unidentified lady about 1529 and Papini surmises a juvenile love for the Contessina de' Medici. The only sincere attachment for an identified woman was the relationship with the Marchioness of Pescara on which we commented earlier. Outwardly Michelangelo seemed the sort of fellow whom a motherly woman would like to take in hand and straighten out. Sebastiano mentions in a letter to him that a matronly neighbor wants to care for Michelangelo. But Buonarroti resisted such treatment, continued to sleep in his day clothes and stockings, and generally kept women servants out of his home—although he occasionally employed maidservants, as Papini shows clearly in his chapter "Le serve di Michelangielo."[161] This man who found Mary Magdalene (1531) and the sinful woman of Samaria (1542) worthy subjects for his art was yet capable of branding as harlots all the housemaids of Rome. He warned his

nephew Lionardo against the idle pursuits of women of the nobility or upper bourgeoisie and reminded him that marriage was a serious thing "for there are many more widows than widowers" (Letter CCLXIII). He cautioned his brother Buonarroto against marrying (LXXXV). Nor did he have too much respect for woman's judgement in art; he thought that Flemish art would please old and young women; he considered oil painting a medium of art which would please "women and idle and lazy persons" ("arte da donna e da persone agiate e infingarde").[162] All in all, it is difficult to go along with the conclusion of Pierre de Bouchaud, "Or, selon moi, rien n'est plus faux qu'un Michel-Ange antiféminin."[163] Michelangelo summarised his own feelings about women in his remark quoted elsewhere that he had wife enough in his art.

Ample discussion has reached print on Buonarroti's inability to respond as an artist to the charms and plastic beauty of the feminine figure. Papini surveys contemporary sources and demonstrates that Vittoria Colonna was "in soul and appearance" more man than woman and also recalls Michelangelo's own lines: "Un uomo in una donna, anzi uno dio, per la sua bocca parla" ("A man in a woman, even a god, speaks through her mouth").[164] Symonds, who, like Papini, rejects the theory of homosexuality, nonetheless summarises his discussion: "I find it difficult to resist the conclusion that Michelangelo felt himself compelled to treat women as though they were another and less graceful sort of male."[165]

Pierre Langeard, who also denies the homosexual supposition, writes in his *L'Intersexualité dans l'art et chez Michel-Ange en particulier* that Michelangelo's art was great because his males were feminine and his females virile. Langeard speaks of the ultimate stage of human evolution as "the intersexual type, complex, attaining at the same time the perfection of the individual and the ruin of the species."[166] There is a simple reason why so many of Michelangelo's female figures had a masculine air about them. As though clinging to the workshop tradition of the fifteenth century, whereas Raphael and the others now used women models, Michelangelo often used men to pose in their stead. A feminine figure drawn from a male model might well look "intersexual." In the Metropolitan Museum there is a study of a young man's torso (Beren-

son, 1544D) which served for the *Sibilla Libica*. In the first sketch for the *Venere e Cupido,* Venus, the prototype of all feminine graces, was drawn from a masculine model. When one reads in Langeard that Michelangelo wanted to achieve the synthesis of the two sexes in his figures one can only echo the cry of the gallant French statesman and antisuffragist, "Vive la petite différence."

Annibal Caro, friend of Buonarroti and Condivi if antagonist of poor Castelvetro, records in his *Dicerie* that he had encountered in a cabinet of curios the statue of an hermaphrodite which Michelangelo wanted to draw (*ritrarre*) and make use of in the Sistine Chapel.[167] He, Caro, had refused the permission. No reason is given. This meager recollection, if true or false, could have been a gibe at Michelangelo's "intersexual figures" about which Langeard wrote his book, and which could only have been the butt of irony to the author of the *Ficheide*.

It is hard to believe that women models were difficult to find in Florence and Rome, despite Raphael's complaint about the dearth of beautiful women models. Similarly, there was no reason for Michelangelo to make masculine the feminine allegorical figures which be borrowed for his *stanze* on rustic life (*veritas* becomes *il vero; adulazione* becomes, despite Ripa, a male iconographical figure, and so on). In a sense, the poet embodies his feminine figures once again with masculinity, as though using male models. Michelangelo's first voiced art criticism, as a callow youth under Ghirlandaio, was directed at some pen drawings of clothed ladies. If he had to allow women into his art, it was principally as Madonnas or allegorical figures. Women dominate the spandrels of the Sistine Vault, but as mothers, uberous instruments to keep alive the generations of Christ's ancestors that the Saviour might finally be born. It is reminiscent of Phidias, whose Venus at Elis stood with one foot poised on the shell of a tortoise, to signify, it was said, that the two duties of woman were to stay home and to keep quiet.

Michelangelo's female nudes, then, are not vases of sweetness, grace, and delicacy à la Giorgione, but rather unsensual counterparts to the male athletes which he early came to prefer. Only Walter Pater, discoverer of the *Gioconda,* could find sweetness and grace in Michelangelo. Bernini more pointedly noted that Michelangelo could never equal the

ancients because he possessed more art than grace. There are just a few exceptions to prove the rule, moments when Michelangelo succeeded in informing the painting of a woman with grace. There is the *Eva* of the Sistine Ceiling, fleshy as a Rubens creation, who had to express some sensuality to give credibility to the Biblical story. Mariani finds in this Eve, or these Eves, a "fiera sensualità." The face of the *Sibilla Delfica,* with its parted lips and wide-opened eyes, has a more markedly feminine and ingenuous character. Some of this quality is found in the face of the thick-limbed *Eritrea,* as a close-up will show (Plate VII). Then there is the lovely blonde consort of Aminadab of the Sistine lunette, engaged in the feminine pastime of combing her tresses. These figures were done when Michelangelo was in his early thirties. In time he withdrew even further from this stillborn tendency. But these figures are a long span from those of Aristide Maillol, who knew when he had finished a feminine nude by his irresistible impulse to slap her buttocks. They are leagues away from the contemporary idea of sensuous beauty contained in the aforementioned verbal painting of Alcina or Angelica in the *Orlando Furioso* or other passages in the gallant and idyllic literature of the Cinquecento. In still another sense Michelangelo was not representative of the Renaissance, in that so much of his production was commissioned by the Vatican rather than by the beauty- and pleasure-loving noblemen of the period. Seriousness and sublimity were forced upon him, even though these happened to coincide with a native, personal preference. No, these qualities could not have been too uncongenial to him, for he had many offers to leave the service of the Church. Tolstóy felt that most of the art of the Renaissance was trivial and sensual because it was created by sycophants dependent upon the nobility. One wonders how Michelangelo's works might have turned out had he been attached for his lifetime to Francis I, whom he hoped to serve in 1529, a monarch who commissioned artists to paint lascivious scenes in the hollows of soup dishes.

Endearing grace is equally absent from the bambini. Like their uncles they are massive and heroic. The child suckling the *Madonna of the Stairs* has the shoulders of a miniature Tarzan, and *gigantismo* descends to the infants *Ezechias* and *Ozias* on the Sistine lunettes. De Tolnay

· *191*

informs us that the name Ozias signifies "Jehovah is my strength" and suggests that this may explain the herculean body. Yet these swollen muscles are quite common on Michelangelo's infants. Why was he disposed to do such unrealistic infants? It was just a projection of his aesthetic canon of titanism. Yet there is another explanation to be considered. If it is true that his own poor physique impelled him to execute massive Apollos bursting with vitality, possibly a consciousness of the high infant mortality of his period may have encouraged him to portray little Atlases. He took gravely to heart the successive deaths of Lionardo's babies, his grandnephews, as one can read in the correspondence. The consciousness that his own family might have no male heirs weighed upon him. One does not gain the impression that Michelangelo's bambini will succumb so easily to the law of averages.

Decorum, knowledge, good taste: a high premium was set on these in neoclassic theory. In the third of the *Dialogos em Roma*, Michelangelo turns to remark to Zapata:

Now what a lofty thing decorum has been in painting! And what little effort to preserve it has been made by those painters who are not really painters! And how carefully the great man watches over this.[168]

Decorum had two meanings in Renaissance theory: finding the correct and consistent attributes for the subject one is portraying and, secondly, observing a moral or social correctness. Michelangelo will refer to both meanings. As an example of the former, there is the definition of Da Vinci: "Decorum, that is, the appropriateness of action, dress, setting, and circumstances to the dignity or humbleness of the subjects you wish to present. Make the king dignified in beard, appearance, and dress. Let the movements of an oldster be not those of a youth, nor those of a woman like those of a man," etc.[169] Da Vinci, Vasari, and even Michelangelo were echoing Horace's counsel on decorum:

Ne forte seniles
Mandentur iuveni partes pueroque viriles...[170]

Vasari virtually translates this thought.[171] Alberti had written of the importance of *conveniente* depiction: Minerva must not be portrayed as a beggar; Helen of Troy must not have calloused hands; no one should be shown slumbering through the tumult of a horde of centaurs.[172] The treatise writers generally remembered to caution about logical propriety. Lomazzo ruled that "Decorum does not permit one to put things in places where they have no natural conformity, and furthermore does not let anything be done which might not reasonably be done."[173] Armenini echoes Vasari's *Introduzione della Pittura*[174] and carries these prescriptions to logical excess by codifying them: one should make "old men of grave aspect, ladies pretty, children quick-witted, soldiers brave, maidens modest [*vergognose*]" and one should maintain the appropriate characteristics of all persons.[175] Lee objects that these prescriptions stressed the statically formal rather than the typical, an objection which can be raised to European neoclassicism in general.

Michelangelo himself made a pronouncement on logical decorum:

For [the painter] will never do anything which may not be likely in its kind; he will not do a man's hand with ten fingers, nor will he paint on a horse a bull's ears or a camel's back, nor will he do an elephant's foot with the same features that a horse's foot has; nor will he place traits of an old man on the arm or face of a child.[176]

Michelangelo continued with the assertion that grotesque has a decorum of its own and that a certain license for inappropriateness or incongruity is permitted of poets and painters working in grotesque.

That one finds as late as Armenini emphasis on the traditional meaning of decorum as suitability, consistency, and appropriateness shows that it persisted into Counter-Reformational times, although moral decorum was by then more loudly discussed. Moral or social decorum had often been implicit or explicit in theorising prior to the Counter Reformation. Leonardo, for example, was shocked by an Annunciation in which the Angel well-nigh menaces Our Lady, who looks anxiously ready to leap out the window.[177] Notwithstanding the censure of his nudes, Michelangelo was keenly aware of the necessity of moral decorum in art, as evidenced by his remarks on the function of religious figures in churches and chapels quoted in the previous chapter.

Social decorum is a cognate of moral decorum. A study of decorum among the literary theorists on whom the art theorists leaned (Minturno, Cinzio, Vida, Fracastoro, and others) prompts Vernon Hall to venture the generalisation that "decorum is essentially a class concept [in the Renaissance] and cannot be understood except as such."[178] There are two passages in which Michelangelo shows how conscious he was of social *convenevolezza*. Since both of these examples are architectural, let us observe in passing that the *decoro* which Michelangelo held to be one of the six elements of architecture is the *decor* and not the *decorum* mentioned in Vitruvius.

The first statement on appropriateness is found in Michelangelo's letter to Pope Paul III, explaining what constitutes good architecture. In this letter, reproduced and translated in Chapter V, he affirmed that buildings must be constructed and ornamented in a manner befitting the use to be made of them and consonant with the social status of the owner.[179] The second example is the amusing letter written in October, 1525, to his dear friend Fattucci regarding the erection of a colossus to be placed in the Piazza San Lorenzo with its nude posterior facing the Stufa Palace. Apparently such a plan was entertained for a while by Pope Clement, who wrote Michelangelo directly about it and had Fattucci also write him. Most scholars credit Michelangelo with killing the plan by the following ironic lines:

"Messer Giovan Francesco: If I took as much strength as I took delight from your last letter, I should believe myself able to execute—and soon—all the things about which you write me; but since I haven't so much strength, I shall do what I can

"About the colossus forty braccia high which you tell me is to go, or to be placed, at the corner of the loggia of the Medici Garden where it meets the angle of Messer Luigi della Stufa's place, I have thought on this and not a little, as you ask me. It strikes me that on the aforesaid corner it wouldn't go so well, since it would occupy too much space on the road. But it would work out much better on the other side, in my opinion, there where the barbershop is, for it would have the square before it and would not encumber the street. And since there might be objections to carrying off said barbershop out of love for the income

[*entrate*] it affords, I have thought that said figure might be made to sit down. The behind would be placed so high that, making the work empty on the inside, as befits something constructed of pieces, the barbershop could stay underneath and would not lose income. And that this shop may have, as it has now, a place for the smoke to disappear through, it seems to me that I could put in the statue's hand a cornucopia which would serve as chimney. Then, since I should leave the head of such a statue empty, the same as the other members, of this too I think we might make some practical use. There is here on the square a huckster—a very good friend of mine—who has told me in confidence that one could put a fine dove-cote in it. Another fanciful thought occurs to me which would be much better, but it would require making the figure much larger. This could of course be done, since you can build a tower out of sections. This thought is that the head might serve as a bell tower for San Lorenzo, which badly needs one. With bells inserted up there and sound issuing from the mouth, it would appear that the colossus were crying mercy and especially on feast days, when the bells ring most often and with the heaviest peals."[180]

Disguised by this broad irony, the basic objections to the colossus are that it would be too large for its location, pieced together, and socially inappropriate and indecorous. Nor does Michelangelo forget his concept of the "living statue" in this letter written not for squeamish Anglo-Saxon sensitivities, but for a Latin pope!

Emerson, an advocate of learning, was impressed by a sketch purportedly by Michelangelo of a bearded old man in a cart facing an hourglass, which spurious drawing illustrated the posy, "Ancora imparo" ("Still I keep learning"). The drawing is not Buonarroti's, but the thought is. The Renaissance ideal of the learned man, evident in the admiration for the *doctus poeta,* in the new veneration of the *savant* over the *clerc,* was expressed by the painters themselves. If Equicola believed that "painting was more often than not exercised by the ignorant," his voice was drowned out by the many who were now defining painting as a liberal art, even a branch of philosophy, and not merely a manual craft. Thus, Fabio in Pino's *Dialogo di Pittura* insists of painting, "Nõ è mecanica,

mà arte liberale" and equates it with music, geometry, and astronomy.[181] One painted with the mind as well as the hand, as Buonarroti insisted. Lomazzo set up the "Pittore letterato" as a congener of the learned poet. Michelangelo was considered a fine example of this literate painter: Condivi held that Michelangelo's figures contained so much learning (*dottrina*) that they were well-nigh inimitable.

True, legion were those before Michelangelo who preached that artists must know many arts and sciences. Vitruvius, whom he read, said that the architect should be a man of letters, draftsman, mathematician, philosopher, musician, astronomer, jurist, and student of medicine. Not merely the theorists of the Italian Renaissance but the practitioners themselves set high demands for those wishing to excel in the fine arts. We present a table of these demands which we have culled from the various treatises:[182]

LEON BATTISTA ALBERTI, *Della Pittura:* geometry, rhetoric, poetry, history, "all the liberal arts."

CENNINO CENNINI, *Il libro del arte:* Theology, philosophy, sciences.

LORENZO GHIBERTI, *I Commentarii:* Grammar, geometry, philosophy, medicine, astrology, perspective, history, anatomy, theory of design, arithmetic.

GIOVAN PAOLO LOMAZZO, *Idea del tempio della Pittura:* Theology, mathematics, astrology, geometry, arithmetic, architecture, music, poetry, anatomy, philosophy, and others.

GIOVAN BATTISTA ARMENINI, *De' veri precetti della Pittura:* Broad humanistic education, all sacred literature and lore, Roman histories, Plutarch, Livy, Appianus of Alexandria, Valerius Maximus, Petrarch, Boccaccio, Cartaro's *Imagines,* Ovid, Apuleius, the *Amadis de Gaula,* etc.

MICHELANGELO BUONARROTI: In his *Trattato,* Lomazzo quotes Michelangelo as agreeing that all these humanistic disciplines are useful, and as adding: "among men all the proportions of geometry and arithmetic or examples of perspective are of no avail without the eye, that is, without one's exercising the eye to learn how to see." In the *Dialoghi* of Giannotti, Antonio Petreo compliments Michelangelo on his "notitie delle altre cose" as well as his familiarity with astronomy.

PAOLO PINO, *Dialogo di Pittura:* Literature, poetry, music, Latin, vernacular, history, geography (through traveling), physiognomy, etc.

Cellini viewed this matter of learning in a different light and opined that a sculptor must be a hero, musician, or rhetorician to portray a soldier, musician, or an orator, just as Michelangelo held that only virtuous men should portray saints and apostles.

After a careful study of the painters' treatments of the Rinaldo-Armida incident in Tasso's *Gerusalemme liberata,* Lee remains convinced that "the learned, nay pedantic painter, was never so much an actuality as he was an idea whom the sixteenth-century critics created far more in their own image than on the basis of knowledge actually revealed by the great painters in their art."[183] Nevertheless, the literal rendering of a literary text (especially when some of the painters rejected literal imitation) is of a different order from the inculcation in one's art of the many branches of learning proposed by Cennini, Lomazzo, Armenini, and others.

Perhaps remembering that Horace had stipulated as the inevitable condition of genius *recte sapere,* Michelangelo preached knowing rightly, the function of the *intelletto,* the "principle and source" to him as well as to Horace. Michelangelo's theory of the *concetto* (Idea) implied possession of divine wisdom. In the Plotinian language, with which Michelangelo was so familiar, real or divine knowledge is distinguished from surface-knowing: "On the other hand, there is the knowledge handling the intellectual objects and this is the authentic knowledge: it enters the reasoning soul from the intellect-principle and has no dealing with the senses."[184] As Alberti and others pointed out, Ideas do not reveal themselves merely to the senses.[185] Discussing the merits of rapid, as opposed to slow, painting, Buonarroti dismisses the question with the opinion that works are not valued so much by the time they require as "by the worth of the knowledge [*saber*] of the hand which makes them."[186] At another point he decrees that one's painting slowly is no weakness and that the only weakness is lack of knowledge.[187]

Michelangelo was trenchant and sure in his opinions. He had little patience with people whose opinions he deemed wrong or whose judgement vacillated in a veil of ignorance. How he must have laughed on learning that a humble tailor had momentarily convinced the entire city of Bologna that the vault of their San Petronio was too low. How he must

have smiled when the Cardinal of San Giorgio gullibly purchased his *Cupido* as an antique. His scorn for ignorance permitted him to perpetrate the fraud.

Knowledge is a luxury bestowed upon the few. It is a corollary that taste also will be rare. The world for the most part has no palate for the creations of genius. In classic times taste and knowledge had become so identified that one verb (*sapere*) conveyed both ideas. In the Renaissance as well they were facets of the same quality. Croce even claimed that Michelangelo fell in with an old tradition: "Ancient in Italy is the metaphorical use of 'taste' or 'good taste' in the sense of 'judgement,' whether literary, scientific, or artistic."[188]

The lack of good taste and discernment among the public is mentioned various times by Michelangelo (CIX, 51):

> *Non sempre a tucti è si pregiato e caro*
> *Quel che 'l senso contenta,*
> *Ch' un sol non sia che 'l senta,*
> *Se ben par dolce, pessimo e amaro.*
> *Il buon gusto è si raro,*
> *C' al uulgo errante cede*
> *In uista, allor che dentro di se gode...*
> *Il mondo è cieco.*

That which contents the senses in this world is not always so precious and dear, that there is none who does not often feel as bitter that which is sweet in semblance.

Good taste is so rare that it sometimes perforce gives in to the crowd, whereas within itself it derives satisfaction...

The world is blind.

This rare quality of taste is mentioned in another sonnet fragment, "Molto diletta al gusto intero e sano" ("Whole and sane taste takes great delight"). In a contemplative sonnet, "Di morte certo, ma non gia dell'ora" (CLVII), he reflects in a general way, not limiting himself to art, but surely including art, upon the world's blindness:

> *Il mondo è cieco, e 'l tristo esempro ancora*
> *Vince e sommergie ogni perfecta usanza.*

The world is blind, and bad examples prevail over and swallow up every best usage.

In a variant upon the first of these pieces Michelangelo decries the vulgar throng ("il folle vulgo") and the ignorant crowd ("il volgo ignaro"). Again, he dismisses "il mondo poco accorto" who failed to appreciate sufficiently the virtues of Vittoria Colonna (XCVIII) or the beauty of Faustina Lucia Mancini ("il vulgo, cieco non adorar lei") (CIX, 68), proving to us in these eulogies derived from Petrarch ("il mondo non la conobbe mentre l'ebbe") that the blind throng could be of the upper classes. How he must have cried "The world is blind!" when he first heard demands that the nudities of his *Giudizio universale* be retouched, whenever his patrons elected to humiliate him in public, or whenever the Sangallo sect of the Vatican workshop ruffled him. Even when the members of this sect were on their good behavior during the earliest days of his stewardship, he thought of them as blind and ignorant. When these artists first heard that Michelangelo was going to supervise the fabric, they graciously indicated their pleasure and told him that "that model [of St. Peter's] was a meadow where there would never lack good pasturage." "Voi dite il vero" ("You speak true words"), Michelangelo replied, and admitted later to a friend that he had meant to imply that there was pasturage for sheep and oxen (dunces) like them, who did not understand art.[189]

The lack of understanding by the public is an ageless theme among artists. Phidias meditated upon it in prison after the public found his decoration of the Parthenon too eccentric. In our own era, Cézanne wrote typically that taste is the best judge, but that it is rare and an artist can appeal to only an extremely restricted audience. As for Michelangelo, his doctrinary feelings about genius created a definite cleavage between the chosen few and the indiscriminate many. There was little middle ground. His pessimistic view of mankind caused Aldo Bertini to interpret the histories of the Sistine Vault as follows: "It did not displease Michelangelo to conclude the cycle with the *Ebbrezza di Noè* to signify the sinful disposition of human kind."[190]

Armenini remembered that Michelangelo had entertained a dark view of mankind and that he had remarked on the poor taste of "those simple people of whom the world is full."[191] There are many plaints of this nature in the *Dialogos em Roma*. At one point Michelangelo complains of those who cannot distinguish a good painting from a bad one.

"That valuation is very impertinent which is made by those failing to understand good or bad in the work. Some paintings of little value are highly prized, whereas others worth more do not even repay the careful work put into them or the discontent which the painter experiences when he knows that such people are to evaluate his work."[192] Michelangelo worked up a very Horatian scorn for the *profanum vulgus*. There are several evidences of it in the third causerie of De Hollanda. "But, however, since the crowd without judgement infallibly loves that which it ought to abhor and blames that which deserves much praise, it is not astonishing that it errs so constantly in matters of painting, an art worthy of none but the most lofty intellects [*entendimentos*]."[193]

Buonarroti then resumes his invective against the ignorant public which cannot distinguish between rank dilettantes who have only the brushes and oils (remember that he deprecated oil painting) of art and those illustrious masters who are born only at great intervals. "And just as some called painters are not really painters, so there is also a painting which is not painting done by these very people. And the remarkable part of it is that the bad painter is neither able nor knows how to imagine, nor even desires to do good painting through his intellect, for most of the time his work varies little from his imagination and is scarcely worse; if he knew how to imagine well or masterfully in his fantasy, he could not have a hand so corrupt that it might not expose some part or indication of his true intention." He then concludes with the thought, quoted elsewhere, that only those with an intellect (perceiving power) understanding the Good can create lofty painting.

Like those competent authors in the Renaissance who shuddered at the spread of printing, convinced that any fool could find his way into print and curry public favor, Michelangelo tended to look down his nose at his many contemporaries taking up the arts. He would have applauded Tolstóy's disdainful view that for every good piece of art produced there are hundreds of thousands of poor ones.[194] A chance remark in the *Dialogos* reveals how widely it was known that Michelangelo included painters in the *profanum vulgus*. When Vittoria Colonna and Messer Lattanzio are conspiring to bring Michelangelo to their colloquy, a priest who knows Buonarroti claims that the artist will not come if he knows

that another painter is to attend. It is not merely a question of shyness. "If Michael recognises the Spaniard as a painter, I don't think that he will under any circumstances consent to talk of painting. For this reason [De Hollanda] ought to hide and merely eavesdrop."[195]

Leonardo, by the way, shared Michelangelo's scorn of the "unmusical" throng. He decried "the ignorant crowd, which wishes nothing more than pretty colors."[196] Michelangelo, who felt that the multitude was too easily taken in by gaudy colors and distracting details, could only assent.

Horace wrote not only that he hated the vulgar throng, but that he kept it at a distance. Michelangelo concurred that the wise artist should spend as much time as possible in his ivory tower. This was not only because he was personally "of slow extrovert temperament," as Joan Evans understated it in her *Taste and Temperament*,[197] but also because he felt that one did one's best work without intrusions. The persuasion about the ivory tower was common enough in the Renaissance and was even expressed in philosophical terminology. Witness Ficino: "All those who have invented anything great in any of the nobler arts did so especially when they took refuge in the citadel of the Soul, withdrawing from the body. . . . Therefore Aristotle writes that all outstanding men in any art were of melancholy temper, either born so or having become so by continual meditation."[198] Armenini alludes to this melancholy in his *De' veri precetti*, denying that painters display an "affected and melancholy bizarreness"—and, anyway, patrons are much worse.[199] Lomazzo, on the other hand, noting the common sentiment that painters are capricious, crazy, fantastic, and excitable in conversation (the progression is his), debates whether artists are born that way or become so by getting wound up in the intricacies and difficulties of their craft.[200] In his *Trattato* Leonardo warns against social distractions: "In order that the prospering condition of the body may not spoil that of genius, the painter or draftsman must be solitary, and especially when he is intent upon speculations and considerations which, appearing continually before his eyes, give material to be well stored away in the memory."[201] He then explains how difficult and delicate it is for an artist to seclude himself and yet escape the slurs (*ciancie*) of his associates.

Probably Michelangelo's most vivid remembrance of hearing this allegation, that artists are queer ducks and "Saturnian," harked back to the scene of his reconciliation with Julius II in Bologna. The unfortunate cleric who was charged with bringing the two strong-willed men together apologised for Michelangelo, reminding the Pope that these artists were ignorant fellows once you encountered them outside their art; as such they should be forgiven their antisocial peccadilloes.[202]

In the first of the *Dialogos* Michelangelo conjures up the picture of a solitary man of genius pestered by the idle and the uncritical. One familiar with his letters becomes soon aware that he is describing himself: "If a man is blind enough to think up such an unprofitable exchange as to withdraw and remain content by himself, losing his friends and turning them all against him, is it not very wrong of them to take it in ill part? When a man observes such a discipline, whether through the force of his self-restraint which demands it or through being born with a dislike of ceremony and excessive pretense, to me it seems very unreasonable for people not to leave him alone."[203] He further questions why idle people, of whom the artist asks nothing, should expect so much from him. Why should people insist on fitting him into incompatible patterns of conduct? He then asks his auditors, "Don't you know that there are areas of knowledge [*sciencias*] which demand the whole man without leaving any part of him unoccupied for these idle doings of yours?" And if the painter indulged in as much leisure as these idlers, then he should be dismissed for making no better use of his time than they.

It is a matter of record how one of these bothersome idlers drew upon his head the wrath of Michelangelo. The story was apparently a favorite of Vasari and Armenini and no doubt of Michelangelo himself. Buonarroti was working on the ill-fated bronze *Giulio II*. A Bolognese gentleman stood indolently alongside, firing many questions and getting few responses. Finally the good fellow inquired whether this statue would be larger than a pair of oxen. Oxen, as mentioned already (note 189), signified dunces and boorish rustics to Michelangelo. This question was the last straw. Turning on him, Michelangelo replied tartly,

"Secondo i buoi, se dite di questi di Bologna, oh, senza dubbio sono minori i nostri di Firenze" ("That depends on the oxen; if you are talking

about those of Bologna, well, there's no doubt that ours in Florence are much smaller").[204]

We return to Michelangelo's lecture to his friends at San Silvestro. The sycophants who chase after notorious painters, like those who pursue popes and emperors, seek only a sort of self-gratification. The artist who satisfies this public rather than the other members of his profession must have little merit. Making this ironical observation, Michelangelo may be recalling his favorite Petrarch: "Vulgi enim laus apud doctos infamia est" ("Praise of the crowd is infamous among learned men"). And the epithet of "singular" and "apartado" applied to some artists by those adulators becomes a title of honor.

In this same outburst Michelangelo reproves dilettantes of genius and imagination who thrive upon discussions of "arty" matters. (How he would have disliked the chattering ladies "talking of Michelangelo" in T. S. Eliot's "Prufrock"!) As noted in our Introduction, Michelangelo shared the prejudice of Delacroix, Cézanne, and others that oral speculation on art is a waste of time.

Our artist has more to say: Fools and unreasoning people always consider great painters capricious and fantastic and cannot tolerate individuality in them. It is true that the eccentricities of real masters stand out, but this is because there are so few real masters. The incompetent and idle must never expect much ceremony or formality from such creative artists. The incompetent have no right to censure. If worthy painters are unsociable, it is not because of conceit but because there are so few intelligences worthy of the fine arts. They are unwilling to corrupt themselves in vain conversation with indolent people and to abase their minds by drawing them down from the lofty and continuous imaginings with which they are always embellished.[205] (Concluding his own discussion on the ivory tower for artists, Leonardo summed up: "If you must have companionship, choose it from your studio.")[206]

There is ample Cinquecento testimony that Michelangelo led a solitary life. There is the famous comment by Raphael, reported by Lomazzo, that Michelangelo was "as lonely as a hangman."[207] Both Condivi and Vasari reported that Michelangelo elected solitude because of the demands of his art, and not because of pride (Condivi) or of eccentricity (Condivi

and Vasari). "Whence it came about that he was considered by some to be proud and by others odd and eccentric, although he was neither. Love of perfection and the continuous practice of the fine arts obliged him to lead a lonely life. He so delighted in these that company displeased and annoyed him, as if turning him away from his meditations. He was never less solitary than when alone, as the great Scipio said of himself."[208] Vasari made the plea: "Let it not appear strange to anyone that Michelangelo delighted in solitude, as one who is in love with his art, which claims entirely the man and his thoughts."[209] Michelangelo's decision to stay in the Giudecca rather than accept the hospitality of the dignitaries of Venice, resulted, by his own admission, from his desire to eschew social intercourse.

The letters offer abundant testimony that Michelangelo avoided human society and "liberated his soul from external events," as Ficino expressed it. As early as 1509 he writes to his brother Buonarroto, "Non ò amici di nessuna sorte, e none voglio" ("I have no friends of any kind, nor do I wish any").[210] When Benvenuto della Volpaia invited him to come to Rome and reside in the Belvedere (ca. 1531), he assured Michelangelo that no one would even know that he was living there except two other members of Benvenuto's family. Volpaia knew that Michelangelo wanted an isolated room, a "stanza grande fuora della conversazione de' popoli."[211]

In 1538 Michelangelo remained unchanged. His unwillingness to join in the dialogues with De Hollanda and the others was characteristic. After the first meeting, during which Michelangelo had appeared to enjoy himself, it was agreed to reconvene the following day. Sure enough, Michelangelo sent word that he could not attend, and the event was postponed for eight days. In 1548, still the same truculence. He writes to his nephew Lionardo: "Vo sempre solo, vo poco attorno, e non parlo a nessuno" ("I always go alone, I get about very little, and I talk to nobody").[212]

In the dialogues of Giannotti, when Michelangelo had reached his seventies, Antonio Petreo and Donato entreat him to come and enjoy a dinner with them. Michelangelo declines, bluntly remarking that he would enjoy himself excessively, that he would attach himself too easily to men

of virtue and genius and give too much of himself to them. (De Hollanda verifies this in his statement that Buonarroti avoids him lest they go on talking until the stars are shining.) He concludes that for this reason it is best to spend one's time alone in order to "rediscover oneself and delight in oneself" ("ritrovar et goder sè medesimo") by reflecting on death.[213] Social contacts use up time, and the rapid flight of time, represented by the four Times of the Day in the Medici Chapel, preyed on his mind.

Michelangelo's withdrawal from society even extended to his correspondence. Many of the letters to Michelangelo collected by Milanesi open with the reminder, now patient, now impatient, that numerous previous letters remain unanswered.

Panofsky draws an interesting parallel between the contained dynamism of Michelangelo's statuary and his dislike of crowds. "In connection with the 'movement without locomotion' so characteristic of Michelangelo's style, it may be noted that, according to the psychoanalysts, an emotional situation of the above-mentioned kind may lead, in ordinary persons, to agoraphobia, because every impulse to move in a certain direction is checked by a reaction in the opposite sense."[214] The result would be to confine oneself to a small orbit and not to "andare attorno," to quote Michelangelo.

According to De Tolnay, Michelangelo's antisocial tendencies and world-weariness are betrayed in his statues, even those done in youth. After studying the frontal expressions of these figures, De Tolnay writes: "In the head of the *Proculus* [Michelangelo's heroic disdain of the world] takes the form of undisguised anger; in the marble head of the *David*, we see the noble indignation of an upholder of the ethical norm; in the *Moses* something like a volcanic eruption shakes the whole being... finally, in the *Brutus*, we have the 'disprezzo eroico.'"[215]

Vasari wrote that Michelangelo even ate in silence and solitude, like the Dominicans whose order he almost joined: "nè amico nessuno mai mangiò seco."[216] It is indeed an unhappy picture, that of the most original artist of the Renaissance downing his meager fare in glum silence. If it is true that he owned sufficient table linen and silverware to entertain several guests,[217] one has little indication that he used them and Vasari's claim remains likely.

Ben Jonson wrote that art has an enemy called ignorance, an enemy of which Michelangelo was apprehensive. The artist's Horatian attitude about the ignorant herd was especially characteristic of neoclassicism. Bembo, in his *Prose*, scoffed that the multitude cannot judge compositions but depend for their opinions upon a few critics who are reputed to be wiser than the rest. The Neo-Platonist Bellori wrote of the crowd: "It scorns reason, tags after opinion, and withdraws from the truth in art upon which the most noble simulacrum of the Idea is based." Yet it is too often the people who decide the fate of a work of art, as Apelles knew, who hid behind his paintings to sample the comments of the crowd. Alberti had warned of the danger in incurring the "censure of the multitude."[218] While Michelangelo might try to pooh-pooh this as the least of his worries, he knew that one could not play deaf to the *vox populi*. Vasari relates that a sculptor showing Michelangelo a statue tried to arrange the lighting to best advantage. (This is evocative of Cellini's bronze head of Altoviti, Letter CDLXXI.) Michelangelo urged him to spare his efforts, reminding him, "Non ti affaticare, chè l'importanza sarà il lume della piazza" ("Don't fret, for the important thing will be the light of the square").[219] Vasari specifically explained that he was referring to the public reaction.

Despite his predilection for the ivory tower, he would make exceptions for men of unusual merit, like Vasari. And in the dialogues of Giannotti, Buonarroti reminisces, "I have always taken delight in conversing with learned persons; and if you remember well, there was not a literary man in Florence who was not my friend."[220]

All too frequently the most ignorant were the patrons themselves. It was hard to work for a pope who could believe Bramante's insinuation that Michelangelo's working on the pontiff's sepulcher would hasten the latter's death. Michelangelo openly asserted that Pope Paul III neither appreciated nor cared about art. The *Leda* found its way to France rather than Ferrara just because Michelangelo found patrons' agents as ignorant as patrons themselves. Michelangelo did his celebrated painting of the wife of Tyndareus at the behest of the Duke of Ferrara. When the agent arrived to pick up the purchase, he looked at it for a bit and then remarked that this was "poca cosa" to turn over to a duke. The artist turned

a withering eye upon him and asked him what his business was. "A merchant," replied the agent.

"Voi farete questa volta cattiva mercantia per il vostro signore. Or, levatevimi dinanzi." ("This time you'll do a bad business deal for your lord. Now, get you hence!")

To Armenini, who tells the story, this explains why the painting never saw Ferrara.

When Michelangelo first entered the papal employ, Julius II caused a drawbridge to be built to facilitate his coming and conversing with Michelangelo "as with his own brother" (Condivi). This attention must have been most flattering. But by 1538 even popes were included among the idlers who must not impinge upon the creative activities of an artist. Bluntly Michelangelo tells his annoyance at the importunities of the pontiff: "And I assure your excellency that even His Holiness himself annoys and bothers me when he occasionally talks with me and keeps asking me why I don't come and see him. At times I consider that I am serving him better in not responding to his call. He doesn't need me and I prefer to serve him in my house. I tell him that I serve him better as Michelangelo than by standing before him all day, like the others."[221]

As a neoclassicist Buonarroti naturally favored and preached verisimilitude while taking a stand against realism. In his own mind, as we have seen, the distinction was as follows: Verisimilitude was the representation of the true inner nature of his subject, a representation satisfying truth, logic, and even faith. Realism, on the other hand, attracts the *vista (visus) exterior*, external vision, and can satisfy spectators devoid of an *intelletto*. Such spectators will demand this overt realism because it is easier for them to understand. They need seek no basic form or basic spirit. They are at home, for example, with the props and details of *paysagisme*.

Michelangelo's principal objection to Flemish art was that it contained a facile exterior realism which easily deceived (gratified) the eye:

They paint in Flanders expressly to deceive the outer vision [*a vista exterior*], either things which delight you or about which you may speak no ill, such as saints

or prophets. Their painting is of patches, masonries, plants in the fields, shadows of trees, rivers, and bridges, all of which they call landscapes, with many figures here and many there. And all this, although it may appear good to some eyes, is done truly without reason or art, without symmetry or proportion, without attention to selection or rejection, and finally, without any substance or muscle.[222]

This realistic treatment, as exemplified on Plate VIII, is of course in polaric contrast to his own practices. His cartoon, *La Battaglia di Cascina*, rejects all details of landscape, as we have noted above, and retains the nude body as the focal point of interest. His criticism of Flemish landscaping could fall equally on some Italian Quattrocentisti, for Italy had a strong national *paysagiste* tradition from Ambrogio Lorenzetti to Giorgione (Buscaroli). Typically, Mantegna's *Dormition of the Virgin* takes place against a setting of the two lakes and open countryside of Mantua. The coincidence of Michelangelo's practice and preachment was noticed by Vasari, who found its best illustration in the Cappella Paolina: "Here Michelangelo has attained the perfection of art, since there are no stretches of land [*paesi*], nor trees, nor dwellings, nor even certain varieties and prettinesses of art to be seen; he never paid attention to these, as one who perhaps disdained to lower that great genius of his to such things."[223] The trees missing from his painting do not reappear in his poetry; almost the only instances are metaphors of withered trees (III; LXXIII, 21). It was as though the "terra inanis et vacua" of *Genesis*, which he translated onto the Sistine Vault, remained his ideal thereafter. He preceded Perriollat in feeling that landscape art "n'est qu'un pis-aller pour les incapables et les paresseux."[224]

It is curious that one who spent his childhood among the Tuscan hills could turn his back so consistently on exterior nature. Had he forgotten so ungratefully Settignano's sweeps of vineyards and fragrant fields and the gardened slopes hemming Florence against her river? Had he not felt the rustic charm of the several *poderi* of which the *Richordi* certify the purchase? It seems as illogical as Corot seeing a sunset and not trying to put it on canvas. It was not until 1556, during his sojourn at Spoleto, that Michelangelo "discovered" external nature after the age of eighty. He wrote of his pleasure to Vasari: "With considerable difficulty and expense I have had during these days a great enjoyment in the mountains

of Spoleto, visiting those hermit monks. As a result, less than half of me has returned to Rome. For truly one cannot find peace except in the woods."[225]

It was at this period that Michelangelo penned his stanzas *In lode della vita rusticale* (CLXIII). To what an extent does external nature capture the artist's eye and soul in these scenes "in praise of country life"?

The first stanza depicts the pleasure of watching goats grazing on rocky crags while a herdsman shrills his horn "with its rough rime." The goatherd's disdainful sweetheart, seated under an oak, watches over the swine. The second stanza is the vignette of a group of peasants about their thatched cabin. Different members of the family set a modest table and kindle an open fire with readied beech logs. Others feed a hog and beat an ass, while an old-timer sits, close-mouthed and patriarchal, outside the entry, sunning himself. One senses that the poet has a talent for rural miniatures and for genre painting even though the treatment is stylised. But wait.

The third stanza is not a verbal *lontano,* as the painters themselves called landscapes (Pino). It describes rather the simplicity of the peasants' life. They are happy and untroubled by avarice. Their doors are never locked. They labor with good cheer. Their food is simple, their sleep untroubled. Nor does the fourth strophe paint a picture. Envy and Pride eschew the rural hut: the peasants' greatest treasure is a plow. Their buffet is a pair of baskets and their golden chalices are mere wooden vessels. These realia are mentioned, not painted. The remaining strophes are devoted to sermons on the beatitude of country life. They echo the "peace in the woods" the poet found at Spoleto. Except for a few occasional stage props (the fecund cow, the young bull, etc.) there is no further picturing of external nature. The subject matter progresses to an enumeration of allegorical vices which admittedly have no place in this pastoral setting: Lust, Doubt, Adulation, and so on. The nature-feeling, which seemed so promising in the first two strophes, disappears and is heard of no more during the succeeding thirteen.

Before commenting on these verses, let us mention another moment when Michelangelo seemed tempted to picture external nature in a poetic

work. This was when he penned the fragment (CLXVI):

> *Al dolcie mormorar d'un fiumiciello,*
> *Ch' aduggia di uerd' ombra un chiaro fonte,*
> *C'a star il cor...*
>
> *To the sweet murmur of a little stream*
> *Which a limpid fountain casts in green shadow...*

Yet the inspiration is more Petrarchan than spontaneous. One need not look into a concordance to know that the words themselves are favorites of Petrarch. The Trecento poet is even more clearly the source of another bucolic line,

> *Valle lochus chlausa tot michi nullus in orbe,*

scrawled on one of Michelangelo's sketch sheets. Here the artist seems to be starting a *carmen* in praise of nature. However, the verse is merely the incipit of an elegy of Petrarch's extolling Vaucluse. No one knows just what prompted Michelangelo to pen this.[226]

Of all Michelangelo's writings, these four documents (letter, *stanze*, fragment, quotation) are the only evidences of an interest in external nature. What may one learn from them? First, the letter to Vasari, coupled with the note to his nephew stating that he had gone to Spoleto to rest before being ordered back to Rome,[227] gives one the impression that this nature meant merely a refuge against the troubles and vicissitudes of city life. Under Paul IV war seemed imminent in the capital, and having reached his eighties Michelangelo can be condoned for fearing another sack of Rome. Nature as an asylum against the vices and concerns of civilisation (including fine arts) is the entire theme of the *stanze*. The temptation to paint a georgic setting is momentary, as is his sympathy for the husbandman's life. We shall refer (p. 238) to the emphatic letter in which he informs his family that he does not wish to have a brother who "follows after oxen" (CLXXI).

Petrarch was the inspiration for two of these four texts extolling nature. We have already posited Angelo Poliziano as another source, just as he was the source for the *Centauromachia*. His *Stanze per la giostra* (I, strophes 45, 46, 73–76) not only exalt the life of the mead but also, by means of allegorical figures, contrast its delights with the stresses and distresses of city life. Even Michelangelo's use of allegorical

figures may have derived from Poliziano. Yet it must be pointed out in Michelangelo's defense that the specific allegorical figures listed by Poliziano do not coincide at all with Michelangelo's parade of figures, any more than do the figures in Lorenzo de' Medici's splendid *Second Selva*. Whereas we are grateful for Buonarroti's sixteen lines depicting the goatherd tending his flock and the stirrings around the cabin, they are a conventional literary word picture. They bespeak, as Farinelli wrote, "a sigh of longing for that peace sought along a thousand paths, among brambles and thorns, but never found; yet now revealed unexpectedly when the span of life is lived, when the future offers nothing more and the past closes everything inexorably behind it." Michelangelo's late feeling for nature, then, is in the Horatian tradition, which views the natural setting as subordinate to a consciousness of agrestic felicity and sincerity. It is the identical tradition behind *La Vida del campo* of his contemporary, Fray Luis de León.

One must certainly question Condivi's attempt to explain away Michelangelo's preoccupation with the nude as a facet of his love for external nature. Aware of the slander of which the artist was the object, Condivi (LXIV) claimed that Michelangelo cherished all that was beautiful: landscapes, plants, mountains, woods, and so on. His rationalisation was inadequate and questionable. His thought has been restated more adequately in modern times: "Michelangelo's fancy is so bent upon molding [*plasmare*] the external world, that Nature herself, to be admitted into his mind, must renounce her infinity and variety and re-create herself anew in the image and semblance of man. Never will the humanistic conviction of the Renaissance find a more clear-cut affirmation than this."[228]

Buonarroti's practices as an artist corroborated his apathy as poet toward external nature. By artist we mean painter, of course, since, as Castiglione reminds us, sculpture "cannot, in sum, show sky, sea, land, mountains, woods, meadows, gardens, rivers, cities, or houses: all of which the painter does."[229] This sentence constitutes a check list of the elements Michelangelo rejected. Why did Michelangelo depart so drastically from the Northerners and the Quattrocentisti? Could he find no validity in the view stated in modern times by F. T. Weber: "Just as an

orchestra brings out a soloist, so the backgrounds and accessories in Holbein's and Dürer's portraits evoke sensations which make the impression of the figure all the stronger"? What is the purpose of exterior landscape if not either to help tell the story or intensify the impression?

Michelangelo believed that these exterior trappings failed to aid true vision and merely "gratified exterior vision." The basic figures, through their expressions but especially through their poses, should of themselves be trusted to tell the story or create the impression. As Blunt recalls, the Council of Trent wanted church painters to depict the story in the simplest and clearest manner possible, without the picturesque or familiar details of Gothic, without the impressive settings of the Venetian. Such details could falsify, the most flagrant case being the "German" soldiers in Veronese's *Feast in the House of Simon.*

Michelangelo's attitude is therefore not only Neo-Platonic and neoclassic, but also Counter Reformational. In him setting becomes reduced to symbol. The mere suggestion of distant city walls in the *Conversione di Paolo* represents the entire city of Damascus. The Old Testament scenes on the Sistine Vault are largely devoid of narrative detail, for here more than ever Michelangelo felt himself dealing with stark truth. Noah's vineyard becomes a barren wasteland. Brion states that there is only one tree in these histories, the Tree of the Knowledge of Good and Evil. Actually, there are two trees in the *Diluvio* (one much effaced), but the barrenness of the landscape is unrelieved. Soldiers are almost entirely lacking on the spandrels of *Giuditta* and *David.* This surprises one more than the absence of background detail, for previous treatments of the David theme had traditionally included soldiery.

What would be gained or lost if one took a typical painting of Michelangelo's and retouched it with a nature background? We have three convenient illustrations of such doctoring. Marcantonio Raimondi's engraving, *Les Grimpeurs* (Berenson, 487) is based on the left-hand segment of the *Battaglia di Cascina.* The figures are virtually unchanged, but they reappear in a setting (apparently copied after Lucas van Leyden) of hills, a thatched hut, and a distant thicket which is beginning to disgorge the armed enemy. Actually, in Villani's *Cronaca* (xcvii), the enemy had not yet come into view when the first warning, "Siam perduti!" ("We

are lost!") came to the bathers from Manno Donati. The allegorical bareness of the original cartoon may have set the mood sufficiently for one who knew the episode from hearsay or from reading Villani. Michelangelo felt that the inner nature and tension of the situation was adequately rendered by his version, which we know from the copy by Aristotile da Sangallo in Holkham Hall, Norfolk. Does Marcantonio's treatment diminish the importance or prominence of the figures? Does it serve to heighten the compassion or terror felt by the beholder? The reader may decide for himself (Plate IX). In any case, here is further proof of the Counter-Reformational attitude that background detail may falsify as much as the misreading of a scriptural passage, for Michelangelo is more faithful to Villani than was Marcantonio, not only because of the absence of the antagonists but also because his soldiers are engaged in the three acts specifically mentioned in the *Cronaca*: disarming, undressing, and bathing.

Another painter tried to make Michelangelo over in like wise. Bacchiacca's *Sacra Famiglia*, from the Constantini Collection in Paris, copies the Doni *tondo* of the *Holy Family* faithfully, but replaces the notorious athletes of the background with a peaceful rustic landscape in which two shepherds converse à la Giorgione while their flock grazes. In other words, he performs the service for which Rubens engaged Jan Wildens. Nature is in full bloom. Yet, although the Holy Family should fit into this bucolic setting more easily than into an Olympiad, somehow the brilliant and vigorous figures scarcely adjust themselves to this particular passive landscape.[230]

Finally, Battista Franco betrayed the spirit of Michelangelo's lost cartoon of the *Noli me tangere*, providing a heavily-draped Christus and Magdalene with prominent masonries of a matutinal Jerusalem as backdrop.

Joshua Reynolds sided with Michelangelo on this issue. Expressing the neoclassical view on background detail, he acknowledges that Michelangelo's works could not "receive any advantage from possession of this mechanical merit" and that they "would lose, in a great measure, the effect which they now have on every mind susceptible of great and noble ideas. His works may be said to be all genius and soul, and why should

they be loaded with heavy matter, which can only counteract his purpose by retarding the progress of the imagination?"[231] Symonds, taking no sides, merely notes this "unrelenting contempt for the many-formed and many-colored stage on which we live and move—his steady determination to treat men and women as nudities poised in the void."[232]

Later we shall posit this unconcern for exterior settings as a reason why Michelangelo at times felt himself to be more sculptor at heart than anything else. Not that sculpture is a total denial of background trappings. Compare Lorado Taft's remark on the empty chair behind Saint-Gaudens' *Lincoln*: "One had only to imagine it eliminated, however, to realise promptly how essential it was to the composition." Nevertheless, sculpture, excepting reliefs, which Michelangelo avoided, eliminates backgrounds and minimises props.

In sum, to Michelangelo incidental external reality was not the "true beauty to which I aspire" ("il ver' della beltà ch'aspiro"). We have still with us the distinction between external and spiritual beauty, as exposed in such a sonnet as "Non vider gli occhi miei cosa mortale" (LXXIX). Being created to reach out to God, the soul of the artist is not content with baser beauties:

> *E se creata a Dio non fusse eguale,*
> *Altro che 'l bel di fuor, ch'a gli occhi piace,*
> *Piu non uorria; ma perch' è si fallace,*
> *Trascende nella forma uniuersale.*

> If the soul were not created in God's image, it would aspire only
> to external beauty, gratifying to the senses; but since it knows
> that beauty as false, it ascends again to the archetype of beauty.

Possessing such a rigid conception of true reality, Michelangelo was not fazed by literal-minded critics who found his figures out of proportion, his Virgins too youthful, his deposed Christs without stigmata, his Adams with navels, his angels without wings, his newly crucified Peters bloodless, and so on.

Knowing Michelangelo's classical prejudices about sublimity, decorum, and restraint, one might expect him to be impatient of the grotesque. Whereas we must deny that until the age of Michelangelo the grotesque

had been viewed almost exclusively as a "subspecies of the comic," as claimed in a recent study,[233] it was a species introducing novelty, extravagance, and irreality. Vasari described grotesques as "pitture licenziose [unrestrained] e ridicole" expressed especially in "fogliami, maschere e bizzarrie."[234] In the Cinquecento the purely decorative, space-filling effect of the grotesque became as important as its ability to elicit emotive reactions or to help set the mood of the total composition. Probably the best contemporary apology for grotesque was Lomazzo's chapter, "Composizione delle grottesche," in his *Trattato*. Lomazzo held that grotesques could be allegorical figures as well as mere fronds, festoons, trophies, and the like. As if to prove that "there is no better sign of the vitality of art than the delight of its master-spirits in grotesque" (Hardy), Lomazzo lists some of the sixteenth-century masters who employed these motivs.[235] Michelangelo is absent. Lomazzo concludes that there are few fine and well-understood grotesques being produced in his day.

Michelangelo several times adopted grotesques in his art. Condivi (v) states that Buonarroti's early painting, *Sant' Antonio battuto da' diavoli*, copied from Schongauer, was peopled with many strange forms and demoniacal monstrosities, the youth studying fish as sources of his ideas and colors. Michelangelo did three grotesques of more typical design for the mascarons on the Porta Pia. His interest in masks, although conventional for his time, from the first faun he executed in the Giardino Mediceo to the sketches of masks in the British Museum (Plate X) and the Royal Library at Windsor, proves that the incongruous appealed to him. His most grotesque and curious mask, with its slitted eyes ascending to meet its hairline, accompanies the *Bacco*. The demons surrounding the Minos of the *Giudizio universale* are horrendous things, akin to masks and gargoyles. Mariani found in this cataclysmic fresco "that grotesque vein of Florentine flavor."

Michelangelo's admiration for the works of Giovanni da Udine reveals that he valued grotesques well done. On the other hand, he scorned them if done poorly or if he suspected that their presence cloaked a technical poverty. He complained that the artist who is ungrounded in design is more likely to try out "bizzarre, varie, e nuove invenzioni."[236] Lest someone object that the *concetto*, or Idea, of a grotesque figure is not consonant

with Neo-Platonism, supporting his objection with Plotinus,[237] there is Guido Reni's convenient if astonishing assurance that "si trova anche l'Idea della bruttezza" ("there exists equally the Idea of ugliness"). Only a master can therefore execute a perfect grotesque, since only masters can render Ideas perfectly. But this perfection is rare. Armenini, who did not favor them, grumbled, "It's quite true that grotesques have declined greatly," and that by his time the artists made them "crude, confuse, e piene di sciocche inventioni."[238]

Reflection on Michelangelo's adoption of grotesque leads to the conclusion that for him the motiv was not "per ornare & per dar vaghezza" ("to decorate and give charm"), as it had been for the ancients.[239] It was adopted to implement his terribility. Although he would be ill at ease to admit the affinity, his use of grotesque was merely the Gothic use, designed to disturb the onlooker with a disquieting presentation of the supernatural or, more properly, the subnatural. This can probably be said of even the frieze of masks in the Medici Chapel. His purpose was the Savonarolian aim of purging through dread and arriving at the instillation of virtue.

In the third of the dialogues in Rome the Spaniard Diego Zapata muses that he cannot comprehend the grotesques he finds so widespread in Rome: monsters and beasts, some with women's faces and legs and tails of fishes, others with tigers' legs and men's countenances; things which have never before been seen in the world.

It is the very question posed in the first verses of Horace's *Poetics* and Michelangelo recognises it as such, since this epistle was a basic source for Renaissance art theory. Michelangelo replies that he will gladly explain why painters have license to paint what has never been seen in the universe. He recalls from memory Horace's passage, allowing poets and painters equal license:

> *Pictoribus atque poetis*
> *Quidlibet audendi semper fuit aequa potestas:*
> *Scimus et hanc veniam petimusque damusque vicissim.*[240]

He gainsays the current opinion that this was written to abuse poets and painters. It rather honors them. He continues: "In most painting and sculpture one has to be extremely cautious about doing any detail which

might be criticised as offending verisimilitude: an ear, an eye, a vein must be exactly set, not a millimeter out of line.

"But if one, to preserve better the decorum of the place and the time, should displace any of the members (as in grotesque, which without this fitting quality would be without grace and false) or fit some part into an alien species (changing the lower part of a griffin or deer into a dolphin, or changing arms to wings or wings to arms), that member which one changes, even if it is of a lion, horse, or bird, will be quite perfect of the species to which it belongs. And this, although it may appear false, can be considered only cleverly invented and monstrous. One may rightly decorate better when one places in painting some monstrosity (for the diversion and relaxation of the senses and the attention of mortal eyes, which at times desire to see what they have never seen before or what appears to them just cannot be) rather than the customary figures of men or animals, however admirable these may be. Whence the insatiable human desire took license and rather neglected at times a building with its columns and windows and doors in favor of some other conception constructed of false grotesque, whose columns are made of children issuing from shoots of flowers, with architraves and capitals of myrtle branches, and gates of cane and other things which appear very impossible and beyond reason. And yet all this is very fine if it is done by one who understands it" (see Plate XI).

While it is true that Michelangelo advised Vasari against placing "intagli di fogliami" on Cardinal del Monte's sepulcher when decorative marble figures would suffice,[241] this advice is further evidence of his unconcern for vernal nature rather than a condemnation of the grotesque, as Aru would have us believe. Despite widespread opinion, Michelangelo did not spurn the grotesque and probably concurred with Lomazzo's conclusion that following one's "natural reason" will assure the successful composition of grotesques, which must be orderly rather than disordered.[242]

Even in the poetry there are grotesque verses, such as the self-portrait in the capitolo "I' sto rinchiuso come la midolla" (translated in Chapter VI) or the mocking "Tu ha' 'l uiso piu dolce che la sapa," but in these cases the artistic intention is purely comic or satirical.

Did Michelangelo ever make a pronouncement on Gothic art? Only indirectly, in commenting upon a plan by Sangallo. He objected that the plan was too dark, "that it had too many orders of columns, one atop the other, on the outside, and with so many protrusive members [*risalti*], spires, and chopped-up details that it resembled a Gothic [*todesca*] work much more than a good classic style, or the pleasing and beautiful modern manner."[243] This comment corresponds to what one would have expected from the Vitruvian Michelangelo, the stay-at-home who never tried to see the great Gothic basilicas of the North and associated Gothic with the worst features of the Milanese cathedral.

Nevertheless, many have claimed that Michelangelo himself displays isolated Gothic characteristics. De Tolnay finds the Sistine Ceiling Gothic: "By the dynamism of the architectonic forms (instead of the rational tectonism), it has a relationship with the Gothic architectural forms. It is Gothic in the idea of the series of isolated figures (Prophets and Sibyls), Gothic in the differing scale of proportions of the figures in the same work, and Gothic in the relationship between the figures and the architecture—a relationship in which the architecture does not form the surroundings of the figures but is the frame which determines their places."[244] To Auguste Rodin, Buonarroti's statuary made of him "l'aboutissant de toute la pensée gothique." Rodin expands the meaning of this adjective, seeing in him the Christian spirit and inspiration which characterised Gothic. Then he adds, "Celui-ci est manifestement l'héritier des imagiers du treizième et du quatorzième siècle. On retrouve à chaque instant dans la sculpture du moyen âge cette forme de console, etc. On y retrouve surtout une mélancolie qui envisage la vie comme un provisoire auquel il ne convient pas de s'attacher."[245] ("The latter is manifestly the heir of the image-makers of the thirteenth and fourteenth centuries. You keep finding at every instant in the sculpture of the Middle Age this console form, etc. You find in it especially a melancholy which views life as a transitory phase to which one must not become attached.") Obviously, to Rodin and to most others the word "Gothic" denotes much more than a temporally circumscribed and spatially localised canon of artistic expression.

A further solution to this apparent paradox of a Gothic Michelangelo

is that artistic "orders" are merely reflections and manifestations of states of mind and moments of intellectual history so composite and comprehensive that by regarding closely the content, form, medium, and intent of his art one can pick out in Michelangelo's works individual elements of primitivism, medievalism, Gothic, classicism, baroque, mannerism, romanticism, realism, naturalism, and impressionism. Such an exercise is provocative and easy to undertake upon this essentially neoclassic figure, but one risks losing sight of the man in the process.

On an earlier page we retold Armenini's story about Michelangelo's drawing a Hercules as a favor to the young Ferrarese artist Vasaro. Recalling the alacrity and sureness with which this drawing was thought out and executed, Armenini marveled, "How facile he must have been in his inventions."[246]

Turning then to Michelangelo's faculty of invention, we have no proof that he saw, as Leonardo professed to see, forms to execute in patches on walls, ashes of the fire, clouds and puddles, although his eye discerned the *concetti* within the stones of Pietrasanta and Seravezza. Also, we are told that his inventiveness was such that he "had to give birth to a concept every day."[247] This fitted into the Platonic view that Ideas reside continually in artists' minds. "In the opinion of the greatest philosophers," wrote Bellori, "Ideas are certainly the exemplary causes in the souls of craftsmen and remain perpetually and surely most beautiful and perfect." One remembers that Michelangelo was gratified to find in Via Mozza a studio in which he could supposedly execute twenty statues at a time.

Invention, we have found, had for Michelangelo logically and etymologically the sense of finding. He held that the artist merely finds pre-existing forms and beauties. In the intellectual process of invention the initial directed impulse and the capturing of the basic form stem from divinity. In this theory little is left to invention other than the choice of subject and the selection of details ("advertencia do escolher," as he called it).

Within either this delimitation or the more normal definition, Michelangelo's conceptual and iconographical inventiveness, like that of Zeuxis,

was occasionally so original as to be revolutionary. In planning the tombs of Giuliano and Lorenzo de' Medici, he did not conceive of them as lying supine on stone biers with flat covers, but rather as detached and sitting up, as though a sort of resurrection had been initiated.[248] He was willing to paint a beardless Christ, contrary to conventions. Judith's servant bears the head of Holophernes on a tray rather than in a sack.[249] His Haman is so un-Biblical as to be crucified (like Dante's) rather than hanged. He was willing to make wingless pagan demons rather than angels accompany the *Profeti*. He was allegedly the first to establish that the left half of the face is not the identical counterpart of the right half (De Tolnay). Thus, Michelangelo often invented with a fine disregard for his contemporaries and for traditions. Buscaroli notes approvingly that Michelangelo never drew invidious comparisons between his own originality and others' lack of it, as did Caravaggio.[250] As Chapter VI will show, there is reason to believe that he was usually given free inventive rein within programs prescribed by his patrons. The originality of invention in the *Giudizio universale* won Michelangelo criticism from the doctrinaire theologians, and Gilio da Fabriano censured him on several counts: his angels bear no wings; his trumpeting angels stay together when actually they will have been sent to the four corners of the earth; winds are blowing when everyone knows that on Judgement Day the winds will cease.

"From the time of Alberti," writes Lee, "it had been assumed, if not actually stated, that the only painter worthy of the name was the painter of history."[251] For that matter, Alberti takes it for granted that there is nothing but historical painting. Since a scant few of Michelangelo's statues, paintings, and sketches treat of anonymous subjects or fanciful, detached incidents, such as the archers aiming at the herm, the bulk of them referring to personages or episodes of Christian or pagan history, Michelangelo's faculty of inventiveness was affected in two ways. First, the question arose for him as for others to what extent these generally recognisable subjects should be identified or labeled. Stefano Guazzo's *Dialoghi piacevoli* scoff at painters who have to identify their subjects by "writing in capital letters" underneath them."[252] What characteristic or characteristics must be stressed, and how, so that the spectator makes

immediate identification without such capital letters? Should symbolism, primary or secondary, be called into play, as with the *Bacco?* Or is the overt expedient of a written label justifiable, as in the cases of the *Profeti* and *Sibille?*

The second question concerned the extent to which his picture should be narrative, that question on which Lessing took such an emphatically negative stand. Should it tell a story with expository detail or offer merely a brief moment or gesture or pose, from which the onlooker must reconstruct the total mood, incident, story, and even setting? Could Michelangelo agree with Leonardo that painting is superior to poetry in presenting the total impression instantly? Should a painter supply all the informative details of a Dürer, a Brueghel, or later, a Ter Borch? Should these details be increasingly fewer as the historical or legendary subject is better known?

Let us dispose of the second question first, since the answer is by now so obvious, particularly after our discussion of landscaping and natural settings. In his art Michelangelo strove to catch the single dynamic pose or symptomatic, half-expressed action which should satisfy "persone accorte" rather than to fall back on the more obvious, overtly narrative action or pose. He wished gestures and actions suggested rather than realised, understated rather than stated. If at times the actions become explicit rather than implicit, as when Michelangelo was obliged to supply narrative "duration," as in the episode-sequences of the Sistine Ceiling, or complex rather than simple, as in the *Centauromachia,* he still wished the actions, almost without stage props, to convey the story. He must have disapproved of the diptych or triptych sequences required on the Sistine Ceiling as much as, and for the same reasons, Lessing disapproved of depicting the rape of the Sabine women and then the reconciliation scene with their husbands. Michelangelo's disinclination to supply full narrative as well as descriptive detail is evident in his sketch (*qua* sketch) of the *Healing through the Brazen Serpent* (Berenson, 1564), where one cannot distinguish the Serpent, or in his *Rape of Dejanira* (*Centauromachia*), where one cannot find Dejanira.

In our discussion of Michelangelo's use of symbolism we shall return to the first question, concerning identification or labeling. He believed

· *221*

in presenting as few paraphernalia of identification (and as few trappings of allegory) as could possibly satisfy his patrons, his friends, and his public. By his own standards, the *Cristo risorto,* with its cross, pole, sponge, and rope, offered twice as many clues as needed. Identifying plaques or inscriptions are so rare that one may deduce that he was thoroughly against them and that only external pressure prompted those labels to the Prophets and Sibyls or those names on the ancestral tablets between the lunettes of the Sistine Vault. Cherchez le pontife!

If, as Lomazzo stated and we earlier acknowledged, Michelangelo accepted in practice that art's function was to "veil" reality or truth (see above, note 75), then his belief in and practice of minimal narrative, minimal allegory, and minimal identification is the inevitable concomitant of the "veiling of art."

Among the very uncommon pieces where Michelangelo may have contrived to tell a complete, light, human-interest story of his own invention is that not completely authenticated study of three foot soldiers at Oxford (Frey, 197), where the three men seem to be trying to outdo one another with their gasconades. Even in this exceptionally overt narrative there is the usual economy of accompanying detail.

Sometimes the "veil of art" is so successful as to leave scholars baffled. Why does the *Cumana* hold her book at arm's length? Justi ingeniously reasons that it is because she is farsighted. Why the pointed forefingers of *Giona*? What relation does the cameo-like head on the fibula of the *Bruto* bear to the head of the bust itself? Why did Michelangelo place a coin box under the elbow of the effigy of the Christian Captain Lorenzo?

In the case of two or three works one is privileged to learn that a statue, devoid of narrative clues, conveys a deeper message than one might discover from the overt invention alone. The case of the *Notte* is a particularly interesting one (see Plate XII). In April, 1521, Michelangelo ordered marble for the *Notte* and set to work on it by the spring of 1524. It was probably completed in August or September of 1531, a decade after the original conception. It was therefore after 1531 that a young Florentine, Giovanni di Carlo Strozzi, penned his epigram (CIX, 16) on the statue:

La Notte, che tu uedi in si dolci atti
Dormir, fu da un Angelo scolpita
In questo sasso, e perchè dorme, ha uita.
Destala, se nol credi, e parleratti.

The Night, which thou dost see sleeping in such gentle pose was
by an Angel carved in this rock, and by her sleeping has life.
Awaken her, if thou believest it not, and she will speak to thee.

Hutton, in *The Greek Anthology in Italy*, agrees with Grimm that Strozzi
may have taken the conceit from the Palatine Anthology: "The Satyr was
put to sleep, not sculptured by Diodorus. If you prod him, you will wake
him; the silver is asleep."[253]

The world is acquainted with Michelangelo's bitter rejoinder. Its
power, according to Grimm, who refused to translate it, could be ap-
preciated only by those who read Italian. (Nevertheless, Rilke's "Schlaf
ist mir lieb, doch über alles preise" is a fine rendering.) It reads:

Caro m'è 'l sonno, et piu l'esser di sasso,
Mentre che 'l danno e la uergogna dura.
Non ueder, non sentir m'è gran uentura;
Pero non mi destar, deh! parla basso.

Dear to me is sleep, and dearer being of stone, while wrongdoing
and shame prevail. Not to see, not to hear is a great blessing.
So do not awaken me, pray! Speak low!

It is improbable, as we observed in Chapter II, that the *Notte* was orig-
inally intended to convey civic protest before the second expulsion from
Florence of the Medici (1527). Indeed, two sonnets afford us knowledge
of the nonpolitical meanings night held for Michelangelo. "O notte, o
dolce tempo, benchè nero" (LXXVIII) reveals that night was the blessed
time of day that soothed away his worries and weariness. "Perchè Febo
non torce e non distende" (LXXVII) views night, on the other hand, as the
unworthy widow of day against whom a mere firefly may wage war. It is
more generally accepted that Michelangelo's bitter rejoinder deplored
conditions in Florence under Alessandro de' Medici after the Medici
restoration of 1530. If, on the other hand, Frey's contention is correct
that Strozzi's epigram was composed in 1545 and Michelangelo's reply
immediately thereafter, then the artist's quatrain decries conditions under

Cosimo de' Medici, who invited him to return to Florence and become a member of the Forty-Eight and against whom Michelangelo penned his bitter "Per molti, donna, anzi per mille amanti." If Michelangelo's reply does date from as late as 1545 or 1546, then the "wrongdoing and shame" may also refer to artistic conditions in Florence, where Bandinelli is coddled and Cellini plays a lackey's role. In any case, Giuliano's tomb came at length to embody for Buonarroti thoughts of intense campanilism and a nostalgia for the good old days of the Republic.

Another example of "veiled" exegesis by Buonarroti is a stanza (XVII) on the *Notte* and *Giorno* (*Dì*), a surprising adoption of free verse:

> *El Dì e la Nocte parlano e dichono:*
> *Noi abiano chol nostro ueloce chorso chondocto alla morte el ducha Giuliano;*
> *è ben giusto, che e' ne facci uendecta chome fa.*
> *E la uendecta è questa:*
> *Che auendo noi morto lui,*
> *lui chosi morto a tolta la luce a noi e chogli ochi chiusi a serrato e nostri,*
> *che non risplendon piu sopra la terra.*
> *Che arrebbe di noi dunche facto, mentre uiuea?*

> > Day and Night speak and say: In our rapid course we have led Duke Giuliano to his death. It is quite meet that he should take vengeance upon us as he does. And the vengeance is this: We having killed him, he thus dead has stolen our light from us and with his closed eyes has sealed our own, which no longer shine over the earth. What might he have done with us, then, had he lived?

The theme is clear enough: the tragedy of premature death. These thoughts may have been on his mind even as he sculptured the Times of Day, for the dialogue was written apparently some time after November, 1523. What would a longer life have meant to the young Duke, dead at thirty-seven? Since Giuliano was not an outstanding young man, he becomes here merely the abstract figuration of youth cut short, allegory rather than individual, just as his features were generalised rather than individualised or lifelike. Is he better off in death? "The last epigrammatic line," if we are to believe De Tolnay, "is evidently a playful enigma. The answer can only be that the Duke Giuliano would have done nothing with Giorno and Notte because the text clearly shows that his act against them was only possible because they brought him to his death."[254] On the

contrary, it is clear from the text that the Duke would have robbed Day and Night of even more of their luster, even though De Tolnay is right in pointing out that this could no longer be considered a vengeance. The conditional triumphs alluded to in the last line need not, in fact, be interpreted as acts of vendetta. To say that the Duke Giuliano would have done nothing is to rob the final line of its tribute.

This same question of premature death and the opportunities and potentialities which the young victim is denied is raised again in a quatrain on the death of young Cecchino Bracci. The poet asks the dead boy how he feels being deprived of life's experiences. The effigy of the boy (designed by Michelangelo and executed by Urbino) replies: that the day he has lived is worth a century for him who knows how to learn everything about life ("il tutto impara") in that brief span.

One may conjecture that the questions raised by the allegories are questions which Giuliano is asking himself in death, even though by tradition it was Lorenzo's effigy that represented the *vir contemplativus*. There is, after all, as De Tolnay agrees, an appearance of "contemplazione pacata e passiva" about the statue,[255] as there is about every Buonarrotian statue in this hushed chapel. Piccoli elaborates a Hamletian dilemma for Giuliano: "Is it better to live or to die? Is it better, by dying, to remove every joy from day and night—or to live many days and many nights, with the perennial dice-throw risk of unhappiness, of despair, of guilt?"[256] Michelangelo, he adds, the first in modern times to do so, poses the problem of pessimism. One must question, of course, whether Michelangelo was a pessimist at the philosophic level. Note in his earlier correspondence such specific passages as "I thank God for this thing, for I esteem everything for the best," written to old Lodovico from Bologna. However, there was a lurking pessimism in his thought, and we refer the reader to the discussion of Michelangelo's optimism and pessimism at the close of Chapter VI.

One question has never been solved to everyone's satisfaction and probably never will be: To what extent did Michelangelo include allegory and abstruse iconography in his works? Dante, representing the general

medieval view, had asserted that creative works should hold two, if not four, meanings. Did Michelangelo feel that there should be at least two imports, a literal and an allegorical? The medieval interest in allegory was still very much alive in the Cinquecento. The complete panoply of symbols from Early Christian art was still present in churches and rituals. Emblem literature stimulated a renewed interest in symbolism and iconology. Any poet or painter whose muse or memory failed him could dip into works like Ripa's *Iconologia,* the *Hieroglyphica* of Horapollo, the emblemata of Alciatus, such legislators of emblems as Henri Estienne, Paolo Giovio, and Girolamo Ruscelli, or even the mythological *Imagines* of Cartarus, to find the appropriate symbols with which to embellish his works. These numerous reference manuals, of which a bibliography has finally been completed by Mario Praz, contained both pagan (including Egyptian) and Christian iconology. A painter wishing to represent Apollo discreetly had his choice of the cricket, dove, crow, cock, griffin, wolf, laurel, sunflower, bow, lyre, tripod, or sun. An artist who felt that Jehovah ought not to be represented in anthropomorphy could turn to such symbols as the rainbow, delta, scepter, eye-in-triangle, circle, globe, crown, alpha-and-omega, and so on. With all this erudition so easily accessible, one need not conjecture that the Cinquecento masters were dependent upon their philological or ecclesiastical friends to help them conceive their works, even though this may have been the case occasionally, as Dejob supposes.

Michelangelo may have heard or read Savonarola on the subject of allegory. The preacher divided allegory into three parts: the literal meaning, the allegorical meaning, and the intention that the second should replace the first ("che quella storia sia stata fatta per significare quelle [altre cose]").[257] No doubt in the mind of Savonarola, according to whom art should teach the unlettered, this intent should be explicit. In Michelangelo's case more and more recent investigation has tried to demonstrate that his intentions were rather implicit than explicit. Michelangelo would disapprove of the pages and pages of interpretation (including romantic and Freudian) to which his works have been subjected during the past century. One cannot forget his words to the group meeting with Donato Giannotti when the speakers began to find political meanings in the *Notte*:

"Upon your faith stop reasoning about these subjects [*casi*] of mine, however true or false may be all that you affirm about me." Yet the quatrain to Strozzi showed that the figure did come to have additional meaning. And his madrigal to Florence ("Per molti, Donna, anzi per mille amanti") allegorises Florence into a wronged woman, ravished from Giannotti and his fellow exiles.

Obviously there is a certain amount of overt allegory in Buonarroti's poetry. There are symbolic figures in the curious fragment "Un gigante u'è ancor, d'altezza tanta" (LXIX). As in the case of his art, there is disagreement over its symbolism. No one is sure whether this giant represents Pride or Fury and whether the Donna, mother of the seven sins, personifies Pride or Cruelty. In his stanzas in praise of rural life (CLXIII) Michelangelo, like an emblematist or iconographer, lists and describes such stock allegorical figures as Doubt, Truth, Fraud, Adulation, Perchè (Why) and Forse (Perhaps). The figures most lengthily described are Truth and Adulation, both occupying an octave. Truth (the masculine adjective rather than feminine substantive) is portrayed:

> *Pouero e nudo e sol se ne ua 'l Uero,*
> *Che fra la giente umile à gran ualore:*
> *Un ochio à sol, qual' è lucente e mero,*
> *E 'l chorpo à d'oro e d'adamante 'l core*
> *E negli afanni crescie e fassi altero*
> *E 'n mille luoghi nascie, se 'n un muore.*
> *Di fuor uerdegia sì come smeraldo*
> *E sta co suo fedel costante e saldo.*

> Truth goes about, poor, naked, and alone, much esteemed by humble people. He has only one eye, but one lucid and clear. His body is of gold and his heart a diamond, and he grows and towers in troubled times. And if he is suppressed in one place, he is reborn in a thousand others. Outside he is verdant green as an emerald and remains constant and true to his followers.

Other figures are depicted with equal inventiveness. Adulation is a beautiful young woman, dexterous but laden with worries, covered "with more colors and raiment than the sky gives to flowers in springtime. She obtains what she wants with sweet deceits and talks only of what others like to hear. She laughs or weeps with equal will; she adores with her

· 227

MICHELANGELO'S THEORY OF ART

eyes while her hands are stealing." Fraud goes about dressed in gold and rich embroideries, his "honest" eyes lowered; he is always accompanied at court by Discord and Mendacity. Doubt moves about, hopping like a locust, continually trembling like a marsh reed. Come (How) and Perchè (Why) are giants whose height is so great that they are blinded by the sun; their shadows blot out the splendors of cities below; they like to walk through twisting and turning streets, groping with their hands to see if the ground is solid enough for them. Here, then, is another evidence of Michelangelo's "gigantism" cropping out in a curious and little known text. Here as well as in the strophe "Un gigante u'è ancora d'alteza tanta" Michelangelo is troubled by the thought of giants crushing cities underfoot. Perchè is an amusing gaunt figure, somehow reminiscent of a Gothic print, who bears many keys around his waist, but since none of them is ever the right key, he must perforce go about at night adjusting the lock mechanisms of doors.

It is a tribute to the artist's inventiveness that no one has yet been able to find a source for these iconographical figures. They do not agree, for example, with the descriptions in Ripa, the most famous contemporary encyclopedist of iconography.

Despite these poetic incursions into allegory, Michelangelo as artist was not naturally inclined toward the esoteric and the hermetic, even though he did admire the learned. Contemporaries granted him learning and depth. Witness the following repartee from Dolce's *Dialogo della Pittura*:

GIOVAN FRANCESCO FABRINI: "For I have heard it said that in the order of his stupendous *Giudizio* are contained several very deep allegorical meanings which are understood by few."

PIETRO ARETINO: "In this he would deserve praise, since it would appear that he had imitated those great philosophers who hid under the veil of poetry the greatest mysteries of philosophy."[258]

Yet Aretino cannot change his spots. He adds that he himself cannot believe that any such deep truths are hidden in Michelangelo's art, especially after he views such stupid things as the beardless Christ. Four pages later he echoes the rejoinder of St. Jerome, who found Persius so

obscure that he threw his writings into the fire. Aretino says that if Michelangelo does not wish to be understood, then he does not wish to understand him.

Vasari supposed that Michelangelo's device of three coronals interwoven might have stood for the three arts, but added, "And yet, since he was a man of lofty genius, he may have had in this symbol a more subtle intention." In recent times, with the increasing interest in historical iconology, Michelangelo's works have been re-examined by the students of graphic arts and iconography. To justify some of their conclusions they might repeat the question of Guillaume: "Y a-t-il quelque inconséquence à professer que Michel-Ange ait pu mettre dans aucune de ses statues autant de pensées qu'il en condense dans un sonnet?"[259] ("Is there any inconsistency in claiming that Michelangelo might have put into one of his statues as many thoughts as he condensed in a sonnet?")

In his remarks on art Buonarroti never got around to the use of allegory. When discussing the *Divina Commedia* in the company of Giannotti, he betrayed considerable interest in the allegorical meaning of the presence of Brutus and Cassius in Cocytus.[260] He wished the artist to be learned, as we have seen, and he agreed that, despite its function of communication, art should aim at an audience blessed with discernment and possessed of *intelletto*. On a higher plane than the grotesque, allegory could nevertheless serve "for the diversion and relaxation of the senses and the attention of mortal eyes."[261]

A reading of the biographies, and especially the correspondence, would lead one to suppose that Michelangelo's temperament was of such a nature as to become impatient with abstruse or involved symbolism, and to sympathise with Da Vinci's opinion that painting is superior to poetry because it is clearer and needs no dubious glossings.[262] Yet the fact remains that allegory was in vogue and in his humanistic milieu he could scarcely fail to pay lip service to learned contemporary fashions. So he did employ allegory, although to a lesser extent than some recent enthusiasts would have us believe. One deterrent to his use of allegory was the Counter-Reformational cast of his thought, which we have mentioned earlier. Gilio da Fabriano and other stalwart defenders of the Council of Trent attacked allegory and extolled clarity and obviousness.

Probably the most conventional example of symbolism is the *Notte*, the whole figure being a sustained allegory (Plate XII). What were the conventional figurative trappings of Night at the disposal of Michelangelo? In the iconology of the time they were the bat's wings, the crown of poppies, the cock, the owl, the peacock with star-spangled plumes, the black sheep, the nightshade, and of course the moon and stars. Night could also be represented by a mask, as Ripa's standard repertory stipulated: "È la Notte una maschera commune, sotto la quale perfino i Modesti si danno in preda alla sfacciataggine."[263] This last thought reminds us of Michelangelo's ribald comment on the dangers of the darkness implicit in Sangallo's revision of the floor plan of St. Peter's (see Chapter IV, note 140). Despite Ripa's titillating theory, the mask usually represented an incubus. Michelangelo borrows heavily from this inventory which was soon to be assembled by Ripa. He forsakes the bat's wings because of his interest in the simple nude figure, just as he rejected wings for his *Ignudi* and *Putti* of the Sistine Ceiling. The mask is present, not overly grotesque. The crescent moon, implying greater darkness than the full moon, is accompanied by an eight-pointed star. The garland of poppies is present, a conventional symbol not only for night, but for sleep, languor, lethargy, Morpheus, Juno, and Venus. The sinister owl is ensconced under the left leg of the *Notte*. An inspection of the back of the statue reveals that the *Notte* holds a firestone, the emblem of her own destruction, which Ripa says is to be struck against steel to bring forth fire and light.[264]

> *E tant' è debol che s'alcun accende*
> *Un picciol torchio in quella parte, tolle*
> *La uita dalla notte . . . (LXXVII)*
>
> *And so weak is she that if anyone kindles*
> *A little torch near her, he takes*
> *the very life from night . . .*

It is said that the other hand once held a steel bar to complete the symbolism. In addition to these trappings, the very drowsiness of the figure is a major part of the allegory. To show what extremes of interpretation have been applied to this statue, the contrast between Day and Night

(which Oeri ascribed to Plato's *Phaedo*) is supposed by Brion to be a conscious or subconscious survival of the Etruscan genii of light and darkness which used to grace Etruscan tombs.[265]

Do any of these stage props hold political meanings? Several generations of scholars have assumed that the *Notte* was a political allegory, an assumption enhanced by Michelangelo's quatrain on the figure. If it were easier to posit a political meaning for the *Notte* which dates back to its conception in the 1520's, the owl might even be a subtle protest against tyranny. The two standard symbols for tyranny were the lobster and the owl. (Callimachus had been one of the first to record that tyrants stayed awake at night plotting, like owls.) Indeed, the currently revived Horapollo (II, 25) made of the owl a symbol of sudden death, a meaning appropriate to this sepulcher. However, an initial political interpretation is a dubious one, and the allegorical meaning of this figure must no doubt be fitted into the total allegory of the Tombs discussed later.

Similar uncertainty exists about the meaning of the notorious horns on the *Mosè*. Some find them derived from libational horns of the ancients or from Near Eastern symbols adorning the diadems of kings in Thrace, Macedonia, and elsewhere. Others accept the more recent theory that these symbols grew out of a misreading of *Exodus*, XXXIV: 29: "et ignorabat quod cornuta esset facies sua,"[266] which would eliminate them as conscious allegory. Many of the applications of symbolism in the statuary are obvious, as we have seen, as obvious as the mask of *Bacco* betokening Dionysian revels.

The allegory may compound to embrace the entire conception as well as the detail. Kaiser, Oeri, Borinski, De Tolnay, and Panofsky have all supported the idea that the ducal tombs of the Medici Chapel are Neo-Platonic in over-all conception, Oeri having first posited similarities with the *Phaedo*. The most recent recapitulation of the points of Neo-Platonic interpretation upon which there is general agreement has been undertaken by De Tolnay, affirming "that each of the Ducal Tombs depicts an apotheosis, that the river gods should be interpreted as the rivers of Hades, that Giuliano and Lorenzo represent the immortalised souls of the deceased rather than their empirical personalities, that their compositional relationship with the Times of Day beneath them is reminiscent

of the Roman sarcophagi where the image of the dead is carried beyond the sphere of earthly life symbolised by the reclining figures of Ocean and Earth, and that both of the dukes are represented in spiritual contemplation of the Virgin."[267] If one grants this contemplative nature of the two Capitani, it displaces the traditional contrast of Giuliano as the active man and Lorenzo as the contemplative. The upper zone of celestial mystery is represented by the empty throne, to complete the allegory of the Neo-Platonic *ascensio*.

Among the paintings, the work most informed with symbolism is the Sistine Ceiling. Panofsky, Steinmann, and De Tolnay have each devoted a study to the Sistine Chapel, weighing overt and covert meanings.[268] De Tolnay sees in the Ceiling a carefully planned anagogy based on the *ascensio* theme, an "embodiment of the philosophic and religious beliefs of Humanism" or "the *summa* of the life-ideals of Humanism" and sees the symbolism of the parts integrated carefully into the over-all symbolism of the whole.[269] Since Michelangelo as architect has often been accused of sacrificing the whole for the parts, it is comforting to suppose such an intellectual unity in this epic fresco, this *légende des siècles*. De Tolnay's surprising interpretation of the Vault presupposes that the histories should not be viewed in chronological or Biblical sequence, but in reverse order starting with the *Ebbrezza di Noè*. His circumscribed reasoning is consistent and provocative. However, there remain doubts and doubters. A similar doubt has been raised about Gustav Vigeland's great monolith showing 121 entwining figures apparently struggling upward in a similar allegory of *ascensio*. A recent magazine article quips that, in the absence of evidence to the contrary, "it is also possible that he intended to show humanity losing its grip."

Panofsky, seeking further *ascensiones*, finds one in the drawing *Il Sogno*, or *Dream of Human Life* (Berenson 1748B). He views it as an allegory in which mortal man is recalled from his lethargy and vice to reascend to the blessed sphere from which his soul descended. The common recurrence of the *ascensio* in Michelangelo's poetry strengthens the claims of these scholars, of course.

Modern students of Michelangelo seem more and more intent upon taking a deep breath and "going beneath the surface." Panofsky, in his

Iconology, suggests that Michelangelo intended each of the Times of Day to serve as a triple allegory, representing a season, a humor, and an element.[270] Wind finds the clue to the spandrels of the Sistine Ceiling in the meanings of the Hebrew names of the ancestors of Christ.[271] And so on.

To Michelangelo the great value of the iconographical or mythographical attribute was in labeling or identifying his statue or painting in an impalpable way, just as he wished his works to bear his artistic imprint without being so obvious as to sign them. A cross distinguishes his *Cristo risorto* from an Apollo. The grape clusters distinguish *Bacco* from a callow and sensuous youth. The pelt of the martyr apostle *Bartolommeo* distinguishes him from other hagiographical casualties. The asp sets *Cleopatra* apart from other beauties of the Ptolemaic world. On some of the statues there was a second order of attributes less immediately attached to the person or role of the figure. For those unable to recognise *Mosè* by the Mosaic tablets, there were also those horns. For those unable to recognise *Bacco* by the vines of his locks, there were the broad hints of chalice and mask. Even on the projected Tomb of Julius II, where the identities of the allegorical figures (the *Prigioni,* or Captive Arts and Sciences; the *Vittorie,* or Victories over cities incorporated into the papal empire) were to be so familiar to the general public as to render trappings superfluous, an occasional secondary symbol crept in. Thus the two crouching monkeys could symbolise several peculiarities of artists: Horatian scorn, vanity, imitativeness; they also stood for taste and were the emblems of Thalia. Aware of Michelangelo's conception of the creative process as a struggle to capture minimum basic form, aware of his belief that form itself can and should assist content in conveying meaning, one may rightly suppose that this generally taciturn artist preferred to adopt in his works only a basic minimum of allegory and that it was with some reluctance that he supplied these secondary symbols and trappings.

Once, probably after his trip to Russia, André Gide wrote that painting satisfies only a small number of privileged people and that every attempt so far to popularise art has met with disastrous results. Be that as it may, Michelangelo would never have been caught in such an attempt.

He gave the classical ideal of nobility or sublimity a triple value: Art is couched in a lofty style; it treats of lofty subjects; it is the indulgence of noble people, whether those who make art or those who view it. That nobility of soul was so often considered identical with nobility of station in neoclassic times needs no elaboration; the artists of the time unconsciously supported this identification almost as much as the playwrights. A dubious but inevitable belief circulated in the Renaissance that in antiquity slaves and persons of low station had not been permitted to learn art.[272] Vasari, Armenini, and Alberti called attention to this fact. Pygmalion, they remembered, had been a king. Condivi (LXVII) records that Michelangelo as a teacher "always sought to inculcate this art in noble persons, as the ancients used to do, and not in plebeians." If Michelangelo really preferred noblemen's sons as students, he did not easily convert this preference into practice, for sons of the highborn were slow to embark on this career whose social dignity was not yet assured. He may have been influenced by his apprenticeship in the Giardino Mediceo, which constituted, according to Vasari, an academy for young artists and "particularly for young noblemen." In his poetry to Cecchino Bracci, Michelangelo is careful to add the particule "dei" to the boy's name (LXXIII, 6, 24, 25, 40, 41, 50.)[273] If Valentiner observed justly in his *Late Years of Michelangelo* that Michelangelo was prey to "an outspoken weakness for rank," shared with Van Dyck, Rubens, Rembrandt, and Velásquez,[274] it was a feeling enhanced by the predilection for nobility in his aesthetics. (Whether Michelangelo would have been more offended by Valentiner's wording or by being thrown in with those portrait painters is hard to tell.)

As an avowed associate of academicians and humanists, Michelangelo was familiar with the ideal of ὕψος decreed by Aristotle and others. Longinus' treatise on sublimity was translated by Robortelli a decade before Michelangelo's death. While taking artists to task for not ennobling men, Bellori backed his censure with implied support from Aristotle, Lucian, and Pliny,[275] the last named disapproving of ancient artists like Peraïkos who portrayed "the worst and lowest men." Loftiness or nobility became a prescription of such contemporary literary critics as Minturno and Tasso, who followed antiquity in their claim that

high literature must not only be couched in lofty style and metaphor but deal with noble ("praestantiores") people. These requirements applied especially to epic and tragedy, whose role among literary genres was comparable to that of architecture and sculpture among the arts. The artists of the Cinquecento shared the standards of the literary arbiters. The lofty concepts in Michelangelo's creations and his preference for the idealised over the particularised forms bespeak his neoclassic bent, as does the language of his poetry, recently described by the Dantean term "aulico."

Even Michelangelo's religious convictions and his theory that art reproduces the concepts of God tell him that good art can only be noble art:

And that subject will be the most noble and perfect in works of painting which will copy the subject most noble and of greatest delicacy and learning. And what barbarous judgement does not consider the foot of a man more noble than his shoe.[276]

As if to support this viewpoint, Michelangelo made most of his figures barefoot. The particular commendation he has won for his treatment of feet would indicate that he proved his point about their nobility as subjects.[277]

In Michelangelo's scale of values there was as much, if not more, nobility in a painted fish as in a painted landscape. Being a living creation of God, the fish demands a display of virtuosity. Even when Michelangelo draws two herrings alongside a menu on the verso of a letter he received from Bernardo Niccolini in 1517, these are scrupulously done. Condivi (v) tells, we remember, how the boy Michelangelo frequented the fish markets to observe forms and tints of scales and fins. (Approximately the same story was told of Leonardo, both stories being probably valid.) It was a prudent preparation. Might not a man destined to become the Church's painter laureate be required to execute one of the common symbols for Christ, for baptism, for hope in God, and for at least two saints, Francis of Assisi and Anthony of Padua?

We possess Michelangelo's own words in which he notes that the painting of a fish or animal is analogous to that of a human body:

But I don't say that because a cat or a wolf may be humble, the man who will paint them skillfully has not so much worth as the man who paints a horse or a lion's body; since even in the simple shape of a fish there is the same perfection and representation of construction as in the form of a man, and I might say the same of all the world and all its cities. But all is to be given its rank according to the work and study which one subject requires more than another.[278]

According to Condivi, Michelangelo would even admit the ridiculous mouse into this hierarchy of nobility and planned to add a mouse, as a symbol of consuming time, to the statuary of the Medici Tombs.

The passage about a man's foot being more noble than his shoe proceeds to the corollary that a man's skin is more noble than his clothing. This remark is a not-so-veiled censure of those contemporary painters who excelled in colorful and realistic textiles. To Michelangelo, either as a man or as an art critic, fine feathers do not make fine birds. Clothing establishes only a pseudo-nobility. Remember his sarcasm to the man who had donned splendid priestly raiment, "If you were as fine inside as I see you outside, 'twere good for your soul!" (See Chapter II, note 13). Thus, he never indulged in cloaking his subjects in rich or voluminous raiment, as did Giovanni Bellini, Fiorenzo di Lorenzo, Benozzo Gozzoli, Ercole Roberti, Antonio Pollaiuolo, Raphael, and the Venetians in general.

Michelangelo's unconcern for clothing, to be expected from a man whose own wardrobe was simple and often unkempt, is revealed in various ways in his poems. In an ironic note appended to a madrigal to Cecchino (LXXIII, 14) he states explicitly, "because I have poor taste, I can't help esteeming a brand-new suit of clothes, even of Romagna wool, as little as the used suits of silk and gold brocade which make a mannequin [*uomo da sarti*] look handsome." He also speaks against *uomini da sarti* in XXXVI. In the Bernesque verse we have translated elsewhere he notes that his own clothes are such as befit a scarecrow (LXXXI). In his stanzas on rustic life he envies the simplicity of peasant dress (CLXIII): "panni rozzi e bigi." Nor should we forget the gold and rich raiments of Fraud and Adulation mentioned above.

When Michelangelo wrote a sonnet in 1507 to an unknown woman with whom he was purportedly in love he mentioned articles of her cloth-

ing in loving detail. Nevertheless, in this sonnet ("Quanto si gode, lieta e ben contesta") the clothing remains general and "unpainted." In fact, furnishing an exact analogy with his art, the clothes, unlike the silken petticoats celebrated by Herrick, serve merely as veils for the more noble body beneath, almost as transparent as the clothing on the statue of Duke Giuliano. The embrace of the clothing is emphasised by the use of three verbs: *stringere, serrare,* and *premere.* "We see of this clothing only that which the artist points out to us and we notice with surprise that the very elements underlined correspond to the plastic emergence of the beautiful feminine form."[279] The mere thought that the tight embrace of the clothing rendered the lover jealous was of course not uncommon.

Despite Michelangelo's admission that many humble subjects tax the abilities of the artist, his objection to the art of Flanders, Holland, and Germany was that it lacked not only nobility of execution, but even more nobility of subject. A subject which was not in itself potentially noble might just as well be left alone.[280] Keeping in mind his own hierarchy of values and conception of nobility, he stated to Niccolò Franco in answer to several compliments, "And who does not know that a noble and sublime subject gives greatness to our souls and lends wings to the most humble and modest *intelletto* ("più umile e dappoco intelletto")? The good burghers of Memlinc and all the rest who preceded Van Dyck lent no wings to Michelangelo's intellect.

Aretino, who studied so carefully the art of delivering a telling blow, was diabolically clever in one of his criticisms of Michelangelo. This barb was uttered during Michelangelo's lifetime and Aretino knew that it would reach his ears. He observed that "Michelangelo has painted porters and Raphael has painted gentlemen."[281] Conversely, Michelangelo admired Donatello's conception of St. Mark as an "upright gentleman" (Plate XVI). Living in a moment and milieu where the concept of nobility tended to equate magnanimity of soul with gentility of birth and station, Michelangelo was prey to the aristocratic bias attributed to him by Valentiner. To understand noble art most easily, one had best to be born to the manor. The spirit of the times encouraged artists to accept this identification. "To make doubly sure that the painter should never again be considered only an artisan 'sans littérature, sans mœurs, sans politesse,' the

critics, leaning heavily on the example of Pliny, who had proclaimed the honorable estate of painters in antiquity, dwelt with wearisome though perhaps pardonable iteration on the free association of painters with princes and learned men during the Renaissance."[282] This might explain why Michelangelo, who was antisocial in so much of his personal life, nevertheless held the greatest respect for the highborn. We know of his protestations (Letters CLXXI and CCXLII) to his nephew that the Buonarroti-Simoni are an ancient and most noble family (*cittadini discesi di nobilissima stirpe*). He was proud of his family's putative descent from the Counts of Canossa (a descent discredited by Giuseppe Campori) and pleased to hear from his "relative" Alessandro da Canossa (Letter CXC). We remember the letter of 1546 in which he urged that his brother Gismondo leave the farm at Settignano and return to Florence to live as a gentleman. He was grateful that Leo X conferred upon his family the title of Palatine Counts (1515). He was proud of his coat of arms representing three golden lilies on a four-pointed stripe,[283] though he was too close-fisted, too busy, and too individualistic to lead the life of a gentleman, even the gracious life depicted by Castiglione. In December, 1546, when he had attained an age to rise above earthly vanities, he wrote to his nephew that he had happened onto a codex of old Florentine chronicles and had found a Buonarroti-Simoni among the nobility mentioned; he told the nephew to sign himself Lionardo di Buonarroto Buonarroti Simoni, later characteristically adding: "If that's too long, let him who cannot read it leave it alone!"[284] Among the drawings of the "idealised heads" was one which represented a Count Canossa.[285]

It is even possible to speculate that at the outset Tommaso Cavalieri's social eminence was a factor explaining Michelangelo's attraction. Michelangelo always used the particule *dei* in addressing him, a practice he adopted with Cecchino. The object of his other major Roman attachment, the Marchioness of Pescara, represented an even more illustrious family. He wished to please Pier Francesco Borgherini, who "is a young gentleman" (*giovane da bene*) (Letter CIX). Michelangelo, who as a youth had come as a humble outsider into the Medici household with even fewer than Candide's threescore and eleven quarterings, must have felt an inner satisfaction when late in his life his nephew Lionardo looked over mar-

riageable daughters of such families as the Medici and the Guicciardini, or when young Don Francesco, the Medici heir, conversed with him at great length hat in hand. As if to perpetuate the gratification of this latter moment, it was painted at the time of Buonarroti's death by Santi di Tito.

There are other passing evidences of this aristocratic bias. In December, 1550, probably turning his thoughts to charity because of the Christmas and Epiphanal season, he informed his nephew Lionardo that he would like to make an anonymous gift and instructed him to find "qualche cittadino nobile" in dire straits. And finally, paraphrasing Vitruvius, Michelangelo felt that building edifices for the wealthy, whom he characterised as "delicate" and powerful, called for a special type of architecture more elegant and worthy.[286]

"Treatises on art and literature written between the middle of the sixteenth and the middle of the seventeenth century nearly always remark on the close relationship between painting and poetry," writes Rensselaer Lee. "The sister arts, as they were generally called—and Lomazzo observes (as had Vasari) that they arrived at a single birth—differed, it was acknowledged, in means and manner of expression, but were considered almost identical in fundamental nature, in content, and in purpose."[287] In Pino's *Dialogo*, Fabio develops the thought that "la Pittura è propria Poesia, cioè Inventione," since both poetry and painting "make appear that which is not," and proceeds to take several precepts out of Horace's poetics and apply them to painting.[288] Assessing classical elements in Michelangelo's thinking, one wonders momentarily what he thought of the doctrine of *ut pictura poesis,* a doctrine being mooted in his lifetime by Minturno, Tasso, Castelvetro, and others, a broad doctrine developed from two slight and casual thoughts in Horace's poetic art.

After all, Michelangelo followed Giotto in being a practitioner of both pictorial art and writing. He applied his theory of the *concetto* to writing as well as to the fine arts, asserting to Tommaso Cavalieri that high and low style were prefigured in ink as the plastic form lies waiting in marble. In the *Dialogos* he claimed that Dame Painting was in olden

times the sovereign of "writing and the writing of histories." In the same text he joined Horace in affirming the kindred rights of poets and painters to be equally daring in their flights of fancy.

His contemporaries, for all their complimenting him as Apollo-Apelles, did not claim that in his case the two professions were identical in "nature, content, and purpose." Lomazzo perhaps came closest in calling Michelangelo a "gymnosophist," referring to the contemplative qualities of his art and writing. Or perhaps it was Berni, writing to Sebastiano del Piombo of Michelangelo's poetry: "Egli dice cose, e voi dite parole" ("He says things while you say words"). In modern times it has become more common to point out the various grounds on which Michelangelo's *Rime* and his art coincide in nature. One of the first of these moderns was the unhappy Ugo Foscolo, introducing his English hosts to Michelangelo's poetry in 1826. Foscolo noted that Michelangelo's sometimes rough poetic style was consonant with the rugged appearance of some of his unfinished statuary. Certain of the poems themselves are *non finiti*, abandoned, as Michelangelo abandoned statuary in which he sensed that he was failing to capture the basic form. Just as he enjoyed bringing a figure out of the confining dimensions of a marble block, he enjoyed working in the limiting sonnet form. Nesca Robb writes, "It was left for Michelangelo to inform the Petrarchan-Neoplatonic lyric with something of the fire and vigour that distinguishes his art." Mariani finds in the epigrammatic and reflective poetry written on the death of Cecchino Bracci a conscious attempt at marmoreal and lapidary expression. Michelangelo's frequent use of images, metaphors, and similes (his *sì come*'s and his *quale*'s) shows a plasticising tendency as a poet and bespeaks a desire to stress the mimetic similarities of art and poetry. Mariani notes that Michelangelo's canzoniere contains not only many plastic metaphors but also terms from the plastic arts: "pietra, sasso, scoglio, marmo, intaglio, martello, ferro, ruina, scorza" and a "hammering recourse to harsh and metallic sounds." "His poetic expression becomes a keen chiseling in hard material and the crudeness of certain words resembles fairly closely the many parts of his statuary consciously left barely indicated, in order that, by contrast, the effect of those verses which he turns and works tirelessly may result in finer workmanship."[289] Further remarks of Mariani

240 ·

on the application to poetry of Michelangelo's *concetto* theory have been translated earlier (see Chapter I, note 50).

Farinelli, with typical exuberance and temerity, advanced the original if perplexing idea that "God was to grant to Michelangelo an art never given through chance to men, an art half-way between poetry and sculpture, which would bring thought into prominence and portray it poetically, without meticulous attention to style and language, metre and versification."[290]

Certainly Michelangelo tried to use the communicativeness of the fine arts to tell the same message as his writings. Thus, De Tolnay notes that the first *pensiero* of the *Venere e Cupido* shows Venus warding off the infant Love and draws an analogy with Michelangelo's incomplete sonnet warning lovers to flee from love ("the burn sears and the wound is mortal"):

> *Fuggite, Amanti, amor, fuggite 'l foco;*
> *L'incendio è aspro, e la piaga è mortale . . .*

We have also remarked elsewhere that the *Cristo giudice* of the Sistine wall and the *Cristo risorto* are the equivalents of Michelangelo's poem decrying the moral dissolution of Rome. The *Ganimede* and *Tizio* parallel the soaring and suffering verses to Tommaso Cavalieri.

Sometimes his artistic creations were to retell the messages of other writers. Primary and secondary literary sources—belletristic and philosophical—have been found for his art: the *Cratylus*, the *Phaedo*, the *Dies Irae*, the Old and New Testaments, hymns of St. Ambrosius, Dante, Petrarch, Villani, Guicciardini, Poliziano, Ficino, Sannazaro, Savonarola, among others. Finally, Michelangelo's *Fetonte* follows closely the text of Ovid's *Metamorphoses*.[292]

In his acceptance of Savonarola's postulate that church painting is the prayer book of the unlettered, Michelangelo acknowledged that art could be a "talking book," as Simonides might have put it. Yet he never entered the debate on the relative values of painting and poetry, as did Leonardo and others, defending painting as a liberal art. Indeed, he claimed to Del Riccio that he was unable to judge the worth of a sonnet of his friend Donato Giannotti "since I have bad taste" (LXXIII, 14, ex-

planatory note). He knew that art and literature should have a didactic purpose. Perhaps for this reason he was ashamed of his sonnets and madrigals which were mere personal divertissements and personal messages to friends and to God. He became self-conscious about his poetising, as we noted in the Introduction, and avowed that it was a sign of his second childhood, of his being *rimbambito*. In his capitolo to Berni he deprecated his writing, "Send' il mio non professo, goffo e grosso."[293] His contemporaries knew better, of course. Two subsequent painters, Matteo Rosselli and Cristoforo Allori, did conventional pictures of him writing at the behest of his muse. Yet Michelangelo never even admitted that he had critical faculties for literature; he complimented Varchi on his *Due lezioni*, but qualified that he was depending not on his own judgement but upon that of other able men such as Giannotti. Then, too, there must have lurked in Michelangelo's mind just a little of the old Christian suspicion of poetry (as, late in life, of art) which he had absorbed from Savonarola and which dated back to such Church fathers as Tertullian and Lactantius, or to Augustine, who was ashamed that he had in his youth wept over Vergil's Dido. And just about the time that his suspicions became most acute, the Congregation of the Index Expurgatorius was established.

Schiller wrote that the painter is, in the execution of his work, a mechanic. Many of the Renaissance artists set down detailed remarks on the techniques of painting. Leonardo and Cennino gave careful instruction on mixing paints, etc. Michelangelo's letters, *ricordi*, and poems occasionally refer to such technical matters as sketches, models, and tools, but offer no instruction.

As we observed in the Introduction, Michelangelo never got around to writing his manual on techniques and instruction on anatomy, but he did write an incomplete capitolo, apparently designed to assist artists in the painting of the organ of sight. It is as surprising a document as the Italian adaptation of Petrus Hispanus' treatise on eye diseases found in Michelangelo's handwriting. This fragment, "El ciglio col color non fere el uolto," reads as follows: "The eyelid, with its shading, does not

prevent my seeing when it contracts, but the eye is free from one end to the other in the socket in which it moves. The eye, underneath the lid, moves slowly. The lid uncovers a small part of the large eyeball, revealing only a small part of its serene gaze. The eye, being under the lid which covers it, moves up and down less. Thus, when not raised up, the lids have a shorter arc; they wrinkle less when extended more over the eye. The whites of the eyes are white and the black more so than funeral drapes, if that is possible, and more than leonine the yellow which crosses from one fiber [*vebre*] to the next.." This poem, however, could be of little use to apprentice painters and one can only regret with Michelangelo the Younger that its beginning and end were lost. It sounds more like an excerpt from Leonardo's pages on optics than an invention by Michelangelo.

Condivi assures us of what is obvious: that Michelangelo set a high premium on mastering the technical procedures of his craft, even down to the proper way to set up a scaffold. Michelangelo became impatient with Bramante for failing in this.[294] In 1589 Michele Mercati's work on obelisks attributes to Michelangelo the invention of the *argano* (capstan) used throughout Italy to raise large stones.[295] The only mention of Michelangelo in all of Leonardo's voluminous notebooks is the jotting, occurring twice, "the chain of Michelangelo," no doubt commemorating Buonarroti's skill in raising stones and columns. In Varchi's funeral oration, Michelangelo won high praise for knowing all the technical tricks of his trade: making chisels with his own hands, fashioning trowels, and grinding colors. Later in his life he left the grinding of colors to others; according to the *Dialogos*, Urbino was paid by the day to perform this task.

These tricks of the trade are important, of course. Tolstóy claimed that these preliminary activities of piano tuners, paint grinders, and stage setters were just as important as any other phase of art. So much of this marginal preparation was undertaken by Michelangelo that his friends protested. The extreme case of noncreative preparation which Michelangelo was obliged to undertake was the construction of a road from Pietrasanta to Florence at the insistence of Pope Leo.

His knowledge of quarrying was another trick of the trade. Quarrying requires an advance knowledge of the exact dimensions of the marble

or rock to be removed, so that the sculptor has to have the entire plan perfect in his mind before ordering the marble. In a letter to Domenico Buoninsegni (*ca.* 1519), Michelangelo writes that he is learned in the art of finding "versi di marmo," suitable veins of marble, and then in digging them out.

One of the most notable of these tricks, although perhaps not of his invention, is related by Vasari. Wishing either to work at night or to obtain the best possible lighting, Michelangelo devised a cardboard hat with a candle inserted into it. In Michelangelo there is no specific mention of his technique of chiseling. He does not tell us that he worked equally well with both hands. It is Raffaello da Montelupo who informs us.[296] Cellini says that Michelangelo devised the technique of outlining in carbon on the four sides of his block of stone and then carving each *veduta* starting with the "principal," as though he were "doing a figure of half-relief."[297] We have already mentioned in our discussion of unity and perspectives two other ways of working into a block of marble practiced by Michelangelo: the working in plane by plane, without favoring any facet, and the copying from a model set in a pan of water.

There are very few literal quotations on other aspects of technique. In the field of painting he did not sympathise with Ugo da Carpi's experimentation in brushless execution.[298] He shared the general feeling that sculpture in porphyry was well-nigh impossible.[299] He felt the same of intaglio in steel until Alessandro Greco disproved him.[300]

One phase of technique on which we have several quotations is the use of models, either living or of wax and clay. Michelangelo felt that one must use living models, not only to get at the basic form, of course, but even to experiment with expressions and gestures. One cannot imagine him, like Parrhasius or Guido, murdering his model to glimpse the agony he wished to represent in a Crucifixion. Such a canard about Michelangelo circulated for two centuries, from Richard Carpenter's *Experience, Histoire and Divinitie* (1642), Sandrart's *Teutsche Academie* (1675), to Pushkin's *Mozart and Salieri*. The story shows the heights which rumors on Michelangelo could attain (see Chapter VI), even making of him a sort of Renaissance Faustus or Paracelsus by the end of the following century.

There is, however, an amusing story in which he partakes of a bit of Guido's zeal. According to Bernini, Cardinal Salviati possessed a little vineyard near the Porta Pia, to which he gave Michelangelo free access. The prelate told his gardener to extend to Buonarroti all appropriate courtesies. Somewhat later the Cardinal asked his man for news of the artist.

"Sire, 'tis a great pity that such a man is crazy."

"Crazy? What do you mean?"

"Why, I have found him in the vineyard many times with his valet, making the poor lad hold his mouth wide open. And he kept crying, 'Ancora più, ancora più!'" ("Still more, more.")

The explanation of such mysterious conduct was that Michelangelo was studying this grimace that he might reproduce it on a mascaron of the Porta Pia.[301]

Small or even life-scale models or sketches were an essential preliminary to doing a permanent work. We have already indicated this when dividing Michelangelo's theory of creative procedure into an art-phase and a nature-phase. Armenini quotes Michelangelo as saying often that he made models for all his works and checked them against the subject when they were completed.[302] Although the temporary nature of most models is underscored in Michelangelo's phrase, "breve e vil modello" (in the sonnet "Se ben concietto à la diuina parte"), the models themselves must have a perfection of their own. When young Giovanni Bologna came to the elderly Michelangelo with a clay model, the old man changed it considerably and lectured him, "Impara prima a abbozzare, e poi a finire!" ("Learn first to sketch out and then to finish!")[303] This is a variant of his scrawled advice: "Disegnia Antonio, disegnia Antonio [Mini], non perder tempo" (see Chapter V, note 33). For good artists models are money-saving devices. Bernini quotes him as saying that "l'argent qui se dépensait en dessins profitait à cent pour un."[304] He prided himself on doing a model of St. Peter's in fifteen days and with 25 ducats, whereas Sangallo had spent many years and 4,000 ducats on the same job.[305]

There were several purposes for models which may be gathered from the letters and poems. The first use, of course, was to guide and control

the larger conceptions. Vasari attributes Michelangelo's superior grasp of foreshortening and of light and shade to the latter's use of wax and clay models as both painter and sculptor. He adds that in being immobile these models have the advantage over living models.[306] Cellini wrote that Michelangelo generally worked with a smaller model, but in later years adopted full-scale models.[307] In 1524 Michelangelo, helped by the carpenter Bastiano, worked out in wood and clay the figures and tombs of the Medici Chapel, in full scale.[308] The large model of the Fiume still exists. He also experimented with a full-size wood facsimile of the Farnese Palace window. Other uses to which he put models as well as drawings were to submit a conception for the patron's approval and to assist the buyer of marble in his dealings with the stonecutters. Later in his life, weary and under constant pressures, he found a new use for models: by supplying models (or sketches) to patrons he escaped having to finish projects. And even after death his miniature of the lanterna of St. Peter's went on guiding completion of that dome.

One letter addressed to Bartolommeo Ammannati (1559) describes Buonarroti's sending from Rome to Florence a clay model which will display the *invenzione* of the San Lorenzo Library stair.[309] Several consecutive letters (to Domenico Buoninsegni, to his brother Buonarroto, and to his father) relate his difficulties in getting a satisfactory model of the Façade of San Lorenzo.[310] From Carrara he complains that a satisfactory model entrusted to Baccio d'Agnolo has not arrived and that he has had to make one himself.[311] Then from Florence he finally complains that the model finally consummated by Baccio is "una cosa da fanciulli" ("a childish thing").[312] Baccio, repentant, promises to do a satisfactory one. The drama continues and can be pieced together through several letters.

Preparation of models enabled an artist to turn over details to assistants, but it was a risk. Michelangelo bewailed the faulty construction of a vault through the carelessness of his assistants at the Vatican fabric. Chagrined, he explained that, having entrusted them with a precise model, he had not considered his daily presence necessary at the fabric. Cellini wrote to Varchi that when Michelangelo needed to show his carpenters and masons how to do certain windows he would make them in miniature

and in terra.[313] Or in wood, as on the Farnese Palace.

Some scholars have claimed that Michelangelo made several figures substrated one within the other in his sculpture. It is no doubt true that his conception of a work evolved and varied as he worked on it, even though he never admitted this possibility in his writings. His theory would rather lead us to conclude that such a practice was unintentional and even contrary to his basic idea of the art process. He began the Apollo of the Bargello as a David and then reworked it into the Hellenic god, reworking the sling into a quiver, according to one theory. Successive sketches of the Medici Chapel or the Sistine Ceiling projects reveal that the nature and intent of the works evolved by stages. De Tolnay sees the nature and content completely altered in two major works. "This was the development of the Sistine Ceiling, which he first planned to execute as a simple decorative system according to tradition and later transformed into a ὑπερουράνιος τόπος, and of the Last Judgement, which he first conceived as a representation of the act of judgement only to transform it into a revelation of cosmic fate."[314] The evolutionary process can become revolutionary, the model or *pensiero* having an ethos utterly independent of the final product. A first draft of the *Venere e Cupido* cast the sensuous female figure as a masculine body.[315] If one grants that these metamorphoses are common in Michelangelo, it betrays a divergence between theory and practice. They are, however, uncommon.

The most obvious use of a model supplies the theme for a sonnet to Vittoria Colonna: the model is the first stage of artistic creation. The theme of "Da che concecto à l'arte intera e diua" is that the divine artist himself uses these aids. The variant stanza, "Se ben concietto à la diuina parte," mentions as well the painters' custom of sketching out their conceptions on "rustiche carte" and presenting them for an opinion to their learned friends. Knowing Michelangelo's self-confidence and keeping in mind his *concetto* theory, one may conclude that he probably did very little of this consulting with friends which Alberti recommended so highly.

According to Armenini, Michelangelo felt that beginners must not study from others' reduced-scale models because these never have the movement and suavity of the larger figures, remaining rather, as Michelangelo called them in a poem, "brief and humble." He was "often wont to

say": "Il studio de i modelli è cattivo a i principianti" ("The study from models is bad for beginners").[316] It is best to work from living subjects whenever possible.

Models and sketches may have their own individuality and ethos, but they are more usually brief and humble and no one should be judged on completing the art-phase without also accomplishing the nature-phase. One day Cardinal Salviati was showing Michelangelo several models by a certain sculptor N. The prelate turned beaming to the artist.

"Doesn't it appear to you that they are the work of a great, talented man?"

"Did he execute them?" ("Ha operato egli?")

Cardinal Salviati replied in the negative.

"*Caspita*, then don't say that he is a great, talented man!"[317]

Since the testimonies of Michelangelo that we have been gathering here concern mainly the relationship between models and the end product rather than sketches and the end product, we refer the reader to discussion of the "art-phase" in Chapter I for an assessment of the *schizzi* as the first phase of the creative procedure.

A final remark indirectly related to technique is Michelangelo's expression of delight on finding that studio in Florence where he "will be able to set up twenty figures at a time."[318] It is only natural for the artist to wish a large workshop, but the passage is interesting in its prediction of the number of statues he and his garzoni may be concurrently engaged upon. As for concurrent projects, neither Michelangelo nor his patrons relished them. His agreement to finish the Tomb of Julius II within nine years provided that no other work of any importance should interfere with this commission, a frequent provision in contracts, as Middeldorf observes, always broken, like the small print in a lease. Actually, in 1518 Michelangelo had contracted to complete both this tomb and the Façade of San Lorenzo by almost the same time (1525, 1528).

One of the few jokes which made Michelangelo roar with laughter (Vasari) was one told him by the merry Menighella. This impulsive and humble friend of his did a figurine of St. Francis for a local peasant.

The yokel studied it briefly and decided that he did not like it. He wanted the gray monastic robe redone in a brighter color. Menighella obligingly painted a pluvial of brocade on the saint's back and satisfied the peasant completely. The incident was not only funny in itself, especially as Menighella told it, but for Michelangelo it contained that great truth which enriches any humor. The greater the ignorance the greater the fondness for bright hues.

Another well-known incident: Pope Julius II, watching Buonarroti at work on the Sistine Ceiling, complained that the hall should be enriched with bright colors and gilt. Michelangelo replied with unmitigated displeasure and innuendo that the men depicted in the chapel were holy men and must have scorned gold. To him this was but another illustration of how the insensitive and untutored are titillated by bright colors. Popes seemed particularly fallible on this point. In July, 1533, Clement VII irritated Michelangelo by deciding that Giovanni da Udine's decorations for the cupola of the San Lorenzo sacristy were done in too dull colors.[319] Even in his poetry his dislike for high colors stands revealed. Appending a note to a stanza to Cecchino (LXXIII, 14), Michelangelo judges gold and silk clothing appropriate to tailors' dummies. When he describes the allegorical figure of Fraud (CLXIII), decked out like a Venetian prince, he dresses him appropriately:

> *Vestito di oro e di vari ricami*
> *El falso va . . .*
>
> *Dressed in gold and varied embroideries*
> *Fraud goes about . . .*

Berni wrote to Sebastiano del Piombo suggesting that if Sebastiano wished to be like Michelangelo he had better sell his colors "to the ladies" as quickly as possible (LVII). Indeed, the high colors of ladies' cosmetics induced Michelangelo to mockery, and in an *anteros* (XXXVII) he compared the white powder and red rouge on a lady's cheeks to red poppies on fresh cheese. This surrealist image is the closest Michelangelo ever came to a *nature morte*.

Michelangelo's preference for line over color was rendered prover-

bial by Tintoretto's motto: "The drawing of Michelangelo and the coloring of Titian." Paolo Pino stated that an artist combining these fortes of the two painters would be a god of painting.[320] Vasari substituted for Titian in this motto another artist who actually collaborated with Michelangelo as a colorist, saying that the *Noli me tangere* was great because of "il disegno di Michelangelo" and "lo colorito di Jacopo [Pontormo]."[321]

Buonarroti's opinion of the role of color resembled that of Ingres: Color exalts painting, but merely as a maid-in-waiting, for she only makes more attractive the perfection of art. His view of color as ancillary is revealed in Vasari's statement that Michelangelo sacrificed such "subsidiary" elements as color in his *Giudizio*. We have already reproduced Michelangelo's definition of "excellent and divine painting," enunciated in a moment of high seriousness, which contains the important concession: "And this neither with gold nor silver, nor with very bright colors, but merely drawn with a pen, pencil, or brush, in black and white" (see Chapter II, note 18).

In denying the crucial participation of color, Michelangelo was apostatising from a long line of thinkers pagan and Christian—Socrates, Plotinus, the Pseudo-Dionysius, Aquinas, Augustine, and even Dante— who spoke of symmetry and color as equally important components of beauty.[322] His minimising of color resulted from his feeling that both painter and viewer would neglect form in the interest of this more superficial element. Vasari records Michelangelo's complaint that incompetent artists endeavor to cloak poverties of technique "con la varietà di tinte ed ombre di colori" ("with a variety of tints and shades of color").[323] Armenini recalls Michelangelo's excoriation of the simple-minded public "which look more at a green, a red, or similar high colors than at the figures which show spirit and movement."[324] One remembers Da Vinci's allegation that the ignorant throng fancies only bright hues. Bellori subsequently echoed his idol Michelangelo: people dote on bright colors because they do not understand forms. Color beguiles the "senso dell'occhio" or external vision.[325] If Bellori and Michelangelo deviate from Plotinus on the subject of color, they are no less Neo-Platonic for it. In defining beauty, Ficino dismissed color as an element of unimportance: "Eadem nos ratio admonet ne formam suspicemur esse colorum suavitatem."[326]

Yet color abounds in uses, even with those who turn their back on it. Lomazzo acknowledged in his *Idea del tempio della Pittura* that color served the "fury and profundity" of Michelangelo's design.[327] In the outer areas of the Sistine Ceiling, for example, color is used effectively to achieve heightened chiaroscuro. Thinking particularly of the histories, Montégut found that Michelangelo used soft tints on the Sistine Vault to temper the severity of the "terribility." De Tolnay also believes that the pale colors of the Sistine histories provide a distant, Olympian unity. This is generally true, except that the coloration of the Noah sequence is in conflict with the over-all gradation. De Tolnay feels that until he reached the *Profeti*, Michelangelo employed color in an abstract way, keeping the figures immobile; with the Prophets the colors become living and "transform themselves along with the substances." The mantle of *Daniele* varies from blue to white in one area, from yellow to green in another. Thus the figures become living and concrete, thanks to color.[328] Naturally the broader masses of color on the Prophets and Sibyls require more apparent nuancing.

As a corollary to Tintoretto's motto, Lomazzo wrote that the two greatest paintings in the world would be *Adamo*, designed by Michelangelo, colored by Titian, and finished by Raphael, and *Eva*, designed by Raphael and colored by Correggio.[329] His contemporaries understood that Michelangelo's preference for line over color resulted not only from a young neoclassical tradition but also an old Florentine tradition. Difficult to believe as it may be, a Venetian, Doni, in his *Dialogo del disegno* of 1549, hails Michelangelo as one of the world's greatest masters since as a Florentine he treats color as a mere accessory. Doni, in fact, asserts that charm does not come from an ultramarine blue at 60 ducats an ounce or the beautiful varnish; if it is colors that lend beauty, these are just as beautiful in their boxes by themselves.[330]

His preference for subdued colors led him as a youth to the fish markets to study the subtle tones and gradations of fishes' skins. If the *David* of marble was actually gilded, as claimed, it was certainly against Michelangelo's will. In fact, by 1538 his passion for line drove him to the assertion that a knowledge of design itself will enable one to master either fresco painting or oils.

One will be able to paint in fresco in the ancient Italian manner, with all the mixtures and varieties of colors which go along with it. One will be able to paint in oils very suavely and with greater wisdom, boldness, and patience than painters [who are not specialists in design].[331]

The day will come when Michelangelo's revolutionary persuasions about line will seem reactionary and ring as offensive in the ears of a generation of artistic rebels. Yet the rumblings will start even before Matisse. Goya will explode, "Always line—line! But where do we find these lines in nature? I see only masses and backgrounds." And Delacroix, with the simple clarity upon which the French pride themselves, "I open my window and look at the landscape. The idea of a line never suggests itself to me."

CHAPTER IV

Applied Criticisms

Ut enim de pictore, sculptore,
fictore nisi artifex iudicare...
<div style="margin-left:2em">PLINY THE YOUNGER</div>

Artists, like Greek gods, are
revealed only to one another.
<div style="margin-left:2em">OSCAR WILDE</div>

A MIDMORNING in the late spring of 1506 finds two men strolling down the Lungarno, one a monk garbed in the Franciscan *bigio*, the other a lean man in his early thirties, bearing an opened letter in his fist. The man of God is explaining:

"You understand, my son, that my role has been merely to transmit this letter to you, to inform you that if the invitation interests you, you will find letters of credit already in your name at the Gondi Bank, and that once you get to Cossa—that's near Ragusi—you will receive an honorable escort to accompany you all the way to Constantinople. The Sultan wishes you to be assured that you will travel with a grandee of his choosing. Knowing your—your distaste for violence, he wishes you to be assured that you will be perfectly safe.

"Now, if I may add in all humility—with this difficulty which has arisen between you and the Holy Father and which the Gonfaloniere claims is by now compromising even the commune of Florence, might it not be a reasonable decision to take this invitation seriously? Not every artist's fame has spread among the paynim this way. And the Sublime Porte has made promises seldom made to a Christian. You would receive gems, servants, horses, gold." The monk smiled. "You understand of

course that such worldly vanities mean nothing to me, but I am informed that you would share the Great Turk's own barber and nail parer—a signal gesture of friendship from a Turk to an Italian."

The younger man reflected. Soderini and his other friends would probably say that it was better to die going to the Pope than to live going to the Turk. Yet it was flattering to have his services solicited by (he read from the letter) the Sultan of the Ottomans, Lord of Lords of this World, Allah's Deputy on Earth, Possessor of Men's Necks, Emperor of the Chakans of Great Authority. Then, too, he would probably score an architectural triumph, doing this bridge between Constantinople and Pera, so that Pope Julius would have to swallow *his* pride and beg him to return. At the worst, it could be a profitable way to wait out until the present unpleasantness blew over.

"I'm interested, father. What sort of man is the Turk? Was it not his army which invaded our country and took Otranto?"

"True. But he did not approve and recalled the general who led the invaders. He is an austere man, a bit melancholy, simple in his tastes, fond of rhymes and speculative philosophy. In sum, something like yourself, my son. He has none of the vices of his late father Mahomet."

"Would I not miss our bell towers at times?"

"At times. But there are many Florentines in Constantinople now. And they are better liked than the Venetians or Genovese."

"Are Christians to the taste of this Bayazid?"

"He was a friend of the late Holy Father."

The two exchanged a glance of amused intelligence. The late pontiff had been Alexander VI, whose dealings with Bayazid over Prince Djem had been a scandal.

The young man fell silent. There was just one basic objection which could not be explained away. This was his own persuasion that one could scarcely create great art outside of Italy. Perhaps the thing was theoretically possible, but the evidence showed that there were almost no great artists in France, Spain, or Germany. What, then, was to be expected of the Levant? Perhaps there were great things in Constantinople, but no one ever talked of them. What was there about these foreign countries which militated against great art? He had thought about going to see for him-

self on two or three occasions. He had thought of going to France and to Spain. But to Turkey—why, that was almost as remote as England, and only a shade more civilised.

What sort of critic was Michelangelo? Bernini claimed that Buonarroti's appraisals of other artists were limited almost entirely to four stock comments:[1]

1. Questo è d'un gran furbo (This is by a cunning rogue)
2. Questo è d'un gran tristo (This is by a knave)
3. Non dà fastidio a nessuno (This won't bother anyone)
4. È d'un buon huomo (This is by a good man)

Fortunately for us, Michelangelo's assessments of other artists were not all so imprecise as these. While some possess this laconic quality, others reveal what standards and criteria he held important. Any standards which emerge as one reviews his criticisms will be welcome, for Michelangelo never actually defined goodness or greatness in art. The only definition which we have is his remark to the company at Monte Cavallo: "The painting which I so celebrate and praise will be only the imitation of one of the things which the immortal God made, with such care and wisdom, and which he invented and painted like a master painter."[2] Nor does Michelangelo oblige with a more concrete or tangible definition of the qualities of great painting in the third Roman dialogue when Francisco, having heard him speak on the excellence of Italian painting and the poor quality of the Spanish, asks simply: "And how does one judge painting?"[3] Buonarroti is consciously or unconsciously evasive in his reply. He says merely that the noble Italian painting which they have been discussing is above evaluation and price and that he has always set a high premium on the work known to be that of a most worthy artist.

Yet in the *Dialogos em Roma* three different passages containing judgements on artists supply us with as many lists of criteria by which Michelangelo measured greatness in art. When he is judging courtier painters, for example, he uses the following criteria of judgement:

I. Nobility, knowledge, profit, substance.[4]

When he judges draftsmen-painters, he measures them by another complexus of qualities:

II. Suavity, knowledge, boldness, patience.[5]

Finally, when he is evaluating the Flemish school, still other standards come into play:

III. Reason, skill, symmetry, effortlessness, substance and muscle, proportion, and selectivity.[6]

During the course of this chapter we shall find that nine of these thirteen criteria were used actively by Michelangelo in other specific cases. Fifteen further criteria will gradually emerge from the pages that follow, making a total of twenty-four active categories which Michelangelo might summon to mind as he stood assessing a work of art.

What evidences of *parti pris* will accompany the subjoined judgements? What personal characteristics will they reveal which may modify their objectivity and detract from their value?

In his ninth memoir Baccio Bandinelli admitted that he was stung by Michelangelo's criticisms (see page 290), even though praising the fairness of Buonarroti, "whose judgement I esteemed above that of any other, not only because he was intelligent, but because he was not moved by a maligning spirit."[7] Well intended or not, Michelangelo will be, we know, a severe critic, for we have recorded his underlying belief that good taste is rare and that the world is blind. It was believed that the severity of his censure of Antonio da Sangallo, written to Pope Paul III, caused that architect to die of grief (see Chapter V, note 84). Cellini's memoirs (I, III, 13) remind us that in his youth Michelangelo always used to taunt (*uccellare*) other art students. Indeed, his early harshness as a critic earned him his disfigured nose. It is not by accident that only one of the four comments recollected by Bernini was favorable. We know that he will be vehement in his opinions and that this vehemence will often be transmuted into irony. Irony and sarcasm could pay off well, as proved by his letter protesting Clement VII's project of setting up a colossus opposite the Stufa Palace in the Piazza San Lorenzo, or the letter criticising the lighting arrangements in Sangallo's model for St. Peter's. He directed irony even at his closest friends. In the first dialogue at San Silvestro, Vittoria Colonna asks innocently whether in the building of a nunnery on the slopes of Monte Cavallo an ancient ruined portico on the spot might not be incorporated into the new edifice. Again adopting the

campanile as a motiv of humor, Michelangelo replies with mock serious-
ness, "The ruined portico can serve as a bell tower." The irony of this
remark is somewhat weakened when one recalls that Michelangelo was
to make of the tepidarium of the Baths of Diocletian the nave of his
church Santa Maria degli Angeli.

One must keep in mind not only the subjectivity behind some of his
judgements but also the possibility of perfunctory flattery. There were
the cases where Michelangelo enjoyed affable relations with the artist,
where he felt coolness or envy (Raphael, Leonardo, Bramante, Perugino,
Antonio da Sangallo, Sansovino), or where his feelings underwent a
radical change, as in the estrangement with Sebastiano del Piombo. The
stinging quality of Michelangelo's judgement on Francesco Francia can
best be understood when one remembers Francia's comment on his *Giu-
lio II*. Michelangelo turned against Jacopo Pontormo, who colored the
Venere e Cupido and then refused to consign it to Bartolommeo Bettini,
to whom Michelangelo had donated it, turning it over instead to Duke
Alessandro.

Most of all, we shall have to cope with and discount his extremely
nationalistic bias. The Renaissance conception of Italy as the home of
the third classicism was obviously shared by Michelangelo. He lived in
a century when the concept of a national state with its concomitant of
political nationalism was coming into definitive existence. Writing of an
Italy centered on Florence, Siena, and Rome, Michelangelo used (Letter
CDLXXXVIII) the word "nation." He was confident that little art
created outside the peninsula was of first quality. Whereas God decreed
to a certain international elect an intellect-for-beauty, his Hebrew was
spoken with an Italian accent. Michelangelo felt that love of form was
the Hellenic patrimony to the New Greece. In the *Dialogos em Roma*
he lauds "Italy, where things are perfect" ("Italia, onde ha a perfeição
das cousas"). He maintains that a work done in Italy bears a particular
stamp which none, not even Albrecht Dürer, can counterfeit.

"Thus, I affirm that no nation or person (I except one or two Span-
iards) can perfectly copy or imitate the Italian mode of painting, which
is the ancient Greek, so as to avoid being recognised easily as an alien,
no matter how much effort and labor he may devote thereto. And if

through some great miracle such a one should succeed in painting well, then, even though he did not do it to imitate Italy, one will be able to say that he painted as an Italian" (see Plate XIII).

"Italian painting does not denote just painting done in Italy, but rather whatever is good and sure, for in Italy works of illustrious painting are done more masterfully and seriously than anywhere else. We call good painting Italian. Even if it were done in Flanders or Spain, which approach us most closely, that painting, if it is good, will be as of Italy."[8] He concludes that painting has been most flourishing in Italy since antiquity and that it will no doubt continue to flower. Michelangelo would have been incredulous and scandalised had he foreseen that a scant four centuries later the government at Rome would try unsuccessfully to summon three painters from New Spain far over the seas (Rivera, Orozco, and Siqueiros) to take charge of the painting of new government buildings being erected in the Eternal City.[9]

In the third dialogue these nationalistic feelings crystallised into advice to Francisco never to leave Italy, lest he regret it. He offers this counsel twice.[10] He seems to betray a partiality toward the city of Rome itself when speaking of painting as "that power which will always be esteemed so long as there will be men in Italy and in this city."[11] Indeed, the city of Rome "produces divine men" (Letter CDXI). A prideful attachment to Italy shows in his letters, where he praises various Italian artists, while wasting almost no paeans on foreigners. The bias is even clearer in the *Dialogos em Roma.* Further proof of this attachment was his unwillingness to leave Italy, even when invited by Francis I and Bayazid the Turk. In fact, he never left the confines of this land he loved so well, even for his projected pilgrimage to St. James of Compostela. He might never have been a better painter or sculptor for doing so, but one wonders how his critical opinions might have changed. As it was, his chauvinism reached the point where he could affirm that apprentices in Italy paint better than masters elsewhere.[12]

There was of course more than a grain of truth in Michelangelo's remarks about his homeland. Throughout Western Europe, painters, sculptors, and architects were favored if they adopted an Italianate style. Even "El Griego" in Spain preferred to retain the more Italian version

of his name. Italianism so dominated almost every phase of life outside of Italy that even the humanists, like Budé, cried out in protest. There was such a basic difference between Northern and meridional art that most theorists, whether in the North or the South, agreed on their irreconcilability. The great architect Palladio wrote in 1572 that what is Tudesque is Tudesque and what is Italian is Italian, and that this is ordained "at birth": "essendo che si vede apertamente quanto si obedisca al nascimento."[13] Vincenzo Scamozzi followed suit in his *Idea dell'Architettura*, adding the bald statement that the majesty of God has given outright preference to the architecture of Italy.

Before reproducing the critical remarks which will constitute the substance of this chapter, let us pinpoint Michelangelo's nationalism and review the claims of Florence and Rome on his loyalty. Great was the initial hold of Florence, the "younger sister of Athens" (Grimm), which remained for Michelangelo a "preziosa gioia" ("precious jewel") (LXVIII). Campanilism or parochialism among Florentines was intense, as it is today, and one of Buonarroti's most impassioned poems (CIX, 48) is addressed to Florence, separated by a tyrant from her loving citizens (see Chapter II). When he was plying his craft in Bologna (1507) he wrote a letter to his brother Buonarroto in which his homesickness cried out. The Bolognese weather made him wish for that of Florence. The wine was worse too. He concluded that it seemed a thousand years since he had last seen Florence ("a me par mille anni di venirne").[14] It had actually been about eight and a half months. At the age of seventy-one, when he still pronounced Italian as a Tuscan, Michelangelo referred to himself as "cittadino fiorentino" to Giannotti and his friends, even though he received Roman citizenship just at this time.[15] His friendships in his native Tuscany were always a loadstone. In later life, when his boyhood friends and family were fewer, he still had three close comrades living along the Arno: Fattucci, Varchi, and occasionally Vasari. Even during the aforementioned talk with Giannotti and his friends in Rome, Buonarroti praises his acquaintances in the Florentine Academy and wishes that he could get back to discuss Dante with them.

Yet Michelangelo's devotion to his art, as well as his ambition, caused Rome to win out. When the opportunity first presented itself to take a

commission in Rome, he viewed the city on the Tiber as a "very broad field in which a man may demonstrate his worth" (Condivi). Yet when he saw the Rome of Alessandro VI he was able to describe it only in terms of censure (x) which anticipate the *Cristo giudice*:

> *Qua si fa elmj di chalicj e spade,*
> *E 'l sangue di Christo si uend' a giumelle,*
> *E croce e spine son lance e rotelle,*
> *E pur da Christo patientia chade.*

> *Here in Rome chalices become helmets and swords,*
> *and Christ's blood is sold by the bucket,*
> *and crosses and thorns become lances and shields,*
> *and even Christ is losing patience.*

One is struck, however, as one reads through Michelangelo's letters, by the continuous refusals to accept commissions which might remove him from Rome. Notes to his family in Florence reveal him inventing all manner of excuses not to take trips to Tuscany. If he journeys to Florence, or contemplates doing so, it is because things are not going smoothly in Rome. When he is disputing with the pontiff, he is prepared to leave Rome for Florence or, as Condivi tells it, Genoa or Urbino. Long-term commissions like the Sacristy and the Façade of San Lorenzo (where Leo X decided to use his talents but keep him at a distance) maintain his interest in Florence, as does the presence of his diminishing family. When misunderstandings and insubordination break out at the fabric of St. Peter's, he threatens to quit Rome and promises darkly, "Finirò la vita in casa mia" ("I'll end my days back home").[16] He always planned to spend his last days in Florence, as Vasari's account of his death shows, and long before his demise he instructed his family to purchase a house where he might spend those last years. Eventually he bought several properties in the Santa Croce neighborhood. Yet by his own admission in 1557, he owned property in Rome worth several thousand crowns. He never saw Florence after September, 1534, the summer his father died, not even returning there for the opening of the Medici Chapel in 1545. Vasari records that Michelangelo stayed on in Rome because its climate was more temperate than that of Florence. It is true that Michelangelo eventually relied on medicinal waters at Viterbo to maintain his health.[17] But the artistic advantages and the facilities of the capital kept him there. He

declared to his nephew that if he left the conveniences of Rome he would be dead in three days. Furthermore, he felt in later life that none of the relicts of the Medici dynasty was an art patron worthy of the Magnificent Lorenzo. In fact the return of Alessandro with his sycophant Bandinelli (1532) made the idea of residence and apparently citizenship in Florence distasteful to Buonarroti. At times Michelangelo, like Dante, upbraided Florence for her ingratitude and arrogance (see Letter XXXVII of 1512 to his father). In his *Marmi,* Doni typically deplores Florence's mistreatment of Michelangelo and the brilliant artists and humanists of his generation.[18] The number of Florentine exiles disturbed Michelangelo and, while he was prudent about conversing with them or even being seen with them, he imparted to them sympathetic counsel (CIX, 64). If Fattucci and Varchi were good friends in Florence, even stronger friendships blossomed in Rome with Tommaso Cavalieri, who closed his eyelids in death, Vittoria Colonna, whom he sustained when her other friends deserted her, Sebastiano del Piombo, later estranged, and Condivi and Vasari, when the latter was not in Florence or Arezzo. Vasari, in fact, expressed gratitude for the opportunities afforded him by Rome akin to Michelangelo's own gratitude. To Vincenzo Borghini the painter-biographer wrote: "This Rome has been a good Rome to me, for it has saved me from poverty so many times, and now these blind fellows [his patrons] are beginning to see the light."

Michelangelo preserved the attitude of the expatriate so common in our century. His conviction remained strong that he would eventually return to his *paese.* By the end of his life the Romans considered him one of their own, safely breveted with Roman citizenship. The Florentines knew better, and Michelangelo eventually returned to them—smuggled back in an ordinary merchandise packing box, a vengeance upon the artist who wished as a matter of principle not to "parer mercante" ("appear commercial").

Michelangelo never forgot what Florence represented in the history of art. Nor did he forget that it was to Florence that he owed his preeminence in line and design. Even while working in Rome, with the best of craftsmen in the capital at his disposition, he continued to send back to Tuscany for assistants.

Recapitulating—as we proceed to analyse Michelangelo's specific judgements on other artists, we shall watch for his dependence upon criteria which he admittedly considered decisive: nobility, knowledge, profit, substance, suavity, boldness, patience, reason, skill, symmetry, effortlessness, proportion, and selectivity. We shall be on guard for subjective judgements stemming from his personal relations with his confreres. We shall be prepared to find nationalism coloring his assessments of foreign artists, just as a Roman and Florentine bias may color his criticisms of craftsmen neither Roman nor Tuscan. One would like to find him as unbiased as the Venetian Paolo Pino, who made it a point of honor to criticise his fellow townsmen: "I am not so intoxicated with love of my *patria* that I am blinded from discerning the true." Michelangelo will certainly not be able to emancipate himself from parochialism to the extent that Leonardo the Florentine could: "I can assure you that from this district you will get nothing except the works of hard, mean, or clumsy masters. There is not one man who is capable—and you may believe me—except Leonardo the Florentine."[19]

We have discussed earlier Michelangelo's veneration for classic art and artists. We have observed that he considered them unsurpassable but not inimitable or without potential peer. Their greatness is explained by the fact that they lived in a primitive period when great men were closer to nature and to divinity and partook more easily of natural and divine powers. Because of their self-imposed laws and disciplines and their consciousness of living up to precepts, even the weakest of the classic sculptors whose statuary lay about Rome were held by Michelangelo to be superior to his own contemporaries.[20] He found constant inspiration among the ancients. His desire to execute a colossus at Carrara was, we are told, inspired by antiquity. Much of the recent source study to which Michelangelo's works have been subjected emphasises more and more his affinity with classic artists.

Occasionally Michelangelo delivered an opinion on a specific artist or masterpiece from the remote past. He avoided the contemporary bad habit of praising some work lauded by Pliny which never survived antiq-

uity. He admired Zeuxis and Polygnotus for their belief in their own genius and their knowledge that their works were priceless.[21] As pointed out in Chapter III, he favored Zeuxis' method of using several models to attain a more generalised form. He held that Apelles was partly responsible for the military successes of Alexander the Great.[22] He secretly admired Apelles for knowing how to manage a difficult patron and eliminate rivals, so that the King would permit no other to do his portrait.[23] He remembered that Apelles' sense of design was so perfect that he could set himself apart from rivals by painting a single line.[24] He recalled that Pausias of Sicyon could paint a child perfectly in a single day.[25] Michelangelo was so impressed by the sense of proportion revealed by the "marvelous statues" of Phidias and Praxiteles that he regretted that modern sculptors had lost their power to visualise measurements and proportions without the aid of instruments.[26] He described the artistic and architectural antiquities of the Forum and Mount Palatine as "ambitious and magnificent."[27]

Yet Michelangelo's greatest admiration was reserved for Apollonius of Athens. In Lomazzo's *Trattato* one reads that a modern artist cannot always equal certain ancients. "Michelangelo testifies to this. He was never able to attain the beauty of the torso of Hercules, by Apollonius of Athens, which is found in the Belvedere at Rome, although he continually strove to do so."[28] It is said that Michelangelo never tired of admiring the Belvedere Torso, that he drew it from every side, and that even when almost blind he studied its perfection by running his hand over its surfaces. Diego de Villalta (1590) quotes Michelangelo as calling this work "his Master."[29] Panofsky thinks that Michelangelo imitated it in the genius above and to the right of *Geremia* of the Sistine Vault.

Bernini relates that Cardinal Salviati encountered Michelangelo kneeling before this torso and admiring it. The prelate spoke to him, but Michelangelo, completely absorbed, did not answer. At length he remarked aloud:

"Questo è l'opera d'un huomo che ha saputo più della natura. È sventura grandissima che sia persa" ("This is the work of a man who knew more than nature. It is a great pity that the total work has been lost").[30] (See Plate XIX).

Rome delighted Michelangelo as a veritable museum of antiquities. Ancient statues which reappeared in his day were the Belvedere *Apollo,* the *Laokoön,* the Belvedere Torso, and many more delivered from the subsoil and from the Tiber bed. From such statues came Michelangelo's inclination to dress his Giuliano and Lorenzo in classical garb. In fact, his lost portrait of his beloved Tommaso Cavalieri showed the Roman youth "vestito all'antica." We have already related the story of his wandering out into a snowfall to "go to school" at the deserted Colosseum. Girolamo Preti wrote: "And if we wish to believe Michelangelo himself, it is notable that he often went to see the ancient columns which are today at the well of the Convent of San Pietro in Vincoli, placed there by Julius II, if I remember correctly. And then the good man would have a seat brought into that courtyard and sit without budging two or three entire hours, contemplating them."[31]

Buonarroti's intransigent classicism was still another reason for his break with Bramante. It was bad enough for the architect to destroy, over Michelangelo's objections, the ancient columns of the old basilica when rebuilding St. Peter's. But when he heard that the "Ruinante" was going so far as to demolish ancient structures in Rome to be used on the Palazzo di San Giorgio, Michelangelo decried this as anticlassical sacrilege.

Michelangelo turned his critical eye upon the art and artists of Renaissance Europe. We remember his remark that Spain and Flanders "approach us most closely." In a moment it will become clear that he by no means considered these countries close runners-up to Italy. Let us turn with him toward Spain.

Claiming that no one outside of Italy could imitate the Italian manner, Michelangelo excepted "one or two Spaniards" (see above, note 8). Vasconcellos suggested that these two were Michelangelo's pupils, Alonso Berruguete and Pedro Machuca. Menéndez y Pelayo proposed that the artist had in mind Berruguete and De Hollanda himself. His Andalusian disciple Gaspar Becerra had not yet appeared in Rome at this date. Buonarroti makes a noncommittal allusion to Berruguete in his corre-

spondence (Letter XXXVIII). Both Machuca and Berruguete imitated Buonarroti, although the latter's "version of Michelangelo's style was, it is true, a manneristic version."[32] What the commentators tend to overlook is that, with two listeners from the Iberian Peninsula before him (Francisco de Hollanda and Diego Zapata, mentioned only when the first dialogue breaks up), there is every reason to suppose that Michelangelo's polite concession to "one or two Spaniards" was purely rhetorical. After all, no painter in Spain during the first half of the Cinquecento stood shoulder high to the Italian masters. Michelangelo's statement predates by nine years the birth of El Greco. Michelangelo's general appraisal of Spanish painting is an accurate one. An entire generation of Hispanic artists traveled to Italy during the mid-Cinquecento to learn that exemplary manner which Michelangelo labeled Italian. If Michelangelo did believe that one or two artists were exceptionally competent, then they were certainly two of this group of Italian-trained artists. He then proceeded to develop an economic thesis to explain the poverty of Spanish painting. While it was true that some grandees claimed an interest in the fine arts, they would neither order nor pay for pictures. They were even disconcerted to learn that people in Italy paid such high prices. Michelangelo had no way of knowing that with Philips II and IV Spanish patronage would begin to assemble one of the richest collections of paintings known to man.

"I know that in Spain they do not pay so well for painting as in Italy, and so you will be surprised at the great amounts paid for it [here] as people brought up on little sums. And I am informed of this by a Portuguese assistant I once had." (*Criado* has been universally translated here as "servant"; it is rather the sixteenth-century use of *creato*, or assistant; *cf.* Vasari, who calls Mini a *creato* of Buonarroti.)[33] "It is for this reason that whatever painters you have live here and not in Spain. The Spaniards withal have the finest nobility in the world. You will find that some applaud and praise and delight in painting just as much as you please. But if you press the point with them, they never intend even to commission a small work and pay for it. And I hold as even more contemptible their astonishment when you tell them that there are those in Italy who pay high prices for works of painting. Certainly, in my opinion,

they do not act, in this, like the nobles they say they are. They underrate that which they cannot experience or carry out. But all this falls back on their own heads, since it reflects no credit upon them and disgraces the nobility of which they boast."[34]

Hans Tietze and, after him, Carlo Aru write that this condemnation of the grandees casts in doubt the trustworthiness of the *Dialogos*, that this insertion is merely a byplay to win greater support for the arts in Francisco's homeland.[35] It is possible that De Hollanda did accentuate or doctor this portion of his record. It is equally possible that Michelangelo placed his criticism of unappreciative patrons in an Iberian frame of reference as a sympathetic gesture not only to Francisco and Zapata, but (as we have remarked elsewhere) to the Hispanophile Vittoria, whose husband's enthusiasm for Spain was such that he regretted not being born Spanish. Actually Michelangelo's concern over stingy patrons was ever-present (see Chapter VI). In further answer to Tietze and Aru it should be noted that the reference is not to Portugal, after all, but to Spain. Had Francisco invented a comment on the situation in his homeland he would not have lumped Portugal under the general term "Spain"—the identical geographical imprecision for which he reproached Michelangelo.

Michelangelo's thoughts about Portuguese art may be summarised in a verse from the *Lusiadas* of Camoẽs:

> *Quem não conhece a arte, não a estima.*[36]
> *Who does not know art does not value it.*

Michelangelo comments that the Portuguese do not esteem great painting because they have none. One cannot prize what one has never seen. He reflects that the Portuguese would do well to see and ponder over the beauty of painting in some of the homes of Italy.[37]

How about Germany, which Michelangelo considered a territory perilous and difficult for visitors and one generally held in scorn by the Italians?[38] We shall see presently that Michelangelo dismissed Sangallo's plan of St. Peter's as "cluttered and Germanic" ("todesca").[39] Among the German artists Buonarroti mentions only Dürer, as "Albrecht, a man delicate in his manner"[40] (see Plate XIV). Michelangelo would prefer that Dürer paint in the Italianate manner, although admitting that

this would be impossible. Dürer had visited Italy the first time in the year that Michelangelo did his *Giovannino* (1495) and had managed to retain his Northern manner. The basic differences between Michelangelo's and Dürer's equally remarkable conceptions of art have been dealt with by Panofsky, who has also studied the Northern Italian sources of Dürer's theories of proportion. Condivi implies that his friend found Dürer's *De Simmetria partium humanorum corporum* (1532–1533) much too involved in mathematical proportions and diversities of the human figure and feared that excessive attention to rules may cause the artist to create figures stiff as posts. "I know perfectly well that when he reads Albrecht Dürer he finds the latter very weak, visualising how this or that conception of his own could be more beautiful and more useful."[41] Furthermore, it appears that Michelangelo dissented from the German's notions on fortification.

In Pierre Nougaret's *Anecdotes des beaux-arts* there is an apocryphal story about Michelangelo's appraisal of Dürer. "Emperor Charles V asking him one day what opinion he held of Albrecht Dürer, an able German painter and estimable man of letters, one claims that Michelangelo dared to reply as follows: 'I esteem him so much that, if I were not Michelangelo, I should rather be Albrecht Dürer than Emperor Charles V.'[42] The irony and bluntness of this reply would of course be characteristic of Michelangelo, although it is a reminiscence of Alexander's famed compliment to Diogenes retold in Diogenes Laertius and Plutarch.[43] There is a possibility that Michelangelo met Charles V during the latter's 1536 sojourn in Rome, as Grimm conjectures. On the other hand, if the remark was made, it signifies not that Michelangelo loved Dürer more but perhaps loved a Spaniard less. It all seems doubtful, in any case, especially since it was possibly at this point that the Emperor tried to get Michelangelo, now for one year chief painter, sculptor, and architect of St. Peter's, to accept a commission from him.

Had Michelangelo known Cranach, Grünewald, and Holbein, whom he does not mention, he would obviously have been displeased at their incompatibly realistic and linear manner and unclassic themes, typifying German taste of 1500–1550. Michelangelo received better treatment from the Germans, for his fame had spread into Germany by the term of his

life. Pier Vettori wrote to Borghini in January, 1557, that some German gentlemen had come to Rome expressly in the hope of seeing Michelangelo.

As Flanders was the most serious contender for the primacy of painting outside of Italy, one might expect Michelangelo to save some of his sharpest barbs for the Flemings. His "unmusical" patron Hadrian VI (1522–1523) had not impressed him favorably with Netherlanders' sensitivity to art. By his nature Michelangelo disliked what was later to be called *genre* painting, with its homespun settings and types, as inconsistent with the neoclassical canon, forgetting that even in antiquity such masters as Peiraecus and Studius had elected this type of subject. Michelangelo does not mince his words in this celebrated comment.

"The painting of Flanders," replied the painter slowly, "will generally satisfy, milady, any devout person, more than any painting of Italy, which will never make him shed a single tear. Flemish art will make him weep many tears, and this, not through the power or excellence of that painting, but through the goodness of that devout person. It will appear good to women, especially the very old and very young ones, and likewise to monks and nuns, and to some gentlemen insensitive (unmusical) to true harmony." Whereupon he expressed the condemnation of Flemish realism quoted earlier,[44] complaining of the desire in the Lowlands to gratify the outer vision with the abundance of realistic details which one might find in a crowded landscape, evincing no form or symmetry (see Plate VIII).[45] He acknowledged the prevalent notion that the Flemings excelled in the painting of textiles and foliage, the textiles of nature, whereas Italian artists eclipsed others in nudes, symmetry, and measure.[46] Yet Michelangelo questioned the validity of the very notion of Flemish specialisation, for if a painter does one thing well he "can paint everything created in the world." He admits, as we saw in Chapter I, no such thing as partial or qualified genius, and transferred application of talent is the normal rule.

Michelangelo could complain of Flemish and Dutch (he lumped the two as he on occasion lumped Spanish and Portuguese) middle-class and exhibitionistically pious subject matter. He could decry the lack of reason, skill, symmetry, effortlessness, substance and muscle, proportion, and the in-

attention to choice of detail which he found in the art of the Lowlands.[47] He no doubt disapproved of the amount of portraiture being done by the Flemings in the sixteenth century. A Neo-Platonist, he may also have taken pride that, as Antoine Coypel was to write later, he, Michelangelo, made men better than they were whereas the Flemings and Dutch made them "plus méchants." Yet even the divine Michelangelo could not summarily dismiss the Flemings, who had learned the art of painting through the discipline of the guilds. He himself was very aware of the need of protracted apprenticeship. (According to Giraldi Cinzio, he scolded a certain pupil Alazone for trying to shorten impatiently his period as apprentice.)[48] The manner and subjects of Jan or Huybrecht van Eyck, Roger van der Weyden, and Hans Memlinc could be criticised, but their worth as craftsmen made them figures to be reckoned with. Some Italians were recognising this by buying altarpieces and portraits in Flanders. As early as 1456 Bartolommeo Facio praised Jan van Eyck and Van der Weyden in his *De viris illustribus*. So Michelangelo tempers his censure with a mild reminder of the Horatian counsel, *sumite materiam vestris:*

Withal they paint worse in other places than in Flanders. Nor do I speak so ill of Flemish painting because it is all bad, but because it tries to do so many things well (each one of which would alone suffice most easily) that it does not do any one thing well.[49]

Justi advanced the debatable claim that Michelangelo made a concession to Flemish primitivism in the style of the Bruges *Madonna.* Also, it is not definitely established whether Michelangelo realised that it would be purchased by Flemish merchants.[50] It is significant that the native strain dominating fifteenth-century Flemish painting was supplanted in the following century, as was that of Spain, by Italianism. By the time of Brueghel, long before Rubens, Italianism had taken root. That the two strains were uncongenial is easily seen by comparing Michelangelo's and Bosch's treatment of the fall of the damned. Joshua Reynolds felt that "to desire to see the excellencies of each style united, to mingle the Dutch with the Italian, is to join contrarieties which cannot subsist together, and which destroy the efficacy of each other."[51] This, despite the fact that there were to be a "Dutch Michelangelo" (Egbert van Heemskerck) and a

"Flemish Michelangelo" (Frans Floris) and that the uncongenial strains produced Rembrandt.

Delacroix once wrote that the French were good only for things spoken or read, that they never had taste in music or painting. This whopper is certainly not disproved by anything Michelangelo wrote. Michelangelo never visited France. By 1529 he felt that it might prove fruitful to do so and he wrote to his friend Giovan Battista della Palla that he had several times requested permission to go there.[52] By 1538 he commented on French painting as follows:

> In France there is also some good painting, and the King of the French has many palaces and pleasure houses [*casas de prazer*] with countless paintings, both at Fontainebleau, where the King gathered together two hundred well-paid painters for a certain period, and at Madrid, the maison de plaisance which he built and where he betakes himself freely on occasion, in memory of the Spanish Madrid, where he was imprisoned.[53]

(The latter residence, better known as the Château de Boulogne, was destroyed in 1792 by order of the National Assembly.) Not one French artist does he name, here or anywhere else. True, the best—the Clouets, Cousin, Goujon, and the vigorous Pilon—were all his juniors. Yet this summary dismissal was the price that France, like Spain, had to pay for her Italianism. (France avenged herself for this dismissal by losing three of his most important works, the *Ercole*, the *Leda*, and the bronze *David*.) Instead of being impressed by the artists, Michelangelo was impressed by the patron, a focus to be expected. Not only was Francis I generous with artists, but he honestly felt that, in his own words, "persons famous in the arts partake of the immortality of princes and are on a footing with them." In 1529 Francis offered Michelangelo employment through his ambassador to Venice, Lazare de Baïf, including a pension and house, but Michelangelo had quit Venice before the written offer arrived.[54] Eight years after the remark quoted above, when the Valois King again wished to engage his services (1546), Michelangelo, unlike Il Rosso, Primaticcio, Cellini, and Da Vinci, elected to decline his offer.

Obviously, England never enters the ambit of Michelangelo's critical thinking, England remaining about as important to him as it had been to Enea Silvio Piccolomini. When Sebastiano del Piombo writes to Buonar-

roti and tries to think of an Ultima Thule to employ in a comparison, he does not refer to New Spain, the Indies of Vasco da Gama, or faroff Vinland. Instead, "He would be glad to send it to you even if you were in England itself."[55]

The prosperous and active cities of Italy, all with their own favorite sons and historic monuments, will receive a much more detailed perquisition by Buonarroti. In the second of the *Dialogos em Roma*, Francisco asks Michelangelo which paintings in Italy a foreigner must not fail to see.

Alberti's obvious truth, applying to men in general applied also to Michelangelo: "There is none who does not consider it an honor to have to pass an opinion on another's labors."[56] Michelangelo obliges at considerable length. Francisco's record of this lengthy and compact answer may be of necessity sketchy. By way of exordium Michelangelo notes that such an enumeration is long, vast, and difficult to establish. In Italy everyone, nobleman or commoner, seeks to own some specimens of painting, grandiose or humble. As a result, he continues, a major part of the finest works are to be found disseminated throughout many noble cities, fortresses, villas, palaces, and churches. Carlo Aru suspiciously suggests that these localities about to be mentioned may be the very towns which Francisco had visited on his Italian itinerary of 1538. There are patent objections to this. First of all, the itinerary of the "1538 trip" to Italy, which actually lasted nine years (1538–1547), is not entirely known, and Menéndez y Pelayo asserts that Francisco saw "all of Italy" during these years.[57] Furthermore, there is evidence that Francisco made a trip to Italy before that of 1538 and Joaquim Ferreira Gordo claims that Francisco got to know "all of Italy" on this initial trip.[58] Lastly, the cities mentioned are patently the crucial centers of Italian painting at the time, almost all known to Buonarroti from personal experience, the centers also in the mind of Armenini when he wrote of the many oil and fresco paintings spoiling and wasting in "all those cities enclosed between Milan and Naples, between Genoa and Venice."[59] Let us turn back to Michelangelo's words:

· *271*

"In Siena there is some singular painting in the Palazzo del Comune and in other places." Buonarroti probably had in mind the newly completed frescoes (1535) of Beccafumi in the Palazzo de' Signori, or, less probably, the frescoes of Ambrogio Lorenzetti, Siena's illustrious native son, who did the Sala dei Nove in the Communal House.

"In Florence, my fatherland, in the palaces of the Medici there is the grotesque work of Giovanni da Udine." Buonarroti's feelings about this painter are analysed later in this chapter. In his impromptu summary—so impromptu as to reduce its value for us—Buonarroti does not mention other, more famous, Florentine masters, such as Giotto, Masaccio, and Ghirlandaio, all of whom he respected and two of whom he copied during his training period. Yet he has been asked to name cities, not men.

Buonarroti hurries on. "In Urbino, at the Palace of the Duke, who was half a painter himself, there is much work to be praised. Also, his country-place, called the Imperial, near Pesaro, and erected by his wife, is magnificently well painted." The painters who are apparently blanketed by this praise are Agnolo di Cosimo (Il Bronzino), Dosso Dossi, Girolamo Genga, and possibly Piero della Francesca, who had taught Vasari painting.

"Thus also the Palace of the Duke of Mantua, where Andrea did the *Trionfo di Caio Cesare*, is noble, but even more noble is the work of the stable, painted by Giulio, a pupil of Raphael, who now flourishes at Mantua." In the Castello of Mantua, in the Sala degli Sposi, Andrea Mantegna did many portraits of the Gonzagas and the *Trionfo di Cesare*, in several parts. Vasari (and Goethe) considered this latter work, now in England, as Andrea's masterpiece. Mantegna was certainly endeared to Michelangelo by his strong handling of design, foreshortening, and form. Being an architect as well as a painter, Giulio Romano (Pippi Giulio) had a similar interest in design, leaving it to his assistants to serve as colorists, all of which Michelangelo approved heartily. This is the second pupil of Raphael whom Michelangelo deigns to mention, the first being Giovanni da Udine. Incidentally, seven years before this reference to the Duke of Mantua, Federigo Gonzaga, Michelangelo had turned down an invitation to serve him.

"In Ferrara we have the painting of Dosso in the palace of the Castello." Dosso Dossi, the "Ariosto of painting," had less in common with

Michelangelo than most of the others mentioned, being known for his creative fantasy and strong coloring. He was the official artist of Duke Alfonso of Ferrara. While Dossi and his pupils did three rooms in the Castello, it is probable that Michelangelo was thinking particularly of the famous ceiling in four parts: *Aurora, Meriggio, Vespero,* and *Notte,* the identical Times of Day which reappear on the Medici Tombs.

"In Padua they also praise the loggia of Messer Luigi and the fortress of Legnago." In this instance Michelangelo seems to have shifted to architecture, and Messer Luigi is apparently Brugnuoli, the architect. The fortress of Legnago, southeast of Verona, is not known for its paintings and no one seems to know whether paintings are referred to here, even indirectly.[60] Is this perhaps a consequence of Michelangelo's identifying all arts as subdivisions of painting around this period? (See Chapter V.)

Michelangelo turns his attention to Venice, the city which offered him an annual income of 600 scudi merely to come and reside there, the city which refused to let him hide away modestly in the Giudecca when he came for a visit. "Now in Venice there are the admirable works of the Cavalier Titian, an eminent man in painting and drawing from nature. Some of these are in the Library of St. Mark and others in the Fondaco dei Tedeschi. Still others are in churches and in equally good hands. All of that city is a beautiful painting." We shall return to Michelangelo's thoughts on Titian (and, incidentally, Venice) later. It is true that the Venetian insistence on high color and rich clothing was not to his taste and that little of Venetian painting was fresco, the type admired as offering the greatest challenge. In passing, one wonders what Michelangelo felt about the Cardinal of San Marco's pillaging stones from his beloved Colosseum (Michelangelo's admitted "school") to build a Venetian palace.

Buonarroti recites the names of other centers particularly worthy of attention: Pisa, Lucca, Piacenza, Milan, and Naples. There is Bologna, which Michelangelo quit after his stay of little more than a year. "Because he knew that he was wasting time there, he returned willingly to Florence," comments Vasari.[61] He also remembered Bologna as the city where the local artists had resented his presence and even threatened him. He had placed a raised right hand on his *Giulio II* so that, as he told the Pope, the pontiff would appear to be admonishing the Bolognese to be

well-behaved. But he had good words for Bologna also. In Pietro Lamo's *Graticola di Bologna* (1560), this painter records that Michelangelo praised the now-destroyed Chapel of the Garganelli in Antonio di Vincenzo's famed San Petronio with the words, "È una mezza Roma di bontà" ("It is half a Rome in goodness").[62] There is Parma, where Il Parmigianino resides. Michelangelo's approval of this artist may have coincided with that of Vasari ("it seemed that he was born with his brushes in hand"), for he mentions only this one artist in Parma, but it is no more than a mention.

The city of Pistoia, well served by Giovanni Pisano and Bernardino del Signoraccio, is not singled out. On the contrary, Michelangelo wrote a bitter satire against that town, echoing the choleric voice of Dante and claiming that Cain was one of the ancestors of the Pistoiesi.[63] He very likely was aiming this piece at Giovanni da Pistoia and Pietro Urbano, whom he now considered spiritual fratricides.

Having made the florid observation that all Venice is a great painting, Michelangelo further observes that Genoa's dwellings are almost wholly painted inside and out. He had come to know Genoa in early 1518 (Letter CXIV). He praises in particular the palace of Prince Doria and the work of Perino del Vaga, founder of the Genoese school. In commending Perino, Michelangelo is again approving someone who is "valente nel disegno" and who was called by Vasari the best draftsman of the Florentine region after Michelangelo and the most competent of Raphael's assistants. His work in Prince Doria's palace is of course his most famous and, as Michelangelo remembers elsewhere in the *Dialogos*, was subsidised "magnificently" by Andrea Doria. Michelangelo was impressed by the fact that for merely accepting the title of painter to Cardinal Farnese, Perino was paid five ducats (twenty cruzados) a month, as well as board, lodging, stable privileges, and a valet. This was in addition to liberal payment for his individual productions.[64] The works in Doria's palace which Michelangelo is quoted as favoring were, "especially, the storm about the ships of Aeneas, in oil, and the ferocity of Neptune and his marine steeds. There is also in another hall a fresco of the titanomachia between Jupiter and the giants in Phlegra, the latter being overwhelmed with thunderbolts."

Michelangelo's nationalistic sentiments impel him to add that there

are pictures nobly painted and of value in many lesser towns of Italy, such as Orvieto, Ascoli, Como, and Jesi. For that matter, if one wishes to include retables and pictures owned by individuals and held more dear than life itself, these would surpass all reckoning. Michelangelo then reverts to his descriptions applied to Venice and Genoa, contending that some of the small towns of Italy are totally covered with valuable painting inside and out. The mention of Orvieto no doubt implied the frescoes by Luca Signorelli in the Cappella Nuova of the Cathedral, dating from 1499 to 1505. It is widely accepted that Signorelli's treatment of the nude inspired that of Michelangelo. Curiously enough, the only direct naming of this original master occurs in a letter of 1518. It tells of a loan of forty *iuli* made by Michelangelo to Luca da Cortona, albeit never repaid, and reveals how Luca's insolence infuriated him.[65] Vasari, however, asserts flatly that Michelangelo always praised the works of Luca "sommamente."[66]

In his catalogue there is obviously no mention of Rome, since all of those present were familiar with the metropolis. (Nevertheless, Vittoria calls attention to this omission and prettily attributes it to Michelangelo's modesty.) Nor is there any mention of Arezzo. Yet Michelangelo admired this town and once said to the Aretine Vasari, "Giorgio, s' i' ho nulla di buono nell'ingegno, egli è venuto dal nascere nella sottilità dell'aria del vostro paese d'Arezzo" ("Giorgio, if I have anything good in the way of genius, it has come from being born into the keenness of the air of your region of Arezzo").[67]

These, then, are the Italian centers and, incidentally, painters that Michelangelo extolled in the convent garden. There are additional favorable judgements on the masters of Italy to be collected from other sources: Vasari, Condivi, the *Lettere*, Bottari, Giannotti, and elsewhere. Equally numerous are the contemporary sculptors and architects praised by Michelangelo. We shall enumerate these after dealing with the rest of the painters commended. Once we have recorded Michelangelo's favorable comments on painters, sculptors, and architects, we shall reproduce the unfavorable criticisms on contemporary painters, sculptors, and architects. The chapter will then close after a few remarks weighing the value of these "brickbats and bouquets" and after a final review of the criteria of criticism which seemed to have continuing validity to Michelangelo.

The Italian painters who received praiseworthy mention in the Roman dialogues were, then, Giovanni da Udine, Andrea Mantegna, Giulio Romano, Titian, Il Parmigianino, and Perino del Vaga; those who appeared to be praised only inferentially were Domenico Beccafumi, Agnolo di Cosimo (Il Bronzino), Dosso Dossi, Girolamo Genga, and probably Bernardino Luini and Luca Signorelli.

There is further tribute to Titian quoted in both Vasari and Dolce. When Michelangelo saw the portrait of Duke Alfonso d'Este by Titian he confessed that he had not believed that "art could do so much" and that "only Titian was worthy of the name of painter."[68] Of the two portraits of the Duke of Ferrara purportedly by Titian, and still in existence, we reproduce as Plate VI the earlier painting given by Titian to Charles V and now in the Metropolitan Museum, the one which Michelangelo had in mind. The version in the Pitti was done after 1534–1536 and Michelangelo had already seen the original version just prior to the siege of Florence. Michelangelo would have preferred the portrait in the Metropolitan, in any case, for the clothing and ornament were simpler and more to his taste. This quoted judgement is an extravagant one for Michelangelo, considering his usual moderation and in view of Titian's connections with Aretino, Sansovino, and others. Michelangelo and Titian were never so close as El Greco painted them in his *Cleansing of the Temple* (Minneapolis Institute of Arts). It is true that Michelangelo liked Alfonso, who climbed onto his scaffold with him in 1512 when he was completing the Sistine Vault and who complimented him profusely, even though he was later to destroy the bronze *Giulio II*. Perhaps a more accurate assessment on Titian is the one quoted to Vasari and reproduced below among unfavorable criticisms.

In the second Roman dialogue there is, as noted above, a good word for the grotesques of Giovanni da Udine. Once again there is no elaboration. Yet the bouquet is interesting for several reasons. It is the first painting in all Florence which suggests itself to Michelangelo at this offhand moment. Second, he chooses to praise a student of Raphael. Lastly and especially, he recommends grotesques. As we have seen, Michelangelo was not intransigent about grotesques, admitting their decorative value and their function in conveying "terribility." In this, Michelangelo was not

unrepresentative of Florence, which, with its grotesque fountains, was more indulgent toward strange inventions than such cities as Livorno, which refused a fountain from Pietro Tacca because of its grotesque qualities.[69] Giovanni was a natural choice to be commended, having come to Florence six years earlier to assist Michelangelo with his work on the Sacristy of San Lorenzo. He did the frescoes of "leaves, birds, masks, and designs" in the cupola, frescoes later covered over with whitewash. He enjoyed excellent relations with Michelangelo. It is important to an understanding of Michelangelo's approval of grotesque to recall that Giovanni set out to renew its vogue after viewing some Roman decorative paintings unearthed near San Pietro in Vincoli.

Michelangelo had ample reason to be jealous of his popular younger rival, Raphael, who had come to the capital from Umbria under the protection of his uncle Bramante. We know already that Michelangelo called the younger man "the troop captain" ("il bargello") because of the crowd of admirers and disciples that followed him about. If we are to believe Condivi, the older artist did have a good word for Raphael. "He praised all universally, even Raffaello da Urbino, with whom he contended somewhat in painting, as I have written; I have heard him say merely that Raffaello did not get this art from nature, but through long study."[70] If Michelangelo could not grant Raphael a divine *intelletto*, he could still admire an artist who studied hard to master color and especially design. We know how many steps Raphael took in preparation for the execution of the final painting: many preliminary and incidental sketches and finally a cartoon full size.[71] Yet the Pre-Raphaelites, through their official historian, claimed that Raphael, unlike Michelangelo, found no need to study at great length. Their view, as we have already recorded (Chapter I, note 148), was that "What had cost Michelangelo [and others] more years to develop than Raphael lived, he seized in a day—nay, in a single inspection of his precursors' achievements."[72] Of this claim Middeldorf writes, "Taken literally, this is wrong. Taken as a description of Raphael's inspiration, it is right." The basic differences between the art of Michelangelo and that of Raphael constitute much of the argument of Lodovico Dolce's *Dialogo della Pittura*, where Giovan Francesco Fabrini upholds Michelangelo and Aretino supports Raphael. The rivalry has been studied

in modern times by Eugene Muntz.[73] As we shall see below, Raphael does not escape a subjective censure by Michelangelo (note 121).

Michelangelo's affection for Sebastiano Luciani del Piombo, whom he addresses as "compar carissimo," was coupled with admiration, although Sebastiano's sense of design was weaker than his feeling for high coloring. Vasari claims that Buonarroti liked especially Sebastiano's handling of color (*colorito*) and his grace. In fact, Michelangelo assisted him in the drafting of some of his works and procured a number of substantial commissions for him. When one reads through the many letters from Sebastiano to Michelangelo collected in Milanesi's *Les Correspondants de Michel-Ange* one gains the impression that none of Michelangelo's friends was more faithful or more sincere. He tried hard to keep the master's relations with the Pope tranquil and to the advantage of the older artist. He endeavored to persuade Buonarroti to restrict his exhausting work schedule. In the garden on Monte Cavallo Michelangelo refers to Sebastiano's *Risurrezione di Lazzaro* as a work worth seeing in Narbonne.[74] (Later it was removed to the National Gallery in London.) Michelangelo had actually corrected one or more of his friend's sketches for this work, perhaps even submitting one or two drawings himself to Sebastiano. Michelangelo's humorous comment on the picture in a letter to its author reads: "Keep your peace and reflect that you will be more famous for resurrecting the dead than for painting figures which appear alive"[75] (see Plate XV). A curious repayment of this dubious compliment paid Sebastiano is reported in Aretino's *La Talanta*, where Sebastiano remarks of the *Giudizio universale*: "È difficile a comprendere quali sieno più vive, o le genti che ammirano le figure, o le figure che sono ammirate da le genti" ("It is difficult to understand which are the more living, the people who admire the figures or the figures which are admired by the people"). While Thode accepts this as a compliment, Erica Tietze-Conrat has rightly suggested that it was ambiguous.[76] At the least, Sebastiano repays ambiguity with ambiguity. His faithful Sebastiano, who signed himself "yours, boiled or roasted," was one of the few artists about whom Michelangelo had both good and bad to say. The disparaging comment will be given below in its appropriate place. This single painting equivocally praised by Michelangelo has been justly applauded in later cen-

turies, even though the detailed landscaping and swarm of draped figures reduced its appeal to him. Michelangelo's enthusiasm for Sebastiano was at a peak in 1525, when he wrote to Il Piombino that people were hailing the latter painter as "unique in the world," and added graciously, "So you see that my judgement is not false."[77] De Tolnay even believes that Sebastiano influenced the technique of Michelangelo's later drawings (emphasised outlines and soft modeling within them).[78]

There is no mention of Tommaso Guidi, called Masaccio, in any of Michelangelo's writings. But here again, if the greatest honor one can pay a man is to copy him, then one may be assured of Michelangelo's admiration for Masaccio. For he studied meticulously the frescoes in the Cappella Brancacci of Santa Maria del Carmine in Florence, where so many great artists practiced. "He drew many months in the Carmine, at the pictures of Masaccio, where he reproduced those works (including Masolino's) with such judgement that the craftsmen and others were stupefied."[79] One can still compare his drawn *San Pietro* with Masaccio's painted version.[80] Michelangelo admired a tavola, *La Madonna della neve,* done by Masaccio in the Church of Santa Maria Maggiore in Rome. In Vasari's presence "he praised it greatly and then suggested that people had been alive [*vivi*] in the time of Masaccio."[81] The allusion is to the figures of Pope Martin and Sigismundo II which appear in the painting. Annibal Caro commemorated Michelangelo's debt to Masaccio in the epitaph over the latter's tomb:

> *Insegni il Bonarroto*
> *A tutti gli altri, e da me solo impari.*[82]
>
> *Teach all the others, Buonarroti,*
> *But learn from me alone.*

Among the earliest painters whom Michelangelo praised was Andrea di Cione, called Orcagna, pupil of Andrea Pisano. Even if modern scholarship has withdrawn several attributions to him (Strozzi Chapel, Loggia dei Lanzi, Camposanto of Pisa), he enjoyed a venerability in the Renaissance. In the dialogues of Donato Giannotti, Michelangelo refers to him in general terms as an "antiquo e nobile dipintore."[83]

Michelangelo did not resent the jealousy and discourtesy of Domenico Ghirlandaio, to whom he had been apprenticed, "but rather praised

Domenico both for his art and his ways."[84] He admired Il Pontormo's work from 1513 on and recommended him to execute his two cartoons of the *Noli me tangere* and *Venere e Cupido*. Vasari quotes Michelangelo as telling Alfonso Davalos that "no one could serve him better than Il Pontormo,"[85] when a colorist for the *Noli me tangere* was being sought. Armenini wrote that Luca Longhi of Ravenna became an able portraitist and, coming to the attention of Annibal Caro, was invited by the latter to do a likeness of Monsignor Giovanni Guidiccione. "It was no surprise that Michelangelo Buonarroti in Rome should praise and publicise it as marvelous."[86] As Middeldorf points out, Armenini's book was published in Ravenna, the home of Longhi, and this compliment (which the deceased Michelangelo could no longer deny) may have been a gratuity. Competent in design, Luca was of the *scuola raffaellesca*.

Michelangelo held in high esteem Andrea del Sarto, his fellow townsman, and recommended him to Vasari as a teacher.[87] Michelangelo declined to do a painting for Pier Francesco Borgherini and had it awarded to Andrea.[88] He could not fail to admire Andrea, a dozen years his junior, whose sense of design and form was so pure that he was nicknamed "flawless Andrea" ("Andrea senza errore") and who paid less attention to his master Piero di Cosimo than to Fra Bartolommeo or even Michelangelo. Michelangelo is quoted as saying to Raphael of Andrea del Sarto, "Egli ha in Firenze un omacceto il quale se in grandi affari, come in te avviene, fosse adoperato, ti farebbe sudar la fronte" ("There is in Florence a little fellow who, if he were engaged upon big projects, as you are, would make your forehead break out in sweat").[89]

Grandiose in manner, learned in design, and able in chiaroscuro, which gave his painting the quality of relief, Giovanni Antonio Pordenone could only please Michelangelo, who felt that painting should approach relief. On a house at San Benedetto owned by the merchant Martin d'Anna, Michelangelo liked especially the fresco of Curtius, done with unusual foreshortenings, so that it appeared like a carved tondo or relief.[90] When at Venice he took a fancy to it, and local tradition says that he even added a figure to it.

Michelangelo admired the miniatures of Francisco de Hollanda. Francisco remarks in the first Roman dialogues that Dom Pedro de Mas-

carenhas and Cardinal Santiquattro can testify to the *mintiras* (here, flatteries) which Buonarroti expressed over Francisco's treatments of Roman and Italian subjects.

The artist always felt a warm affection for Giorgio Vasari, who had studied as his pupil. When the *Vite* first appeared, Michelangelo penned the congratulatory sonnet which hails Vasari as both painter and biographer:

> Se con lo stile o coi colori hauete
> Alla natura pareggiato l' arte,
> Anzi a quella scemato il pregio in parte,
> Che 'l bel di lei piu bello a noi rendete,
> Poi che con dotta man posto ui sete
> A piu degno lauoro, a uergar carte,
> Quel che ui manca a lei di pregio in parte
> Nel dar uita ad altrui tutta togliete.
> Che se secolo alcuno omai contese
> In far bell' opre, almen cedale, poi
> Che conuien, ch' al prescritto fine arriue.
> Hor le memorie altrui, gia spente, accese
> Tornando, fate hor, che fien quelle e uoi
> Mal grado d' esse eternalmente uiue.[91]

We have already translated this sonnet piecemeal: the two quatrains (page 48) and the respective tercets (pages 145 and 136). In a letter to Vasari from Rome (10 October, 1563), Don Miniato Pitti tells of meeting Michelangelo in church and hearing him commend Vasari on achieving so much with the remark, "Voi operavi [*sic*] solo per più di mille" ("You alone have executed for more than a thousand"), although this wording is somewhat ambiguous.[92] Michelangelo could be more severe on Vasari, as we shall point out below (note 123). He found Giorgio's *Genealogy of the Gods* in the Palazzo Vecchio "a marvelous thing" (Letter CDLXXXIX).

After his reputation was established, a kind word from Michelangelo helped and encouraged numerous younger painters. According to Baglione, his praise of a *Resurrection of Lazarus* helped Girolamo Muziano win his first fame.[93] Bellori tells how younger artists would run to show Michelangelo their drawings as he approached. At such a moment Michelangelo praised a copy of his own *Mosè* drawn by young Federico Barocci and incited him to further his studies.[94]

There are a number of sculptors who won the acclaim of Michelangelo. The one modern he most admired was Lorenzo Ghiberti. His appraisal of the magnificent doors on the Baptistery of San Giovanni has been frequently recalled: "They are so beautiful that they would well befit the portals of Paradise."[95] In another place Buonarroti reflects that, while Ghiberti's children and grandchildren have run through his fortune, "the gates are still standing in their place."[96]

Vasari records the exclamation uttered by Michelangelo on beholding the statue of *San Marco* by Donatello in Or San Michele: "He had never seen a figure which had more the air of an upright gentleman than this one; and if St. Mark were really such a man, then one could believe what he had written"[97] (Plate XVI). By this Michelangelo was complimenting Donatello on capturing the essential inner spirit of the man he portrayed. This was the aim of Michelangelo's own sculpture and painting, as demonstrated elsewhere in this volume. No one recorded Buonarroti's opinion of the *San Giorgio,* that masterpiece also made for Or San Michele, although it has been alleged that the head of the marble *David* derives from it. He also agreed that his bronze *David* should be Donatellian in spirit. Yet Michelangelo had some reservations about even Donatello's craftsmanship, as will be shown below (note 135).

A minor sculptor to whom Michelangelo gave his blessing was Antonio Begarelli. Passing through Modena, Michelangelo saw some terracotta statues by this artist, colored to simulate marble, and made the following comment: "Se questa terra diventassi marmo, guai alle statue antiche" ("If this clay were to become marble, woe to the statues of antiquity").[98] One might assume this to be ironical did not Vasari further specify that these terra cottas "appeared to him to be outstanding works." Although Michelangelo did not entrust the reliefs of the Façade of San Lorenzo to Jacopo Sansovino, alienating this sculptor for a while, he did propose him for the statuary of the tomb of the Duke of Sessa as substitute for himself. We have already related the circumstances in which Guglielmo della Porta's restoration of the Farnese Hercules won him highest praise from Buonarroti (see Chapter III, note 121).

Michelangelo shared the contemporary admiration for Benvenuto Cellini. He wrote unstintingly to the 52-year-old Benvenuto in 1552, "I

have known you for so many years as the best goldsmith that has ever come to my notice and now I see you as a sculptor of comparable stature."[99] The occasion for this plaudit was a trip to Bindo Altoviti's home in Rome to see the handsome head in bronze executed by Benvenuto. Cellini lost no time showing this missive to his patron. In his *Vita*, Cellini reveals that Buonarroti had set great store by his ability to coin medals, had come to watch him work several times, and had encouraged him to greater efforts.[100] Michelangelo admired the goldsmith so much that after he himself had designed a *medaglia* for Federico Ginori to be executed by Cellini, the usually sensitive Buonarroti did not even care when Cellini altered his design. Michelangelo apparently thought Cellini's cameo showing Hercules binding Cerberus "the most wonderful thing he had seen."[101] So claims Cellini, with Renaissance ebullience. In his *Due Trattati* he notes that he began to work on life-size marble and bronze statuary after Michelangelo had paid the following tribute to a *medaglia* of his: "If this little work, finished with the care and beauty which I perceive, were carried out [*condotta*] in a large size, either in marble or bronze, it would appear a marvelous work; and in my opinion, I don't believe that those goldsmiths of antiquity could have executed their works with greater excellence than has been employed on this one."[102] All of Cellini's works abound in paeans to the "divine" Michelangelo. Perhaps the extravagant terminology he employed proved infectious to Michelangelo. More likely, Michelangelo's praises gathered accretions in Benvenuto's memory.

Another instance of generous praise for a specialist in *medaglie*, and one whom posterity has almost forgotten, was voiced in Vasari's presence. When Michelangelo was shown various medals by Alessandro Cesati he remarked that the hour for the death of art was at hand, for one could not see anything better.[103] While the compliment has a superficial banality, Vasari attributed deep conviction to it. Did Buonarroti feel that if Cesati, too, did beautiful medals, he should try his hand at life-size figures?

In his *Memoriale*, Baccio Bandinelli recalls (*Memoria* VII) that Michelangelo confessed to the Cardinal of Santa Maria in Portico a fondness for Bandinelli's *medaglie* and *bassorilievi*. In this same *memoria* he remembers Michelangelo's saying that if Bandinelli's natural son Cle-

mente had lived he would have equaled the fame of the most famous Greek sculptors. Michelangelo admired him as surpassingly good "in design." Another goldsmith Michelangelo favored was Piloto, to whom he supplied several drawings or *pensieri*.

On a technical plane, Michelangelo was much impressed by the manner of working porphyry discovered by the sculptor Francesco del Tadda. Before Duke Cosimo related the discovery to Buonarroti, the latter had not thought this medium practical. The Duke sent him Francesco's *Testa di Cristo* in this igneous rock.[104]

Worthy of encouragement, in Michelangelo's opinion, were the great-nephew of Lorenzo Ghiberti, Vittorio di Buonacorso Ghiberti, a sculptor and architect; Valerio Belli, a glyptographer from Vicenza for whom he designed one or two motivs;[105] and Antonio di Bernardo Mini, his apprentice to whom he donated many drawings, as well as the tempera of the *Leda*.[106] There is no specific quotation regarding Jacopo della Quercia, but it is universally believed that Michelangelo thought well of Jacopo's statuary in Bologna and was to a certain extent influenced by it.

A fine portrait of the fiery Savonarola is found on an intaglio by Giovanni delle Corgniole, now in the Uffizi. Of this work, alleges Symonds, Michelangelo claimed that art could go no further.[107] Neither Vasari nor Condivi records the tribute, however.

Michelangelo considered Bartolommeo Ammannati superior to Raffaello da Montelupo as a carver of human figures.[108] He favored Ammannati among the competitors seeking to execute the Neptune fountain in the Piazza della Signoria, which was to be in honored proximity to his own marble *David*. Indeed, he praised the plans of the fountain as "something marvelous" in a letter (CDLXXIX) to Duke Cosimo of Florence. Ammannati, who had pilfered drawings from Michelangelo's home in 1530, wrote gratefully in 1559 of Michelangelo's faith in him.[109] If Michelangelo discredited Montelupo by thus comparing him with Bartolommeo, it was after illness and other reasons had caused Raffaello's failure to execute the five statues he was to provide in the late endeavor to complete the Tomb of Julius II (1542). At the outset of this project Michelangelo had recommended Montelupo as "approvato fra e' migliori maestri di questi tempi."[110] This optimistic opinion expressed his

earlier feelings when he requested Raffaello to do a *San Damiano* for the Medici Chapel.

Sometimes Michelangelo's judgements were discernible from the side he espoused in disputes. Swayed by both personal and artistic considerations, he favored Daniele da Volterra in the latter's rivalry with Francesco de' Salviati.[111] (Messer Daniele was to repay him richly by executing that magnificent head based on Michelangelo's death mask, reproduced as the frontispiece of this volume.) In the litigation between Giovan Francesco Rustici and the Consoli della Mercanzia over the monetary value of three bronze statues Rustici did for the Arte de' Mercatanti, Michelangelo upheld Rustici's high appraisal of them, governed by a sense of professional solidarity and perhaps also by his haughty attitude toward merchants, already mentioned.[112]

One may cull a final apparent commendation of a sculptor in Lomazzo's *Trattato*. Speaking of artists who showed skill in portraiture, he refers to Alessandro Greco, "who portrayed with intaglio in steel Pope Paul III, to the great astonishment of Michelangelo, who had judged that such intaglio was impossible of execution."[113]

Three specific texts disclose Michelangelo's admiration for as many architects. First, there is a good word for Filippo Brunelleschi, who spent four years studying the classical principles embodied in the old buildings of Rome. When Michelangelo was asked to complete the Sacristy and Library of San Lorenzo, friends suggested that he alter the form of the lantern turret designed by Brunelleschi. He responded, "Egli si può ben variare, ma migliorare, no!" ("It can be altered all right, but bettered, no!").[114]

Although Michelangelo felt some rancor toward Donato Bramante, convinced that the latter was instrumental in causing him to be commissioned to paint the Sistine Ceiling against his will, he was capable of paying Bramante a fine tribute in a letter dating from about 1555: "It cannot be denied that Bramante was competent in architecture, as much as anyone from ancient times to now. He laid out the first plan of St. Peter's, not full of confusion but clear and pure, well-lighted and set apart so that it would not interfere with any part of the palace. It was held to be a beautiful thing, as is still manifest"[115] (Plate XVII). He then con-

cludes that one who strays from the pattern set by Bramante, which he tried to preserve, deviates from the truth, certainly high praise for a former adversary and one from whom at a certain moment he had feared personal harm. Here is an excellent case where subjectivity is excluded completely from a judgement.

The third architect praised is Simone Pollaiuolo (Il Cronaca), who executed the monastery church of San Salvatore, or San Francesco, del Monte. Buonarroti called this simple but stately church, in its natural setting, "la sua bella villanella" ("his beautiful country lass").[116]

It now becomes our less gracious duty to set down the disparaging criticisms by Michelangelo. One consolation—and one which comes as a surprise—is that there are fewer of these than there are recorded plaudits. Sarcasm and irony will come into play, as in his dispraise of an unknown *Pietà* someone showed him:

"È una pietà a vederla!" ("It's a pity just to see it!")[117]

A typically sarcastic comment is retold by Giraldi Cinzio in his *Hecatommithi*. Michelangelo was asked to comment on a portrait done by his presumptuous disciple Alazone. To a large assembled company he announced that the portrait was unusual and that it could speak. When asked what the picture said, Michelangelo replied, "che non ha parte alcuna in sè che sia buona" ("that not a single one of the parts in it is any good").[118]

We have quoted Michelangelo's commendation of Titian's portrait of the Duke of Ferrara. However, in Vasari's life of Titian there is a more detailed and critical opinion pronounced around 1546.

Michelangelo and Giorgio are examining Titian's *Danaë* in the Belvedere: "Buonarroti praised it considerably, saying that its coloring and manner pleased him greatly, but that it was a shame that in Venice people did not learn from the beginning to draw well, and that Venetian painters did not have a better manner in their study. If this man were strengthened by art and design as he is by nature, and especially in the counterfeiting of living things, no one could do more or better, for he possesses a very fine spirit and a very pleasing and lively manner. And it is in fact true;

for he who has not studied design a great deal nor mulled over selected ancient and modern works cannot do well by himself in practice nor bestow upon works drawn from life that grace and perfection which is displayed by art beyond the order of nature."[119] Here is a verbal reflection of that motto of Tintoretto: "Il colorito di Tiziano, il disegno di Michelangelo," which reduced *ad homines* the long-standing contention between Venice and Florence. For Buonarroti, Titian was living proof that a man could be endowed by nature with great talent and yet show a want of art. The art-phase and nature-phase were in imbalance. We shall see in Chapter V that Michelangelo considered draftsmanship as the basis of all major and minor arts. The emphasis on a selective study of ancient works is certainly characteristic of Michelangelo, who stated that the artistic canon of Italy was that of ancient Greece.

There is an analogous quotation in Bernini's *Journal de voyage*: Pope Paul III accompanied Michelangelo to see a *Venere* which Titian had painted. The pontiff solicited his judgement. The artist replied, "God was right in doing what he did, for if these painters knew how to draw, they would be angels and not men."[120]

While Michelangelo could speak favorably of Raphael, as we saw, there is nevertheless a highly subjective criticism of Raphael in a letter to a Roman prelate. Blaming his troubles with Julius II on the coalition of Bramante and Raphael, at that period when Raphael was trying to "horn in" on the Sistine Chapel, he asserts that Raphael had tried to ruin him, and with good reason, since "what he had of art he got from me" ("ciò che aveva dell'arte, l'aveva da me").[121] In refusing to recognise any denigration in this remark, Grimm disregards the context in which it occurs. Raphael did acknowledge his indebtedness to Buonarroti (Condivi), although he owed more to Perugino and others. Pope Leo X is reported as saying to Sebastiano del Piombo that Raphael abandoned the style of Perugino after seeing that of Buonarroti.[122] Vasari, too, records that Raphael copied from some of Michelangelo's works, including the cartoon of the *Battaglia di Cascina*.

Despite his warm friendship for Giorgio Vasari, despite the encouragement he offered Giorgio, despite the laudatory sonnet quoted earlier in this chapter (note 91), Michelangelo criticised the hastiness

of some of Vasari's work. We have recorded in another context his sarcastic comment ("E' si conoscie") when informed that Vasari's paintings in the Sala della Cancelleria had been completed in just a few days.[123] As pointed out earlier, he admired *sprezzatura* and rapidity in painting, providing, however, that the preliminary studies or models had been meticulously worked out.

Michelangelo was impatient with people who resorted to subterfuges and unusual techniques to camouflage weakness. He censured Ugo da Carpi, whose drawings were correct but whose paintings were mediocre. Ugo decided that since he could not win fame with brush painting he would achieve his reputation by painting with his fingers and other "capricious instruments." When Michelangelo saw a painting which Ugo had identified as done without a brush, the Florentine made the characteristic rejoinder: "Sarebbe stato meglio che avesse adoperato il pennello, e l'avesse fatta di miglior maniera" ("It would have been better if he'd used a brush and painted it better").[124] Posterity has confirmed Michelangelo's judgement here, even though according Ugo due fame as an engraver.

We have already tarried over Michelangelo's appraisal of Sebastiano del Piombo. To complete the picture one should add a recantation contained in one of the conversations recorded by De Hollanda. At the time of the remark, 1538, Michelangelo's feelings had revolved somewhat. He referred to Il Piombino as lazy and overpaid. "And now what shall I say of this very amusing Venetian Sebastiano, to whom (although he did not come at a favorable moment) the Pope gave the leaden seal with the honor and profit which belong to such a post, without the lazy painter's even having painted more than two single things while in Rome, things which will scarcely impress Messer Francisco very much."[125] In Longfellow's dramatic poem on Michelangelo, the latter complains that he must do the *Giudizio* alone, for "the Papal Seals, like leaden weights on a dead man's eyes, press down his lids."[126] The reference is to Sebastiano's appointment seven years earlier as Keeper of the Papal Seal. Another evidence of Sebastiano's *dolce far niente* is that the frescoes he was commissioned to paint for San Pietro a Montorio in 1516 were not finished until 1524. Michelangelo further criticised Il Piombino for his

decision to paint a monk in this chapel, asserting that it would spoil the work. He immortalised this criticism with the quip that since monks (Luther) were spoiling the world, which was so large, they could easily spoil such a little chapel.[127] Furthermore, this objection to inclusion of the monk might even have grown out of Michelangelo's condemnation of portraiture, which type of art constituted Sebastiano's chief title to fame. Michelangelo broke definitively with Sebastiano after the latter urged Pope Paul III to make Buonarroti do the *Giudizio* in oil. In his biography of Sebastiano del Piombo, Vasari records Michelangelo's assertion that oil painting is an art for ladies, for lazy (*agiati*) and slack persons like Fra Sebastiano.[128]

As Papini justly writes, the mechanical and static compositions of Perugino would appeal little to Michelangelo.[129] After seeing a *tavola* of Our Lady and three figures which Perugino did for the Church of San Domenico da Fiesole, later removed to the Uffizi, Michelangelo permitted himself a few sarcasms audible to some of Perugino's garzoni still working on them. He announced to those within earshot that Perugino was "clumsy in art" ("goffo nell'arte").[130] The ensuing dispute ended up before the Magistrato degli Otto. Michelangelo is also reported to have called Perugino's manner "assurda e antiquata" ("absurd and out of date").[131] Recording this censure, Ugo Ojetti shrugs his shoulders: "Superabundant erudition makes moderns more equanimous, and no one would any longer dare to cast at these turned figures of wax the fiery condemnation by Michelangelo."

Meeting one of Francesco Francia's sons, Michelangelo told the lad with his customary bluntness that his father made better living figures than painted ones.[132] This acrimony resulted from the fact that Francesco had happened to express his admiration for the casting and material of the *Giulio II* without actually praising the artistry. (Paolo Pino sagaciously advised readers of his *Dialogo*: "Don't praise the material, but the perfection of the artist!") As we see demonstrated so many times, Michelangelo was resentful of criticism and quick to suspect adverse attitudes. On this occasion Michelangelo exploded, "Go to the bordello! Thou and Il Cossa are two solemn dunces in art." By the way, in the *Notebooks*, Da Vinci records the *contre-partie* of this comment on Francia. Leonardo

jokes about the painter whose children are ugly but whose canvases are beautiful, the explanation being that paintings are made by day but children by night.[133] Leonardo's quip is an ancient one, dating back to Macrobius and recalled in Petrarch's *De rebus familiaribus*.

Among the Florentine painters of his own generation invited to collaborate on the Sistine Ceiling and then dismissed were Francesco Granacci, Giuliano Bugiardini, Agnolo di Donnino, Aristotile da San-gallo (whose copy of the cartoon for the *Battaglia di Cascina* gives us our only inkling of that major work), l'Indaco Vecchio, and Jacopo di Sandro. Although denied an important role in the Sistine project, most of them continued their careers as minor but competent decorators.

From Michelangelo's favorable and unfavorable comments on paint-ers it becomes clear that one may disagree with the conclusion that he "admired extravagantly such minor painters as Sebastiano del Piombo, Vasari, Jacopo del Conte, or Venusti because they imitated him or agreed with his opinions."[134] After all, several of the painters most praised were Raphaelites. Furthermore, Michelangelo rather tended to scorn those who imitated him, as we have seen.

Four sculptors at least felt the sting of Michelangelo's tongue.

From his apprentice days under Bertoldo di Giovanni, who had studied under Donatello, Michelangelo heard the latter warmly praised. We have reproduced Michelangelo's warm tribute to Donatello's *San Marco*. However, according to Condivi, he qualified that Donatello's statues lost their effect under close scrutiny because of a want of finish they betrayed. Condivi mentioned "Donatello, a man excellent in his art and much praised by Michelangelo, except for one thing: he did not have the patience to refurbish his works, so that while they appeared wonder-ful at a distance, they lost their reputation when seen at close hand."[135]

Michelangelo does not mention Baccio Bandinelli by name except in the passage of Bandinelli's *Memoriale* quoted earlier. It is widely ac-cepted that Buonarroti passed a derogatory remark on Bandinelli's rep-lica of the *Laokoön* (1525) for which the Pope held such high hopes, claiming that it would be better than the original. The remark was to the effect that whoever follows after others does not surpass them and that whoever cannot do well by himself cannot profit by the works of

others (see Chapter III, note 97). The reproach may also have been aimed at Bandinelli the Antibuonarroti (Papini), who chose one subject after another which had already been treated by Michelangelo. Vasari's rumor that Bandinelli had a part in the destruction of the cartoon of the *Battaglia di Cascina* could not enhance Michelangelo's opinion of him, nor were relations improved when Baccio bested Michelangelo in getting the marble which the latter planned to use for his *Ercole e Caco*.

We have quoted a passage from the correspondence in which Michelangelo spoke well of Raffaello da Montelupo.[136] One of the chief characteristics of this artist was his ability to draw skillfully with his left hand. If we are to believe Raffaello's autobiography, Michelangelo and Sebastiano del Piombo once stopped in astonishment, even though each was "mancino naturale" ("naturally lefthanded"), to watch him sketch the Arch of Constantine with this hand. Yet Buonarroti's basic opinion of him was an unflattering one after Raffaello botched the five figures he was to execute for the Tomb of Julius II. Vasari records that Michelangelo opposed Montelupo's working on a chapel at San Pietro a Montorio and adds that at this point Michelangelo felt disdainful of the artist.[137]

Leonardo's greatest claim to fame as a sculptor was to be his equestrian statue of Francesco Sforza, Duke of Milan. The "Horse" was never cast, however, even though the full-scale model was exhibited on a triumphal arch in the Piazza del Castello. Michelangelo was struck by the paradox of a statue sixteen years in preparation, completed except for the casting, being discarded entirely. Although this was not the result of Leonardo's negligence or indolence, he threw it up to Leonardo in a cruel manner. In 1506 Michelangelo encountered Da Vinci and some friends strolling in Florence and discussing a passage of Dante. Leonardo turned to Michelangelo and remarked to his friends: "Michelangelo will interpret the verses for us."

Despite his pretensions as an incipient Dante scholar, which were to make of him the learned exegete of the *Divina Commedia* in the dialogues of Giannotti, Michelangelo feared that he was being mocked and cried out: "Explain it yourself, you who tried to make a bronze equestrian statue and couldn't. Only those asses of Milan would have thought that you could." In the *Codice Magliabechiano* version, Michelangelo retorted,

"Et che t'era creduto da que' caponj de Milanesj?" ("And what had you thought to get done among those fools of Milan?")[138]

Papini writes that Michelangelo felt toward his older rival "an almost physical repugnance, disdain, haughtiness, and jealousy."[139] There was ample reason for disagreement. First, there had been the rivalry while painting the Sala di Gran Consiglio. They had both coveted the block of marble from which the *David* was formed. Yet beyond the several biographical reasons which could be adduced, there were, as this book shows, many deep-rooted points of variance in their individual aesthetics: on the question of instruments and aids to assist the painter, on the question of mathematical or geometric proportion, on the relative importance of painting and sculpture (see Chapter V, note 67), and so on. Nevertheless, despite incompatibilities of temperament and aesthetics, the outburst by the younger artist was unjustified.

Michelangelo, whose architectural efforts have been censured from so many quarters, was able to find fault with other architects, his special victim being Antonio da Sangallo, with Nanni di Baccio Bigio in runner-up position. Three documents bear the censure meted out to Sangallo: a letter probably addressed to Bartolommeo Ammannati, a report by Vasari, and a letter to Pope Paul III.

In the letter discussing Sangallo's model revising the floor plan of St. Peter's—the same document in which Bramante is so handsomely praised—Michelangelo expressed irritation at the dark interior and generally cluttered effect. The letter adopts a devastatingly humorous tone: "Sangallo's circle of chapels robs light from the interior as Bramante planned it. And not only this, but the structure provides no light whatsoever of itself. There are so many hiding places above and below and so dark that they lend themselves easily to an infinite number of ribaldries: to the hiding of bandits, the counterfeiting of money, the impregnating of nuns and other monkeyshines, so that in the evening, when the church would close, you would need twenty-five men to seek out whoever might be concealed within, and it would be so built that they could scarcely find them. There would be this further inconvenience: the addition of the circle of structures superimposed on the plan of Bramante would require the razing of the Cappella Paolina, the halls of the Segnatura

and the Ruota and many others; not even the Sistine Chapel, in my opinion, would escape."[140] A comparison of the floor plans done by Bramante, Raphael, Peruzzi, Antonio, and Michelangelo will justify Michelangelo's criticism (Plate XVII). Michelangelo expresses the hope that all the work "done in my time" (e.g., the efforts of Bramante and Peruzzi, but also his Sistine Ceiling) will not come to naught. In this letter Michelangelo explains that in abandoning Sangallo's plan and tearing down some of the outside construction, which he believes cost only 16,000 ducats and not the reputed 100,000, the stones can be retrieved and put to other use.

Vasari also mentions Michelangelo's censure of Sangallo's wooden model of St. Peter's. The biographer relates that Michelangelo proclaimed publicly that "Sangallo had built it closed to all light and had piled so many orders of columns, one atop the other, and with so many protruding members, spires, and details that it resembled a Gothic work much more than a good, classic style, or the pleasing and beautiful modern manner."[141] This particular criticism by Michelangelo, which reflects three criteria typical of his thinking (interest in light, unity of style, classical convictions), has not remained uncontested. One modern historian of architecture raises the questionable objection: "Thus did the greatest critic of the age set magnitude against multiplicity and encourage by precept as well as example the worship of mere bigness. Many architectural critics of today, having the benefit of such mistakes as St. Peter's before them, would much prefer Antonio's elevation, which involved three orders in height, to that of one order which supplanted it."[142] Yet, as one studies Antonio's elevation, or the wooden model, one must agree with Michelangelo that Gothic spirelets and stalagmites seem to be mushrooming out of the lanterna, steeples, and roof. In sum, Buonarroti found Sangallo's detailed and cluttered conception too much at variance with neoclassic simplicity. As for the two campaniles which Michelangelo suppressed, Michelangelo indicated his feelings about bell towers by his exploitation of them as a motiv of humor.

Michelangelo also censured poor Antonio's plan to fortify Borgo with great severity and in the presence of the Pope, who was obliged to quiet the two of them. Michelangelo boasted that he knew more about

fortification than the entire clan of Sangalli, as stated earlier.[143] He was also vehement in tearing down Sangallo's plan for the third storey and cornice of the Villa Farnesina. His vituperation is contained in a lengthy letter to Pope Paul III, translated and analysed in Chapter V.

Although Nanni di Baccio Bigio must have stayed up nights plotting against him, like that symbolic owl under the arched leg of the *Notte*, Michelangelo was able to condense his various reactions into a summary sarcasm: "Chi combatte con dappochi non vince a nulla" ("He who fights nobodies wins nothing").[144]

While Michelangelo acknowledged the competence of Bramante in architecture, he thought him inept and impractical in solving the technical problems of building. Michelangelo told Condivi an ironical story about the amount of rope Bramante had wasted on suspending a platform for the painting of the Sistine Ceiling, a mechanism, by the way, which required cutting holes through the surfaces to be painted. By replacing the suspended scaffold by one supported from underneath, he saved enough rope so that an assistant, to whom he donated it, was able to sell it and dower two daughters! As has been already noted, Michelangelo felt that Bramante did not venerate ancient art sufficiently and never forgave this architect for pulling down the marvelous columns supporting the *tavolato* of the roof on the old basilica of St. Peter's "without respecting them or caring whether they were shattered or not."[145]

Finally, he criticised Baccio d'Agnolo's revision of Brunelleschi's plan for the cupola of Santa Maria del Fiore, the "cricket cage," as being without "design, art, or grace," and submitted a model of his own, which was rejected.[146] (Michelangelo could take consolation from the fact that in our enlightened decade a neon cross was affixed for a while on this lanterna, an indignity he was thus spared.)

Although there are familiar names absent from the foregoing catalogue of Michelangelo's criticisms, our culling of many different sources provides an interesting cross section of his likes and dislikes. The criticisms are only occasionally intensive and never extensive. Their brevity is sometimes surprising or baffling, preventing the reader from grasping

which criteria of judgement are operating. The favorable remarks tend toward hyperbole, which one scarcely expects in a man of Michelangelo's stamp, although he used hyperbole freely with "literary" people: Aretino, Varchi, and Vasari. Nor for that matter does one expect to find favorable judgements outweighing unfavorable ones by a ratio of five to two, as is the case. The unfavorable comments tend toward the inexplicative succinctness of irony or sarcasm. Yet by knowing something of the artists assessed one works back through the brevity of the criticism and sometimes reaches an understanding of the standard called into play.

A recapitulation of the preceding pages enables one to determine which are the dominant and most meaningful criteria for Michelangelo. The list extends to twenty-four bases of criticism. Names of individual artists evaluated by these specific criteria will accompany the list. It must be remembered that some artists will have been praised by these standards and some censured. If an artist praised in general terms by Michelangelo was strong by one of these standards, but Michelangelo does not refer specifically to that standard, then his name is not appended. Thus, while Giulio Romano was lauded by Buonarroti in a general way and was at the same time strong in design, we shall not associate him with the criterion of design, even though such a criterion may have been in Michelangelo's mind. We shall mention only the immediate associations and leave implied connections to the reader. These criteria, enumerated in approximate correspondence to their hierarchy of importance to Michelangelo, fall into two major categories:

I. Criteria which emerge independently from the judgements reproduced in this chapter.

II. Criteria specifically proposed by Michelangelo in the *Dialogos em Roma* (see above, notes 4, 5, and 6).

I. 1. DISEGNO (drawing, draftsmanship): Apollonius of Athens, Clemente Bandinelli, Ugo da Carpi, Titian, Baccio d'Agnolo.

 2. BEAUTY: Apollonius of Athens, Giorgio Vasari, Lorenzo Ghiberti, Benvenuto Cellini, Simone Pollaiuolo (Il Cronaca).

 3. RIVALRY WITH ANCIENTS: Antonio Begarelli, Benvenuto Cellini, Clemente Bandinelli, Donato Bramante.

4. JUDGED BY SUBJECT MATTER: Perin del Vaga, Sebastiano del Piombo, Flemish artists, Italian artists.

5. COLOR: Jacopo Pontormo, Titian.

6. APPROACH TO PERFECTION: Giovanni delle Corgniole, Alessandro Cesati, Filippo Brunelleschi.

7. NATIONALISTIC JUDGEMENT: Albrecht Dürer, Alonso Berruguete, Francisco de Hollanda.

8. SELF-CONSCIOUSNESS AS ARTISTS: Zeuxis, Polygnotus, Apelles, artists of Forum and Mount Palatine.

9. WORTHY OF MORE IMPOSING MEDIUM: Antonio Begarelli, Benvenuto Cellini, Andrea del Sarto.

10. STUDY: Raphael, Titian.

11. MATHEMATICAL ANALYSIS: Albrecht Dürer.

12. SOCIAL OR MILITARY VALUE: Apelles.

13. RIVALRY WITH NATURE: Giorgio Vasari, Titian.

14. LIFELIKE QUALITY OF FIGURES: Sebastiano del Piombo, Tommaso Guidi, Antonio Begarelli, Alazone.

15. INNER VISION: Donatello.

Although it is not listed above as a criterion of judgement, since it applies to only one of the arts, an appearance approximating sculpture or relief (note 90) is one of the basic ideals in his aesthetics and will be a feature he will always seek in the best painting (see Chapter V, note 58).

Of the thirteen criteria mentioned in the *Dialogos em Roma*, four are never exploited or applied by Michelangelo while passing the judgements reproduced in this chapter: profit, symmetry, reason, and substance. He merely notes in a general way that Flemish art is lacking in reason, symmetry, and substance, as well as in skill, proportion, effortlessness, and selectivity.

II. 1. NOBILITY: Andrea Mantegna, Giulio Romano, Andrea di Cione (Orcagna), Donatello.

2. KNOWLEDGE: Apollonius of Athens, architect of the Colosseum.

3. SUAVITY (GRACE): Albrecht Dürer, Baccio d'Agnolo.

4. SKILL (ARTISTRY): Titian, Giovanni Antonio Licinio, Benvenuto Cellini, Donato Bramante, Ugo da Carpi, Raffaello da Montelupo, Leonardo da Vinci, Baccio d'Agnolo.

5. PROPORTION: Phidias, Praxiteles, Dürer, Donato Bramante, Antonio da Sangallo.

6. EFFORT AND SPEED: Pausias of Sicyon, Giorgio Vasari, Sebastiano del Piombo.

7. PATIENCE: Alazone, Raphael, Donatello.

8. BOLDNESS: Baccio Bandinelli, Flemish artists.

9. SELECTIVITY: Titian, Antonio da Sangallo.

Personal feelings color his assessments of Jacopo Pontormo, Leonardo da Vinci, Baccio Bandinelli, Sebastiano del Piombo, Luca Signorelli, and Francesco Francia. Despite his rivalry with Raphael, Michelangelo finds it possible to praise Raphael and such Raphaelites as Giovanni da Udine, Giulio Romano, and Luca Longhi.

It is reassuring to find a number of critical persuasions emerging from his applied criticisms and his speculative theorising alike. His attitudes on such criteria as design, nobility, beauty, knowledge, effort and speed, transfer, etc., have already been dealt with extensively in earlier sections of this volume.

If Michelangelo will not admit the greatness of a single artist outside the precincts of Italy (with the exception of one favorable comment on Dürer and two unnamed Spaniards who may have enjoyed only a rhetorical existence), he is surprisingly impartial toward the many centers within the peninsula. The Genoese and Lombard schools win his plaudits as readily as do those of Rome and Florence. He is more reserved only about the Venetians. He is partial to artists from anywhere in Italy who demonstrate his avowed conviction that the manner of Italian art is that of ancient Greece. Antiquity meant ancient Greece more readily than ancient Rome; the seven ancients listed above are all Greeks.

In view of the curious blind spot which Michelangelo had in regard to most minor arts (see Chapter V), it is not surprising to read that the highest praise he could find for an artist working in a minor medium or one which he himself did not exercise (Begarelli's terra cotta or Cellini's

medaglie) was to observe that his works would be great if done in a more imposing or compatible medium.

Although there is ample evidence of Michelangelo's resort to irony or satire to prove his points, his criticisms are by no means as sterile or blunt as the four comments allotted to him by Bernini (note 1 above). Expressed with vehemence, these comments are not all black or white: Michelangelo was able to find both good and bad traits in a few individual artists, such as Sebastiano, Donatello, Vasari, and Dürer. Despite his originality and individualism as a thinker, posterity seems to have generally approved and accepted his pronouncements in these matters. Although he failed to understand Leonardo's greatness and we are not sure whether he recognised Leonardo as a lasting figure, Michelangelo foretold with a clear intuition which of his contemporaries were going to endure under the withering gaze of posterity, "il lume della piazza."

Michelangelo, like the rest of us, found it easier to dispense criticism than to receive it. Somehow one wishes that he could have been a bit more gracious in his censures (it is not too hard to believe the rumor that Antonio da Sangallo died of grief under Michelangelo's hammering criticisms), that he might have explained his criteria unequivocally, and that somewhere he might have admitted categorically that good artists do not necessarily conform to a fixed standard as rigidly as he himself adhered to the neoclassic code. One wishes that he might have read that fine passage in Cicero's *De Oratore* (III, 7): "Myron, Polyclitus, and Lysippus were eminent; they were all unlike one another, and yet their works are so excellent that you would not wish any one of them to be other than he is. Zeuxis, Aglaophon, and Apelles are most unlike, though in none is there a perceptible absence of any requisite of his art!" At least one of his contemporaries understood that Michelangelo needed to broaden his neoclassical canons of criticism and recognise the worth of various types of art and artists. De Hollanda's parting shot to Michelangelo at the close of the third dialogue in the convent garden on Monte Cavallo makes this exact point. Unconsciously Francisco echoes Cicero's *memento* and replaces the names of Myron, Polyclitus, Lysippus and company with names of dissimilar contemporaries who have figured in the present chapter. Michelangelo could also have learned a greater respect for a multiplicity

of standards from a popular text in which he figured and which was available to him after 1528. For the second time we close a chapter with sagacious words of Michelangelo's supposed relative, Count Lodovico, in the *Book of the Courtier:* "You have as most excellent in painting Leonardo da Vinci, Raphael, Michelangelo, and Giorgio da Castelfranco [Giorgione]; nevertheless, in their work all are dissimilar one from the other; yet not a one of them appears to be wanting anything in any way and each is known to be most perfect in his style."[147]

CHAPTER V

Comparison and Differentiation of the Arts

Tous les beaux-arts sont frères.
VOLTAIRE

AN APRIL morning in 1543. Eager for the warming rays of the spring sun, an elderly man sits on a bench overlooking the Tiber. Behind him looms the imposing mass of Hadrian's Tomb, where his foolish and beloved Cellini made his famous leap for freedom. The old man finishes reading a letter which has just arrived from Florence. There are few people left to write him from there these days. He always welcomes the informative letters of his brother's boy Lionardo. It is good to have his own kin up in Tuscany to look after his interests, as this letter proves. The boy may not have invented cannon powder, but he means well and apparently has a real affection for his uncle, continually sending him pears, grapes, and the Trebbiano wine, which the old man should not drink, and distributes largely to friends. If he could only get the lad married off to some nice girl, he would save the family line from extinction.

His eye returns to the letter. Suddenly he catches sight of the address on the back. He inspects it more closely and his thin lips set in displeasure. Turning to the address over the salutation he finds the same wording. There is no doubt about those words, even though Lionardo's handwriting (his irritation is mounting) is sometimes so undecipherable that he has been obliged to throw letters unread into the hearthfire. What has come

over the boy, addressing a letter in this way? Has he forgotten that his uncle has painted the two greatest frescoes of Christendom—to say nothing of the architectural pieces which have won the admiration of all Italy? He will have to give the lad a piece of his mind when he replies. He will reply this very day. The more he thinks on this the less interested he becomes in the warmth, the spring, and the view of the Tiber. At length he rises and starts off at a purposeful gait in the direction of the distant basilica of St. Peter's. As he walks his mind is at work phrasing his reprimand:

E quando mi scrivi, non far nella sopra scritta: Michelagniolo Simoni, nè scultore. Basta dir: Michelagniol Buonarroti, che cosi son conosciuto qua.

And when you write me, don't put on the address: Michelagniolo Simoni, or sculptor. Just say: Michelagniolo Buonarroti, and that's all, for thus am I known here.

By "arts" (or "art" in those rare cases where it is used as a generic term) Michelangelo understood four arts particularly. In his early days the "prime art" was sculpture. If a medieval Christian tradition had held sculpture in suspicion, a Renaissance dogma held sculpture the major art, since God had practiced it to form man. On the subject of painting Michelangelo entertained various ideas during different periods of his lengthy life. In his maturity he equated it with design, the most basic and pervasive art. Architecture, always important, becomes predominant during his later years. Bronze casting always remained a relatively unimportant art, and a hazardous one at best. In spite of the renown of his drawings and sketches, despite the fact that they have been accepted by art historians as finished products in themselves, Michelangelo habitually considered them as no more than *pensieri* of greater conceptions. He seldom mentioned additional arts, but in one way or another paid tribute to goldsmiths, engravers, workers in terra cotta, and so on, even though tending to consider their products, too, *pensieri* of greater conceptions, and managed to record his low esteem for weavers. In order to arrive at his general evaluation and definition of the several arts, we shall start out by studying his own relations and loyalties to them.

Joan Evans has written flatly, "Michelangelo was never meant to be

a painter, nor Piranesi to design chimney pieces."[1] In his earliest years Michelangelo would not have quarreled with this, for he was in his own estimation a sculptor and only a sculptor. He had withdrawn from Ghirlandaio's studio to be a pupil of Bertoldo. The training in the Giardino Mediceo was that of a sculptor. Michelangelo even resented the little time spent under Ghirlandaio, for after he had done his *mezzorilievo* of the *Centauromachia* at the suggestion of Poliziano he confided that he had wronged his nature in not starting out promptly at the art of sculpture and in wasting several years.[2] Buonarroti used to say that he had a natural bent for sculpture, since his wet nurse had been both daughter and wife of stonecutters, and the sound of mallet and chisel against stone had been among the first he ever heard.[3] There was room in Florence for a great sculptor of his age, for when he was born Ghiberti had been dead for twenty years, Donatello for ten, and Verrocchio was about to pass out of the picture. Almost all of Michelangelo's first letters after his initial journey to Rome were signed "Michelagniolo scultore"—until 1526, in fact—and he advised his family during that period to address their communications to "Michelagniolo scultor in Roma." In those early days he thought he would win his greatest fame with the forty colossal statues of the Tomb of Julius II. In suggesting that the terminal date of these signatures was only 1512, Carlo Aru forgets the later letters to Fattucci and Spina.[4] In *De Sculptura*, Pomponius Gauricus conceded Michelangelo to be "etiam pictor" as early as 1504.[5]

The period during which Michelangelo executed the Sistine Ceiling (1508–1512) marked his most insistent protests that he was not a painter, but a sculptor. In a *Ricordo* of 10 May, 1508, he states, with a magnificent rigidity, "I, Michelangelo Buonarroti, *sculptor*, have received 500 ducats on account, for the *paintings* of the Sistine Chapel." It is common knowledge that when commissioned for this ceiling he maintained that painting was not his art and that he was being compromised by Bramante, so that Donato's nephew Raphael would benefit by the contrast.[6] When this painting got off to a poor start, he complained to the Pope: "Lo avevo pur detto a Vostra Santità che io non ero pittore" ("Yet I told your Holiness that I was no painter").[7] He went so far at this juncture as to propose Raphael for the task.[8] At the close of an amusing poem relating his vex-

ations in painting the Sistine Ceiling, the world's most heroic painting, he adds this same disclaimer, "Nè io pictore."⁹ Condivi claimed that before attempting this monumental job Michelangelo had never used colors (fresco).¹⁰ Vasari, whose second edition often reflects Condivi, also noted that Michelangelo had had "poca prattica" with colors beforehand.¹¹ According to Piero Rosselli, Bramante quoted Michelangelo to the Pope as asserting several times "I don't want to take on the Chapel" because he had not "done too many figures" and it was something quite different to paint "in terra."¹² Michelangelo's success with the cartoon of the *Battaglia di Cascina* left him with something more than amateur standing as a painter or draftsman, but he was still without experience in colored fresco, something he had learned from neither Ghirlandaio nor Granacci. He was much concerned. Such useful guides as Cennini's chapter on "El modo e ordine allavorare in muro, cioè in fresco, e di colorire" were not yet in print, although the latter manual was available to Vasari in manuscript.¹³ Before 1508 Michelangelo's success as a sculptor left him little desire to branch out into a new field. As early as 1498 Jacopo Galli had predicted that one of Michelangelo's works of statuary would be "the most beautiful creation in marble that Rome has ever seen, and no other master today could make it better."¹⁴ The rediscovery of ancient statuary which young Buonarroti witnessed in Rome could not fail to impress upon him that immortality was best won by sculpture. In 1518, when the Florentine Academy hoped to have Dante's bones returned to Florence, Michelangelo requested permission of Leo X to do a sepulchral monument to Dante and his part of the request bore the signature "Michelangelo, scultore." Even later in his life, a variant verse of the sonnet "Com' essere, Donna, può quel ch' alcun vede" reveals his attachment to his first love:

> *Io 'l so ch' amica ho sì l'alma scultura.*¹⁵
> *This I know, who hold so dear sweet sculpture.*

Nevertheless, the fame of the Sistine Ceiling in Italy and abroad was bound to produce a gradual change, and it was not long before he became Michelangelus Dismegistus in his own and others' eyes. In May, 1510, the Cardinal of Pavia addressed him as the "prince of painting and the statuary art."¹⁶ In 1523, Cardinal Grimani, desiring a work by Michel-

angelo, left it to the latter "to select material and subject: painting, bronze, or marble, according to his choice." About eight months later Michelangelo wrote to Fattucci that he would look into the matter of the Library of San Lorenzo, "although it isn't my profession."[17] Dismegistus, but not yet Trismegistus. Apparently he grew to consider himself an architect only after he had decided that he was a painter. The fiasco of the Tomb of Julius II gave him no occasion to feel this any earlier, nor did a few smaller architectural commissions.[18] It is probably true that his interest in the mortuary chapel of San Lorenzo was stimulated by the fact that it could provide an opportunity to combine sculpture, painting, and architecture. Writing a moving poem on the death of his father in 1534, Michelangelo seems to grant a slight edge to sculpture one final time (LVIII):

> La memoria 'l fratel pur mi dipignie
> E te sculpiscie uiuo in mezzo 'l core,
> E piu ch'allor pietà 'l uolto mi tignie.

> While memory paints for me my brother
> It sculptures thee living within my heart
> And more than ever grief moistens my face.

It was in 1535 that official recognition of his mastery of the three art-forms was granted, for in September of that year Pope Paul III appointed Michelangelo chief architect, painter, and sculptor of the Vatican. Late in 1544 Buonarroti's plans for the completing of the Farnese Palace were chosen over those of several of the principal architects of the time.[19]

By April, 1543, he was urging his nephew and family to discard the title of sculptor when writing to him. Gone was the exclusive devotion to stone and marble inculcated in him when he was an infant playing in his foster parents' yard. In fact, it was during the previous year that he had begun to sign letters as "pittor in Roma" and firmly believed that Raphael had learned from him the art of painting. Even earlier, in the dialogues at San Silvestro, Francisco de Hollanda had stated in Michelangelo's presence and without contradiction or protestation: "The great drawer, Michelangelo, here present, also sculptures in marble, which is not his field."[20] Michelangelo was painting the *Giudizio universale* at the time. Aru, in his attack on the veracity of the *Dialogos*, cites this remark of

Francisco's as proof that the Portuguese did not know Michelangelo's true preference for sculpture. On the contrary, this testimony is a subtle proof of their authenticity, for by now Michelangelo considered himself a painter first and foremost—that is, when he was not now stressing his competence in all three major fields. Moreover, Francisco's painting of Buonarroti bears on its round frame the identification: "Michael Angelus Pictor." But by this time his definition of painting had been aggrandised until it had the broad scope of "design," as he explained in the *Dialogos*. An example of his boasting of a triple competence is found in the *Dialoghi* of Donato Giannotti, which record a social evening occurring about February of 1546. In this report Michelangelo mentions "everyone's knowing" ("sappiendo ognuno") that he is a sculptor, painter, and also architect.[21] At almost this same time, on the second Sunday of Lent, 1546, Varchi compliments Michelangelo on his mastery of several arts.[22]

A study of the addresses or salutations on the letters collected in Frey's *Briefe an Michelangelo* is a revealing indication of what his friends and correspondents understood to be his chief title or titles to glory. Before 1518 he is addressed exclusively as "schultore." In February, 1518, Il Menighella who knew his mind well, first addresses him as sculptor and painter; others follow suit later: Giovanni da Udine in 1522 and 1531, Ruberto Nasi in 1536. Bartolommeo Barbazza as early as 1525 identifies him as architect and painter in that order. In 1560 Tiberio Calcagni salutes him as sculptor and architect. In 1556 Condivi alone among all the correspondents addresses Michelangelo as painter, sculptor, and architect. Yet the one title universally employed in the other letters from 1507 to 1558 was sculptor.

Thus, Michelangelo the sculptor of 1508 progressed gradually, if one accepts his own testimony and partly that of his correspondents, to become Michelangelo the painter between 1538 and 1542. Condivi states that before starting the statues of the Medici Tombs, Michelangelo had been fifteen years (actually the interval was 1520–1531) without using his chisels (*ferri*).[23]

As a painter Michelangelo preferred the medium of fresco, perhaps because it offered "a conflict to be won rapidly and completely if at all" (Brion). As we have seen, he rejected vehemently Sebastiano's proposal

that he paint the *Giudizio* in oil, "an art for women and for such indolent people as Fra Sebastiano."[24] His great relief on finishing the Sistine Ceiling was intensified by the knowledge that he had mastered fresco. Like Brunelleschi, he finally derived satisfaction from the knowledge that he was successful in whichever art he touched. In addition to the quotations from the 1540's reproduced above, there is his confident reminder (*ca.* 1542) to a correspondent in Rome: "Let it be remembered what I have done for Pope Julius in Bologna, Florence, and Rome, of bronze, of marble, and of painting."[25] Michelangelo called his Façade of San Lorenzo "the mirror of all Italian architecture and sculpture."[26] And in 1546, like Leonardo writing to Lodovico Il Moro, Michelangelo promises Francis I that he will turn out for that Christian monarch, "una cosa di marmo, una di bronzo, una di pittura."[27]

Michelangelus Trismegistus at last. By the latter part of his life fame had crowned him with three laurels and it was becoming almost impossible to think of himself as other than expert in three arts. His device was three circles, representing these three arts, interwoven to show the interdependence of each one on the other two, as he explained,[28] and the equal importance of each, if one believes Saavedra Fajardo's *Juicio de Artes y Ciencias*. At his death the academicians of Florence changed the interwoven circles to interwoven crowns, with the motto *Tergeminis tollit honoribus* to signify this triple mastery. Most of the poems in the *Esequie* harped on the theme of Buonarroti's triple or quadruple talent. Varchi wrote for the master's tomb the following feeble epitaph:

> *Quis iacet hic? unus: qui unus? Bonarotius: unus.*
> *Hic vere est? erras: Quatuor unus hic est.*

In his *Ercolano* (1570) Benedetto Varchi registers that Michelangelo's primacy in the three arts is "beyond all risk and peril,"[29] a triple mastery commemorated in the following century by a satire of Salvator Rosa.[30] Michelangelo had a name for people who wanted to do many things at once. He called such a person a Signor Tantecose.[31] He finally admitted to being a Signor Tantecose himself, despite a certain number of formal disclaimers born largely of a desire to avoid unwanted commissions.[32]

If one were to select the two most characteristic and crucial words in Michelangelo's aesthetics, they would probably be *intelletto* and *disegno*, the former designating the principle of genius and the latter the application of genius. Michelangelo was one of the insistent artists of all time to preach the essentiality of draftsmanship and a knowledge of design. On a copy by Antonio Mini of one of his drawings (now in the British Museum) Michelangelo wrote:

"*Disegnia Antonio, disegnia Antonio, disegnia, non perder tempo.*"[33]

"Draw, Antonio, draw, Antonio, draw, don't waste time!"

To Pietro Urbano he preached much the same thing (Letter CCCXLIX): "Try hard and don't, for anything in the world, fail to draw!" Vasari reports that even while Michelangelo was a schoolboy in the classroom of Francesco da Urbino he spent all his time secretly drawing. He was so thoroughly admired as a draftsman that even such an antagonist as Aretino conceded his being "profondissimo nel disegno."[34] Ingres asserted that if he were asked to put a sign over his door he would inscribe it "School of Design," confident that it would bring forth painters. Michelangelo, too, was convinced that design was the basis of every medium of art. For Michelangelo, who submitted projects for so many works undertaken by others (paintings, statues, bridges, churches, villas, tombs), design remained that basis, for his own relationship to the executed form of these works never passed beyond the drawing board. This was but an extension or transfer of his preoccupation with the *concetto* which made him view painting and sculpture as the capture of minimal basic form or "breaking the formula."

Although Michelangelo's remarks on design to his friends gathered around Vittoria Colonna (see below, note 46) were highly individual, he was by no means alone in his insistence on a knowledge of design or drawing. One of the earliest of the Renaissance artists to stress the matter was Ghiberti, who posited several classes of knowledge required of the painter and sculptor, the most important of which was a sense of design, "il fondamento et teorica" of the arts.[35] Alberti wrote of the importance of outline and indicates that it is now more customary to speak of this as design.[36] Vasari, like his master Buonarroti, called *disegno* the parent

of all the arts.[37] Lomazzo coupled beauty with design as the basis of all fine art: "bellezza, e quello che i Greci chiamano Euritmia e noi nominiamo disegno."[38] In Paolo Pino's *Dialogo di Pittura*, which echoed Lancilotto's *Tractato di Pictura* (1509), his spokesman Lauro held that painting surpasses other arts by its "order and perfection of design"; he subdivided design into four parts: *giudicio* (native talent); *prattica*; *circonscrittione* (skill in contour and shading); and *retta compositione* (the end product of the first three).[39] In his *Trattato* Leonardo even tended to equate draftsmanship with painting, as Buonarroti did;[40] he then explained that painting (as design) is the common link of the arts of the potter, goldsmith, weaver, embroiderer, and others. This identical idea we shall shortly encounter in Michelangelo. The universal acceptance of design as the common denominator of the arts is revealed in even such an unexpected source as that compendium of Renaissance thought, *Il Libro del cortegiano*, where it is pointed out that "although painting may differ from statuary, yet the one and the other rise from the same source, which is good design."[41] The final proof of this general acceptance, if one were needed, is the fact that the generic term for the fine arts after the middle of the Cinquecento became "arts of design."

Let us now turn to the second of the Roman dialogues, where Michelangelo, elaborating on differentiations and similarities of the fine arts, dwells upon the unifying principle of design. Francisco de Hollanda recalls that historians qualify Phidias and Praxiteles as painters, whereas they were most certainly sculptors in marble. He accepts as the reason for this that the basic principle of painting, design, is the basis of all the arts, including sculpture. He refers to Donatello's insistence that his students learn first to draw before hoping to become sculptors. He mentions with Renaissance erudition that Pomponius Gauricus, in his *De re statuaria*, was of like mind. (Gauricus did, indeed, stress that symmetria underlay all arts, speaking of it as "de Sculptorum parente, Artificiorum omnium nutrice, amica totius generis humani, ex qua tantam iam laudem consecuti sunt, Antiqui omnes et Statuarii et Pictores et Architecti."[42] It is at this point that De Hollanda identifies Michelangelo as a painter rather than a sculptor and proceeds to quote him: "He himself has told me several times that he finds the sculpturing of stones less difficult than

working with colors, and that he deems it a much greater feat to make a masterful stroke with the brush than with the chisel."[43] He further claims that a talented draftsman can sculpture in marble, bronze, or silver without ever having exercised these crafts, thanks to a knowledge of design (*debuxo* and *desenho* are the words used). He notes that Michelangelo, Raphael, and Baldassare Peruzzi, as painters, could and did teach sculpture and architecture. However, sculptors are not capable of mastering painting with such facility, having a less keenly developed sense of design.

All are waiting for Michelangelo to express an opinion. He concurs with Francisco's previous remarks about design and does not take issue at being called primarily a painter. "I should add, moreover, that the painter of whom Francisco speaks will be instructed not only in the liberal arts and sciences, such as architecture and sculpture, which are his own fields, but also in all the other manual disciplines which are practiced the world over. If he likes, he will practice them with much more skill than the very masters of those arts themselves. Be that as it may, I sometimes get to reflecting that there has been among men only one single art or science and this is the art of drawing or painting [*sic*], from which all others are derivative members." This view of art as one basic mimetic process is to be expected from one versed in Neo-Platonism. This entire exposition makes sense if one keeps in mind that Michelangelo, with an ultra-Florentine dismissal of color, is equating painting with drawing.

Michelangelo then avers that we all consciously or unconsciously contribute painting to the world, creating forms and figures in our varied clothing, in our buildings and homes of many colors, in the cultivation of our fields overlying the soil, in the sails of our ships, in the arraying of our armies, in the decorations at funerals, and in most of our everyday activities. Considering painting as a great fountainhead, its derivative streams are sculpture and architecture, its rivulets are the mechanical arts, and such minor arts as cutting designs with scissors are stagnant ponds.

Classicist that he was, Michelangelo then relates how painting was the master art of the Romans. The Romans' knowledge of painting accounts for the superb antiquities which have come down to us: vases, fabrics, gold, silver, and metal objects, ornaments, coins, statuary, vestments, arms, and all their elegant works. When Rome was the mistress

of the world, Dame Painting was the sovereign of all Roman productions, trades, and sciences, even extending herself to writing and the writing of histories. (This polemic exaggeration rings true of Michelangelo's expounding before a social company, and its "unreasonable" quality had parallels in the record of his remarks to the Florentines gathered at Giannotti's.) Michelangelo continues: Whoever considers human production carefully will find that it is either of the nature of painting or of some part of painting. Although the painter is capable of inventing that which has never yet been found, and of practicing all the other arts and crafts with even more grace and elegance than those who make a profession of them, none of the latter can hope to be designers or painters.

We are struck by the elasticity of Michelangelo's thought. Yet, strange as these applications of painting may appear to us, let us remember that when Da Vinci and Alberti claimed painting to be the keystone of even minor arts, Leonardo had included pottery and weaving and Alberti included carpentry. Vasari, too, included under the heading of painting a multitude of special arts, such as copper-plate engraving and tapestry weaving.[44] In the Renaissance, when painting had barely issued from the guild system, artists' talents were still applied to humble services. Practice as well as theory supported this extended definition of painting. "Giotto painted armour; Pollaiuolo made candlesticks and designs for embroidery; Donatello made picture-frames and designed cartoons for glass; Ghirlandaio painted the handles of old women's market baskets."[45]

Later, in the third dialogue, Michelangelo returns to this dada. Lattanzio has just expressed his surprise that some men, like Francisco de Hollanda, who have never painted oils, are suddenly capable of it, and some miniaturists are unexpectedly able to execute full-scale canvases or frescoes. Again equating painting with drawing, Michelangelo announces that he wishes to make a "declaration concerning the noble art of painting" and requests that all within earshot heed his words:

"Design, known also by the other name of drawing [debuxo], constitutes the source and body of painting, sculpture, architecture, and of every other kind of painting. It is the root of all sciences. Let him who has attained a mastery of it know that he holds a great treasure in his power. He will be able to create figures more lofty than any tower, either

310 ·

out of colors or carved from the block, and will never find a wall or screen which will not prove narrow and small for his sublime imaginings."[46] Again Michelangelo's thinking reverts to the conflict between *concetto* and material, a leitmotiv of his thinking (cf. his "Non ha l'ottimo artista alcun concetto"), as he gives voice to the High Renaissance ideal of magnitude.

Michelangelo continues: The painter endowed with a sense of design has many further attainments. He can paint frescoes in the ancient Italic manner, even mastering the blends and varieties of color usual to this form. In oil painting he will surpass even the greatest experts with his suavity, knowledge, boldness, and patience. He is equally at ease with a tiny piece of parchment, with the largest canvases, or with other media. All this because of the power inherent in a sense of design.

This sense of design, like an eye for divine beauty, is a gift accorded only a fortunate few. Many artists who do not possess it try to hide this basic weakness under an excessive use of color or bizarre inventions: "Whence some, not so well founded in design, have tried with a variety of hues and shades of color, and with bizarre, different, and novel inventions—in sum, by a different path—to create a place for themselves among the first masters. But Michelangelo, always remaining firm in the depth of his art, has shown to those who are intelligent how they were to arrive at perfection."[47] One begins to understand why Michelangelo was willing about this time (1538–1542) to discard the title of sculptor in signing letters and to assume that of painter, in the broad and individual sense that he attributed to the term. The feeling seems warranted that in the last two passages quoted from the *Dialogos* Michelangelo is, as elsewhere in Francisco's chronicle, actually referring to himself. It becomes clear, then, how his possession of a sense of design could make of him a Signor Tantecose.

Granted that design tends to tie together painting and sculpture, wherein do distinctions and differentiations lie?

Armenini recounts that Michelangelo was once asked by a Roman gentleman how to tell good painting from bad. The reply:

"This must be kept in mind, that the closer you see paintings ap-

proach good sculpture, the better they will be; and the more sculptures will approach paintings, the worse you will hold them to be. Whence it is to be understood that good paintings consist essentially of much relief [roundness] accompanied by a good style. Let it be understood also that sculptures and reliefs, which perfect paintings must resemble, are of course not only those of marble or bronze, but even more, living sculptures, like a handsome man, a beautiful woman, a fine horse, and other similar things; and because the most true paintings are expressed with these, one sees then how wrong are those simpletons of whom the world is full, who would rather look at a green, a red, or some other high colors than at figures which show spirit and movement."[48] In this statement Armenini apparently leaned heavily on Buonarroti's letter to Varchi, published in 1549, and reproduced below.

Michelangelo's belief that painting should approach relief enjoyed wide circulation among contemporary artists. In his *Discorso sopra la differenza nata tra gli scultori e pittori*, Cellini remembers that the really great masters, like Michelangelo, held both orally and in writing that painting is only the shadow of its mother sculpture.[49] In his *Idea del tempio della Pittura* Lomazzo quotes Michelangelo as saying that "la Pittura, tanto più rilievo mostra, quanto più s'accosta & avicina al vivo" ("the more relief a painting shows the more it approaches and draws nigh to lifelike quality").[50] This wording evokes Vasari's thought that some favor sculpture, since things are more noble and perfect "quanto elle si accostano più al vero" ("the more they approach the lifelike").[51] Lomazzo draws the very just conclusion that even in painting one should work with models to capture highlights and shadows. Finally, Anton Francesco Doni's *Disegno* also cites Michelangelo to the effect that there is "as much difference between Painting and Sculpture as there is between shadow and truth."[52]

Michelangelo's most pertinent document on the Paragone, the relationship between painting and sculpture, is a letter to his academic friend Varchi. This epistle was written on 28 January, 1546 (1547 *stile commune*), on the occasion of a referendum in which seven artists, replying to a questionnaire of Varchi's, contributed their views on the relative merits of the two arts. The theme of the debate was no doubt "sophistic

and puerile," as Menéndez y Pelayo declared, noting its reappearance in Spain with Jáuregui (1618).[53] Vasari himself, who attempts patiently and thoroughly to clear up the matter of the Paragone in a proem, grants that it was a "dispute born and sustained among many people to no purpose."[54] Yet the rivalry between painting and sculpture forming the argument of so much Renaissance contention, as both Vasari and Michelangelo claimed, had a parallel and precedent in the numerous, often sterile, humanistic debates on the relative values of literary forms: epic vs. romance, tragedy vs. comedy, rhyme vs. prose. The Paragone was argued not only by such practitioners of art as Alberti, Cennini, Lomazzo, and Da Vinci, but even turns up in such extraneous places as Galileo's letter to Lodovico Cardi da Cigoli. Lomazzo, for example, found sculpture inferior by its lack of color.[55] Vasari complained that in debating this issue painters display disdain and sculptors violence.[56] If the reader is interested in sampling other opinions, the replies to Varchi's questionnaire published with Benedetto's *Due Lezioni,* are available in the Bottari-Ticozzi *Raccolta di lettere.*[57]

Although it contains no paean to design and drawing, as did the earlier dialogues in Rome, Michelangelo's letter again pays lip service to the view that painting and sculpture are parts of one and the same phenomenon. Michelangelo concedes that "philosophically speaking" neither one can be considered more noble than the other. Each serves the same purpose and derives from the same experience and inspiration. In his letter Buonarroti modestly avows that he speaks in ignorance. Yet he does feel that the more painting approaches relief the better it seems to him to be considered. (Such early paintings as the Doni *Madonna* and the Sistine "medallions" come promptly to mind, as does his praise of Pordenone's fresco of Curtius, "resembling entirely a tondo or relief.")[58] And relief "worsens as it approaches painting." Therefore sculpture has always seemed to him to be the beacon light (*lanterna*) of painting, and between the two there has seemed to exist all the difference between the sun and the moon. However, now having Varchi's opinion with its philosophical premise that things aiming at the same purpose are the same thing, he has changed his mind. The apparent recantation is done with reluctance and reservations:

· *313*

Et dico, che se maggiore iudicio et difficultà, impedimento et fatica non fa maggiore nobiltà; che la pittura et scultura è una medesima cosa: et perchè ella fussi tenuta così, non doverebbe ogni pittore far manco di scultura che di pittura; e 'l simile, lo scultore di pittura che di scultura.[59]

And I say that, if greater judgement and difficulty, obstacles and effort do not make for a greater nobility, then painting and sculpture form a single art. So that this idea may prevail, no painter ought to do less well in sculpture than in painting; nor, on the other hand, should any sculptor do less well in painting than in sculpture.

Obviously, since greater judgement, challenge, and effort do make for greater art, Michelangelo is merely baiting Varchi. Then ensues the well-known distinction:

Io intendo scultura, quella che si fa per forza di levare: quella che si fa per via di porre, è simile alla pittura.

By sculpture I understand that which is accomplished by means of taking away; that which is accomplished by means of laying on is like painting.

Knowing Michelangelo's preference for carving over modeling, an inevitable consequence of his Neo-Platonic theory of the implanted *concetto*, one may read into this sentence a detraction of painting.

These verbs *porre* and *levare* were used in the Italian translation of Alberti's *De Statua* to describe the essentially different procedures of *scultura* and *plastica*.[60] *Porre* is used for modeling in stucco, wax, or earth. *Porre* could also be used exceptionally as synonymous with *comporre* to describe the sculptor's art, as in Dante. Michelangelo so uses it in his lyric, "Sì come per levar, donna, si pone / im pietra alpestra e dura."

Then Michelangelo's letter abandons inferences to modeling and returns to the basic similarity between painting and sculpture:

Basta, che venendo l'una e l'altra da una medesima intelligenza, cioè scultura e pittura, si può fare loro una buona pace insieme, e lasciar tante dispute; perchè vi va più tempo, che a far le figure. Colui che scrisse che la pittura era più nobile della scultura, s'egli avessi così bene inteso l'altre cose ch'egli ha scritte, le àrebbe meglio scritte la mia fante.

It is enough that, since each comes from a single intelligence, one can reconcile sculpture and painting and forget so many disputes, for more time is spent on

them than in the making of figures. He who wrote that painting was more noble than sculpture, if he understood no better the other things he has written—well, my biddy would have written them better.

He then writes that there are infinite numbers of things which he would like to add, but that he is too old and pressed for time, "almost among the number of the dead." The last thought is reminiscent of the concluding section of Vasari's *Proemio di tutta l'opera,* in which he speaks of the brotherhood (*fratellanza*) of painting and sculpture and condemns "those who set out to disunite and separate them one from the other."[61]

Scholars have reacted to this passage in various ways. Chambers comments, "The reader may see in it the unhappy perplexities to which the rivalry of painting and sculpture reduced some contemporary philosophers."[62] Blunt draws a secondary conclusion: "Implicit in these arguments is a belief in the superiority of the intellectual over the manual or mechanical, which corresponds to the desire of artists at this time to shake themselves free from the accusation of being merely craftsmen."[63] Regarding the so-called change of opinion mentioned in this letter, Buscaroli finds it "more a concession to the philosophical talk of Varchi than a true persuasion."[64] There is no real change of opinion involved, despite Michelangelo's verbal deference to the wordy pedant who was always heaping encomiums on him. Varchi had written that "philosophically" painting and sculpture are a single art, if one considers their identity of purpose and principle. He admits that in all other particulars (*accidenti*) they may differ.[65] It took no great reversal on Michelangelo's part to agree to such a limited view of the identity of these arts. We have had ample occasion to observe that he agreed on their common principle and purpose. He will even go further and posit a common source (*intelligenza*). Then, vaguely aware that mutuality of principle, purpose, and source still does not account for identity of nature—and apparently still considering sculpture a beacon light to painting—he impatiently resents the argument as a waste of time and words. It is his same disinclination to bandy thoughts about art that was pointed out in the *Dialogos em Roma.*

Michelangelo again conceded willingly the identity of purpose underlying painting and sculpture when he replied to Vasari's questioning on the Paragone with the "sibylline answer" (Buscaroli) that sculpture

· *315*

and painting are "a single purpose achieved with difficulty in both" ("un fine medesimo difficilmente operato da una parte e dall'altra").[66] He refused to explain or expand this comment to Vasari and in the same mood kept the "satyr" of the Florentine Academy waiting so long for his answer that his reply arrived almost too late to be included in Varchi's little volume.

As a practitioner rather than a theorist, Michelangelo could have preferred painting for several reasons. It demanded fewer of his precious energies. Painting presented no problem of *veduta unica*. Painting took relatively less time. One recalls Cellini's testimony that Michelangelo did "a hundred paintings for every single statue." And so on. Yet he did not at this period prefer painting in its normal, narrow sense. If he was at this time signing his letters "pittor in Roma," it was because of his enlarged view of painting as universal design. Otherwise his unreconstructed preference here, in 1546, remains for sculpture, and he does not even welcome sculpture which approaches the levelness of painting, those reliefs, half-reliefs, and tondi in which he had worked before proceeding to isolated pieces.

Some recent scholars repeat that Michelangelo's letter aims at Leonardo da Vinci, even though Leonardo had been long since dead (1519). In his *Trattato* Leonardo wrote that he could approach the Paragone with impartiality, since he was competent in both painting and sculpture. What was there about Da Vinci's allegedly impartial analysis, according to these scholars, which so embittered Michelangelo that he found his housemaid better able to handle the subject?

Although Leonardo's treatise on painting was not printed until 1651, when an incomplete edition was issued in Paris, his opinions were apparently known to Michelangelo, either in written form or *viva voce*. Several sections of the tractate were devoted to the Paragone. Leonardo stated that the sculptor works with greater bodily fatigue and the painter with greater mental exertion. Even the necessity of creating a piece of sculpture beautiful from all perspectives requires more physical than mental expenditure, according to Da Vinci. One can hear Michelangelo's strong protest at this point: "But one fashions statues with the mind as well as the hands" (see Chapter I, notes 76 and 77). Da Vinci did not

meet squarely Michelangelo's later definition of sculpture as the action of removing superfluous stone from a sealed-in form, but indulged in chicanery over the word "superfluous." "The sculptor says that if he removes the superfluous [*soverchio*], he can no longer lay on, as does the painter. To which one may add that if the sculptor's skill were perfect, he would have taken away by attentive measuring just enough and nothing superfluous, the latter excessive removal being the result of his ignorance, which makes him take away more or less than he ought."[67] The painter has to fret over light, shade, color, and depth, in addition to the concerns he shares with the sculptor.

Like Michelangelo, Leonardo viewed sculpture as the art of removing and painting as an art of adding. The principal distinction remains that Leonardo considered painting the more mental task.[68] He did not use the adjective "noble" which Michelangelo ascribed to his antagonist. Still the idea was easily implied. Leonardo added that if anyone knows a sculptor who understands painting, then that sculptor is a painter. Those who do not understand painting remain merely sculptors. (Michelangelo was one of the first master sculptors to oppose polychromy, thus asserting the right of the sculptor not to be of necessity a colorist.) But the painter must of necessity comprehend sculpture, that is, "il naturale," which has relief generating by itself light and dark and foreshortening. Thus, to Da Vinci sculpture, which reproduces most easily natural effects, underlies the more complex art of painting, whereas to Buonarroti it was painting (as design) that was the underlying feature of all arts.

If we are to believe Cellini, Michelangelo accepted in practice Leonardo's point about the painter's necessarily understanding sculpture as a more direct translation of nature, for Benvenuto explains Michelangelo's genius as a painter by the fact that he copied every figure he painted from carefully sculptured models.[69] Almost every critic who ever wrote on Michelangelo's sketched or painted figures has commented on their plastic or sculptural qualities. "Michelangelo considers the white of the paper as a plastic substance—the original surface of a hypothetical block. He realises the forms by 'penetrating' in a succession of planes, by means of a differentiation of hatchings, into the 'block,' just as he was to do later in sculpture with a chisel."[70] Symonds, noting the plastic qual-

ities of Michelangelo's sketches, asserts, "On paper he seems to hew with the pen, on marble to sketch with the chisel."[71] De Tolnay even states, "Good painting is not with Michelangelo an art *sui generis;* for him who estimates sculpture superior to painting, it is merely 'painted sculpture.'"[72] By the same token, Georges Seurat defined painting as the art of hollowing a surface.

Masoliver, among others, claims that Michelangelo's sculptural qualities found in his painting are also found in his architecture, including the plans for the Florentine church of San Lorenzo, the mausoleum of Julius II, and the piazzale of the Capitolium.[73]

For many moderns all this reasoning (or, as Michelangelo put it, "tante dispute") did not really begin to pose adequately the question "of the value which the distinctions among the various arts hold in aesthetics."[74] Croce observes that the technical emphases of the treatises of Cennino, Leonardo, Palladio, and Scamozzi left little room for discussion of these more basic issues and questions. "One can barely perceive a glimmering of them in the comparisons and in the questions about precedence between poesy and painting, painting and sculpture, which appear in a few paragraphs of those books." According to Croce, as to his generation, it was not until the *Laokoön* of Lessing that the issue of distinctions among the arts received serious study. One can only answer that if the nature of Palladio's technical manual permitted no speculations of an aesthetic nature, the level and amount of theoretics or speculation in Lomazzo, Bellori, and two or three others of their era compare favorably with those found in the more voluminous eighteenth-century Germans.

What of "frozen music," or architecture? Both Condivi and Vasari record Michelangelo's statement to Pope Paul that architecture was not his art.[75] More than one architect or historian of architecture has assented. Charles Garnier accused Michelangelo of being ignorant of the very language of architecture. Even in his own century Michelangelo's name occurs but once in Andrea Palladio's lengthy *Dell'Architettura*, and then only in a list of several architects who worked on the "Temple of Bramante." His associate on the Farnese Palace, Vignola, treats him better.

Among the criticisms which have been made are that Buonarroti's thought exceeded his execution and that he treated architectural details arbitrarily. One historian deplores what he considers the fundamental weakness: "But what could we expect of a generation of architects who were careful about the proportions of a column and careless as to its use: who discussed its proper proportions and entasis, the depth of its base and capital, and yet were indifferent whether it did its constructive work or merely carried a bust or filled a recess? The loss of conformity to constructive principle was the decisive cause of the decay of Renaissance architecture, and if the responsibility can be attached to one man, that man was Michelangelo."[76] Not all modern appraisals of Michelangelo are so severe; some even accord him a portion of the greatness Cellini saw in his architecture. His revolutionary designs after 1546 caused a reaction to the ideal of the (static) building which had prevailed through the High Renaissance. Michelangelo thought, as did Cellini, that his own greatness as architect rather than his weakness (the disclaimers to Pope Paul being outbalanced by some of his confident boasts) was due to his experience with sculpture. Francesco Villamena allegedly possessed a letter by Michelangelo stating that he would prefer Ammannati to Vasari as assistant on the Laurentian Library (apparently Michelangelo is merely theorising here), since sculptors know more about architecture than painters: "Ma in egual sapere, bisogna scegliere per l'architettura il scultore."[77]

One finds in Michelangelo's writings no critical self-analysis relating to architecture. There are various self-assured statements among the letters. When his sketch for the Façade of San Lorenzo has triumphed over the entries of Raphael, Baccio d'Agnolo, Giuliano da Sangallo, Andrea and Jacopo Sansovini, Michelangelo is encouraged to write that he will do this work to be the mirror of Italian architecture and sculpture. In his old age he promises of his plan for San Giovanni dei Fiorentini: "Neither Romans nor Greeks ever constructed such a thing among their temples."[78] Vasari hastens to add, "Words which never before or since issued from Michelangelo's mouth, because he was exceedingly modest."[79] We, too, have commented on the unusual nature of this particular boast (see Chapter III, note 122).

There are three documentary sources from which one may glean

Michelangelo's views on architecture. These are his criticisms, favorable and unfavorable, applied to individual architects in Chapter IV, and especially to Antonio da Sangallo. There is his lesson on architecture, treating of the harmony of the parts within the whole, contained in a letter (1560) purportedly addressed to Cardinal Rodolfo Pio da Carpi, who had expressed himself as dissatisfied with some phase of the construction at St. Peter's. In this letter Michelangelo decrees that all major parts of an architectural unity must be decorated in the same way. With the anthropomorphic ideas of Vitruvius in mind, he develops the theory that the proportions of architecture are akin to those of the human figure:

"When a plan includes several parts, all those which are of the same qualitative and quantitative kind are to be decorated in the same mode and manner, as must the parts corresponding to them (e. g., a pilaster corresponding to a column). But when the plan is radically changed, it is not only permissible but necessary to change the decoration of the corresponding parts. What is in the very center always is as free as you like, just as the nose, which is in the middle of the face, need not conform to either one or the other eye. But one hand is quite obliged to be like the other, and one eye like the other with regard to position and correspondence. For it is an established fact that the members of architecture resemble the members of man. Whoever neither has been nor is a master at figures, and especially at anatomy, cannot really understand architecture."[80] The two points made by Michelangelo, that parts of an architectural unity must correspond to the whole and that such parts are like parts of the human body, reappear in Vasari's chapter, "Come si ha a conoscere uno edificio proporzionato bene" ("How one recognises a well-proportioned building").[81] This insistence upon one change necessitating another to preserve a *consensus* we have already encountered in his remark to Volterra that to alter *tantini,* one had to make adjustments on *tantoni* (see Chapter I, note 96). Michelangelo will return to the need for homogeneity of decoration and the harmony of the whole with its parts in the letter to Paul III below.

This letter to Cardinal Rodolfo is a more independent, personal, and forceful instruction on architecture than the better-known epistle to Pope Paul III (1544). The latter document is a criticism of Antonio da San-

gallo's intended main cornice for the Palazzo Farnese, although it could apply even more easily to Antonio's model for St. Peter's. The pedantic language has none of the Tuscan vigor of the other letters. As already noted, rumor claimed that it was this censure which caused Antonio to die of grief. Michelangelo finds fault with the proportion, decoration, and arrangement of the plan. Although his own plan is going to break with tradition (complete entablatures will be omitted from over the arched windows) and he never wished to "submit himself to ancient or modern laws of architecture,"[82] he leans as critic on the most conservative pages of the most traditional writer. To give his criticism an authoritative tone he bases it upon the "chapter of Vitruvius," the only writer on architecture in antiquity whose works were extant and who was so popular at the moment that Serlio called him the infallible standard of excellence. Michelangelo's procedure is a humiliating one for poor Antonio. He lists the basic components of architecture and proceeds to claim that each is missing from Sangallo's plan. In addition to demolishing the plan which Sangallo had been preparing to execute, this letter attempts to win favor for Michelangelo's own plan which he is submitting in competition with Vasari, Sebastiano, and Del Vaga.

With his meager Latin he was very likely utilising a Latin edition of Vitruvius, for at least nine of these were available by 1550. True, Italian translations were issued in steady succession after the Cesariano edition of 1521, bringing with them "an exaggerated view of the importance of dogmatism in classical design."[83] We suspect that Michelangelo used a Latin text for two reasons. The Latin of Vitruvius is not especially difficult. Any good translation into Italian, moreover, would have afforded clearer sentences than we find in Michelangelo's letter.

Michelangelo bases his entire critique on the definition of architecture "as is understood in Vitruvius," that is, "non altro che ordinazione e disposizione et una bella spezie et un conueniente consense de' membri dell'opera, et conueneuoleza et distribuzione," ("nothing other than ordering and disposing and furnishing a beautiful species and a suitable consensus of the members of a work, and suitability and distribution").[84] The definition as Michelangelo read it in Vitruvius reads: "Architectura autem constat ex ordinatione, quae graece *taxis* dicitur, et ex dispositione,

hanc autem Graeci *diathesin* vocitant, et eurythmia et symmetria et decore et distributione, quae graece *oeconomia* dicitur."[85] These three italicised terms derived from Democritus.

Michelangelo then proceeds to gloss these terms, as Vitruvius had done. He steers clear of Greek, a language unknown to him. "Ordinazione" is clarified as "una piccola comodità de' membri dell'opera separatamente et universalmente posti, di consenso apparechiati." There must be no inner disorder. He finds that the members of Sangallo's cornice are disproportionate among themselves and do not conform to one another. "Disposizione" is defined as "una certa collocazione elegantemente composta secondo le qualità e efetto dell'opera." The cornice which he is criticising has no such elegant arrangement or proper assembling of details, but is, rather, barbarous in nature. The third element is restated as "una bella spezie de le comodità della composizione de' membri in aspetto." By this Michelangelo understands uniformity of architectural order; he explains that one part of a monument should not contain Doric elements mingled with Ionic or Corinthian. The Sangallo drawings in the Uffizi included a complete Corinthian entablature crowning a third storey, whereas on Antonio's design for the base of the portico facing the court one reads: "For the Farnese palace; for the second Ionic order." A work which does not fit into one single *generazione* is bastard. Cellini claimed that Michelangelo preferred the "ordine composto" to the antique Doric, Ionic, or Corinthian,[86] but a consciously composite order differs from an inharmonious juxtaposition, which juxtaposition Buonarroti found on Antonio's plan for St. Peter's, and consequently rejected. Furthermore, the modest third storey which Sangallo was planning seemed in Michelangelo's opinion neither large enough to look right with the more grandiose first two storeys nor able to support the cornice which Antonio had planned.

By following a fixed *generazione* one is enabled to keep down the expenses of construction and the work is assured sturdiness, since the construction does not get out of hand. Vitruvius' word for this third element is *eurythmia* and it means the "suitable display of details in their context."

The fourth element is stated as "dell'opera e de' membri un conue-

niente consenso, che le parte separatamente rispondino all'universa spezie della figura, con la rata parte." From Buonarroti's explanatory remark, it would appear that the *consenso* describes the correct harmony of the various parts. In Antonio's plan he finds not a single part of the cornice well proportioned to the total: the corbels are too small and few for such a large size; the friezes are too small for the general breadth, and the astragal at the bottom is too small for the total volume. Even niches must fit into the total harmony. One of Michelangelo's criticisms, based on this fourth principle, is sarcastically worded. Vasari tells how a prince placed in a building some niches which were far too deep for their height and for the rest of the plan. A ring was attached to the top of each niche. When several statues proved to fit awkwardly into them, Michelangelo was asked what to do about the niches. "Hang some bunches of eels on the rings," he countered.[87] He criticised the lack of *consenso* resulting from Baccio d'Agnolo's *ballatoio* (which he condemned as a cricket cage) around the cupola of Santa Maria del Fiore: "Such a large structure [*macchina*] required something bigger and of different design, art, and grace."[88]

The fifth element is defined as a faultless ensemble based on decorum, precedent, and authority. This precept refers to impeccable observance of convention. One must not let an outsized top piece dominate a small or low façade. Michelangelo objects that a cornice as large as that planned by Antonio befits a larger and higher façade; although he will construct a cornice just as large, he will heighten the façade by building a higher third storey. Here Michelangelo misconstrues Vitruvius for the first time in his simplification.

El decoro è uno amendato aspetto nell' opere prouar le cose composte con alturità detta conueneuoleza.	*Decor autem est emendatus operis aspectus probatis rebus conpositi cum auctoritate.*

Michelangelo makes *decor* refer to proportion rather than decorum. Vitruvius was here more interested in ruling that stark and simple Doric temples suited Mars or Hercules, whereas billowy Corinthian befitted Venus or Proserpina. It is in this discussion of *decor* that Vitruvius warns against mixing Ionic, Doric, and Corinthian, whereas Michelangelo held this to be an offense against *eurythmia*.

The final element is clarified as "la distribuzione secondo l'abundanzia delle cose, de' loci una comoda dispensazione." The architect must avoid being liberal in assigning elements to one part while frugal toward another. Sangallo has been capricious in this matter. Michelangelo's thought is not out of line with that of Vitruvius, who merely wished that an architect should use his materials economically and control his expenses carefully. Vitruvius wishes the materials destined for the structure to be available near the chosen site and seeks to avoid costly transportation. This could only have won an amen from Michelangelo, who had to oversee the building of a road to Pietrasanta to reach the quarries there.

With these remarks Michelangelo concludes his pedantic criticism of Sangallo's plan, excusing himself for not having visited the Pope in person with the reminder that he is still sick and suffers a relapse every time he goes out. However, having abstracted so much from Chapter II of *De Architectura*, mere momentum carries him to a paraphrase of the final thought of Vitruvius, even though it no longer has anything to do with Sangallo's plan. The architect who designed villas and gardens for such wealthy patrons as the Marchese di Mantua notes that there is another type of distribution dependent upon the use to which the structure is to be put: "There is another grade of distribution when the work will be planned according to the living habits of the householder and according to the abundance of money. The buildings should be ordered lofty or humble according to his elegance and dignity. [Sangallo himself had aggrandised his original plans, declaring that "the palace of the Pope should be quite different from that of a cardinal."][89] It is also evident that one must build city dwellings otherwise than rustic possessions, where fruits may be stored. Nor will usurers' [in Vitruvius: *feneratores*] homes be the same as those of the rich and delicate and powerful, who with their cogitations govern the republic. Their homes will be constructed suitable to these uses. The unerring distribution of the buildings is to be undertaken in such a way as befits the rank of their proprietors" (see Plate XVIII).

This idea has been formulated in modern times in Smith's *Economic Laws of Art Production*, which makes economic fitness a requisite of art. "Economic fitness includes two ideas: (1) that in the production of a work of art there should be a just and fitting relation between the cost

incurred, in terms of effort and materials, and the degree of importance, dignity, and nobility [Buonarrotian terms] of the ends which the work is to serve; (2) that there should be, similarly, a fitting relation between the cost of the work and the level of well-being or purchasing power of the persons for whose use it is intended."[90] Both (1) and (2) are anticipated by Vitruvius and Michelangelo and a host of others.

Perhaps Michelangelo added these last remarks about social rank and architecture merely to complete his summarising of the brief chapter of Vitruvius—through momentum, as we have suggested. Perhaps—and this seems equally possible—he was recalling to the Farnese Pope that if the Farnesi were to achieve their aim of rivaling the splendor of the Medici, they had better entrust their projects to him, a former Medici artist and one who backed up his ideas with the solid principles of Vitruvius. His psychology, if such it was, proved effective, and the Pope rejected the cornice in question. Michelangelo's own plan was accepted. In any case, the remark from Vitruvius on economic and social propriety appeared in other treatises on architecture at this time. In his second book, Palladio rules that the city homes of gentlemen must display "molto splendore e commodità," since their householders "rule the republic," but that country villas will be more homey and modest.[91]

To summarise, Michelangelo's paraphrase of Vitruvius is both hasty and impatient and shows the same distaste for literal interpretation that characterised him as artist. In view of the harmonious ensemble of the two storeys already completed by Antonio and the simple elegance of the plans preserved in the Uffizi, Michelangelo seems unduly severe in his criticisms. The furore created by the windows which Michelangelo later designed for the Farnese Palace (called "architectural solecisms and barbarisms")[92] does not strengthen his righteous stand condemning Antonio's plan, a condemnation larded with emphatic negatives and double negatives whenever he weighs his fellow Florentine against Vitruvius. It is curious that he does not condemn the loggia facing the garden, which Antonio planned to include, Michelangelo rejected, and Giacomo della Porta restored in 1580.

Before leaving the subject of architecture, let us recall that one of the criteria by which Michelangelo habitually judged the structural qual-

ity of a building was its provision for adequate lighting. Whether or not he accepted the *veduta unica* principle in regard to the illumination of statues, he was as architect most conscious of lighting effects. We have introduced his ironic criticism of Sangallo's floor plan of St. Peter's, with its dark interior, and his fanciful listing of all the mischief which this would permit within the sacred basilica.[93] Vasari, as we have seen, recalls this concern of Michelangelo's for lighting.[94] The latter praises Bramante's first plan for St. Peter's as "chiara" and "luminosa."[95] De Tolnay believes that Michelangelo "modeled the light of the [Medici] Chapel, so to speak." The lighting creates the "effect of a deep crypt" and creates "a harmonious blending of light and shade into a half-tone" in the lower reaches. It not only enhances the rich modeling of the statues, but "this diffuse, silvery light is an unreal light, which helps to transport the beholder from the everyday world into an ideal Cosmos."[96] However, we have no record of Michelangelo's true intentions about this lighting. There were to be frescoes on the ceiling and perhaps even stained glasses as in the Laurenziana, and the effects would vary with times and seasons.

It must have come as a telling blow when in 1551 the Sangallo "sect" complained to the Pope that Michelangelo had spoiled the plans for St. Peter's by making too little allowance for light.[97]

In the *Dialogos em Roma* Michelangelo tells his listeners that painting is the fountain-spring of all the arts and crafts, that sculpture and architecture are the rivers which are born therefrom, and that the mechanical arts are rivulets. The peripheral arts are stagnant ponds "formed with the water which the fountain-spring gushed forth when in ancient times this water submerged all in its dominion and empire." In general, Michelangelo did not share his friend Vasari's awareness of the importance and vitality of the subsidiary arts.

Although his early painting of St. Anthony derived from an engraving by Schongauer, Michelangelo never turned his talents to making or designing woodcuts and engravings. Others in this century were making their fortunes at this, some even using motivs supplied by him. In 1520 Valerio Belli apparently sent him a sample of a new type of copper-

plate engraving and requested a motiv "something like last time."[98] At least once in Michelangelo's life the art of printing and typography, so rich then in plates and emblemata, was shown and elucidated to him. He remained struck with admiration, if one is to believe the record of Donato Giannotti. The collocutors of Giannotti's second dialogue meet in the home of the printer and philologist Francesco Priscianese. Michelangelo arrives ahead of the others and employs the time to good advantage. When Donato shows up, Michelangelo greets him: "But this time during which we have waited for you has not been wasted, since Priscianese has shown me the beautiful things he does and explained this whole matter of printing, which I had never examined so closely. It certainly is marvelous, and it was a great genius who discovered it."[99]

Another artistic competence which Michelangelo admired was the art of making medals. We have recorded in Chapter IV his praise for the creations of Alessandro Cesati, Cellini, and even Baccio Bandinelli. As for the art of the goldsmith, we have the accurate testimony of Benvenuto that this type of craftsmanship was "totalmente incognito" to Michelangelo.[100]

However, the art could make a pretty conceit for Michelangelo the poet, who could "give off sparks like steel in a burning fire" (xxxvi) or write a quatrain on the value of fire to the metalworker and the goldsmith (cix, 87):

> Sol pur col foco il fabbro il ferro stende
> Al concecto suo caro e bel lauoro,
> Ne senza foco alcuno artista l'oro
> Al sommo grado suo raffina e rende,
> Ne l' unica fenice se riprende,
> Se non prim' arsa . . .

> Only with fire can the smith bend iron
> Into his dear art-form and beautiful work
> Nor without fire can any artist to utmost purity
> Refine and shape his gold,
> Nor can the unique phoenix revive itself
> If not first consumed by fire . . .

A letter from the court of Madrid to the Palatine Elector in Austria (1694) makes isolated reference to a porcelain plate painted by Michelangelo, an activity never mentioned in Buonarroti's records.[101]

The art of weaving, which was contributing to the prosperity of several Italian cities, was slighted by Michelangelo. There is in fact a scornful remark on weavers in the *Dialogos*. Noting the length of time and meticulousness required by this craft (the Jacquard loom having not yet been invented), Michelangelo compares weavers unfavorably with lawyers and even tillers of the soil. The day's work of a barrister is worth no less a reward than the lifework of a weaver.[102] There is perhaps a minor, subjective reason behind this remark: Raphael's co-operation with Leo X as a tapestry designer was another motive for the latter's casting Michelangelo into the shade. A more basic reason was Michelangelo's dislike of the ornate and intricate tapestries reflecting the taste of Venice, one of the chief producers of them. We have support for this in a quotation of Buonarroti's recorded in Bernini's *Journal*: "If a room were adorned with tapestries woven with gold, and in another room there were only one beautiful statue, the latter room would appear to be adorned royally and would make the first look like a nun's cell ["stanza di monache"].[103] All in all, tapestry weavers rank almost as low in Michelangelo's hierarchy of values as muleteers and marriage brokers.

These, then, are the reflections of the universal genius of the Renaissance on the several arts "which have been my ruin." In closing this chapter, we cannot help wishing that the preliminary version of the Tomb of Julius II had been preserved and executed in its entirety, for it was to be adorned with the allegorical figures of Painting, Sculpture, and Architecture. Would they have been noncommittal and conventional, resembling the standardised figures to be found in Ripa and other iconographers? Or would they have been so individual as to reveal something further of the relative consequence and meaning to Michelangelo of the three major arts?

CHAPTER VI

The Ordeal of Art

Idem facit fortuna: fortissimos sibi pares quae it,
quosdam fastidio transit. Contumacissimum quem-
que et rectissimum aggreditur, adversus quem vim
suam intendat.

<div align="right">SENECA</div>

...animus tamen omnia vincit
Ille etiam vires corpus habere facit.
Sustineas ut onus, nitendum vertice pleno est,
Aut, flecti nervos si patiere, cades.

<div align="right">OVID</div>

"SWEET are the uses of adversity," says the English immortal whose career started in the very year that Michelangelo's closed, as though nature wished to support Buonarroti's claim that the chain of genius wanted no links. For two obvious reasons Michelangelo could not have read this line of the Stratford bard, but on one occasion he read the same thought in a letter (20 September, 1518) he received from Jacopo Salviati: "Great men, and of courageous spirit, take greater heart under adversities and become more powerful." And his reading from classic authors, whose moral essays gave the humanists as much strength as the sermons of the Church fathers, taught him that "ut efficiatur vir cum cura dicendus, fortiore fato opus est."[1] Milton, Beethoven, Leopardi, and even Nietzsche come to mind readily as men whose spirit and genius dominated their infirmities and adversities. Michelangelo deserves his place in such a company. Habitual exhaustion brought on by overwork, maladies, and attrition spurred Michelangelo to create his dynamic beings and titanic forms. Perhaps without the "pinpricks" of fortune, as he called them,

<div align="right">· 329</div>

Buonarroti might have been a different artist. The theory of genius *per aspera* is too ancient to be taken lightly.

Heretofore we have begun chapters with an illustrative anecdote (albeit solidly rooted in fact) to indicate how Michelangelo's patterns of thought and theory trespassed upon his daily living. No such memoir is needed to launch this final major chapter, the very warp and weft of which are materials personal, subjective, and anecdotal.

No assessment of Buonarroti's ideas on art should exclude his *obiter dicta* on his craft, his shop talk. These abundant personal remarks and reminiscences are inextricably linked with his opinions and theories on art, being now the cause and now the effect of those opinions. Almost all of them treat of the personal and technical difficulties encountered by the Renaissance artist in general and Michelangelo in particular. Some of the topics "spread like ivy" into the Renaissance dialogues, memoirs, and *artes* treating of painting.

These remarks fall into several easily defined categories: the meager financial rewards of art (personal financial distress, stinginess of patrons, gratuitous service, personal generosity), technical vexations (poor materials, adverse weather, delays, incompetent assistants), poor health (illnesses, old age, thanatophobia, overwork), pressures and humiliations (time deadlines, servitude, the Tragedy of the Tomb, public mortifications, persecution real and imagined, personal danger and flights, rumors and slander), and blanket condemnations of the fine arts as a profession.

It is difficult to visualise a protégé of Medici and popes as tortured by penury and financial concern. Were not the Medici responsible for the revival of the arts and sciences, for "the restoration of the Muses in disgrace," a role immortalised by Vida's poetics (I, 192–193)?

> *Iampridem tamen Ausonios invisere rursus*
> *Coeperunt, Medicum revocatae munere, Musae . . .*

Yet even great patrons can keep an iron grip on the purse strings, perhaps shrinking from possible criticism, as Pericles was blamed for spending the Delian League moneys on art, or more likely through the thoughtlessness which Tolstóy attributed to wealthy Renaissance Maecenases. Al-

though Michelangelo felt himself to be a descendant of the Counts of Canossa (and related to the Count who speaks so admirably in the *Libro del cortegiano*), his was certainly an impoverished family. Condivi writes that old Lodovico Buonarroti gratefully accepted customhouse employment paying but eight ducats a month—such a pittance that Lorenzo the Magnificent put his hand gently on the father's shoulder and remarked, "You will always be poor." Financial concern colored Michelangelo's very patterns of thinking and conduct, if we are to believe his letters. There is one which recalls a period when he "lacked bread."[2] In a letter to Luigi del Riccio, he admits to fleeing penniless from creditors, having "gran debito e pochi denari."[3] To Fattucci he complains that his belongings will be confiscated if he cannot meet his taxes. He reflects that the fine arts have reduced to this strait the member of a family which has paid taxes in Florence for 300 years. Likewise to Fattucci, to whom he bared his soul more readily than to any other except Riccio, he divulges, "I haven't received my stipend [*provigione*] for over a year and I'm combating poverty: I am much given to worries and I have so many of them that they keep me more occupied than does art."[4] It appears that poverty is no spur to the artist, any more than we shall find Michelangelo accepting other pressures as incentives to create great art. Rather, he agrees with Paolo Pino (*Dialogo*, p. 114) that "poverty assassinates us" and one painting won't support an artist until he has finished the next.

In his early days in Bologna he wrote his brother not to come and pay him a visit, "for I am here in a wretched room and have bought a single bed in which we are four persons."[5] In a letter written later he recalled how he had lived on scraps and slept fully clothed in a chair. One humiliation in Michelangelo's earlier days was typical of the embarrassments caused by being stone broke, *al verde*. Returning to Florence after their sudden flight to Venice, he and two friends passed through Bologna and could not pay the fine they incurred for failing to wear the distinguishing wax seal required of all foreigners.

The majority of these letters or incidents refer to the early days of his career. There are other complaints dating from later years. Typical is his capitolo from which we have quoted (LXXXI): "Anyone would be really seeing something if he saw my humble house here among the rich

· *331*

palaces." Most of his laments betray scorn for stingy, heedless, or insensitive patrons. Rare indeed were those Maecenases like Jacopo Salviati, the papal counselor, who assured Michelangelo that he would want for nothing in constructing the Façade of San Lorenzo and that the city would remain under a deep obligation not only to Michelangelo but to his family. Or Cardinal Grimani, who commissioned a painting (in vain) with the assurance, "Non cureremo il prezzo" ("We'll not worry about the price"). Or Metello Vari, who paid for the *Cristo* which Pietro Urbano had spoiled, refusing Michelangelo's offer to nullify the contract and granting him the extra bonus of a horse. Or kindly champions like Giovanfrancesco Aldovrandi of Bologna, with whom Michelangelo worked for a year. Aldovrandi not only rewarded liberally the artist's efforts, but delighted in his Tuscan lispings of Dante, Petrarch, and Boccaccio. Or Pope Clement VII, who paid him a fifty-ducat salary when the sculptor had requested only fifteen. These were distinctly in the minority.

On various occasions Buonarroti railed at patrons who would not pay the artist a living wage and shared Vasari's regret that Renaissance patrons did not display the same largess as art patrons of antiquity. He informed his listeners in San Silvestro that the poverty of Spanish art is due to stinginess of the grandees.[6] Later in this same dialogue he aims another barb at these patrons: "It does not seem to me that ancient painters would be content with your [i. e., Spaniards'] payments and your evaluations."[7] Lomazzo compiled a list of noble patrons of the arts and their protégés; only four patrons outside of Italy grace the list: Maximilian (Dürer), Charles V (Titian), Louis XI, and Francis I.[8] We have quoted Michelangelo's commendation of Francis I, "who had gathered together two hundred well-paid painters," the adjective being an unconscious bit of characterisation.

Cellini was sent by Duke Cosimo de' Medici to induce Michelangelo to return to Florence from the capital. The plea was embellished with promises of many favors and honors. Michelangelo, aware of the difficulties Benvenuto was undergoing with this patron, replied with a mocking laugh, "E voi come state contento seco?" ("And you, how satisfied with him are you?")[9] Yet this patron could be generous and Michelangelo congratulated Vasari on serving one who "has no care for expense";[10] he

hastened to add that other painters appearing in Giorgio's *Vite* did not normally have patrons displaying such generosity.

Michelangelo made it a point to pay his assistants regularly, even when his own patrons were lax in this matter. He felt himself a better than average employer of artists. He asked his faithful assistant Urbino, "If I die, what wilt thou do?" The latter replied that he would work for someone else. "O povero a te!" exclaimed Buonarroti, "I am going to repair thy poverty." And he gave Urbino (whom he survived) 2,000 ducats forthwith.[11] Yet his assistants sometimes had to complain as he himself complained. Topolino writes him from Carrara in 1525, "Io mi trovo senza denari" ("I find myself out of funds") and appeals for immediate relief.[12]

Michelangelo entertained a lurking conviction that patrons who hold the purse strings are generally incompetent in art. This made him resent more and more his financial dependence on them, on their judgements, on their caprices, and on their notaries, *arcinotai, proveditori*, and *sotto-proveditori*. This resentment is abundantly evident in his letters and in the *Dialogos em Roma*. In the latter record he reflects momentarily that even generous patrons are usually ignorant of art. Thus, Andrea Doria and Cardinal Farnese knew naught of art, nor did Cardinal della Valla or De Cesis.[13] Michelangelo had visited De Cesis at Pescia in September, 1534, four years earlier, and had designed an *Annunciation* for this churchman, painted by Marcello Venusti. One assumes that the financial arrangements were favorable even though the patron was insensitive and without taste. Michelangelo admits that Doria, one of the greatest of contemporary patrons, had little relish for painting. Cardinal Farnese had no understanding of art and, even though Pope Paul paid Michelangelo well "or at least better than I asked," the pontiff "is not much of a connoisseur or curious where painting is concerned." Ignorant patrons could pay too well as easily as too little. Certainly his reference to Perino del Vaga holds this implication, as does his rueful recollection that Sebastiano del Piombo, who painted almost nothing of value, was supported by the indiscriminate generosity of a pope. Michelangelo disliked taking his salary from a patron or treasurer ignorant of art, as he admits in the *Dialogos,* and it is said that on occasion, when he was disgusted with patrons, he would simply refuse to draw any salary.

Buonarroti was impressed if discomfited by those painters of old who, convinced that there was not enough wealth in the country to reward them for their efforts, gave their works away freely, even though they had lavished on these works time, money, and the exertions of their minds. Among these were Zeuxis and Polygnotus. Alberti had also recorded that Zeuxis gave his creations away, specifying the same reason as Michelangelo.[14] In the *Dialogos* Buonarroti continues to speak with a touch of envy of those painters who destroyed their creations rather than accept a fee which scarcely requited their pains and talents. A contemporary example of this intransigent sincerity is furnished by Torrigiano dei Torrigiani, the painter who as a boy flattened Michelangelo's nose after being subjected to one of the latter's sarcasms. Torrigiano went to Spain, where he was ill paid by those unappreciative Spanish patrons censured by Michelangelo in the *Dialogos*. When Torrigiano's patron underpaid him for a statue of the Virgin, the artist destroyed it and was condemned by the Inquisition. He starved to death in prison. Did Michelangelo sympathise with his former enemy as he sympathised with his Greek counterparts?

Michelangelo faced a situation not unlike that of Torrigiano with another Virgin—the Doni *Madonna*. When he had completed it he sent it to Agnolo Doni's home with a bill for sixty ducats. When Agnolo gave the porter only forty ducats, Michelangelo's hostility toward patrons came to the fore. He demanded a hundred ducats or the return of the picture. Doni countered with an offer of the sixty originally requested, but Michelangelo in a fury declared that the price was now one hundred forty ducats or nothing.[15] If, as Condivi states, the final agreed sum was only seventy, Michelangelo's point was gained and the patron paid an extra ten ducats for his truculence—all of which illustrates Beethoven's caution that one should not drive a hard bargain with artists.

Another incident in which the patron finally overpaid is recounted by Michelangelo with pleasure. A certain painter in ancient Rome demanded a sizable fee of Caesar, who rejected his request *illico*. When the painter prepared to destroy his work, despite the outcries of his wife and children, Caesar, with that tardy magnanimity displayed by emperors in neoclassical tragedy, paid the artist double the original price asked and told him that he was mad if he hoped to outwit Caesar.[16]

We have reproduced in Chapter II (note 140) Michelangelo's elaborately developed thesis that in time of peace and the toga princes are accustomed to spending great sums on things of little importance and value when they should be distributing their munificence upon artists.

Amid all these complaints about the parsimony of patrons, it should be pointed out that Michelangelo was not personally avaricious. Before Giannotti and his friends, Michelangelo branded avarice as one of the vices which "keep us from being our true selves."[17] The *Stanze* in praise of rustic life also condemn avarice as a vice fostered by city living. In these *Stanze* the figure of Wealth "goes about pensively adorned with gold and gems and with terrified countenance." In theory at least Michelangelo wanted to be among the Pneumatici rather than the Hylici. The theorists on art, like the theorists on literature of the time, insisted like Claudian that virtue is its own reward and scorned money-minded artists as "shopkeepers." Boccaccio had encouraged creative minds to become enamored of Dame Poverty.[18] Alberti, in *Della Pittura*, preached: "The aim of the painter is to seek to acquire praise, grace, and benevolence by means of his works, rather than riches."[19] Or again, "the soul intent on gain will rarely acquire the fruit of posterity."[20] In his *Dialogo* (p. 89), Paolo Pino has Fabio state that he has no intention of talking about "those fellows who put colors to work to pull in the *quattrini*." Lomazzo warned that no painter can blame poor or careless work on the avarice of his patrons or on his financial straits.[21] Despite his disillusionment about the financial remuneration of art and his awareness that in everyday practice it is hard to take solace from theory, Michelangelo seemed to consider it axiomatic that competent painters did not usually have to endure privation. This idea became more deeply rooted in his mind with the passing of the years. Such seems to be the conclusion to be drawn from an incident recorded by Vasari. When asked to comment on a canvas by a new artist, Michelangelo shook his head and commented, "Mentre che costui vorrà esser ricco, sarà del continuo povero" ("While this fellow will want to become rich, he will always be poor").[22] Da Vinci also decided that competent painters do not starve. In his *Trattato* he scoffed, like Lomazzo, at mediocre artists who complain that they could accomplish greater things if they were better treated. Such individuals would do better to admit out-

right that, while some specimens of their work have a modest value, others should be sold dirt cheap.[23]

Michelangelo was as impatient as Alberti with people who worked exclusively for money. He was bitter about his stonemasons who would work long enough to accumulate a little money and then skip off "con Dio." We have mentioned his gesture of accepting only fifteen ducats monthly rather than the fifty offered by Clement VII. When he became architect-in-chief of St. Peter's he refused an extra emolument from Paul III, stating that he was accepting the position only for his love of God. Such worthy actions, he was sure, would enrich his soul "dell'unica moneta/Che 'l ciel ne stampa" ("with the only money minted by heaven") (LXXXVI). At one point Pier Giovanni brought him 100 gold scudi in person for his month's services as architect-in-chief. Again Michelangelo refused.[24] He carried this financial disinterestedness into his family relationships. When his paternal uncle Francesco bequeathed him a legacy, he relinquished all claims to it, surrendering his share to his brothers. Outliving his brothers, he refused inheritances in turn from their estates. These were cases where Michelangelo practiced what he preached, for it was he who wrote (CLXIII):

> O Auaritia cieca, o bassi ingiegni,
> Che disusate 'l ben della natura!
> Cercando l'or, le terre e richi regni ...
>
> Oh blind avarice, oh unworthy spirits,
> who misuse the wealth of nature!
> Seeking gold, property, and rich dominions ...

Elsewhere (Letter LXXXV) he wrote: "Avarice is a very great sin and nothing tainted with sin can come to a good end."

Not only did Michelangelo decline moneys due him but, as his fortunes improved, he disbursed moneys rather widely, if discreetly. One cannot imagine him emulating Donatello, who left his money in a basket suspended from the ceiling, where it always remained available to his needy friends. Michelangelo was a bit more prudent, as his friend Vittoria Colonna remarked: "And in this you are excellent, since you give as one discreet and generous [discreto liberal] and not as one prodigal and ignorant."[25] This is precisely the impression one gathers from the

Lettere, which show the artist being freehanded, especially to members of his family, but demanding concessions in return and specifying how the bounty should best be spent. Money, he reminded his nephew, "isn't found in the streets" (Letter CLXV).

Condivi (LXVII) strives lengthily to demonstrate that Michelangelo was not money-minded and to recall that he had done many favors gratis for many people, both in teaching and in practicing his art. Vasari also attested that Michelangelo was generous to many and that he had secretly dowered several young women and defrayed the expenses of others who wished to enter convents. We can read Michelangelo's generous provisions for one such case in Letter CCXC. Several hitherto unpublished letters from the Archivio Buonarroti give further evidence that Michelangelo was generous to artists and individuals with both materials and moneys.[26] Michelangelo lent money not only to friends and such chance acquaintances as Luca Signorelli (a bad risk) and Piero Buonaguisi, but during the siege of Florence he was obliged to lend the Signory 1,500 ducats. On the former type of loan he charged 7 per cent interest. He preferred lending his money to depositing it in banks, "perchè non me ne fido" ("because I don't trust them").[27] Again, he voices the countryman's suspicion (Letter CLV) that "all banks are *fallaci*" (fraudulent). Several years passed before restitution was made by the Signory, and this only through papal intercession. Michelangelo gave away a few of his works, only to see them sold later, commanding substantial prices. He could, then, have sympathised with Degas, who saw one of his paintings sold for a huge sum and observed that he understood how the winning race horse feels when the trophy is presented to the jockey. Michelangelo must have shared this feeling when Antonio Mini, the garzone whom he was helping, wrote him from Lyon in 1532 that he was making a small fortune by selling copies of the *Leda* to wealthy Lyonese and had multiplied his income eighteenfold.[28]

Having taken the precautions of absolving Michelangelo from charges of avarice, explaining his reflections about this defection of Christian character, and reviewing the attitude toward money in Renaissance art theory, we are now in a position to examine certain moments of his career at which he, as a typical or better-than-typical painter, sculptor, or archi-

tect reaped a harvest of thorns for his pains. His preoccupation with money or lack of it was so ever-present in the *Lettere* that we can offer only a sampling of some of the most poignant or bitter passages. From the outset in Rome he could not obtain money to start even the drafting of the Sistine Ceiling. Costs of freight, materials, and labor had to come from the meager hoard of his own coins. In 1524, as he will again in 1542, he writes down the long story of his financial anguishes embarking on the Tomb of Julius II. "After paying the freight charges of these marbles and lacking moneys due for the aforementioned work, I furnished the house which I had on the Piazza di San Pietro [in 1542 this becomes "behind Santa Caterina"] with my own beds and furnishings, counting heavily on the Tomb. And I had garzoni, still among the living, come from Florence to proceed with the work. And I gave them their money before my own."[29] His fruitless visit to Pope Julius to collect his expense money terminated abruptly when a papal groom ejected him bodily from the room. Michelangelo's 1542 account of his reaction is detailed: He returned home, wrote hastily to inform the Pope that he was quitting Rome immediately, called in a carpenter and mason who were living with him, ordering them, "Go get a Jew and sell what is in this house, and then come up to Florence." Thereupon he caught the mail coach for Florence, refusing to return even when five horsemen dispatched by the pontiff caught up with him at Poggibonsi. Although he felt a sense of moral victory ("ne fu gran rumore con vergogna del Papa") ("there was a lot of talk to the shame of the Pope"), he figured that he was out of pocket at this moment a total of 5,000 ducats. On another occasion a commissary of the Duke of Urbino left him out of pocket to the tune of 1,400 ducats. Although enemies charged that he received 16,000 ducats for the ill-fated Tomb of Julius II before his recall to Rome by Pope Clement, Condivi serves as *porte-parole* to record that only a third of this sum was ever paid him.[30]

The most poignant passages in Buonarroti's correspondence are those in which one sees his creative genius struggling to break the bonds of financial and procedural restrictions imposed by the papal curia or other patrons. Lapses of payment from the papal treasury are frequently mentioned. In as many letters, numbered according to Milanesi, he claims that his salary is in arrears: a year (X), thirteen months (V), two years

(CCCLXXXIII), and eight years (CDLXXV). Finally, in 1560, he records that he has worked seventeen years gratis in the workshop of St. Peter's (CDXCIII). After the celebrated reconciliation with Julius II at Bologna, the Holy Father promised the artist riches, but Michelangelo told Fattucci that for the labor of the succeeding two years he was wealthier by only four and a half ducats.[31]

The niggardliness of the popes was in harsh contrast with the earlier expectations of young Michelangelo who, when first encouraged by Lorenzo de' Medici at the age of fifteen, had been paid five ducats a month, plus room and board. By October, 1542, Michelangelo complained that he saw a host of idlers with incomes of 2,000 or 3,000 ducats lying abed while he continued to grow poorer.[32] Every major work seemed to involve financial embarrassment. At one point he exhausted all his savings to create the statues for the inescapable Tomb of Julius II. His experience with the Façade of San Lorenzo was even more discouraging. He jotted a memorandum to the effect that "this building has ruined me" and that after three years only 500 ducats remain to him, although his debits exceed that sum.[33] Michelangelo admired Mantegna as an artist, but no more than he admired him for his spunk. Weary of the Pope's parsimony, Andrea tried to teach the pontiff a lesson. As Vasari records it and Michelangelo probably heard it, Mantegna, asked to paint the seven deadly sins, placed an eighth figure alongside them, explaining to the Pope that this symbol was ingratitude, the most deadly of all, almost a reminiscence of Dante. Michelangelo managed to include a similar hint in one of his works. Condivi reports that the bound captives on the Tomb of Julius II were to represent the Liberal Arts and the three Fine Arts, captive by death, since they would never find another patron to subsidise them as Julius had done. The irony of this is understood only when one remembers the complaints we have recorded above on Julius' tightfistedness.

Michelangelo suffered most of all from his treatment at the hands of Julius II, precisely because he expected so much from that pontiff. He felt as a young man that he was destined to rise with the ambitious Julius II and share in the luster of his reign. The temperamental Pope made things harder for the young Florentine by alternating between encouragement and hostility. At one point, probably in 1506, after a distressing

trip to Carrara, Michelangelo took refuge in poetry and poured out his feelings in a bitter sonnet (III):

> *Signor, se uero è alcun prouerbio antico*
> *Questo è ben quel, che chi puo mai non uuole.*
> *Tu ai creduto à fauole e parole*
> *E premiato chi è del uer nimico.*

> *Sire, if any ancient proverb is true,*
> *It is surely the one that goes: "He who can never wishes to."*
> *You have given credence to rumors and slurs*
> *And favored him who is an enemy of truth.*

There were so many hostile and envious individuals back at the papal court, from Bramante down, that it is difficult to conjecture which slanderers exerted this deplorable influence on Michelangelo's patron. The sonnet continues: "I've been and still am your same old devoted slave. I was given to you as rays to the sun. My length of servitude affords you neither regret nor pain, and the harder I try the less I please you. I had hoped to ascend to your lofty heights, and that fair dealing and the powerful sword would be all that was needed, and not the echoing of rumors. But when heaven locates some virtue in the world, it spurns any man who tries to go and take fruit from a tree that is withered."

This is not the only time in his poetry when Michelangelo suggests that worthy people who try hardest to accomplish something in life have the greatest obstacles placed in their way. The last verse of this sonnet is based on a bitter pun: The Pope is a tree that no longer gives fruit: the oak, the Italian *rovere*, being the family name of Julius II. It is doubtful that the young artist dared to show these angry verses to the Pope.

Sometimes in the early days, when financial embarrassment seemed almost unbearable, he would console himself with the thought, "When there will be nothing left to spend, God will help us" ("Quando e' non ci fia da spendere, Idio ci aiuterà").[34] Nevertheless, in addition to the understanding treatment of such patrons as Salviati, Metello Vari, Aldovrandi, mentioned earlier, there were moments of unexpected bounty, as when the consuls and *operai* of Florence decided to pay 400 florins for the *David* after a flexible minimum of 144 had been agreed upon (1502). Eventually, of course, Providence did help, most generously. Michel-

angelo acquired substantial sums which he spent in many ways, keeping a modicum for himself, lending, and especially investing in real property. At his death he possessed some 8,000 ducats in cash, having given 7,000 to Lionardo and 2,000 to Urbino. He had invested in a considerable number of houses and properties. The *Denunzia de' beni* showed that as early as 1534 he had acquired eleven properties.

Romain Rolland spoke very properly of this "hereditary peasant instinct" in Michelangelo. It is also an "instinct" of the landsman to pretend great poverty. So Michelangelo, like Parrhasius, Zeuxis, Apelles, or in his own era Pollaiuolo, eventually amassed a comfortable fortune, despite a traditional reputation for poverty. The days were still well in the future when a Degas was to leave a $2,500,000 estate and a Renoir a fortune of $3,000,000.

Lest we appear to have devoted excessive space to the matter of finances in a study of Michelangelo's patterns of thought (a thorough Marxist analysis here could be as provocative as it would be misleading), let us conclude with the reflection that this very matter of money may have been the major reason why his contributions as painter were so much greater than he had anticipated as a young sculptor. De Tolnay makes a careful breakdown of the cost of the Sistine Ceiling from May, 1508, to January, 1512, and notes that the entire salary paid Michelangelo amounted to 6,000 ducats. He then concludes: "When we consider that the salary for the Tomb of Julius II was set at 10,000 ducats, then it can be said that the Sistine Ceiling was a relatively inexpensive assignment. This may help to explain the Pope's decision to suspend Michelangelo's work on the Tomb; and since he wanted to keep the artist in his charge, he decided to have him do the less expensive frescoes."[35] De Tolnay also feels that financial pressures and not personal motives impelled Cardinal Giulio to cancel the contract for the Façade of San Lorenzo. The salary of 10,000 ducats was of course only one item of the total cost of the Mausoleum of Julius II; the projected edifice would have required enormous expenditures on the part of the papal treasury. Papini holds that to meet such a need the sale of indulgences increased, causing the Reformation to break out. He posits a direct connection between this project of Buonarroti's and the split of Christendom into two factions.[36]

Whether as painter, sculptor, or architect, Michelangelo faced many technical difficulties other than financial, and these became subjective factors of his thinking on art.

Condivi, Vasari, and Bernini all tell the amusing story that after Michelangelo finished the Sistine Ceiling he had to read books and look at objects by holding them over his head. Certainly the arduous task of painting the Ceiling would have taxed a far stronger man than he. Possessed of a brittle sense of humor, he left us on this subject his most witty and personal poem:

> I' o gia facto un gozo in questo stento
> Come fa l'aqua a gacti in Lombardia
> Ouer d'altro paese che ci sia,
> Ch' a forza 'l uentre apicha socto 'l mento.
> La barba al cielo e la memoria sento
> In sullo scrignio e 'l pecto fo d'arpia,
> E 'l pennel sopra 'l uiso tuctauia
> Mel fa gocciando un richo pauimento.
> E' lombi entrati mi son nella peccia,
> E fo del cul per chontrapeso groppa,
> E passi senza gli ochi muouo inuano.
> Dinanzi mi s' allunga la chortecia
> E per piegarsi adietro si ragroppa,
> E tendomi com' archo soriano.
> Però fallace e strano
> Surgie il iuditio, che la mente porta,
> Che mal si tra' per cerboctana torta.
> La mia pictura morta
> Difendi orma', Giouanni, e 'l mio onore,
> Non sendo in loco bon nè io pictore [37]

In this hardship I have grown a goiter, like the cats who drink the water of Lombardy, or whatever that country is, which thrusts the belly up against the chin. My beard turned toward heaven, I feel the back of my head against my hump and I imitate the harpy's breast. Meanwhile, my brush over my face makes a rich surface of it with its dripping. My loins have entered into my belly, and my rump counterbalances it, as a crupper. I take my steps in vain without seeing them. In front my hide is stretching and in back it is gathering in folds from my leaning, while I strain like a Syrian bow.

Therefore, false and strange must judgement issue forth, borne

by such a mind, for one can ill shoot with a bent barrel. Now,
Giovanni, defend my lifeless painting and my honor, for I am in
the wrong place and am no painter.

There was further wear and tear upon the artist occasioned by this same
chapel. In 1540 or 1541 Michelangelo fell and seriously injured his leg
while painting the *Giudizio universale*.[38]

It is the *Lettere* which acquaint us with the greatest number of techni-
cal difficulties, especially those involving availability and quality of
materials. Even by traveling to Carrara and choosing his marbles on the
spot he could not always find that quality of stone which he sought. Often
the marbles were either faulty in texture or too small for his purposes.
The worst was when these marbles, paid for and transported to his studio,
proved defective. "And wherever I have bought them the marbles have
not measured up to my requirements, because they are deceptive—even
more so these large blocks which I need and which I desire so beautiful.
In a stone from Poggio which I have already had cut certain weaknesses
have come out which one could not have anticipated, with the result that
I cannot get out of it the two columns which I wanted to make; I have
thrown away half of the expense money on it."[39] Of course, such stones
constituted a calculated financial risk, but they made patrons short-
tempered and strained the already tenuous relations between patron and
protégé.

Other tensions resulted from the quarrying itself. Leo X obliged
Michelangelo to select marble from Pietrasanta, although this marble was
poor and there were no suitable roads over which to transport it. Further-
more, as a result of this switch to quarries in another area, the Marquis
Malaspina of Carrara became so embittered with Michelangelo that the
artist never dared return to Carrara, even for marbles which he had al-
ready quarried. When the artist wrote to the Pope that the marble of
Pietrasanta was inferior, Cardinal Giulio responded that he and the Pope
were beginning to question the integrity of Buonarroti, who would enter
into collusion with the Marquis of Carrara against the interests of the
Florentines. After Michelangelo set to quarrying at Seravezza, a few kilo-
meters from Pietrasanta, he wrote, "The site here is rough for quarrying
and the men very ignorant in work of this sort."[40] The ignorant fellows

· *343*

accepted 100 ducats to supply a quantity of marble, he adds, but six months later they had not fulfilled their part of the bargain while refusing to return the payment. Seventeen letters from Topolino, reproduced *in extenso* by De Tolnay, detail the many technical difficulties presented by the stonecutting process.[41]

Vasari relates how a poor marble troubled Michelangelo during the carving of the *Deposizione*. Michelangelo had complained from the first of a *pelo* (thin crack) which caused him to dislike the block. Then a piece came out of the elbow of the *Madonna*. Losing patience, Michelangelo would have shattered the work completely had not his assistant Antonio intervened.[42] In the summer of 1514 Michelangelo started on the marble figure of the *Cristo risorto*. While he was blocking it out, black streaks showed up in the stone, causing him to abandon the project until 1518. The three defects of stone which most worried Topolino and Michelangelo were *peli* (cracks), *rotture* (breaks) and *isforzature* (strains).[43]

When materials resisted his efforts and intentions, Michelangelo must have thought of three verses of the book which he knew almost by heart:

> *come forma non s' accorda*
> *molte fiate alla intenzion dell'arte*
> *perch' a risponder la materia è sorda.*[44]
>
> *as oftentimes form is not in*
> *accord with the intention of art, because*
> *the material is too deaf to respond.*

The very hardness of some marbles came to inform them with hostility as Michelangelo aged and his forces diminished. It is symptomatic how many times he refers to "alpine and hard" stone in his poetry.

Later in his life Michelangelo wrote acidly to the superintendents of the fabric of St. Peter's that the lime supplied his workers by one Balduccio was defective and that he suspected graft and collusion going on behind his back.[45] Condivi claimed that Michelangelo had scarcely terminated the *Diluvio* of the Sistine Ceiling before it developed such a mold that the figures could scarcely be seen through it. This of course might be attributed to the faulty technique of a beginner in fresco as well as to faulty materials.

A defective iron chain led to catastrophe. Writing to Piero Urbano from Seravezza, Michelangelo tells how he had been raising a large stone column for the Façade of San Lorenzo, trying to load it on a barge by means of a wedge and pulley. When it had been cautiously raised to a height of fifty *braccia*, the chain snapped and the column ended up shattered into a hundred pieces in the river. Because of this weak link, which appeared deceptively strong, a "marvelous" stone was ruined and several lives, including Michelangelo's, were endangered. Examining the broken chain, he decided that the link contained too little iron. This, he writes, was the consequence of his entrusting to Donato the commission of buying a chain. The memory of such a disaster was keen enough thirty years later to cause him to refuse Paul III's request to supervise the erection of the Egyptian obelisque which Caligula had brought from Heliopolis. According to Michele Mercati, Michelangelo refused in a few words, "E se si rompesse?" ("And if it broke?")[46] As we noted in Chapter III, the only two references to him in all of Leonardo's notebooks are two occurrences of the phrase, "the chain of Michelangelo," which seem to indicate that he had applied himself to finding a solution to this problem of hoisting.

One of the reasons Michelangelo may have enjoyed portraying Bologna's patron, San Petronio, in marble (1494) was that this saint was canonised partly for having resuscitated an artist crushed by a falling column.

It seemed that the weatherman himself often conspired to defeat Michelangelo's plans. Heavy rains and severe drouths plagued the artist. In 1521 Marcuccio and Francione complain from Carrara that they cannot cut Michelangelo's stone "per lo mal tempo."[47] In 1523 the roads from Carrara are washed out (*isfondate*) and Topolino's cutting is delayed.[48] The weather even made him fear acquiring the reputation of a cheat. "Eight days ago Pietro who stays with me returned from Porto Venere, with Donato who stays over there at Carrara for the task of loading the marbles. They left a loaded barge at Pisa and it has not put in an appearance, because it has not rained and the Arno is really dry. And four other boats are in Pisa, chartered for these marbles. When it rains they will all arrive loaded and I shall begin to work hard. In this matter I am the

least contented man there ever was."[49] Messer Metello Vari is pressing
him for the *Cristo risorto,* which is waiting in rough block form in Pisa,
due to come on the first boat. He has not even dared to reply to Vari until
actually working again. "For I am dying of vexation and seem to myself
to have become a cheat against my will."[50] Incidentally, when Michel-
angelo writes that Vari's *figura* (rather than *abbozzo*) is waiting at Pisa,
he is conscious of the essential form waiting within the marble block for
the liberating action of the sculptor.

The weather offends him doubly. In this same letter he complains
that, while he has found a capacious studio in Florence (apparently the
one on Via Mozza), it lacks a roof and he cannot find timber for one.
Only when it rains will there be timber coming in by boat. The same
drouth that is holding the marbles in Pisa is keeping the roof from his
studio. And probably the rains will vex him as much as the dry spell. "I
don't believe that it will ever rain again, except when it will be to do me
some hurt."[51] In 1545, after fire had destroyed part of the Pauline Chapel,
Michelangelo fears that the repairs may not be made before rain comes
to harm the paintings and even "move" the walls.[52]

As early as 1506 he complained to his father that he was encounter-
ing delays of every sort despite his impatience to make good his word to
the Pope. His marbles do not arrive, and ever since he has been in Rome
there have not been two days of good weather. One boatload of marble
from Carrara did arrive despite the wretched weather, but when the mate-
rials were unloaded they were submerged by the swollen river, creating
new delays. If it wasn't the rain, it was the sun, whose burning rays
"annoy" him when he must examine marbles outside (Letter CCCLXIX).

All these mishaps and disasters were probably normal occurrences in
the lives of most Renaissance artists, but, as Middeldorf comments, Buo-
narroti decried them "harder and more for eternity" than the others and
his egotism made each seem a lese majesty. In any case, they made Buo-
narroti bitterly aware of the possible breach between theory and practice,
aware that possession of *intelletto* or *visus interior* was no guarantee of
the sculptor's eventual success in uncovering the forms hermetically sealed
in the ὕλη. Nor was it always true that, in Ovid's words, "materiam su-
perat opus."

In Michelangelo's theory of inspiration and genius little place is left for assistants and specialised hirelings. Perhaps if assistants were to be endowed with *intelletto* they migh prove effective co-workers, but it would appear from the innumerable criticisms of his assistants that Michelangelo deemed most of them utterly devoid of genius and more of a hindrance than help. Cellini definitely used the wrong approach when, urging Michelangelo to leave Rome for Florence, he suggested that Michelangelo could leave his work at the capital in the hands of his loyal assistant Urbino (even though Cellini's private opinion was that Urbino "had learned nothing of art").[53] Buonarroti's feelings about assistants—and it would be difficult to determine where the frontier lies between objective theory and subjective impression—may be reduced to the following specific convictions:

I. Assistants are costly beyond measure

II. Assistants are incompetent, lazy, and troublesome

III. Assistants' incompetence can spoil an artist's work

IV. Assistants' incompetence can endanger life and limb

V. Assistants imperil an artist's reputation by taking undue credit.

First, the complaint that assistants cost to excess: Since Michelangelo was of a disposition to leave as little as possible to garzoni, possibly a consequence rather than a condition, he would expect their cost to remain relatively small. In discussing his own salary, he complains that his assistant receives *ten cruzados,* about two and a half ducats a month plus board for merely mixing and grinding his colors. Assistants are generally ungrateful anyway. "These stonecutters whom I brought here don't understand anything in the world either about quarries or marbles. They are already costing me more than 130 ducats and they haven't yet quarried a flake of marble which is any good. They go about assuring everyone falsely that they have found fine things and seek to work for the *Opera* (works division of the cathedral) and for others with the moneys which they have received from me. I don't know how they are being received, but the Pope shall know of all this."[54] This unhappy letter was written to his brother from Pietrasanta. Again he writes to Buonarroto that his chief stonecutter Sandro does nothing else but fish and make love, having wasted 100 ducats on stones worth less than 25. Buonarroto seems

to be the recipient of most of these plaints about the costliness of garzoni, perhaps because the family always leaned on the artist for financial assistance. It was also to him that Michelangelo related his dilemma of being unable to send any assistant with an appreciable sum of money to buy marble, lest the latter cheat or be cheated: "Like Bernardino, the low-life who defrauded me of 300 ducats here and then went about Rome gossiping and complaining about me."[55] In a letter to the superintendents of St. Peter's, Michelangelo stresses how easy it is for assistants (he had sixty of them now) engaged on large assignments to benefit by graft and kickbacks through purchase of faulty materials. "Promises, tips [*mancie*], and presents corrupt justice."[56]

Two assistants who annoyed him in 1507 were Lapo di Lapo and Lodovico Lotti, sculptor and founder, respectively, who, after being paid thirty-five ducats plus expenses, loafed for six weeks and then had the audacity to claim to be his collaborators.[57] "They never noticed that they weren't the maestro until I booted them out." They cheated him (Letter IV). What could he do but dismiss them? And now they go about complaining of mistreatment. Lapo had corrupted Lodovico and the two of them together were not worth three *quattrini*.

Buonarroti calls to task his sculptor-foreman Donato Benti, who is overseeing work for him at Pietrasanta. He explains that a worker, Cecone, has come to him requesting money. He has paid the worker nothing, since he is unaware of what they have been accomplishing at Pietrasanta. He asks Donato to have the workers on the project keep him currently informed on their progress, adding that he will pay them as one who lives up to the letter of his contracts. He then expresses worry over reports which have reached him concerning Donato's own management. "As for your own affairs, this Cecone tells me that you are short-measuring them, that they cannot work, and that the men from Pietrasanta whom I put to work have left the undertaking and are doing nothing."[58]

More serious than the feeling that assistants were a financial drain was the conviction that they were incompetent. This conviction impelled him to take on too many petty tasks himself. Sebastiano del Piombo constantly urged him not to waste his energies on details. Although Michelangelo did recruit some competent assistants, as we shall see, his read-

iness to believe them incapable took root early and endured long. Vasari was no doubt echoing his sentiments in judging Pietro Urbano talented but lazy, Antonio Mini willing but untalented, and Ascanio Condivi a slowpoke who never finished anything.[59] It is a matter of record how Michelangelo treated the Florentines he imported to Rome to assist on the Sistine Ceiling: Granacci, Bugiardini, and the rest. As we have stated, Michelangelo disliked their initial efforts so heartily that he obliterated their work by scraping the ceiling clean and beginning anew. Michelangelo is supposed to have locked these collaborators out of the Chapel and his home, so that they returned crestfallen to Tuscany.[60]

Michelangelo entertained not only dissatisfaction but also distrust of assistants. He often had reason to be distrustful. "Pietro Urbano betrayed him; Antonio Mini had to leave him and died quite young; Montorsoli abandoned him; Sansovino insulted him and later spoke of him with acrimony; Jacopino del Conte slandered him; Guglielmo della Porta repaid his benefactions with hatred; Raffaello da Montelupo failed in his trust, etc."[61] An early letter (6 July, 1507) to Buonarroto contains the lengthy indictment of a smith, Messer Bernardino del Ponte, Master of Ordnance, who was to cast the *Giulio II* for him, but who through "ignorance or misfortune" had not fully melted the metal. The figure came out waist high, while the rest of the metal remained unmolten in the furnace. To achieve a recasting it was necessary to dismantle the furnace and reliquefy the metal. The entire operation took only a few days, but involved "a vast amount of passion, effort, and expense."[62] (The anguished Cellini took to his bed when the *Perseus* threatened to have this same fate.) Michelangelo was mightily aggrieved at Bernardino: "I should have believed that Maestro Bernardino could cast without fire, so much faith did I have in him. Nonetheless, it's not that he isn't a good master or that he didn't act with devotion. But he who tries often fails. And he has really failed, to my damage and to his as well, for he has disgraced himself to such an extent that he dares no longer raise his eyes throughout Bologna."[63] Here is another trace of that satisfaction Michelangelo derived from seeing that those who wronged him suffered public indignation in return. Compare also his gratification at the brief public resentment when Julius II ordered him ejected bodily from the papal quarters.[64]

After entrusting the designing of a model of the Façade of San Lorenzo to an assistant, Baccio d'Agnolo, he is now convinced that he might as well have undertaken it himself.[65] The assistant's efforts are childish. In a letter to Berto da Filicaia he complains that there are no longer stonemasons of any value, so that jobs which should be finished in days require weeks. His own stonecutters are as ignorant and sluggish as any. "Great patience will be required for a few months, until the mountains are *domesticati* and the men trained; then we shall proceed more quickly."[66] Topolino's reports on the workers' failings made Michelangelo wince as he read them. The stonecutters were guilty of absenteeism,[67] malingering when not supervised,[68] greed,[69] until Topolino begins to despair of his sanity: "Io ho paura di non inpazare."[70] When such assistants are set to such dangerous tasks as raising and lowering columns, life and limb are at a small premium. When the benighted Cecone breaks a column, his fellow workers in Pietrasanta endeavor to cover up the fact.[71] Injuries and death can result from the awkward maneuvering of a column. When such an accident occurs, Michelangelo takes it so seriously as to share in the responsibility: "È stata maggior cosa che io non stimavo a collarla giù."[72]

When an assistant like Rubecchio (called a *tristerello*) almost spoils a stone column which Michelangelo has quarried, the master dismisses him (1518). Rubecchio and his fellows have worked "few days and with ill temper." It pains Michelangelo to have them "come here and give a bad name to me and to the quarries." He wishes that they would at least be quiet, since they frighten away other workers and since they have swindled him. He concludes by asking his brother to find some way to frighten them into silence, because these *giottoncegli* are harming him and his work infinitely.[73]

Egotistic motives determine his feelings about assistants. One of the hazards of employing garzoni is that you may wake up some morning and find your works credited to them, especially if you prefer, as did Michelangelo, not to encumber those works with signatures. Sebastiano del Piombo expressed displeasure that Piero Urbano gained the reputation of having executed the *Cristo risorto*.[74] Those scoundrels Lapo and Lodovico angered him by claiming to have collaborated as equals on the

Giulio II.[75] Michelangelo would have felt an even greater grievance against his assistants if he had foreseen to what an extent subsequent critics were to detect "the hand of an assistant" on so many of his pieces, as, let us say, the *Madonna* of Bruges. Even the minor operations of the assistant's hand may be enough to spoil a work; Michelangelo was no doubt incensed when Sebastiano wrote him that Urbano's final touches on the *Cristo risorto* were said by the public to be the product of a jumble-cake (*zanbele*) baker.

Vasari held that Michelangelo's unwillingness to have other artists collaborate on the Façade of San Lorenzo prevented the project from being concluded and caused the men to leave this task for other pursuits. In fact, a letter from Bandinelli accuses Michelangelo of deliberately preventing the completion through jealousy of the younger masters. Although it is likely that abandonment of this project stemmed from other and more complex reasons, Michelangelo's mistrust of collaborators whose efforts might be fused with his stands again revealed. Some parts of the Sistine Ceiling, probably a few of the medallions, are obviously the work of lesser artists. In the field of architecture, an anonymous contemporary claimed that many errors Michelangelo committed in designing the bastions of Florence (1529) were due to his inexperienced coadjutors.[76]

At the collaborator level, higher than that of garzoni, Michelangelo did have capable assistance on detailed finishing after he had "captured the basic form." At one period there were the cabinetmakers Ciapino and Battista del Cinque and the woodcarvers Tasso and Carota, all of high competence. Despite later events, he deemed his co-worker Raffaello da Montelupo at one point "approved among the best artists of these times" (see Chapter IV, notes 110 and 136). Architectural details could be entrusted to the able Giovanni de' Marchesi and Francesco da Urbino.

Michelangelo has been criticised for not having organised a school of capable fellow workers, like Raphael's, to further his ideas and ideals. The bulk of the foregoing attacks, criticisms, reservations and rationalisations show, as did his antagonistic attitude toward the "sect" of Sangallo, how temperamentally unfitted Michelangelo was to organise a "school," in the sense of a personally inspired and directed group. (We shall return shortly to his feud with the "sect.") He was not the *bar-*

gello or *proposto* type, to use the words he reportedly hurled at Raphael. Symonds poses another contributing reason why Michelangelo was not a *caposcuola*. He asserts that Buonarroti failed to command the respect of assistants and even servants by such actions as sleeping in a miserable single room in the company of three workers. Living in such a familiarity as breeds contempt, Lapo could easily consider himself a full copartner.[77] Middeldorf finds Symonds' hypothesis too Victorian and foreign to the Renaissance. Cellini posits still another reason for Michelangelo's failure to establish a school of these workers staying with him: Michelangelo constantly exploited his devoted Urbino as a valet and servant girl, "and one could see why he had learned nothing in his art."[78] Typically, Michelangelo asks his father in 1511 to send him a young Florentine to be an apprentice in art, but also to do the marketing and errands as needed.[79] De Tolnay adds a final reason to explain why the assistants were not really disciples, at least in the beginning, and why so many squabbles could arise. The birth dates of the assistants on the Sistine Ceiling would make of them an age more appropriate to co-workers than helpers. "With only one exception, all were either older than Michelangelo or of approximately the same age." At the end of his life the opposite was true: Michelangelo was too aged to win the confidence of the assistants in the fabric of St. Peter's.

In a larger, less personal sense Michelangelo did create a school. In his *Trattato* Lomazzo praises Michelangelo and Raphael "in whose schools one may say that all the excellent painters of Italy have made themselves worthy and famous."[80] Certainly many artists could accurately call him their "maestro," as did Cellini and Luis de Vargas, painting far away in the Cathedral of Seville. In a letter to Michelangelo Bronzino termed himself "your creature and disciple."[81] Giambattista Zabacco, who exported Michelangelo's style and spirit to alien soil—Venice—never ceased considering himself his "scolaro."[82] Aretino complained of the legion of *pittorucci* who were in his day "apes of Michelangelo."[83]

In this less restricted sense Michelangelo left not only a school, but an academy as well. The Florentine Academy of Design was dominated by his memory and principles. His influence was such that Battista Naldini, a disciple of Pontormo, painted at Michelangelo's death a picture

of the master surrounded by the Scuola delle Arti: children and youths all offering him their first labors of art for criticism. Underneath one reads the inscription:

Tu pater, tu rerum inventor, tu patria nobis
Suppeditas praecepta tuis ex, inclyte, chartis.

Francesco Furini executed a similar canvas, to be found in the Casa Buonarroti.

In any case, Michelangelo was not without some admiration for the young craftsmen of Italy pictured in these romanticised projections. Despite the bitter comments contained in his letters, he felt that the mere disciples in the ateliers of Italy surpassed the masters of other lands:

Take a great man from another kingdom and tell him to paint whatever he likes and is best able to do; and then have him do it. Then take a poor Italian apprentice [*descipolo*] and have him make a drawing or paint whatever you like; you will find, if you understand well, that the drawing of that apprentice, as regards art, has more substance to it than that of the other master.[84]

Nor should we forget the great affection he was able to bestow on such an assistant as Urbino, whose death loosened Michelangelo's own hold on life (CLXII) (see note 87 below).

How is Michelangelo's theory of the *concetto* to be reconciled with his use of assistants? First of all, it might explain his unwillingness to delegate responsibility to others. Also, many of the assistant's tasks merely prepare for, but do not participate in the discovery process—such tasks as grinding or mixing colors, making under guidance a wooden or earthen model, measuring columns to be used in architecture, etc. Other contributions of assistants are undertaken only in the wake of the discovery process, after the "basic form" has been found. *Intelletto* is a talent for fathoming the basic patterns in nature. Once that basic form (*concetto*) was ascertained, the fundamental problem was "broken" and henceforth offered only a modicum of interest. As Michelangelo grew older he knew this to be more and more true, being increasingly content to leave this finishing process to others, technically co-workers or assistants, satisfied that this final step required a lesser genius or at least a different order

· *353*

of ability. Persuaded that the assistant's task was a less demanding one, Michelangelo could indulge in a righteous wrath when a garzone botched his job.

Old age, weakness, sickness, sense of imminent death—these constituted an anxiety which in Michelangelo was as constant as that occasioned by financial and technical troubles. Every artist dreads the age when his hand is no longer firm and his conceptions are dimmer. Matisse wrote that he longed to recapture the freshness of vision which had characterised his youth, when the world was new. Rare are those men of genius like Sophocles, Michelangelo, Titian, and Verdi who can keep producing until about their ninetieth year. If we pause now to examine Michelangelo's thoughts on senescence and death, it is because his mention of them is so often related to his artistic productivity.

Michelangelo's strange obsession with death has been viewed as a carry-over of an Etruscan artistic tradition and as a philosophical preoccupation of the Florentines from Dante to Savonarola (Pater). It comes out in even such indirect ways as the thematic withered trees in his poetry (III; LXXXIII, 21). Mariani observes that one finds throughout Michelangelo's writings and thought a "binomio Notte-Morte." Death is thematically more common than night (the Time of Day to which he devoted five poems). Buonarroti speaks of his approaching death ("la mia propinqua morte") in a madrigal composed forty-eight years before he passed away! This piece ("Com' arò dunque ardire") dates from between 1513 and 1518. Should the reader question whether this madrigal is not more of a literary exercise than an autobiographical document, one may adduce a letter to Domenico Buoninsegni from about this same period (1516 to 1518) in which he speaks of himself as an old man ("perchè io sono vechio") although he had barely reached his forties and death was to spare him until 1564.[85] In fact, a rumor that he had died circulated as early as June, 1508. In October, 1525, he wrote to his friend Giovan Francesco Fattucci that he had few energies left for his art, "perchè son vechio."[86] The identity of this wording with that in the letter to Buoninsegni indicates that it had by this date become a catch phrase with him.

Indeed, he laments to Varchi, "non solo son vecchio ma quasi nel numero dei morti" ("not only am I old, but almost numbered among the dead"). It strikes us that as he ages he links the adjective "vivo" with his art more and more frequently, as though transmuting his ebbing life into greater living qualities in his works.

The catechistic phrase "la mia propinqua morte" has many variants in Michelangelo's poetry and the thought engenders some of his most powerful verses:

> con la morte appresso
> Nemico di me stesso (XLIX)
>
> with death at hand
> and enemy of myself
>
> Sì presso a morte e sì lontan da Dio (XLVIII)
>
> So near to death and so far from God
>
> Com'io a morte, che la sento ogniora (CIX, 28)
>
> As I to death, which I feel even now
>
> Mio parto ... co' la morte scherza (CXXII)
>
> My birth is playing with death.

This sense of imminent death led him to one of the most powerful and poignant motivs in his poetry: the sensation that his skin was drying and decaying, was transforming itself into a pelt. One cannot realise how this thought preyed on his mind until one reads through his entire *canzoniere*, after which the collective evidence is overwhelming. The words he adopts to describe his decaying flesh are *corteccia, pelle, spoglia, carne*, and twice *terrestre velo* (LXXIII, 31, 37). Time destroys and changes the skin (XLIX). The soul sheds the flesh (LXIV). Man sheds his skin as a serpent does against a rock (LXVI). The flesh is made of earth (LXXIII, 61). It lives in slime (LVIII). The bones are prisoners of the skin (LXXXI). Man lives in a "sack of leather" (*sacco di cuoio*) (LXXXI). The skin holds in the flesh surrounding the soul, as the surface contains the *soverchio* around a *concetto* (LXXXIV). Infirm souls are captives of "tired *spoglie*" (LXXXVII). The skin withers like fallen fruit (CIX, 81). There are many

other variants of this obsession, more striking than the more common theme that the body is earth which returns to earth (LXXIII, 37; CIX, 33), to worms (CIX, 86), or to ashes (CIX, 92).

So inherent was this preoccupation that when he wishes to describe the dissolution of Rome he charges the clergy with selling the pelt of Christ.

It is only after reading the *Rime* of Buonarroti that one can understand how he came to paint himself in the *Giudizio universale* as the leathery pelt of San Bartolommeo.

After the death of Urbino, Michelangelo set to speculating upon his own death, if one is to believe a curious sonnet (CLXII) written to Monsignor Lodovico Beccadelli in Dalmatia:

> *Sua morte poi*
> *M' affretta et tira per altro camino,*
> *Doue m' aspetta ad albergar conseco.*[87]

His death then goads me and draws me along another path where he waits for me to dwell with him.

We have already shown how Michelangelo's religiosity caused him to look forward to the balm of heaven and long to escape from earthly bondage. In addition to the mystical passages quoted, there is his scrawling on a sheet found in the Casa Buonarroti of a few words from Petrarch's *Trionfo della Morte,* "La morte el fin d'una prigione scura" ("Death the end of a dark prison").[88]

To understand better this obsession with death one must consult a curious passage in Giannotti's *Dialoghi* where Michelangelo refuses a dinner invitation and explains that instead of becoming addicted to social pleasures one should spend considerable time reflecting upon death:

Questo pensiero è solo quello che ci fa riconoscere noi medesimi, che ci mantiene in noi uniti, senza lassarci rubare a' parenti, agli amici, a' gran maestri, all'ambitione, all'avaritia, et agli altri vicij et peccati che l'huomo all'huomo rubano e lo tengono disperso et dissipato, senza mai lassarlo ritrovarsi et riunirsi. Et è meraviglioso l'effetto di questo pensiero della morte, il quale—distruggendo ella per natura sua tutte le cose—conserva et mantiene color che a lei pensano, et da tutte l'humane passioni li difende.[89]

This thought is the only one which makes us recognise our true selves, which maintains us united within ourselves, without letting us be robbed by our relatives, friends, great masters, ambition, avarice, and other vices and sins which rob a man from himself and keep him dispersed and dissipated, without ever letting him find and unite himself again. And a marvelous thing is the effect of this thought of death, which thought—death destroying all things by its very nature—preserves and maintains those who think upon death and defends them from all human passions.

In May, 1525, Michelangelo had written to Sebastiano of accepting an invitation "so that I might get away for a while from my melancholy or rather madness." By the age of seventy-one, his Christian asceticism has become dominant. He is correct in informing Giannotti's group that he has expressed in poetry this belief in the therapeutic value of thanatophobia, for it appears in the madrigal: "Non pur la morte, ma 'l timor di quella." Another poem (CIX, 75) stresses the disruptive rather than beneficial impact of thoughts on death, developing the macabre belief that they may be counted on to blot out happy memories, to change fire into ice and laughter to weeping:

> Nella memoria delle cose belle
> Morte bisognia per tor di costui
> Il uolto a lei, com' e uo' tolto à lui . . .

The uncertainty of the afterlife makes him cry out (XLIX), "Io vo lasso, oilmè, nè ben so doue!" ("I am going, alas, alack, but I know not where!") Since thinking fearfully upon death is actually beneficial to the soul, the souls in heaven can smile in their omniscience at human efforts to evade thoughts on death (LVIII):

> . . . che 'l ben morto in ciel si ridj
> Del timor della morte in questo mondo.

Savonarola, erstwhile spiritual guide of Michelangelo, had cautioned: "In every work of thine remember death." Buonarroti betrayed this influence when he declared, "No thought comes into my mind which does not contain within itself the image of death."[90] Verses like "Ch'un uom morto non risurge a primauera" (LXXIII, 21) abound in the sequence of fifty poems written on the death of one individual alone—Cecchino Bracci. Bernardo Buontalenti is witness that Michelangelo painted on the stair-

case of his house in Rome a huge skeleton toting a coffin on its shoulders. The gruesome thought accompanying this painting reads:

> Io dico a voi, ch' al mondo auete dato
> L'anima e 'l corpo e lo spirito 'nsieme:
> In questo cassa oscura a 'l uostro lato.[91]

I say to you who have given to the world your soul and body and spirit together: This dark coffin is the place where you belong.

Death of course provided greater subjects for his art than this lank skeleton. Emblems of death: acorns, ram skulls, and shells decorate the spandrels of the Sistine Ceiling: "motifs found on ancient sepulchral altars" (De Tolnay). Naturally, such motivs decorate the mortuary chapel of the Medici. The theme of death provided the pathos of much of his religious art (the *Pietà*, the *Deposizione*, and other projects linked with the Passion). It abounds in the *Giudizio universale*, of course, and hovers throughout the Sistine Ceiling: the *Diluvio*, the *Oloferne e Giuditta*, the *Storia di Ester*, the *David e Golia*, the medallions of the *Morte di Giorem*, the slaughter of the sons of *Acabbo*, and so on. Michelangelo never quite met the challenge contained in Alberti's admonition that dead figures "are the most difficult of all subjects," for his dead figures "won't lie down," as do those of Mantegna or the Flemings. The crucified Haman looks like a racer hurtling across a finishing line. We have already proposed the theory that Michelangelo consciously tried to transfer to his figures the life and vitality which was being sapped from his own body. These necrological themes allowed the artist to instill feelings of piety and awe among his fellows, to make others share the constant preoccupation to which he was victim. Yet these subjects took their toll on the artist himself. Some of the concepts which Michelangelo hoped to introduce into his art brought with them thoughts of death and the futility of life. When this happened, it destroyed his inspiration completely (CXLVI):

> S' a tuo nome ò concecto alcuno inmago,
> Non è senza del par seco la morte,
> Onde l' arte e 'l'ingegnio si dilegua.

If in thy name I have conceived some image, it is not without death's having appeared with it at the same time, whence art and genius vanish.

Do these sentiments sound alien to the author of the Medici "House of the Dead," consulted as a specialist on tombs by Piero Soderini, Federigo Frizzi, the Duke of Suessa, Bartolommeo Barbazza, Orlando Dei, the Cardinal Cybo, and others?[92]

Growing old seemed sometimes to Michelangelo a betrayal of the man and the artist. He cried, "Alas! Alas! I am betrayed by the fleeting days and by the mirror which tells the truth!" (XLIX). He further resented old age because of his personal conviction that the longer he lived, the less would be his chance of receiving grace, a belief clearly stated in his poetry (CIX, 32):

> Dunche a men gratia chi piu qua soggiorna;
> Che chi men uiue piu lieue al ciel torna.

To what extent and in what ways did senescence affect Michelangelo's production? Vasari records that Michelangelo complained of the demands of painting at the age of sixty-five and that his last paintings were done at that age.[93] An exception should have been made for the Pauline Chapel. The biographer alleges that in his old age Buonarroti could no longer design or draw clear (nette) lines.[94] Yet the Giudizio (1536–1541), the frescoes of the Cappella Paolina (1542–1549), and the Deposizione (1553–1555) are products of Michelangelo's later period. About the time he became architect-in-chief of St. Peter's (1547) his attention turned largely to building and he devoted his time to the Palazzo Farnese (1546), the Capitoline piazzale (1549), the dome of St. Peter's (1557), the Church of San Giovanni dei Fiorentini (1559–1560), the Porta Pia (1561), and the design of Santa Maria degli Angeli (1563). It is almost true that "after the execution of (the Deposizione) the sculptor-painter became architect and poet and laid aside brush and chisel forever."[95] Yet, six days before his death poor Michelangelo spent the entire day working on the Rondanini Pietà. The exception does not disprove the rule, and it seems that Vasari was right, that Michelangelo did not feel sculpture to be an old man's art. The very uncertainty of the execution of this Pietà and the Palestrina Pietà, even granting their incompletion, would support this acknowledgement. Finally, old age reduced Michelangelo's efficiency even as architect. About 1557 he confesses to Vasari that ad-

vanced age prevents him from supervising his workers closely enough to prevent costly mistakes. Furthermore, they contrive to prolong their jobs until he is ready to die of "shame and sadness."[96]

The birth and death of his nephew's babies set him to thinking on death and led him to unusual comments. In a brief consolation piece (Letter CCLXXV) to Lionardo on the death of the infant Michelagniolo, the artist states his bereavement and then adds: "one must bear this patiently and realise that it was better than if he had died during his old age." This curious statement of March, 1555, is explained by Michelangelo's conviction late in life that the longer one lives the more difficult it is to attain salvation. Baby Michelagniolo has died securely in a state of grace, and old Michelangelo envies him. This conviction, which was, as the poems attest, a source of anguish to the artist as his life span increased, explains also his letter (CDLXXII) to Vasari. Giorgio had written to inform him of the birth of Lionardo's son Buonarroto (1554). Michelangelo acknowledges the pleasure he has received at the news, but objects that his nephew is celebrating excessively a newborn child, "with that gayety which is to be reserved for the death of those who have lived well."

The pathos of Michelangelo's diminishing forces makes for the strength of Longfellow's drama on this artist. In a moving scene Vittoria Colonna reminds the artist that when Sophocles' sons accused him of dotage before the Areopagus, the playwright read to the judges his *Oedipus Coloneus*, conceived in his extreme old age.

Without ever mentioning the syphilis with which modern scholarship has afflicted him,[97] Michelangelo asserted that several specific maladies curbed his genius just as much as old age itself, further subjectivising his thoughts on art. Sometimes he complained of illness and senescence in the same breath. A letter to Lionardo, posted in Rome in March, 1544, explains that he must reject a commission because of old age and an inability to "see light": " . . . come è vero che io non posso per le noie che ò, ma più per la vechiezza, perchè non veggo lume."[98] In this letter he reflects that he should be purchasing a retreat in Florence where he might yet enjoy the fruits of his labors in his old age, for he may keep the house

provided by the Holy Father only so long as he serves that pontiff. In 1546 he states flatly, "I can no longer work" (Letter CLXII). In a later letter (1558–1559) to Bartolommeo Ammannati he again mentions old age and failing vision, but admits to two additional afflictions of age: "I remain entirely yours, old, blind, deaf, and scarcely in control of my hands and my person."[99] As early as 1518 he complained of his hearing, for in March of that year he divulged to Domenico Buoninsegni that a harness bell (*sonaglio*) in his ear prevented him from thinking straight.

That his eye troubles came at an early date is indicated by the fact that probably in the 1520's he copied (Codex Vaticanus 3211) an Italian adaptation of Petrus Hispanus' treatise on eye diseases.[100] Whether Michelangelo or another was the translator is not certain, but the handwriting is established as his.

Someone has recently brought out a study on tuberculosis and genius to support further the old school of thought which holds that ill-health fosters creativeness. One can safely assert that Michelangelo himself was not of this persuasion, any more than Da Vinci, one of whose counsels was "Strive to preserve your health, and in this you will the better succeed as you keep clear of physicians."[101] By Michelangelo's own testimony, his maladies reduce and imperil his productivity. Before proceeding to his complaints about dysuria ("the stone") and other specific maladies, one may extract from the *Lettere* several jeremiads concerning his general physical debility. In a brief to Bartolommeo Angiolini in Rome, he states (again referring to his old age in July, 1523) that he is "mal disposto" ("in bad shape") and that for every day he works he must rest four.[102] To the same correspondent he writes several years later, "My dear Bartolommeo, although it may appear that I am jesting, know that I am saying in all good sense that since I have been here I am aged by twenty years and diminished by twenty pounds."[103] At another time he wrote that if he were obliged to leave the conveniences of the capital his fragile health would not stand up for three days more.[104]

Michelangelo's concerns over art indisputably affected his state of health. Paolo Mini wrote to Bartolommeo Valori that Michelangelo was suffering from two maladies, one of the heart and one of the head, the first ailment resulting from the unsettled wrangle over the Tomb of

Julius II.[105] Another impairment to his health arose directly out of his art: Condivi alleged that Michelangelo's early anatomical dissections affected his stomach and ruined his digestion.

Considering the general debility already mentioned, it sounds typical when Michelangelo affirms that even the discussion of painting demands more strength than he has left: He has released his innamorata, painting, and turned her over to Francisco de Hollanda, "for I do not find myself in possession of the energies which such loves require."[106]

Michelangelo is reported to have suffered from rheumatism, headache, giddiness (Paolo Mini), and cramps (*granchio*: Condivi). To this clinical anatomy his letters add a painful gout in his leg (CCLXXX), an arthritic back which prevents him from ascending stairs (CCCIV), and colic pains (CCCXXXV). With this propensity for illness, he was fortunate to escape the plague in Bologna (Letter CXXIV). The chief malady to plague his later years was the painful dysuria, or calculus. He wrote to Lionardo Buonarroti that this disease had crept upon him over the years and that at length he found relief in the mineral waters of Viterbo. As Masoliver and others have observed, it is a curious irony that a man who spent his life among stones should be afflicted with the "sickness of the stone," as it was called. Finally, the seriousness of his stone caused him to make out his will and modify the mode of living to which his art had adapted him. If his dysuria put him in a bad humor, as he admits, and this affected his disposition to work, at least the ailment furnished him with a pretext to eschew social and professional engagements which impeded his work. Thus, he is able to write to Pope Paul III, "And if I don't show myself more before your Holiness, the cause of this is my illness, since every time I have gone out I have had a relapse."[107]

A fragment invariably included with the complete verse of Michelangelo refers to the artist's ailments:

> *Febbre, fianchi dolor', morbi ochi e denti.*[108]
> Fever, pains in my sides, diseased eyes and teeth.

It is quite possible that this line was originally intended to fit into a longer piece, one enumerating all the various complaints mentioned in the correspondence, along with some additional afflictions. Although Michel-

angelo as a poet was scarcely "tagliato al bernesco," as the expression
goes, this longer poem is certainly Bernesque. It was found among the
papers of Luigi del Riccio and bore corrections by Donato Giannotti. The
poet coarsely enumerates the physical disabilities which are the harvest
of the fine arts:

> I' sto rinchiuso come la midolla
> Da la suo scorza, qua pouer' et solo,
> Come spirto legat' in un' ampolla.
> Et la mia scura tomba et (è?) picciol uolo,
> Dou' è Aragn' e mill' opre et lauoranti
> Et fan di lor filando fusaiuolo.
> D' intorn a l'uscio ho mete di giganti,
> Che chi mang' uu' o ha presa medicina
> Non uann' altrou' à cacar tutti quanti. [109]

Here am I poor and alone, enclosed like the pith in its rind,
or like a spirit enclosed in a decanter; and my dark tomb
affords little flight; where Arachne and a thousand spiders
labor, and in spinning make of themselves spindle-racks. About
the exit are dung-heaps of giants, as though all those who have
eaten grapes or taken physic do not go elsewhere to stool.

The poem runs along in this disjointed and crude manner. "I have learned
to know urine and the tube whence it issues through the perineum which
summons me before the morning sun. Cats, carrion, beetles, or cess—he
who comes to change me never fails to encounter them heaped up by the
housekeeper. My soul has this advantage over the body, that through age
it has no sense of smell; that if it afforded access to odor, bread and
cheese would no longer hold the soul united to the body. Coughs and cold
do not let the soul die; if it cannot issue forth from the exit below, it can
scarce issue forth with the breath from the mouth. My loins are strained;
I'm out of breath; I'm fractured and broken by my labors, and the hostel
where I live and eat on credit is death."

At this point the tone of this piece in tercet rhyme becomes more
elevated, and the reader will agree that it is high time. Michelangelo now
develops the thought that since, after all, an artist chooses his own pro-
fession, he finds comfort in the very discomforts of his craft:

> La mia allegrez' è la maninconia,
> E 'l mio riposo son questi disagi;
> Che chi cerca il malanno, Dio gliel dia.

· *363*

Chi mi uedess' à la festa de' Magi,
Sarebbe buono, et piu se la mia casa
Vedessi qua fra sì ricchi palagi.

My joy is melancholy, and my repose is made up of these
discomforts, for he who seeks after calamity, God will give it to
him. Anyone who might see me out celebrating the Day of the
Magi would be really seeing something, or even more if he saw
my house here among such rich palaces.

Then, for a single line, his mind turns wistfully back to the past. The con-
trast with the present becomes more keenly felt, while the portrait of his
broken body and dilapidated appearance becomes all the more extrav-
agant. "No flame of love has remained within my heart, for the greater
pain always expels the lesser, and the wings of my soul have been clipped
and shorn. I have a voice like a hornet in an oil jar, coming from a leath-
ern sack with a halter of bones; and I have three pebbles of pitch in a
tube [the *mal della pietra*]. My eyes are purplish, spotted, and dark. My
teeth are like the keys of an instrument, for according to their movement,
the voice sounds or is silent. My face has a shape which strikes terror. My
clothes are such as to chase crows to the wind, away from the dry seeds,
without the aid of other weapon. A spiderweb lies hidden in my one ear,
while a cricket chirps in the other all night long. Because of my catarrh-
ous breathing, I can neither sleep nor snore."

All of his scrawlings have come to naught, have proved nothing more
than childish pranks (an admission made in the correspondence as well),
and his beloved fine arts have reduced him to a servile old age. "Love,
the Muses, and the flowery grottoes—my scribblings on these subjects and
my crude drawings have been put to use by innkeepers for wrapping, for
privies, and for brothels. [Is Michelangelo momentarily recalling Are-
tino's vicious slur?] What does it avail me to try to create such childish
things (*bambocci*), if they have merely brought me to this pass, like a
man who has crossed over the sea and then drowned in the slime of the
shore? Precious art, in which for a while I enjoyed such renown, has
brought me to this—poor, old, and a slave in the power of others. I am
undone if I do not soon die." The general condemnation of the fine arts
in these last four verses may surprise the reader, even in this seriocomic

text. Yet it is by no means unique in Michelangelo's writings, as we shall observe later in this chapter.

Michelangelo once burst out: "Every day I am lapidated, as if I had crucified Christ!"[110] If the stinginess of patrons was a specific cause of many of his hardships, the patronage system could be ruthless to artists in an over-all way. Compare Da Vinci's blunt "Li Medici me creorono e distrussono" ("The Medici created me and destroyed me").[111] Two categories of headache imputable to patrons receive much attention in Michelangelo's writings. There are, first, the constant pressure and deprivation of liberty which result from the ignorance and misunderstanding displayed by patrons. Then there are the humiliations inflicted consciously or unconsciously by employers. In Michelangelo's case "patron" is often synonymous with "pope." In a letter (CXCIX) Michelangelo admits having served several popes but stresses that this has been a matter of necessity ("che è stato forza"); sometimes they were like Medusas, turning him powerless into stone.

While a certain amount of pressure may incite a Mozart to compose a *Don Giovanni* or a Balzac to write most of the *Comédie humaine*, it seems permissible to conclude that time pressures or social exhortations hindered rather than abetted the total production of Buonarroti. At one moment (1522), for example, the following prospective patrons in addition to the Pope were clamoring for him to undertake commissions: Duke Francesco Maria della Rovere, Cardinal Giulio de' Medici, Cardinal Grimani, the Board of Public Works of San Petronio in Bologna, the Senate of Genoa, and others. The Marchese di Mantova suggested that the busy artist do something for him by fitting it into holidays.[112] Condivi speaks with shared pride of "the contention which the world's princes have engaged in to get him." These princes were the seven great popes from Julius II to Pius IV, Francis I, Charles V, and Bayazid the Turk. It was the pontiffs who were the most contentious, not merely for their own glory or that of the Church but also for that of their families: the Medici, Farnese, Della Rovere, and Del Monte. Not only did each wish to exalt his own house, but sometimes crushed projects which might glorify

· *365*

another. The manner in which these influential men goaded the artist was varied. On 21 November, 1531, the Pope issued a brief in which, under penalty of excommunication, he ordered Michelangelo to devote his time exclusively to the Sacristy of San Lorenzo. Duke Alfonso of Ferrara, when Michelangelo was visiting that city, announced in grim jest, "Michelangelo, you are my prisoner. If you wish me to release you, I want you to promise to do something of your hand for me, whatever occurs to you: in whichever medium you like, sculpture or painting."[113] An actual threat or not, this was under the circumstances a strong pressure. Vasari notes that when popes ran out of persuasive arguments they would resort to outright demands.[114] Pius IV used a more hectic and effective technique. When Buonarroti was in his eighties and his services were solicited vigorously by Catherine de Médicis and by Duke Cosimo, each stirring old loyalties to the Medici, this Pope piled upon the aged artist all manner of commissions: tombs, bridges, gates, and so on. All that one can say of these demanding pontiffs, Julius II and Pius IV, is that they understood and appreciated Michelangelo as a Leo X never could. A more ingenious type of pressure was exerted by Francis I and Bayazid, and one difficult to resist. These monarchs deposited moneys in Michelangelo's name in selected banks before inviting him to accept a commission.

Various pressures were applied to the artist by others than patrons. Michelangelo claimed that he ruined the *Deposizione* because his assistant Urbino nagged at him to finish it. Many of the pressures from potential outside employers came at a moment when Michelangelo had just grievances against his current patron, thus making their overtures increasingly difficult to refuse. Refusals required tact. Even as early as 1497 (Letter I) the young artist realised that "you have to go slow with these bigwigs." This blunt artist became with time more effective in talking or writing his way out of these extra chores. Vittoria Colonna praised him for knowing how to extricate himself from painting for all those princes who requested it of him.[115] His letter turning down the King of France is a good blend of tact and resolution.[116] Michelangelo seasoned with promises his recital of failing health. Tactful was his sonnet to Gandolfo Porrino, who had requested a portrait of La Mancina (Faustina Mancini); Michelangelo insisted that only God could do justice to her beauty ("E

quel solo, e non io, far la potea") (cix, 68). He turned down Del Riccio's request that he execute the sepulchral bust of Cecchino Bracci even though he consented to write those fifty poems on the boy's death. The riposte to Aretino, taken out of its historical context, might appear equally gracious, but actually represents Michelangelo's ability to reject a commission pointedly and even ironically. But there were recidivisms. In 1547 Michelangelo turned down a pope's (Paul III) request in a few blunt words.[117]

Pressures came from groups as well as individuals. As Schiller observed, the artist is the child of his time, but woe to him if he is its favorite. Sebastiano had this in mind when he wrote to Michelangelo: "Nothing hurts you except yourself, that is, the great credit you enjoy and the greatness of your works."[118] Michelangelo writes of his work at St. Peter's, "In this I am entreated by all Rome as well as Cardinal de' Carpi."[119] The year after completion of the Sistine Vault he is "solicited so much that I can't find time to eat" (Letter XCII). In 1559 he wrote to his nephew that all the Florentines in Rome were unanimously applying pressure on him to do their church for them: "tutti d'accordo m'ànno fatto e fanno forza ch'io ci attenda."[120]

The greatest and longest pressure was exerted in connection with the Tomb of Julius II. It was Condivi who gave this extended commission the now-familiar title, the Tragedy of the Tomb;[121] Fattucci regretted "this blessed sepulcher," and Giovanbattista di Paolo Mini recorded that it became a curse (maledizione) for the artist. The first indication of trouble came when the Pope was incited to abandon the project by a warning that it would shorten his life. Julius or members of his family exerted pressures for thirty-seven years to see the monument executed, even threatening lawsuits. Condivi records that Michelangelo wept when Pope Leo made him abandon the Tomb. The long story is too well known to be retold here. Buonarroti sighed over this broken dream, "I find myself having wasted my entire youth tied to this sepulcher."[122] Did he come at length to identify himself with its Prigioni? It is certainly possible.

It is interesting to observe that even as a poet Michelangelo underwent these pressures. When Cecchino Bracci died, Luigi del Riccio plagued Michelangelo with requests for commemorative poems, even sending him as incentives gifts of trout, fennel, mushrooms, melons, wine, fig-

bread, and truffles to keep the poems coming. Admitting that these delicacies "sforzerebbero il cielo," Michelangelo finally objects that his inspiration is drying up under the pressure ("La fonte è secca ... e voi avete troppa fretta") (LXXIII, 33).

His fundamental misgiving about his profession, then, was that the vast majority of Renaissance artists had to live in economic or social dependency, even though his known remarks are limited to his own experience. The profession of art seemed to involve a lack of personal and spiritual freedom. From the beginning of his career he was in others' hands. In fact, even before his career started, his father and uncles whipped him for his interest in art (Condivi). Lorenzo asked his father for him, much as Cimabue had asked Giotto's father for the boy Giotto. Michelangelo was "emancipated" by his father only at the age of thirty-three. In any case, Michelangelo was born at the tail end of a period when painters and sculptors had been on a social par with apothecaries, goldsmiths, and shopkeepers, to whose guilds they had belonged. It is to Michelangelo's tremendous credit that by his intransigent self-consciousness as artist he did much to raise the social status and personal dignity of the artist. De Sanctis has written, perhaps optimistically, "The habit of freedom kept firm the temper of the soul, and made possible Savonarola, Capponi, Michelangelo, and Ferruccio." De Sanctis might also have mentioned Leonardo, whose love of freedom (and, incidentally, flight) was so intense that he bought captive birds from the hawkers in the streets of Florence for the pleasure of opening their cages and setting them free.

The feeling that he was more slave than artist was ever-present. In a letter to Bishop Minerbetti (26 October, 1553) Michelangelo complained, "Those who start early to be asses of princes have their burden prepared for them until after death."[123] To Vasari (Letter CDLXXXII) he wrote that Paul III forced him "against his will" to work for ten years in St. Peter's. In Rome he is still working under the "express command" of Duke Cosimo (Letter CDLXXXIII). What bitterness lies behind the lines he penned:

> Con tanta seruitù, e con tedio
> E con falsi concecti e gran periglio
> Dell'alma, a scolpir qui cose diuine.[124]

368 ·

With such servitude, with such tedium,
With false conceits and at great peril
To my soul, sculpturing here things divine.

Pouero uecchio et seru' in forz' altrui [125]

Poor, old, and a slave in another's power.

In letters to Michelangelo, Sebastiano del Piombo agreed that his idol was a *stiavo* (slave) and referred to his *servitù*. Many are Michelangelo's poems in which he describes himself as a slave: to Julius II (III), to sin (XXV), and, of course, to love (XI, XXXVI, XXXVIII).

Taking a historical view, Charles Dejob admits that there was a tight artistic control on the part of the Church during most of Michelangelo's lifetime and that this impetus finally brought about the Counter Reformation. "This suspicious surveillance . . . explains why the Church States produced fewer artists and especially writers than did many other parts of Italy, and why the few writers of value they did furnish show more aversion than sympathy for the spirit of their government."[126] Uneasy under this surveillance, Buonarroti on several occasions told off his employers. Of the Pope and Cardinal commissioning him to do the Façade of San Lorenzo he insisted, "They must commission me by a definite contract and confidently leave everything entirely in my hands."[127] There were the sharp words directed at Clement VII when the latter had not "left in his hands" the charge of acquiring marbles for the Sepulcher of San Lorenzo. "Having no authority in the matter, I feel no guilt about it. And I beg to remind your Holiness that if you wish me to do anything, you must put no one over my head, and you must trust me and give me full charge."[128] The Sangallo "sect" got the Pope to call a meeting during which they might accuse the elderly Michelangelo of not informing them in advance of his plans for St. Peter's. Buonarroti's reply to his accuser, Marcello Cervini (later Marcellus II), was bitter: "I am not obliged to tell you, nor even less do I wish to, either to your Lordship or to anyone, what I must and what I intend to do. It is your business to keep the money coming and keep it out of the hands of thieves. As for the planning of the

building, leave that to me."[129] When the recipient of this outburst shortly was elected Pope, Buonarroti knew that he was worse than a slave and made plans to flee Rome. Fortunately, Marcellus II did not live long enough to exact a vengeance, had he been so inclined.

If the popes were capable of sudden outbursts of generosity and warmth, as when in Bologna Julius II reprimanded the bishop who unintentionally slurred Michelangelo, these sudden *élans* did not really improve matters, for they merely meant that the artist never knew what to expect. How much better was the consistent attitude of a Henry VIII, replying to the accusers and detractors of Holbein, "I tell you, of seven peasants I can make as many lords, but of seven lords I could not make one Holbein."

This passion for artistic and personal freedom may well have been a reason why Michelangelo resisted Pope Clement's suggestion that he remain a bachelor and take minor orders. He remained celibate, all right, but the acceptance of Clement's proposal would have placed him hierarchically under the authority of the Pope. He did, however, enroll in the Company of San Giovanni Decollato.

Some scholars tend to minimise this artistic bondage, at least where invention is concerned. De Tolnay is of the opinion that Michelangelo was always allowed great freedom in the "formal and iconographic conceptions" of his productions. Contrary to Wind, he believes that the patrons established only a few general lines of the work, imposing no detailed program. He recalls a passage from Michelangelo's letter to Fattucci in which the artist complained of the inadequacy of the projected design for the Sistine Chapel, only to be told by the pontiff "that I do whatever I wanted and whatever would satisfy me."[130] In connection with the Medici Chapel, De Tolnay adduces a letter by Domenico Buoninsegni to Michelangelo stating that Cardinal Giulio de' Medici, who suggested wall tombs rather than free-standing tombs, "says he knows that you understand this matter better than he and refers it to you."[131] Another similar letter quotes this cardinal as assuring Michelangelo that he need not follow the model made by Baccio d'Agnolo. He is advised, "In everything follow your own fancy." Finally, De Tolnay reproduces part of Gabriello Pachagli's plea that Michelangelo do something for Francis I: "Je n'ai pas de conseils

à vous donner, car vous êtes sage et prudent et saurez prendre le meilleur parti." One might also mention the assurance in Giovanni Gaddi's letter to Michelangelo (3 January, 1532) that the Pope is disposed to "carry out every intent of yours"; still in the same breath he adds that the Pope requires the artist's immediate presence.

Nevertheless, generalisations break down. From the outset of his career patrons proved meddlesome, justifiably or not—from those first days when Julius II found the incompleted Sistine Ceiling too poor and subdued. Perhaps the most intrusive was Clement VII, who not only wanted a share in the planning of the tombs and decoration of the Sacristy of San Lorenzo, but wished Michelangelo to execute the whole according to his (Clement's) ideas. Michelangelo evidently did not welcome even the slightest suggestion from patrons, least of all popes and cardinals, even though such practice was in line with the principle established by the Council of Trent. In Carlo Borromeo's *Instructiones* one reads that painters must depend upon priestly counsel. Despite Michelangelo's attitude, Wind believes that he did lean on the counsel and theological knowledge of his Dominican friend Sante Pagnini in painting the Sistine Ceiling.[132] If so, it is still another doctrinary resemblance to Vasari, who relied on the counsels of Vincenzo Borghini. It seems, from a reading of Michelangelo's own writing, that the continuous complaints about interference far more than overbalance those passages where patrons, aware of their own inadequacies or indulgent by nature, left the artist a free hand. The interference of minor clerics and intermediaries annoyed him to the point of his becoming artistically anticlerical. He could feel that these frocked antagonists were the most ignorant of all people and must have relished the current anecdote (related by Da Vinci among others) about the priest who sprinkled holy water over the works of a painter, who then angrily doused the man of God with a bucket of water.

An artist's hands are tied without freedom of mind, for, as we demonstrated in Chapter I, the mind represents nature and the hand represents art, the two interacting agencies of creation. "Your Lordship sends word to me that I should paint and not have doubts about anything. I reply that one paints with the brain and not just with the hands. And he who cannot have his brain about him does himself an injustice [*si vitu-*

pera]."[133] Later in this letter Michelangelo admits that he will do a com-
mission unwillingly, that "I shall paint discontented [*malcontento*] and
shall create discontented things." He was especially angry with those popes
whose personal caprice or trumped-up reasoning removed him from an
interesting commission to saddle him with a different one. Pope Leo dis-
patched him from Rome to Florence as though he were moving a pawn
and similarly Pope Julius switched the artist from sculpture to painting.
Vasari recalls Michelangelo's resentment at a certain patron who had a
brain like the weathervane on a bell tower, veering with each wind.[134]
(The bell tower is still a motiv of irony with Buonarroti.)

A final expression of his conviction that an artist can create master-
pieces only with a free mind is contained in a letter to Fattucci:

*e non m'ànno lasciato far cosa ch'io voglio, già più mesi sono che e' non si può
lavorare con le mani una cosa e col ciervello una altra, e massimo di marmo. Qua
si dice che son fatti per ispronarmi; e io vi dico che e' son cattivi sproni quelli che
fanno tornare adietro.[135]*

and they haven't let me do anything I want for several months now, for one cannot
work on one thing with the hands and on another with the brain, and especially
when one deals in marble. Here people are saying that these things are done to
spur me on; I tell you that those are poor spurs which make one turn backward.

Here is Michelangelo's definitive judgement on Longinus' idea that genius
benefits by the curb and the spur. Too often the spur is merely the curb
in disguise. Michelangelo would have little sympathy with a recent state-
ment that his bondage to these patrons, like Haydn's service to Prince
Esterházy, actually served as spur. "Often, indeed, the reciprocal arrange-
ments of patron and artist result less to their mutual advantage than to
the spirit of mankind."[136]

Michelangelo apparently resisted successfully one specific type of
pressure: the contemporary passion for portraits. If any patron ever at-
tempted to get Michelangelo to include his physiognomy among the faces
on a fresco, as the Estensi and Tornabuoni were wont to appear as shep-
herds in the Biblical scenes of lesser painters, Michelangelo remained
stonily obdurate, for reasons we have developed in Chapter III.

Sometimes pressures aroused him to epigrammatic rejoinders. When

Aretino presumed to suggest a Venetian manner for the *Giudizio*, Michelangelo replied that it was too late to accept Pietro's *immaginazione*, but that Aretino must have witnessed the Last Judgement in person, so detailed was his description.

Through ignorance or misunderstanding, even well-wishing patrons caused Michelangelo anguish. They urged him to paint on walls before the plaster dried. They coaxed him to exhibit his works before completion, as Julius II prematurely opened up the Sistine Chapel for the Mass of the Assumption in 1511. They came to make gratuitous comments over his shoulder while he was busily engaged.[137] They tried to make him play the role of sycophant and courtier-in-waiting. Michelangelo as *mignon*! They could give him such a vain commission as sculpturing a snowman, just as they required able court poets to pen occasional or seasonal rhymes. Worst of all, they could neglect his talents and give him no commission whatever, a charge (recently questioned) which Condivi leveled at Michelangelo's first employer in Rome, the Cardinal di San Giorgio.

Public humiliation constituted the final type of difficulty directly attributable to the patron. Such indignities came particularly hard to a Renaissance artist who tacitly espoused a Pindaric ideal of glory. Tradition has it that Soderini's insulting payment to Da Vinci in bags of small change was the last straw which drove that genius from Florence. Michelangelo was subjected to more than his share of humiliation. Condivi relates how Julius II, impatient because Michelangelo could not set a date for the completion of a commission, struck the artist "incontinently" with his cane.[138] The various threats or plans to have certain nudes of the *Giudizio* draped or fronded were a source of humiliation; the most important retouches were decreed just before Michelangelo died. Fortunately, he never knew how Vanvitelli was going to remodel completely his church, Santa Maria degli Angeli. An infuriating type of humiliation was the melting down of the bronze *Giulio II* and the recasting of it into a cannon. There was the incredible moment when Julius ordered a groom to eject Michelangelo bodily from his quarters. When this rupture was repaired, it was Michelangelo who had to make the overtures (a cord about his neck, as he expressed it) when all Rome and Florence were wondering which temperament would be the first to give in. Michelangelo was obliged

to travel to Bologna and seek for a reconciliation while Julius regarded his kneeling figure from a dining table. This was, indeed, his Canossa. This was the moment when Michelangelo had most difficulty in living up to the fine sentiments he framed in one of his poems (CIX, 64):

> *Un generoso, alter' e nobil core*
> *Perdon' et porta a chi l'offend' amore.*

> *A generous lofty and noble heart*
> *Pardons and bears love to him who offends it.*

Then there was the irritating period when Michelangelo, having rejected the inferior marbles of Pietrasanta and contracted for stone from Carrara, was ordered by Pope Leo to cancel the contract with Carrara, since Jacopo Salviati deemed satisfactory the marble of Pietrasanta. This whole episode caused Michelangelo to burst out in a curious paraphrase of Petrarch's famous sonnet XXXIX: "Cursed a thousand times the day and the hour that I left Carrara!" (Letter CXVI). The same pope (requiring him to forget about the Tomb of Julius II) ordered Michelangelo to turn his efforts to a façade for San Lorenzo in Florence, even if another architect's design should be preferred to his. Is it any wonder that whenever a new pope was heralded by the wisp of smoke over the Vatican Buonarroti shuddered a bit, wondering what new mortifications were in store and preparing to abandon his work at hand to start afresh for the new pontiff? Is it any wonder that he confessed to Vasari that he had worked in St. Peter's "con grandissimo mio danno e dispiacere" ("to my great harm and displeasure")?[139] Or, to quote again from his poem, "to the great peril of my soul"?

Michelangelo could not leave the bondage of art under any circumstances. The ecclesiastical offers which he turned down would have brought him an easier way of life. But liberty would be a questionable goal if it drew him away from his real love. Was he thinking of himself when he wrote the following lines (CXIII)?

> *Quand'il seruo il signior d'aspra catena*
> *Senz' altra speme in carcer tien legato,*
> *Volge in tal uso el suo misero stato,*
> *Che libertà domanderebbe appena.*

When a master holds a slave in prison, bound with a harsh chain,
without any hope, the slave in his miserable state gets used to
such condition so that he would scarce wish to become free
again.

Thus Michelangelo, like his *Prigioni,* displays shame, but not revolt.

In the preceding pages we have examined technical difficulties which
colored Michelangelo's feelings about art. More and more they crossed
over into the domain of personal difficulties. These technical difficulties
were not unusual crosses to bear, for they could and did weigh upon other
Renaissance artists. They were the tribulations of genius to which any
sensitive artist could be subjected if poor in health and dependent upon
the whims and subsidies of patrons. If one lists the difficulties of which
Cellini complains in his memoirs one finds that they correspond more or
less with those mentioned heretofore in this chapter.

There is, however, another category of tribulations more peculiar to
Michelangelo. These difficulties resulted from what one might call, for
want of a better term, a minor persecution complex. We shun the word
"paranoia," with its unpleasant and clinical connotations. At least two
professional psychologists, Lange-Eichbaum and Kretschmer, agree that
Michelangelo was, like Byron and Tasso, "at least psychopathic."[140] "In
Michelangelo, and still more clearly in his father, there are fits of perse-
cution-mania, which at any rate are closely related to the schizophrenic
type."[141] In his *Michelangelo, A Study in the Nature of Art,* (1955)
Adrian Stokes interprets Michelangelo's art as stemming from "a super-
human effort to repair his tormented psyche." We have been aware all
along that there was a touch of hypersensitivity and irrationality in Mi-
chelangelo. These sometimes protect an artist from slipping into an un-
creative conventionality. However, Kretschmer held that in Michelangelo's
case the psychopathic component had also detrimental effects.

One need not be a psychiatrist to discern in Michelangelo's life and
letters three types of evidence revealing tendencies toward irrationality.
These might be stated:

1. References to enemies and personal danger

2. Proclivity to flight

3. Sensitivity to rumors and slander, real or imagined.

First, the references to enemies. He sensed these all about him, like the monsters surrounding his St. Anthony or the Centaurs closing in on his Hercules. The more difficult the temperament of the artist the more numerous will be his rivals and enemies. In his *Idea del tempio della Pittura* Lomazzo characterises the enemies of Michelangelo as "petulanti, ansiosi, tediosi, melancolici, tristi, ostinati, rigidi, disperati, bugiardi, invidiosi, & simili."[142] From Buonarroti's first arrival in Bologna, he was viewed as a dangerous rival, and Condivi reports that one sculptor threatened him with bodily violence.[143] A clause in the contract for the Piccolomini Altar in Siena provided that as soon as Michelangelo completed each statue it would be removed to a place of greater security in Florence "so that rival and malevolent hands might not spoil and break them."[144] In March, 1524, Leonardo Sellaio cautions Michelangelo from Rome that the latter has many enemies who say all they can against him: "Chonpare, io ui richordo che uoi auete assai nimici, che dichono quanto possono."[145] Bramante's enmity has been mentioned in Chapter IV. Michelangelo wrote: "All the discords which arose between Pope Julius and me were due to the envy of Bramante and Raffaello da Urbino: and this was the reason he did not carry out his sepulcher in his lifetime, to ruin me." Yet Condivi (xxv) claimed that Bramante endeavored to have Michelangelo removed from Rome during his early residence there and was successful in having the Tomb of Julius II halted. As a parallel Nanni di Baccio Bigio persisted later in trying to have Michelangelo removed as chief architect of St. Peter's. As proof of his calumny, Nanni was eventually dismissed. Probably Michelangelo was, as civilian and military architect, in his greatest personal peril when Florence fell after Malatesta Baglioni's treachery. The Medici troops ransacked his home and sought him in vain throughout Florence while he hid in the bell tower of San Niccolò oltr' Arno.

Suspicion of such enemies caused Michelangelo to become skittish and ready to bolt from trouble. As he penned in a poem (CIX, 98): "Che 'l ueder raro è prossimo al' oblio," a variant of our "out of sight, out of

mind." He was subject to moral crises and delusions of persecution. Fear
for his life stands out in a letter (1506) explaining to Giuliano da San-
gallo why he had fled Rome: "But this alone was not the only reason for
my departure; it was rather something else, which I don't wish to write;
suffice it to say that it made me think that if I stayed in Rome, my own
sepulcher would be made before that of the Pope."[146] One remembers
that Baldassare Peruzzi was apparently poisoned by a jealous confrere
before he could execute his magnificent plan of St. Peter's and that Cesare
da Castel Durante was killed with three knife wounds right in St. Peter's
not long after Michelangelo turned over to him the administration of the
Vatican fabric. Recalling the very real dangers Cellini incurred, Symonds
suggests that Bramante might have been so treacherous as to justify
Michelangelo's apprehensions. At the risk of subjectivising history, we
suggest that concern for his personal safety was the real reason which
caused Michelangelo to tear down Bramante's scaffold in the Sistine
Chapel. Bramante's platform had been suspended from ropes through
holes in the lofty ceiling, a very hazardous arrangement to be accepted
complacently by a man with admitted enemies. Michelangelo prudently
rebuilt the scaffold from the ground up, offering the very plausible ex-
planation that perforations in the ceiling would disrupt and punctuate
the painting. The man who made this new scaffold was Piero Rosselli,
who on 6 May, 1506, wrote to Michelangelo that he, Piero, in the pres-
ence of the Pope upbraided Bramante for the latter's intriguing against
Buonarroti.

The most famous flight of Michelangelo was the hegira to Venice
when his native city was threatened by the Spaniards in 1529. By his
own testimony, it was not fear of the common foe that caused this im-
pulsive action but rather apprehension over his personal enemies within
the city. In a letter to Giovan Battista della Palla, artistic adviser to
Francis I, Michelangelo tells a curious story of being warned by an anon-
ymous stranger: "But Tuesday morning, the twenty-first day of Sep-
tember, a man came forth from the gate at San Niccolò, where I was at
the bastions, and whispered in my ear that there was no staying any
longer if I wished to save my life; he came home with me and dined
there and brought me mounts, never leaving my side until he got me out

· *377*

of Florence, showing me that it was for my own welfare. What he was, God or the devil, I do not know!"[147] Whether this agent was God, the devil, or Michelangelo's friend Rinaldo Corsini, it is reported that Malatesta Baglioni was plotting to kill the artist. A later version of this flight in Condivi attributes it to his hearing traitorous mutterings among the soldiery.

It was a curious vision which prompted Michelangelo to flee from Florence to Bologna in 1494, although no reason involving the fine arts apparently came into play. An intimate of Piero de' Medici, one Andrea Cardiere, twice dreamed that Lorenzo de' Medici returned from the other world and bade him warn Piero that the latter would soon be expelled. When Cardiere warned the young Medici scion, the latter merely scoffed. But then, in Condivi's words, Cardiere, "having returned home and shared his sorrow with Michelangelo, so effectively spoke to him of the vision that Michelangelo accepted the thing as certain and two days later left Florence with two companions, fearing that if what Cardiere forecast should come true, one was not safe in Florence."[148] Many years later, in the autumn of 1556, the same skittishness overcame him and he hastened from Rome to Spoleto, fearing a second Sack of Rome from the forces of the Duke of Alva.

Not only did Michelangelo elect to flee civil disturbances, but he also advised this recourse to his family whenever the Tuscan city was threatened. In 1512, for example, he urged them to abandon their possessions and get out of town. Property can be replaced, whereas life cannot. He volunteered money to assist them. He further urged them not to get involved in local politics by either action or word. "Fate come si fa alla moria: siate e' primi a fugire" ("Do as people do during the plague: be the first to flee!").[149] Or, again, he cautions in a letter, "Have confidence in no one. Sleep with your eyes open." Just as his contemporary Tasso became known to his age as Omero Fuggiguerra, Michelangelo might well have been nicknamed Apelle Fuggiguerra.

Condivi, whose justifications of Michelangelo's fearfulness are a further evidence that he is often recording the artist's own words, stressed that Michelangelo was immune from Duke Alessandro in Florence only because of papal protection. "Considering the nature of the Duke, Michel-

angelo had a right to be afraid. And certainly he was aided by the Lord God, since he was not in Florence at Clement's death."[150]

Symonds, apparently in seriousness, attributes Michelangelo's unusually nervous temperament to a fatiguing journey on horseback made by the artist's mother when she was awaiting the accouchement.[151] He could have strengthened this fanciful thesis by adding that the mother fell from a horse during that pregnancy.

As one reads through Michelangelo's correspondence, the impression grows that Michelangelo lived in a world of wagging tongues, as malevolent as the Malebouches of medieval allegories. Sometimes these made it more difficult to ply his profession. Lomazzo spoke of Michelangelo's enemies, we remember, as "bugiardi" (liars). Sebastiano del Piombo called these many detractors the *cichale* (crickets). In another letter he calls them flies and, paraphrasing the proverb *Aquila non capit muscas*, bids Michelangelo pay no attention to trifling talk, "Le aquile non degna di mosce e basta" ("Eagles don't notice flies and that's that!").[152] Similarly, addressing a sonnet (CLII) to Christ, Michelangelo begs the Saviour to turn a deaf and chaste ear to talk of him. Some of the slanders and slurs were professional in nature; others were merely personal. It will obviously be difficult to maintain a clear distinction. One of the personal rumors to which Michelangelo was most thin-skinned reported that old Lodovico Buonarroti was a man of opulence and that his son stole from him, thus deserving punishment. Who purportedly initiated this rumor? Lodovico himself. Michelangelo accused him of spreading this vicious nonsense throughout Florence. Only the most bitter resentment or the grossest misunderstanding could have impelled him to write:

Saretene molto lodato! Gridate e dite di me quello che voi volete, ma non mi scrivete più, perchè voi non mi lasciate lavorare.[153]

You will be much praised for this! Shout and say what you like about me, but don't write me anymore, for you don't let me work.

He reminded his father acidly that the latter had received charity for twenty-five years, that the old man was near death, and that once dead

· *379*

he would be unable to repair the wrongs he had wrought. "Idio v'aiuti!" ("God help you!")

It is interesting to compare this filial tongue-lashing with his sermon to his brother Giovansimone, who had apparently "imperiled" the good name of Buonarroti-Simoni. Accusing him "Anzi se' una bestia" ("Thou art even a brute"), he admonished him to fall into line lest he ruin in an hour the family respectability which Michelangelo had sought for twelve years to establish. "By the body of Christ it shall not be so!"[154]

Somehow the most curious and incredible rumors could arise about Michelangelo. In 1508 the canard reached Florence that Michelangelo had died in Rome.[155] (This was the year of the peril of the Sistine scaffold.) In 1516 old Lodovico was spreading the report that Michelangelo had thrown him out into the street.[156] Lodovico's rumor about being robbed by his son dates from 1523.[157]

Michelangelo was especially sensitive to being branded a cheat, swindler, or usurer (ciurmatore, giuntatore, usuraio). In a long postscriptum to an unknown Monsignore (1542) he decries an allegation by Gianmaria da Modena that he lent 8,000 ducats of Pope Julius' moneys at usurious rates. Of course, usury was still a mortal sin and the stench of the usurer's circle in the Inferno was still pungent in the artist's nostrils. Michelangelo finds usury a fast-spreading big-city vice in his stanzas on rustic life. After explaining heatedly how false this charge was, he added firmly, "I never cheated anyone, and yet in defending myself from louts [tristi] it is necessary at times that I become crazy, as you see."[158] People who level such accusations are ignoranti. With what seems from this distance an almost unnecessary emphasis, he keeps on insisting that he is no "ladrone usuraio." In the Renaissance the 7 per cent interest which he collected on his loans was not considered usurious. Francis Bacon was shortly to propose 6 per cent for personal loans and 7 per cent for real estate loans. Even 20 per cent would not have been exorbitant. However, from the viewpoint of the Church any moneylending whatsoever was usury, as Benjamin Nelson shows in the first chapter of his Idea of Usury. Charges of usury were frequently coupled with charges of heresy and sodomy, which might further account for Michelangelo's violent reaction to these imputations.[159] Nor should one forget that up-

raised arm, sketched six times, which the Christus turned against the money-changers just as he raised it against the most depraved of sinners in the *Giudizio universale*. In a letter to Luigi del Riccio of approximately the same date as the postscript above he complains of not receiving moneys from the Pope and cries, "I don't want to remain any longer under this weight [*peso*] or be reviled as a cheat every day by him who has taken away my life and my honor."[160] These two lengthy letters bear many indications of his touchiness about possible slurs on his honesty. The words "cheat," "thief," and "usurer" recur with surprising frequency. In a letter to Giovanni Spina (1526) he mentions the slanderous canard that he, Michelangelo, is the fellow who "throws about the Pope's money."[161] This touchiness stayed with him until his death. In 1561 he writes his nephew to arrange to repay the heirs of Pius III a hundred ducats to honor an unfulfilled contract of 1504, when he had supplied only four of fifteen statues for the Piccolomini Altar.[162]

Although it does not treat directly of artistic matters, as do the quotations above, a letter to his nephew (1548) illustrates further the importance Michelangelo attached to wagging tongues. He thanks Lionardo for informing him of a decree prosecuting all those who have taken a stand against Cosimo de' Medici. The rumor that he had stayed in the household of the Strozzi (enemies of Duke Cosimo) is inexact, for he had been closeted in Luigi del Riccio's room. After Luigi died, it is explained, Michelangelo no longer frequented that house, but resumed his former solitary life. Now he no longer speaks with anyone, especially Florentines. If he is greeted in the street, he cannot avoid responding with civilities, but he passes straight ahead.[163] He adds cautiously that if he knew just who among those who speak to him were exiles he would by no means answer them. He will be doubly careful henceforth, especially since he has other concerns and life is wearisome enough. In the face of these damaging rumors about him, Michelangelo is trying to protect not only himself but also his nephew, since a law framed by Jacopo Polverini threatened not only exiles but heirs of the seditious as well. These concerns about the Medici were of long date. Thirty-six years earlier (1512), he had written his father just such a letter as he was now writing his nephew. In the 1512 letter he requested that his brother try "subtly

to find out where that fellow heard that I had spoken ill of the Medici, to see if I can track down the source of the rumor." Perhaps the rumor had originated with people feigning to be his friends. He must be on his guard.[164]

Michelangelo confided to Vasari that many were whispering that he was in his second childhood. Vasari supposed that this gammon was launched by the Neapolitan Pirro Ligorio, the architect and antiquarian who hoped to supplant Michelangelo as director of the fabric of St. Peter's.[165] In actual fact, Michelangelo on several occasions admitted to friends, and especially Vasari, that he was *rimbambito*.

All this hypersensitivity affected his relations with his assistants, of course. These were already strained, as we have seen, by his general lack of confidence in them. He openly told the workers inherited from Antonio da Sangallo in the fabric of St. Peter's that he intended to fire the lot of them, thus instilling in them a desire to make trouble for him.[166] Naturally, they responded with continual rumors to the effect that he was spoiling all their endeavors, that he was not interested in the project,[167] and that the situation could scarcely be worse, finally causing their boss to write a letter of resignation evidently to the Cardinal da Carpi.[168]

Rumors of another sort were still being bandied about in 1563. It was said that Michelangelo had admitted untrustworthy servants into his household. Lionardo, and some of the artist's friends, felt that the aged artist should take in as housekeeper some stable person who would keep track of his drawings and paintings in case of "an emergency." Denying that anyone had stolen from him, Michelangelo wrote to Florence the heated lines: "I see by thy letter that thou lendest credence to certain envious and worthless fellows who, not able to control or rob me, write thee many lies. They are a brigade of villains [*giottoni*]: and thou art so stupid as to believe them about me, as if I were a child. Dismiss thou these men as scandal-mongers, envious, and low-lived."[169]

With all the conviction of a theorist, Alberti had written in *Della Pittura* that "there is no doubt that the judgement of those who blame and are envious cannot in the slightest degree detract from the praises of the Painter."[170] Yet blame and slander not only could but did cause Michelangelo deep suffering. They also caused him to withdraw further

within himself and contributed to his reputation as an asocial individualist, if not a crank, in an age well populated with cranks, as Vasari's biographies show.

There is a theoretical and classical basis to Buonarroti's preference for the ivory tower, as we learned in Chapter III. His surliness was acquired elsewhere than from books. As early as 1506, writing a safe-conduct for Michelangelo, Soderini set down the revealing caution: "He is of a sort who will do anything if people will treat him with some kind words and a caress. One must show him love and favor."[171]

That he was quick to sense a slight or take offense, complacently sure of being in the right, is well known to students of his life. This sensitivity led to his sending to his benefactor Luigi del Riccio the curious sonnet LXXIV, charging that some offense real or imagined was destroying any gratitude he might have felt to Del Riccio:

Nel dolce d'una immensa cortesia
Dell' onor, della uita alcuna offesa
S' asconde e cela spesso e tanto pesa,
Che fa men cara la salute mia.

Che gli omer' altru' impenna e po' tra uia
A lungo andar la rete ochulta a tesa,
L'ardente carita d'amore accesa
Là più l'ammorza, ou' arder più desia.

Often an offense to honor or to life is hidden within the very sweetness of an immense courtesy, and this realisation is so painful to me that it makes my recovery less dear to me. He who gives wings to a friend's shoulders and then with time reveals that he has spread a hidden net, blots out the feelings of gratitude kindled by love even when one wishes most to keep them alive.

The impersonal, moralistic tone becomes a personal one. "Yet, my Luigi, keep shining bright that first feeling of gratitude, which I bear all my life untroubled by storm or wind. Scorn leads one to overcome every sense of thanks. If I am conscious of the quality of true friendship [I assure you that] a thousand past pleasures cannot compensate for a present affliction." Michelangelo's sense of gratitude referred to here concerns of course the hospitality extended to him by Strozzi and Del Riccio during

his illness. Whether the offense he resents is the pressure exerted by Del Riccio to require Michelangelo to write fifty mortuary pieces on the death of Cecchino Bracci and to execute a bust of the lad, we cannot know. It seems more likely that this poem (one of the several poetic "escape valves" for his pent-up feelings found in the *Rime*) alludes to Luigi's refusal to destroy plates of his poems to Cecchino or of one of his paintings; the poem conforms in spirit to the bitter and even threatening letter he penned to Del Riccio in 1546 (Letter CDLX).

When Jacopo Sansovino became aware that Michelangelo was not going to offer him an opportunity to work on the Façade of San Lorenzo, he addressed a tongue-lashing to Michelangelo (21 June, 1517): "You never did a good turn to anyone. For me to expect kindness from you would be the same as wanting water not to wet. May the day be cursed on which you ever said any good about anyone on earth." This surliness of which Michelangelo stood accused is discerned in the *Dialoghi* of Donato Giannotti, even though Donato may have tempered his report. The artist has no compunctions about being generally disagreeable and accusing Donato of knowing nothing about Dante, the topic under discussion. He finally explodes with, "Voi mi fate quasi adirare!" ("You almost make me angry"!)[172]

In 1517 his brother Buonarroto had felt moved to offer a fraternal counsel: "Nevertheless, making oneself liked of everyone is a good thing."[173] An almost inevitable recent comment suggests that "it was as hard for Michelangelo to make his figures accord with one another as it was for him personally to accord with his fellows. As artist he was spiritually and creatively autonomous, his figures were autonomous, and every one is sufficient to itself as a detached statue."[174]

Another indication of Michelangelo's contrary nature are the twenty-seven incipits of his poems which begin with negatives. Pope Julius II said freely that Michelangelo was a terribly difficult fellow, as all could see, and that people simply could not get along with him.[175] The artist admitted in a note to a poem (CIX, 78) that he'd like to be as sweet as preserved fruit (*pomo d'Adamo*) but that he had no honey in him: Pope Leo X informed Sebastiano del Piombo in 1520 that Michelangelo frightened everyone, even popes.[176] Even his beloved friend, Vittoria

Colonna, alludes to his ability to lose his temper with people in everyday conversations. During a discussion she wonders aloud whether he "will now fall into one of those tempers in which he is accustomed to turn against others."[177] It was as though Michelangelo wished to transfer the *terribilità* of his art into his everyday life.

One could only be impatient with a man who claimed, "I have no friends of any sort, nor do I wish any";[178] who thought few men worthy to become a friend, "perchè pochi si truova de' buoni" (Letter CLIV); who could insult masters and apprentices alike in their presence; who could alternate gruff personal charm with humiliating affronts. Late in his life he admits to his nephew Lionardo that he has no friends left to whom he can give the Trebbiano wine sent him from Florence (Letter CCXCII). Only an intimate friend like Sebastiano could call him to task for his behavior: "Consider for a moment who you are and reflect that you have no one making war on you other than yourself."[179] The somber character which came to typify the man is brought out in a chance remark of De Hollanda during one of the causeries: "He laughed again, despite the absence of the Marchioness."[180] A reading of Michelangelo's correspondence, like a glimpse of the *faccia di spavento* of his death mask, heightens the impression that he was a man who never laughed. Auguste Barbier sensed this when he wrote:

> Que ton visage est triste et ton front amaigri
> Sublime Michel-Ange, ô vieux tailleur de pierre!
> Nulle larme jamais n'a mouillé ta paupière:
> Comme Dante, on dirait que tu n'as jamais ri. [181]

The four moods which have been read into the figures of the Times of Day—pain, resignation, rebellion, and unfulfilled desire—are four major leitmotivs of Michelangelo's dissatisfaction with his life as an artist.

Michelangelo's tribulations, real and imagined, as well as his atrabilious temperament may have inspired one of the most curious engravings of the Renaissance. This crowded picture, entitled "Raphael's Dream" or "The Melancholy of Michelangelo," was executed by Giorgio

Ghisi after Luca Penni and bears the date 1561. The allegorical scene depicts an elderly man, traditionally identified as Michelangelo, groping through a monster-infested *selva oscura*. In the distance ahead looms a landscape glowing in the rising sun and graced by a rainbow's end. At Michelangelo's feet one reads, "Sedet aeternumque sedebit ïfoelix," a phrase from the *Aeneid* (VI, 617–618), where it refers to Theseus. At the right a female symbol of Virtue, Philosophy, or Fame watches his progress hopefully and bears the legend "Tu ne cede malis, sed cõtra audentior ito," the exhortation of the Sibyl to Aeneas (VI, 95). (This was, as Elio Gianturco reminds me, the motto adopted by Giordano Bruno.) Under this scene one reads, "Raphaelis urbinatis inventum, Philippus Datus animi gratia fieri iussit." Although Raphael had died in 1520, when Buonarroti was still in his mid-forties, and the style of the composition is not Raphaelesque, it is likely that Luca Penni, a friend of Raphael, was originally inspired by an earlier drawing of Sanzio. Whether Raphael, who called Michelangelo "lonely as the hangman," actually intended to portray the Florentine artist in the figure of the melancholic pilgrim cannot be proved. But such may have been the case, since Michelangelo's countrymen attached his name to the figure.

We have enumerated many heartaches of both a technical and a personal nature which beset Michelangelo and would certainly have cut down the productivity of a lesser talent. Yet his genius dominated them, resisting alike curbs and so-called spurs. Not in vain was his boast (CIX, 38), "E di quel ch'altri muor sol godo e uiuo" ("Yet I enjoy and thrive on what kills another").

There remain for us to consider several outbursts where Buonarroti condemned the fine arts as a profession, completely forgetting all fine mouthings about art's bringing a Pindaric glory to its practitioners. One of his letters to Luigi del Riccio conveys the wish that he had hired himself out in some menial trade. After thirty-six years of devoted and unselfish service,

La pittura e la scultura, la fatica e la fede m'àn rovinato, e va tuttavia di male in peggio. Meglio m'era nei primi anni che io mi fussi messo a fare zolfanelli, che io non sarei in tanta passione.[182]

Painting and sculpture, fatigue and faith have ruined me, and things are still going from bad to worse. It would have been better if in my youth I had hired myself out to make sulphur matches; I should not now be in such a passion.

The long, hard climb up toward recognition and the elusiveness of that recognition tried the artist's patience. Van Gogh recalled that St. Luke was the patron saint of painters and that his symbol, the ox, was equally the emblem of patience. The demands and exhausting quality of artistic creation, as has been noted above, are revealed by such snatches of thought as "In my art I stool blood" and "Men forget how much blood it costs." A vexed letter to Lionardo describes the miserable life which his vocation has entailed and serves as a perfect legend for the engraving of Luca Penni:

Io son ito da dodici anni in qua tapinando per tutta Italia; sopportato ogni vergognia; patito ogni stento; lacerato il corpo mio in ogni fatica; messa la vita propria a mille pericoli . . .[183]

I've gone about through all Italy leading a wretched life for twelve years; I've endured every shame, suffered every hardship, racked my body in every labor, exposed my very life to a thousand perils . . .

The Dantean line translated just above, "Non vi si pensa quanto sangue costa" (*Paradiso*, XXIX, 91), is copied by Michelangelo on the lost relief of the *Pietà* which he made for Vittoria Colonna.[184]

Although the greatest temptation to abandon the fine arts occurred to Michelangelo late in life, there was a hint of this later attitude of renunciation as early as 1538. Replying to an observation that Portuguese noblemen do not value painting, Michelangelo retorts merely, "Fazem bem" ("They do rightly"). In Chapter II we studied the strong religious compulsion which led him to view the arts as an empty vanity which "steals from him the time granted to contemplate God."[185] A late poem, "Mentre che 'l mio passato m'è presente" (CIX, 32; see also 34), expresses regret that behind the temptations and delights of his past life lie the error and damnation (*danno*) of mankind. It is of course paradoxical to find Michelangelo turning against art through religious scruples, for he had always believed that an artist can best serve God by an honest and

moral exercise of his craft, even maintaining that God himself guides the arm of the worthy sculptor or painter.

Such tergiversations—not forgetting the renunciation of art at the close of the capitolo "I' sto rinchiuso come la midolla" (see above, note 109)—are perhaps better understood after one considers all the tribulations enumerated in this chapter. Michelangelo often felt, as he wrote to his brother, "Non mi sia data più noia, che io none potrei soportar più un' oncia" ("Let there be given me no more annoyances, for I could not endure an ounce more").[186] As Michelangelo progressed in his career, then, he was sometimes assailed by what he called (CLXIII) "el Dubio e 'l Forse e 'l Come e 'l Perchè rio" ("Wicked Doubt and Perhaps and How and Why"). Granted all the frustrations, disappointments, and difficulties which were his heritage as a Renaissance artist with the peculiar temperament of genius, what were the compensations that buoyed him up over seventy-five years?

First of all, he was generally sustained by a religious conviction which grew out of that sentence he had heard on the lips of Savonarola in a Lenten sermon many years back: "In our churches only the most distinguished masters should paint and they should paint noble things." We have discussed the religious inspiration of his art in Chapter II.

The second or alternative answer is that Michelangelo was an illustration of, or victim of, artistic compulsion. He admitted:

Io non posso vivere non che dipigniere.[187]

I cannot live without painting.

This was written not as a pretty piece of theory but in a moment of bitter self-revelation in a letter to Luigi del Riccio. It is the only place in his works where the admission is so simply stated.

Moreover, one can read into certain passages the contentment afforded Michelangelo by his art. Early in life he wrote to his father from Rome that he had acquired a block of stone for five ducats and was making a figure, not for a commission but "for my own pleasure" ("Fo una figura per mio piacere").[188] This therapeutic and soul-satisfying virtue of the practice of art was acknowledged by most of the theorists. Cennini had written, "Not without motivation of a genteel soul are

people moved to come to this art, it pleasing them through a natural love."[189] In his *Della Pittura* Alberti asserted: "There is almost no art which men of wisdom ['uomini che sanno'] or men without wisdom may exert themselves in learning and practicing with so much delight throughout their lives."[190] To Da Vinci the practice of painting was identical with "the study of virtue" and "nourishment [*pasto*] of the soul and body."[191] The practice of art was conducive to mental health and physical well-being, as modern psychology knows. Vasari records: "Michelangelo's mind and creative power could not remain long inactive. And since he could not paint, he got hold of a piece of marble to carve four *tonde* figures larger than life. He made from this stone a dead Christ as a delectation and to pass time and, as he said, because exercising with the mallet kept him sound of body."[192]

Then, too, despite the hardships we have been reviewing, there were material compensations brought by art, especially during the latter half of Michelangelo's long life. We have already mentioned the real properties listed in the *Denunzia de' beni*, as well as the clamor for his services by the greatest princes and noblemen. Il Bruciolo was sent by the Signory of Venice to offer him an income of 600 crowns a year merely to honor the Queen of the Adriatic with his presence, plus liberal payment for any individual creations. Many other friends showered him with lesser gifts: after the death of Cecchino he received, as we have seen, all kinds of food, from Luigi del Riccio; we have a grateful sonnet composed perhaps to Vasari around 1554–1555 graciously and wittily thanking the donor for gifts of sugar, candles, Malvasia (Greek) wine, and a mule (CLXI):

> *Too much of a calm so takes the swell from the sails*
> *That without a sea wind my fragile little bark*
> *Loses its way and seems a floating straw*
> *On a rough and cruel sea.*
> *As for your kindness and the fine gift,*
> *The food, the drink, and the means of getting around*
> *That for every need of mine is dear and useful,*
> *My dear lord, even if I gave you all of myself*
> *I should be nothing compared to your merit;*
> *For I do not have it in me to requite you as I should.*

· 389

Even his letters of thanks for the provisions sent him by his nephew Lionardo gradually assume a more gracious tone. In addition to the comfortable living which his art finally afforded him, less material honors came his way. His friends found it easy to call him divine and to note that he was universally honored like Homor, claimed by many cities as their own.[193] Even his enemies had to admit his greatness. Aretino acknowledged in Dolce's *Dialogo* that as a sculptor Michelangelo was "unique, divine, and equal to the ancients,"[194] just as the real-life Aretino called him a "god" in a letter to Vasari (1535).

Four signal honors won by Michelangelo for his art were: honorary citizenship conferred by the city of Rome in 1546, the honorary vice-presidency of the Florentine Academy of Fine Arts, the invitation extended by Duke Cosimo to become one of the Forty-Eight (senators) and take his choice of public offices, and the appointment as chief architect-painter-sculptor of the Vatican (1535), which distinction made him a member of the papal household with a permanent salary of 1,200 crowns.

Patrons were moved to make more friendly and appreciative gestures as time went on. They were not the noble gestures of a colorful or incongruous nature which season the history of art patronage: Alexander sharing his mistress Campaspe with Apelles, Charles V picking up a brush dropped by Titian with the exclamation, "Titian deserves to be served by Caesar," or Philip IV viewing *Las Meniñas* and seizing a brush to paint on the tunic of Velázquez the Cross of the Order of Santiago. Or even Pope Clement's extraordinary tribute paid to Cellini—a papal absolution covering not only previous but future sins. Yet there were the aforementioned financial gestures by Jacopo Salviati, Cardinal Grimani, Metello Vari, and Aldovrandi. Two amical gestures were Julius III's declaration that he would sacrifice his own blood and his few remaining years to Michelangelo, if that were possible,[195] and that pontiff's expressed desire to have Michelangelo's body embalmed so that it would be immortal (see Chapter III, note 38). When things came to a showdown between the aged artist and his detractors, his patrons generally took his part: Julius III rebuking Marcello Cervini or Cosimo de' Medici rebuking Nanni di Baccio Bigio. When his master of ceremonies sought redress for Michelangelo's having painted him as *Minos* in the *Giudizio*

390 ·

universale, according to the *Empresas morales* of Lorenzo Ortiz, Paul III defended the artist with the remark, "En el infierno no tenemos potestad" ("We have no authority in hell").

These gratifications came late. For the most part, vexations and tribulations analysed in this chapter made them seem "too little and too late." In his early and middle years he could take solace from the knowledge that his idol Dante had shared his lot. Writing a sonnet "Per Dante Alighieri" (CIX, 37) he alluded to the misfortunes of Dante and unconsciously and inevitably indulged in self-projection:

> *Di Dante dico, che mal conosciute*
> *Fur l' opre suo da quel popolo ingrato,*
> *Cha solo a' iusti manca di salute.*
> *Fuss' io pur lui! c' a tal fortuna nato,*
> *Per l'aspro esilio suo con la uirtute*
> *Dare' del mondo il più felice stato.*

I speak of Dante, whose works were so poorly understood by that ungrateful people which withheld favor to only the worthy. Would that I were he! Born to such a choice, I should give up the most felicitous state in the world for bitter exile, just to possess his virtue.

A second sonnet on Dante reveals Michelangelo identifying himself with this man "without peer," taking bitter comfort in the fact that misfortunes befall most commonly "the most perfect" of people (CIX, 49).

Michelangelo, who set a high premium on personal asceticism, may have tried to rationalise that the hardships which plagued him were toughening and disciplining him for ever greater creations, despite his misgivings about curbs and spurs. Such wishful thinking would be attested by a fragment of his *Rime* (CV) which unconsciously betrays his preoccupation with the serpentine:

> *Come fiamma piu crescie piu contesa*
> *Dal uento, ogni uirtu, che 'l cielo esalta,*
> *Tanto piu splende quant' è piu offesa.*

As a flame grows greater assailed by the wind, every virtue (power) which heaven exalts shines the more as it is the more offended.

A recent comment on this fragment reads: "In the weariness of his later years, even the art to which he had dedicated himself as to a divine mission seemed to him only one of the 'favole del mondo' by which he had been led astray. But it is precisely his sense of the tragic dichotomy of the human spirit which gives nerves and sinews to his poetry. His despair and sorrow spring from the deep consciousness of infirmity and his rare moments of joy have the authenticity of things won perilously out of the toil and heat of the fight."[196]

In Chapter III we recorded the opinion of an editor of the *Rime* that Michelangelo was the first modern man to pose the problem of pessimism, and we granted that Michelangelo harbored in his thinking a pessimism which ran deeper than the mere outbursts of a frustrated or unhappy artist. There dwelled in the recesses of his mind a belief that not only mortal men but even the forces of nature and God himself withhold success particularly from those who try hardest to achieve it. This very real belief is never elaborated upon, but traces of it are discerned in his letters and his poetry. It was stated loosely in the letter which recounts the difficulties of Master Bernardino in casting the bronze effigy of Julius II: "He who tries often fails." It appears more succinctly in the poems.

Perhaps the earliest expression of this pessimistic belief was set down (III) during his first troubles with Julius II:

> *Ma 'l ciel è quel ch'ogni uirtu disprezza*
> *Locarla al mondo, se uuol ch'altri uada*
> *A prender fructo d'un arbor, ch' secho.*

This plaintive conviction, translated earlier in this chapter, depersonalises the strained relations existing between artist and patron and lays blame for his difficulties upon Providence itself.

We have observed that the lesson which Michelangelo read into the unhappy life of Dante was that the most worthy men have to fight hardest against the most terrible obstacles:

> *Che solo a' giusti manca di salute (CIX, 37)*
>
> *For favor is withheld to only the worthy.*

ond' è ben segno
Ch'a ' più perfecti abbonda di più guai (C I X , 49)

whence it is a clear sign
That the most perfect men abound in the most misfortunes.

The fourth articulation of this pessimistic belief to be found in the *Rime* occurs in the allegory of the two evil giants and their offspring, the seven sins. Michelangelo speaks of their constant fight against mankind, and finds that they make things hardest for the righteous, intriguing and declaring war only against the just:

E solo a' giusti fanno insidie e guerra (L X I X).

Yet, as we shall see in our final chapter, a great mind like Michelangelo's will of necessity contain paradoxes, inconsistencies, and contrarieties. We think again of that letter to his father from Bologna, "I thank God for this thing and esteem everything for the best." Or the statement to Giannotti and his assembled friends that God satisfies every just desire of man.

Despite all the misfortunes and *piccolezze* which beset him, Michelangelo seemed to have arrived at an attitude, one could hardly say philosophy, of stoicism and renunciation intermixed with positivism. In the *Dialoghi* recorded by Giannotti there occurs an animated argument over whether Caesar might have become benevolent had he been spared by Brutus and Cassius. Michelangelo, in the maturity of his seventy-first year, notes that fate sometimes arranges a reversal of fortune, a peripeteia. Like Boethius, he observes that out of what we may, in haste or ignorance, deem evil circumstances good may eventuate. This thought, incidentally, he had already set to poetry (xxxix):

Non dura 'l mal, doue non dura 'l bene,
Ma spesso l'un nell'altro si trasforma.

Evil does not last where good does not last
And often the evil is transformed into good.

He takes to task individuals like Brutus and Cassius, who have recourse to violent thinking and acting unaware that good is often engendered

· *393*

directly of evil. He adds, "Nor do they realise that times vary, concealing new or different eventualities [*accidenti*], men change their wills or grow weary; whence many times beyond hope or expectation, without anyone's planning, without anyone's being imperiled, we witness the birth of that good which we have all along desired."[197] This reminder that the ways of fortune are as immanifest as an "anguis in herba" (Vergil) dates as a written record as far back as Aristotle's *Metaphysics*. The philosophical source of this notion best known to Michelangelo was of course Vergil's lesson to Dante on Dame Fortune, with its two clarifications that the ways of Fortune are "oltre la difension de' senni umani" and that "vostro saver non ha contrasto a lei." Michelangelo's statement recorded by Giannotti is an important evidence in the study of his biography. It explains in part his well-known tendency to disengage himself from political or social disturbances whenever they started brewing. The passage shows, more-over, that despite all the heartaches and vexations which tended to make of him a misanthrope capable of such jeremiads as CLXIV,

> *Di più cose s'actristan gli ochi mei*
> *E 'l cor di tante quant' al mondo sono ...*
>
> *My eyes are depressed by many things*
> *And my heart by as many things as are in the world ...*

he was sustained by a quasi-philosophical belief that fortune often con-ceals good under the appearance of evil, that from his own trials destiny planned that great and lasting things be wrought. This man in whose poetry the lesson of the phoenix occurs four times took consolation in the fact that this bird could never make its lofty flight without passing first through searing flames: "Nor does the unique phoenix take on new life if not first burned, whence I, if I die burning, hope to rise up again more bright [*più chiar*]" (CIX, 87).

CHAPTER VII

Summations and Paradoxes

THE QUESTION must arise regarding the continuity and consistency of Michelangelo's thinking. To what extent did his thoughts on the basic issues of aesthetics evolve during his long life, a life which coursed, as someone has stated, from the peak of the High Renaissance to the peak of the Counter Reformation? Of course, if one accepts the view of Vasari, Dolce, and Armenini, initiators of the concept of a *rinascita,* that the High Renaissance coincided exactly with the span of Buonarroti's career, then the chronological clause of the question must be dropped, but the question remains pertinent.

In the world history of art theory the contributions of individual thinkers are dealt with as net products, as summations. Minor deviations, self-contradictions, reservations, and *esprit d'escalier* afterthoughts are made to accommodate the absolute theory or are cast into shadow. The theories of Vico, Du Bos, or even Croce are accepted as absolutes because of one recognised expression of them in a given text at a given date, and there is no allowance for what Blake called "the contrarieties without which there is no progression." These summations synthesise and reconcile not only the ideological discrepancies, but also the chronological ones. The only moment in Lessing's career as aesthetician which matters to us is 1766. For Gautier the year is 1857, when his poem *L'Art* gave such perfect expression to the Parnassian ideal that anything he wrote or said before or after has to be reconciled to this piece. In view of this situation, it is fortunate that thinkers on art do not change their basic convictions so readily as some artists change their styles or their "periods." The fact that for Michelangelo there was no such convenient moment does

not mean that an absolute summation of his theory remains impossible. It merely means that the "absolute" summation has to be constructed with available materials covering a very long "moment." The same accommodation of deviations and contrarieties has to be made. There are, however—and this is the important point—few of them in this man who was, as he preferred his statues to be, of a single block and grain. As we shall proceed to explain, three factors co-operated to make his theory static: a classicism rapidly becoming codified, a religion opposed to divergence, and a stubborn character to lend a fixity of mind.

Before studying these fixative factors of his thinking, a few more remarks about dating the elements in Michelangelo's aesthetics are in order. We have of course brought to the reader's attention evolving attitudes toward other artists, some of them striking, as in the case of Montelupo or Fra Sebastiano. Even in such cases the change of attitude did not imply a change of the measuring stick being used, of course. We have also assumed the obligation throughout of keeping the reader aware of the dates of the most significant pronouncements. The remarks on the social and military values of art center on 1538, the year of the Roman dialogues; the most Vitruvian enunciations on architecture come from the correspondence of 1544, 1555, and 1560; the opinion on the Paragone dates from the letter of 1546. The dating of these testimonies is important if one relates them to the respective events that prompted them: the siege of Florence in 1529, the enmity with the Sangallo sect, and the opinion poll of Varchi. However, as moments in the history of Michelangelo's thinking they may be viewed as absolutes: convictions which he had held before and which he continued to hold thereafter. The continuity of his thinking on even these issues which were not an integral part of the neoclassical baggage is admitted by his biographers and by his practices. One need only consider the *Battaglia di Cascina* of 1505–1506 to understand the statement of 1546 that that painting is best which approaches relief. If these views on topics peripheral to classical doctrine were continuous, how much more understandable is the continuity of his thinking on the strictly classical issues which had come out of Aristotle, Longinus, Cicero, and Horace without variation and with more than a millenary momentum. Thus, as one fills in the components of a neoclassical system, the dis-

covery of the missing element is more important than the dating of it. If Michelangelo mentions decorum as logical appropriateness in 1538 and decorum as social propriety in 1544, there is no reason to suppose that both meanings were not apparent to him during his entire mature life. In any case, if the reader is interested in dating any opinions or seeking other progressions of theory than those pointed out, the where-withal is given him in this book.

As is well known, the neoclassic temper is one opposed to fluctuation or change. The covenants of classicism, founded on reason and compromise, teaching especially the basic issues and universals, lent themselves so little to change that they have prevailed longer than any other intellectual temper in the Western world, being strengthened particularly under every conservative or authoritarian government. In writing "the fourth necessity is that a character be consistent," Aristotle was prescribing not only for persons in plays but also persons in life. When the generation of Manzoni and Hugo attacked neoclassicism, they opposed it as intellectual staticality and a *vis inertiae*. Michelangelo was a purist in his classicism. That is, he did not evolve in his thinking on classical issues. He merely picked up additional precepts and predictable prejudices as he read and listened. At a certain point he had arrived at a classical state of mind and his preference for nobility, for the universal, for decorum, for form even at the expense of content, and so on, grew out of this state of mind. Indeed, by the end of his life he had taken the lead in expressing and fixing many canons of classicism, so that such a doctrine as his "intellectual measurement" remained static even after his death, thanks to Bellori and others.

The Church was a similar stabilizer of Buonarroti's thought. In Chapter II we pointed out the continuity of his religious convictions. The movement of the Counter Reformation did not change his outlook on life or on art, for he had already lived through and accepted the principles of the parochial counterreformation of Savonarola long before that of Loyola. Sympathetic to the Piagnoni during the former movement, Michelangelo could still echo in the year of the first decree of the Council of Trent, "Io vi dico che in questo mondo è da piagnere."[1] The popular rumor that Savonarola put one of Michelangelo's paintings to the pyre

· *397*

in the first counterreformation merely adumbrated the retouchings of the *braghettone* (1559–1560) four years before the last decrees of the Council of Trent. The Counter Reformation was not an historical force which altered Michelangelo's fundamental theories on the religious inspiration or application of the fine arts, or any of his theories whatsoever, so far as can be judged.

In the age of the anchor and the dolphin and of baroque tensions, Michelangelo preferred stability as a personal inclination—intellectual stability, for emotional stability was not always possible. One of his reasons for embracing art was that it was a means of unalterably preserving his thoughts and concepts "al par degli anni." Note also his prediction: "Si che mill' anni dopo," ("So that a thousand years hence . . ."). He disliked to alter his beliefs or his habits, a side of his character manifest in his letters. An even more pointed demonstration of this side is afforded by a reading of the transcript of Donato Giannotti, with its revealing and recurring insistences: "nondimeno . . . io sto saldo nel mio parere" ("nevertheless, I'm firm in my opinion"); "io non mi contaddico" ("I don't contradict myself"); io ve lo consento, *ma . . .*" ("I grant you that, *but . . .*"), and "se voi non havete altro che dire, io mi starò nella mia antica opinione" ("if that's all you have to say, I'll stick by my original opinion").[2] The static quality of Michelangelo's theories and prejudices was, therefore, the product not only of the stabilising neoclassic and ecclesiastical milieu in which he spent most of his life but of his personality itself, which evolved little and which buttressed his thinking. When he wrote to Varchi that the Florentine academician's views on the Paragone had won him over, the rest of the letter shows that his stand had not budged an inch.

We have stated that the Counter Reformation did not alter the premises of Michelangelo's belief. There was no other historical or biographical circumstance in his middle or late years to prompt such a change. The increased number of Neo-Platonic poems following the death of Vittoria Colonna in 1547 show only an intensification and not an evolution of his thinking, for the Ficinian-Plotinian presentation of Platonism was known to him all his life, indeed, known to him *viva voce* when he was privileged to know Marsilio Ficino under the Medici roof. His sudden

appreciation of nature after the trip to Spoleto in 1556 had no effect upon his art, poetry, or theory, beyond possibly the writing of one poem. His heightened religiosity during the period of his diminishing powers only intensified thematic interests that had been present during his entire lifetime.

An effort has been made in the preceding chapters to situate Michelangelo's pronouncements in their moment and milieu through liberal quotations from other Cinquecentisti. Our intention has been to point out thereby how many of the issues that preoccupied him were shared by the other thinkers on art just prior to the age of baroque, when new preoccupations were to be brought into focus: rationalism, ethics, taste, philosophicalness, and a compulsion to arrive at definitions and codifications. Having reached this point, the reader may have concluded for himself, then, to what extent Michelangelo's thoughts and their expression were consonant or dissonant with those of his contemporaries. It has been variously stated that what distinguishes Michelangelo's thought on art is rarely its content, but rather his private forms of expression of that thought. A cursory recollection of the preceding pages makes this seem an oversimplification, for the thematic character of his thought was sometimes atypical while some of his forms of expression were typical. Naturally Michelangelo's neoclassicism would incline him toward orthodoxy in choosing the issues he feels important and wishes to treat; but by the same token the expression of those issues should be conventional, for neoclassicism sets the "tone" as well as the substance of theory. Any divergence from the neoclassic pattern will be noteworthy, whether the divergence is in content or in form. A recapitulation is therefore in order, measuring to what extent the conflict between the complacency of his neoclassical temper and the stirrings of his restless intellect is apparent from his theories and to what extent those theories are typical or atypical of his time.

Since a final summation of his theories is incumbent at this point, it may be fruitful to present this conspectus as follows: We shall review in order those issues which are (1) typical and typically expressed, (2)

typical and atypically expressed, (3) atypical, but typically expressed and (4) atypical and atypically expressed. After assessing these issues and their formulation in the light of Renaissance thinking, we shall analyse in the same way and for the same purpose Michelangelo's twenty-four criteria of criticism which emerged in Chapter IV.

The majority of the issues prominent in Michelangelo's theorising are conventional and the expression or interpretation of them is no more individual or unconventional than that found in any other contemporary theorist.

His thoughts on mimesis and his expression of those thoughts are representative of his age, even though he could resent to an unwarranted degree those who copied from him. His acceptance of the Horatian precaution *sumite materiam vestris aequam viribus* finds such conventional utterance that one momentarily forgets that Michelangelo was being frequently pressured to undertake tasks too numerous or exceeding his forces in other ways. One forgets his pained objection, "non è mia arte," voiced on many occasions. He carried his subscription to the Horatian *odi et arceo* right into his daily life, obliging Condivi, Vasari, and Sebastiano to explain away his antisocial attitudes and his preference for introspection (better explained by Buonarroti himself in the dialogues of Giannotti); he was not alone in numbering among the *profanum vulgus* princes of church and state. Typical was his dual view of decorum as a logical and as an ethicosocial requirement, as were his enunciations of it; however, the amusing letter on the social inappropriateness of the colossus to face the Stufa Palace hits a high level in Bernesque prose. His diffused and indirect comments on the conflict between art and nature show him inclined toward the classical compromise position: art is borne down from heaven, but one must exert oneself in every way to achieve perfection in it. His expression of the religious nature and inspiration of art has the orthodoxy of Scholasticism and the Counter Reformation behind it, as do his persuasions on the ethical and moral comportment of the artist, persuasions which were the source of much *Seelenangst* in his own life. His feelings on unity and "arte intera," unsystematically presented, were conventional and, if Michelangelo transferred them to the question of the *veduta unica,* this attitude was not so different from that of his

contemporaries as we have been led to believe. He nurtured the idea of unity so that it could come to fruition in the Grand Siècle, when Le Brun applied the three Aristotelian unities of time, place, and action to painting. Michelangelo's belief that works of art should be painstakingly elaborated while appearing spontaneous and effortless was in complete harmony with the Renaissance ideal of *sprezzatura* as a goal for one's work and one's life. He was completely a man of his century in his adherence to and expression of the cult of glory; he was sublimely more than typical in his desire to carve immense figures out of mountains, as Vasari tells us, "per lasciar memoria di sè."[3] Such an exaltation of art and the artist was inevitable in a man doing more than anyone else to raise the status of painting and sculpture from that of a manual to that of a liberal art. One remembers that in Michelangelo's boyhood his father and uncles had resented the stigma of his becoming an artist, even though they themselves were humble people. His definition of beauty is in line with the Neo-Platonism of his time; it was rather Dürer who was atypical in declaring, "I surely do not know what the ultimate measure of true beauty is." Buonarroti's views on creative furor, on "innutrition," and on art as a veiling or fictive process were common coin in his time, even though the documentary evidence on these beliefs is fragmentary and indirect. His stands on invention, verisimilitude, and the grotesque were Horatian in character and form even if broadened and deepened in his artistic practices; the Horatian view of invention, which is less interested in new subject matter than in better and more individual treatment of familiar subjects ("Difficile est proprie communia dicere"), was compatible to Michelangelo as both theorist and artist. On the question of verisimilitude he insisted on artistic license more than did his contemporaries. "Di qui a mille anni nessuno non ne potea dar cognitione che fossero altrimenti" ("A thousand years from now nobody would know that they looked different!") he replied to critics looking for beards on the Medici Dukes. If one took seriously a good deal of the hyperbole and adulation found in the Renaissance *artes pictoriae*, prefaces, liminary verses, and Pindaric odes—much of it aimed at the "divine" Michelangelo himself—one would be entitled to assume a contemporary belief that certain moderns could surpass the ancients, a belief to which Michel-

angelo could not subscribe; however, as we have demonstrated, the vast majority of Renaissance writers, with a rare exception such as Giovanni Pico, believed that the moderns were further removed from nature and divinity than the ancients had been and therefore could not really surpass them; on this point there was no real disagreement between Michelangelo and his fellows. Nor was there disagreement with his compatriots in his opposition to Gothic, which he called "tudesco" (or "todesco") and failed to understand. His partiality toward nobility and sublimity was part of the current neoclassicism and led him to believe that noble subjects encouraged lofty artistic expression and to suppose that nobility of soul and that of station were identical, an identity perpetuated by the propagators of the "grand style" under the seventeenth-century French monarchy. A peculiarity of detail was Michelangelo's certainty that the noblest subject was the nude "Apollo," which made him atypical in the eyes of the landscapists and the Venetian "costumers." It is particularly regrettable that Michelangelo was silent on the subject of allegory and iconography, except in the stanzas in praise of rustic life. He obviously paid some lip service to this contemporary interest, even more than lip service in a figure like the *Notte,* but a few more hints on the part of Michelangelo would have enabled us to evaluate more critically some of the recent *tours d'ingéniosité* which have been devoted to his Neo-Platonic symbolism. The foregoing articles of theory are those on which Michelangelo's position and articulation are generally typical of his time and place.

Another corpus of theories, numbering slightly better than half of those just enumerated, were inherent in Renaissance aesthetics, whereas Michelangelo's particular expression or interpretation of them set him, and them, apart. It is this category which has been erroneously supposed to represent the bulk of Michelangelo's theory:

Foremost was his tenacious theory of art-forms as timeless *concetti* resident in the ὕλη, a theory he considered applicable to every medium of art. An occasional contemporary exploited the idea as metaphor, but to Buonarroti it was a basic belief and has remained identified with him, as has the notion that the artist is a finder of pre-existent harmonies. Another individual articulation of his Neo-Platonism is his argument that

the initial agent of art is the νοῦς, which he correctly translates as *intelletto*. Whereas the idea of innate genius was especially rampant in the Renaissance, which witnessed a resurgence of the doctrine of predestination, Michelangelo was the first of the theorists on art to utilise the word *intelletto*. His particular stand on the Paragone of painting and sculpture, a much-debated issue in his day, was opposed to that of Leonardo and others. An unschooled man, he respected knowledge as the *principium et fons* of art and wished artists to master as many different disciplines as those stipulated by the most learned tractators; but he differed from the other theorists in excluding from these disciplines physics, optics (despite his poetic fragment on the eye), mathematics, and geometry. Whereas the Renaissance treatises on art borrowed from the *artes poeticae* the notion that art purges through pity and fear, they did not carry over the third element of empathy explicit in Aristotle: τό Θαυμαστòν , or wonderment; this missing element is supplied in the *terribilità* mentioned in Michelangelo's correspondence and is of course strident in his works. His view of painting as "a music" and of those incapable of understanding it as "the unmusical" is a peculiar rendering which gets recalled in histories of art. Da Vinci's more detailed and better-known writings on art and warfare prevent us from considering Buonarroti's apologia as unique, but the expression of his ideas on the subject, inspired and supported by Vitruvius, becomes unusually personal and dramatic. His application of the principles of anatomy to all the other arts is also Vitruvian in origin, but intensified in one who viewed the human body as the incarnation of "immortal form" or "universal form." It was only after Michelangelo that Dolce could construct his theory of idealised imitation on an anthropomorphic basis, around "the human figure in action," a theory which persisted until the time of Lessing: "Die höchste körperliche Schönheit existiert nur in dem Menschen, und auch nur in diesem vermöge des Ideals." Michelangelo's subordination of color to line, a corollary of his preference for form over content, constitutes an individual stand on a conventional issue, less individual for a Tuscan; his statement that "a green, a red, or similar high color" will distract attention from the spirit and movement of the figures corroborates his practices as an artist. His persuasion that if one paints as

a classic one paints therefore as an Italian is an accentuated expression of the current view of Italy as the home of the third classicism. Those of his compatriots who got about, as Michelangelo never did, would back away from his extreme claim that apprentices in Italy painted better than masters elsewhere. As we have stated, Michelangelo accepted the bipartite doctrine of imitation as enunciated by Vasari but could not bring himself to approve plagiarism by mature artists; after all, he had been victimised in his lifetime by forgers and fraudulent attributions of his works. He dragged his heels on this issue, as did Castelvetro, who wrote that "the glory which ought to belong entirely to the first finder is diminished when shared."[4] Michelangelo accepted the varied inter-relations which his century read into Horace's *ut pictura poesis*, but betrayed a slight prejudice by asserting that Dame Painting had been in antiquity the patroness of writing, anticipating by two decades Dolce's statement in his *Dialogo* (1557) that poetry and all literary compositions are a form of painting, a fusion which became a confusion by the time of Lessing. Probably the most conspicuous case of Michelangelo's divergence from his contemporaries on a commonly discussed issue of art was his view of design as so fundamental a property of painting that he ended up by equating the two terms, to the dismay of many of his exegetes. Another issue on which he took a revolutionary approach was the old one concerning the didactic or hedonistic function of art; whereas most theorists were following Horace and taking a compromise stand, this artist who had resolved to serve God as artist rather than as Dominican friar did not try to synthesise opposites; what Edgar Allan Poe was to call the "heresy of the didactic" was orthodoxy to Michelangelo; hedonism was the heresy, and his *Bacco* was never joined by Silenus and the rest.

Yet there were also issues so conceived or redefined by Michelangelo that they were unique in his century, although he often expressed such unorthodox issues or attitudes in a conventional manner. Michelangelo was certainly alone among the thinkers and practitioners of his time in his almost militant rejection of external nature as a motiv of art ("consigliò che non vi si facessi intagli di fogliami"); that this was a lifelong rejection is attested by written evidence and by his artistic

productions. There was nothing unusual in the expression of that rejection, however. Michelangelo was also alone among his contemporaries when he dipped into the *Enneads* of Plotinus and came up with specific assertions about the relative offices of eye and hand. The same Alexandrian philosopher set him thinking about the dichotomy of mind and hand, symbols of nature and art, respectively, which reappear notably in the fourth verse of his most famous sonnet ("La man, che ubbidisce all'intelletto"). Even though all neoclassicists preferred the universal to the particular, Michelangelo was equally alone in his intransigent attitude about portraiture; his rejection of portraiture was firmly set on Christian, Neo-Platonic, and personal bases; Michelangelo more than anyone else prepared the way for Bellori to state that imitating an individual is less noble than imitating an Idea. In stating the case for the therapeutic values of art or for art as an outlet ("io non posso vivere non che dipigniere"), he raised a new issue for which his century was scarcely prepared. His vehement apologia for the fine arts in the 1538 dialogues, couched in the simple terms of a lesson *ad usum delphini,* was a vocal reminder of the social and political values of art without immediate echo. His vigorous claim that an artist can be considered a master for one single work has an unusual stress, despite its classical provenience, upon qualitative rather than quantitative production. It implied a complementary belief in artistic transfer, as we have seen—a belief equally implicit in his wishing that such artists as Andrea del Sarto, Antonio Begarelli, and Cellini would try out other media. Whereas Buonarroti was not the only artist in the neoclassic period to set form over content, if one had to outweigh the other, he was alone in his century in his special view of basic form as overshadowing tributary form; as we have seen, he viewed every *concetto* as offering its own basic challenge of formal composition or *disegno* in relation to the materials ("alcun concetto / Ch'un marmo solo in se non circoscriua"), a challenge to be met or a problem to be solved or "broken"; once the general lines of the solution have been achieved, the details become as unimportant as hatchings, shading, *sfumatura,* or coloring.

One arrives now at the last group of issues by which Michelangelo showed his complete unorthodoxy, both thematic and expressive. Al-

though there was a vague consensus among the Aristotelians that painting and sculpture, like epic and tragedy, should portray "men in action," Michelangelo's views on contrapposto, *furia* of design, and the serpentine or flamelike line of beauty are an undated and undatable testimony from Lomazzo which seems to prefigure the canons and license of baroque. Another highly individual assertion of an article of faith is Michelangelo's well-known statement that a great artist carries his compasses in his eyes, in outright defiance of the mathematical and geometrical formulations of Alberti, Dürer, Pacioli, and of Leonardo, who had stated, incidentally, that the painter must not sail without a rudder or compass. Complementary to Michelangelo's rejection of the mathematicians and Pythagoreans was his revival of the Platonic notion of "inner vision" with the support of Ficino and Plotinus. Even Michelangelo's supporter and exegete Varchi, in the *Due lezzioni* of 1546, concedes that this notion was slow of acceptance: "Ben è vero, che i Pittori non possono esprimere così felicemente il di dentro, come il di fuori" ("It's of course true that Painters can't express the inside as felicitously as the outside"). Yet the notion was so vigorously propelled by Michelangelo that it became a commonplace by the end of the century. One is tempted to add to these unorthodox ideas individually expressed such plaintive condemnations of the fine arts as abound in Chapter VI (e.g., the manufacture of sulphur matches is a more rewarding vocation than the exercise of the fine arts). Yet, even if such opinions are valuable as reminders of the states of mind over which some of Buonarroti's masterpieces triumphed, one hesitates to group them here with his more permanent convictions and theories.

A last group of data remains to be taken into account. To what extent do the twenty-four criteria of criticism by which Michelangelo rated other artists and works of art make him a typical or atypical thinker? Exactly half of the twenty-four are issues we have enumerated during the preceding paragraphs. We shall distribute these twelve criteria into the four categories already established:

Typical issue typically expressed: Beauty; ancients vs. moderns; self-consciousness as artist (glory); nobility; effort and speed.

Typical issue atypically expressed: Design; color; nationalism; sociomilitary value of artist; knowledge.

Atypical issue typically expressed: None.

Atypical issue atypically expressed: Mathematical formulation; inner vision.

Of these dozen criteria, ten are related to typical issues and two to atypical ones.

The remaining twelve criteria are dissociated from the issues we have been enumerating. Of these latter criteria, six were common enough in the Renaissance: perfectionism; study; rivalry with nature; lifelike quality of figures; skill; sense of proportion. The other six were individual if not atypical: choice of subject matter; suavity (grace); patience; boldness; selectivity (of detail); worthiness of more imposing medium. The expression of them is succinct and inconclusive and will not figure in our statistics.

Can one therefore generalise, as has been done, that Michelangelo's thinking on art was typical of his time, but that the expression of that thinking was atypical? Reviewing our sampling of issues and criteria, and disregarding for the moment that not all of these are of equal weight and not every minor issue adumbrated throughout this volume is included, one can tabulate them as follows:

Typical and typically expressed:	22 issues	(5 criteria)*	27 data
Typical and atypically expressed:	14 issues	(5 criteria)*	19 data
Atypical and typically expressed:	8 issues	(0 criteria)	8 data
Atypical and atypically expressed:	3 issues	(2 criteria)*	5 data
Typical and expression inconclusive:		6 criteria	6 data
Atypical and expression inconclusive:		6 criteria	6 data
	47 issues	24 criteria	71 data

* These criteria duplicate the issues from which they stem.

Our tabulation shows that one should not assume or conclude flatly that Michelangelo's thinking was orthodox and his forms of expression unorthodox. A classicist and conformist, Michelangelo shared in common with his contemporaries an interest in 42 issues and criteria (22+ 14+6), coupling those pairs of issues and criteria which duplicate each

· *407*

other. Yet he initiated discussion on as many as 17 issues and criteria (8+3+6) to which he, unlike his contemporaries, assigned major importance. The ratio in favor of thematic orthodoxy is 5 to 2, which is not at all high for an age when rediscovery of a few authoritative texts from antiquity prescribed the issues for the humanists and when original issues were at a premium.

Granted that Michelangelo was creditably original in the issues of his thinking, what may one conclude about his forms of expression? Writing on 47 issues of conventional and unconventional nature, he expressed himself typically on 30 (22+8) issues and with originality on 17 (14+3) issues. Since a recognised trait of Renaissance writers was their ability to manipulate, reshuffle, and improvise on the themes and subjects which were part of their heritage from the classics, one is entitled to expect a high ratio of originality in Michelangelo's articulation and interpretation of the issues he admitted into his aesthetics. Quantitatively one cannot, then, make the flat assertion that Buonarroti was typical in the themes of his thinking and atypical in his form of expression. Qualitatively, that is, reading into the statistics the fact that Cinquecento writers were generally more original in their articulation than in their ideologies, one might even conclude that, while Buonarroti reflected his age in both the themes and the expression of his thinking on art, his contribution of 17 new issues and criteria of criticism was a far more important one than the 17 new forms of expression. In the words of Michelangelo himself, the concept or idea is more important than the translation of it.

As we have performed the delicate operation of sifting the typical from the atypical thoughts, we have sought to observe whether either category characterised Michelangelo the academician apart from Michelangelo the technician. No such correlation was possible. Both the typical and atypical thoughts are speculative or theoretical in nature, which comes somewhat as a surprise when one reflects on the large number of pages in the *artes pictoriae* and dialogues on painting devoted to considerations of technique. Michelangelo's devotion to the *philosophia libero digna*, like his well-known unwillingness to enter into "shop talk," was a part of his consistent effort to raise painting and sculpture to the status of

liberal arts and the artist from the level of technician to that of philosopher.

We have cast a last backward glance at the continuity and orthodoxy of Michelangelo's thinking patterns. Now we must pause once more over the mosaic of those thoughts to comment on their consistency. His claim "io non mi contraddico" has been invoked as evidence of his consistency-in-depth. Leaving aside the question of continuity and dating, how well does this boast of consistency apply to his theories viewed absolutely? Conceding with Emerson that a great soul need have nothing to do with consistency, how well do the tesserae at hand match or fit together in the mosaic? There have been paradoxes and inconsistencies, apparent and real, in his reflections on both art and life, reflections which intrude upon one another. There have been fewer of these than one has a right to expect from such a complex mind, one of the five greatest of the Christian Era, according to Taine. Some, however, were the familiar paradoxes which confronted every Renaissance theorist on art. A few dealt with the artistic process. There was the conciliation to be effected between beliefs in inborn genius and acquired skill or, as Michelangelo phrased it to Cardinal Salviati, "the learning of the alphabet of his profession." There was his belief in the requirement of models and sketches (*pensieri*) in working out a basic form, opposed to his conviction that *concetti* exist in nature to be "discovered" independent of any warming-up process. There was his acceptance of the artist's role as imitating God's forms, contrasted with his belief that God himself guides the artist's chisel or brush. Other paradoxes dealt with the themes or subject matter of his art: the contrary pulls of Hellenic myth and of Christian lore; a conservative penchant for decorous sublimity alongside an indulgence in grotesque, just as incongruous as the inclusion of his Bernesque verse alongside his religious sonnets; a certainty that the greatest art serves the Church by inspiring compassion and fear of God alongside a hesitancy to sculpture or paint a Crucifixion. There was his theory synthesising painting and sculpture as a single art opposing a practice breaking down that synthesis into two differing theses or competing antitheses.

· *409*

Despite the apparent incompatibility of these particular theories, we have found that there were generally avenues of reconciliation left open. A man's patterns of thought never divide into so complete a scission as that of which his inner nature is capable. The paradoxes of Michelangelo's thinking on art or on life are overshadowed by the greater paradox of the man himself, a curious compound of genius and all-too-human mortal, in whom pride was morganatically wedded to humility. It is with a few considerations of this human paradox that our volume will close. Just before abandoning the subject of Michelangelo, we shall once more probe deep into the soul of this often unfathomable man who could boast of his noble lineage and yet "habitually ride about on a little mule,"[5] like a Sancho Panza. This final paradox will arise from the dual nature of the artist as a humble agent or tool of God and a prideful maestro teeming with the consciousness of his mature powers and his professional importance.

Let us first assess the feelings of modesty of this artist who could write, "I'm a simple man of little worth" (Letter CDXXII). Michelangelo's modesty was tripartite: social, Christian, and professional. In Donato Giannotti's *Dialoghi* one glimpses evidences of the former type. When Antonio Petreo tells the company that Michelangelo is as good a painter, sculptor, and architect as ever existed, Michelangelo is graciously and sincerely uncomfortable. He objects that, unless Messer Donato spares him from this flattery, he will be like the crow in Aesop: "talchè se i legittimi padroni di quegli ornamenti de' quali voi mi havete vestito verranno per essi, restando io ignudo darò materia di ridere a ciascuno" ("so that if the legitimate owners of these ornaments with which you have clothed me will come for them, I shall remaining nude be the laughingstock of all").[6] Later in the same colloquy he begs them to stop lauding his poetry with the plea, "There is nothing which makes a modest person blush more than praising him in his presence."[7] In his correspondence (Letter CCXCVI) he regrets that self-love deceives all men. It is fortunate that Michelangelo, who was so set against the "clasping of ecstatic hands" (Lucian), never had to read the rash of poetic tributes contained in the *Esequie* following his death. In the *Stanze in lode della vita rusticale* he claimed that among honest people pride has none

or nothing to feed upon. "La superbia se stessa si divora" ("Pride feeds upon itself").[8]

Yet the depth of this social modesty to which he appears to claim title remains open to question. When discussing Dante with the *cenacolo* at Giannotti's, he protests, "I well realise that you have today made me engage upon a theme which exceeds my forces, and each one of you would have dealt with it much better than I."[9] Nevertheless, when Donato, probably the most learned of them, disagrees with Buonarroti's eventual exculpation of Brutus and Cassius, the artist becomes indignant and overbearing, prey to the Dantean lion of the *Inferno*. Michelangelo's social modesty was no more real than it was apparent.

The same cannot be said of his Christian humility. He honestly felt that at best man was a mere collaborator of God. The corner spandrels of Haman and the Brazen Serpent are archaic Christian sermons against the proud. The only irrepressibly egotistic note here is at a lower level of reasoning: only a few men were qualified to serve in this auxiliary capacity of collaborator, and Michelangelo knew himself to be one of these happy few. When he finished the Sistine Ceiling (1509 phase), which he had undertaken to embellish for the greater glory of God, he wrote modestly to old Lodovico, "Io ò finito la capella che io dipignievo" ("I've finished the chapel I was painting").[10] His Christian humility has been assessed at some length in Chapter II. That it tended to curb his professional pride is demonstrated by the *Pietà* at Florence, where Michelangelo is willing to portray himself as *Nicodemo* but shrouds himself in a hood so that only the minimal center of his face is revealed.

Of his professional modesty there is grave doubt. Noting the complacency of his friend Giuliano Bugiardini, he would declare with humility that he Michelangelo had never finished a work of art which satisfied him fully.[11] The register of Michelangelo's disclaimers of professional competence is a long one. The phrase "it is not my profession" recurs over and over again in the letters and poems of Michelangelo, a surprising aggregation of modesty. Collecting these disclaimers, one finds the phrase "non è mia professione" applied in the letters to fresco painting (X), making daggers (XLVIII), writing business letters (XCVIII), running a shop (CLXXXIII and CXCV), painting, sculpturing, or practic-

ing architecture (CDLX), and writing letters of any sort (CDLXXXII). In the *Rime* the identical phrase is used to disclaim ability in poetry (LVII) and the wording is varied to deny any competence in painting (IX and CII) and literary criticism (LXXIII, 14). He assured Vasari (*Vite*, VII, 218) and Condivi (*Vita*, LXI) that he was no architect. Yet this was the same artist who came to feel that no art was worth anything which had not passed "through his anointed hands" (Masoliver) and could even make what was for him the consummate boast, that he, like a god, put *concetti* into marble:

> Com' io fo in pietra od in candido foglio,
> Che nulla ha dentro, et euui cio ch' io uoglio.[12]

He could toss off the statement, without appearing to boast, that in his slavery and his tedium he kept sculpturing divine things: "a scolpir qui cose diuine" (CXLIV). Yes, Michelangelo could even be disarmingly frank about his professional pride. After taking time to show Niccolò Franco about the constructions at St. Peter's, he breaks in on the effusive thanks being uttered by this friend of Aretino: "Badate: forse la mia cortesia nacque dall'amor di me stesso; badate, io forse ho porto troppo facile orecchio alle lodi che voi faceste di questo edificio" ("Be careful, perhaps my courtesy was born of love of myself; be careful, perhaps I have lent too willing an ear to the praises you expressed of this building").[13] Other evidences of Michelangelo's professional pride have been presented in earlier chapters: There was his adherence to the neoclassic ideal of glory. There were his claims of a competence, even primacy, in the several arts, and a willingness to compare himself favorably with the ancients, as his contemporaries were so ready to do on his behalf. We have seen how he was the despair of many assistants and even colleagues through his sense of superiority. Vasari acknowledges that Buonarroti was possessed of a "viva fierezza" as far back as the Giardino Mediceo, a keen pride which, colliding with Torrigiano's, earned for him his disfigured nose.[14] During the succeeding centuries his social modesty and Christian humility tended to be forgotten and his professional haughtiness remembered. In *Art and Scientific Thought*, Martin Johnson posits him as a superlative example of *hybris* and finds his works themselves expressive of this fatal flaw: "At the two opposite extremes, the gentle

piety of Fra Angelico and the tense and superb arrogance of Michelangelo are inescapable in their painting and sculpture."[15]

Michelangelo, like Timaeus, could not take criticism from anyone, even though dispensing it widely and gratuitously. He lived for praise and once revealed a fundamental concern by describing dispraise as something equivalent to death: "Io non so già qual si pesi più o 'l vituperio o la morte." To accept the inference in Symonds' statement that "neither in his letters nor in his poems does a single word of self-complacency escape his pen" is to delude oneself about the intense coals of professional pride which lay smoldering and awaiting the slightest breath of criticism to burst into flame. Read the words of Michelangelo's bitter letter to Luigi del Riccio (1546) when the latter refused to destroy the plate of one of Michelangelo's works and the copies he had struck off.[16] Diego de Mendoza and Nuñez Alba both record a painfully human rejoinder of Michelangelo's to someone who was running down one of his paintings: "You who are such a great painter, take this brush and paint me a pumpkin!" Michelangelo's inability to accept criticism may even be the mysterious reason which prompted him to write his father to remove from his studio in Florence "quella Nostra Donna di marmo" (the Bruges *Madonna*) and to forbid that anyone be admitted to see it.[18] His allergy to criticism made him so hypersensitive as to find censure where none existed, as in the case of Francesco Francia (see Chapter IV, note 132) or the case of Il Rosso Fiorentino, who protested fearfully to Michelangelo (1526) that he had never uttered a disparaging remark about the Sistine Ceiling.[19]

Granted the existence of this intense professional egotism, is it possible that it is manifest in Michelangelo's sculpture and painting, as Johnson claimed above? Can an artist betray his own pride and self-confidence in paint or stone? True, people seem to concede that other sentiments and emotions are so revealed. Scholars have not been timid about positing those emotions. Justi saw Michelangelo's statues as vehicles of his melancholy. Rodin found in Michelangelo's figures the Florentine's "reploiement douloureux de l'être sur lui-même." Masoliver asserts broadly that in all his works Buonarroti painted his soul and passions.[20] Remembering the lines

è natura altrui pinger se stesso
ed in ogni opra palesar l'affetto
It is natural for one to paint himself
and display his feelings in every work

or the similar confession in his madrigal to Vittoria Colonna (CIX, 89) reported in Chapter III, one may conclude that Michelangelo himself believed he revealed his moods in his creations. In the case of one who bared his soul so completely in letters and poems, we are justified in seeking a similar revelation in his artistic creations. Thus Mariani finds that the *Notte*, craving in sleep a deliberate refuge from the world's woes ("Non mi destar!"), corresponds to that Michelangelo of the escapist velleities who pleaded to Giannotti, "Lasciatemi stare nei miei panni ravvolto" ("Just let me alone wrapped up within myself").[21] One cannot deny that many of Michelangelo's figures are "wrapped up" as he often longed to be. Perhaps the sculptor was sometimes loath to "unwrap" the figure, which would account for the number of *non finiti*. Granted that this is conjecture, it is nevertheless supported by his poem sympathising with the stone figure of Cecchino's sepulcher which had never wanted to be brought down from its mountaintop and "unwrapped" by a sculptor (CXXV).

Panofsky accepts this premise of self-revelation in one's works and believes that a feeling of humiliation on the part of the artist is discernible in the sketch of *Fetonte*, that Phaethon's fall is a graphic counterpart to the humiliation exposed in Michelangelo's letters to Cavalieri.[22] Other acknowledgements of the moods inspired by Tommaso Cavalieri may be the soaring Ganymede, the tortured Tityus, and the *Genio della Vittoria*, called by Justi Michelangelo's "most puzzling work" (Plate V). This group, done at the very time when the artist was first attracted to Cavalieri, would seem to express the sentiments he wrote (L) to that Roman nobleman:

Se nel uolto per gli ochi il cor si uede,
Altro segnio non ò piu manifesto
Della mia fiamma; addunche basti or questo,
Signior mie caro, a domandar mercede.

If through the eyes the heart is seen on the face,
No other sign more manifest have I

Of my flame; let this then be enough,
My beloved lord, to ask mercy of thee.

The statue incarnates the confession Michelangelo made to Donato Giannotti and his friends:

Qualunche volta io veggio alcuno che abbia qualche virtù, che mostri qualche destrezza d'ingegno, che sappia fare o dire qualche cosa più acconciamente che gli altri, io sono costretto a innamorarmi di lui e me gli do in maniera di preda, che io non sono più mio, ma tutto suo.[23]

Whenever I see someone who possesses some virtue, who displays some agility of mind, who knows how to do or say something more fittingly than the rest, I am constrained to fall in love with him and I give myself to him as prey, so that I am no longer mine, but all his.

Believing as he did that the work of art itself can divulge an artist's sentiments, disposition, intention, or mood, Michelangelo eschewed accompanying verses, scholia, or even titles which might betray the artist's state of mind. Once in a great while he left an overt clue, however. In concluding this volume, let us look at two marginalia which may teach us something further concerning Michelangelo's egotism. The first inscription (1), which we shall call a distich although it could possibly be a conventional hendecasyllable from some lost sonnet, reads simply:

> *Dauicte cholla fromba*
> *e io choll' archo*
>
> *Michelagniolo*
>
> *David with the sling*
> *and I with the bow*
>
> *Michelagniolo*

Lower on the page stands the isolated verse:

> *Roctè lalta cholonna el uerd*
>
> *Broken is the lofty column and the green.*

Before attempting to gloss these words, which have baffled so many historians, let us scrutinise the page on which they occur (Plate XX). On the left third of the sheet is a pen sketch of the now-lost bronze *David*

which was commissioned by Pierre de Rohan, Maréchal de Gié. This sketched figure, which Rohan had hoped would resemble Donatello's *David* in the courtyard of the Signory, differs from the famed marble *David* in both conception and pose. The vital and energetic youth of the drawing rests a triumphant foot on the head of Goliath. The middle vertical area of the page is occupied by a pen study generally acknowledged as the right arm of the marble *David,* drawn upside down. To the right are the verses, which must of necessity bear upon both of the drawings, since the Idea of *David* constituted a single *concetto* to Michelangelo's mind. It is probable that the sketch for the marble *David* was executed in late 1501 and for the bronze in 1502. No date has been assigned the verses.

Let us return to the hermetic meaning of these four lines. The last, detached verse is an incomplete form of the incipit "Rotta è l'alta colonna e 'l verde lauro," from Petrarch's sonnet CCIX, which mourns the passing of Laura and Cardinal Giovanni Colonna.

The first two lines are not Petrarchan in origin. There is no occurrence of the word "fromba" in Petrarch's *Rime* and the word "arco" is applied by Petrarch almost exclusively to Cupid's or the hunter's bow (and once to the rainbow). Since obviously some ego–alter-ego symbolism is announced, it becomes necessary to examine further the iconographical value of the words "arco" and "fromba." The "arco," most ancient of weapons, had various emblematic meanings in the Renaissance which must be rejected at the outset: America; Arduinna or Diana; Cupid; Lucina, bearer-of-light-to-the-newborn. The bow was also the symbol of war, of tumult, of counsel (from the bowed shape of the lips), and of the stings of love. Two meanings which Michelangelo may have borne in mind were: sharp pain (from the birth pains of creation at which Lucina is attendant) and Apollo, the god of light and creative genius, whose brilliant rays sting like arrows. Vasari claims that Michelangelo's *Apollo* is drawing an arrow from his quiver.[24] (The missing word "lauro" of the last line was also an emblem of Apollo, of course.) A third possible value for "arco" which would be relevant might have come from Michelangelo's beloved Dante: attention, zeal, or desire.[25]

There have been additional interpretations, more prosaic, of this second line. Symonds finds a clue in the expression "coll'arco della

schiena," meaning "with all one's might." Brion thinks that the word "arco" refers to a bow and string operating a drill which Michelangelo employed to pierce marble. Papini sees in "arco" the meaning of intelligence or mind and interprets the verse as a promise to vanquish the Philistines, or Michelangelo's rival artists.[26] Others have suggested that it referred to the bowed back of the sculptor engaged on his work. Perhaps they recall Michelangelo's satirical poem on painting the Sistine Ceiling (ix) where he described himself as bent like a Syrian bow, identified elsewhere as the most twisted kind (xxxvii).

The meaning of "fromba" is clearer in the scholium. It has no novel iconographical value, being precisely the symbol of David in all manuals of iconology. The word is nonexistent in the poetry of Dante and Petrarch, by the way. The "fromba," then, as David's symbol of strength, represents service to God. Accordingly, the "arco," in any of the more logical acceptances above, serves as a parallel symbol of the creative process by which Michelangelo serves God—whether he intended to stress the pain of artistic parturition, the brilliance of his artistry, or his creative enthusiasm. Even if some actual instrument as that suggested by Brion were intended, the ultimate sense of the inscription would be altered little. The burden of the distich is that David and Michelangelo are powerful and triumphant in the service of God. It claims for the sculptor an heroic stature no less great or puissant than his great *concetti*, which as Ideas "swell within his mind." That Christian strength over enemies of God is the theme of the lines is verified by the lost quatrain which Michelangelo apparently inscribed on the pedestal of the bronze *David*, set into French by a Loire Valley poet alleged to have been Ronsard:

> *Moy, David, en moins de trois pas*
> *Que je fis devant tout le monde*
> *Je mis Goliath au trépas*
> *D'un seul juste coup de ma fronde.*[27]

This bronze, when the completed work was last seen at Bury in France, was informed with this triumphant note. For David no longer trod on the giant's head but held aloft "devant tout le monde" the head of Goliath (if one accepts the architect Ducerceau's contemporary elevation of the

château and gardens of Bury). Christian strength as a weapon becomes more trenchant and effective in Michelangelo's mind as time goes on: the marble *David* bears an idle (resting) sling. The bronze *David* bears a triumphant, drawn sword (in Ducerceau's drawing). And the *David* of the corner spandrel of the Sistine Ceiling wields a flying scimitar.

We know that at the period of Michelangelo's life represented by these Louvre sketches and their enigmatic verses Michelangelo had gone through the searing experience of deciding not to enter the Dominican Order but to serve God in a more compatible way, through art. Although he resisted the priestly calling, he wondered on and off throughout his life whether the exercise of the three arts was sufficient to satisfy God or whether they were vanities "charged with error." In dedicating himself to the portrayal of inspirational Christian heroes, the young artist still in his twenties felt that his bow was just as much at the active disposal of God as was the sling of the young David. He was aware that he had a lifetime ahead of him which must justify this decision to serve through art and that the present triumphs in sculpture were not necessarily an earnest of a succession of triumphs. As happened often, his artistic self-confidence was modified by his Christian humility. The example of David, who was to prove inadequate to God's trust and endure disgrace among his people, was before him. The wheel of fortune could turn for him as it had for David, and in the well-known words of his first patron, "Di doman non c'è certezza" ("There's no certainty about tomorrow"). The old King David of the Sistine *antenati* knows this.

Thus, if one assumes that the line below is associated in time and meaning with the distich above, Michelangelo's mind lingers momentarily on the thought of the peripeteias of life and the personal catastrophes which lie in wait for us. For the lower line from Petrarch, inspired by the loss of two friends, laments that a lifetime of accomplishment and effort can be easily swept away in a single morning. Michelangelo's humanist friends in Florence knew how easily and quickly this could happen from their study of Greek tragedies, where Oedipuses suffered complete reversals of fortune within the mere circuit of the sun. This concern for the future resulted in a long series of letters filled with psychomachy, fears of personal inadequacy, and dread anticipation of

failing powers, until that last pitiful letter in which Michelangelo confessed to Fattucci, "I have lost my brain entirely." The Petrarchan line, a lesson in humility and the fear of God's ways (a friend of Savonarola found Michelangelo's outstanding characteristic that he was "timorato di Dio"),[28] continues the ego–alter-ego theme of the distich. In this line he is not merely comparing, but is identifying himself with the *David* (in either of the two media represented on the page), just as at other periods of his life he purportedly identified himself with *San Proculo, San Bartolommeo, Nicodemo, Oloferne,* and others. But this *David* the giant killer was at this planning stage transforming himself into a triumphant colossus. The Florentines were quick to call the marble *David* "the giant," as quick as they were to find similar epithets for the sculptor.

There may even have been a more immediate provocation for the recording of the verse from Petrarch. Curiously enough, while Michelangelo was still engaged on the bronze *David,* an event occurred which threw into clear focus the lesson of Petrarch's sonnet. In 1504 Pierre de Rohan, for whom Soderini originally ordered the metal *David,* fell from his lofty station as the favorite of Louis XII and endured public disgrace. The ignominy was so complete that the Florentine Signory took it for granted that the *David* would not be sent him, inciting Pandolfini to write to them that they must not emulate Fortune, which abandons people. If by chance the lower line was added when Michelangelo was pondering on this vicissitude of fortune, which made him wonder for whom he was actually executing this bronze, the reference is not Biblical, but contemporary. Even so, the lesson in humility that we have read into the line remains unchanged and unweakened. Thus, the conflicting pulls of *hybris* and humility stand revealed even in these jotted lines.

Tradition, following Vasari and not concerning itself with scholia, has attributed a civic meaning to the marble *David,* the significance which was assigned to the figure even before the Signory had chosen the sculptor to execute it. "Just as he [David] had defended his people and governed with justice, so should anyone governing the city of Florence defend it stoutheartedly and govern it justly." Tradition has not fretted particularly about the meanings in the disappeared bronze version. Yet the scholia

(and the quatrain translated into the French) point to a religio-personal interpretation. Even the last line can strike a more religious note than it had in Petrarch, if we recall that one of the statutes which God imposes upon us all is to overthrow the altars of his enemies and "break their columns" (Deuteronomy, XII: 3) ; in this Biblical terminology the line becomes a figurative record of services rendered unto God, consonant with the general note of triumph. Be this as it may, David and Michelangelo are Christian servants and heroes alike. The breath of divinity has passed into them. Both have been given life and force and will by the Creator. And both are thankful. "Deus qui accinxit me fortitudine et complanavit perfectam viam meam . . . Dilatabis gressus meos subtus me, et non deficient tali mei . . . Propterea confitebor tibi, Domine, in gentibus [i.e., "devant tout le monde"], et nomini tuo cantabo," sings David.[29] "Noi abbiáno sommamente da ringraziare Idio," echoes Michelangelo,[30] while still engaged on the bronze *David*. He cannot forget the affinity between the two, between the artist and his creation, which caused him to declare in that sonnet, "Then I can give us both long life in either color or stone, the face of each thus preserved."[31]

ALTRO NON M'ACADE

NOTES TO

Michelangelo's Theory of Art

INTRODUCTION

1. Donato Giannotti, *Dialoghi de' giorni che Dante consumò nel cercare l'Inferno e 'l Purgatorio* (Florence, 1939), p. 42.
2. Ernst Steinmann and Rudolf Wittkower, *Michelangelo-Bibliographie* (Leipzig, 1927), no. 304. The source is Condivi, *Vita*, lx.
3. Giorgio Vasari, *Le Vite de' più eccellenti pittori, scultori, ed architettori* (Florence, 1878–85), VII, 274.
4. Ascanio Condivi, *Vita di Michelangelo Buonarroti* (Pisa, 1823), p. 73.
5. Giorgio Vasari, *ed. cit.*, VII, 228.
6. John Addington Symonds, *Life of Michelangelo Buonarroti* (London, 1893), I, 215.
7. Valerio Mariani, *La Poesia di Michelangelo* (Rome, 1941), p. 3.
8. Gaetano Milanesi, *Le Lettere di Michelangelo Buonarroti* (Florence, 1875), p. 462. Cf. Letter CXXVI: "Io non ti scrivo particularmente l'animo mio."
9. On Michelangelo as poet, *v.* also Thode, *Michelangelo* (Berlin, 1903), II, 132 ff.
10. Vasari, *ed. cit.*, VII, 305.
11. Charles de Tolnay, "La théorie d'art et Michel-Ange," in *Deuxième Congrès international d'esthétique et de science de l'art* (Paris, 1937), II, 25.
12. Sherman Lee, "Daniel's Dream," *Art Quarterly*, IX, 3 (1946), 260.
13. Nesca Robb, *Neoplatonism of the Italian Renaissance* (London, 1935); Anthony Blunt, *Artistic Theory in Italy, 1450–1600* (Oxford, 1940).
14. Juan Ramón Masoliver, "Las ideas estéticas de Miguel-Ángel y de sus poesías de escultor," *Escorial*, May, 1942.
15. Rezio Buscaroli, *Il concetto dell'arte nelle parole di Michelangelo* (Bologna, 1945). Pp. 31.
16. Bianca Toscano, *Il pensiero di Michelangelo sull'arte* (Naples, 1951). Pp. 34.
17. *V. supra*, note 7.

18. Vasari, *ed. cit.*, VIII, 293.
19. Blunt, *op. cit.*, p. 58.
20. Robb, *op. cit.*, chap. VIII.
21. Mariani, *op. cit.*, p. 60.
22. Masoliver, *op. cit.*, p. 233.
23. Robb, *op. cit.*, p. 241.
24. Hans Tietze, "Francisco de Hollanda und Donato Giannotti's Dialoge und Michelangelo," *Repertorium für Kunstwissenschaft*, XXVIII (1905), 295–320; Carlo Aru, "I Dialoghi romani di Francisco de Hollanda," *L'Arte*, XXI (1928), 117–28.

 Although the contents of the refutation in the *PMLA Quarterly* (note 31) as well as the present volume itself should serve to dispel the doubts voiced by Tietze and Aru, certain immediate replies may be made here to several of their main points. Tietze admits more readily than Aru that the spirit of Michelangelo informs these dialogues. Both feel that De Hollanda consciously introduced Michelangelo into the dialogues so that the latter's few remarks on patronage would win better treatment for artists in Spain and Portugal. Yet, however dictated by self-interest the inclusion of these few lines may have been, this does not necessarily disprove the accuracy of the entire book. Three of Michelangelo's listeners, moreover, had a special interest in Spain and Portugal, as Aru fails to point out.

 Both Tietze and Aru (who apparently borrows some doubts from Tietze) object to certain statements attributed to Michelangelo by De Hollanda on the ground that they resemble in a general way opinions encountered in other Renaissance treatises on art (by Alberti, Leonardo, and others). Most of Aru's article is predicated on this objection, and that is its major weakness. In no way does he prove or try to prove that De Hollanda would be more likely to know or draw upon these Italian sources than would Michelangelo. As a speaker in the *Dialogos*, Michelangelo very possibly echoed certain general ideas on art which he had gathered from his contemporaries; this in no way invalidates the *Dialogos* as an authentic statement. Aru and Tietze seem to assume that the mature Michelangelo was a mere technician unfamiliar with the *artes pictoriae* of the time and unacquainted with the leading theorists, rather than the second-top figure in the Florentine Academy and one of the influential thinkers of his day. Furthermore, Michelangelo's poems and letters very often present a closer correlation with his quoted statements than is offered by the contemporary tracts on art.

25. Symonds, *op. cit.*, II, 116.
26. Elías Tormo edition of *De la pintura antigua* (Madrid, 1921), p. xxiv.
27. Marcelino Menéndez y Pelayo, *Historia de las ideas estéticas en España* (Madrid, 1901), IV, 112.

28. Valerio Mariani, *Michelangelo* (Torino, 1942), p. 218.
29. Buscaroli, *op. cit.*, p. 9.
30. Emilio Radius, *Colloqui con Michelangelo* (Milan, 1945), p. 21.
31. R. J. Clements, "The Authenticity of Francisco de Hollanda's *Dialogos em Roma*," *Publication of the Modern Language Association,* LXI (1946), 1018–28. The general argument of this article may be gathered from the following four paragraphs :

Two paths of investigation lie open to us, the examination of exterior and of inner evidence

When one is dealing with an historical figure about whom so few biographical facts are known, a demonstration of authenticity based on exterior evidence becomes an ingenious but unreliable exercise in detectivism. There are a few data adduced by the historians which might help us to conclude that the *Dialogos* are authentic. The mere fact that Francisco was a friend of Buonarroti is attested by a cordial personal letter sent from Lisbon to Rome, 15 August, 1953. It is historically proved that Michelangelo visited Vittoria Colonna frequently in the garden of the Church of San Silvestro. One of her invitations to him still exists. One can add these facts to other historical evidence and demonstrate with reasonable certainty that Francisco de Hollanda did actually meet with Michelangelo, Vittoria Colonna, Lattanzio Tolomei, Fra Ambrosio da Siena, and the others, much as he described it. But all these data together cannot prove the veracity of the dialogues as recorded. In fact, no exterior evidence could of itself establish at this late date whether Francisco recorded honestly what he heard.

Can examination and assessment of the inner evidence prove more fruitful? We believe that it remains the only way to make an honest appraisal of Francisco's veracity. By inner evidence we understand the words themselves which he attributes to Michelangelo and the others. By studying and systematising the principal statements of Michelangelo recorded in the dialogues, we shall endeavor to show that they coincide with and complement opinions which he voiced in his letters and poetry. We shall note how accurately De Hollanda captured the attitudes and personality of Michelangelo as we know them through other sources. In a few instances, our attempt to demonstrate the truthfulness of Francisco will lean on testimony of such contemporaries as Condivi and Vasari and the rest.

In this enterprise, we shall not choose a few hand-picked passages which tend to support our view, but shall select the dominant themes or opinions which constitute the bulk of Michelangelo's remarks. These passages will fall under the following headings: inspiration and genius, religious motivation of art, differentiation of the arts, exclusiveness (Ivory-Towerism) of the artist, the financial rewards of art, social value of art, nationalistic ideas, personal characteristics, and biographical data.

To these arguments on behalf of De Hollanda one could at this later date add many others, many of which will be pointed out in this volume.

32. Irene Cattaneo, *La Vie d'Italie*, March, 1928; A. M. Bessone Aurelij, "Della Sincerità di Francisco d'Olanda," *Il Vasari* (1930), p. 202; for Bianca Toscana, *v. supra*, note 16.

33. Giannotti, *op. cit.*, p. 82.

34. Symonds, *op. cit.*, I, 10.

35. For example, Michelangelo copied the first verse of a Latin elegy of Petrarch: "Valle lochus chlausa toto michi nullus in orbe." *V.* E. Panofsky, *Studies in Iconology* (New York, 1939), p. 179.

36. Giannotti, *op. cit.*, p. 65.

37. Cesare Guasti, *Le Rime di Michelangelo Buonarroti* (Florence, 1863), p. xli.

38. Carl Frey, *Michelangelo: Quellen und Forschungen* (Berlin, 1907) I, 16 f.

39. Eugène Guillaume, *Michel-Ange sculpteur* (Paris, 1896), p. 110.

40. Buscaroli, *op. cit.*, p. 30.

41. Giovanni Bottari, *Raccolta di lettere sulla pittura, scultura ed architettura* (Milan, 1822), III, 476.

42. Also, Vasari praised Homer for "sculpturing and painting" the shield of Achilles rather than writing of it. *Le Vite, ed. cit.*, I, 218.

43. Giovan Paolo Lomazzo, *Idea del tempio della Pittura* (Milan, 1590), p. 16.

44. Alberti, *Della Pittura* (Florence, 1950), p. 78.

45. Frank P. Chambers, *Cycles of Taste* (Cambridge, U.S.A., 1928), pp. 14–16.

46. Rensselaer W. Lee, "*Ut Pictura Poesis*: The Humanistic Theory of Painting," *Art Bulletin*, XXII (1940), 201.

47. The reader will encounter references to two different editions of Alberti's *Della Pittura* (Milan, 1804, and Florence, 1950), since these represent varying translations from the original *De pictura*.

48. The existence of variant autograph codices in the Vatican and in Florence was the source of uncertainties and disputes in the mid-nineteenth century. *V.* Cesare Guasti, "Di alcune critiche tedesche sulla nuova edizione delle *Rime di M. A. Buonarroti*," *Il Buonarroti* (Rome, 1868), pp. 3–22. On the history of the manuscripts and editions, the definitive survey is the "Nota Filologica" in Girardi's edition of the *Rime* (Bari, 1960).

CHAPTER I: BEAUTY, INTELLECT, AND ART

1. Paolo Pino, *Dialogo di Pittura* (Venice, 1946), p. 67.

2. *Ibid.*, p. 92.

3. P. O. Kristeller, "Francesco Diacceto and Florentine Platonism," *Miscellanea Giovanni Mercati* (Vatican City, 1946), IV, 1–45.

4. Quoted in Frey, *Die Dichtungen*, p. 263.

5. Sarah Brown, "Plato's Theory of Beauty and Art," *Deuxième Congrès International d'esthétique et de science de l'art* (Paris, 1937), pp. 13–18.
6. *Enneads*, I, vi, 9.
7. This compilation appears in H. Ritter and L. Preller, *Historia Philosophiae Graecae et Romanae ex fontium locis contexta* (Gothae, 1864). It is Englished in Stephen MacKenna's *Plotinus: The Ethical Treatises* (Boston, n. d.), I, 129.
8. P. O. Kristeller, *The Philosophy of Marsilio Ficino* (New York, 1943), p. 266.
9. Ficino, *Commentarium in Convivium*, V, iii; also Plotinus, *Enneads*, I, vi, 1.
10. Blunt, *Artistic Theory in Italy, 1450–1600* (Oxford, 1940), p. 93.
11. Ficino, *Commentarium*, VI, vi.
12. *Ibid.*, II, ix.
13. Condivi, *Vita*, lxv.
14. Ficino, *Commentarium*, V, iv.
15. Mariani, *La Poesia*, p. 41.
16. De Tolnay, *The Youth of Michelangelo* (Princeton, 1943), p. 30.
17. Sappho, *Oxyrhynchus Papyri*, xv, (1922), no. 1787.
18. Vasari's *Lives of Seventy Painters, Sculptors, etc.*, Blashfield-Hopkins edition (New York, 1926), IV, 245.
19. Vincenzo Danti, *Il Primo libro del trattato delle perfette proportioni* (Perugia, 1830), p. 87.
20. Mariani, *La Poesia*, p. 148. Cf. Michelangelo's criticisms of his nephew Lionardo's handwriting in the *Lettere*.
21. De Hollanda, *Da pintura antigua* (Porto, 1930), p. 185.
22. *Ibid.*, p. 190.
23. *Ibid.*, p. 235.
24. The *lezione* is reproduced in the Guasti edition of the *Rime* (Florence, 1863), pp. lxxxv–cxii. Original edition was *Due lezzioni di M. Benedetto Varchi* (Florence, Lorenzo Torrentino, MDXLIX).
25. Lorenzo de' Medici, *Opere* (Bari, 1914), II, 68.
26. De Hollanda, *op. cit.*, p. 234.
27. *Ibid.*, pp. 208–209.
28. Mariani, *La Poesia*, p. 12.
29. Vasari, *ed. cit.*, I, 169.
30. Ficino, *Commentarium*, II, iv.
31. Cicero, *Divinatione*, I, 13, 23; Pliny, *Hist. Nat.*, XXXVI, 14.
32. Giovanni Battista Bellori, *Le Vite dei pittori, scultori ed architettori* (Rome, 1672), p. 13.
33. Plotinus, *Enneads*, V, viii, 3.
34. *Ibid.*, V, ix, 3.

35. *Ibid.*, V., viii, 1.
36. Leon Battista Alberti, *Della Pittura e della Statua* (Milan, 1804), p. 108.
37. Anthony Blunt, *op. cit.*, p. 20.
38. Giovanni Papini, *La Vita di Michelangelo* (Milan, 1949), p. 324.
39. De Tolnay, *The Medici Chapel* (Princeton, 1948), p. 159.
40. Gaye, *Carteggio*, III, 256.
41. De Tolnay, *The Medici Chapel*, p. 59.
42. J. A. Symonds, *op. cit.*, I, 112.
43. Vasari, *ed. cit.*, VII, 272–73.
44. De Tolnay, *The Medici Chapel*, p. 39.
45. Mariani, *La Poesia*, p. 44.
46. Vasari, *ed. cit.*, VII, 270.
47. *Aeneid*, VI, 847–48.
48. *Georgics*, III, 34.
49. Doni, *I Marmi* (Bari, 1928), II, 20–21.
50. Mariani, *La Poesia*, p. 16.
51. Galileo Galilei, *Dialogo dei massimi sistemi*, VII, 130.
52. Jacob Epstein, *The Sculptor Speaks* (London, 1931), pp. 60, 85.
53. Alain, *Système des beaux-arts* (Paris, 1926), p. 36.
54. *Anthologia Palatina*, 5. 94.
55. Condivi, *Vita*, lii.
56. Lomazzo, *Trattato della pittura, scultura ed architettura* (Rome, 1844), II, 165.
57. Vasari, *ed. cit.*, VII, 156.
58. G. K. Loukomski, *Les Sangallo* (Paris, 1934), p. 88.
59. Lomazzo, *Idea*, p. 44.
60. De Tolnay, *The Medici Chapel*, plate 266.
61. Lodovico Castelvetro, *Poetica* (Basilea, 1576), pp. 214 f.
62. De Tolnay, *The Medici Chapel*, plate 77.
63. Milton Nahm, *Aesthetic Experience and its Presuppositions* (New York, 1946), p. 155.
64. Full title, *Vier Bücher von menschlicher Proportion* (Nuremberg, 1528).
65. Warren Cheney, "What Sculptors have learned from Michelangelo," *London Studio*, January, 1940, pp. 2–5.
66. Cf. Panofsky, *Idea* (Leipzig, 1924), p. 131.
67. Vincenzo Danti, *Primo libro del trattato delle perfette proporzioni* (Perugia, 1830), pp. 44, 52.
68. De Hollanda, *Dialogos* (Porto, 1930), p. 189.
69. Armenini, *De' veri precetti* (Ravenna, 1586), p. 23.
70. E. Panofsky, *Studies in Iconology* (New York, 1939), p. 140.
71. Frey, *ed. cit.*, p. 83.
72. George Santayana, in the *Philosophical Review*, XXXIV (May, 1925), 288.

73. Frey, *ed. cit.*, p. 118. Here the admirer becomes the artist speaking, as noted by Mariani, *La Poesia*, p. 65.
74. Plotinus, *Enneads*, V, ix, 6.
75. Vasari, *ed. cit.*, VII, 270, supports the truth of this remark by citing Michelangelo's words: "Si conosce che, quando e' voleva cavar Minerva dalla testa di Giove, ci bisognava il martello di Vulcano."
76. Milanesi, *Le Lettere*, p. 489.
77. *Ibid.*, p. 450.
78. James Hutton, *The Greek Anthology in Italy* (Ithaca, 1935), p. 213.
79. Pino, *Dialogo* (Venice, 1946), p. 92.
80. Giovanni Papini, *Vita di Michelangiolo* (Milan, 1949), p. 583.
81. Horace, *Ars poetica*, vv. 38–39.
82. De Hollanda, *ed. cit.*, p. 240.
83. Alberti, *Della Pittura* (Milan, 1804), p. 97.
84. Lomazzo, *Trattato, ed. cit.*, II, 68.
85. Condivi, *ed. cit.*, p. 83.
86. Vasari, *ed. cit.*, VII, 270.
87. De Hollanda, *ed. cit.*, p. 185.
88. Condivi, *ed. cit.*, p. 65.
89. Giannotti, *Dialoghi, ed. cit.*, p. 86.
90. De Hollanda, *ed. cit.*, p. 234.
91. *Ibid.*, p. 240.
92. T. M. Greene, *The Arts and the Art of Criticism* (Princeton, 1940), p. 407.
93. Horace, *Ars poetica*, vv. 32–35.
94. *The Notebooks of Leonardo Da Vinci* (New York, 1939), p. 880.
95. Condivi, xiv.
96. In M. de Chantelou, *Journal du voyage du Cavalier Bernin* (Paris, 1885), p. 69.
97. Cellini, *Vita* (Florence, 1829), III, 386.
98. Cellini, *Due Trattati* (Milan, 1811), p. 213.
99. Carlo Aru, "La veduta unica e il problema del non finito in Michelangelo," *L'Arte*, January, 1937, pp. 49–51.
100. Cellini, *Due Trattati, ed. cit.*, p. 213.
101. Buscaroli, *Il Concetto dell'arte nelle parole di Michelangelo* (Bologna, 1945), p. 36.
102. T. M. Greene, *The Arts and the Art of Criticism, ed. cit.*, p. 168.
103. De Tolnay, *The Medici Chapel*, p. 32.
104. J. G. Phillips, "Michelangelo: A New Approach to his Genius," *Bulletin of the Metropolitan Museum of Art*, New Series, I (1942), 47.
105. Pino, *Dialogo* (Venice, 1946), p. 143.
106. Lomazzo, *Trattato* (Rome, 1844), II, 67.

107. Pontus de Tyard, *Discours philosophiques* (Paris, 1587), fol. 8r.
108. Cellini, *Due Trattati* (Milan, 1811), p. 213.
109. In De Tolnay, *The Medici Chapel*, pp. 110, 197.
110. Benedetto Croce, *La critica e la storia delle arti figurative* (Bari, 1934), p. 128. Earlier version: Shaftesbury, *Second Characters* (London, 1914), p. 132.
111. Milanesi, *Lettere*, p. 488.
112. Alberti, *Della Pittura* (Milan, 1804), p. 93.
113. Longinus, *On the Sublime*, ii; Quintilian, *Inst. Orat.*, II, 17, 9: "Illud admonere satis est omnia, quae ars consummaverit, a natura initia duxisse."
114. L. Salviati, *Il primo libro delle Orationi* (Florence, 1575), p. 47.
115. Vida, *Ars poetica*, iii, 530–32.
116. Dante, *Inferno*, xi, 99–100; also 103–105.
117. Armenini, *De' veri precetti, ed. cit.*, p. 14.
118. Vasari, *ed. cit.*, VII, 280 f.
119. F. P. Chambers, *History of Taste* (New York, 1932), pp. 58–59.
120. M. de Chantelou, *Journal du Voyage, ed. cit.*, p. 140.
121. Vasari, *ed. cit.*, VII, 278.
122. Condivi, lvi.
123. Lomazzo, *Idea, ed. cit.*, p. 114.
124. De Hollanda, *ed. cit.*, p. 190.
125. *Ibid.*, p. 189.
126. *Ibid.*, p. 230.
127. *Ibid.*, p. 198.
128. Leonardo da Vinci, *Trattato* (Carabba, 1914), no. 25.
129. Vitruvius, *De Architectura*, I, i, 8.
130. Pino, *Dialogo* (Venice, 1946), p. 148.
131. Lomazzo, *Idea, ed. cit.*, p. 34.
132. *Ibid.*, p. 129.
133. Baldassare Castiglione, *Il libro del Cortegiano*, I, XLVII.
134. Cellini, *Vita* (Florence, 1890), p. 79.
135. Frey, *ed. cit.*, pp. 147, 49.
136. Milanesi, *Lettere*, p. 480.
137. P. O. Kristeller, *The Philosophy of Marsilio Ficino, ed. cit.*, p. 307.
138. Ficino, *Commentarium*, V, xii.
139. Kristeller, *The Philosophy of Marsilio Ficino, ed. cit.*, p. 308.
140. Ficino, *Commentarium*, V, xiii.
141. M. de Chantelou, *Journal du voyage du Cavalier Bernin* (Paris, 1885), p. 174.
142. Dante, *Paradiso*, xxix, 91. See Ludwig Goldscheider, *Michelangelo Drawings*, (London, 1951), p. 54.
143. Giovanni Papini, *Vita di Michelangiolo* (Milan, 1949), p. 128.
144. Lionello Venturi, "La critica d'arte in Italia durante i secoli XIV e XV,"

L'Arte, 30 November, 1917, p. 310.

145. Girolamo Savonarola, Sermon of 20 May, 1496.

146. Lodovico Dolce, *Dialogo della Pittura* (Florence, 1734), p. 94.

147. Ascanio Condivi, *Vita di Michelangelo* (Pisa, 1823), p. 82.

148. Holman Hunt, *Pre-Raphaelitism and the Pre-Raphaelite Brotherhood* (New York, 1905), pp. 11–12.

149. Lodovico Dolce, *Dialogo della Pittura, ed. cit.,* p. 264.

150. *Ibid.,* p. 258.

151. Valerio Mariani, *La poesia di Michelangelo* (Rome, 1941), p. 73.

152. Vida, *De arte poetica,* II, 227.

153. Carl Frey, *Die Dichtungen* (Berlin, 1897), p. 196:
 A la bell' arte, che, se dal ciel seco
 Ciascun la porta, uince la natura,
 Quantunche se ben prema in ogni loco.

154. Francisco de Hollanda, *Da pintura antigua* (Porto, 1930), p. 242: "Este é o por que se mais ha de trabalhar e suar nas obras da pintura e, com grande somma de trabalho e de studo, fazer a cousa de maneira que pareça, depois de mui trabalhada, que foi feita quasi depressa e quasi sem nenhum trabalho, e muito levemente, não sendo assi."

155. Giovan Battista Gelli, *Ragionamento* (Florence, 1551), p. 29.

156. Liviu Rusu, *Essai sur la création artistique* (Paris, 1935), p. 221.

157. Leonardo da Vinci, *Trattato* (Lanciano, 1914), p. 61.

158. Charles de Tolnay, *Old Master Drawings* (New York, 1943), p. 48.

159. Vasari, *Le Vite* (Florence, 1878–85), VII, 270.

160. Charles de Tolnay, *The Sistine Ceiling* (Princeton, 1946), p. 102.

161. *Ibid.,* p. 102.

162. *Ibid.,* p. 104.

163. Blaise de Vigenère, *Les Images ou tableaux de la plate peinture* (Paris, 1614), p. 885. First edition: 1578.

164. Vasari, *ed. cit.,* VII, 282.

165. Horace, *Ars poetica,* v. 365.

166. Plotinus, *Enneads,* V, ix, 6.

167. Gaetano Milanesi, *Le lettere di Michelangelo* (Florence, 1875), pp. 450, 489.

168. Vasari, *ed. cit.,* VII, 214.

169. De Hollanda, *ed. cit.,* p. 229: "que as obras não se hão de stimar pelo spaço do trabalho perdido nellas e inutel, senão pelo merecimento do saber e da mão que as faz."

170. Paolo Pino, *Dialogo di Pittura* (Venice, 1946), p. 113.

171. M. de Chantelou, *Journal, ed. cit.,* p. 103.

172. De Hollanda, *ed. cit.,* p. 230.

173. Plutarch, *Education of Children,* vii.

174. Condivi, *ed. cit.*, lvi.
175. Giraldi Cinzio, *Hecatommithi, overo Cento novelle* (Venice, 1608), II, 218: "La prestezza poco giova in cosa alcuna, se non nel saper prendere l'occasione, la quale in un momento di tempo si offerisce, & nell'istesso momento si fugge a chi non la conosce. Ma nelle cose delle arti, essa prestezza manca di giudicio, & perciò si può dir cieca. Imperoche l'Arte, la quale è imitatrice della Natura, non si dee partire, se vuole, che le sia data loda nell'operare, da quel modo istesso, che noi veggiamo, che la Natura usa nella generatione de gli animali, i quali, quanto son per hauer più lunga vita, tanto più di tempo vi spende ella a produrgli per le più."
176. Benvenuto Cellini, *Due trattati* (Milan, 1811), p. 213.
177. Armenini, *De' veri precetti della Pittura* (Ravenna, 1586), p. 75–76.
178. The phrase is used by Vasari, *ed. cit.*, VII, 150.
179. Warren Cheney, "What Sculptors have learned from Michelangelo," *London Studio*, January, 1940, p. 2.
180. Paolo Pino, *Dialogo, ed. cit.*, p. 113.
181. Armenini, *De' veri precetti, ed. cit.*, p. 55.
182. Paolo Pino, *Dialogo, ed. cit.*, p. 111.
183. Donato Giannotti, *Dialoghi de' giorni che Dante consumò nel cercare l'Inferno e 'l Purgatorio* (Florence, 1939), p. 68: "Qualunche volta io veggio alcuno che abbia qualche virtù, che mostri qualche destrezza d'ingegno, che sappia fare o dire qualche cosa più acconciamente che gli altri, io sono costretto a innamorarmi di lui..."
184. Baldassare Castiglione, *Il Libro del Cortegiano*, I, 24 ff.
185. Anthony Blunt, *Artistic Theory in Italy* (Oxford, 1940), p. 99.
186. Edward Williamson, "The Concept of Grace in the Work of Raphael and Castiglione," *Italica*, XXIV (1947), 317, 320.
187. Lomazzo, *Idea del tempio della Pittura* (Milan, 1590), p. 56.

CHAPTER II: RELIGION, MORALITY, AND THE SOCIAL FUNCTION OF ART

1. Savonarola, Sermon on *Ezekiel*, xvi, 6, Monday after third Sunday of Lent, 1497.
2. Jean Choux, *Michel-Ange et Valéry* (Paris, 1932), p. 17. Yet the recent definitive edition of the *Oeuvres complètes de Renan* (Paris, 1947–49) has only one passing reference to Michelangelo that is pertinent.
3. Alessandro del Vita, *Un parere di Michelangelo sul Vasari* (Arezzo, 1928), p. 5.
4. Vasari, *ed. cit.*, VII, 294.

5. Condivi, *Vita*, xxv.
6. Milanesi, *Lettere*, p. 248.
7. Guasti, *ed. cit.*, p. xl.
8. See the chapter, "Rilke, Michelangelo, and the *Geschichten vom lieben Gott*," in R. J. Clements, *Peregrine Muse* (Chapel Hill, 1959).
9. In Steinmann, *Michelangelo im Spiegel seiner Zeit* (Leipzig, 1930), p. 34.
10. De Tolnay, *Youth of Michelangelo*, pp. 250–51.
11. On the relations with Loyola, *v.* the *Cartas de San Ignacio de Loyola* (Madrid, 1874), IV, 228–29; also, J. Klaczko, *Jules II*, p. 437.
12. Vasari, *ed. cit.*, VII, 220.
13. *Ibid.*, p. 279.
14. Milanesi, *Lettere*, p. 78.
15. Vasari, *ed. cit.*, VII, 279. A monk thought by some to resemble Luther wails at the very bottom of the *Giudizio universale*, which would further explain the Lutheran attitude toward this work.
16. De Hollanda, *ed. cit.*, p. 191.
17. *Ibid.*, p. 241.
18. *Ibid.*, p. 239.
19. Milanesi, *Lettere*, p. 473.
20. Vasari, *ed. cit.*, VII, 214.
21. Guasti, *ed. cit.*, p. 226.
22. *Cratylus*, ix, C; also Frey, *ed. cit.*, p. 386.
23. *V. supra*, chap. I, note 75.
24. Alberti, *Della Pittura* (Milan, 1804), p. 37; also (Florence, 1950), p. 76.
25. Luigi Manzoni, *Statuti e matricole dell'Arte dei Pittori delle città di Firenze, Perugia e Siena* (Rome, 1904), p. 83.
26. Da Vinci, *Trattato*, *ed. cit.*, p. 22.
27. Savonarola, *Predica XIV sulla prima Epistola di San Giovanni*.
28. Savonarola, *Predica XXVIII su Rut e Michea*.
29. *Psalms* LI: 13.
30. De Hollanda, *ed. cit.*, pp. 189–90.
31. *Ibid.*, p. 189.
32. Carlo Aru, *L'Arte*, XXI (1928), pp. 117–28.
33. De Hollanda, *ed. cit.*, p. 235.
34. Savonarola, *Predica su Ezekiel* (Lenten Sermon of 1497).
35. G. Guyer, *Les Illustrations des écrits de Savonarole* (Paris, 1879), p. 207.
36. Vasari, *ed. cit.*, VII, 275.
37. Condivi, *Vita*, lxv.
38. De Tolnay, *The Medici Chapel*, p. 68.
39. Blunt, *Artistic Theory in Italy*, *ed. cit.*, p. 108.
40. Philostratus the Younger, *Imagines* (New York, 1931), p. 285.

41. Alberti, *Della Pittura* (Florence, 1950), p. 76.
42. De Hollanda, *ed. cit.*, p. 189.
43. Vasari, *ed. cit.*, VII, 152.
44. *Ibid.*, p. 167.
45. Cf. *Exodus* XXXI: 3–7.
46. De Hollanda, *ed. cit.*, p. 236.
47. Dolce, *Dialogo, ed. cit.*, p. 226.
48. Paolo Pino, *Dialogo, ed. cit.*, pp. 32, 35.
49. De Hollanda, *ed. cit.*, p. 235.
50. Letter of Ammannati in *Lettere Pittoriche*, III, 539.
51. Buscaroli, *Il Concetto dell'arte nelle parole di Michelangelo*, p. 17.
52. Masoliver, "Las ideas estéticas de Miguel-Ángel y de sus poesías de escultor," *Escorial*, May, 1942, p. 244.
53. Vernon Hall, *Renaissance Literary Criticism* (New York, 1945), p. 66.
54. Da Vinci, *Notebooks* (New York, 1939), p. 88.
55. Savonarola, *Predica XXVII* (Lenten season, 1497).
56. Savonarola, *Predica XVI sul Salmo: "Quam bonus."*
57. Lomazzo, *Idea, ed. cit.*, p. 12.
58. Armenini, *De' veri precetti, ed. cit.*, p. 209.
59. Frey, *ed. cit.*, p. 159.
60. Papini, *Vita di Michelangiolo, ed. cit.*, pp. 498, 512.
61. Masoliver, *op. cit.*, p. 239.
62. Charles Dejob, *L'Influence du Concile de Trente sur la littérature et les beaux-arts* (Paris, 1884), p. 15.
63. De Hollanda, *ed. cit.*, p. 236.
64. G. Gaye, *Carteggio inedito d'artisti* (Florence, 1839–40), II, 489.
65. G. Milanesi, *Les Correspondants de Michel-Ange* (Paris, 1890), p. 24.
66. Vasari, *ed. cit.*, VII, 166.
67. *Ibid.*, p. 213.
68. Lomazzo, *Idea, ed. cit.*, p. 53.
69. *Ibid.*, p. 57.
70. Dolce, *Dialogo, ed. cit.*, p. 94.
71. Savonarola, *Predica XVI sul Salmo: "Quam bonus."*
72. Blashfield-Hopkins edition of the *Lives* of Vasari (New York, 1926), IV, 142.
73. De Hollanda, *ed. cit.*, p. 189.
74. See Armenini, *ed. cit.*, I, 2, among others.
75. Alberti, *Della Pittura* (Milan, 1804), p. 83.
76. E. Kretschmer, *Physique and Character* (New York, 1936), p. 239.
77. De Hollanda, *ed. cit.*, p. 197.
78. Frey, *ed. cit.*, p. 78.
79. *Ibid.*, p. 87.

80. *Ibid.*, p. 31.
81. E. Panofsky, *Idea* (Leipzig, 1924), p. 65.
82. Auguste Rodin, *L'Art* (Paris, 1924), p. 286.
83. Symonds, *ed. cit.*, II, 65–66.
84. Judith Cladel, *Aristide Maillol* (Paris, 1937), p. 135.
85. Condivi, *Vita, ed. cit.*, p. 65.
86. Charles de Tolnay, "Michelangelo's Rondanini Pietà," *Burlington Magazine,* LXV (October, 1934), 152.
87. It seems obvious that "una statua piccolina per un Cristo con la croce in spalla e non finita," found in his house after his death and subsequently lost (De Tolnay, *The Medici Chapel*, p. 180), could not be a Crucifixion. This might have been a study for the Christ in the Minerva.
88. F. W. Ruckstull, *Great Works of Art* (Garden City, 1925), p. 45.
89. Vasari, *Vite, ed. cit.*, VI, 180, note.
90. P. Langeard, *L'intersexualité dans l'art et chez Michel-Ange en particulier* (Montpellier, 1936), p. 161.
91. Alberti, *Della Pittura* (Florence, 1950), p. 88.
92. Alberti, *Della Pittura* (Milan, 1804), p. 72.
93. Vasari, *ed. cit.*, VII, 240.
94. Dejob, *op. cit.*, p. 242.
95. Alberti, *Della Pittura* (Florence, 1950), pp. 92–93.
96. Vasari, *Vite, ed. cit.*, IV, 179.
97. *Ibid.*, III, 318.
98. Da Vinci, *Trattato, ed. cit.*, p. 22.
99. Dejob, *op. cit.*, pp. 265–66.
100. Vasari, *ed. cit.*, V, 353.
101. H. Thode, *Michelangelo und das Ende der Renaissance* (Berlin, 1912), I, 352.
102. Buscaroli, *op. cit.*, p. 28.
103. E. Panofsky, *Studies in Iconology*, pp. 198–99.
104. Blunt, *Artistic Theory in Italy, ed. cit.*, p. 60.
105. De Tolnay, *The Sistine Ceiling*, p. 46.
106. Milanesi, *Les Correspondants, ed. cit.*, p. 104.
107. R. G. Collingwood, *The Principles of Art* (Oxford, 1938), p. 100.
108. E. Panofsky, *Studies in Iconology, ed. cit.*, p. 229.
109. C. R. Morey, *Christian Art* (New York, 1935), p. 62.
110. Vasari, *ed. cit.*, VII, 275.
111. E. Guillaume, *op. cit.*, p. 64.
112. Hegel, *Aesthetics*, III, iii, 2.
113. R. R. Tatlock, "A Florentine Pietà," *Apollo*, XXI (1935), 125.
114. De Tolnay, *The Medici Chapel*, p. 15; Thode, *Kritische Untersuchungen*, II, 419.

115. Vasari, *ed. cit.*, IV, 569.

116. Milanesi, *Les Correspondants, ed. cit.*, p. 98.

117. *Burlington Magazine*, May, 1941, pp. 159–60.

118. J. G. Phillips, *Bulletin of the Metropolitan Museum*, September, 1937, p. 213.

119. M. Gómez-Moreno, *Archivo español de arte*, 1930, pp. 192–96; 1933, pp. 81–84.

120. De Hollanda, *ed. cit.*, p. 240.

121. E. Guillaume, *op. cit.*, p. 113.

122. Alberti, *Della Pittura* (Florence, 1950), p. 55.

123. Lomazzo, *Idea, ed. cit.*, p. 36.

124. Lomazzo, *Trattato, ed. cit.*, I, 47.

125. Dolce, *Dialogo, ed. cit.*, p. 242.

126. Du Bellay, *Oeuvres* (Paris, 1931), VI, 164–65.

127. Mariani, *La Poesia*, p. 39.

128. Diego Rivera, *Creative Art*, IV (1929), xxviii–xxix.

129. Milanesi, *Lettere*, p. 210.

130. Thomas McGreevy, "The Severe Bearing of Christ in the Last Judgement," *London Studio*, XX (1940), 202–203.

131. Fritz Lugt, "Man and Angel," *Gazette des Beaux-Arts*, XXV (June, 1944), 345.

132. De Tolnay, *The Medici Chapel*, p. 110.

133. *Ibid.*, p. 62. *V.* also Thode, *Kritische Untersuchungen*, I, 502.

134. Gaye, *Carteggio, ed. cit.*, II, 296.

135. De Tolnay, *The Medici Chapel*, p. 98; Thode, *Kritische Untersuchungen*, I, 288 ff.

136. Masoliver, *op. cit.*, p. 244.

137. Giannotti, *Dialoghi, ed. cit.*, p. 93.

138. Mariani, *La Poesia*, p. 8.

139. Alberti, *Della Pittura* (Milan, 1804), p. 97.

140. De Hollanda, *ed. cit.*, p. 227.

141. Vitruvius, *De architectura*, preface.

142. De Tolnay, *The Medici Chapel*, p. 7; *Thode, Michelangelo*, I, 286 ff.

143. Milanesi, *Les Correspondants, ed. cit.*, p. 34.

144. Frey, *Briefe an Michelangiolo* (Berlin, 1899), p. 28.

145. De Hollanda, *ed. cit.*, p. 221.

146. Vasari, *ed. cit.*, VII, 217.

147. Condivi, xliii; also Thode, *Kritische Untersuchungen*, II, 147–48.

148. Donato Giannotti, *Della Repubblica fiorentina* (Venice, 1722), pp. 273—74.

149. Vasari, *ed. cit.*, VII, 197–200.

150. Giambattista Busini, *Lettere sopra l'assedio di Firenze* (Florence, 1861), pp. 103–115.

151. Aurelio Gotti, *Vita di Michelangelo* (Florence, 1875) II, 62.

152. Symonds, *op. cit.*, II, 379.
153. Cf. the letter by Donna Argentina Malaspina de' Soderini: Frey, *Briefe an Michelangiolo*, p. 28.
154. Vasari, *ed. cit.*, VII, 217.
155. Da Vinci, *Notebooks* (New York, 1939), pp. 806–41.
156. Vitruvius, *De architectura* (London, 1934), II, 344.
157. Baldassare Castiglione, *Il Libro del Cortegiano*, I, xlix.
158. Lomazzo, *Idea, ed. cit.*, p. 30.
159. Shakespeare, *Richard III*, V, iii.

CHAPTER III: NEOCLASSICAL AND GENERAL THEORIES

1. Hans Tietze, "Centaur and Lapith Fighting," *Art in America*, October, 1942, pp. 238–43.
2. See De Tolnay, *The Medici Chapel*, p. 199.
3. E. Panofsky, *Studies in Iconology, ed. cit.*, p. 221.
4. Alberti, *Della Pittura* (Milan, 1804), p. 44.
5. Da Vinci, *Trattato*, part I, no. 15.
6. Alberti, *Della Pittura, ed. cit.*, p. 37.
7. Milanesi, *Les Correspondants, ed. cit.*, p. 24.
8. Vasari, *Vite, ed. cit.*, VII, 280.
9. Longinus, *On the Sublime*, ix.
10. *Beaux-Arts*, 30 November, 1934, p. 3.
11. G. F. Hill, "The Portraits of Michelangelo," *Burlington Magazine*, XXV (1914), 345.
12. Papini, *La Vita di Michelangiolo*, pp. 619–21.
13. De Tolnay, *The Sistine Ceiling*, p. 95.
14. De Tolnay, *Burlington Magazine*, LXVII (1935), 24–25.
15. Vasari, *ed. cit.*, VII, 281.
16. Pino, *Dialogo* (1946), p. 93.
17. Milanesi, *Les Correspondants*, p. 4.
18. Vasari, *Vite, ed. cit.*, VII, 281.
19. Frey, *Dichtungen, ed. cit.*, p. 14.
20. De Tolnay, *The Medici Chapel*, p. 73.
21. Milanesi, *Lettere*, p. 225.
22. Da Vinci, *Notebooks* (New York, 1939), p. 1132.
23. Blunt, *Artistic Theory in Italy, ed. cit.*, p. 49.
24. Pino, *Dialogo* (1946), p. 154.

25. Frey, *Briefe an Michelagniolo, ed. cit.,* p. 294.

26. Vasari, *ed. cit.,* VII, 236.

27. G. Bottari, *Raccolta di lettere* (Milan, 1822), VI, 133–34.

28. Giannotti, *Dialoghi, ed. cit.,* p. 69.

29. Vasari, *ed. cit.,* I, 92.

30. *Ibid.,* p. 222.

31. Pierre de Ronsard, *Oeuvres* (Paris, 1914–19), V, 187.

32. Cesare Fasolo, *Le Gallerie di Firenze e la guerra* (Florence, n. d.), *s. v.: Bacco.*

33. De Hollanda, *ed. cit.,* p. 240.

34. Vasari, *ed. cit.,* VII, 270.

35. Milanesi, *Lettere,* p. 520.

36. Horace, *Epistolae,* I, xvii, 35.

37. Bartolommeo Cavalcanti, *Giudicio sopra la tragedia di Canace* (Venice, 1566), concluding speech.

38. Condivi, lviii.

39. Vasari, *ed. cit.,* I, 222. Four notably competent works should be consulted for an understanding of *imitatio* among the Cinquecento artists: Rensselaer W. Lee's "*Ut Pictura Poesis*: The Humanistic Theory of Painting," *Art Bulletin,* December, 1940, pp. 197–269; Anthony Blunt, *Artistic Theory in Italy: 1450–1600, ed. cit.;* Erwin Panofsky, *Idea* (Leipzig, 1924); Eugenio Battisti, "Il Concetto d'imitazione," in *Commentari* (VII, 2) 1956.

40. Boccaccio, *Decamerone,* VI, v.

41. E. Panofsky, *Iconology,* pp. 195–96.

42. Alberti, *Della Pittura* (Milan, 1804), p. 82.

43. *Ibid.,* p. 88.

44. *Ibid.,* p. 89.

45. *Ibid.,* p. 76.

46. Da Vinci, *Trattato, ed. cit.,* p. 202.

47. Blunt, *op. cit.,* p. 28.

48. De Hollanda, *ed. cit.,* p. 239.

49. Cervantes, *Galatea,* II, 135.

50. Rensselaer W. Lee, *op. cit.,* p. 207.

51. Frey, *ed. cit.,* p. 50.

52. Dolce, *Dialogo, ed. cit.,* p. 176.

53. Frey, *ed. cit.,* p. 54.

54. Chantelou, *Journal, ed. cit.,* p. 119.

55. Xenophon, *Memorabilia,* Loeb edition, p. 237.

56. Alberti, *Della Pittura* (Milan, 1804), p. 64.

57. *Ibid.,* p. 57.

58. Ficino, *Commentarium in Convivium,* VI, xviii.

59. Quoted in De. Tolnay, *The Medici Chapel*, p. 68, from Niccolò Martelli.
60. See Symonds, *Life, op. cit.*, I, 263.
61. Vincenzo Danti, *Il Primo Libro del Trattato* (Perugia, 1830), p. 92.
62. Vasari, *ed. cit.*, VII, 271.
63. Thode, *Kritische Untersuchungen*, II, 306.
64. Odoardo Giglioli, "Un Ritratto di Andrea Rinieri Quaratesi," *Rivista d'Arte*, April, 1938, pp. 174–81.
65. Gaye, *Carteggio*, III, 41.
66. Milanesi, *Lettere*, p. 173; Thode, *Krit. Unt.*, II, 306.
67. Aurelio Gotti, *Vita di Michelangelo, ed. cit.*, I, 177.
68. De Hollanda, *ed. cit.*, p. 235.
69. Vasari, *ed. cit.*, VII, 272.
70. Papini, *Vita*, p. 363.
71. Alberti, *Della Pittura* (Milan, 1804), p. 63.
72. Vasari, *ed. cit.*, VII, 284, note; Armenini, *De' veri precetti, ed. cit.*, p. 191.
73. Vasari, *ed. cit.*, IV, 178–79.
74. Condivi, xvi.
75. Lomazzo, *Trattato, ed. cit.*, I, 47.
76. Blashfield-Hopkins edition of Vasari, p. 251, note 323.
77. Dolce, *Dialogo, ed. cit.*, p. 254.
78. Vasari, *ed. cit.*, VII, 270.
79. Condivi, lxv.
80. Ficino, *Commentarium in Convivium*, VI, xviii.
81. Bottari-Ticozzi, *Raccolta*, I, 116.
82. Dolce, *Dialogo, ed. cit.*, p. 190.
83. Giambattista Vico, *Il Metodo degli studi del tempo nostro* (Florence, 1937), p. 89.
84. Vasari, *ed. cit.*, VII, 270.
85. *Ibid.*, VI, 145.
86. For Michelangelo's borrowings from antiquity, see A. Hekler, "Michelangelo und die Antike," *Wiener Jahrbuch* (1930), p. 201.
87. De Tolnay, *The Sistine Ceiling*, p. 60.
88. De Tolnay, *Youth of Michelangelo*, p. 92.
89. Alfredo Melani, *Manuale di scultura italiana* (Milan, 1899), p. 131.
90. Heinrich Brockhaus, *Michelangelo und die Medici Kapelle* (Leipzig, 1909), pp. 13, 15.
91. De Tolnay, *The Medici Chapel*, p. 65.
92. W. L. Bullock, "The Precept of Plagiarism in the Cinquecento," *Modern Philology*, XXV (1928), 307.
93. Condivi, *ed. cit.*, p. 80.
94. Vasari, *ed. cit.*, VII, 277.

95. Panofsky, *Iconology*, p. 171.
96. Vincenzo Danti, *Il Primo libro del Trattato delle perfette proporzioni* (Perugia, 1830), p. 11.
97. Vasari, *ed. cit.*, VII, 280.
98. Armenini, *ed. cit.*, pp. 66, 228.
99. See Mariani, *La Poesia*, p. 100.
100. Vasari, *ed. cit.*, VII, 281.
101. Armenini, *ed. cit.*, pp. 226–27.
102. *Ibid.*, p. 66.
103. F. Baldinucci, *Vocabolario toscano dell'arte del disegno* (Florence, 1681), p. 89.
104. Chantelou, *Journal, ed. cit.*, p. 226.
105. André Gide, *Journal* (Paris, 1948), I, 714.
106. De Tolnay, *The Medici Chapel*, p. 192.
107. Lomazzo, *Idea, ed. cit.*, p. 39.
108. Condivi, *ed. cit.*, p. 83, In his *Pincel* (Madrid, 1681), p. 38, Espinosa y Malo considers this avoidance of repetition to be Michelangelo's "principal grandeza."
109. Vasari, *ed. cit.*, VII, 278.
110. Da Vinci, *Trattato, ed. cit.*, p. 75.
111. Alberti, *Della Pittura* (Milan, 1804), p. 63.
112. Vasari, *ed. cit.*, III, 586–87.
113. *Ibid.*, VII, 278.
114. *Ibid.*, I, 222.
115. E. Panofsky, *Idea, ed. cit.*, p. 137.
116. De Hollanda, *ed. cit.*, pp. 190–91.
117. Vasari, *ed. cit.*, I, 223.
118. Lomazzo, *Idea, ed. cit.*, pp. 16, 40; *Trattato, ed. cit.*, II, 460.
119. Lomazzo, *Trattato, ed. cit.*, II, 165.
120. Cf. Vasari, *ed. cit.*, IV, 13–14.
121. Giovanni Baglione, *Le Vite de' Pittori, ecc.* (Naples, 1733), p. 143.
122. Vasari, *ed. cit.*, VII, 263.
123. Alberti, *Della Pittura* (Milan, 1804), p. 59.
124. Vincenzo Danti, *op. cit.*, pp. 26–27.
125. Ficino, *Commentarium in Convivium*, II, vi.
126. Nesca Robb, *Neoplatonism of the Italian Renaissance* (London, 1935), pp. 225–26.
127. Arturo Farinelli, *Michelangelo e Dante* (Torino, 1918), pp. 39–40.
128. Vasari, *ed. cit.*, VII, 226.
129. Chantelou, *Journal, ed. cit.*, p. 160.
130. Vincenzo Danti, *op. cit.*, pp. viii, 13.

131. Condivi, lvi.
132. Milanesi, *Lettere*, p. 554; Vitruvius, *De architectura*, I, i, 2–9.
133. Ghiberti, *I Commentarii* (Berlin, 1912), p. 6.
134. Lomazzo, *Trattato, ed. cit.*, I, 41.
135. Bottari-Ticozzi, *Raccolta*, VIII, 205.
136. Lomazzo, *Trattato, ed. cit.*, II, 81.
137. Joshua Reynolds, *The Idler*, LXXIX, 20 October, 1759.
138. Chantelou, *Journal, ed. cit.*, p. 40.
139. See chap. I, note 104.
140. De Tolnay, *The Medici Chapel*, p. 45.
141. Vasari, *ed. cit.*, VII, 210.
142. Walter Pach, *Ananias, or the False Artist* (New York, 1928), p. 213.
143. Lomazzo, *Trattato, ed. cit.*, I, 34–35; II, 97.
144. Buscaroli, *Il Concetto dell'arte nelle parole di Michelangelo* (Bologna, 1945), p. 9.
145. De Tolnay, *The Medici Chapel*, p. 45.
146. J. Wilde, "Eine Studie Michelangelos nach der Antike," *Mitteilungen des Kunsthistorischen Instituts in Florenz*, IV (1931–34), 41.
147. Da Vinci, *Trattato, ed. cit.*, p. 150.
148. Alberti, *Della Pittura* (Milan, 1804), p. 67.
149. Henry Poore, *Pictorial Composition* (New York, 1903), p. 125.
150. Lomazzo, *Trattato, ed. cit.*, I, 184.
151. Rensselaer W. Lee, *op. cit.*, p. 234.
152. Antonio Canova, letter to Cicognara. Bottari-Ticozzi, *Raccolta, ed. cit.*, VIII, 203.
153. Jacob Epstein, *The Sculptor Speaks* (London, 1931), pp. 85–86.
154. See Panofsky, *Idea, ed. cit.*, p. 138.
155. E. Panofsky, *Iconology* (New York, 1939), p. 172. On this subject, see also R. J. Clements, "Michelangelo as a Baroque Poet," *Publications of the Modern Language Association*, June, 1961.
156. Pliny, xxxiv, 81.
157. Milanesi, *Les Correspondants, ed. cit.*, p. 96.
158. Vasari, *ed. cit.*, VII, 284.
159. Anton Francesco Doni, *I Marmi* (Bari, 1928), p. 101.
160. De Tolnay, *The Sistine Ceiling*, p. 20.
161. Papini, *Vita, ed. cit.*, pp. 516–19.
162. Vasari, *ed. cit.*, V, 584.
163. Pierre de Bouchaud, *Les Poésies de Michel-Ange* (Paris, 1912), p. 51.
164. See Papini, *Vita, ed. cit.*, p. 363.
165. J. A. Symonds, *op. cit.*, I, 269.
166. Pierre Langeard, *L'Intersexualité dans l'art et chez Michel-Ange, ed. cit.*, p. 177.

167. In *Biblioteca Rara* (Milan, 1863), xii, 183 ff. Also, Erica Tietze-Conrat, *Art Bulletin*, XXV (June, 1943), 156–57.
168. De Hollanda, *ed. cit.*, p. 234.
169. Da Vinci, *Trattato, ed. cit.*, p. 78.
170. Horace, *Ars poetica*, vv. 176–77.
171. Vasari, *ed. cit.*, I, 149.
172. Alberti, *Della Pittura* (Milan, 1804), p. 59.
173. Lomazzo, *Idea, ed. cit.*, p. 64.
174. Vasari, *ed. cit.*, I, 173.
175. Armenini, *op. cit.*, p. 145.
176. De Hollanda, *ed. cit.*, p. 230.
177. Da Vinci, *Trattato, ed. cit.*, p. 53; see also p. 188 for a definition of decorum as *convenienza*.
178. Vernon Hall, *Renaissance Literary Criticism* (New York, 1945), p. 57.
179. Milanesi, *Lettere*, p. 501.
180. *Ibid.*, pp. 448–49.
181. Pino, *Dialogo* (Venice, 1946), p. 85.
182. Alberti, *Della Pittura*, Book III; Cennini, *ed. cit.*, p. 16; Ghiberti, *ed. cit.*, p. 4; Lomazzo, *Idea, ed. cit.*, pp. 33–34; Armenini, *ed. cit.*, p. 209; Lomazzo, *Trattato, ed. cit.*, II, 36; Pino, *Dialogo, ed. cit.*, pp. 148–51.
183. Rensselaer W. Lee, *op. cit.*, p. 241.
184. Plotinus, *Enneads*, V, ix, 7.
185. Alberti, *Della Pittura* (Milan, 1804), p. 89.
186. De Hollanda, *ed. cit.*, p. 229.
187. *Ibid.*, p. 242.
188. Croce, *Estetica* (Bari, 1946), p. 208.
189. Vasari, *ed. cit.*, VII, 218.
190. Aldo Bertini, *Michelangelo fino alla Sistina* (Torino, 1945), p. 65.
191. Armenini, *ed. cit.*, pp. 226–27.
192. De Hollanda, *ed. cit.*, p. 230.
193. *Ibid.*, p. 234.
194. Tolstóy, *What is Art?* (London, 1938), p. 219.
195. De Hollanda, *ed. cit.*, p. 182.
196. Da Vinci, *Trattato, ed. cit.*, p. 203.
197. Joan Evans, *Taste and Temperament* (London, 1939), pp. 90–91.
198. P. O. Kristeller, *The Philosophy of Marsilio Ficino* (New York, 1943), p. 304.
199. Armenini, *ed. cit.*, p. 206.
200. Lomazzo, *Idea, ed. cit.*, p. 38.
201. Da Vinci, *Trattato*, ed. cit., p. 50.
202. Vasari, *ed. cit.*, VII, 169–70.
203. De Hollanda, *ed. cit.*, p. 186.

204. Armenini, *ed. cit.*, p. 288; also Vasari, *ed. cit.*, VII, 171.
205. De Hollanda, *ed. cit.*, p. 185.
206. *The Notebooks of Leonardo da Vinci* (New York, 1939), p. 886.
207. Lomazzo, *Idea, ed. cit.*, p. 56.
208. Condivi, lxii.
209. Vasari, *ed. cit.*, VII, 270.
210. Milanesi, *Lettere*, p. 97.
211. Frey, *Briefe an Michelangiolo, ed. cit.*, p. 312.
212. Milanesi, *Lettere*, p. 221.
213. Giannotti, *Dialoghi, ed. cit.*, p. 69.
214. Panofsky, *Iconology*, p. 178.
215. De Tolnay, *Burlington Magazine*, LXVII (July, 1935), 24.
216. Vasari, *ed. cit.*, VII, 276.
217. De Tolnay, "Le Menu de Michel-Ange," *Art Quarterly*, III, 2 (1940), 240–43.
218. Alberti, *Della Pittura* (Milan, 1804), p. 97.
219. Vasari, *ed. cit.*, VII, 280.
220. Giannotti, *Dialoghi, ed. cit.*, p. 66.
221. De Hollanda, *ed. cit.*, pp. 185–86.
222. *Ibid.*, p. 189. See Buscaroli, *op. cit.*, p. 9.
223. Vasari, *ed. cit.*, VII, 216.
224. C. F. Perriollat, *Le surnaturel dans l'art* (1927), p. 34.
225. Milanesi, *Lettere*, p. 541.
226. E. Panofsky, *Iconology*, p. 179. Cf. the nature feeling in cix, 91.
227. Milanesi, *Lettere*, p. 330.
228. Mariani, *Michelangelo*, p. 122.
229. Castiglione, *Il Libro del cortegiano*, I, li.
230. Reproduced in *La Rivista d'arte*, January, 1937, pp. 44–46.
231. Joshua Reynolds, *The Idler*, LXXIX, 20 October, 1759.
232. J. A. Symonds, *Life, ed. cit.*, I, 172.
233. Gino Gori, *Il Grottesco* (Rome, 1927), chap. I.
234. Vasari, *ed. cit.*, I, 144, 193.
235. Lomazzo, *Trattato, ed. cit.*, II, 352.
236. Vasari, *ed. cit.*, VII, 210.
237. Plotinus, *Enneads*, V, ix, 14.
238. Armenini, *ed. cit.*, p. 195.
239. *Ibid.*, p. 193.
240. Horace, *Ars poetica*, vv. 9–11.
241. Vasari, *ed. cit.*, VII, 218.
242. Lomazzo, *Trattato, ed. cit.*, II, 358.
243. See chap. IV, note 141.

244. De Tolnay, *The Sistine Ceiling*, p. 45.
245. Auguste Rodin, *L'Art* (Paris, 1924), p. 267.
246. Armenini, *ed. cit.*, p. 76.
247. Condivi, *ed. cit.*, p. 65.
248. Middeldorf reminds us that Michelangelo could see such a plan executed in the tomb of Bishop Antonio d'Orso, by Tino di Camaino, placed in the Florentine Duomo (*ca.* 1321).
249. *Juditha*, xiii, 10.
250. Buscaroli, *op. cit.*, p. 25.
251. Rensselaer W. Lee, *op. cit.*, p. 211.
252. Stefano Guazzo, *Dialoghi piacevoli* (Venice, 1590), p. 180.
253. James Hutton, *The Greek Anthology in Italy* (Ithaca, 1935), p. 312.
254. De Tolnay, *The Medici Chapel*, p. 73.
255. *Ibid.*, pp. 143–44.
256. Piccoli edition of the *Rime* (Torino, 1944), p. 16.
257. Savonarola, *Predica III su Amos e Zaccaria.*
258. Dolce, *Dialogo della Pittura, ed. cit.*, p. 242; also 246.
259. E. Guillaume, *Michel-Ange sculpteur, ed. cit.*, p. 71.
260. Giannotti, *Dialoghi, ed. cit.*, p. 96.
261. De Hollanda, *ed. cit.*, p. 232.
262. Da Vinci, *Trattato, ed. cit.*, p. 17.
263. Cesare Ripa, *Iconologia, s. v.: Notte.*
264. J. G. Phillips, "Michelangelo: A New Approach to his Genius," *Bulletin of the Metropolitan Museum of Art*, New Series, I (1942), 48.
265. Marcel Brion, *Michelangelo* (New York, 1940), p. 225.
266. Margaret MacLean, "The Horns on Michelangelo's Moses," *Art and Archeology*, VI (August, 1917), 97–99.
267. De Tolnay, *The Medici Chapel*, p. 168.
268. E. Panofsky, *Die Sixtinische Decke* (Leipzig, 1921); E. Steinmann, *Die Sixtinische Kapelle* (Munich, I: 1901; 2: 1905); Charles de Tolnay, *The Sistine Ceiling* (Princeton, 1945).
269. De Tolnay, *The Sistine Ceiling*, p. 117.
270. E. Panofsky, *Iconology*, pp. 199 ff.
271. Edgar Wind, *Journal of the Warburg Institute*, I (1938), 322.
272. Vasari, *ed. cit.*, I, 219.
273. 1658 edition of Vasari, p. 322; quoted in De Tolnay, *Youth of Michelangelo*, p. 52.
274. W. R. Valentiner, *Late Years of Michelangelo* (New York, 1914), p. 34.
275. In Panofsky, *Idea, ed. cit.*, p. 132.
276. De Hollanda, *ed. cit.*, p. 240.
277. E. Guillaume, *op. cit.*, p. 100.

278. De Hollanda, *ed. cit.*, p. 240.
279. Mariani, *La Poesia*, p. 28.
280. *Il Buonarroti*, IV (April, 1866), p. 91.
281. Dolce, *Dialogo della Pittura, ed. cit.*, p. 258.
282. Rensselaer W. Lee, *op. cit.*, p. 261.
283. H. Thode, *Michelangelo, ed. cit.*, I, 117.
284. Milanesi, *Lettere*, p. 214.
285. Concerning the authenticity of these "teste divine," see Thode, *Kritische Untersuchungen*, II, 331 ff.
286. Milanesi, *Lettere*, p. 501.
287. Rensselaer W. Lee, *op. cit.*, p. 197.
288. Pino, *Dialogo* (1946), pp. 105–107.
289. Mariani, *La Poesia*, 135.
290. A. Farinelli, *Michelangelo e Dante, ed. cit.*, p. 5.
291. De Tolnay, *The Medici Chapel*, p. 108.
292. *Ibid.*, p. 113.
293. Frey, *ed. cit.*, p. 236 does not include these self-deprecations, but Guasti's edition (pp. 230, 232) does so; also, Frey edition, p. 76, where he calls his verses "heavy pastries."
294. Condivi, lxi.
295. Papini, *Vita*, p. 469.
296. Vasari, *ed. cit.*, IV, 552.
297. Cellini, *Trattati* (Leipzig, 1835), pp. 137–38.
298. Vasari, *ed. cit.*, VII, 284.
299. *Ibid.*, p. 260.
300. Lomazzo, *Trattato, ed. cit.*, II, 374.
301. Chantelou, *Journal, ed. cit.*, p. 26.
302. Armenini, *ed. cit.*, p. 234.
303. Vasari, *ed. cit.*, VII, 219; also F. Baldinucci, *Notizie de' professori del disegno* (Florence, 1846), II, 556.
304. Chantelou, *Journal, ed. cit.*, p. 33.
305. Vasari, *ed. cit.*, VII, 219.
306. *Ibid.*, I, 177–78.
307. Cellini, *Trattato della scultura*, iv.
308. De Tolnay, *The Medici Chapel*, pp. 54–55.
309. Milanesi, *Lettere*, p. 550.
310. De Tolnay, *The Medici Chapel*, pp. 4–5.
311. Milanesi, *Lettere*, p. 133.
312. *Ibid.*, p. 381.
313. Cellini, *Trattato, ed. cit.*, p. 238.
314. De Tolnay, *The Medici Chapel*, p. 40.

315. De Tolnay, *Art Bulletin,* September, 1940, p. 128.

316. Armenini, *ed. cit.,* p. 87.

317. Chantelou, *Journal, ed. cit.,* p. 112.

318. Milanesi, *Lettere,* p. 398.

319. De Tolnay, *The Medici Chapel,* p. 157.

320. Paolo Pino, *Dialogo di Pittura* (Venice, 1946), p. 131.

321. Vasari, *ed. cit.,* VI, 277.

322. B. Bosanquet, *History of Aesthetic* (London, 1922), p. 135.

323. Vasari, *ed. cit.,* VII, 210.

324. Armenini, *ed. cit.,* pp. 226–27.

325. E. Panofsky, *Idea, ed. cit.,* p. 137.

326. Ficino, *Commentarium,* V, iii.

327. Lomazzo, *Idea, ed. cit.,* p. 47.

328. De Tolnay, *The Sistine Ceiling,* p. 51.

329. Lomazzo, *Idea, ed. cit.,* p. 60.

330. Pino, *Dialogo* (1946), pp. 112–13.

331. De Hollanda, *ed. cit.,* p. 238.

CHAPTER IV: APPLIED CRITICISMS

1. Chantelou, *Journal, ed. cit.,* p. 31.

2. De Hollanda, *Da Pintura antigua* (Porto, 1930), p. 239.

3. *Ibid.,* p. 229.

4. *Ibid.,* p. 225.

5. *Ibid.,* p. 238.

6. *Ibid.,* p. 189.

7. Baccio Bandinelli, *Il Memoriale,* memoria ix.

8. De Hollanda, *ed. cit.,* pp. 190–91.

9. *New York Times,* 16 January, 1946.

10. De Hollanda, *ed. cit.,* pp. 228, 229.

11. *Ibid.,* p. 228.

12. *Ibid.,* p. 190.

13. Gaye, *Carteggio,* III, 322.

14. Milanesi, *Lettere,* p. 84.

15. Thode, *Michelangelo,* I, 444.

16. Vasari, *ed. cit.,* VII, 265.

17. Milanesi, *Lettere,* p. 253.

18. Anton Francesco Doni, *I Marmi* (Bari, 1928), II, 22–23.

19. Pino, *Dialogo, ed. cit.,* p. 66; *The Notebooks of Leonardo da Vinci* (New

York, 1939), p. 1148.

20. De Hollanda, *ed. cit.*, pp. 94–95.

21. De Hollanda, *ibid.*, p. 230.

22. *Ibid.*, p. 224.

23. *Ibid.*, p. 235.

24. *Ibid.*, p. 241.

25. *Ibid.*, p. 241.

26. Lomazzo, *Trattato, ed. cit.*, II, 165.

27. See Michelangelo's comment on Augustus Caesar in chap. II, following note 140.

28. Lomazzo, *Trattato, ed. cit.*, II, 381.

29. F. J. Sánchez Cantón, *Fuentes literarias para la historia del arte español* (Madrid, 1923), I, 291.

30. Chantelou, *Journal, ed. cit.*, p. 26.

31. Giambattista Marino, *Epistolario seguito da lettere* (Bari, 1912), II, 247.

32. Oskar Hagen, *Patterns and Principles of Spanish Art* (Madison, 1943), p. 136.

33. Cf. Vasari, *ed. cit.*, VII, 227.

34. De Hollanda, *ed. cit.*, p. 227–28.

35. Tietze, *op. cit.*, p. 308; Aru, *op. cit.*, p. 119. See Introduction, note 24.

36. Luis de Camões, *Os Lusiadas*, V, 97.

37. De Hollanda, *ed. cit.*, p. 198.

38. Milanesi, *Lettere*, p. 457; Vasari, *ed. cit.*, I, 137–38.

39. Vasari, *ed. cit.*, VII, 218.

40. De Hollanda, *ed. cit.*, p. 190.

41. Condivi, lx. See E. Panofsky, *Dürer's Kunsttheorie* (Berlin, 1915); also Panofsky's *Idea, ed. cit.*, pp. 64–72.

42. Pierre Nougaret, *Anecdotes des beaux-arts* (Paris, 1776), I, 295–96.

43. Diogenes Laertius, vi, 32; Plutarch, *Alexander*, xiv.

44. See chap. III, note 222.

45. De Hollanda, *ed. cit.*, p. 189.

46. *Ibid.*, p. 240.

47. See above, note 6.

48. Giraldi Cinzio, *Hecatommithi* (Venice, 1608), p. 219.

49. De Hollanda, *ed. cit.*, p. 189.

50. W. R. Valentiner, "Alessandro Vittoria and Michelangelo," *Art Quarterly*, 1942, V, 2, pp. 149–57; De Tolnay, *Youth of Michelangelo*, p. 156.

51. Joshua Reynolds, *The Idler*, LXXIX, 20 October, 1759.

52. Milanesi, *Lettere*, p. 457.

53. De Hollanda, *ed. cit.*, p. 205.

54. De Tolnay, *The Medici Chapel*, pp. 10–11.

55. Milanesi, *Les Correspondants,* p. 36.

56. Alberti, *Della Pittura* (Milan, 1804), p. 98.

57. M. Menéndez y Pelayo, *Historia de las ideas estéticas* (Madrid, 1901), IV, 113.

58. In Vasconcellos edition of *Da pintura antigua* (Porto, 1930), p. 27.

59. Armenini, *ed. cit.,* p. 12.

60. Léo Rouanet, *Quatre dialogues sur la peinture de Francisco de Hollanda* (Paris, 1911), p. 208.

61. Vasari, *ed. cit.,* VII, 147.

62. Pietro Lamo, *Graticola di Bologna* (Bologna, 1844), pp. 30—31.

63. Frey, *ed. cit.,* p. 57.

64. De Hollanda, *ed. cit.,* p. 228.

65. Milanesi, *Lettere,* p. 391.

66. Vasari, *ed. cit.,* III, 690.

67. *Ibid.,* VII, 137.

68. *Ibid.,* VII, 284, note 1; Dolce, *Dialogo, ed. cit.,* p. 132.

69. Paul Heilbronner, "Grotesque Art," *Apollo,* XXVIII (1928), 221—23. Baldinucci, *Notizie* (Milan, 1812), X, 457.

70. Condivi, *ed. cit.,* p. 82.

71. U. Middeldorf, *Raphael's Drawings* (New York, 1945), pp. 11—12.

72. Holman Hunt, *Pre-Raphaelitism and the Pre-Raphaelite Brotherhood* (New York, 1905), pp. 11—12.

73. Eugene Müntz, *Une rivalité d'artistes au XVIe siècle* (Paris, 1882).

74. De Hollanda, *ed. cit.,* p. 205; Vasari, *ed. cit.,* V, 568.

75. Milanesi, *Lettere,* p. 458.

76. Erica Tietze-Conrat, *Art Bulletin,* XXV (1943), 156.

77. Milanesi, *Lettere,* p. 446.

78. De Tolnay, *The Medici Chapel,* p. 21.

79. Vasari, *ed. cit.,* VII, 144; also II, 299.

80. De Tolnay, *Youth of Michelangelo,* plates 71, 72.

81. Vasari, *ed. cit.,* II, 294.

82. *Ibid.,* II, 301.

83. Giannotti, *Dialoghi, ed. cit.,* p. 40.

84. Condivi, v.

85. Vasari, *ed. cit.,* VI, 276—77.

86. Armenini, *De' veri precetti, ed. cit.,* p. 191.

87. Vasari, *ed. cit.,* VII, 8.

88. Milanesi, *Lettere, ed. cit.,* p. 129.

89. See Papini, *Vita,* pp. 152—53.

90. Vasari, *ed. cit.,* V, 115.

91. Frey, *ed. cit.,* p. 227.

92. Alessandro del Vita, *Un parere di Michelangelo sul Vasari* (Arezzo, 1928), p. 5.

93. Giovanni Baglione, *Le Vite dei pittori, scultori, architetti ed intagliatori* (Naples, 1733), p. 46.

94. Giovanni Pietro Bellori, *Le Vite dei pittori, scultori, et architetti* (Rome, 1672), p. 172.

95. Vasari, *ed. cit.*, VII, 280.

96. *Ibid.*, p. 281.

97. *Ibid.*, p. 278.

98. *Ibid.*, p. 281.

99. Milanesi, *Lettere*, p. 532; Thode, *Michelangelo*, I, 83 f.

100. Cellini, *Vita*, I, viii, 41.

101. *Ibid.*, I, v, 27.

102. Cellini, *Due trattati, ed. cit.*, pp. 62–63.

103. Vasari, *ed. cit.*, V, 385–86.

104. *Ibid.*, VII, 360; also I, 113.

105. Thode, *Michelangelo*, I, 382; 399.

106. De Tolnay, *Youth of Michelangelo*, pp. 224–25.

107. J. A. Symonds, *Renaissance in Italy* (New York, 1935), I, 256.

108. Vasari, *ed. cit.*, VII, 226–27.

109. Gaye, *Carteggio, ed. cit.*, III, 12.

110. Milanesi, *Lettere*, p. 485.

111. Vasari, *ed. cit.*, VII, 35.

112. *Ibid.*, VI, 605.

113. Lomazzo, *Trattato, ed. cit.*, II, 374.

114. Vasari, *ed. cit.*, VII, 192.

115. Milanesi, *Lettere*, p. 535.

116. Vasari, *ed. cit.*, VII, 284, note.

117. *Ibid.*, p. 279.

118. Giraldi Cinzio, *Hecatommithi* (Venice, 1608), p. 221.

119. Vasari, *ed. cit.*, VII, 447–48.

120. Chantelou, *Journal, ed. cit.*, p. 88; also p. 222.

121. Milanesi, *Lettere*, p. 494.

122. De Tolnay, *The Sistine Ceiling*, pp. 247–48.

123. Vasari, *ed. cit.*, VII, 279.

124. *Ibid.*, V, 421–22; VII, 284.

125. De Hollanda, *ed. cit.*, pp. 228–29.

126. H. W. Longfellow, *Michelangelo: A Dramatic Poem* (Boston, 1884), p. 17.

127. Vasari, *ed. cit.*, VII, 279.

128. *Ibid.*, V, 584.

129. Papini, *Vita*, p. 149.

130. Vasari, *ed. cit.*, III, 585.

131. Ugo Ojetti, *Bello e brutto* (Milan, 1930), p. 34.

132. Condivi, lxviii. See also Vasari, VII, 170.

133. *The Notebooks of Leonardo da Vinci* (New York, 1939), p. 1059.

134. Marcel Brion, *Michelangelo, ed. cit.*, p. 232.

135. Condivi, *ed. cit.*, p. 22.

136. Milanesi, *Lettere*, p. 485.

137. Vasari, *ed. cit.*, VII, 227.

138. *Il Codice Magliabechiano* (Berlin, 1892), p. 115.

139. Papini, *Vita*, p. 106.

140. Milanesi, *Lettere*, p. 535.

141. Vasari, *ed. cit.*, VII, 218.

142. W. J. Anderson, *Architecture of the Renaissance in Italy* (London, 1896), p. 94.

143. Vasari, *ed. cit.*, VII, 217.

144. *Ibid.*, VII, 281.

145. Condivi, xxxviii.

146. Vasari, *ed. cit.*, V, 354.

147. Castiglione, *Il Libro del cortegiano*, I, xxxvii, 43.

CHAPTER V: COMPARISON
AND DIFFERENTIATION OF THE ARTS

1. Joan Evans, *Taste and Temperament* (London, 1939), p. 69.

2. Condivi, *Vita*, ix.

3. Vasari, *Vite, ed. cit.*, VII, 137.

4. Carlo Aru, "I dialoghi romani di Francisco de Hollanda," *L'Arte*, XXI (1928), 126.

5. Pomponius Gauricus, *De Sculptura* (Leipzig, 1886), p. 252.

6. Condivi, xxxiii.

7. Condivi, xxxvi.

8. Condivi, xxxiii.

9. Frey, *Dichtungen, ed. cit.*, p. 7.

10. Condivi, xxxiii.

11. Vasari, *ed. cit.*, VII, 173.

12. De Tolnay, *The Sistine Ceiling*, p. 217.

13. Julius Schlosser, *La Letteratura artistica* (Florence, n. d.), p. 77.

14. De Tolnay, *Youth of Michelangelo*, p. 91.

15. Reproduced in the Guasti edition of the *Rime*, p. 175.

16. Letter of 3 May, 1510.

17. Milanesi, *Lettere*, p. 431.

18. De Tolnay, *The Medici Chapel*, pp. 15–16.

19. Thode, *Kritische Untersuchungen*, II, 195 ff.
20. De Hollanda, *Da Pintura antigua, ed. cit.*, p. 206.
21. Giannotti, *Dialoghi, ed. cit.*, p. 40.
22. This *lezione*, first published by Torrentino (Florence, 1549), is reproduced in the Guasti edition of Michelangelo's *Rime*.
23. Condivi, xliv.
24. Vasari, *ed. cit.*, V, 584.
25. Milanesi, *Lettere*, p. 490.
26. *Ibid.*, p. 383.
27. *Ibid.*, p. 519.
28. Vasari, *ed. cit.*, VII, 313.
29. Benedetto Varchi, *Ercolano* (Trieste, 1858), II, 155.
30. Salvator Rosa, *Poesie e lettere* (Milan, 1822), p. 309.
31. Vasari, *ed. cit.*, VII, 231.
32. In chap. VII our discussion of his professional modesty will include protestations by Michelangelo that he is no fresco painter, architect, writer, poet, businessman, critic, or dagger maker.
33. Berenson, 1502. Berenson and Goldscheider believe that these Madonna sketches are originals by Michelangelo rather than copies by Mini.
34. Dolce, *Dialogo della Pittura, ed. cit.*, p. 86.
35. Ghiberti, *I Commentarii* (Berlin, 1912), p. 5.
36. Alberti, *Della Pittura* (Milan, 1804), p. 46.
37. Vasari, *ed. cit.*, I, 103.
38. Lomazzo, *Idea, ed. cit.*, p. 44.
39. Paolo Pino, *Dialogo di Pittura* (Florence, 1950), pp. 92, 100.
40. Da Vinci, *Trattato, ed. cit.*, p. 20.
41. Castiglione, *Il Libro del cortegiano*, I, xlix.
42. Pomponius Gauricus, *ed. cit.*, p. 130 f.
43. De Hollanda, *ed. cit.*, p. 206.
44. Vasari, *ed. cit.*, I, 96.
45. Margaret H. Bulley, *Art and Understanding* (London, 1937), p. 65.
46. De Hollanda, *ed. cit.*, p. 238.
47. Vasari, *ed. cit.*, VII, 210.
48. Armenini, *De' veri precetti, ed. cit.*, pp. 226–27.
49. Cellini, *Due Trattati, ed. cit.*, p. 258.
50. Lomazzo, *Idea, ed. cit.*, p. 36.
51. Vasari, *ed. cit.*, I, 94.
52. Anton Francesco Doni, *Disegno* (Venice, 1549), p. 44.
53. Menéndez y Pelayo, *Historia de las ideas estéticas en España* (Madrid, 1901), IV, 137.
54. Vasari, *ed. cit.*, I, 92.

55. Lomazzo, *Idea, ed. cit.,* p. 21.

56. Vasari, *ed. cit.,* I, 102.

57. Bottari and Ticozzi, *Raccolta di lettere* (Milan, 1822–25), vol I.

58. Vasari, *ed. cit.,* V, 115.

59. Milanesi, *Lettere,* p. 522.

60. Alberti, *Della Scultura* (Milan, 1804), pp. 108–109.

61. Vasari, *ed. cit.,* I, 103.

62. F. P. Chambers, *History of Taste* (New York, 1932), p. 44.

63. Blunt, *Artistic Theory in Italy, ed. cit.,* p. 54.

64. *Buscaroli, op. cit.,* p. 8.

65. Benedetto Varchi, *Due Lezzioni* (Florence, 1549), p. 101.

66. Vasari, *ed. cit.,* VIII, 293.

67. Da Vinci, *Trattato, ed. cit.,* pp. 34–35.

68. *Ibid.,* p. 40.

69. Cellini, *Due Trattati* (Florence, 1857), pp. 217, 219.

70. De Tolnay, *Youth of Michelangelo,* p. 68.

71. J. A. Symonds, *Life,* I, 109.

72. De Tolnay, *Youth of Michelangelo,* p. 105; De Tolnay, *Old Master Drawings* (New York, 1943), pp. 47–48.

73. Masoliver, "Las ideas estéticas de Miguel-Ángel y de sus poesías de escultor," *Escorial,* May, 1942, p. 242.

74. Croce, *Estetica* (Bari, 1908), p. 523.

75. Condivi, lxi, and Vasari, VII, 218.

76. W. J. Anderson, *Architecture of the Renaissance in Italy* (London, 1896), p. 128.

77. Chantelou, *Journal,* pp. 50, 59–60.

78. Milanesi, *Lettere,* p. 383; Vasari, *ed. cit.,* VII, 188; 496.

79. Vasari, *ed. cit.,* VII, 263.

80. Milanesi, *Lettere,* p. 554. Fabio, in Pino's *Dialogo* (Venice, 1946, p. 79) notes also that ancient architects drew upon the human anatomy.

81. Vasari, *ed. cit.,* I, 145–48.

82. *Ibid.,* VII, 233.

83. A. E. Richardson and H. O. Corfiato, *The Art of Architecture* (London, 1938), p. 90.

84. Milanesi, *Lettere,* p. 500.

85. Vitruvius, *De architectura,* I, ii.

86. Cellini, *Due trattati, ed. cit.,* p. 250.

87. Vasari, *ed. cit.,* VII, 280.

88. *Ibid.,* V, 353–54.

89. G. K. Loukomski, *Les Sangallo* (Paris, 1934), p. 77.

90. H. L. Smith, *The Economic Laws of Art Production* (London, 1924), p. 133.

91. Palladio, *De Architectura*, 1570 edition, II, 45. Available now in facsimile edition (Milan: Hoepli, 1945).
92. C. H. Moore, *Character of Renaissance Architecture* (New York, 1905), p. 116.
93. Milanesi, *Lettere*, p. 535.
94. Vasari, *ed. cit.*, VII, 218.
95. Milanesi, *Lettere*, p. 532.
96. De Tolnay, *The Medici Chapel*, p. 32.
97. Vasari, *ed. cit.*, VII, 232.
98. Frey, *ed. cit.*, p. 507.
99. Giannotti, *Dialoghi, ed. cit.*, pp. 71–72.
100. Cellini, *Vita*, I, viii, 41.
101. Miguel Herrero García, *Contribución de la literatura a la historia del arte* (Madrid, 1943), p. 82.
102. De Hollanda, *ed. cit.*, p. 229.
103. Chantelou, *Journal, ed. cit.*, p. 103.

CHAPTER VI: THE ORDEAL OF ART

1. Seneca, *De providentia*, V, ix.
2. Milanesi, Lettere, p. 187.
3. *Ibid.*, p. 510.
4. *Ibid.*, p. 451.
5. *Ibid.*, pp. 61–62.
6. De Hollanda, *Da Pintura antigua, ed. cit.*, p. 227; see Vasari, I, 96–97.
7. *Ibid.*, p. 230.
8. Lomazzo, *Idea, ed. cit.*, p. 26.
9. Cellini, *Vita* (Florence, 1890), p. 482.
10. Milanesi, *Lettere*, p. 286.
11. Vasari, *ed. cit.*, VII, 277.
12. De Tolnay, *The Medici Chapel*, p. 238.
13. De Hollanda, *ed. cit.*, p. 228.
14. Alberti, *Della Pittura* (Milan, 1804), p. 38.
15. Vasari, *ed. cit.*, VII, 159.
16. De Hollanda, *ed. cit.*, p. 230.
17. Giannotti, *Dialoghi, ed. cit.*, p. 69.
18. Boccaccio, *De genealogia deorum*, xiv.
19. Alberti, *Della Pittura* (Milan, 1804), p. 83.
20. *Ibid.*, p. 44.
21. Lomazzo, *Idea, ed. cit.*, p. 8.

22. Vasari, *ed. cit.*, VII, 279.
23. *The Notebooks of Leonardo da Vinci* (New York, 1939), p. 879.
24. Condivi, lxi.
25. De Hollanda, *ed. cit.*, p. 184.
26. De Tolnay, *Youth of Michelangelo*, pp. 244–49.
27. Papini, *Vita*, p. 508.
28. Frey, *Briefe an Michelangiolo*, p. 317.
29. Milanesi, *Lettere*, pp. 426; 492–93.
30. Condivi, xlviii.
31. Milanesi, *Lettere*, p. 427.
32. *Ibid.*, p. 490.
33. Cf. Grimm, *Life of Michelangelo* (Boston, 1898), I, 474.
34. Milanesi, *Lettere*, p. 12.
35. De Tolnay, *The Sistine Ceiling*, pp. 191–92.
36. Papini, *Vita*, p. 127.
37. Frey, *ed. cit.*, p. 7.
38. Vasari, *ed. cit.*, VII, 211.
39. Milanesi, *Lettere*, p. 383.
40. *Ibid.*, p. 394.
41. De Tolnay, *The Medici Chapel*, pp. 225–44.
42. Vasari, *ed. cit.*, VII, 244.
43. De Tolnay, *The Medici Chapel*, p. 237.
44. Dante, *Paradiso*, I, 127–29.
45. Milanesi, *Lettere*, p. 555.
46. Papini, *Vita*, pp. 469–71.
47. De Tolnay, *The Medici Chapel*, p. 228.
48. *Ibid.*, p. 230.
49. Milanesi, *Lettere*, 398.
50. *Ibid.*, p. 398.
51. *Ibid.*, p. 398.
52. *Ibid.*, p. 513.
53. Cellini, *Vita*, II, xii, 81.
54. Milanesi, *Lettere*, p. 137.
55. *Ibid.*, p. 119.
56. *Ibid.*, p. 555.
57. *Ibid.*, pp. 8, 65.
58. *Ibid.*, p. 389.
59. Symonds, *Life*, II, 339.
60. Vasari, *op. cit.*, VII, 175. As De Tolnay reminds us (*Sistine Ceiling*, p. 8), we possess written documents verifying the dismissal of only one of these garzoni, Iacopo di Sandro.

61. Papini, *Vita,* p. 631.
62. Milanesi, *Lettere,* p. 79.
63. *Ibid.,* p. 79.
64. *Ibid.,* p. 493.
65. *Ibid.,* p. 381.
66. *Ibid.,* p. 394.
67. De Tolnay, *The Medici Chapel,* p. 229.
68. *Ibid.,* p. 229.
69. *Ibid.,* p. 229.
70. *Ibid.,* p. 231.
71. *Ibid.,* p. 225.
72. Milanesi, *Lettere,* p. 394.
73. *Ibid.,* p. 140.
74. Milanesi, *Les Correspondants,* p. 24.
75. Milanesi, *Lettere,* pp. 8–9.
76. J. A. Symonds, *Life,* I, 434.
77. *Ibid.,* I, 189.
78. Cellini, *Vita* (Florence, 1890), pp. 482–83.
79. Milanesi, *Lettere,* p. 16.
80. Lomazzo, *Trattato, ed. cit.,* I, 363.
81. Frey, *Briefe an Michelangiolo, ed. cit.,* p. 383.
82. De Tolnay, *The Medici Chapel,* p. 231.
83. P. Barocchi, *Trattati d'arte del Cinquecento* (Bari, 1960), p. 148.
84. De Hollanda, *ed. cit.,* p. 190.
85. Milanesi, *Lettere,* p. 384.
86. *Ibid.,* p. 450; for the 1508 rumor of his death, see p. 11.
87. Frey, *ed. cit.,* p. 248. This sonnet is to be compared with Michelangelo's expressed desire to join Urbino in Letter CCLXXXIV.
88. De Tolnay, "Die Handzeichnungen Michelangelos im Archivio Buonarroti," *Münchner Jahrbuch der bildenden Kunst,* V (1928), 425.
89. Giannotti, *Dialoghi, ed. cit.,* p. 69.
90. See Marcel Brion, *Michelangelo* (New York, 1940), p. 313.
91. Guasti edition of the *Rime,* p. 4.
92. De Tolnay, *The Medici Chapel,* p. 15.
93. Vasari, *ed. cit.,* VII, 216.
94. *Ibid.,* p. 262.
95. Blashfield-Hopkins English translation of Vasari, *ed. cit.,* IV, 249.
96. Milanesi, *Lettere,* p. 546.
97. Papini, *Vita,* pp. 497–98. His chap. CLII lists Michelangelo's several maladies.
98. Milanesi, *Lettere,* p. 173.
99. *Ibid.,* p. 550.

100. Codex Vaticanus 3211, fol. CII v.–CIII v.
101. *The Notebooks of Leonardo da Vinci, ed. cit.*, p. 216.
102. Milanesi, *Lettere*, p. 420.
103. *Ibid.*, p. 469.
104. Gaye, *Carteggio*, II, 228.
105. *Ibid.*, II, 229.
106. De Hollanda, *ed. cit.*, p. 217.
107. Milanesi, *Lettere*, p. 501.
108. Frey, *ed. cit.*, p. 88.
109. *Ibid.*, p. 87.
110. Milanesi, *Lettere*, p. 489.
111. *The Notebooks of Leonardo da Vinci, ed. cit.*, p. 1123.
112. Gaye, *op. cit.*, II, 227.
113. Condivi, xlvii.
114. Vasari, *ed. cit.*, VII, 218.
115. De Hollanda, *ed. cit.*, p. 185.
116. Milanesi, *Lettere*, p. 519.
117. Papini, *Vita*, p. 470.
118. Milanesi, *Les Correspondants*, p. 74.
119. Milanesi, *Lettere*, p. 333.
120. *Ibid.*, p. 345.
121. Condivi, xxxix.
122. Milanesi, *Lettere*, p. 490.
123. Papini, *Vita*, p. 283.
124. Frey, *ed. cit.*, p. 234.
125. *Ibid.*, p. 88. For Sebastiano's references to Michelangelo's bondage, see *Les Correspondants*, pp. 46, 92.
126. Charles Dejob, *De l'Influence du Concile de Trente, ed. cit.*, p. 336.
127. Milanesi, *Lettere*, p. 383.
128. *Ibid.*, p. 424.
129. Vasari, *ed. cit.*, VII, 232.
130. Milanesi, *Lettere*, p. 427.
131. De Tolnay, *Youth of Michelangelo*, p. 254.
132. E. Wind, "Sante Pagnini and Michelangelo," *Gazette des beaux-arts*, XXV (1944), 211 ff.
133. Milanesi, *Lettere*, p. 489.
134. Vasari, *ed. cit.*, VII, 280.
135. Milanesi, *Lettere*, pp. 450–51.
136. Grace Overmyer, *Government and the Arts* (New York, 1939), p. 16.
137. Vasari, *ed. cit.*, VII, 175.
138. Condivi, xxxix.

139. Milanesi, *Lettere*, p. 537.
140. E. Kretschmer, *Psychology of Men of Genius* (New York, 1931), II, 5, 110; W. Lange-Eichbaum, *Genie-Irrsinn und Ruhm* (Munich, 1928), pp. 356–431; also, Adrian Stokes, *Michelangelo, A Study in the Nature of Art* (London, Tavistock, 1955), whose central theme is that M. lived "on anxiety and death."
141. E. Kretschmer, *Physique and Character* (New York, 1936), p. 240.
142. Lomazzo, *Idea, ed. cit.*, p. 42.
143. Condivi, xvii.
144. Papini, *Vita*, p. 95.
145. Frey, *Briefe an Michelangiolo, ed. cit.*, p. 220.
146. Milanesi, *Lettere*, p. 377.
147. *Ibid.*, p. 457.
148. Condivi, xiv.
149. Milanesi, *Lettere*, p. 107.
150. Condivi, xlvi.
151. J. A. Symonds, *Life, ed. cit.*, I, 7.
152. Milanesi, *Les Correspondants*, p. 42.
153. Milanesi, *Lettere*, pp. 55–56.
154. *Ibid.*, p. 151.
155. *Ibid.*, p. 11.
156. *Ibid.*, p. 49.
157. *Ibid.*, p. 55.
158. *Ibid.*, p. 492.
159. Benjamin Nelson, *The Idea of Usury* (Princeton, 1949), chap. I. The identity of usurers and sodomites is discussed in Nelson's article, "Usury, Heresy, and Inquisition," unpublished at this date.
160. Milanesi, *Lettere*, p. 488.
161. *Ibid.*, p. 455.
162. *Ibid.*, p. 362.
163. *Ibid.*, p. 221.
164. *Ibid.*, p. 46.
165. Vasari, *ed. cit.*, VII, 245.
166. *Ibid.*, p. 219.
167. *Ibid.*, pp. 264–65.
168. Milanesi, *Lettere*, p. 558.
169. *Ibid.*, p. 371.
170. Alberti, *Della Pittura* (Milan, 1804), p. 98.
171. Papini, *Vita*, p. 155.
172. Giannotti, *Dialoghi, ed. cit.*, p. 96.
173. Frey, *Briefe an Michelangiolo, ed. cit.*, p. 77.
174. Blashfield-Hopkins English translation of Vasari, *ed. cit.*, IV, 252.

175. Gaye, *op. cit.*, II, 489.
176. Milanesi, *Les Correspondants*, p. 20.
177. De Hollanda, *ed. cit.*, p. 188.
178. Milanesi, *Lettere*, p. 97.
179. Milanesi, *Les Correspondants*, p. 92; also p. 44.
180. De Hollanda, *ed. cit.*, p. 227.
181. Auguste Barbier, *Jambes et poèmes* (Paris, 1888), p. 127.
182. Milanesi, *Lettere*, p. 488.
183. *Ibid.*, p. 151.
184. Ludwig Goldscheider, *Michelangelo Drawings* (London, 1951), p. 54.
185. Frey, *ed. cit.*, pp. 236, 238.
186. Milanesi, *Lettere*, p. 97.
187. *Ibid.*, p. 488.
188. *Ibid.*, p. 4.
189. Cennini, *Il libro dell'Arte* (New Haven, 1932), p. 3.
190. Alberti, *Della Pittura* (Milan, 1804), p. 43.
191. Da Vinci, *Trattato*, *ed. cit.*, p. 57.
192. Vasari, *ed. cit.*, VII, 217.
193. Condivi, lvii.
194. Dolce, *Dialogo della Pittura*, *ed. cit.*, p. 272.
195. Condivi, lviii.
196. Nesca Robb, *Neoplatonism of the Italian Renaissance*, *ed. cit.*, p. 245.
197. Giannotti, *Dialoghi*, *ed. cit.*, p. 97.

CHAPTER VII: SUMMATIONS AND PARADOXES

In this chapter passages which have already appeared in earlier sections will not be footnoted.

1. Donato Giannotti, *Dialoghi*, *ed. cit.*, p. 87.
2. *Ibid.*, pp. 60, 88, 91, 96.
3. Vasari, *ed. cit.*, VII, 163.
4. Lodovico Castelvetro, *Poetica d'Aristotele vulgarizzata e sposta* (Basel, 1576), p. 217.
5. Giovanni Pietro Bellori, *Le Vite dei pittori, scultori, et architetti* (Rome, 1672), p. 172. See also Michelangelo's grateful sonnet (clxi) on the gift of a mule.
6. Giannotti, *Dialoghi*, *ed. cit.*, p. 43. *Cf.* Horace, *Epist.* I, 3, vv. 15–20; and Aesop, corpus of Chambry (Paris, 1937), fable 162.
7. *Ibid.*, pp. 45–46.

8. Frey, *Dichtungen, ed. cit.*, p. 250.
9. Giannotti, *Dialoghi, ed. cit.*, p. 86.
10. Milanesi, *Lettere*, p. 23.
11. Vasari, *ed. cit.*, VI, 202.
12. Frey, *ed. cit.*, p. 111; Masoliver, *op. cit.*, p. 237.
13. "Un Dialogo tra Niccolo Franco e il Buonarroti," *Il Buonarroti*, IV (April, 1866), 91.
14. Vasari, *ed. cit.*, VII, 144.
15. Martin Johnson, *Art and Scientific Thought* (London, n. d.), p. 135.
16. Milanesi, *Lettere*, p. 520. These may actually have been plates containing some of Michelangelo's too-revealing poems to young Cecchino de' Bracci.
17. M. Herrero García, *Contribución de la literatura a la historia del arte* (Madrid, 1943), pp. 77–78.
18. Milanesi, *Lettere*, p. 7.
19. Papini, *Vita, ed. cit.*, p. 223.
20. Masoliver, "Las ideas estéticas de Miguel-Ángel y de sus poesías de escultor," *Escorial*, May, 1942, p. 244.
21. Mariani, *La Poesia, ed. cit.*, p. 87.
22. Panofsky, *Iconology*, ed. cit., p. 218.
23. Giannotti, *Dialoghi, ed. cit.*, p. 68.
24. Vasari, *ed. cit.*, VII, 201.
25. Dante Alighieri, *Purgatorio*, xvi, 48; *Paradiso*, viii, 103, etc.
26. Papini, *Vita*, pp. 98–99.
27. *Mémoires de la Société des antiquaires de France*, X (1868), 58; also Thode, *Kritische Untersuchungen*, I, 85; and R. J. Clements, *The Peregrine Muse: Studies in Comparative Renaissance Literature* (Chapel Hill, 1959), chap. IX, which treats this question fully.
28. "Una Visione del Buonarroti," *Il Buonarroti*, IV (April, 1866), 103.
29. *Il Samuelis* XXII: 33, 37, 50.
30. Milanesi, *Lettere*, p. 65.
31. Frey, *ed. cit.*, p. 194.

BIBLIOGRAPHICAL NOTE

Because of the multitude of existing titles devoted to Michelangelo's life and works, no bibliography is appended to this volume. Instead, the reader is referred to four bibliographies which include all significant items appearing before 1950.

1. Ernst Steinmann and Rudolf Wittkower, *Michelangelo Bibliographie*. Leipzig: Klinkhardt and Biermann, 1927.
 Covers the period 1510–1926.
2. Ernst Steinmann and Rudolf Wittkower, *Michelangelo im Spiegel seiner Zeit*. Leipzig, 1930.
 Covers the period 1927–1930.
3. P. Cherubelli, *Supplemento alla bibliografia michelangiolesca*, in *Michelangelo Buonarroti nel IV centenario del Giudizio universale*. Florence: Istituto nazionale di studi sul Rinascimento, 1942.
 Covers the period 1931–1942.
4. *Zeitschrift für Kunstgeschichte* (Munich). Brings bibliography from 1942 to present.

American scholarship devoted to Michelangelo is generally reflected in *The Art Index* (New York: H. W. Wilson Co.), covering the period 1929 to the present. Equally important are the *Répertoire d'art et d'archéologie* (Paris) and the *Annuario bibliografico di storia dell'arte, Pubblicazioni della Biblioteca dell'Istituto nazionale d'archeologia e storia dell'arte* (Rome), covering years from 1952 to the present.

TABLE OF ITALIAN AND ENGLISH TITLES
OF MICHELANGELO'S MAJOR WORKS

For reasons advanced in the Introduction, we have chosen to adhere for the most part to the original Italian titles of Michelangelo's works of art. The following table presents Italian and English equivalents of those titles which have appeared in this volume, omitting only a few titles immediately identifiable as cognates.

SCULPTURE

Madonna della Scala	Madonna of the Stairs
Il Centauromachia (Il ratto di Deianira)	The Battle of the Centaurs (The Rape of Dejanira)
Il Bacco	Bacchus
La Madonna della Febbre	The Pietà in St. Peter's
La Madonna di Bruges	The Bruges Madonna
Il David (Il Gigante)	David (The Giant)
La Madonna Pitti	The Round Madonna Relief in Florence
San Matteo	St. Matthew
Mosè	Moses
I Prigioni (Schiavi, Stiavi)	The Captives
Le Vittorie	The Victories
Il Genio della Vittoria (Il Vincitore)	The Genius of Victory (The Victor)
Il Cristo risorto	The Risen Christ
La Cappella dei Medici	The Medici Chapel
Il Giorno	The Day
La Notte	The Night
Il Crepuscolo	The Dusk
L'Aurora	The Dawn
La Madonna Medicea	The Madonna of the Medici Tombs

Bruto	Brutus
La Vita attiva (Lea)	The Active Life (Leah)
La Vita contemplativa (Rachele)	The Contemplative Life (Rachel)
La Deposizione	The Florentine Entombment
La Pietà Rondanini	The Rondanini "Pietà"
La Pietà Palestrina	The Palestrina "Pieta"
Cupido dormente	The Sleeping Cupid

PAINTING

La Madonna Doni	The Holy Family
La Battaglia di Cascina	The Battle of Cascina
La Cappella Sistina	The Sistine Chapel
Dio separa la luce dalle tenebre	The Separation of Darkness and Light
La Creazione del sole e della luna	The Creation of the Sun and Moon
Dio separa l'oceano dalla terra	The Separation of Waters and Land
La Creazione di Adamo (dell'uomo)	The Creation of Adam (of Man)
La Creazione di Eva	The Creation of Eve
L'Espulsione, Il Peccato	The Expulsion, The Fall of Man
Il sacrificio di Noè (di Abel e di Caino)	The Sacrifice of Noah (of Cain and Abel)
Il Diluvio	The Great Flood
L'Ebbrezza di Noè	The Drunkenness of Noah
Gl'Ignudi	The (20) Nude Youths
I Putti	The (4 groups of) Putti
Daniele	Daniel
Ezechiele	Ezekiel
Geremia	Jeremiah
Gioele	Joel
Giona	Jonah
Isaia	Isaiah
Zaccaria	Zechariah
Sibilla di Cuma	Cumaean Sibyl
Sibilla di Delfo	Delphic Sibyl
Sibilla d'Eritrea	Erythraean Sibyl
Sibilla Libica	Libyan Sibyl
Sibilla Persiana	Persian Sibyl
Il Giudizio universale	The Last Judgement
Il Cristo Giudice: Christus Iudex	Christ the Judge
Il Monaco	The Monk

I Dannati	The Damned Souls
San Bartolommeo	St. Bartholomew
Antenati di Cristo	The Ancestors of Christ
La Conversione di San Paolo	The Conversion of St. Paul
La Crocifissione di San Pietro	The Crucifixion of St. Peter
Leda col Cigno	Leda and the Swan

DRAWINGS

Le teste divine	The divine heads
Il Sogno (della vita umana)	The Dreamer, The Dream (of Human Life)
La Baccanalia dei putti	The Children's Bacchanal
I Saettatori (Gli arcieri)	The Archers (Archers shooting at a Herm)
Il Fetonte	The Fall of Phaeton
I Fiumi	The Rivers; River-Gods
Ercole e Caco	Hercules and Cacus
Tizio	Tityus
Madonna che allatta il Figlio	Sketch for the Medici Madonna (Vienna, Albertina)

PLATES

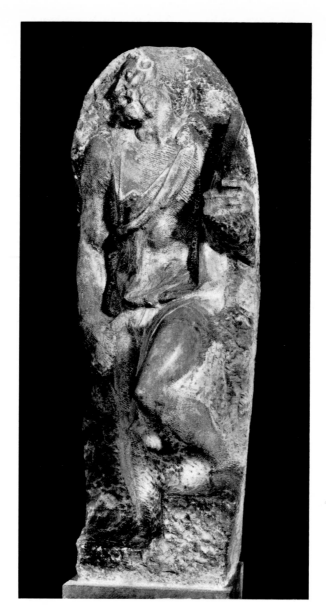

PLATE I / SAN MATTEO

Florence, Accademia delle Belle Arti

Si come per leuar, Donna, si pone
Im pietra alpestra e dura
Una uiua figura
Che là piu crescie, u' piu la pietra scema.

Just as one places, my lady,
In hard and alpine stone,
A living figure to be drawn out
Growing there the more as the stone is chipped away.

See page 21.

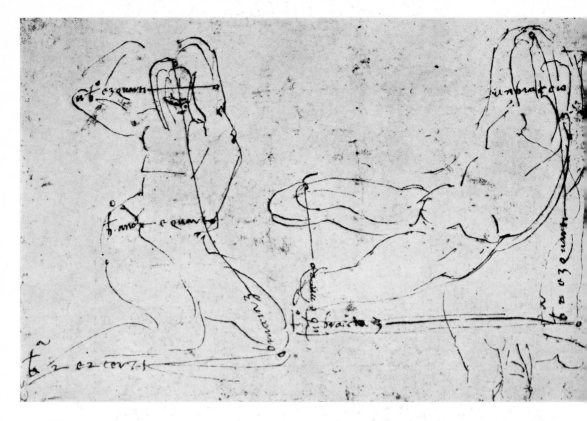

PLATE II / STUDY OF FIGURES FOR MEDICI TOMBS,
WITH ANALYTICAL LINES

London, British Museum

"Imperò egli usò le sue figure farle di nove e di dieci e di dodici teste, non cercando altro che,
col metterle tutte insieme, ci fussi una certa concordanza di grazia nel tutto, che non lo fa il na-
turale; dicendo che bisognava avere le seste negli occhi e non in mano, perchè le mani operano,
e l'occhio giudica" (Vasari).

"Nevertheless he used to make his figures the sum of nine, ten, and twelve heads, seeking nothing
else in placing them all together than that there should be a certain graceful harmony of total
effect which the natural does not give; saying that you had to have your compasses in your eyes
and not your hands, for the hands execute, but it is the eye which judges."

See page 31.

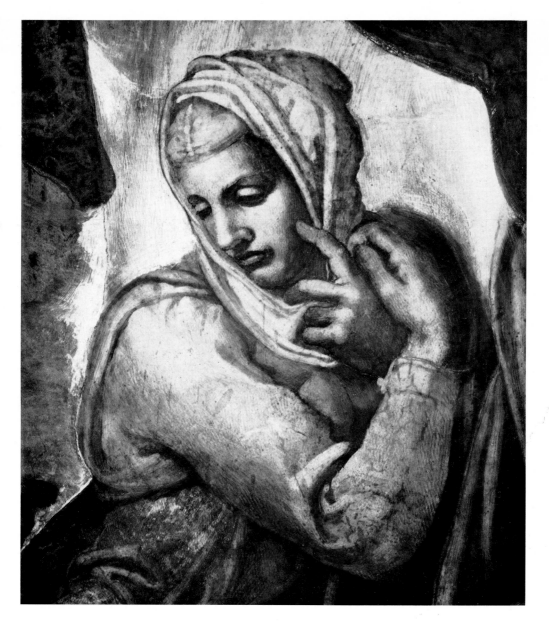

PLATE III / MADONNA,

DETAIL FROM THE GIUDIZIO UNIVERSALE

Rome, Sistine Chapel

"E pois um povre homem da terra isto pos por edito da sua fegura, quanta mór razão tem os principes eclesiasticos ou seculares de porem mui grande cuidado em mandarem que ninguem pintasse a benignidade e mansidão de Nosso Redemptor nem a pureza de Nossa Senhora e dos sanctos, senão os mais ilustres pintores que podessem alcançar em seus senhorios e provincias!"

"And since a poor mortal man established this as a decree regarding his own image, how much greater reason have the ecclesiastical and secular princes to take great care in having none but the most illustrious painters to be found in their realms and provinces paint the benignity and mansuetude of our Redeemer or the purity of Our Lady and the saints."

See page 82.

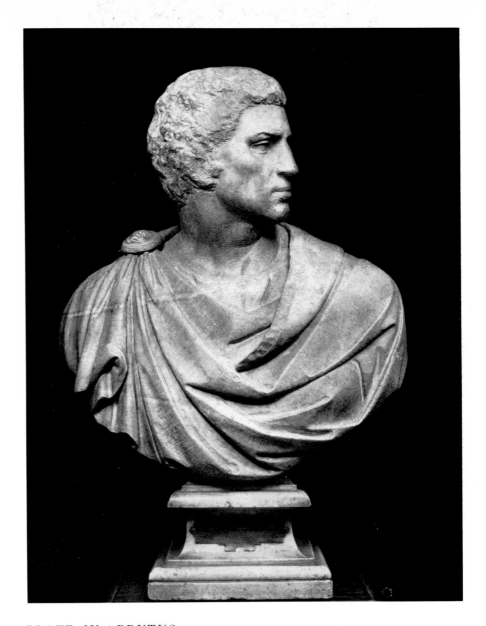

PLATE IV / BRUTUS

Florence, Museo Nazionale

"E, dunque, chiaro che chi ammazza un tiranno non commette homicidio, ammazzando un huomo, ma una bestia. Non peccarono, adunque, Bruto e Cassio quando ammazzarono Cesare."

"It is therefore clear that he who kills a tyrant does not commit homicide, killing a man, but rather a beast. Brutus and Cassius did not sin, then, when they killed Caesar."

See page 115.

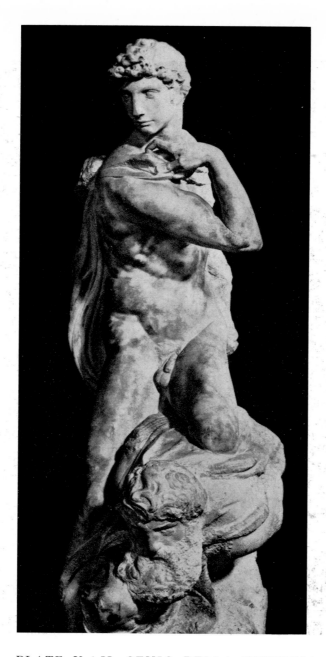

PLATE V / IL GENIO DELLA VITTORIA

Florence, Palazzo Vecchio

Se nel uolto per gli ochi il cor si uede,
Altro segnio non o piu manifesto
Della mia fiamma; addunche basti or questo,
Signior mie caro, a domandar mercede.

If through the eyes the heart is seen on the face,
No other sign more manifest have I
Of my flame; let this then be enough,
My beloved lord, to ask mercy of thee.

See page 139.

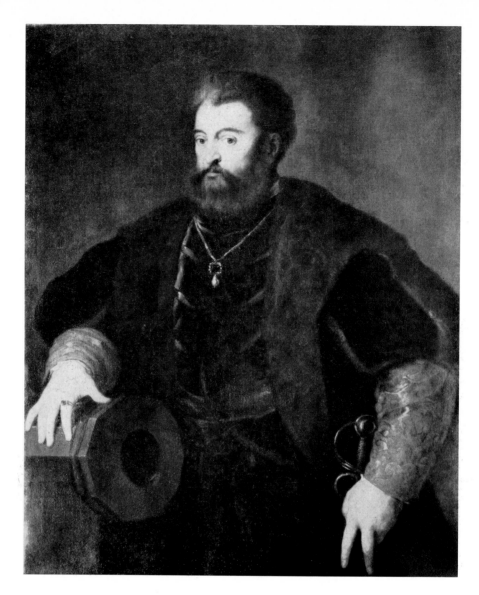

PLATE VI / PORTRAIT OF DUKE ALFONSO OF FERRARA

Titian. New York, Metropolitan Museum

"Il quale veduto poi da Michel' Agnolo, ei lo ammirò e lodò infinitamente, dicendo, ch'egli non haveva creduto, che l'arte potesse far tanto; e che solo Titiano era degno del nome di Pittore."

"Which portrait being seen later by Michelangelo, he admired and praised it infinitely, saying that he had not believed that art could accomplish so much; and that only Titian was worthy of the name of Painter."

See page 276.

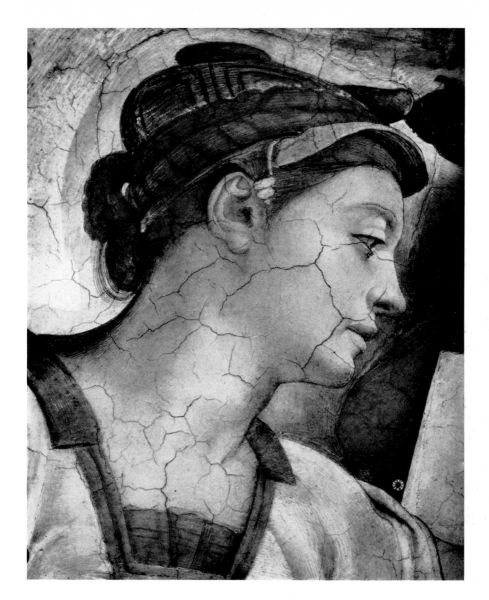

PLATE VII / SIBILLA ERITREA, DETAIL

Rome, Sistine Chapel

Per fido esemplo alla mia uocazione
Nel parto mi fu data la bellezza,
Che d'ambo le arti m'è lucerna e specchio.

As a faithful precedent for my vocation
Beauty was granted me at my birth
Which is to me in both arts a guiding lamp and mirror.

See page 14.

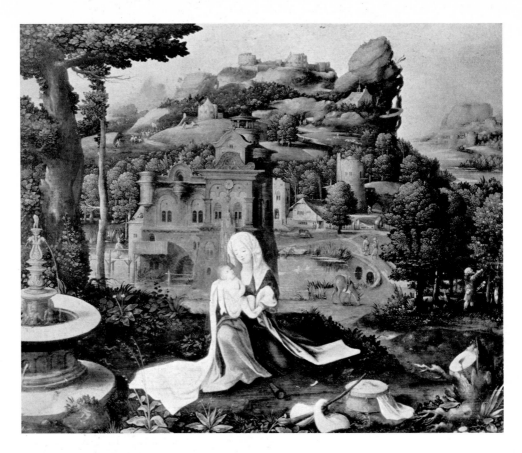

PLATE VIII / REST ON THE FLIGHT INTO EGYPT

Flemish School, XVIth Century. New York, Metropolitan Museum

"Pintam em Frandes propriamente para enganar a vista exterior, ou cousas que vos alegrem ou de que não possaes dizer mal, assi como santos e profetas. O seu pintar é trapos, maçonerias, verduras de campos, sombras d'arvores, e rios e pontes, a que chamam paisagens, e muitas feguras para cá e muitas para acolá."

"They paint in Flanders expressly to deceive the outer vision, either things which delight you or about which you may speak no ill, such as saints and prophets. Their painting is of patches, masonries, plants in the fields, shadows of trees, rivers, and bridges, all of which they call landscapes, with many figures here and many figures there."

See pages 207, 268.

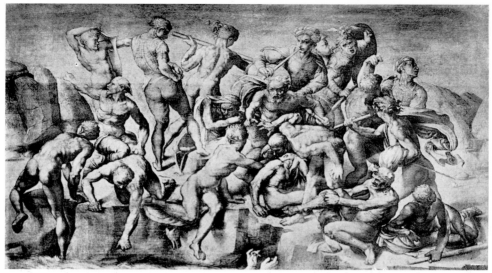

A

B

PLATE IX / LA BATTAGLIA DI CASCINA

A. Detail, from copy by Aristotile da Sangallo. Norfolk, Holkam Hall.

B. Detail, from engraving by Marcantonio Raimondi. Boston, Museum of Fine Arts.

"He never paid attention to [stretches of land, trees, or dwellings], as one who perhaps disdained to lower that great genius of his to such things."

See page 212.

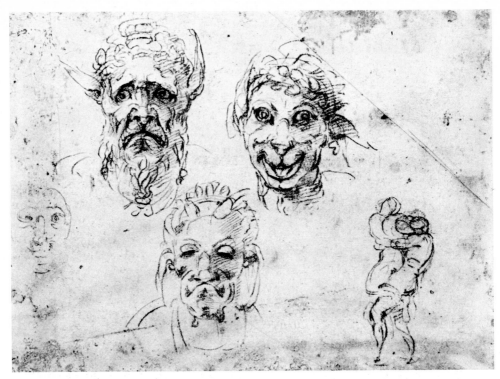

PLATE X / SKETCHES OF GROTESQUE MASKS

London, British Museum

"E melhor se decora a razão quando se mete na pintura alguma monstruosidade (para a variação e relaxamento dos sentidos e cuidado dos olhos mortaes, que ás vezes desejam de ver aquilo que nunca inda viram, nem lhes parece que pode ser) mais que não a costumada fegura (posto que mui admirabil) dos homens."

"And one may rightly decorate better when one places in painting some monstrosity (for the variety and relaxation of the senses and the attention of mortal eyes, which at times desire to see what they have never before seen or what appears to them just cannot be) rather than the customary figures of men (or animals), however admirable these may be."

See page 215.

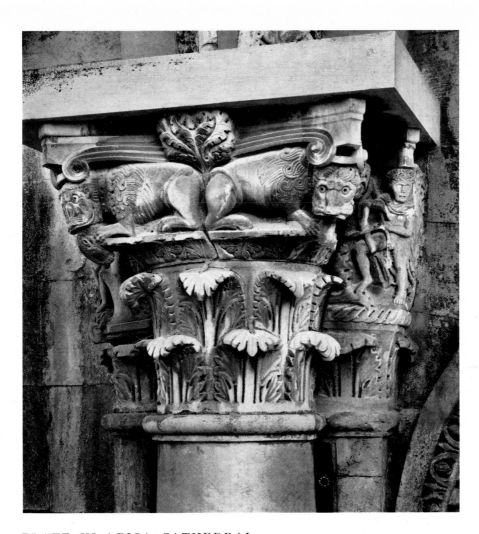

PLATE XI / PISA CATHEDRAL

West Façade, Detail of Capital

"E d'aqui tomou licença o insaciabil desejo humano a lhe de avorrecer alguma vez mais um edificio com suas columnas e janellas e portas que outro fingido de falso grutesco, que as columnas tem feitas de crianças que saem por gomos de flores, com os arquitraves e fastigios de ramos de murta, e as portadas de canas e d'outras cousas, que muito parece(m) impossibeis e fora de razão."

"Whence the insatiable human desire took license and rather neglected at times a building with its columns and windows and doors in favor of some other constructed of false grotesque, whose columns are made of children issuing from shoots of flowers, with architraves and capitals of myrtle branches, and gates of cane and other things, which appear very impossible and beyond reason."

See page 217.

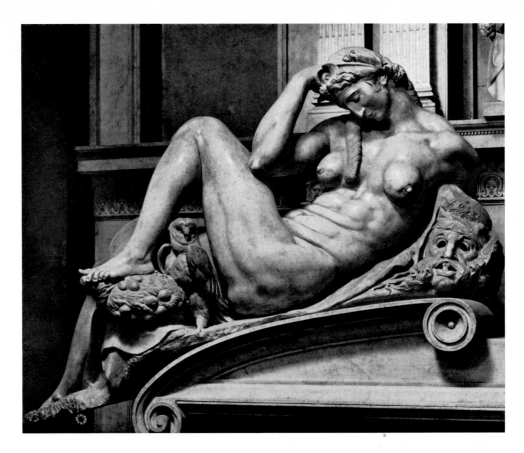

PLATE XII / LA NOTTE

Florence, Medici Chapel

Tu mozzi e tronchi ogni stanco pensiero
Che l'humid' ombra et ogni quiet' appalta,
Et dall'infima parte alla più alta
In sogno spesso porti, ou' ire spero.

Cutting off and cutting short every weary thought
 That the humid darkness and every quiet moment contract,
 Thou bearest often in dream from the very lowest
 To the very highest, where I long to go.

See pages 222 – 23.

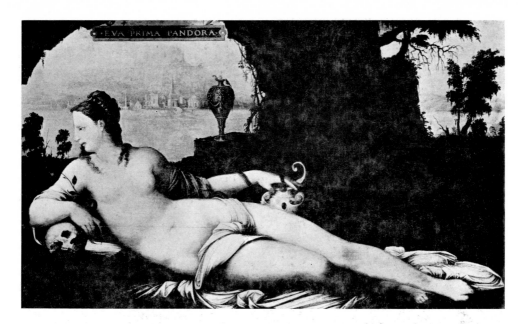

PLATE XIII / EVA PRIMA PANDORA

Jean Cousin the Elder. Paris, Louvre

"Assim affirmo que nenhuma nação nem gente póde perfeitamente fartar, nem imitar o modo do pintar de Italia (que é o grego antigo), que logo não seja conhecido facilmente por alheo, por mais que nisso esforce e trabalhe. E se por algum grande milagre algum vier a pintar bem, então, se poderá dizer que o sómente pintou como Italiano . . ."

"Thus I affirm that no nation or people can perfectly copy or imitate the Italian mode of painting (which is that of ancient Greece), so that it will not thereafter be easily recognised as alien, no matter how much effort and labor is put into it. And if by some great miracle someone might happen to paint well, then it will be possible to say merely that he painted as an Italian [even though he did not do it to imitate Italy]."

See page 258.

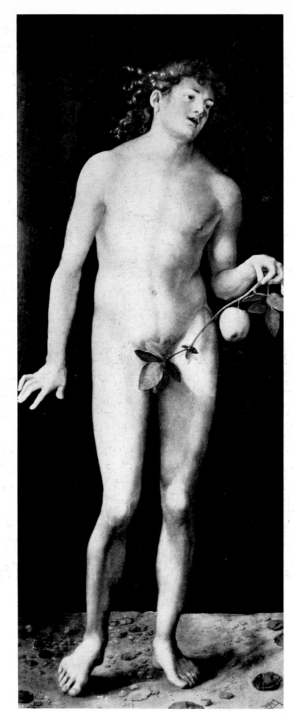

PLATE XIV / ADAM

Albrecht Dürer. Madrid, Prado Museum

"Alberto, homem delicado na sua maneira."

"Albrecht, a man delicate in his manner."

See page 266.

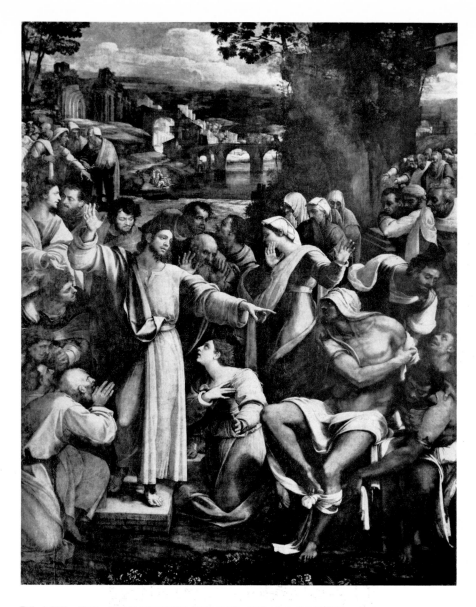

PLATE XV / RESURRECTION OF LAZARUS

Sebastiano del Piombo. London, National Gallery

"Portate in pace, e pensate d'avere a essere più glorioso a risuscitare morti che a fare figure che paino vive."

"Keep your peace, and reflect that you will be more famous for resurrecting the dead than for painting figures which may appear alive."

See page 278.

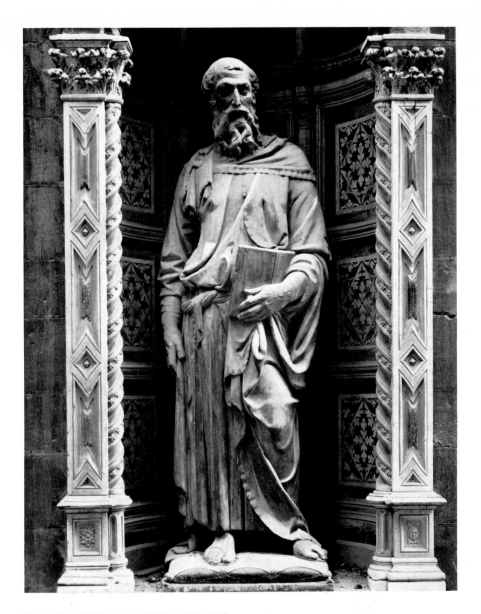

PLATE XVI / SAINT MARK

Donatello. Florence, Or San Michele

"Michelangelo rispose: che non vedde mai figura che avessi più aria di uomo da bene di quella; e che se San Marco era tale, se gli poteva credere ciò che aveva scritto."

"Michelangelo replied that he had never seen a figure which had more the air of a courteous gentleman than this one; and that if Saint Mark was such a man, one could believe what he had written."

See page 282.

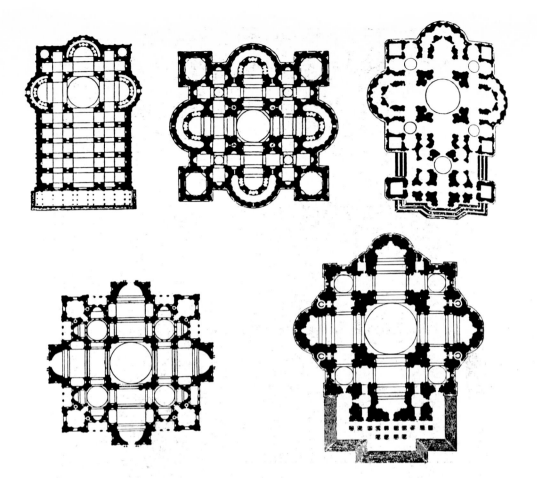

PLATE XVII / PROJECTS FOR THE BASILICA OF
SAINT PETER'S

Top: Raphael, Peruzzi, Antonio da Sangallo
Bottom: Bramante and Michelangelo

"It cannot be denied that Bramante was talented as an architect, as much as any other from
the ancients down to the present. He laid the first plan of Saint Peter's, not full of confusion
but clear and pure, well-lighted and detached from its surroundings, in such a manner that
it did not harm any part of the palace; it was held to be a beautiful thing, as is still manifest;
so that whoever has strayed from the aforesaid order of Bramante, as Sangallo has done, has
strayed from truth; and any dispassionate observer can see whether this is so and can see
it in his model; with that outside circle which he sets up, the first thing he does is to remove
all the light from Bramante's plan. And not only this, but the structure provides no light
whatsoever of itself. There are so many hiding-places above and below and so dark that they
lend themselves easily to an infinite number of ribaldries: to the hiding of bandits, the
counterfeiting of money, the impregnating of nuns and other monkeyshines, so that in the
evening, when the church would close, you would need twenty-five men to seek out whoever
might remain concealed within."

See page 293.

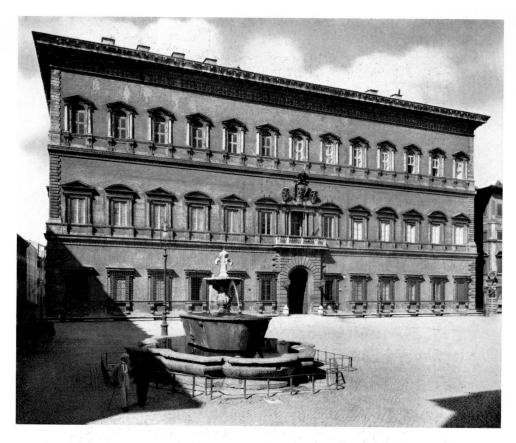

PLATE XVIII / PALAZZO FARNESE

Window and Cornice by Michelangelo, Rome

"Egli è un altro grado di distribuzione quando l'opera sarà fatta secondo l'uso del patre della famiglia, et secondo l'abundanzia de' danari, et secondo l'eleganzia e degnità sua ..."

"There is another grade of distribution when the structure will be made according to the habits of the householder and according to the abundance of money, and according to his elegance and dignity ..."

See page 324.

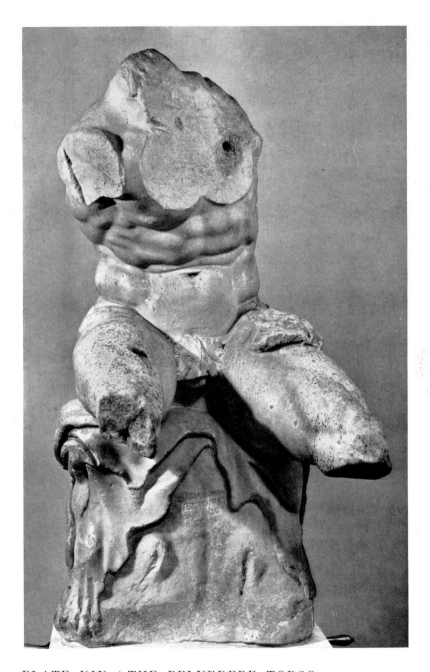

PLATE XIX / THE BELVEDERE TORSO

Rome, Vatican Museum

"Questo è l'opera d'un huomo che ha saputo più della natura. È sventura grandissima che sia persa."

"This is the work of a man who knew more than nature. It is a great pity that the total work has been lost."

See page 263.

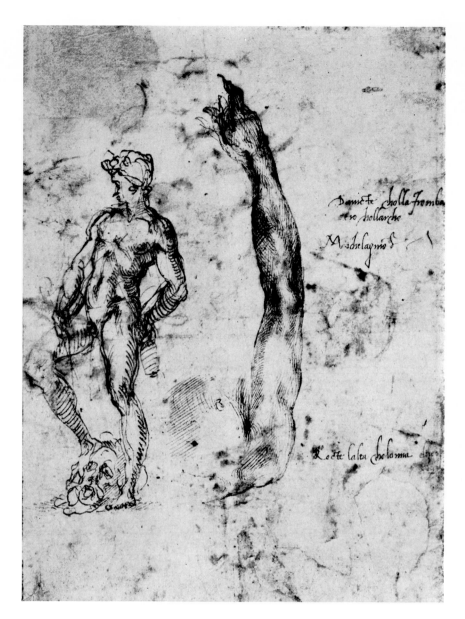

PLATE XX / SKETCH OF BRONZE DAVID
WITH STUDY OF RIGHT ARM OF MARBLE DAVID

Paris, Louvre

"Davicte cholla fromba e io choll'archo
 Michelagniolo"

"David with the sling and I with the bow
 Michelagniolo"

See page 415.

INDEX OF NAMES

Addison, Joseph, 28

Alazone, 63, 269, 286, 296–97

Alberti, Leon Battista, ix, xxviii, xxx, 6, 22 to 23, 30, 34, 37, 64–65, 80, 84, 95, 100, 102, 111, 117, 135, 147–48, 152, 156–57, 165, 167, 169, 176, 178, 193, 196–97, 206, 220, 234, etc.

Alciati, Andrea, 226

Aldovrandi, Giovan Francesco, 332, 340, 390

Alexander VI, 103, 254, 260

Altoviti, Pindo, 206, 283

Ammannati, Bartolommeo, 55, 86, 100, 102, 246, 284, 292, 319, 361

Apelles, xxx, 40, 49, 62, 125, 140, 154, 158, 166, 168, 185, 206, 263, 296, 298, 341, 378, 390

Apollonius of Athens, 263, 295–96

Archadelt, Jacob, 54

Aretino, Pietro (including appearance in Dolce's *Dialogo*), 13, 56–57, 65, 88, 93, 100–101, 111, 153, 155, 228–29, 237, 276–78, 295, 307, 352, 364, 367, 373, 397, 412

Ariosto, Lodovico, xvii, 158, 187, 191, 272

Aristotle, xxv, xxx, 13, 23, 80, 94–96, 131, 133, 146, 148, 150, 156, 201, 234, 394, 396–97, 401, 403, 406, 418

Armenini, Giovan Battista, xxiv, xxviii, 34, 47, 64–65, 87, 107, 142, 162–63, 167, 193, 196–97, 199, 201–202, 207, 216, 219, 234, 245, 247, 250, 271, 280, 311–12, 395

Augustine, Saint, 242, 250

Baccio d'Agnolo, 294–97, 319, 323, 350, 370

Baglione, Malatesta, 113, 376, 378

Baldinucci, Filippo, 163

Bandinelli, Baccio, xxiv, xxvi, 100, 115, 143, 158, 161, 224, 256, 261, 283–84, 290–91, 297, 327, 351

Bandinelli, Clemente, 284, 295

Barbaro, Daniele, 103

Barocci, Federico, 281

Battisti, Eugenio, ix, 436

Bayazid II, 253–55, 258, 365–66

Beccadelli, Lodovico, xxiii, 356

Begarelli, Antonio, 168, 282, 295–97, 405

Belli, Valerio, 284, 326

Bellori, Giovanni Battista, 22, 33, 148, 153, 160, 166, 185, 206, 219, 234, 250, 281, 318, 397, 405

Bembo, Pietro, 46, 48, 187, 206

Berni, Francesco, 4, 55, 88, 92, 236, 240, 242, 249, 363, 400, 409

Bernini, Lorenzo, xxiv, 13, 49, 136, 151, 153, 163, 170, 173, 185, 190, 245, 255, 263, 287, 298, 342

Berruguete, Alonso, 264, 296

Bertoldo di Giovanni, 290, 302

Biagio da Cesena, 103

Bible, 5–6, 20, 28, 68, 81, 83, 85, 87, 107–108, 191, 208, 212, 220, 231–32, 241, 372, 419–20

Blunt, Anthony, xx, 6, 23, 66, 105, 141, 148, 212, 315

Boccaccio, Giovanni, 111, 146, 196, 332, 335

Boethius, 393

Bonasone, Giulio, 139

Borghini, Raffaello, xxiv

Borghini, Vincenzo, 261, 371

Bosch, Hieronymus, 269

Bottari, Giovanni, 275, 313

Botticelli, Sandro, 102, 138

Bracci, Cecchino, xxvi, 26–27, 77, 89, 136, 156, 183–84, 186, 225, 234, 236, 238, 240, 249, 357, 367, 384, 389, 414

Bramante, Donato, 126, 168, 206, 243, 257, 264, 277, 285–87, 292–95, 297, 302, 318, 326, 340, 376–77

Bronzino, Angelo (di Cosimo), 17, 36, 53, 272, 276, 352

Brueghel, 221, 269

Brugnuoli, Luigi, 273

Brunelleschi, Filippo, 167, 285, 294, 296, 306

Buonarroti, Buonarrota, 113

Buonarroti, Buonarroto, 55, 113, 189, 204, 246, 259, 347, 350, 384, 388

Buonarroti, Filippo, 113

Buonarroti, Giovansimone, 70, 380

Buonarroti, Gismondo (Sigismondo), 70, 238

Buonarroti, Lionardo, 9, 37, 70, 113, 130, 141, 189, 192, 204, 238–39, 261, 300–301, 341, 360, 362, 367, 381, 385, 388, 390 (nephew)

Buonarroti, Lionardo, 9, 37, 70, 113, 130,

Buonarroti, Lodovico, 183, 225, 246, 304, 331, 346, 352, 368, 375, 379–81, 393

Buoninsegni, Domenico, 244, 246, 354, 361, 370

Buscaroli, Rezio, xx, xxiii, xxix, 42, 64, 86, 105, 220, 315, 421

Busini, Giambattista, 122

Calcagni, Tiberio, 305

Calderón de la Barca, 180

Calvin, Jean, 74

Camoens, Luis de, 266

Canova, Antonio, 99, 173, 179

Caracci, Annibale, 173

Caravaggio (Michelangiolo da), 92, 220

Cardiere, Andrea, 378

Charles V, 114, 116, 118, 126, 167, 267, 276, 332, 365, 390

Caro, Annibale, 190, 279–80

Castelvetro, Lodovico, xxiv, 32, 95, 110, 190, 239, 404

Castiglione, Baldassare, 53, 57, 65–66, 125, 157, 211, 238, 299, 308, 331

Cato the Censor, xxvi

Catullus, 187

Cavalieri, Tommaso, xviii, xxiii, 9–10, 17, 58, 60, 89, 91, 112, 139, 154, 169, 182, 184, 238–39, 261, 264, 414

Celano, Thomas of (Dies Irae), xxx, 91, 114, 241

Cellini, Benvenuto, xvii, xxiv, 24, 26, 42, 44 to 45, 54, 64, 121, 137–38, 153, 186, 197, 206, 224, 244, 246, 256, 270, 282–83, 295–97, 300, 312, 316–17, 319, 322, 327, 332, 347, 349, 352, etc.

Cennini, Cennino, 88, 196–97, 242, 303, 313, 318, 388

Ceriello, G. R., xxxii, 140

Cervantes, Miguel de, 92, 150, 158, 410

Cesati, Alessandro, 283, 296, 327

Cézanne, 40, 199, 203

Cherubelli, P., 458

Cicero, xxx, 21, 56–57, 115, 135, 298, 396

Cimabue, 167, 368

Cinzio, Giraldi, xxiv, 38, 62, 95, 194, 269, 286

Clement VII, xxvi, 72, 121, 123, 141, 184, 194, 249, 256, 332, 336, 338, 369, 371, 379, 390

Colombo, Realdo, xviii

Colonna, Vittoria, xxiii, 9, 11–12, 24–25, 70, 73, 78–79, 88, 95–96, 110, 129, 136–37, 139, 153–54, 188–89, 199–200, 238, 247, 256, 261, 266, 275, 307, 336, 360, 366, 385, 387, 398, 414

Condivi, Ascanio, xviii, xxii, xxiv, xxxii, 10, 14, 37–38, 41, 43, 52, 56, 69, 72, 82, 100, 122–23, 134, 143, 156, 160, 164–66, 172, 190, 196, 203, 207, 211, 215, 234–36, 243, etc.

Corgniole, Giovanni delle, 284, 296

Correggio, 251

Cossa, Il, 289

Croce, Benedetto, 44–45, 176–77, 185, 198, 318, 395

Cronaca, Il (Simone Pollaiuolo), 286, 295

Da Carpi, Rodolfo, 41

Dante, xxv, xxvi, xxx, 38, 46, 55, 71, 73, 82, 129, 133, 151, 159, 178, 220, 225, 229, 234, 241, 250, 259, 261, 274, 291, 303, 314, 332, 339, 354, 380, 384, 387, 391–92, 394, 416–17

Danti, Vincenzo, xviii, xxiv, 16, 23, 33, 153, 161, 169, 172

Degas, xxi, 337, 341

Deinokrates, 3

Delacroix, Eugène, xvii, xxi, 44, 174, 203, 252, 270

Della Quercia, 98, 284

Del Riccio, Luigi, xvii, xxiii, 43–44, 89–90, 114–15, 145, 156, 241, 331, 363, 367, 381, 386, 388–89, 413

Del Sarto, Andrea, 280, 296, 405

Desportes, Philippe, 17, 28

Diogenes Laertius, xxx

Dolce, Lodovico, xxiv, 13, 56, 85, 93, 111, 148, 155, 157, 228, 276–77, 390, 395, 403 to 404

Donatello, 98, 133, 144, 160, 173, 175, 237, 282, 290, 296–98, 302, 308, 310, 336, 416

Doni, Anton Francesco, xxiv, 26, 135, 186, 251, 261, 312

Dossi, Dosso, 272–73, 276

Du Bellay, Joachim, 111

Dubos, Abbé, 3, 395

Dürer, Albrecht, xxi, 6, 30, 33, 53, 125, 159, 173, 212, 221, 257, 266–67, 296–98, 332, 401, 406

El Greco, 108, 179, 258, 265, 276

Fattucci, Giovan Francesco, xxi, 36, 194, 259, 261, 302, 304, 331, 339, 354, 367, 370, 372, 419

Febo di Poggio, 88–89, 182, 184

Festa, Costanzo, 54

Ficino, Marsilio, xxv, 4–7, 9–10, 15, 20, 22, 33–35, 54–55, 133, 152, 157, 169, 201, 204, 241, 250, 398, 406

Foscolo, Ugo, 240

Fra Angelico, 87, 412

Francia, Francesco, 257, 289, 297, 413

Franco, Niccolo, 87, 237, 412

François I, 115, 118, 158, 164, 191, 258, 270, 306, 332, 365–66, 370, 377

Frey, Carl, xx, xxvi, xxxi, 4, 41, 79, 129, 223, 305

Galilei, Galileo, 28, 313

Galli, Jacopo, 303

Gaurico, Pomponio, xxiv, 30, 167, 302, 308

Gautier, Théophile, 21, 395

Gelli, Giovanbattista, 57–58, 60

Ghiberti, Lorenzo, xix, xxvii, 140, 159, 167, 172, 196, 282, 295, 302, 307

Ghiberti, Vittorio, 284

Ghirlandaio, Domenico, 166, 190, 272, 279–280, 302–303, 310

Giannotti, Donato, xvii, xxiv, xxv, xxvi, 38, 65, 115, 118, 122, 142, 204, 206, 226–27, 229, 241–42, 259, 275, 279, 305, 310, 327, 335, 356, 363, 384, 393–94, 398, 400, 410–411, 414–15

Gianturco, Elio, ix, 386

Gide, André, 163, 233

Gilio da Fabriano, 102, 179, 220, 229

Giorgione, 190, 208, 213, 299

Giotto, 86, 142–43, 146, 158, 239, 272, 310, 368

Giovanni da Pistoia, 89, 274, 343

Giovanni da Udine, 215, 249, 272, 276–77, 297, 305

Girardi, Enzo, xxxi, xxxii

Goethe, Wolfgang von, 1, 3–4, 58, 94, 272

Goldscheider, Ludwig, 23

Góngora, Luis de, 182

Gotti, Aurelio, 122–23

Greco, Alessandro, 244, 285

Gregory the Great, 80, 108

Grimm, Hermann, xx, 105, 158, 223, 259, 267, 287

Grünewald, 95, 267

Guasti, Cesare, xxvi, xxxii, 70, 78, 80, 92, 140

Guazzo, Stefano, 220

Guicciardini, Francesco, 241

Hadrian VI, 268

Hall, Vernon, 194

Hispanus, Petrus, 242, 361

Hogarth, William, 177–78

Holbein, 212, 267, 370

Hollanda, Francisco de, xxi, xxiii–xxiv, xxxi, 10, 18, 41, 57–58, 60–61, 63, 76, 86, 120, 122–23, 151, 170, 200, 204–205, 255, 258, 264–65, 271, 280–81, 288, 296, 298, 304–305, 308–11, 362, 385

Homer, 138, 152, 166, 378

Horace, xix, xxv, xxx, 34, 36–41, 44, 60, 85, 110, 135, 145, 192, 197, 200–201, 206, 211, 216, 233, 239–40, 269, 396, 400–401, 404

Horapollo, 226, 231
Hutton, James, 223

Julius II, 69, 74, 113–14, 126, 184, 202, 207, 249, 254, 264, 273, 287, 306, 338–40, 349, 365–67, 369–74, 380, 384, 392
Julius III, 146, 390

Kretschmer, E., 95, 375
Kristeller, P. O., 5, 424, 428, 440

Landino, Cristoforo, 38
Lanfranco, 92
Laokoön, xxx, 98, 131–33, 157–60, 179, 264, 290, 318
Lapo di Lapo, 348, 350, 352
Lattanzio, 18, 75, 86, 92, 95, 97, 149, 201
Lee, Rensselaer W., 150, 193, 197, 220, 239
Leo X, xxvi, 238, 243, 260, 287, 303, 328, 343, 366–67, 372, 374, 384
Leonardo da Vinci, xvii, 13–14, 30, 33, 36–38, 41, 53–54, 58, 80, 82, 87, 102, 110, 121, 123, 125, 135, 141, 144, 147–48, 160–161, 165, 167, 172, 178, 190, 192–93, 201, 203, 219, etc.
Leoni, Leone, 81
Leopardi, Giacomo, 329
Lessing, Ephraim, xxx, 221, 395, 403–404
Lippi, Fra Filippo, 86
Livy, 196
Lomazzo, Giovan Paolo, xxiv, xxviii, xxx, 6, 30–32, 44, 47, 52–53, 66, 87, 93–94, 102, 111, 115, 125, 147–48, 150, 164, 167, 172, 175–77, 193, 196–97, 201, 203, 215, 217, 222, 239–40, 251, etc.
Longhi, Luca, 154, 280, 297
Longinus, 46, 138, 234, 372, 396
Lorenzetti, Ambrogio, 272
Loyola, Ignatius, 72, 74, 181, 397
Luther, Martin, 74, 289

Machiavelli, Niccolo, 121
Machuca, Pedro, 264
Magliabechiano (Anonimo), xxiv, 291
Maillol, Aristide, 98, 191
Mancina, La (Faustina), 16–17, 156, 184, 186, 199, 366
Mantegna, Andrea, 208, 272, 276, 296, 339, 358

Marcello II, 369–70, 390
Marco da Siena, 175
Mariani, Valerio, xviii, xxi, xxii, xxiii, 11, 18, 20, 25, 28, 57, 81, 94, 105, 112, 115, 129, 191, 215, 240, 354, 414
Marini, Giovanni Battista, xxx
Martelli, Niccolò, 77, 83
Masaccio, 86, 158, 272, 279, 296
Masoliver, Juan Ramón, xx, xxii, 86, 90, 318, 362, 412–13
Medici, Duke Alessandro de', 113, 115, 223, 257, 261, 378
Medici, Duke Cosimo de', 113, 115, 117, 153, 224, 284, 332, 366, 368, 381, 390
Medici, Lorenzo de' (Il Magnifico), 19, 158, 187, 211, 261, 331, 339, 368, 378
Medici, Piero de', 378
Memlinc, 237, 269
Menéndez y Pelayo, xxiii, 264, 271, 313
Menighella (Domenico di Terranuova), 110, 248–49, 305
Michelangelo the Younger, 90, 100, 129, 243
Middeldorf, Ulrich, ix, 44, 248, 277, 280, 346, 352
Milanesi, Gaetano, xxxi, xxxii, 205, 278, 338, 421
Mini, Antonio, 143, 164, 245, 265, 284, 307, 337, 349
Minturno, Antonio, 87, 160, 194, 234, 239
Morey, C. R., 106–107
Muziano, Girolamo, 281

Nanni di Baccio Bigio, 292, 294, 376, 390

Orcagna (Andrea di Cione), 279, 296
Ovid, xxv, 187, 196, 241, 329, 346

Pacioli, Luca, xxiv, 29–30, 406
Palladio, Andrea, 259, 318, 325
Panofsky, E., xx, 3, 96, 106, 134, 141, 147, 161, 171, 185, 205, 231–32, 263, 267, 414
Papini, Giovanni, xx, 69, 88–89, 109, 154, 175, 188–89, 289, 291–92, 341, 417
Parmigianino, Il, 52, 274, 276
Paul III, 35, 103, 122, 125, 194, 206, 256, 285, 287, 289, 294, 304, 318–20, 336, 345, 362, 368, 391
Paul IV, 210

Pausias of Sicyon, 63–64, 263, 297
Pericles, xxx, 330
Perini, Gherardo, 88–89, 182
Perino del Vaga, 274, 276, 296, 321, 333
Peripatetics, The, 19
Perugino II, 86, 165, 257, 287, 289
Peruzzi, Baldassare, 293, 309, 377
Petrarca, Francesco, xxii, xxvi, xxix, 15, 23, 88, 143, 196, 199, 203, 210, 241, 290, 332, 356, 374, 416–20
Phidias, 31, 84, 108–109, 167–68, 190, 199, 263, 297, 308
Philostratus, 67, 84
Pico della Mirandola, 19, 34, 68, 171
Piloto, Il, 284
Pino, Paolo, xxiv, 3, 17, 36, 43, 53, 61, 65, 86, 111, 140–41, 187, 195–96, 209, 239, 250, 262, 289, 308, 331, 335
Pius IV, 365
Plato, xxiii, xxv, 3–6, 19, 21–23, 33, 44, 46, 52, 54, 78, 96, 105, 109, 133, 146, 149–50, 152, 181–82, 231, 241, 398, 402, 405–406, 413
Pliny, xxx, 21, 100, 132–33, 152, 234, 238, 253, 262
Plotinus, xxv, 3–6, 15, 22, 33, 35, 54, 71, 87, 96, 197, 216, 250, 405–406
Plutarch, xxx, 62, 64, 267
Poggini, Domenico, xix
Poliziano, Agnolo, xxv, 4, 19, 72, 134, 161, 210–11, 241, 302
Polygnotus, 263, 296, 334
Pontormo (Jacopo Carrucci), 186, 250, 257, 280, 296–97, 352
Pordenone, Il, 53, 280, 313
Porrino, Gandolfo, 16, 156, 366
Praxiteles, xxx, 31, 100, 167, 263, 297, 308
Praz, Mario, 226
Priscianese, Francesco, xxvi, 327
Pulci the Younger, Luigi, 54
Pushkin, Alexander, 244
Pygmalion, 26, 234
Pythagoras, 30, 53, 104, 406

Quevedo, Francisco de, 116, 182
Quintilian, xxx, 46, 56–57, 157

Raffaello da Urbino, xxvii, 13, 48, 52, 56–57, 66, 104, 157–58, 187, 189–90, 203, 236

to 237, 251, 257, 272, 274, 276–78, 280, 287, 293, 296–97, 299, 302, 304, 309, 319, 328, 351–52, 376, 386, etc.
Raffaello da Montelupo, xxiv, 244, 284–85, 291, 297, 349, 351, 396
Raimondi, Marcantonio, 212–13
Rembrandt van Rijn, 234, 270
Reynolds, Joshua, xvii, 172–73, 213, 269
Riario, Raffaele, 41, 198, 373
Rilke, Rainer Maria, 67, 70, 223
Ripa, Cesare, 147, 190, 226, 228, 230
Robb, Nesca, xx, 240
Rodin, Auguste, 97, 218, 413
Rohan, Pierre de, 115, 415–16, 419
Rolland, Romain, 101, 341
Romano, Giulio, 272, 276, 295–97
Ronsard, Pierre de, 111, 417
Rosselli, Matteo, 242
Rosselli, Piero, 303, 377
Rubens, Peter Paul, 191, 213, 234, 269
Rustici, Giovan Francesco, 285

Sadoleto, Jacopo, xxx
Sangallo, Antonio da, 72, 81, 122–23, 199, 218, 230, 245, 256–57, 266, 292–94, 297–298, 320–26, 351, 382
Sangallo, Giuliano da, 123, 131–33, 179, 294, 319, 377
Sannazaro, Jacopo, 241
Sansovino (Andrea Contucci), 319
Sansovino (Jacopo Tatti), 23, 120, 257, 276, 282, 319, 349, 384
Santayana, George, 34
Santi di Tito, 40, 239
Sappho, 14
Savonarola, Girolamo, 5–6, 56, 67–69, 71–73, 81–83, 87, 93, 102, 104, 106, 113, 137, 148–49, 155, 160, 216, 226, 241–42, 284, 305–306, 354, 357, 368, 388, 419
Scamozzi, Vincenzo, 104, 259, 318
Schongauer, Martin, 108, 215, 326
Sebastiano del Piombo, xxii, 53, 74, 93, 106, 109, 120, 137, 139–40, 143, 186, 188, 240, 249, 257, 261, 270, 278–79, 287–91, 296–98, 321, 333, 348, 350–51, 357, 367, 369, 379, 384–85, 396, etc.
Seneca, 109, 329
Shakespeare, William, xxvi, 40, 51, 53, 62, 126, 225, 329

Signorelli, Luca, 159, 171, 275–76, 297, 337
Simonides, xxix, 241
Socrates, 78, 151–52, 178, 250
Soderini, Piero, 30, 254, 359, 373, 383, 419
Spinoza, 150
Steinmann, Ernst, xx, 123, 232, 458
Strabo, 87
Strozzi, Giovanni, 26, 85, 113, 222–23, 227, 381, 383
Strozzi, Roberto, 113–15, 381, 383
Symonds, J. A., xviii, xx, xxiii, xxx, 24, 79, 97, 106, 123, 159, 214, 284, 317, 352, 377, 379, 413, 416, 421

Tadda, Francesco del, 284
Taft, Lorado, 214
Tasso, Torquato, 197, 234, 239, 375, 378
Teresa, Saint, 70, 182–83
Thode, Heinrich, xx, 69, 81, 123, 138, 147
Tintoretto, Jacopo, 34, 65, 250–51
Tiziano, 40, 154, 187, 250–51, 273, 276, 286 to 287, 295–97, 332, 354, 390
Tolnay, Charles de, ix, xx, xxi, 13, 23–24, 43, 72, 83, 98–99, 114, 123, 139, 159–60, 174, 176, 191, 205, 218, 220, 224–25, 231–232, 241, 247, 251, 279, 318, 326, 341, 344, 352, 358, etc.
Tolstóy, Leo, 107, 110, 191, 200, 243, 330
Topolino, Il, 333, 344, 350
Torrigiani, Torrigiano, 10, 137, 256, 334, 412
Tromboncino, Bartolommeo, 54

Ugo da Carpi, 244, 288, 295, 297
Urbano, Piero, 137, 274, 307, 332, 345, 349, 350–51
Urbino (Francesco Amadori), 27, 136, 156, 183, 225, 243, 333, 341, 347, 351–53, 356, 366

Valéry, Paul, 16

Varchi, Benedetto, xix, xxi, xxii, xxiv, 17, 19, 20–21, 23, 35, 122, 148, 242–43, 246, 259, 261, 295, 305–306, 312–16, 355, 396, 398, 406
Vari, Metello, 332, 340, 346, 390
Vasari, Giorgio, xviii, xxi, xxiii, xxiv, xxix, xxxii, 6, 11, 15, 24, 31, 37, 42, 48, 52, 59–62, 66, 69, 72, 77, 87–88, 93–94, 99, 103, 107–109, 122, 123, 127–28, 136, etc.; Michelangelo's judgements on: 275, 281 to 282, 287–88
Vauban, Sebastien, 123
Velásquez, 234, 390
Venturi, Lionello, 56
Venusti, Marcello, 333
Vergil, xxx, 26, 179, 242, 274, 386, 394
Veronese, Paolo, xvii, 102, 212
Verrocchio, 302
Vico, Giambattista, 158, 395
Vida, Girolamo, 57, 99, 157, 194, 330
Vigenère, Blaise de, 44, 59
Vignola, Jacopo, 186, 318
Villani, Giovanni, xxx, 171, 212–13, 241
Villon, François, 129
Vitruvius, xxv, xxvii, xxx, 6, 13, 30, 53, 103, 120, 124–25, 168, 172, 194, 196, 218, 239, 320–25, 396, 403
Voltaire, 73, 238
Volterra, Daniele da, 41, 101, 151, 285, 320, 398

Winckelmann, xxx, 98
Wind, Edgar, 233, 370–71
Wittkower, Rudolf, xx, 109, 123, 458

Xenophon, 151

Yeats, William Butler, 19

Zeuxis, 30, 136, 156–58, 220, 263, 296, 298, 334, 341

INDEX OF MICHELANGELO'S WORKS

(For Italian-English equivalents of titles, consult pp. 459–461.)

Adone, 106
Antenati di Cristo, 108, 222
Apollo, 133–34, 177, 247, 416
Atlas, 134
Aurora, 26, 33, 273

Baccanalia dei putti, 134, 180
Bacco, 106, 133–34, 144–45, 215, 221, 231, 233, 404
Battaglia di Cascina, 98, 112, 143, 171, 179, 208, 212, 287, 290–91, 303, 396
Bruto, 106, 115–16, 134, 137, 152, 159, 205, 222, 229

Capitolium, 43, 318, 359
Centauromachia (Rape of Dejanira), 60, 134, 177, 179, 188, 210, 221, 302, 376
Creazione di Adamo, xix, xxxiii, 155, 159, 169, 174, 184, 190, 214
Creazione di Eva, 191
Crepuscolo, 160, 173–74, 273
Cristo giudice, xix, 91, 114, 220, 228, 241, 260, 381
Cristo risorto, xix, 81, 99, 137, 173–74, 177, 222, 233, 241, 332, 344, 346, 350–51
Crucifixions, 109–10, 128–29
Cupido dormente, 104, 106, 134, 158, 165, 198

Daniele, 99, 108, 251
Dannati, 98, 159
David (bronze), xix, 115–16, 139, 270, 282, 415–20

David (marble), xix, 23, 30, 115–16, 139, 144, 160, 171, 177, 205, 251, 284, 292, 340, 415–20
David sketches (Louvre), xxvi, 137, 415–20
David e Golia (spandrel), 94, 108, 116, 158, 212, 358, 418
Deposizione (Florence Pietà), xxii, xxxiii, 45, 59–60, 73, 81, 97–99, 106, 109, 139, 176–77, 214, 344, 358–59, 366, 411, 419
Dio crea il sole e la luna, 169
Dio separa la luce dalle tenebre, 83, 169
Dio separa l'oceano dalla terra, 169

Ercole, 134, 177, 270, 291
Ercole (drawing), 64, 134, 219
Ercole (model), 115, 134
Espulsione di Eliodoro, 114
Ester, 116–17, 358
Expulsion of Moneychangers (drawing), 109, 381
Ezechiele, 5–6, 67–68, 108, 177

Fetonte, xxxiii, 97, 107, 134, 241, 414
Fica (drawing of obscene gesture), 11–12, 89, 139
Fiumi, 32, 246
Flagellation, 109
Fortifications, 116, 121–23, 294, 351
Furia, xxv

Ganimede, 106, 112, 134, 186, 241, 414
Genii, 171, 263
Geremia, 99, 108, 139, 394

Gioele, 108, 177

Giona, 60, 108, 222

Giorno (Dì), xix, 23, 26, 99, 273

Giovanni Battista, 73, 104

Giovannino, 267

Giuditta ed Oloferne, 107, 117, 139, 212, 220, 358, 419

Giudizio universale, xxxiii, 13, 39, 61, 71, 74, 77, 93–94, 98, 101–103, 105, 116, 159, 163, 179, 184, 199, 215, 220, 247, 250, 278, 288–89, 301, 304, 343, 359, etc.

Giuliano (statue), xix, 8, 43, 100, 105, 114, 134, 152, 155, 171, 174, 176, 220, 224–25, 231–32, 237, 264, 401

Giulio II (bronze), 144–45, 153, 202, 257, 273, 276, 289, 349, 351, 373, 392

Haman, 107, 133, 160, 179, 220, 358, 411

Ignudi, 144, 156, 159, 170, 230

Leda, 102, 134, 159, 164, 206, 270, 284, 337

Lorenzo (statue), 8, 43, 114, 134, 142, 146, 152, 155, 174, 176, 220, 222, 225, 231–32, 264, 401

Madonna che allatta il Figlio, 173

Madonna della Febbre (Pietà in Saint Peter's), xxii, xxv, 8, 33, 85, 98, 137, 155, 159, 214, 358

Madonna della scala, 191

Madonna di Bruges, 144, 269, 351, 413

Madonna Doni (Holy Family), 99, 105, 159, 170–71, 184, 213, 313, 334

Madonna Medicea, 13, 83

Madonna Pitti (Florence tondo relief), 24

Madonna Taddei, 24

Medici Chapel, xix, xxii, 24, 32, 43, 103, 106, 108–109, 121, 141, 143, 160, 216, 236, 246–47, 249, 260, 304–305, 326, 358–359, 366, 370

Mosè, xxx, xxxiii, 20, 60, 73, 85, 93, 99–100, 105, 108, 116, 139, 160, 184, 205, 231, 233

Noè (Diluvio), xxxiii, 144, 159, 212, 251, 344, 358

Noè (Ebbrezza), 83, 171, 199, 212, 232, 251

Noè (Sacrificio), 251

Noli me tangere, 109, 113–14, 213, 250, 280

Notte, xix, 23, 26, 114, 116, 159, 164, 184, 222–23, 226, 230–31, 273, 294, 354, 402, 414

Palazzo dei Conservatori, 103

Palazzo Farnese, 103, 111, 186, 246–47, 294, 304, 318, 320–25, 359

Peccato, Il (The Fall), 155, 212

Piccolomini Altar, 137, 376, 381

Pietà Palestrina, xxii, 98–100, 129–30, 359

Pietà Rondanini, xxii, 98–100, 129–30, 359

Porta Pia, 103, 215, 245, 359

Prigioni (Slaves), 24, 71, 115, 134, 147, 169, 177, 180, 233, 367, 375

Putti, 99, 171, 220, 230

Resurrection, 109, 128–29

Saettatori (Archers), 60, 90, 134, 139, 171, 220

St. Peter's Cupola, 31, 69, 246, 359

Samson, 108, 170

San Bartolommeo, xxii, 73, 108, 138, 153, 184, 233, 356, 419

San Francesco (at Siena), 137, 235

San Lorenzo (Church and Facade), 120, 246, 248, 260, 285, 306, 318–19, 332, 339, 341, 350, 369, 374, 384

San Matteo, 23–24, 108, 159

San Paolo (Conversione), 93, 102, 107, 212, 346, 359

San Paolo (Siena), 139

San Petronio, 345

San Pietro (drawing), 279

San Pietro (Crocifissione), 93, 107, 112, 139, 174, 214, 346, 359

San Proculo, 73, 138, 205, 419

Sant'Antonio (after Schongauer), 215, 326, 376

Santa Maria degli Angeli, 257, 359, 373

Self-portraits, 138–39, 413–14

Serpente di bronzo, 107, 171, 221, 411

Sibilla Cumana, 184, 222

Sibilla Delfica, 191

Sibilla Eritrea, 159, 191

Sibilla Libica, 33, 99, 137, 190

Sistine Ceiling, xxii, 28, 36, 46, 48, 59, 62, 64, 83, 105, 108, 156, 187, 190, 208, 212, 218, 221, 232, 247, 251, 276, 294, 301–

303, 306, 338, 341–42, 351–52, 358, 367, 371, etc.
Sistine Chapel, xxi, 34, 163, 184, 190, 287, 293, 373
Sogno, Il, xx, 169, 180, 232

Testa di Fauno, 158
Teste divine, 58, 134, 153, 233
Times of Day, xix, 141, 205, 224, 230–31, 233, 273, 385
Tizio, xix, 97, 134, 241, 414

Tomb of Julius II, 105–106, 248, 284, 291, 302, 304, 318, 330, 338–39, 341, 362, 367, 374, 376
Tritone, 134

Venere e Cupido, 134, 190, 241, 247, 257, 280
Vittoria, Genio della, 134, 139, 177, 414
Vittorie, 134, 233

Zaccaria, 5, 108

Printed in Switzerland